A SCARLET RENAISSANCE

A SCARLET RENAISSANCE

Essays in Honor of Sarah Blake McHam

■

Edited by Arnold Victor Coonin

Italica Press
New York
2013

Copyright © 2013 by Italica Press

ITALICA PRESS, INC.
595 Main Street
New York, New York 10044
inquiries@italicapress.com

Italica Press Studies in Art & History

All rights reserved. No part of this publication may be reproduced, stored in a retrieval system, or transmitted, in any form or by any means, electronic, mechanical, photocopying, recording, or otherwise, without prior permission of Italica Press. It may not be used in a course-pak or any other collection without prior permission of Italica Press. For permission to reproduce selected portions for courses, please contact the Press at inquiries@italicapress.com.

Library of Congress Cataloging-in-Publication Data

A scarlet Renaissance : essays in honor of Sarah Blake McHam / edited by Arnold Victor Coonin.
 pages cm -- (Italica Press Studies in Art & History)
 Includes bibliographical references and index.
 Summary: "This publication features current scholarly work undertaken by former students of Sarah Blake McHam and exhibits a wide ranging discussion of Italian art from the trecento to the early seventeenth century, covering works in various media but primarily sculpture"--Provided by publisher.
 ISBN 978-1-59910-225-2 (hardcover : alk. paper) -- ISBN 978-1-59910-226-9 (pbk. : alk. paper) -- ISBN (invalid) 978-1-59910-227-6 (e-book)
 1. Art, Italian. 2. Sculpture, Italian. I. McHam, Sarah Blake, honouree. II. Coonin, Arnold Victor, editor of compilation.
N6914.S33 2013
709.45--dc23 2013001686

Cover Image: Frontispiece, Strozzi Family's hand-painted copy of Cristoforo Landino's translation of Pliny's *Natural History*. Oxford University, Bodleian Library, Arch. G b.6, 1476.

For a Complete List of
Studies in Art and History
Visit our Web Site at
www.ItalicaPress.com

CONTENTS

ILLUSTRATIONS	VII
PREFACE AND ACKNOWLEDGMENTS	
Arnold Victor Coonin	IX
INTRODUCTION	
"LIKE A GOOD SHEPHERD": A TRIBUTE TO SARAH BLAKE MCHAM	
Debra Pincus	XIII
PERSPECTIVE AND NARRATIVE IN THE JACOB AND ESAU PANEL OF	
LORENZO GHIBERTI'S *GATES OF PARADISE*	
Amy R. Bloch	1
SCULPTORS' SIGNATURES AND THE CONSTRUCTION OF IDENTITY	
IN THE ITALIAN RENAISSANCE	
David Boffa	35
BRONZINO, GIAMBOLOGNA & ADRIAEN DE VRIES: INFLUENCE, INNOVATION	
AND THE *PARAGONE*	
Meghan Callahan	57
THE SPIRIT OF WATER: RECONSIDERING THE *PUTTO MICTANS* SCULPTURE IN	
RENAISSANCE FLORENCE	
Arnold Victor Coonin	81
FROM MEDALIST TO SCULPTOR: LEONE LEONI'S BRONZE BUST OF CHARLES V	
Kelley Helmstutler Di Dio	111
"CIVITAS FLORENTI[A]E": THE NEW JERUSALEM AND	
THE *ALLEGORY OF DIVINE MISERICORDIA*	
Phillip Earenfight	131
GOD'S ODDITIES AND MAN'S MARVELS: TWO SCULPTURES OF MEDICI DWARFS	
Gabriela Jasin	161

A SCARLET RENAISSANCE ■

Medici Continuity, Imperial Tradition and Florentine History:
 Piero de' Medici's *Tabernacle of the Crucifix* at S. Miniato al Monte
 Linda A. Koch 183

A New Interpretation of Paolo Veronese's *Saint Barnabas Healing the Sick*
 Heather R. Nolin 213

Medici Power and Tuscan Unity: the Cavalieri di Santo Stefano and
 Public Sculpture in Pisa and Livorno under Ferdinando I
 Katherine Poole 239

Embellishing the Queen's Residence: Queen Christina of Sweden's
 Patronage of Gian Lorenzo Bernini and Members of
 His Circle of Sculptors
 Lilian H. Zirpolo 267

Sarah Blake McHam: List of Publications 305

Index 311

ILLUSTRATIONS

BLOCH, PERSPECTIVE AND NARRATIVE IN THE JACOB AND ESAU PANEL OF LORENZO GHIBERTI'S *GATES OF PARADISE*

1. Lorenzo Ghiberti, *Sacrifice of Isaac,* 1401-2. 25
2. Lorenzo Ghiberti, *The Resurrection* and *The Flagellation.* 25
3. Lorenzo Ghiberti, Adam and Eve panel from the *Gates of Paradise.* 26
4. Lorenzo Ghiberti, Noah panel from the *Gates of Paradise.* 27
5. Lorenzo Ghiberti, Jacob and Esau panel from the *Gates of Paradise.* 28
6. Lorenzo Ghiberti, Detail of the Jacob and Esau panel from the *Gates of Paradise.* 28
7. Lorenzo Ghiberti, Cain and Abel panel from the *Gates of Paradise.* 29
8. Lorenzo Ghiberti, Solomon and the Queen of Sheba panel from the *Gates of Paradise.* 30
9. Lorenzo Ghiberti, Jacob and Esau panel (with orthogonal lines added) from the *Gates of Paradise.* 31
10. Masolino, *Feast of Herod.* 31
11. Lorenzo Ghiberti, Detail of the Jacob and Esau panel (with pairs of tiles of equal width indicated) from the *Gates of Paradise.* 32
12. Lorenzo Ghiberti, Jacob and Esau panel (with various distance points indicated) from the *Gates of Paradise.* 33
13. Lorenzo Ghiberti, Detail of the Jacob and Esau panel from the *Gates of Paradise.* 34

BOFFA, SCULPTORS' SIGNATURES AND THE CONSTRUCTION OF IDENTITY IN THE ITALIAN RENAISSANCE

1. Lorenzo Ghiberti, *St. John the Baptist.* 51
2. Wiligelmo, inscription from the facade of the Modena Duomo. 52
3. Donatello, *Judith and Holofernes.* 52
4. Niccolò Lamberti, *St. Mark.* 52
5. Lorenzo Ghiberti, North Doors, Florence Baptistery. 53
6. Michelangelo Buonarroti, *Pietà.* 54
7. Benvenuto Cellini, *Perseus.* 55
8. Piero di Niccolò Lamberti and Giovanni di Martino da Fiesole, *Mocenigo Tomb.* 56
9. Donatello, *Pecci Tomb.* 56

A SCARLET RENAISSANCE ■

CALLAHAN, BRONZINO, GIAMBOLOGNA & ADRIAEN DE VRIES
1. Agnolo Bronzino, *Venus with Cupid and a Satyr*. 75
2. Giambologna, *Reclining Nymph/Venus with Satyr*. 75
3. *Sleeping Ariadne*. 76
4. Bronzino, *Morgante*. 76
5. Giambologna, *Morgante Riding a Dragon*. 77
6. Giambologna, *Morgante*. 77
7. Giambologna, *Reclining Venus with Satyr*. 78
8. Adriaen de Vries, *Satyr*. 79
9. Giambologna, *Reclining Venus with Satyr*. 80

COONIN, *THE SPIRIT OF WATER*
1. Lavabo, Florence Cathedral, North Sacristy. 102
2. Lavabo, Florence Cathedral, South Sacristy. 102
3. Desco da Parto, attributed to Bartolomeo di Fruosino. 103
4. Relief with scene of Urinalysis. Andrea Pisano. 103
5. *Spiritello d'acqua*. Attributed to an assistant of Bernardo Rossellino. 104
6. *Spiritello d'acqua*. Attributed to a participant on the Pazzi Frieze. 105
7. *Spiritello d'acqua*. Anonymous Sculptor. 105
8. *Spiritello d'acqua*. Anonymous Sculptor. 106
9. *Spiritello d'amore*, Mino da Fiesole. 106
10. *Spiritello d'acqua*. Designed by Antonio Rossellino. 107
11. *Spiritello d'acqua*. Andrea della Robbia. 108
12 Geloiastos Fountain Sculpture. From Francesco Colonna, *Hypernotomachia Poliphili*. 109
13. *Spiritello d'acqua*. Pierino da Vinci. 110
14. *Spiritello d'acqua*, Musée de la Chartreuse. 110

DI DIO, FROM MEDALIST TO SCULPTOR
1. *Bronze Bust of Charles V*. 123
2. Base of the *Bronze Bust of Charles V*. 123
3. Leoni, Doria/self-portrait medal. 124
4. Leoni, Philip II medal. 124
5. North Italian inkstand. 125
6. Venetian andiron. 126
7. Leoni, Bust of Charles V. 127
8. Unknown sculptor, *Giacomo Maria Stampa*. 128
9. Angelo Marini, *Bust of Alessandro Grassi*. 129
10. Unknown sculptor, *Gabrio Serbelloni*. 130

ILLUSTRATIONS

EARENFIGHT, "CIVITAS FLORENTI[A]E"
1. Follower of Bernardo Daddi, *Allegory of Divine Misericordia* (detail). 153
2. Follower of Bernardo Daddi, *Allegory of Divine Misericordia*. 154
3. Plan of the Piazza S. Giovanni. 155
4. Alberto Arnoldi, Loggia/Oratory and Residence of the Compagnia di Sta. Maria della Misericordia. 156
5. Reconstruction of Loggia/Oratory and Residence of the Compagnia di Sta. Maria della Misericordia with the *Allegory of Divine Misericordia*. 156
6. Interior of the Entrance Hall showing the *Allegory of Divine Misericordia*. 157
7. *Divine Misericordia*, detail. 158
8. *Last Judgment* (detail), Baptistery, Florence. 158
9. *Last Judgment*. Rome, Vatican, Pinacoteca. 159
10. *Last Judgment*, Augustine, *De civitate Dei*. 160
11. Andrea di Bonaiuti, *Way of Salvation*. 160

JASIN, GOD'S ODDITIES AND MAN'S MARVELS
1. Valerio Cioli, *Morgante*. 178
2. Valerio Cioli, *Pietro Barbino*. 179
3. Agnolo Bronzino, *Nano Morgante*. 180
4. Giambologna, *The Dwarf Morgante Riding on a Dragon*. 181
5. Giusto Utens, *Pitti Palace and Boboli Gardens*. 181
6. *Man Riding a Tortoise*. Moss agate ringstone. 182
7. Aldus Manutius, *Festina Lente*. 182

KOCH, MEDICI CONTINUITY, IMPERIAL TRADITION AND FLORENTINE HISTORY
1. *Tabernacle of the Crucifix*. S. Miniato al Monte. 206
2. Interior view of nave toward altar. S. Miniato al Monte, Florence. 207
3. Altar of the *Tabernacle of the Crucifix*. S. Miniato al Monte, Florence. 207
4. *Tabernacle of the Crucifix*. S. Miniato al Monte, Florence. 208
5. *Tabernacle of the Crucifix*, back side. S. Miniato al Monte, Florence. 209
6. *Tabernacle of the Crucifix*, canopy. S. Miniato al Monte, Florence. 209
7. Falcon Impressa, *Tabernacle of the Crucifix*. S. Miniato al Monte, Florence. 210
8. Scale-covered sarcophagus. Mausoleum of Galla Placidia. Ravenna. 210
9. Plan. S. Miniato al Monte, Florence. 210
10. Masaccio, *Holy Trinity*. 211

NOLIN, A NEW INTERPRETATION OF PAOLO VERONESE'S *SAINT BARNABAS HEALING THE SICK*
1a. Paolo Veronese, *Martyrdom of Saint George*. 230
1b. *Martyrdom of Saint George* in situ. 230
2. Paolo Veronese, *Saint Barnabas Curing the Sick* or *the Miracle of Saint Barnabas*. 232
3. Plan of S. Giorgio in Braida's altars. 233
4. Moretto da Brescia, *The Virgin Saints Cecilia, Catherine, Agatha, Agnes and Lucy*. 234

IX

5. North (*à Cornu Evangelii*) side of the transept of S. Giorgio in Braida. 235
6. South (*à Cornu Epistolae*) side of the transept of S. Giorgio in Braida. 235
7. Reconstructon of Veronese's *Saint Barnabas Healing the Sick*. 236
8. Evidence of the original cloister entrance. 236
9a. Bernardino India, *Martyred Saint*. 237
9b. Bernardino India, *Martyred Saint*. 237
10a. Bernardino India, *Pope Saint Gregory*. 238
10b. Bernardino India, *Saint Jerome*. 238

POOLE, MEDICI POWER AND TUSCAN UNITY
1. Pietro Francavilla. *Monument to Cosimo I*. 258
2. Giovanni Bandini and Pietro Tacca. *Monument to Ferdinando I*. 259
3. Pietro Francavilla. *Monument to Cosimo I*. 260
4. Giambologna. *Oceanus*. 260
5. Pietro Francavilla. *Monument to Cosimo I*, detail of breastplate. 262
6. Giovanni Bandini. *Monument to Ferdinando I*, detail of Bandini's colossus. 263
7. Plan of Livorno with the *Monument to Ferdinando I* and the slave *bagno* identified. 264
8. Anonymous. *View of the Port at Livorno*. 264
9. Pietro Tacca. *Monument to Ferdinando I*, detail. 265
10. Pietro Tacca. *Monument to Ferdinando I*, detail. 266

ZIRPOLO, EMBELLISHING THE QUEEN'S RESIDENCE
1. Antonio Tempesta, Pianta di Roma. 296
2. Giovanni Battista Falda (attr.), Aerial view of the Palazzo Riario. 296
3. Palazzo Riario, plan, cantina and piano terra, rendered by Tommaso Corsini. 297
4. Palazzo Riario, plan, piano nobile and third story, rendered by Tommaso Corsini. 298
5. Gian Lorenzo Bernini, *Salvator Mundi*. 299
6. Bacchic Altar. Madrid, Prado Museum. 299
7. *Dioscuri* (San Ildefonso Group). 300
8. *Euterpe*. Madrid, Prado Museum. 301
9. Francesco Maria Nocchieri, *Apollo*. 302
10. *Clytie*, Madrid, Prado Museum. 302
11. Camillo Arcucci, Palazzo Riario, Sala delle Muse, plan and elevations. 303

PREFACE AND ACKNOWLEDGMENTS
ARNOLD VICTOR COONIN

With great affection and humility the contributors to this volume dedicate studies to Sarah Blake McHam. The title "A Scarlet Renaissance" may elicit various connotations but in the context of Rutgers University the color refers to our moniker, the Scarlet Knights. The term "Renaissance" has obvious meaning to the expected audience, being our collective historical specialty, but it has added significance to the graduate program in Italian Renaissance Art. The graduate program in Art History had its birth at Rutgers under the direction of James Stubblebine, the great art historian and connoisseur of duecento and trecento Italian art. Sarah came to the department in 1978, working alongside Stubblebine. Upon Stubblebine's untimely death in 1987, the graduate program reached a significant crossroads. Sarah's impact became magnified, and under her guidance the specialization in Italian Renaissance Art had a substantial rebirth, with Sarah eventually working closely with Rona Goffen (from 1990 to 2004) and currently with Benjamin Paul (since 2007) to direct students. Professors Tod Marder and Catherine Puglisi, specialists in the Italian Baroque, have also played key roles alongside Sarah in shaping this part of the program, serving as readers and rigorously preparing students as art historians.

Over the past thirty-five years, Sarah has guided more than a score of students through their Ph.D. dissertations, has acted as a mentor to many more, and she continues to shepherd new students through the program. All the while Sarah has contributed remarkable work as a scholar. It is a rare professor who serves as teacher, role model and critic, then gracefully transitions to supportive colleague and good friend. Sarah's students have all had similar experiences in witnessing her generosity by sharing her wisdom and offering her kindness.

The best plots are often hatched serendipitously and take on a life of their own. The idea to honor Sarah for her many years of teaching was discussed by several of her former graduate students at various times. A symposium coalesced under the guidance of Catherine Puglisi, and this publication is a further outgrowth of these discussions. All had to be kept quiet because Sarah would never have encouraged such behavior. She was informed once we were past the point of no return. Kelley Helmstutler di Dio spearheaded the

symposium, while I had the privilege of soliciting and editing a collection of essays to be presented in Sarah's honor. The contributors are Sarah's former students, all but one of whom wrote dissertations under her primary guidance.

This publication is not a record of the symposium but rather a complement to it as tribute. It features current scholarly work undertaken by her former pupils, vetted through the peer-review process and presented as a gift at the time of the symposium. The essays exhibit a wide range of discussion of Italian art, in keeping with Sarah's interests. Chronologically the papers range from the trecento to the early seventeenth century, covering work in various media but primarily sculpture. There is also a common method of using interdisciplinary evidence and attempting to rigorously understand the role art played within its producing culture. We hope that the quality of discussion meets her high standards.

There are many to thank for helping make this publication possible. It was remarkably easy to engage colleagues in the sense that at every crucial stage all we had to do was mention Sarah's name and the answer to any request was an unequivocal "yes." I first wish to thank Ronald G. Musto and Eileen Gardiner at Italica Press for including this tribute to Sarah in their stellar list of Festschrift volumes devoted to Renaissance studies. It is particularly fitting that two other volumes in this series honor Sarah's mentors and friends, Irving Lavin (with whom she studied at the Institute of Fine Arts) and Marilyn Aronberg Lavin. Both have been enormously supportive of Sarah's students. We feel privileged to include Sarah's tribute alongside theirs.

Colleagues from all corners offered their assistance in vetting and editing the essays. Special thanks goes to Stephen Campbell, Michael Cole, Tracy Cooper, Sally Cornelison, Roger Crum, Estelle Lingo, Alison Luchs, Tod Marder, Barnaby Nygren, Allison Palmer, Benjamin Paul, John Paoletti, Catherine Puglisi, Gary Radke, Joaneath Spicer and Louis Alexander Waldman. Additional thanks goes to Catherine Puglisi for helping to secure funds to make this possible. Financial assistance for the publication was provided by Rhodes College and Rutgers University. Finally, I need to thank my family who allowed me to drive them crazy while I worked on this project.

Memphis, April 2012

INTRODUCTION
"LIKE A GOOD SHEPHERD"
A TRIBUTE TO SARAH BLAKE MCHAM
DEBRA PINCUS

Sarah Blake McHam has been my dear friend and colleague for over thirty years. We met in those august halls of the Institute of Fine Arts on Fifth Avenue and 78th Street, in New York City. We were both involved in sculpture, with a focus on Venice, and we belonged to a circle of sculpture enthusiasts. There was always much to discuss — time spent with Sarah never seemed long enough. I recall once our running into each other on a plane on our way to the annual medieval conference at Kalamazoo and immediately plunging into a detailed art history discussion. As the plane was landing, the man across the aisle leaned over: "How fortunate you are as colleagues to be able to discuss and inform each other with such passion!"

She is one of those scholars who handle sculpture and painting with equal ease. But it is "the powerful physical presence of sculpture," as she once expressed it, that has most consistently fired her imagination. She is one of the many important scholars working in the field of Italian Renaissance sculpture who were early inspired by the teaching of James Holderbaum, with whom she studied as an undergraduate at Smith College in Northampton, Massachusetts. Holderbaum's own focus was on Giambologna — a sculptor on whom Sarah herself was later to work. Sarah has indicated her debt to Holderbaum in the acknowledgements of almost every one of her publications. At the Institute of Fine Arts, she worked with Irving Lavin, whose focus on teasing out multiple strands of style and reference in a work of art has been fundamental for the kind of art history that she has developed.

Tullio Lombardo was front and center in the first phase of her work. Her dissertation on Tullio, done under Lavin, was completed in February of 1977 and published in 1978 in the Garland series of Outstanding Dissertations in the Fine Arts as *The Sculpture of Tullio Lombardo: Studies in Sources and Meaning*. A bellwether of Sarah's work to come, it went for depth. Three commissions were considered, each representing a difficult problem in Tullio studies. Profiting from the Lavin methodology, the dissertation demonstrated what has become McHam's signature style — her ability to show how a particular work of art gathers and reshapes numerous sources to produce its own statement.

A SCARLET RENAISSANCE ■

Thanks to Sarah and other scholars, Tullio has begun to be recognized as a major figure in the formation of High Renaissance sculpture in Italy. The scholarly literature hasn't quite caught up with this information — but it will. Sarah's work, and those inspired by her, are making sure that the gap is closed. Benefiting from the road opened up by her, for example, Alison Luchs produced a beautiful and comprehensive book on the double portrait relief in the Veneto and Tullio's crucial role in its development, a study that bore further fruit in the riveting exhibition held at the National Gallery of Art, Washington, DC in 2009.

Over a decade of work, beginning in the early 1980s into the mid 1990s, brought to press Sarah's study on the chapel of Saint Anthony in the basilica of Saint Anthony — the Santo — in Padua: *The Chapel of St. Anthony at the Santo and the Development of Venetian Renaissance Sculpture.*[1] In the initial stages of this project, she worked in collaboration with Wendy Stedman Sheard, whose early and untimely death was a severe blow to all of us. Sarah and Wendy worked together with the Santo authorities to produce a full photographic documentation of the chapel — the first thorough photographic campaign to have been undertaken.

The Santo volume stands as the most complete study of the veneration of a saint as it took place in Renaissance Italy. The range and the detail of the investigation is astonishing. To name a few of the topics included here: collaboration between the artists who worked on the project and the patrons who served on the Santo's directorate; the Renaissance veneration of a saint within the frame of Catholic and Protestant developments; the analysis of Tullio as both sculptor and architect. Part of the contribution was the combing through the mass of documents preserved in the Santo archives to produce a clear chronology of the progress of the architecture of the chapel and its sculptures. The book is hard-core art history at its best.

Balancing documents and visual analysis, Sarah argued for the project as the result of a collaboration between Tullio and the *massari* — the overseers of the fabric of the basilica, a body that included leading intellectuals of sixteenth-century Padua. Tullio was brought forward here as the designer, giving impetus to what has become a major development in Tullio research — his activity as an architect. I never "got" the chapel until Sarah made me see that here, for the first time in the handling of a saint's shrine, narrative reliefs previously confined to the sarcophagus were monumentalized in scale and placed on the walls surrounding the tomb. The result is an animated space that wraps viewer and pilgrim in the heady world of miracles.

1. New York: Cambridge University Press, 1994.

Spin-offs from the large Santo project include a small booklet prepared for the Santo itself, *A Guide to the Chapel of the Arca of St. Anthony of Padua*,[2] and the article on "Donatello and the High Altar in the Santo, Padua."[3] Inspired by her work on the arca of Saint Anthony, the Donatello study argues that the form of the altar and the disposition of the reliefs represents a deliberate incorporation from the model of saints' tombs as already well known in the thirteenth century. Her essay concludes with a moving comment on the change in artistic taste that had radically altered the altar, destroying "one of the most beautiful creations of the greatest sculptor of the fifteenth century."

A close second to Tullio in Sarah's scholarship has been her interest in public sculpture. In a certain sense, the Santo project also fits into this frame, in the way that it unites public space with private devotion. She was interested in public sculpture at an early stage in her career. Even in the years of Tullio concentration, there was the essay on Donatello's *Dovizia* for the Mercato Vecchio in Florence.[4] A complete demonstration of this aspect of her work is the masterful article, "Public Sculpture in Renaissance Florence," her contribution to *Looking at Italian Renaissance Sculpture*, a volume Sarah edited.[5] The article systematically deals with the filling of the Piazza della Signoria with public monuments, creating a political history in sculpture — "a permanent record of the different definitions of the city's image." The essay begins with Donatello's *Judith and Holofernes*, brought from the Medici Palace to the *ringhiera* of the piazza in 1495 on the reinstatement of the Florentine Republic, then moves forward to the colossal statues of Michelangelo and Bandinelli, sculpture groups celebrating allegorically the rule of Cosimo I, finishing with the unabashed celebratory equestrian statue with elaborate base by Giambologna, erected by Cosimo's son Ferdinando between 1587 and 1594.

Longer individual studies of many of these monuments were to follow. Particularly impressive among these is the step-by-step examination of the preparation of Giambologna's Cosimo equestrian monument.[6] The Cosimo monument was placed in the piazza — its base still only partially completed — in 1594: a symbolic statement "erasing" the expulsion of the Medici from Florence one hundred years earlier in 1494. Among the many satisfying aspects of this essay is the examination of the narrative reliefs of the base — practically

2. Padua: Edizioni Mesaggero Padova, 1995.
3. *IL60: Essays Honoring Irving Lavin on his Sixtieth Birthday*, ed. Marilyn Aronberg Lavin (New York: Italica Press, 1990), 73–96.
4. "Donatello's *Dovizia* as an Image of Florentine Political Propaganda," *Artibus et historiae* 14 (1986): 9–28.
5. New York: Cambridge University Press, 1998, paperback edition 2000.
6. "Giambologna's Equestrian Monument to Cosimo I: The Monument Makes the Memory," in *Patronage and Italian Renaissance Sculpture*, ed. Kathleen Wren Christian and David J. Drogin (Aldershot, UK: Ashgate, 2010), 195–222.

passed over in the scholarly literature prior to her treatment — "charged to make them seem first-hand, documentary visualization." A companion analysis of the decorations of the Palazzo della Signoria, "Structuring Communal History through Repeated Metaphors of Rule," was published in the volume edited by Roger J. Crum and John T. Paoletti.[7] Here the focus was on detailing changes from the fourteenth through the late sixteenth century, in the building and its decoration, as the palazzo was pulled into the Medici orbit and as its identity took on successive layers of reference, moving from celebrating Florentine republicanism to glorifying Cosimo and his family.

One of my favorites of her public sculpture essays, one that has been particularly useful to me in my own work, is "Renaissance Monuments to Favorite Sons."[8] Discussed in exquisite detail here is the entire corpus of public monuments erected at civic expense in fifteenth-century Italy to honor ancient Roman figures. Notices of these works were to be found in articles by local antiquarians. But no one prior to Sarah had understood that the lack of an analysis of them as a group was a major gap in the literature. She rightly saw that filling that gap would help in understanding another piece of the Renaissance connection to antique culture. Her footnotes are always gold mines; the ones in this essay are among the richest. I find myself marveling at the brain power that brought all this together.

Tombs are another category of public sculpture, and her studies of tombs stresses the gamesmanship of these monuments. In her essay on the tomb of Doge Giovanni Mocenigo in the church of SS. Giovanni e Paolo in Venice, that monument is analyzed as the most explicit statement of a group of Venetian tombs and monuments that present the doge as the divinely designated ruler of an eternal Venetian empire: "La tomba del doge Giovanni Mocenigo: Politica e culto dinastico."[9] Her study of the tomb of the sculptor Andrea Bregno investigates the antique and contemporary sources that would allow for the celebration of the achievement of a working sculptor.[10]

And let's not overlook the mountain of book reviews that this formidable scholar has produced along the way. There is a focus on books on sculpture to be sure, but the reviews range widely, serving as another indication of the breadth of her interests, and knowledge. One finds here finely honed analyses of paintings, drawings, exhibitions, iconographic studies and conference proceedings. These reviews stand as a clear demonstration of her synthetic

7. *Renaissance Florence: A Social History* (New York: Cambridge University Press, 2006), 104–37.
8. "Renaissance Monuments to Favourite Sons." *Renaissance Studies* 19.4 (Sept. 2005) : 458–86.
9. In *Tullio Lombardo: Scultore e architetto nella Venezia del rinascimento. Atti del convegno di studi, Venezia, Fondazione Giorgio Cini, 4-6 aprile 2006*, ed. Matteo Ceriana (Verona: Cierre Grafica, 2007), 81–98.
10. "Tomba come testamento. Il monumento funerario di Andrea Bregno," in *Andrea Bregno: Il senso della forma nella cultura artistic del Rinascimento*, ed. Claudio Crescentini and Claudio Strinati (Rome: Ministero per i Beni e le Attività Culturali and Maschietto editore, 2009), 414–29.

facility — the ability to get to the core of an author's argument and to nail it in a single sentence.

Finally we come to Sarah's Pliny book — *Pliny and the Artistic Culture of the Italian Renaissance: The Legacy of the Natural History*[11] — the major project of her mature scholarly career. The germ of the book goes back to her very early years as a scholar. I have been struck by the thread of references to Pliny running through it all. The book has, in fact, been preceded by several essays focusing on the influence of Pliny in specific Renaissance projects. It is typical of Sarah that she would take a hard look at the literary texts that serve as the underpinning of Renaissance art history and identify as a major lacuna in the scholarly picture the encyclopedia of Pliny the Elder. The Renaissance recognized Pliny as a lifeline to important vanished fonts of information. But exactly how the Renaissance used Pliny and how his information was assessed and analyzed had never been systematically investigated. There are a number of strengths that have made her a natural to do the Pliny. First, that ferocious, wide-ranging knowledge of Renaissance art production, encompassing painting and sculpture as well as architecture. Then there are the language strengths — wide reading in Latin, for example, poses no problem for her. And finally, her sheer enjoyment in the handling of texts, whatever language they might be in, reminding me of the pleasure she takes in nineteenth-century English literature.

How our dear friend has managed to combine this intensive scholarly publication schedule (and there is much that I have left unmentioned here!) with a program of full-out service to the academic community is something difficult to understand. She is the person who organizes up-to-the-minute sessions at annual meetings, gives keynote addresses at major conferences, reads prospective manuscripts for book publishers, for whom she provides long and detailed reports. It is Sarah who steps up to the plate when a writing slot needs to be filled as the result of unexpected developments. Her involvement in the Renaissance Society of America deserves a chapter in itself. There she has been one of the major organizers of sessions — three and four per meeting — and now inspiring her students to do the same. When Sarah attends a conference, it is never as a casual participant. She makes it a point to hear every talk given by one of her students. And if she is present as a member of the audience, one waits with pleasure for her calm, intelligent comments. All of this is done without fanfare, as if it were just a normal part of an ordinary working scholar's life.

I cannot end this review of Sarah's career without a word about her involvement with her students. This volume is itself impressive testimony of what they have achieved. This is no small aspect of the total picture. She may

11. New Haven and London: Yale University Press, in press.

A SCARLET RENAISSANCE ■

have produced more Ph.D. dissertations than any American scholar of her generation. As of last year (July 2011), twenty-two students had completed their dissertations under Sarah, with another five in process. The subjects — as might be expected — range across the map of the Renaissance: fourteenth through sixteenth century, small, focused studies and broad embracing topics. One finds within the list major centers — Florence, Venice and Siena — and smaller territories, manuscripts, sculpture and painting, fresco cycles and pictorial strategies, religious orders and rulers. Her students have gone on to hold major positions in museums, universities, galleries and public institutions across the country. It is fitting that the last word here should be a description coming from one of Sarah's students, "Incredibly nourishing as a professor, always giving you the sense that she cares about you as a person, taking you through complicated issues like a good shepherd."

■

PERSPECTIVE AND NARRATIVE IN THE JACOB AND ESAU PANEL OF LORENZO GHIBERTI'S *GATES OF PARADISE*

AMY R. BLOCH

Throughout his career Lorenzo Ghiberti produced works in which illusionistic spaces hold and highlight dramatic narratives.[1] The first evidence of his engagement with the representation of story in space comes in the work that launched his career, the *Sacrifice of Isaac* of 1401–2, his entry in the competition for the commission to create the Florence Baptistery's second set of bronze doors (Fig. 1).[2] In this famous image Ghiberti represented all of the essential episodes of the Bible's story of God asking Abraham to sacrifice his only son Isaac as a demonstration of faith (Gen. 22). We join the action just as he aims a dagger at Isaac's neck. Abraham, of course, never does complete the act, because God, seeing Abraham's willingness to obey as adequate proof of his faith, sends an angel to stop the sacrifice and provides a ram to offer in Isaac's place. In the panel, the angel, who swoops down from behind the human figures, is masterfully foreshortened and appears to cut through the hard bronze background as it flies into the image, thus demonstrating Ghiberti's early interest in representing the illusion of depth in a relief. But in this panel we also see another element that occupied him from the very beginning: the illustration of, and emphasis on, the human emotions that accompany biblical narratives. Indeed, to enhance the drama, Ghiberti represented not an Abraham blindly following the order of his God, but a man who, when asked to kill his own son, can lift the knife but cannot immediately bring himself to use it, and who in fact extends his index finger in order to steady the blade. The image suggests not Abraham's unwavering faith, but his hesitation and

1. This essay develops ideas first presented in a lecture I gave at the Metropolitan Museum of Art in New York in November 2007. I owe special thanks to James Draper, who invited me to speak on that occasion, to Barry Trachtenberg for his bibliographic assistance and to John Najemy for his much appreciated suggestions and advice.
2. On the circumstances of the competition and on those who participated in it, see Richard Krautheimer, *Lorenzo Ghiberti* (Princeton: Princeton University Press, 1956; reprint eds. 1970, 1982), 31–43; and the entries in *Lorenzo Ghiberti: "Materia e ragionamenti"* (Florence: Centro Di, 1978), 58–72.

thus internal conflict. The angel increases the dramatic quality of the scene as it bursts through the plane that serves as the boundary between the human world and the divine to convey God's interdiction.

Such dramatic representations dominate the spaces Ghiberti created in the panels of his first (1403–24) and second sets of baptistery doors (1425–52; the *Gates of Paradise*). The small quatrefoil panels of Ghiberti's first doors (Fig. 2) provided only limited amounts of surface on which to arrange the New Testament stories, which take place in confined landscapes or in front of simple, often schematic architectural settings. For the *Gates of Paradise*, Ghiberti used much bigger panels that measure thirty-one inches square, and this larger format allowed him to insert numerous episodes from extended, continuous narratives into each visual field. The stories contained in the four earliest panels (Adam and Eve, Cain and Abel, Noah, and Abraham and Isaac) unfold in fictive outdoor worlds, within deep spaces filled with rocky outcroppings, open fields, flowing streams, groves of trees and hills (e.g., Figs. 3, 4 and 7). In the fifth relief (Fig. 5), located exactly halfway down the doors' left valve — about a foot above eye level — and depicting events from the lives of Isaac, his wife Rebecca and their twin sons Esau and Jacob, a massive architectural structure and tiled floor dominate the image. The edges of the building and the outlines of the tiles form part of the grid of orthogonal and transverse lines that serves as a skeleton for the fictive space that exists illusionistically beyond the panel's flat surface.[3] This image represents one of the earliest perspectival spaces produced during the fifteenth century, and numerous studies have focused on the system that Ghiberti employed in designing its internal framework.[4] Most treatments of the panel's spatial composition, however, leave aside considerations of the biblical story of Isaac, Rebecca, Jacob and Esau, even though the work's primary function is to represent events from their lives as part of the expansive Old Testament cycle contained within the doors' ten panels and twenty-four framing strips. As this essay will show, in the Jacob and Esau relief the construction of space and the production of a convincing illusion of three-dimensionality must be understood in the context of Ghiberti's desire to depict compelling and

3. For a comprehensive treatment of Ghiberti's use of linear perspective in the *Gates of Paradise*, see Krautheimer, *Lorenzo Ghiberti*, 229–53.

4. On the perspective structure of this panel, see, among many: Martin Kemp, *The Science of Art: Optical Themes in Western Art from Brunelleschi to Seurat* (New Haven and London: Yale University Press, 1990), 24–27; John White, *The Birth and Rebirth of Pictorial Space* (New York: Harper & Row, 1972), 160–63; Krautheimer, *Lorenzo Ghiberti*, 249–52; and Alessandro Parronchi, "Le 'misure dell'occhio' secondo il Ghiberti," *Paragone* 12 (1961): 18–48, where the author suggests that Ghiberti's spatial calculations were adjusted according to a presumed viewpoint located in front of the *Gates*. Like Parronchi, I do not think Ghiberti planned the panels by employing Alberti's perspectival rules. But, as I stress in this essay, I do not agree that the doors and their panels are meant to be examined from single viewpoints. Reading the narratives successfully requires the viewer to shift positions in order to take in all of the reliefs' details and examine the scenes both individually and in pairs.

expansive biblical stories. Moreover, his experimentation with linear perspective — a system Ghiberti and others developed in the early decades of the fifteenth century — led him to create, in the panel, a revolutionary type of narrative.[5]

NARRATIVE

The architectural structure in the Jacob and Esau panel, an elegant arcaded hall two bays wide and two bays deep, with a one-bay-wide porch attached to its right side, is an ideal, fictional notion of Isaac's dwelling, complete with classicizing Corinthian pilasters possibly designed, and probably chased into the panel, by Michelozzo, an active member of Ghiberti's workshop during the period when the doors were being completed.[6] It culminates a series of architectonic structures found in the first three panels of the doors' left valve. The Adam and Eve panel (Fig. 3), which opens the cycle, contains a single arched gate that serves as the entrance to the garden of Eden, as well as a low fence made of smoothed tree branches and located next to the representation of Adam sleeping during Eve's creation. These rudimentary structures are followed in the Noah panel (Fig. 4) by a shed comprised of post-and-lintel walls and a thatched roof, to which Ghiberti attached another porch, this time a pergola defined by single beams supporting trellises around which grow vines heavy with grapes. In the next panel of the left valve Ghiberti represented Isaac's palace (Fig. 5), which includes all of the architectural elements found in the panels located above it: its form, with a main section and attached porch, follows in its general outlines the simple ground plan of Noah's shed, and its component parts — arched openings flanked by pilasters that support classicizing entablatures — combine, in refined form, the arch of the gate of Eden and the simple, trabeated supports employed in the construction of both Noah's shelter and the fence in the Adam and Eve panel.[7]

Within Isaac's palace, in front of it, above it, and to the right, Ghiberti distributed seven episodes from the Old Testament's account of the lives of Isaac, Rebecca, Jacob and Esau, which come from two chapters of the book

5. Throughout this chapter I refer to the doors' fifth polyscenic narrative as the Jacob and Esau relief or panel.
6. Krautheimer, *Lorenzo Ghiberti*, 265 n. 21; idem, "Ghiberti architetto," *Bulletin of the Allen Memorial Art Museum* 12 (1955): 48–67; and Howard Saalman, "Filippo Brunelleschi: Capital Studies," *Art Bulletin* 40 (1958): 113–37, esp. 119–20.
7. Related, evolving architectural forms are also found in the three upper panels of the doors' right valve, which depict respectively stories of Cain and Abel, Abraham and Isaac, and Joseph. In the first of these, Adam, Eve and the young Cain and Abel sit beside a round, thatched hut; next comes a round, cloth tent in the scene of the announcement of Isaac's birth, which occupies the lower-left corner; and finally in the Joseph panel, a centralized, monumental grain market based on a circular plan dominates the image.

of Genesis (25:21–34 and 27:1–40).[8] In the autobiographical section of his *Commentaries* Ghiberti summarized the panel's narrative, but his description, like most of those he gave for the other nine reliefs, does not mention all of the individual episodes that actually appear and instead recounts, in general terms, a selection of the image's scenes along with additional details included in the Bible but not actually represented in the relief:

> In the fifth panel is [depicted] how Esau and Jacob are born to Isaac, and how he sent Esau to hunt, and how the mother [Rebecca] instructs Jacob and gives him the kid and the skin and puts it on his neck and tells him to ask Isaac for his blessing, and how Isaac feels for [Jacob's] neck and, finding it hairy, gives him the blessing.[9]

Ghiberti not only omits scenes but also mentions events that do not appear, giving modern readers the impression that he was simply summarizing the biblical stories as he remembered them when he was writing.[10] It should be stressed that Ghiberti left the *Commentaries* unfinished at his death in 1455, and the version that survives today is essentially an incomplete draft. It is possible that Ghiberti's descriptions came from notes, perhaps connected to an early or incomplete version of the plan, and that he intended in the final version of his text to adjust these descriptions so that they agreed with what he had actually depicted in each relief.

The narrative of the Jacob and Esau panel opens with one of the events that Ghiberti does not mention. Rebecca, the Bible claims, endured a difficult pregnancy during which she felt her children struggle within her womb, and in the panel she is perched atop the hall's porch, having asked God why her unborn children fight (Fig. 6). God offers his response through speech in the Bible, and in the relief, emerging from the clouds, he communicates his reply through two gestures: pointing fingers and a hand with an open palm. Throughout the *Gates* the latter action signifies speech. In the 57 panel (Fig. 7), for example, God makes such a gesture when, knowing that Cain has already murdered Abel, he asks Cain about his brother's whereabouts (Gen. 4:9–12). God's open right hand

8. On the date of composition, literary structure and interpretation of these chapters, see Claus Westermann, *Genesis 12–36: A Continental Commentary*, trans. John J. Scullion, S.J. (Minneapolis: Fortress Press, 1995), 410–19 and 431–44.
9. Ghiberti, *I commentarii*, ed. Lorenzo Bartoli (Florence: Giunti, 1998), 96: "Nel quinto quadro è come a Ysaach nasce Esaù et Iacob, e come e' mandò Esaù a cacciare e come la madre amaestra Iacob, e porgeli il caveretto e la pelle, e poglele al collo e dicegli chiegga la benedictione a Isaach; e come Isaach gli cerca il collo e truovalo piloso, dagli la benedictione."
10. On this issue, see Janice L. Hurd, "Lorenzo Ghiberti's Treatise on Sculpture: The Second Commentary" (Ph.D. Diss., Bryn Mawr College, 1970), 239 n. 157; and Creighton Gilbert, "The Archbishop on the Painters of Florence, 1450," *Art Bulletin* 41 (1959): 75–87, esp. 84 and n. 40.

announces his question, Cain replies with the same gesture to tell God that he does not know where Abel is and to deny responsibility for him, and then God communicates his condemnation of Cain's violent act by extending his left hand, this time its palm facing the ground. In the Jacob and Esau panel God extends his open right hand — his speaking hand — towards Rebecca and, to remind viewers of his words at this moment, extends the first two fingers of his left hand: two opposing nations, he says in the Bible and in the relief, will derive from her offspring, and one will triumph over the other. The two fingers are especially evident when light illuminates the panel's surface directly.

This scene is one of two that take place outside the regular, perspectival space that structures most of the panel. The other, in which Esau ascends a hill as he leaves to hunt, focuses on a figure who is, like Rebecca in the first episode, fundamentally unaware. Just as Rebecca appeals to God to understand why her children struggle, Esau, in this moment, does not realize that his mother and brother conspire against him in his absence (more on these episodes later) and act in ways that will define his destiny. Appropriately enough, Ghiberti removed both of these figures from the rationally and logically composed space of the image, perhaps as a way to remind viewers that Rebecca and Esau, in these two different moments, lack understanding of what is happening to them. The placement of the scene of Rebecca's inquiry outside the perspectival space also communicates the status of the event as imagined vision rather than something actually seen. Artists understood linear perspective as a system capable of reproducing a place or event as it appeared to human sight, which medieval writers, in optical treatises, described as conical or pyramidal in shape, the cone's or pyramid's apex corresponding to a point in the eye and its base to the object, body or scene viewed.[11] Ghiberti, relying mostly on the theories of Alhazen, Roger Bacon, John Peckham and Witelo, wrote extensively about the pyramid of human vision in the third book of his *Commentaries*.[12] Perspectival paintings and reliefs, he believed, represent in fictive form a visual pyramid that, theoretically, replicates, or takes the place of, the visual pyramid of human sight. The connection between perspective and actual vision made problematic, or at least awkward, the representation of God in perspective images, since according to nearly all major theologians humans could not see God through bodily vision. Augustine and Aquinas, for example, argue that normal eyesight cannot capture an image of God, and that one can know God

11. David C. Lindberg, *Theories of Vision from Al-Kindi to Kepler* (Chicago: The University of Chicago Press, 1976), 147–77.
12. *I commentarii*, 146. The authoritative analyses of the third book of Ghiberti's *Commentaries* and his use and citation of optical sources are: Gezienus ten Doesschate, *De derde commentaar van Lorenzo Ghiberti in verband met de mildeleeuwsche optiek* (Utrecht: Hoonte, 1940); and Klaus Bergdolt, *Der dritte Kommentar Lorenzo Ghibertis: Naturwissenschaften und Medizin in der Kunsttheorie der Frührenaissance* (Weinheim: VCH, 1988).

only through a process of profound, inner contemplation that Augustine termed "intellectual vision."[13] Placing Rebecca and the half-length image of God floating above her outside the perspective space and in front of a flat, unarticulated gold background helped Ghiberti suggest to viewers what theologians had argued, namely, that in this moment Rebecca conversed with God but did not see in front of her any image of him that could be captured and registered through the action of human sight.

On the left Rebecca reclines either just before or after giving birth to Esau, who, the biblical text says, arrived first and was "red and hairy," and then to Jacob, who held onto his brother's foot during the birth (25:25: "...[Esau] rufus erat et totus in morem pellis hispidus ... alter [Jacob] egrediens plantam fratris tenebat manu..."). Ghiberti acknowledged the Bible's characterization of Esau as "hairy" only in the depiction of the hair on his head, which, at least in the scene in the center of the foreground, grows in tightly curled locks that cascade down his neck and hang in front of the uppermost section of his back. The rest of his body, in this and every other scene, is perfectly smooth. A curtain hanging from a rod above Rebecca's bed has been pulled back, and the recumbent Rebecca looks forward towards the foreground of the relief, where four women, most often identified as her attendants, stand and seem to converse. In the next episode, which takes place in the center of the panel in a space between the foreground and background, her sons have grown and already possess their divergent personalities. In this scene a teenaged Esau, hungry after a hunting trip and having thrown his bow to the ground so that he can extend his arms and hands, trades his birthright to Jacob for some bread and a bowl of lentil pottage, which Jacob, in the moment represented, holds tauntingly in front of his brother.

Ghiberti's narrative then skips ahead several decades, to the end of Isaac's life. Blind, old and anticipating his death, he asks Esau to hunt and bring him meat to eat before he gives him the blessing typically bestowed on the eldest son. The biblical text reports that, after Esau goes off to hunt, a scene that Ghiberti depicted in low relief on the far right, Rebecca conspires with Jacob to trick Isaac into blessing him instead of Esau, an event that takes place beneath the porch attached to the right side of the building. In the Bible Rebecca tells Jacob to find quickly two goats so she can cook a meal

13. Augustine articulates this most clearly in his *De videndo Dei*, a letter written around 413 to Paulinus of Nola; see *Patrologia Latina*, ed. Jacques-Paul Migne, 221 vols. (Paris: Migne, 1844–55 and 1862–65, henceforth PL), 33, cols. 613–14. For Aquinas' discussion of the impossibility of seeing God through bodily vision and his citation of Augustine's ideas, see his *Summa theologiae*, 60 vols. (Cambridge: Blackfriars; New York: McGraw-Hill, 1964–81), 3:10–13 (pt. 1, ques. 12, art. 3). For an overview of Augustine's ideas about intellectual sight, see Scott MacDonald, "The Divine Nature," in *The Cambridge Companion to Augustine*, ed. Eleonore Stump and Norman Kretzmann (Cambridge and New York: Cambridge University Press, 2001), 71–90.

for Isaac, a prelude to the blessing she wants him to give to Jacob. Jacob, in the text, reacts to these orders hesitantly, fearing that, should his father discover the subterfuge, Isaac will not bless but instead curse him (Gen. 27:12-13). Jacob reminds his mother that this could well happen, since he is a smooth-skinned man (Gen. 27:11: "lenis") while Esau is hairy, and fears that his true identity will surely be revealed to Isaac when he reaches out to touch him while offering the blessing. Only after Rebecca reassures him that she will accept the burden of the curse in the event that Isaac becomes aware of the trick does Jacob agree to the plan. He brings her the goats, and Rebecca then prepares a meal for Isaac. She next gives Jacob some of Esau's clothing and an animal skin to wrap around himself so that he will smell and feel like the hairy Esau. From the moment after Jacob's return with the goats the Bible reports no verbal communication between Rebecca and Jacob, but in the scene in the porch her open palm implies speech, and here Ghiberti seems to have combined two moments in the narrative: the early conversation in which Rebecca instructs and reassures Jacob; and his later return with the results of his hunt (in the relief, one small goat and not the two she requests in the Bible). The panel thus brings together two episodes — Rebecca persuading Jacob to carry out the deception and Jacob holding the goat that signifies his decision to go along with his mother's plan — that are separated in the biblical text.

Once disguised, and after having been reassured by his mother that he will not be cursed, Jacob, in the scene that occupies the right side of the foreground, kneels before his blind father, who mistakes him for Esau and gives him the blessing meant for his older brother. Jacob here wears a swath of drapery around his waist, another across his back, and a pair of boots with bunched tops, his costume matching that of Esau in every other scene. With his left hand Isaac reaches around Jacob's neck to find Esau's curly hair, and the palm of his right hand, its fingers beginning to form the gesture that will bestow upon him the blessing, faces the kneeling Jacob. Although she stands in close proximity to Isaac and Jacob, Rebecca, her head resting on her right hand, looks away from the blessing and instead toward the other side of the panel, in the direction of the group of women standing at the left. Her emotional distance in this moment, and the sense that she is pondering some other place or moment in time, are appropriate given common exegetical interpretations of this scene, which explain that Rebecca engineered the deception in order to ensure the fulfillment of the prophecy that God announced to her during her pregnancy. Josephus, for example, believed that Rebecca put Jacob in Esau's place because the blessing, once given, would cause God to see Jacob favorably and would lead to the realization of God's prediction about Jacob's ultimate

triumph over his brother.¹⁴ As we shall see, the four women on the left side of the panel, who seem the focus of Rebecca's attention in this moment, may indeed represent a vision of Jacob's future.

In the Bible, Esau, after returning from the hunt with game that he prepares for his father's meal, goes to Isaac to receive the blessing and, upon learning that his brother has taken it from him, weeps bitterly and begs his father to bless him too. The episode in the center of the foreground, in which Esau looks towards and listens to Isaac, whose mouth is open but whose eyes are mostly closed to indicate his blindness, surely depicts the moment when Esau learns of Jacob's trickery from Isaac and not, as most interpreters of this scene claim, Isaac sending Esau out to procure meat.¹⁵ A number of details support this conclusion. In this scene Esau wears the quiver that, as the biblical text relates, his father tells him to get before he goes hunting (Gen. 27:3), and his hunting dogs already accompany him. He appears ready to take a step forward with his left leg, but his upper body contradicts this imminent motion as it leans away from Isaac, the simultaneous forward and backward movement reflecting the transitional nature of the moment when, in an instant, Esau's anticipation turns into disappointment. By including this scene Ghiberti followed a long visual tradition. Esau's return, often combined with Isaac's announcement that he has already bestowed his blessing on another, appears in numerous medieval Italian cycles that Ghiberti had seen in person before beginning work on the *Gates*, including the nave paintings of Old St. Peter's (fourth century) and S. Paolo fuori le Mura in Rome (c.400) and many that derive from these two influential cycles, like the frescos by the so-called Isaac Master in the upper church of S. Francesco in Assisi (1280s–90s), those by Pietro Cavallini in Sta. Cecilia in Trastevere in Rome (c.1300), and Giusto de' Menabuoi's extensive painted cycle in the vaults and dome of the Padua Baptistery (1370s).¹⁶

14. Josephus, *Jewish Antiquities: Books I–IV*, in *Josephus*, trans. by H. St. J. Thackeray, 8 vols. (London: William Heinemann; New York: G.P. Putnam's Sons, 1930), 4:132–33 (1.269). On Josephus' characterization of Jacob, see Louis H. Feldman, "Josephus' Portrait of Jacob," *The Jewish Quarterly Review* 79 (Oct. 1988–Jan. 1989): 101–51.

15. Most books — textbooks, popular books and scholarly monographs — interpret this scene as the moment before Esau hunts. See, for example, Fred S. Kleiner, *Gardner's Art Through the Ages: The Western Perspective*, 2 vols. (Boston: Wadsworth, 2010), 2:427; John Pope-Hennessy, "The Sixth Centenary of Ghiberti," in *The Study and Criticism of Italian Sculpture* (New York: The Metropolitan Museum of Art; Princeton: Princeton University Press, 1980), 39–70, esp. 51; and Aldo Galli, *Grandi scultori: Lorenzo Ghiberti* (Rome: Gruppo Editoriale L'Espresso, 2005), 193. I know of only two sources that suggest that this scene depicts the moment after Esau returns from hunting and learns of the deception: Frederick Hartt, "*Lucerna ardens et lucens*: Il significato della Porta del Paradiso," in *Lorenzo Ghiberti nel suo tempo: Atti del convegno internazionale di studi (Firenze, 18–21 ottobre 1978)*, 2 vols. (Florence: Olschki, 1980), 1:27–57, esp. 43; and David Finn, Kenneth Clark and George Robinson, *The Florence Baptistery Doors* (New York: Viking Press, 1980), 257.

16. In 1424 Ghiberti traveled to Venice in the retinue of Palla Strozzi, who was carrying out a diplomatic mission on behalf of Florence, and very likely saw Giusto's paintings in Padua. On

In this episode, Esau's two greyhounds not only play a part in the narrative, accompanying him and letting viewers know that this episode happens after he returns from the hunt, but also comprise a condensed and symbolic version of the entire story.[17] One dog, perfectly smooth like Jacob, looks up and out with alert eyes. The other, representing Esau with its long, shaggy fur (Fig. 11), lowers his head forlornly in defeat and lifts one leg off of the ground to take a step, its pose mirroring Esau's stance throughout the panel. In every episode Esau lifts one foot away from the surface beneath him while the other is planted firmly on it, and the similarity between these poses and that of the shaggy dog reinforces the link between this sad hound and its master. The dogs carry the narrative forward by evoking the destinies of Esau and Jacob and of their lineages.

In the scene of Esau's return from the hunt, his left foot, lifted away from the panel with its sole facing the relief's viewers, also recalls the brothers' birth and Esau's words upon learning of Jacob's ultimate deception. The biblical text (Gen. 25:25) states that Isaac and Rebecca gave Jacob his name (Ya'aqob; יַעֲקֹב), which derives from the word for "heel" ('aqeb; עָקֵב), because he grasped Esau's heel during his and Esau's birth.[18] Jerome, author of the first

the Venice trip, see Margaret Haines, "Ghiberti's Trip to Venice," in *Coming About... A Festschrift for John Shearman*, ed. Louisa Matthew and Lars Jones (Cambridge: Harvard University Art Museums, 2001), 57–63. Ghiberti mentions the frescos of the lower church of S. Francesco in Assisi and Cavallini's paintings in *I commentarii*, 84 and 87. He visited Rome sometime before 1416 and must have seen the cycles in Old St. Peter's and S. Paolo; on these, see Herbert L. Kessler, "L'antica basilica di San Pietro come fonte e ispirazione per la decorazione delle chiese medievali," in *Fragmenta picta: Affreschi e mosaici staccati del medioevo romano*, ed. Alessandra Ghidoli [catalog of an exhibition, Rome, 1989–1990] (Rome: Argos, 1989), 45–64; and idem, "'Caput et Speculum Omnium Ecclesiarum': Old St. Peter's and Church Decoration in Medieval Latium," in *Italian Church Decoration of the Middle Ages and Early Renaissance*, ed. William Tronzo, Villa Spelman Colloquia 1 (Bologna: Nuova Alfa, 1989), 119–46. Seventeenth-century copies of the St. Peter's frescos are reproduced in *Descrizione della basilica antica di S. Pietro in Vaticano: Codice Barberini latino 2733*, ed. Reto Niggl (Vatican City: Biblioteca Apostolica Vaticana, 1972), 142–43, fig. 52. For the depictions of Esau visiting Isaac after returning from the hunt by the Isaac Master, Cavallini and Giusto de' Menabuoi, see Joachim Poeschke, *Italian Frescoes, The Age of Giotto: 1280-1400* (New York and London: Abbeville Press, 2005), 91–93, figs. 32–34; 171, fig. 45; and 409, fig. 243. Raphael included the episode in the Vatican Loggia (begun c.1516), following closely Ghiberti's formulation of the episode: Esau walks into a room, his back to the painting's viewers, and stops in his tracks as Isaac, reclining in a bed, tells him that he has already given his blessing to another. See Bernice F. Davidson, *Raphael's Bible: A Study of the Vatican Logge* (University Park and London: The Pennsylvania State University Press, 1985), fig. 49.

17. On these dogs, as well as the two others included in the *Gates*, see my "Ghiberti's Dogs," forthcoming in *Renaissance Studies in Honor of Joseph Connors*, ed. Machtelt Israëls and Louis Waldman (Florence: Villa I Tatti, 2013).

18. *The Five Books of Moses*, trans., with commentary, by Robert Alter (New York and London: W.W. Norton, 2008), 130. On the possible meaning of these terms in the original biblical text, see S.H. Smith, "'Heel' and 'Thigh': The Concept of Sexuality in the Jacob-Esau Narratives," *Vetus*

and most influential treatise on the meaning of biblical names, and many subsequent exegetes offered interpretations of this passage that built on, and expanded, the Bible's explanation, claiming that "Jacob" meant not simply "heel" but *supplantator* — one who trips up another.[19] The suggestion was a play on words that relied on the Vulgate's claim that Jacob "held onto the sole [*plantam*] of Esau's foot" during their birth, as well as on Esau's much later exclamation that Jacob, when he stole the blessing, "supplanted [*subplantavit*] me a second time!" (Gen. 27:36). Standing beneath the panel and looking up at the bottom of Esau's foot (Fig. 5), viewers are literally *sub planta* or *sotto pianta* — the latter evoking the verb *soppiantare*, the Italian for "supplant." This foot's placement thus reminds the spectators of the words that, according to the Bible, Esau speaks aloud in the next instant — the culminating moment of the panel's long narrative.

SPACE

Richard Krautheimer claimed that the Jacob and Esau relief contains an interior space constructed "in terms of a homogenous linear perspective" and that in this relief and the Joseph panel, the next in the cycle, Ghiberti "applied verbatim" the system of single-point perspective outlined by Leon Battista Alberti in his treatise *On Painting*, written in Latin in 1435 and translated into Tuscan by Alberti himself in 1436.[20] In the first book of his treatise Alberti provided step-by-step instructions for a system, the so-called *costruzione legittima*, that artists could follow in order to produce illusionary space in a painting or relief sculpture. His rules instructed painters and sculptors in the production of a grid of orthogonal and transverse lines — in appearance, like the networks of lines visible on the floors in the Jacob and Esau and Joseph panels — that, in Alberti's system, order space and help artists determine the correct size of figures located in various locations within an image's depth.[21] Ghiberti used a system of linear perspective again in the relief that depicts the meeting of Solomon and the Queen of Sheba (Fig. 8) on the right-hand side of the lowest register of the doors, where, because the floor is unlined

Testamentum 40 (1990): 464–73; and Meir Malul, "ʿĀqēb 'Heel' and ʿĀqab 'to Supplant' and the Concept of Succession in the Jacob-Esau Narratives," *Vetus Testamentum* 46 (1996): 190–212.
19. Jerome, *De nominibus Hebraicis* in PL 23, col. 781. For an elaboration of this same interpretation dating to the early seventh century, see Isidore of Seville, *Etymologiarum sive Originum libri xx*, ed. W.M. Lindsay, 2 vols. (Oxford: Clarendon Press, 1911), 1: n.p. (7.7.5): "Iacob subplantator interpretatur, sive quod in ortu plantam nascentis fratris adprehenderit, sive quod postea fratrem arte deceperit. Unde et Esau dixit (Genes. 27, 36): 'Iuste vocatum est nomen eius Iacob, subplantavit enim me ecce secundo!'"
20. Krautheimer, *Lorenzo Ghiberti*, 249–51.
21. Alberti, *Della pittura/De pictura*, in *Opere volgari*, ed. Cecil Grayson, 3 vols. (Rome and Bari: G. Laterza, 1973), 3:36–41 (1.19–1.21). This edition contains both the Tuscan and Latin versions of Alberti's treatise. In this essay I cite the Tuscan.

instead of squared, the architraves, friezes and cornices of the buildings form the skeleton of the perspective system and guide the viewer's gaze into and through the fictive space.[22]

The chronology of the designing and casting of the ten panels of the *Gates* makes it unlikely that Ghiberti applied Alberti's rules "verbatim," and Ghiberti's perspective system in the Jacob and Esau panel indeed does differ — and quite dramatically — from that described by Alberti. Ghiberti signed the contract for his second set of baptistery doors on 2 January 1425, began modeling their ten narrative panels probably around 1427, and had cast in bronze all ten, as well as twenty-four strips of relief for the doors' frame, by April 1437.[23] The years between 1437 and 1452 were dedicated to the cleaning and chasing of the panels and the casting of the doors' massive framework, time-consuming tasks he carried out with the help of his large workshop. It is impossible to determine precisely when Ghiberti designed and modeled individual panels, since no document provides details about the specific progress of work between 1427 and 1437.[24] A careful stylistic analysis led Krautheimer, who believed that the work of designing and casting was begun only in 1429, to argue that Ghiberti created the panels in the order in which they appear on the door from the top down, a suggestion accepted by most art historians.[25] Krautheimer thus dated the Adam and Eve panel to around 1429, the Cain and Abel, Noah, and Abraham and Isaac reliefs to 1432–34,

22. For an explanation of the unlined floor, see Parronchi, "Le 'misure dell'occhio' secondo il Ghiberti," 32.

23. On the general chronology of the commission, see Krautheimer, *Lorenzo Ghiberti*, 159–68. Francesco Caglioti revised very slightly Krautheimer's chronology, claiming that Ghiberti probably began around 1427; see his "Reconsidering the Creative Sequence of Ghiberti's Doors," in *The Gates of Paradise: Lorenzo Ghiberti's Renaissance Masterpiece*, ed. Gary Radke (New Haven and London: Yale University Press, 2007), 86–97. I agree with Caglioti's proposal. The document recording the completion of the panels is dated to either 1436 or 1437 (Krautheimer, *Lorenzo Ghiberti*, 368, doc. 23). On the evidence supporting 1437 as the date of completion, see Krautheimer, *Lorenzo Ghiberti*, 164–65; and, for further corroborating evidence regarding this suggestion, my "Lorenzo Ghiberti, the Arte di Calimala, and Fifteenth-Century Florentine Corporate Patronage," in *Florence and Beyond: Culture, Society, and Politics in Renaissance Italy*, ed. David Peterson with Daniel Bornstein (Toronto: Centre for Reformation and Renaissance Studies, 2008), 135–51, esp. 146–47.

24. One reference, albeit brief, to Ghiberti's work in this period comes in Francesco Scalamonti's biography of Cyriac of Ancona, where, writing perhaps in the 1450s and drawing from Cyriac's own travel diary and writings, he mentions that, while Cyriac was in Florence in 1433, he saw in Ghiberti's house both ancient sculptures and several the sculptor had made in bronze. See *Vita viri clarissimi et famosissimi Kyriaci anconitani*. Transactions of the American Philosophical Society 86.4, ed. and trans. Charles Mitchell and Edward W. Bodnar, S.J. (Philadelphia: American Philosophical Society, 1996), 70 and 132.

25. Pope-Hennessy, in "The Sixth Centenary of Ghiberti," offered a radical revision of this scheme, claiming that Ghiberti must have worked in reverse, starting with the Solomon and the Queen of Sheba relief and ending with the Adam and Eve panel. His suggestion has never been accepted; and I, too, support Krautheimer's proposal about the order of the completion of the panels.

the Jacob and Esau and Joseph panels to 1434 or 1435 and, finally, the last four reliefs, Moses, Joshua, David, and Solomon and the Queen of Sheba, to the period between 1435 and 1437.[26] However, if Ghiberti created the panels on a regular schedule, and if he began earlier, around 1427, as seems to have been the case, the Jacob and Esau and Joseph panels would have been modeled around 1431 or 1432, several years before Alberti went to Florence in 1434 or 1435 and saw, and was so impressed by, works of Brunelleschi, Donatello, Ghiberti, Luca della Robbia and Masaccio — the artists he mentions in the dedicatory letter to the Tuscan version of *On Painting*.[27]

Ghiberti, it should be stressed, sculpted the Jacob and Esau and Joseph panels toward the end of a period of intense experimentation in the emergent science of perspective in Florence, and in a time immediately before any particular set of rules became normative. Around 1410 Filippo Brunelleschi demonstrated his new perspectival system in two painted panels, one of the Florence Baptistery in its piazza and another of the Palazzo dei Priori and the space surrounding it.[28] What we know of these long-lost images comes from the description Antonio Manetti included in his biography of Brunelleschi from the 1480s. According to Manetti, the architect depicted the baptistery and palace receding realistically into space, approximating what the viewer sees when looking towards these buildings from, in each case, a dominant viewpoint.[29] Brunelleschi's experiment piqued the interest of a group of progressive artists active in Florence, including Ghiberti, Donatello and Masaccio, and in the years after 1410 each experimented on his own with perspective, not in small

26. Krautheimer, *Lorenzo Ghiberti*, 192–202.
27. The men of the Alberti family had been exiled from Florence in January 1401 (after individual family members had been exiled in 1387 and then again in 1393) and were allowed back into the city only in 1428. See Susannah Foster Baxendale, "Exile in Practice: The Alberti Family in and out of Florence: 1401–1428," *Renaissance Quarterly* 44 (1991): 720–56, esp. 723–33; and Luca Boschetto, *Leon Battista Alberti e Firenze: Biografia, storia, letteratura* (Florence: Olschki, 2000), 3–67. Leon Battista Alberti went to Florence as a member of the retinue of Pope Eugenius IV. Although Eugenius arrived in June 1434, Alberti is first documented in the city in August 1435. On Alberti's arrival and presence in Florence in the 1430s, see again Boschetto, *Leon Battista Alberti e Firenze*, 77–83. For the dedicatory letter to *On Painting*, see *Della pittura/De pictura*, 7–8.
28. On the appearance of, and theory behind, Brunelleschi's experimental panels, see, among others: Alessandro Parronchi, "Le due tavole prospettiche del Brunelleschi," *Paragone* 9 (1958): 3–32 and 10 (1959): 3–31; Renzo Beltrame, "Gli esperimenti prospettici del Brunelleschi," *Rendiconti delle sedute dell'Accademia Nazionale dei Lincei. Classe di scienze morali, storiche, e filologiche* 28 (1973): 417–68; Samuel Y. Edgerton, *The Renaissance Rediscovery of Linear Perspective* (New York: Harper & Row, 1976), 143–52; White, *The Birth and Rebirth of Pictorial Space*, 113–21; Rudolf Arnheim, "Brunelleschi's Peepshow," *Zeitschrift für Kunstgeschichte* 41 (1978): 57–60; Martin Kemp, "Science, Non-Science and Nonsense: The Interpretation of Brunelleschi's Perspective," *Art History* 1 (1978): 134–61; and Kemp, *The Science of Art*, 11–15 and 344–45.
29. Antonio di Tuccio Manetti, *Life of Brunelleschi*, ed. Howard Saalman (University Park and London: The Pennsylvania State University Press, 1970), 42–43.

wooden panels, but in altarpieces, monumental frescos, marble relief sculptures and bronze relief panels like those of Ghiberti's second set of doors. Our knowledge of developments leading to Alberti's codification of perspective is limited because no written accounts of theoretical advances in the field of perspective survive from the first thirty-five years of the fifteenth century. We must therefore rely on the extant images, and the first good pictorial evidence of a sophisticated perspective theory comes in 1426, when Masaccio used his paintbrush, as Vasari says, to pierce the wall of the left side aisle of Sta. Maria Novella.[30] There Masaccio painted his fresco of the *Holy Trinity*, which represents an illusionary space dominated by a barrel-vaulted chapel and occupied by images of God the Father, Christ, the Holy Spirit, Mary, John the Evangelist and, on the front steps, the patrons of the work.[31] The picture contains the basic elements found in perspectival images: orthogonal lines, disguised as edges of the fictive vault's coffers, join together at a centric point several centimeters below the bottom step; the transversals, which Masaccio represented as ribs of the vault, run parallel to the surface of the image and the spaces between them decrease proportionately.[32] The many similarly structured images from the years just before and after Masaccio painted the *Holy Trinity* demonstrate deep interest in experimenting with perspective among artists in the early fifteenth century. Already in 1417 Donatello had employed a rudimentary perspective system in the schiacciato relief beneath his statue of St. George at Orsanmichele; in 1425 he used a different version of it in his bronze panel of the *Feast of Herod* for the Siena baptismal font; in addition to the *Trinity* fresco, Masaccio used perspective to structure the buildings on the right side of his *Tribute Money* fresco in the Brancacci Chapel, which he painted around 1425; and, as described above, in the 1430s Ghiberti took advantage of this new mode of representing space when he designed his Jacob and Esau, Joseph, and Solomon and the Queen of Sheba reliefs.[33]

30. Vasari, *Le vite de' più eccellenti pittori, scultori, ed architettori*, ed. Gaetano Milanesi, 9 vols. (Florence: G.C. Sansoni, 1906), 2:291.
31. For basic bibliography on the *Trinity*, see the essays and bibliography in *Masaccio's Trinity*, ed. Rona Goffen (Cambridge: Cambridge University Press, 1998).
32. For in-depth discussions of the perspective system that structures Masaccio's *Trinity*, see, among many, G.J. Kern, "Das Dreifaltigkeitsfresko von S. Maria Novella: Eine perspektivisch-architekturgeschichtliche Studie," *Jahrbuch der königlich preussischen Kunstsammlungen* 34 (1913): 36–58; and J.V. Field, Roberto Lunardi and Thomas B. Settle, "The Perspective Scheme of Masaccio's *Trinity* Fresco," *Nuncius* 4 (1989): 31–118.
33. On Donatello's *St. George* relief, see H.W. Janson, *The Sculpture of Donatello*, 2 vols. (Princeton: Princeton University Press, 1957), 2:30–31; and John White, "Developments in Renaissance Perspective–II," *Journal of the Warburg and Courtauld Institutes* 14 (1951): 42–69, esp. 44–45. On the perspectival system he used in the Siena relief, see Janson, *The Sculpture of Donatello*, 2:69; White, "Developments in Renaissance Perspective–II," 45–47; John Paoletti, "The Siena Baptistry Font: A Study of an Early Renaissance Collaborative Program, 1416–1434," (Ph.D. Diss., Yale University,

A SCARLET RENAISSANCE ■

If in the first four decades of the fifteenth century artists shared a general interest in perspective as a structuring device, they certainly did not employ any consistent approach in implementing it.[34] Different artists used radically different versions of perspective, and individual artists even used different systems in separate commissions. For example, Masaccio's *Holy Trinity* contains a single centric point, while, either intentionally or because of some miscalculation, he included two such points in the *Tribute Money*, one on Christ's nose and another on his forehead.[35] Donatello used so many different constructions in his works that his approach to perspective — a tool he often used not to unify the spaces he represented but to enliven them by disrupting their spatial regularity — has been called "anarchic" by one art historian.[36] Such varied visual evidence leads to the obvious conclusion that, in the early decades of the fifteenth century, many different systems co-existed and that Alberti did not therefore simply record in *On Painting* a commonly recognized or applied set of rules. In fact, no such set of rules existed. It seems likely that Alberti combined early fifteenth-century workshop practices he learned from contemporary artists with his own theoretical innovations. Surely for many artists and interested readers Alberti's greatest contribution was to outline in written form a system of rules that, before 1435, had never existed as such. But while he codified and simplified perspective theory, his treatise helped bring to an end an exhilarating period of early experimentation.

Ghiberti favored clarity in space and storytelling over rigorous spatial and geometric coherence, and he constructed the fictive realm of the Jacob and Esau panel and its figures with the requirements of the rather intricate biblical story he wanted to tell in mind. Inserting seven episodes of the long narrative of Isaac, Rebecca and their children within and around an architectural structure, and not into a landscape, presented Ghiberti with a challenge. The landscapes included in the doors' first four panels (e.g., Figs. 3, 4 and 7) provided him with compositional flexibility, because into a landscape he could, with relative freedom, insert elements like hills that reach upwards and thus allow figures to be set almost anywhere on the panel's surface — the top, bottom, right, and left — and in a number of locations

1967), 84–87 and 131 n. 61; and Kemp, *The Science of Art*, 15–16.
34. Kemp has stressed the lack of uniformity among the earliest applications of perspective. See his "Science, Non-Science and Nonsense," 136.
35. J.V. Field, "Masaccio and Perspective in Italy in the Fifteenth Century," in *The Cambridge Companion to Masaccio*, ed. Diane Cole Ahl (Cambridge: Cambridge University Press, 2002), 182 and 186; and Field, *Piero della Francesca: A Mathematician's Art* (New Haven and London: Yale University Press, 2005), 44, citing Ornella Casazza, "Il ciclo delle storie di San Pietro e la 'Historia Salutis': Nuova lettura della Cappella Brancacci," *Critica d'arte* 51 (1986): 69–84.
36. Field, *Piero della Francesca: A Mathematician's Art*, 42. On the disruption of spatial continuity in Donatello's Siena Baptistery relief, see Paoletti, "The Siena Baptistery Font," 85.

within its fictive depth.³⁷ The presence of an immense and visually dominant architectural structure, with its squared floor, precluded the addition of an expansive landscape or even sizeable natural elements in the panel and thus limited the possibilities for the placement of individual figures and groups. A general guideline that seems to have been accepted by Ghiberti and his contemporaries also reduced the amount of space he could potentially utilize within the perspectival zone. As Donatello and Masaccio had learned by about 1425, figures standing on the floor of a perspective space should not appear above the horizon line (what Alberti later termed the "centric line"), and often their heads line up exactly at the level of the horizon, a phenomenon that Samuel Edgerton has called "horizon line isocephaly."³⁸ Although in the Jacob and Esau panel Ghiberti's most prominent orthogonals, which originate in the work's front edge, do not come together at a single point (Fig. 9), making it impossible to fix the location of the horizon line with perfect precision, he did position the heads of the figures who stand on the floor of the relief just at or below the horizon. In order to create a space both wide and deep, and thus a maximum amount of usable surface, Ghiberti set the small vanishing area, and thus the zone of the horizon, about half-way up the panel, within the central, most distant arch of the architectural structure. Alberti later recommended that it be located lower down in the visual field, at the eye level of a figure whose feet touch the bottom of the image.³⁹ When possible and appropriate, Ghiberti did utilize space above the area of the vanishing point, but the inclusion of a perspectival grid that covers the entire ground level of the image's fictive space and leads the viewer's gaze into depth meant that most of the relief's seven episodes had to be located in its lower section. Placing the vanishing point (or area) higher in the panel increased the amount of usable space, and Ghiberti filled the panel with figures who are placed everywhere beneath the horizon and in several zones of spatial depth.

For most observers, the beauty of the Jacob and Esau panel stems primarily from the presence of individual spatial zones that flow together organically to form an aggregate space that is at once elegant, logically constructed and totally unified. A distinction should be made, however, between evident visual unity and scientific or mathematical consistency. While to a broad sweep of the gaze the panel gives the impression of a single space, a close look at

37. On the organization of space and the determination of the size of various figures and elements in the landscape panels, see Kathryn Bloom, "Lorenzo Ghiberti's Space in Relief: Method and Theory," *Art Bulletin* 51 (1969): 164–69.
38. Edgerton, *Renaissance Rediscovery*, 26. Alberti mentions this rule as part of his perspectival system in *Della pittura/De pictura*, 36–37 (1.19): "Sarà bene posto questo punto [centrico] alto dalla linea che sotto giace nel quadrangolo non più che sia l'altezza dell'uomo quale ivi io abbia a dipingere, però che così e chi vede e le dipinte cose vedute paiono medesimi in suo uno piano."
39. *Della pittura/De pictura*, 36–37 (1.19).

details now revealed by the brilliant restoration of the panel establishes that the work is not mathematically unified and thus not, as Krautheimer asserted, constructed according to the rules outlined in Alberti's linear perspective scheme.[40] The central eight orthogonals that define the foreground ledge converge (Fig. 9), or come very close to doing so, but the two outermost orthogonals cross over each other just beneath and slightly to the right of the intersection point of the other eight lines. The placement of these outer two orthogonals is not unusual in fourteenth- and early fifteenth-century perspectival images. Erwin Panofsky observed that orthogonals originating in the outermost sections of such works frequently converge beneath or above the main centric point; from this evidence Panofsky concluded that, in the decades before Alberti's treatise, artists often did not realize mathematically and geometrically consistent space.[41] In these cases, wrote Panofsky, "rigorous coherence" was limited to "a 'partial plane'."[42] The specific configuration of the two outer orthogonals in the Jacob and Esau panel — the fact that they both drop below the main vanishing point, and to about the same degree — very likely resulted from Ghiberti's awareness of theories that described the distortion of objects located at the outer boundaries of the visual field. Many ancient and medieval writers dealt with edge distortion in vision. During the Middle Ages, numerous authors who wrote on optics claimed that objects located at the periphery of sight often appear less sharp.[43] Alhazen, for example, in the optical treatise he wrote in the eleventh century (often given the title of *De aspectibus* when translated into Latin), claimed that portions of images in front of the eye are always seen more clearly than those located in the outermost zones of the field of vision (2.2.27–30).[44] A related theory, that entities located far to the left or right in a viewer's field of vision appear slightly higher than those occupying its center, is found in Vitruvius' *De architectura*, where the principle determined his ideas about the appearance and design of horizontal elements in architectural structures. For example, the central part of a building's platform base (its stylobate) must rise slighter higher than the two outer sides, says Vitruvius, because to human vision the farthest edges of a form always appear higher than its central section. Without the correction he

40. On the restoration, finished in 2012, see Annamaria Giusti, "Ghiberti's Gold: Restoration of the Gates of Paradise," in *The Gates of Paradise: Lorenzo Ghiberti's Renaissance Masterpiece*, 99–109.
41. *Perspective as Symbolic Form*, trans. Christopher S. Wood (New York: Zone Books, 1991), 58–59 and, on the divergence from the centric point of orthogonals located at the edges of images, 122–23 n. 47.
42. *Perspective as Symbolic Form*, 58–59.
43. Lindberg, *Theories of Vision from Al-Kindi to Kepler*, 26–30.
44. *Alhacen's Theory of Visual Perception: A Critical Edition. Transactions of the American Philosophical Society* 91.4 and 91.5, ed. and trans. A. Mark Smith, 2 vols. (Philadelphia: American Philosophical Society, 2001), 1:96–97 and 2:428–29.

recommends the central section of any horizontal form, he claims, will seem as if sagging (3.4.5).[45] Alberti described clearly this same principle of distortion in *Della prospettiva*, his treatise on the principles of optics.[46] Ghiberti knew well Vitruvius' text and cited it often in his *Commentaries*, and his recognition of this optical principle probably determined his decision to drop slightly the outer orthogonals in the Jacob and Esau panel.[47] According to Vitruvius, the orthogonals on the far right and left would appear slightly higher when examined by a viewer standing in front of the panel and taking in, through a broad sweep of vision, Isaac's grand palace and the capacious space it encloses and defines. By directing the outer orthogonals to a convergence point below the vanishing point of the eight central orthogonal lines, Ghiberti countered the effects of this distortion and made these two outermost orthogonals seem to align precisely with the other eight incised into the foreground pavement.

Of course, while many surely took in, at least in the initial stage of the viewing process, the space bounded by Isaac's palace and the floor and zone in front of it, Ghiberti knew that to read the entire story viewers would also focus on individual scenes and thus small pockets of space. For Ghiberti, the legibility and visibility of these discrete spatial zones and the episodes they contain at times surpassed in importance the creation of one unified realm constructed with absolute geometric and mathematical consistency. For example, the groups of orthogonals (Fig. 9) articulating the pavement of the porch and the flat, open space in front of Esau's hill do not come together at the same centric point (or area) on which the eight foreground orthogonals converge. Instead all but one of them pass above the vanishing area of the foreground lines and converge at separate points above the horizon.

The panel's location in the doors, above the head of the viewer, necessitated the placement of the background orthogonals at angles greater than those dictated by the perspective system of the foreground lines. Had the back

45. Vitruvius, *De architectura*, ed. and trans. Frank Granger, 2 vols. (Cambridge: Harvard University Press, 1998), 1:184–85.
46. Alberti, *Della prospettiva*, in *Opere volgari*, ed. Anicio Bonucci, 5 vols. (Florence: Galileiana, 1847), 4:103 (1.1).
47. On Ghiberti's knowledge of Vitruvius' treatise, see Gustina Scaglia, "A Translation of Vitruvius and Copies of Late Antique Drawings in Buonaccorso Ghiberti's *Zibaldone*," *Transactions of the American Philosophical Society* 69 (1979): 3–30, esp. 17 and n. 69. On knowledge of Vitruvius' text in the fourteenth and fifteenth centuries in Italy, see Lucia A. Ciapponi, "Il 'De architectura' di Vitruvio nel primo umanesimo," *Italia medioevale e umanistica* 3 (1960): 59–99; and Giorgio Tabarroni, "Vitruvio nella storia della scienza e della tecnica," *Atti della Accademia delle scienze dell'Istituto di Bologna. Classe di scienze morali. Memorie* 66 (1971–72): 1–37. Copies of Vitruvius' treatise were bequeathed to the Florentine libraries of Sto. Spirito in 1374, when Boccaccio willed his copy to a friar at Sto. Spirito who then left it to the convent library, and S. Lorenzo in 1359, by Niccolò Acciaiuoli. On this, see Carol Herselle Krinsky, "Seventy-Eight Vitruvius Manuscripts," *Journal of the Warburg and Courtauld Institutes* 30 (1967): 36–70, esp. 37–38 nn. 33 and 36.

zones been constructed in accordance with the calculations employed in the front, parts of some of the lines, when seen from below, would have disappeared behind the projecting, high relief figures of the foreground. If the orthogonals in the floor at the far right, for example, converged at the vanishing point of the foreground orthogonals rather than passing above it, their lower position in the panel would have caused portions of them to drop behind the representations of the seated Isaac and kneeling Jacob in front of them. The same effect would be evident in the section of the panel in which Rebecca and Jacob plot against Esau, where segments of lines directed towards the major convergence area might have been masked by Isaac when viewers examined the scene from below. As a result of the correction, viewers find clear and prominent lines articulating these portions of pavement, which in turn communicate a sense that individual pockets of space recede realistically into the distance. Moreover, on the far right side, the inclusion of dramatically receding lines that converge towards a unique point would not be visually compatible with the flat, lower part of the rocky hill, which already occupies a slightly awkward and indeterminate position somewhere behind and, it seems, to the right of the squared pavement. In certain zones, it should be said, Ghiberti sketched in some of the isolated orthogonals without any attempt whatsoever to direct them towards the convergence area of the foreground lines. Those of the intermediate step on which Jacob kneels on the right (Fig. 9), as well as those represented by the edges of the capitals of the pilasters, recede wildly into depth, never converging at any single point or in any restricted area of space. In some cases, it seems, Ghiberti freely chased lines into the relief's surface without worrying about consistency or following any specific system.

Ghiberti's placement of the transverse lines in the central section of the panel, which lead the gaze from the foreground to the distant horizon, represents another significant difference between his perspective system and that developed by Alberti. Alberti mentions with some disapproval that fourteenth-century painters frequently decreased the distances between transverse lines by a consistent fraction, often a third, an approach that remained popular into the early fifteenth century.[48] Ghiberti, a student of fourteenth-century, especially Sienese, painting, himself employed this method to locate the transversals in the ceiling of his relief of *St. John before Herod*, a work he finished in 1427 for the Siena Baptistery font.[49] In the fifteenth century new methods for calculating the placement of transversals replaced

48. *Della pittura/De pictura*, 36–39 (1.19). See also Miriam Schild Bunim, *Space in Medieval Painting and the Forerunners of Perspective* (New York: Columbia University Press, 1940), 146 n. 46. Bunim was not able to determine whether such a system was in fact employed in fourteenth-century painting.

49. Kemp, *The Science of Art*, 24.

this traditional approach. Donatello, in his *Feast of Herod* for the Siena font, may have used the so-called "lateral-focus method."[50] In *On Painting* Alberti outlined and endorsed another, similar set of rules often called the "distance-point construction" that involves slightly different steps but produces results similar to those obtained by Donatello's system.[51] With both techniques the artist chooses an assumed viewing point outside the image, extends lines from it towards the base of the image, and inserts transversals at resultant points of intersection. In images in which these methods are applied consistently, the transversals step towards the horizon line, and the spaces between them decrease steadily and proportionately.

All three of the methods potentially available to Ghiberti for the determination of the placement of the transversals — the fraction method, the lateral-focus method and Alberti's distance-point construction, which Ghiberti theoretically could have learned about before the completion of *On Painting* — result in the production of fictive spaces that contract quickly, and therefore all three presented him with a serious quandary. Figures made to scale for the middle ground or background of a rapidly contracting space are very small and thus difficult, if not impossible, to see. For an artist like Ghiberti, whose task in the *Gates* was to depict stories comprised of individual scenes that could be discerned within a vast expanse of fictive space, the inclusion of nearly illegible figures that disappear into the background was simply not an option. Other artists evidently concurred, and, in order to avoid the problem, early fifteenth-century artists who depicted space according to a rule of perspective tended to cluster figures and objects in the foreground of the image, where their large size made them easy to see. Masolino's *Feast of Herod*, painted around 1435 for the baptistery (originally the family chapel of Cardinal Branda Castiglione) of Castiglione Olona (northwest of Milan), contains an example of this approach (Fig. 10).[52] In this scene — not, incidentally, constructed with Albertian perspective but with a system that Masolino devised — figures stand and sit in the foreground while a groin-vaulted arcade and the space it encloses zoom away from them toward the horizon.[53] Masolino did place one episode, the burial of John the Baptist, in

50. Kemp, *The Science of Art*, 16.
51. *Della pittura/De pictura*, 36–39 (1.19). For a concise summary of Alberti's selection of the distance point and a description of its function, see Edgerton, *Renaissance Rediscovery*, 42–49.
52. On this fresco and others that Masolino painted at Castiglione Olona, see Perri Lee Roberts, *Masolino da Panicale* (New York: Oxford University Press, 1993), 129–49; Paul Joannides, "Masolino a Castiglione Olona: Il Battistero e la Collegiata," in *Arte in Lombardia tra Gotico e Rinascimento* (Milan: Fabbri, 1988), 284–96, esp. 288–90; and Samuel Y. Edgerton, *The Mirror, the Window, and the Telescope: How Renaissance Linear Perspective Changed Our Vision of the Universe* (Ithaca and London: Cornell University Press, 2009), 105–6 and fig. 58.
53. Roberts, *Masolino da Panicale*, 145–46.

the distance, and the figures, who attend the burial in a cave inserted into the side of a mountain, are indeed extremely small and, as a result, exceedingly difficult to see. Here the rules of perspective that dictate the figures' size interfere with the viewers' ability to read an episode that should represent one of the emotional and dramatic focal points of Masolino's *istoria*.

The great achievement of the Jacob and Esau panel lies in Ghiberti's success in accomplishing what so many had not been able to do: he forged a deep space that extends realistically from the foreground towards a distant horizon and within which the separate scenes of an intricate narrative can be seen and read easily. To insert the transverse lines that carry the fictive space towards the horizon in the center of the image, Ghiberti adopted his own unique method, using neither the approach of Donatello nor that later devised by Alberti. We do find in the foreground of Ghiberti's image steadily decreasing amounts of space between transverse lines, but in the area between the low wall and the face of the arcaded hall the rate of decreasing distance between lines slows, and even stops, at certain points (Fig. 11). The first two tiles in this space are the same width; the next two are slightly narrower than the preceding pair but are of equal width; and the same holds for the subsequent three pairs. It is only after these five sections, in the area just beyond Esau's bow, that regular recession of the transversals resumes. By slowing, and sometimes stopping, the diminution of distance between the lines, Ghiberti ensured that the space between the transversals in the center of the background would not be too narrow, and this allowed for the insertion of larger, and thus more visible, figures that would not appear awkward when seen in concert with the floor tiles beneath them; smaller tiles would have contrasted uncomfortably with the relatively large figures above them.[54] He was evidently concerned that the transition between the receding spatial zones might appear awkward, and to help mask the shift back to steady contraction he placed at the point of transition Esau's bow, an unexpectedly prominent element (not warranted by the biblical story) that seems to have been included not only because it helps the viewer identify the hunter Esau but also because it allowed Ghiberti to restart the contraction of the transversals at a regular rate in this area of the panel without the worry that the junction between the differently constructed zones would be jarring. In designing and carrying out this part of the panel Ghiberti thus meticulously controlled the placement of the transversals, allowing the receding space to subtly expand, contract and then expand again, almost like the bellows of an accordion.

54. As is well known (see Krautheimer, *Lorenzo Ghiberti*, 247 and 249), in the relief's foreground Ghiberti calculated the size of figures by using the floor tile's width as the determining unit; each figure in the foreground is approximately three-floor-tile-widths tall, a recommendation later advocated by Alberti. He did not follow this same guideline for the figures located in the background of the panel, which are larger than warranted by the size of the floor tiles so as to ensure their legibility.

The transversals in the other sections of the panel do recede with relative regularity and proportionality. If for these subsidiary zones we assume that he utilized a system for inserting transversals close to that earlier employed by Donatello or eventually codified by Alberti, as Masaccio seems to have done in his *Holy Trinity*, one finds that Ghiberti selected for each section of the relief a unique distance point. Locating this point at a distance from the panel equal to the presumed location of the viewer was, in Alberti's recommendations, the first step in determining the placement of an image's transversals. Inverting the method by tracing lines through the corners of the floor tiles reveals the location of the distance point and thus the assumed viewpoint for any perspective construction based on these rules. When one performs such a calculation for the Jacob and Esau panel (Fig. 12), it becomes clear that the scenes that take place farther back in the panel's fictive depth have been constructed with distance points closer to the panel than the point selected for the foreground, where the assumed viewing distance is approximately equivalent to the width and height of the panel. Ghiberti, knowing that viewers would draw close to the panel when reading the scenes in lower relief in the background, logically utilized a smaller viewing distance when placing the transversals in these sections. When inserting the transversals in the foreground, he assumed a greater viewing distance, imagining that viewers would take in the broad swath of space stretching across the foreground through a sweeping gaze and while standing about two-and-a-half feet from the front of the image. The panel's space is not homogenous but has been constructed with immense precision.

SPACE AND THE EXPANSION OF NARRATIVE

Due to the presence of the expansive squared pavement, which forms part of the perspectival grid, most of the figures had to go beneath the horizon and thus in the lower part of the panel, and fitting all of the narrative's figures into the fictive space while ensuring their visibility was a delicate and difficult task. Ghiberti did manage to use some of the relief's upper section, placing Rebecca atop the porch and inserting a depiction of Esau climbing the hill at the right, but he carefully located the other episodes in the lower half, distributing them across the panel and distinguishing them either by enclosing them within architectural spaces or by having figures face inwards towards each other and thus serve as their own confining frames. In the panel's lower half, scenes placed in the compressed zone of space inevitably overlap one behind the other, and the viewer, especially when looking from below, necessarily sees them together and not in isolation. Ghiberti brilliantly exploited the inevitable overlapping of a perspective image to expand the narrative possibilities. When one views the panel from below, the episode of Esau exchanging his birthright for the bowl of lentils offered by Jacob appears behind, and also slightly above, Esau's post-hunt conversation with Isaac. The

background scene does of course function as one part of a long story, but here, hovering right behind the adult Esau's head, it also becomes his recollection — his memory of having traded away his birthright.[55] The biblical text suggests the connection between the two episodes and thus this configuration, as it states that, when Isaac told Esau that he had already blessed Jacob, the memory of how Jacob earlier took his birthright flooded Esau's mind, and he exclaimed "he has supplanted me these two times: he took away my birthright; and behold, now he has taken away my blessing!" (Gen. 27:36). The gaze and facial expression of the young Jacob, holding the bowl of lentils in front of him, enhance and reinforce the drama. When one examines Jacob's face in profile and from a point below the panel, he seems emotionless, but when the viewer shifts to the right, approximating the angle of vision of Esau in the last episode of the story, and looks directly at the young Jacob's face — and Ghiberti made sure members of his audience had to do this by placing the bowl of lentils behind the older Esau's head and shoulders so it cannot be seen from a viewpoint directly in front of the panel — he or she finds the teenaged Jacob glaring intently towards the representation of his brother returning from the hunt as an adult (Fig. 13). Jacob's sharp and direct expression cuts across both space and time and seems to imply that Jacob, even when young, understood that his destiny, which he controlled through his often dishonest actions, was to triumph over his brother.[56]

Other pairs of background and foreground episodes, when read together, expand the narrative's dramatic content.[57] In the porch, Rebecca and Jacob stand together in a scene that represents both Rebecca's announcement of the plan to trick Isaac and Jacob's return with the animal that she will cook for her husband. In front Jacob kneels to receive the blessing, and the scene directly behind them can likewise be read as a recollection — Jacob's memory of his mother's reassurance and of his complicity in the scheme to steal the blessing. The paired episodes can also be understood as indicating Jacob's acknowledgment of his deceitful action and as a representation of his guilty conscience; Jacob carries

55. Jules Lubbock has also highlighted Ghiberti's ability to represent memories. See his *Storytelling in Christian Art from Giotto to Donatello* (New Haven and London: Yale University Press, 2006), 231–32.
56. The figure of Jacob might be compared to Michelangelo's *David* of 1501-4, a figure whose face appears calm when the statue is seen from the front (when the face is studied in profile), but instead projects a sense of anxiety when the statue is examined from the side (and when the viewer looks directly at the front of the face with its furrowed brow).
57. Lew Andrews has called attention to the way continuous narrative allows viewers to compare and contrast figures in images; this idea, Andrews acknowledges, was previously proposed by Richard Brilliant in his "Temporal Aspects in Late Roman Art," *L'Arte* 10 (1970): 65–87 and *Visual Narratives: Storytelling in Etruscan and Roman Art* (Ithaca: Cornell University Press, 1984): 18–19 and 104–6. In the context of this discussion he mentions Ghiberti's Jacob and Esau panel but does not discuss in any detail the relief's individual scenes. See Andrews, *Story and Space in Renaissance Art: The Rebirth of Continuous Narrative* (Cambridge and New York: Cambridge University Press, 1998), esp. 117–19.

out the deception and knows — suggests the pair — that it is wrong. On the far right in the foreground Rebecca stands stoically beside the result of the deception — the blessing — as Esau dutifully walks up the hill behind her. We can only guess what Ghiberti intended to bring out with this juxtaposition: perhaps we are meant to see in it Rebecca ruminating over her rejection of one son and preference for the other. Or maybe her thoughts about Esau trigger a consideration of the future effects of her machinations, an idea suggested by interpretations offered by exegetes like Josephus. The juxtapositions of overlapping foreground and background scenes transform the biblical episodes into anguished memories and guilty thoughts that evoke the complex emotions of the protagonists: the central pairing, with its evocation of Esau's painful recollection, reminds the viewer of his anger and embarrassment over losing the blessing; in the next pair to the right Ghiberti suggests Jacob's fear and guilt over his deception — an image of his guilty conscience literally hangs over him; and at the far right Ghiberti perhaps suggests Rebecca's callousness as she coldly ponders having shunned Esau in favor of Jacob. Ultimately, Ghiberti invites viewers to study these overlapping figures in order to decide for themselves what the panel's protagonists think and feel in these dramatic, tense moments.

While the three background scenes just discussed represent (from left to right) a vision of a distant past, a recent past and a simultaneous present, the four women on the extreme left might also relate diachronically to the figure behind them, Rebecca. The biblical text states that when Rebecca asked God why her children struggled within her, God told her that "two nations are in your womb, and two people from within you will be separated," and that one nation would become "stronger than the other, and the older will serve the younger" (Gen. 25:23). These words, which Christian exegetes interpreted as not only a foretelling of Jacob's ascendancy over Esau but also a prediction of the triumph of Christianity over Judaism, led many theologians like Augustine to characterize Rebecca as a prophet — as capable of receiving and transmitting divine messages regarding future events.[58] The stronger "nation" mentioned in God's prediction eventually derived from the twelve sons of Jacob and his four wives, Rachel, Leah, Bilhah and Zilpah. Are these perhaps the four wives, the representatives of the future that Rebecca envisions and ponders? As already discussed, the Rebecca who stands next to Isaac and Jacob during the scene of the blessing looks to these four women from the other side of the panel. According to exegetes like Josephus, at this moment she thought about Jacob's future and the eventual triumph of his "nation" — the descendants of his children with his wives — over Esau and

58. Augustine, *The City of God Against the Pagans*, ed. and trans. R.W. Dyson (Cambridge and New York: Cambridge University Press, 1998), 749-50 (16.35). On interpretations of the story as symbolic of the triumph of Christians over Jews, see Gerson D. Cohen, "Esau as Symbol in Early Medieval Thought," in *Jewish Medieval and Renaissance Studies*, ed. Alexander Altmann (Cambridge: Harvard University Press, 1967), 19-48, esp. 32-34.

his lineage. These four women, suggests the panel, exist as Rebecca's prophetic vision in two episodes: she envisions them from her bed and in the moment of the blessing. Pairs of images in the panel thus function as constituent parts of the narrative of Isaac, Rebecca, Jacob and Esau while communicating a particular vision of biblical history in which we find represented not only divine mysteries, celestial interventions and mystical prophecies but also the thoughts, emotions, memories, hopes, predictions and dreams of the protagonists. Finally, if these are indeed Jacob's four wives, they also point to future events in Ghiberti's cycle. The Joseph relief, which follows the Jacob and Esau panel, tells stories that include all of Joseph's brothers — the sons of Rachel, Leah, Bilhah and Zilpah.

This type of narrative, where pairs of images affect and redefine one another when examined together and out of chronological order, succeeds only through the participation of an active viewer who examines the episodes in sequence and then considers them in pairs, lingering over these juxtapositions to extract greater significance from the story. The employment of the perspectival pavement in a narrative image must have triggered Ghiberti's realization that the story's constituent events would necessarily be seen together: perspective, which allowed for the suggestion of fictive depth, also condensed scenes into a limited area and resulted in the overlapping of figures and groups. The rules of the system, I would argue, stimulated Ghiberti's consideration of how he could exploit these juxtapositions to dramatize the narrative.

Although his employment of a perspectival space determined in part the placement of the relief's figures and elements, Ghiberti did not allow perspective to dictate or define the number of figures he could include. He struck a balance between creating a mathematically or geometrically homogenous space and ensuring the presence of individual spatial zones capable of holding and highlighting groups of legible figures. Assuming that viewers would first take in the relief at a single glance, and then break the story down into its constituent scenes and then eventually pairs of events in order to absorb its content, Ghiberti inserted the major orthogonals in the foreground to imply the presence of an expansive space but also introduced significant variation. He subtly expanded spatial zones to provide sufficient room for the narrative's figures, contracted them to ensure the sense of continuing recession into depth and constructed individual spatial pockets in accordance with their viewing points. His creative process revolved around striking a delicate balance between consistency and legibility. The panel, he knew, would be read through both sweeping glances and the kind of focused looking that allowed for the comprehension of the narrative's constituent parts — singly or in pairs.

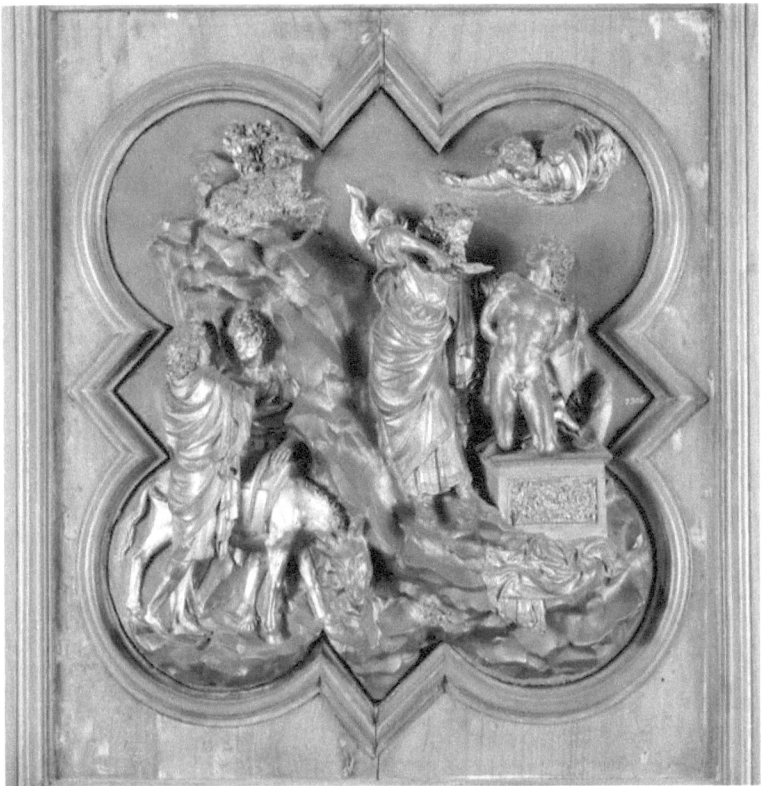

Fig. 1 (above). Lorenzo Ghiberti, *Sacrifice of Isaac*, 1401-2. Museo Nazionale del Bargello, Florence. Photo: Erich Lessing / Art Resource, NY.

Fig. 2 (below). Lorenzo Ghiberti, *The Resurrection* (left) and *The Flagellation* (right), 1403–24, from the north doors of the Florence Baptistery. Photo: Opera di Santa Maria del Fiore, Florence.

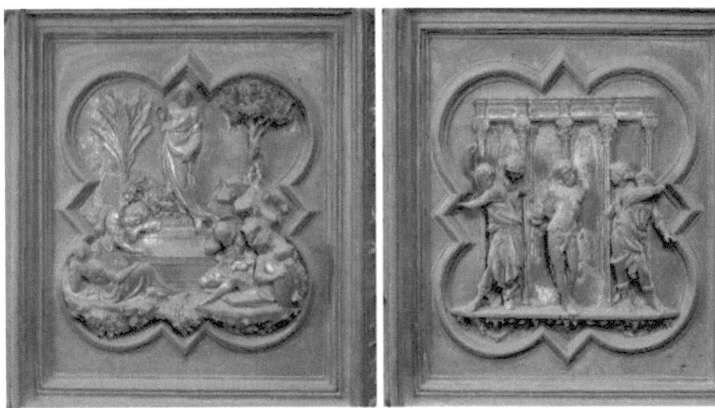

A SCARLET RENAISSANCE

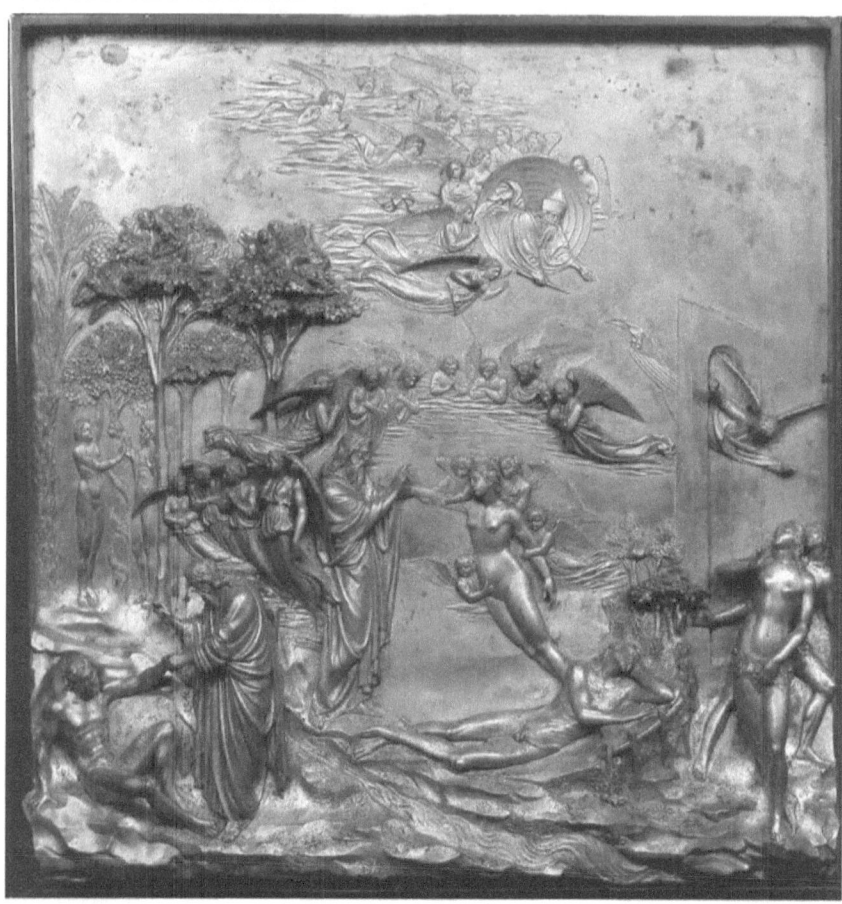

Fig. 3. Lorenzo Ghiberti, Adam and Eve panel from the *Gates of Paradise*, 1425–52, originally on the east side of the Florence Baptistery, now in the Museo dell'Opera di Santa Maria del Fiore, Florence. Photo: Opera di Santa Maria del Fiore, Florence.

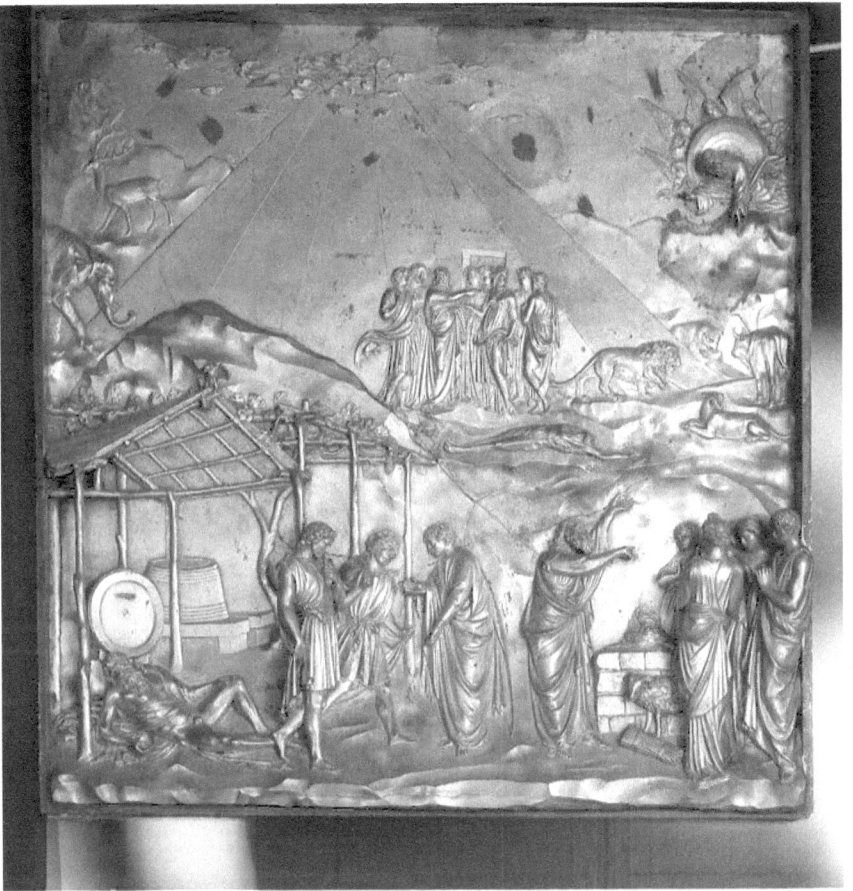

Fig. 4. Lorenzo Ghiberti, Noah panel from the *Gates of Paradise*, 1425–52, originally on the east side of the Florence Baptistery, now in the Museo dell'Opera di Santa Maria del Fiore, Florence. Photo: Opera di Santa Maria del Fiore, Florence.

A SCARLET RENAISSANCE

Fig. 5 (above). Lorenzo Ghiberti, Jacob and Esau panel from the *Gates of Paradise*, 1425–52, originally on the east side of the Florence Baptistery, now in the Museo dell'Opera di Santa Maria del Fiore, Florence. Photo: Opera di Santa Maria del Fiore, Florence.

Fig. 6 (left). Lorenzo Ghiberti, Detail of the Jacob and Esau panel from the *Gates of Paradise*, 1425–52, originally on the east side of the Florence Baptistery, now in the Museo dell'Opera di Santa Maria del Fiore, Florence. Photo: Opera di Santa Maria del Fiore, Florence.

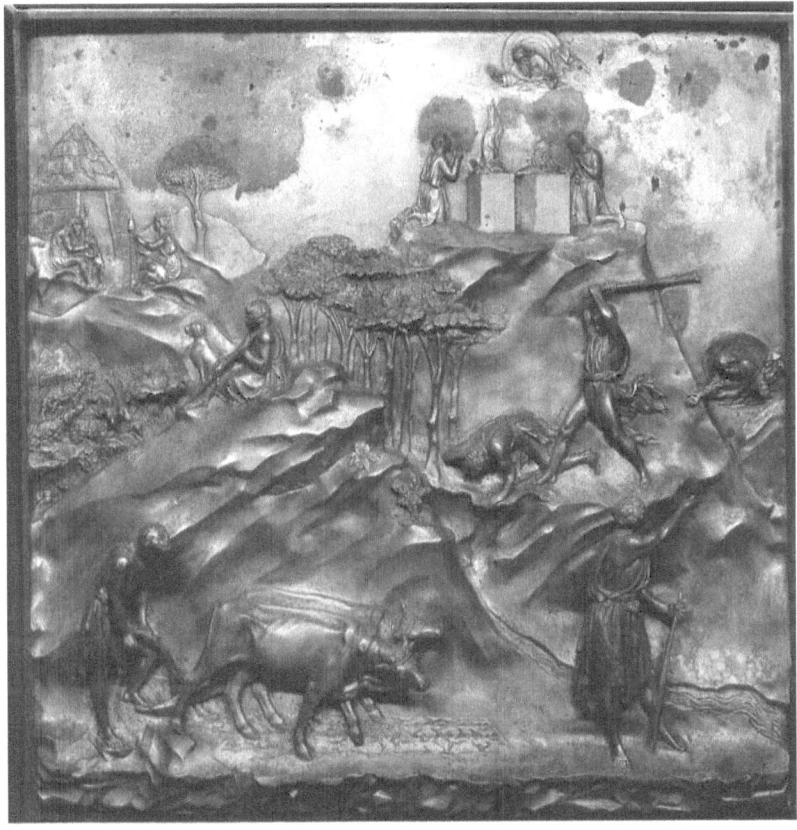

Fig. 7. Lorenzo Ghiberti, Cain and Abel panel from the *Gates of Paradise*, 1425–52, originally on the east side of the Florence Baptistery, now in the Museo dell'Opera di Santa Maria del Fiore, Florence. Photo: Opera di Santa Maria del Fiore, Florence.

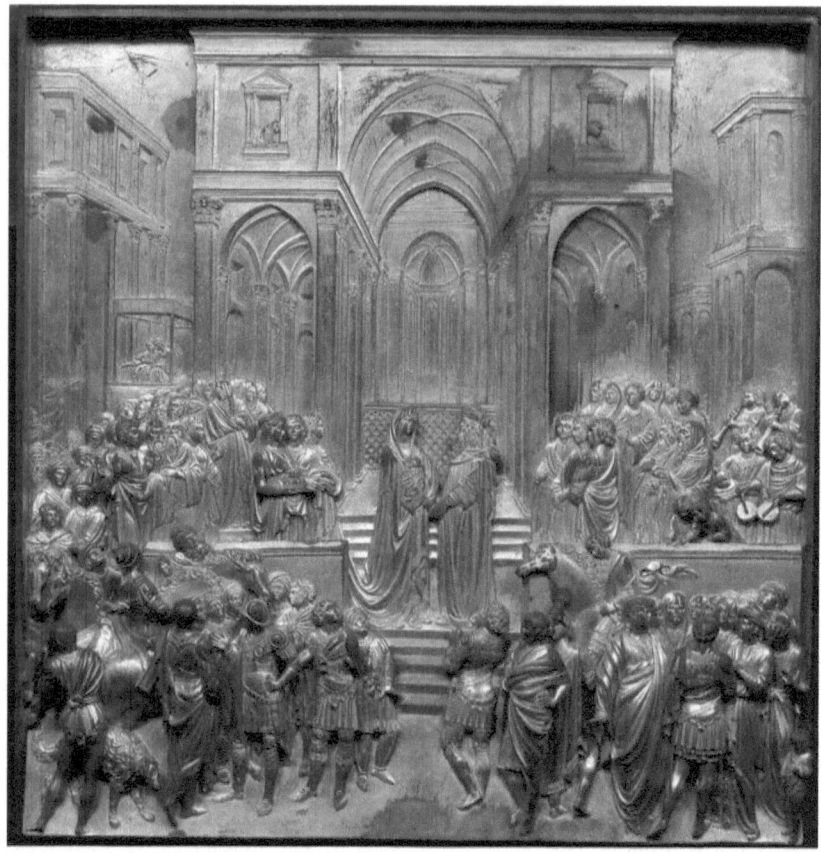

Fig. 8. Lorenzo Ghiberti, Solomon and the Queen of Sheba panel from the *Gates of Paradise*, 1425–52, originally on the east side of the Florence Baptistery, now in the Museo dell'Opera di Santa Maria del Fiore, Florence. Photo: Opera di Santa Maria del Fiore, Florence.

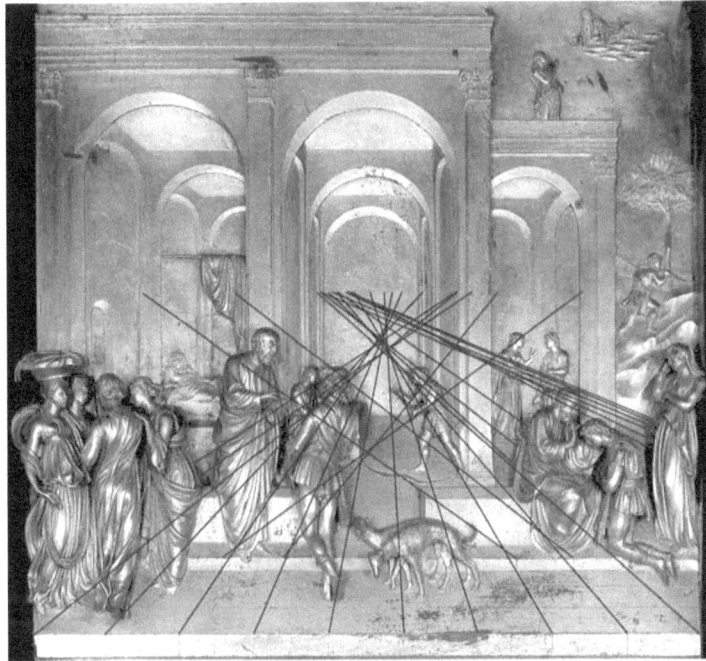

Fig. 9 (above). Lorenzo Ghiberti, Jacob and Esau panel (with orthogonal lines added) from the *Gates of Paradise*, 1425–52, originally on the east side of the Florence Baptistery, now in the Museo dell'Opera di Santa Maria del Fiore, Florence. Photo: Opera di Santa Maria del Fiore, Florence.

Fig. 10 (below). Masolino, *Feast of Herod*, c. 1435. Baptistery, Castiglione Olona. Photo: Universal Images Group / Art Resource, NY.

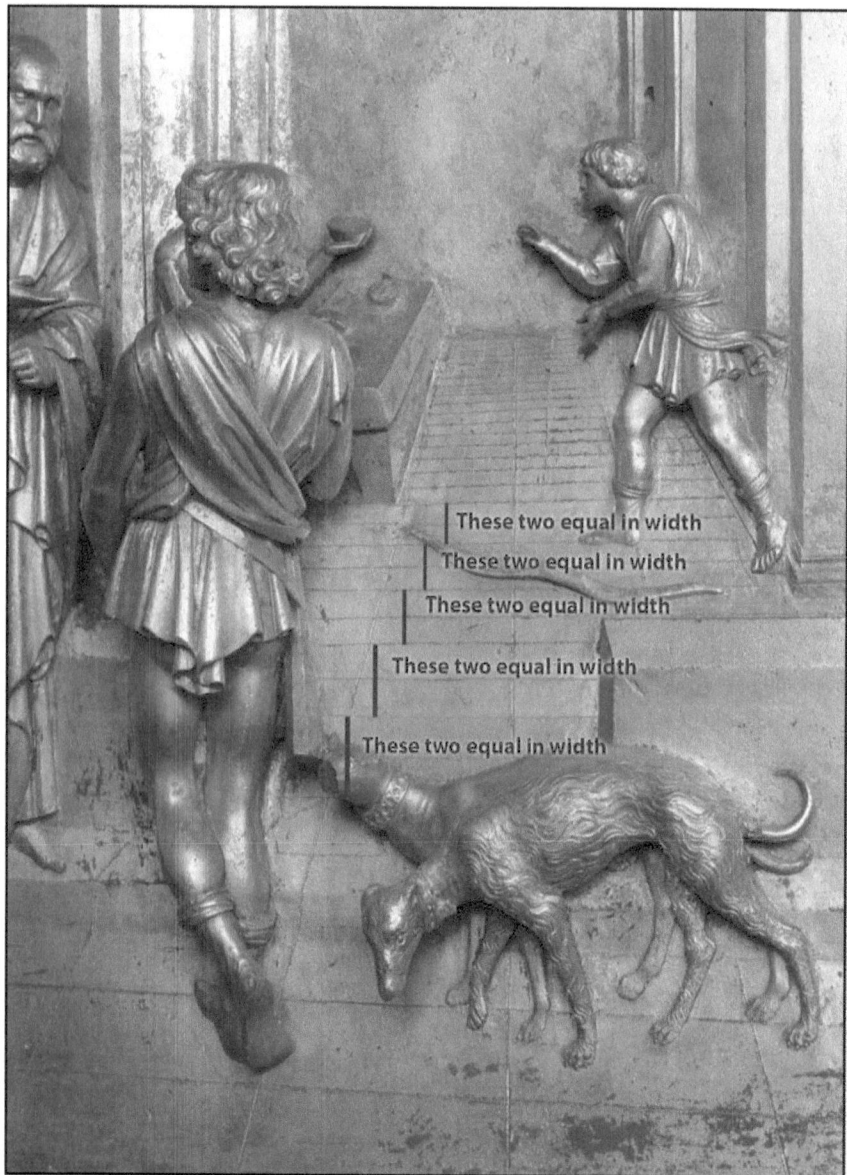

Fig. 11. Lorenzo Ghiberti, Detail of the Jacob and Esau panel (with pairs of tiles of equal width indicated) from the *Gates of Paradise*, 1425–52, originally on the east side of the Florence Baptistery, now in the Museo dell'Opera di Santa Maria del Fiore, Florence. Photo: Opera di Santa Maria del Fiore, Florence.

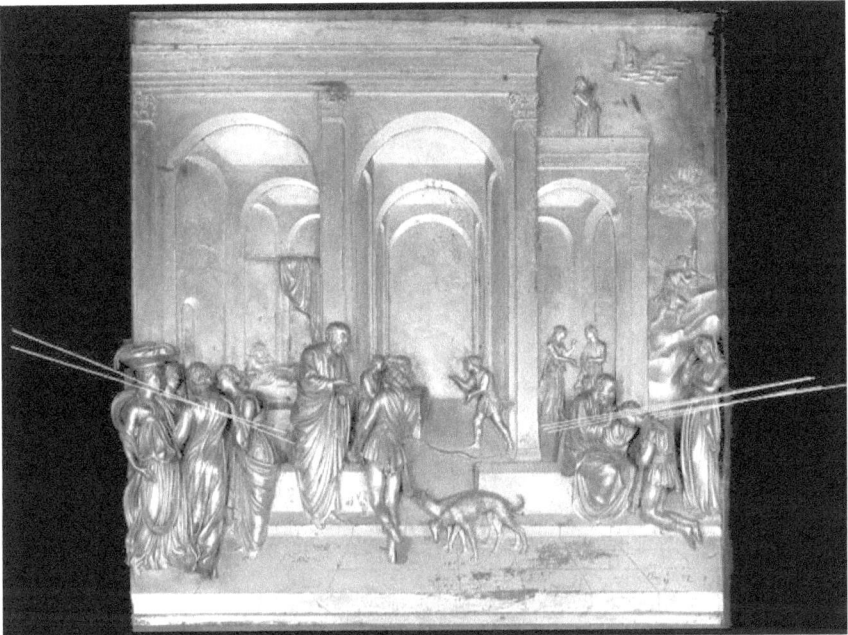

Fig. 12. Lorenzo Ghiberti, Jacob and Esau panel (with various distance points indicated) from the *Gates of Paradise*, 1425–52, originally on the east side of the Florence Baptistery, now in the Museo dell'Opera di Santa Maria del Fiore, Florence. Photo: Opera di Santa Maria del Fiore, Florence.

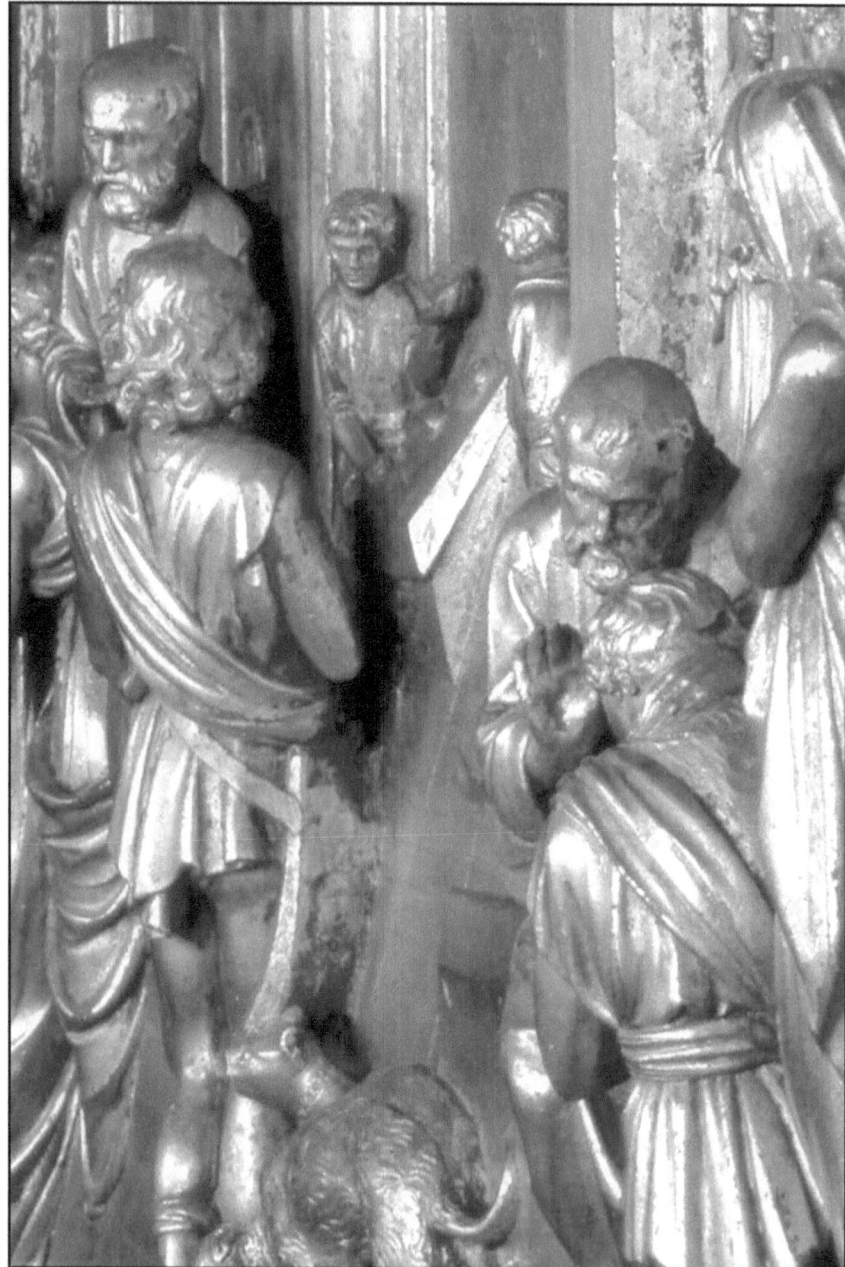

Fig. 13. Lorenzo Ghiberti, Detail of the Jacob and Esau panel from the *Gates of Paradise*, 1425–52, originally on the east side of the Florence Baptistery, now in the Museo dell'Opera di Santa Maria del Fiore, Florence. Photo: Opera di Santa Maria del Fiore, Florence.

SCULPTORS' SIGNATURES AND THE CONSTRUCTION OF IDENTITY IN THE ITALIAN RENAISSANCE

DAVID BOFFA

Compared to their medieval predecessors, sculptors' signatures in the Italian Renaissance can appear rather formulaic and unoriginal, especially for an era that supposedly gave rise to the modern notion of the artist. The OPVS LAVRENTII FLORENTINI (Fig. 1) on Ghiberti's *St. John the Baptist* — "the work of Lorenzo, the Florentine" — is a shadow of the inscription on the early twelfth-century facade of the Modena duomo by Wiligelmo (Fig. 2), which is signed, "Among sculptors how greatly are you worthy in honor. / Now, oh Wiligelmo, your sculpture shines forth."[1] Or consider that Ghiberti's contemporary Donatello signed in a nearly identical format on several of his works, seen, for example, in the OPVS DONATELLI / FLO on his *Judith and Holofernes* (Fig. 3).[2] Far more personalized and self-laudatory is a signature of Wiligelmo's pupil, Niccolò, from 1138 on the tympanum of S. Zeno in Verona: "We want to praise the renowned artist Niccolò, who has carved this, and beg Christ in heaven, that he himself guarantees you the highest

I would like to extend sincere thanks to the individuals who helped shape this article. Sarah McHam first led me to the topic of sculptors' signatures and guided the dissertation that formed the basis of this article. Susannah Fisher read several drafts of this and provided insightful comments at every step. The anonymous reader offered excellent feedback that helped me to sharpen and reconsider many of my claims. Victor Coonin facilitated the entire effort of turning this into a finished essay. To all of them I owe my thanks. A version of this paper was presented at the 2011 annual meeting of the Renaissance Society of America, in the panel "Early Modern Italian Identities III."

1. Translated in John Larner, "The Artist and the Intellectual in Fourteenth Century Italy," *History: The Journal of the Historical Association* 54 (1969): 15. Full Latin inscription from Albert Dietl, *Die Sprache der Signatur: Die mittelalterlichen Künstlerinschriften Italiens*, 4 vols. (Berlin: Deutscher Kunstverlag, 2009), cat. A365: "† DV(M) GEMINI CANCER / CVRSV(M) CONSENDIT / OVANTES • IDIBVS / IN QVINTIS IVNII SVP T(EM)P(O)R(E) / MENSIS • MILLE DEI / CARNIS MONOS CEN/ TV(M) MINVS ANNIS • / ISTA DOMVS CLARI / FVNDATVR GEMINI/ANI • INTER SCVLTORES QVAN/TO SIS DIGNVS ONORE • CLA/RET SCVLTVRA NV(N)C WILIGELME TVA."
2. For a thorough investigation of the inscriptions on this sculpture, see Sarah Blake McHam, "Donatello's Bronze *David* and *Judith* as Metaphors of Medici Rule in Florence," *Art Bulletin* 83 (2001): 32–47.

place in heaven."[3] In examining these and other examples it becomes clear that after the Middle Ages — a period that witnessed what Peter Claussen referred to as the "flowering and maximal public effectiveness"[4] of artists' inscriptions — signatures became increasingly simple and straightforward. There are exceptions, but in general sculptors from the fifteenth and early sixteenth centuries tended to conform to a few established norms when they signed their works.

This information does not fit comfortably within the still prevalent worldview of the Italian Renaissance, in which that era's individualism is contrasted with the anonymity and collective identity that supposedly prevailed during the Middle Ages. Furthermore, the textual austerity of so many fifteenth- and sixteenth-century signatures suggests they have little to offer modern scholars beyond attribution and dating. Despite these initial appearances, such views are an oversimplification and fail to do justice to both medieval and Renaissance artists and their means of proclaiming authorship and identity. To understand signatures requires a consideration of the context in which they were produced and their relation to contemporary and earlier texts, including — but not limited to — other signatures.[5] Visual or formal analysis must then contribute to our understanding of the appearance of the inscriptions as well as their relation to the works of art on which they appear and the broader world of the period's visual culture.

When signatures are returned to their proper context it becomes clear that Renaissance sculptors deliberately employed recognizable textual and stylistic topoi in their inscriptions. Doing so was a means of aligning themselves with the great sculptors of antiquity and with their artistic contemporaries while still noting their unique association with a work of art. This paper will demonstrate that such associations, with antiquity and with contemporary artists, formed an important part of many sculptors' identity formation. It will begin by looking at the widespread use of *opus* signatures by early quattrocento Tuscan sculptors, such as Ghiberti, Donatello, Mino da Fiesole and Andrea da Firenze. It then turns to a discussion of a similarly popular trope in the High Renaissance, the *faciebat* or "Plinian" signature,[6] made most famous by

3. Albert Dietl, "*In arte peritus*: Zur Topik mittelalterlicher Künstlerinschriften in Italien bis zur Zeit Giovanni Pisanos," *Römische historische Mitteilungen* 29 (1987): 106.
4. Peter Cornelius Claussen, "L'anonimato dell'artista gotico: La realtà di un mito," in *L'artista medievale*, ed. Maria Monica Donato (Pisa: Classe di Lettere e Filosofia, 2003), 286.
5. The examination of medieval signatures within their proper literary context, and with regard to the literary precedents to which they were heir, has been done to great effect by Albert Dietl in his *Die Sprache der Signatur*; see, e.g., his chapter on Daedalus topoi in medieval signatures (186-208); also see his article "*In arte peritus*."
6. Sarah McHam has done much to further our understanding of this signature trope. See, for example, Sarah Blake McHam, "Reflections of Pliny in Giovanni Bellini's *Woman with a Mirror*," *Artibus et Historiae* 58 (2008): 157-71.

its appearance on Michelangelo's only signed work of art, the St. Peter's *Pietà*. Although Michelangelo was not the first artist to use the trope, he certainly became the most famous sculptor to do so, and it is likely that the rise in popularity of *faciebat* is at least partly attributable to sculptors wishing to associate themselves not only with antiquity but with him as well. This study of identity formation continues with an examination of the epigraphic styles of these sculptors' signatures, as artists from throughout the period were quick to conform to the trends set by their peers. Finally, the paper will consider the unusual stylistic and epigraphic elements of Michelangelo's signature and what they suggest about his own identity creation and promotion within the broader context of artistic identity in the Italian Renaissance. While it is not the intent of this paper to suggest an inversion of medieval and Renaissance ideologies of communal and individual identity, sculptors' signatures will be used to highlight the complex and relational nature of identity and individualism[7] and to illustrate that both are part of a set of interactions that varies across time and place rather than concepts that emerge spontaneously as an outgrowth of Renaissance humanism.[8]

■

The first extant signature to use *opus* in fifteenth-century sculpture is Ghiberti's *St. John the Baptist* for Florence's Orsanmichele (c.1412–15), which is signed OPVS LAVRENTII FLORENTINI on the hem of the figure's cloak (Fig. 1). Niccolò Lamberti's roughly contemporaneous *St. Mark*, originally for the facade of Florence Cathedral, was similarly signed at the base: OPVS / NICH/ OLAI (Fig. 4). Around a decade later Ghiberti used the same format on his first set of doors for the Florence Baptistery — OPVS LAVREN//TII FLORENTINI (Fig. 5) — and fellow Florentine sculptors like Donatello, Mino da Fiesole and Andrea da Firenze soon followed suit. Within a few short decades, this signature became the most common type in use by Tuscan sculptors, who subsequently spread the format to artists outside their immediate circle.

7. On some aspects of identity and selfhood in the Middle Ages, see Bruce W. Holsinger and Rachel Fulton, "Introduction: Medieval Communities and the Matter of Person," in *History in the Comic Mode: Medieval Communities and the Matter of Person*, ed. Bruce W. Holsinger and Rachel Fulton (New York: Columbia University Press, 2007), 1–12; and Caroline Walker Bynum, "Did the Twelfth Century Discover the Individual?" in *Jesus as Mother: Studies in the Spirituality of the High Middle Ages* (Berkeley: University of California Press, 1982), 82–109.

8. On selfhood and identity, see Charles Taylor, *Sources of the Self: The Making of the Modern Identity* (Cambridge: Cambridge University Press, 1989); Anthony Low, *Aspects of Subjectivity: Society and Individuality from the Middle Ages to Shakespeare and Milton* (Pittsburgh, PA: Duquesne University Press, 2003); Stephen Greenblatt, *Renaissance Self-Fashioning: From More to Shakespeare* (Chicago: University of Chicago Press, 2001); as well as the essays in *Rewriting the Self: Histories from the Renaissance to the Present*, ed. Roy Porter (London: Routledge, 1997).

A SCARLET RENAISSANCE ■

Prior to the fifteenth century this sort of signature was exceptionally rare on sculpture; out of over 800 examples collected by Dietl, he lists only six inscriptions that use the construction *opus* + name.[9] The last sculptor known to have done so before the fifteenth century was Giovanni Pisano, on his *Madonna and Child* (c.1305/6) in Padua, which includes OPVS / IOH(ANN)IS MAGISTRI at the base.[10] The rarity of this type of signature is somewhat unusual given its appearance in at least three paintings by Giotto or his workshop from c.1300 to 1330 and likely in other trecento paintings.[11] Not until a century later did the trope become appropriated by sculptors.

The ultimate source for the *opus* signature was classical sculpture. The renowned colossal statues from antiquity known as the *Dioscuri* that still stand in Rome are signed OPVS FIDIAE and OPVS PRAXITELES.[12] The inscriptions were additions from late antiquity and do not date to the statues' second-century execution, but they were accepted as signatures in the fourteenth century, when Petrarch mentioned them.[13] As noted by Ulrich Pfisterer, the survival of these inscriptions was likely responsible for the appearance

9. Dietl, *Die Sprache der Signatur*, Tab. XVII: Signaturformeln in italienischen Künstlerinschriften, 283–90, esp. 288.

10. The full signature reads: DEO GRATIAS † OPVS / IOH(ANN)IS MAGISTRI NICOLI / DE PISIS. See Dietl, *Die Sprache der Signatur*, cat. A426.

11. Interestingly, Giotto's authorship of the three paintings is also disputed. The paintings are the *Stigmatization of St. Francis* (c.1295–1300; Louvre, Paris; orig. S. Francesco, Pisa), signed: OPVS IOCTI FIORENTINI; the *Polyptych with Madonna and Child* (c.1330; Pinacoteca; Bologna), signed OP(VS) MAGISTRI IOCTI D(E)FLORE[NT]I; and the *Coronation of the Virgin* (c.1330; Baroncelli Chapel, S. Croce; Florence), signed: O/PVS MA/GISTR/I IOCT/I. For more on Giotto and attribution problems, see the essays and bibliography in *The Cambridge Companion to Giotto*, ed. Anne Derbes and Mark Sandona (Cambridge: Cambridge University Press, 2004).

12. Phyllis Pray Bober and Ruth Rubinstein, *Renaissance Artists & Antique Sculpture: A Handbook of Sources* (London: Harvey Miller Publishers, 1986), 159–61. The pair is thought to be a second-century CE copy after fifth-century BCE Greek prototypes.

13. The Dioscuri are mentioned in *Rerum familiarum libri*, I.1.37; V.17.5; VI.2.13, and XVIII.5.4; *De remediis utriusque fortunae*, I.41, and II.88; *Canzoniere* CXXX; *Seniles* II.3; and *Africa* VIII.910. The preceding list is provided in Ulrich Pfisterer, "Phidias und Polyklet von Dante bis Vasari: Zu Nachruhm und künstlerischer Rezeption antiker Bildhauer in der Renaissance," *Marburger Jahrbuch für Kunstwissenschaft* 26 (1999): 66 and n. 31. Also see Maurizio Bettini, *Francesco Petrarca sulle arti figurative: Tra Plinio e sant'Agostino* (Livorno: Sillabe, 2002), 28–29. See Ulrich Pfisterer, *Donatello und die Entdeckung der Stile 1430–1445* (Munich: Hirmer Verlag, 2002), Appendix D, 598–602 for a more extensive list of medieval and Renaissance references to Phidias and Praxiteles. Prior to Petrarch it seems the inscriptions were not recognized as signatures. The *Mirabilia Urbis Romae*, the earliest version of which dates to 1143, incorrectly identified the figures themselves as philosophers named "Fidias" and "Praxiteles." On this error, see Ernst Robert Curtius, *European Literature and the Latin Middle Ages*, trans. Willard R. Trask (Princeton: Princeton University Press, 1953), 405–6. On the *Mirabilia Urbis Romae* and sculpture, see Antje Middeldorf Kosegarten, "Remarks on Some Medieval Descriptions of Sculpture," in *Santa Maria del Fiore: The Cathedral and Its Sculpture* (Florence: Cadmo, 2001), 31–32. For the *Mirabilia* see Francis Morgan Nichols, trans., *Mirabilia Urbis Romae*, 2nd ed. (New York: Italica Press, 1986).

of this formula in the signatures of fifteenth-century artists.[14] Presumably Ghiberti could have seen these signatures in Rome, possibly during a trip made sometime before 1416.[15] In his own writings he mentions seeing a signature of Lysippus on a statue in Siena, and so it is apparent that he found the presence of ancient inscriptions significant.[16]

The widespread use of the *opūs* formula by quattrocento Tuscan sculptors suggests that, at least initially, it was a component of these artists' identity formation. The ubiquity of the form highlights the great importance placed on antiquity by nearly all central Italian sculptors from the early fifteenth century, not just those thought of as classicizing by modern standards. It also speaks to the desire for in-group identification that was at least partially dependent on associations with classical Rome. Whatever the relationship between these artists' individual styles and antiquity, in their mode of self-presentation via signatures they overwhelmingly chose to appropriate an ancient trope. Furthermore, the concentration of the format among a relatively small group of artists trained in or working out of Florence suggests a degree of identification with, and pride in, one's communal and civic identity, despite the presence of other signature options. This is perhaps the most interesting aspect of this phenomenon: whatever the stylistic differences we perceive among artists like Ghiberti, Donatello, Mino and others, the words they used to present themselves were overwhelmingly uniform. Inscribing oneself using the classically inspired *opus* signature was thus a means of proudly declaring one's identification with both a specifically Florentine artistic heritage as well as with the admirers of, and alleged successors to, the great sculptors of antiquity.

14. Pfisterer, "Phidias und Polyklet."
15. Richard Krautheimer and Trude Krautheimer-Hess, *Lorenzo Ghiberti*, 2 vols. (Princeton, NJ: Princeton University Press, 1970), 1:288, claim that it seems Ghiberti was in Rome sometime before 1416.
16. Julius von Schlosser, *Lorenzo Ghibertis Denkwürdigkeiten (I commentarii): Zum ersten Male nach der Handschrift der Biblioteca Nazionale in Florenz vollständig herausgegeben und erläutert* (Berlin: J. Bard, 1912): "Vna ancora [statua] fu trouata, simile a queste due, fu trouata nella città di Siena, della quale ne feciono grandissima festa et dagli intendenti fu tenuta marauigliosa opera, et nella basa era scripto el nome del maestro, el quale era excellentissimo maestro, el nome suo fu Lisippo; et aueua in sulla gamba in sulla quale ella si posaua uno alfino" (63). This is mentioned in Dietl, *Die Sprache der Signatur*, 12 n. 4. Chiara Scappini informed me that this statue was the alleged "Venus" on the first Fonte Gaia. Alternatively, Donatello would have seen the *Dioscuri* during his trip to Rome with Brunelleschi in the early fifteenth century, and perhaps it was through him that Ghiberti learned of this allegedly ancient signature form. Mentioned in Antonio Manetti, *Life of Brunelleschi*, ed. H. Saalman (University Park: The Pennsylvania State University Press, 1970), 50–55; per Roger Tarr, "Brunelleschi and Donatello: Placement and Meaning in Sculpture," *Artibus et Historiae* 16 (1995): 101 n. 1. On Donatello and Brunelleschi, see Giorgio Castelfranco, "Sui rapporti tra Brunelleschi e Donatello," *Arte Antica e Moderna* 34–36 (1966): 109–22.

The trend of using textual means as a part of one's identity formation and promotion continues throughout the quattrocento. By the second half of the fifteenth century the *opus* + name format had diffused widely to artists from outside the Tuscan milieu, notably to sculptors from or working in northern Italy. Andrea Bregno, Pietro Lombardo, Andrea da Fusina, Sperandio and Moderno are just a few of the sculptors who appropriated what had once been a characteristically Tuscan means of signing a work. In doing so, they were employing a signature type that was now laden with even more significance than it originally had at the beginning of the century. The reference now was not simply to classical antiquity, although certainly that sense was retained; also included was a modern sense of community and identity with the quattrocento's most famous and sought-after sculptors, the Tuscans. Three of the early exponents of this trope — Ghiberti, Donatello and Mino da Fiesole — were all sculptors whose fame stretched far beyond Tuscany. Donatello and Mino da Fiesole, in particular, were recognized for the instrumental roles they played in bringing a new (Renaissance) idiom to sculpture in Rome.[17] The ability to align oneself not only with the great masters of antiquity but with prominent contemporaries as well must have increased the appeal of signing in such a characteristically "Tuscan" manner.

The use of the *opus* signature form by early Renaissance sculptors in Tuscany and elsewhere mirrors some contemporary trends observable in other elements of the visual and intellectual culture of the period. For example, the significant decline in the number of early fifteenth-century signatures that feature a verb of creation, such as *fecit* or *sculpsit*, suggests a possible reevaluation of how sculptors thought of themselves in relation to their creations. Although it is dangerous to read too deeply into inscriptions consisting of only a few words, it is tempting to see the increase in *opus* signatures as the manifestation of sculptors who wanted to present themselves as men whose creative output is the result of their intellectual prowess rather than their manual dexterity.[18] Yet this does not necessarily imply support for what modern scholars have claimed as the mythical rise of the modern artist in the fifteenth century any more than it suggests an actual change in the way sculptors executed their works. Rather, it suggests a change in what sculptors perceived was important for ideas of authorship and its relationship to the creative process.

17. See, e.g., Shelley E. Zuraw, "Mino da Fiesole's First Roman Sojourn: The Works in Sta. Maria Maggiore," in *Verrocchio and Late Quattrocento Italian Sculpture*, ed. Steven Bule et al. (Florence: Editrice Le Lettere, 1992), 303–19; and John W. Pope-Hennessy, *Donatello, Sculptor* (New York: Abbeville Press, 1993).

18. Rona Goffen, "Signatures: Inscribing Identity in Italian Renaissance Art," *Viator* 32 (2001): 310, argued that fourteenth-century viewers would have understood this concept, as well, recognizing that a signature referred as much (or more) to the "*conception* of the work of art, its science and doctrine" as it did to its manual execution.

Scholars have already noted how mentions of an artist's "hand" had long been understood in a broader and more metaphorical sense to refer to the artist's creative faculties in general;[19] with the use of *opus* signatures it appears that such stand-ins became unnecessary. Associations via *opus* carried the necessary implications of a sculpture's conception and execution.

It is interesting to note that the changes seen in sculptors' signatures from the fifteenth century are also seen in broader epigraphic trends from the period. As lengthy signatures composed in verse went out of fashion, so too did carved epitaphs in verse. By the middle of the fifteenth century the verse epitaph, once popular on tomb monuments, was almost entirely replaced by prose epitaphs, which became the dominant form for the next hundred years.[20] Contemporaneously, artists and epigraphists began composing and executing inscriptions with an eye toward their visual presentation. Greater attention was given to creating an interesting and visually appealing arrangement of writing, via features like Roman lettering and centered lines of text, and occasionally these elements made important contributions to an inscription's meaning.[21] These parallel developments in sculptors' signatures and quattrocento epigraphy underscore the significant interplay and exchange between the artists and humanists of the period. Furthermore, the related developments support the notion that artists, in addition to signing for other

19. Goffen, "Signatures," 308: "It is as though 'hand' were understood as a metaphor for 'mind,' the implication being that the conception of the work belongs to the master, and that his authorship consists in this intellectual act as much or more than in the manual execution." This idea was also noted by Dietl, "*In arte peritus,*" 94, in the context of medieval signatures. Dietl also mentions that the inclusion of references to an artist's hand in medieval signatures may be a means of exhibiting the proper fulfillment of a contract that specified a particular artist execute a work himself (as overseer, "by his hand"); in this sense the signature may have had something like a legal function as well (94–96). For a specific examination of phrasing related to an artist's "hand" in the fifteenth century, see, e.g., Charles Seymour, Jr., " 'Fatto di sua mano': Another Look at the Fonte Gaia Drawing Fragments in London and New York," in *Festschrift Ulrich Middeldorf*, ed. Antje Kosegarten and Peter Tigler (Berlin: Walter de Gruyter, 1968), 98.

20. John Sparrow, *Visible Words: A Study of Inscriptions in and as Books and Works of Art* (Cambridge: Cambridge University Press, 1969), 13–23. Sparrow notes that the epitaph for Pope Nicholas V (d.1455) was the last papal one to be written in verse. A similar situation is seen in Venice, where not a single doge is commemorated in verse after 1450, as well as in the epitaphs of jurists in Bologna who were *lettori* in the city's university. Sparrow attributes this change to an increasing cooperation between the texts' composers and executors (i.e., sculptors, carvers, architects of the monument), as well as to the greater influence of classical inscriptions, such as the prose *elogia* on Roman tombs and memorials.

21. Sparrow, *Visible Words*, 89–90. But see Covi's review and criticism of some of Sparrow's claims, in Dario A. Covi, "A Study of Inscriptions," *Burlington Magazine* 113 (1971): 158–60. For some other changes in fifteenth- and sixteenth-century Roman epigraphy, see Iiro Kajanto, *Classical and Christian: Studies in the Latin Epitaphs of Medieval and Renaissance Rome* (Helsinki: Suomalainen Tiedeakatemia, 1980), esp. 11–16.

artists and for posterity, were signing in response to and for their humanist peers, a point to which this paper will return later.

■

Another signature trope developed toward the end of the fifteenth century became just as popular as *opus* had been previously and just as critical for conveying artistic identity. Starting at the end of the fifteenth century, the imperfect form of *facio*, "*faciebat*," begins to appear in sculpture. Michelangelo's St. Peter's *Pietà*, signed MICHAEL A(N)GELVS BONAROTVS FLORENT FACIEBA(T), is often (erroneously) thought to be the first example of this signature type (Fig. 6).[22] Vladimir Juřen has argued that the humanist poet and tutor Angelo Poliziano, who was in the Medici household at the time when Michelangelo was there in the early 1490s, would have brought this classical signature type to the young sculptor's attention.[23] Following the emergence of *faciebat* in a handful of signatures on sculptures and paintings from the 1490s, it becomes a highly popular means for sculptors — as well as others — to sign their works.[24] For central and northern Italian sculptors it is the most common signature trope found in the examples from the first half of the sixteenth century, although other traditions persist, and signatures continue to vary from place to place and even work to work for some artists.[25]

The genesis of this development within quattrocento Italy is not entirely clear, although the ultimate source — a mention of this signature type by Pliny the Elder in the introduction to his *Natural History* — is well known. According to him, signing works in this way was a topos from antiquity. He writes:

> I should like to be accepted on the same basis as those founders of the arts of painting and sculpture who, as you will find in my book, inscribed their completed works, even those we never tire of admiring, with a sort of provisional signature—*Apelles faciebat*, for instance, or *Polyclitus faciebat*: 'Apelles

22. See, e.g., Aileen June Wang, "Michelangelo's Signature," *The Sixteenth Century Journal* 35 (2004): 460.
23. Vladimir Juřen, "Fecit–faciebat,"*Revue de l'Art* 26 (1974): 28–29.
24. Some of the earliest uses of *faciebat* are by the north Italian painter Macrino d'Alba, who signed a number of works in the 1490s with the term. Early examples include his *Madonna and Child* (tempera on wood, Frankfurt, Städelsches Kunstinstitut), c.1493–94, with a *cartellino* bearing the words MACRINVS / FACIEBAT: see Giovanni Romano, ed., *Macrino d'Alba: Protagonista del Rinascimento piemontese* (Savigliano: Editrice Artistica Piemontese, 2001), cat. 1; *Madonna and Child* (main panel of triptych; Turin, Museo Civico d'Arte Antica), 1494–95, signed MACRINVS / FACIEBAT / 1495; and the *Madonna and Child* (main panel of triptych; Certosa di Pavia, Sta. Maria delle Grazie), 1496, signed MACRINVS D. ALBA / FACIEBAT 1496: see Kandice Rawlings, "Liminal Messages: The *cartellino* in Italian Renaissance Painting" (Ph.D. diss., Rutgers University, 2009), 232 nos. 258 and 252.
25. Jacopo Sansovino, for example, used both *opus* + name and *faciebat* signatures.

has been at work on this'—as if art was something always in progress and incomplete; so that in the face of any criticisms the artist could still fall back on our forbearance as having intended to improve anything a work might leave to be desired, if only he had not been interrupted. There is a wealth of diffidence in their inscribing all their works as if these were just at their latest state, and as if fate had torn them away from work on each one. Not more than three works of art, I believe, are recorded as being inscribed as actually finished: *fecit*.[26]

Pliny's claim is a linguistic one, dependant on the imperfect form of the verb being used (e.g., *faciebat*). In Latin, the imperfect is a past tense with an imperfective aspect. Among other things, this aspect indicates the repetition or continuity of a past action.[27] English lacks a specific verb form to indicate the imperfect tense, although the typical translation of *faciebat* as "was making" is sufficient to convey the intended meaning.

The surviving evidence complicates our picture of *faciebat*'s rise in popularity, as both central and northern Italy offer possible sites of origin. The trope appears in a number of signatures from the north of Italy, suggesting a possible

26. English version quoted and translated in Michael Baxandall, *Giotto and the Orators: Humanist Observers of Painting in Italy and the Discovery of Pictorial Composition 1350–1450* (Oxford: Clarendon Press, 1971), 64. The original Latin reads: "inscriptionis apud graecos mira felicitas: κηρίον inscripsere, quod volebant intellegi favum, alii κέρας Ἀμαθείας, quod copiae cornu, ut vel lactis gallinacei sperare possis in volumine haustum; iam ἴα Μοῦσαι, πανδέκται, ἐγχειρίδια. λειμών, πίναξ, σχεδίων: inscriptiones, propter quas vadimonium deseri possit; at cum intraveris, di deaeque, quam nihil in medio invenies! nostri graviores antiquitatium, exemplorum artiumque, facetissimi lucubrationum, puto quia bibaculus erat et vocabatur. paulo minus asserit Varro in satiris suis sesculixe et flextabula. apud graecos desiit nugari diodorus et βιβλιοθήκης historiam suam inscripsit. apion quidem grammaticus — hic quem tiberius caesar cymbalum mundi vocabat, cum propriae famae tympanum potius videri posset — immortalitate donari a se scripsit ad quos aliqua componebat. me non paenitet nullum festiviorem excogitasse titulum et, ne in totum videar graecos insectari, ex illis mox velim intellegi pingendi fingendique conditoribus, quos in libellis his invenies absoluta opera et illa quoque, quae mirando non satiamur, pendenti titulo inscripsisse, ut "Apelles faciebat" aut "polyclitus," tamquam inchoata semper arte et inperfecta, ut contra iudiciorum varietates superesset artifici regressus ad veniam velut emendaturo quicquid desideraretur, si non esset interceptus. quare plenum verecundiae illud, quod omnia opera tamquam novissima inscripsere et tamquam singulis fato adempti. tria non amplius, ut opinor, absolute traduntur inscripta "ille fecit," quae suis locis reddam. quo apparuit summam artis securitatem auctori placuisse, et ob id magna invidia fuere omnia ea." Pliny the Elder, *Naturalis Historia*, ed. Karl Friedrich Theodor Mayhoff (Leipzig: Teubner, 1906), Praef., 6, accessed November 27, 2011, http://www.perseus.tufts.edu/hopper/text?doc=Perseus%3Atext%3A1999.02.0138%3Abook%3 Dpreface%3Achapter%3D6.

27. Grammatical "aspect" is the temporal flow, or lack of it, described by a verb; it is thus distinct from "tense," which refers to the temporal location of an event. English does not have a verb form that marks the imperfect in the same way that Latin does; the progressive and continuous tenses are the closest approximants.

genesis in that region.[28] Gian Cristoforo Romano used *faciebat* for his signature on the tomb of Gian Galeazzo Visconti, in the Certosa, Pavia, which dates to c.1491-97; the brothers Tommasso and Giacomo Rodari signed an aedicule (dated 1498) below the figure of Pliny the Elder on Como Cathedral's facade with THOMAS ET IACOBUS DE RODARIIS FACIEBANT; and it appears in the signature of Giovanni Antonio Amadeo on his arca of S. Lanfranco, in the church of S. Lanfranco, Pavia: IOANNES ANTONIVS HOMODEVS FACIEBAT.[29] This evidence seems to suggest that the rise of *faciebat* was, initially at least, a northern development,[30] although arguments can also be made for Tuscan origins. A possible scenario would be the development in both areas independently, simply as part of the cultural milieu of late fifteenth-century humanist scholarship in much of Italy. The situation is made even more ambiguous by a *faciebat* signature — ADRIANVS FLOR FACIEB — on a bronze statuette of uncertain date depicting a Satyr (or Pan) by the sculptor Adriano Fiorentino, who may have spent time in the household of Lorenzo de' Medici and who also spent time in northern Italy.[31] The statuette is not dated precisely, although a *terminus ante quem* of 1499 is provided by the artist's death that year. If it was made during the artist's Florentine period, possibly in the 1480s or early 1490s, it would be the earliest example of a *faciebat* signature on a quattrocento sculpture, but the lack of precise information on the work prevents such conclusions (nor would an early dating preclude the possibility that the signature type was revived elsewhere independently).[32]

28. I am grateful to Dr Sarah Blake McHam for bringing this possibility to my attention, as well as for sharing several signatures from northern Italy with me.
29. See Charles R. Morscheck, Jr., *Relief Sculpture for the Façade of the Certosa di Pavia, 1473-1499* (Garland: New York, 1978), 222, and fig. 167. The dating of this monument is c.1498-1508. The signature's authenticity has also been questioned, on account of its dissimilarity to the other known signatures of Amadeo. See Maria Giuseppina Malfatti, "L'arca di San Lanfranco," in *Giovanni Antonio Amadeo: Scultura e architettura del suo tempo*, ed. Janice Shell and Liana Castelfranchi (Cisalpino: Milan, 1993), 224-25 and 225 n. 6.
30. Interestingly, and perhaps significantly, an early appearance of a painted signature with the imperfect form of a verb is in Albrecht Dürer's *Self-Portrait* of 1500, which features *effingebam*. The full signature, one of two that appear in the painting (the other being his famous monogram) reads: *Albertus Durerus Noricus / ipsum me proprijs sic / effin / gebam coloribus aetatis / anno XXVIII*. For more on this, see Renate Trnek, Rudolf Preimesberger, Martina Fleischer, eds., *Selbstbild: Der Künstler und sein Bildnis* (Ostfildern: Hatje Cantz, 2004); and Erika Boeckeler, "Painting Writing in Albrecht Dürer's *Self-Portrait* of 1500," *Word & Image* 28 (2012): 30-56. On the word *fingere*, see Anne-Marie Lecoq, "'Finxit': Le peintre comme 'fictor' au XVIe siècle," *Bibliothèque d'humanisme et Renaissance* 37 (1975): 225-43.
31. The signature was discovered in 1970. See Andrea Bacchi and Luciana Giacomelli, eds., *Rinascimento e passione per l'antico: Andrea Riccio e il suo tempo*, (Trent: Castello del Bonconsiglio, 2008), cat. 48.
32. The fact that Adriano also spent time in northern Italy could lend further support to the idea that the trope of *faciebat* signatures has its genesis in that area. However, he is also documented in Naples and Germany. See L. Forrer, *Biographical Dictionary of Medallists* (London: Spink & Son Ltd, 1904), 1:26-27.

By the sixteenth century the so-called Plinian signature was the most popular format employed by sculptors; Andrea Sansovino, Jacopo Sansovino, Baccio Bandinelli and Benvenuto Cellini were just a few of the sculptors who signed works in this manner. The consistent use of *faciebat* by sculptors of the High Renaissance illustrates a continued desire for identification with antiquity and great contemporaries that mirrors the fifteenth-century phenomenon of signing with *opus*. Even if Michelangelo was not the first artist to use the trope, he certainly became the most famous sculptor to do so, and it is likely that the rise in popularity of *faciebat* is at least partly attributable to sculptors wishing to associate themselves not only with antiquity but with him as well. Benvenuto Cellini even went so far as to imitate the imagery of Michelangelo's signature, as he placed his own on a strap that runs across the torso of Perseus (Fig. 7). The so-called Plinian signature thus became an important component of identity formation for many sixteenth-century sculptors, who employed recognizable and widely used tropes even while seeking to distinguish themselves from their peers.

■

The choices sculptors made about lettering in their signatures also played a role in identity formation, especially in the fifteenth century, when the revival of Roman letterforms made new epigraphic styles available. Ostensibly, sculptors during this period had a variety of alphabetic options from which to choose when signing their works, and the options increased as the century progressed: Romanesque, Gothic, Florentine sans serif, Roman, as well as variations on each of these. Yet with very few exceptions the leading sculptors of fifteenth-century Italy, those working in or around central and northern Italy, chose to sign in the dominant forms used by their famous peers: in the first half of the century this was a sans-serif style pioneered by Ghiberti and Donatello, and in the second half of the century it was a truer Roman revival exemplified in the works of Andrea Bregno. On a basic level this is a choice that reflects the following of prevailing trends set by the century's leading artists; presumably, to sign in Gothic letterforms after the early part of the fifteenth century would have seemed *retardataire* in light of the period's epigraphic developments.

Beyond the straightforward component of signing with what was fashionable, the use of similar epigraphic styles in signatures is a further element of identity promotion available to artists. In one sense, signing with particular styles can convey an element of group identity or cohesiveness, and at the very least a signature's lettering can suggest a component of identity that is based on associations with the admired figures of past and present times. When Piero di Niccolò Lamberti and Giovanni di Martino da Fiesole signed the tomb of Doge Tommaso Mocenigo their decision to use sans-serif lettering — totally at

odds with the tomb's primary Gothic inscription — was as much a part of their statement of identity and Tuscan pride as was the inclusion of their native cities' names (Fig. 8).[33] These identifiably Florentine letterforms made the sculptors' artistic origins and allegiances clear. Furthermore, inscriptions like this were also an expression of a sculptor's broader artistic identity, beyond his particular civic identity. For sculptors working within a humanist milieu in the fifteenth century, the proper appropriation of ancient elements, including letterforms, was a significant component of their self-presentation and fashioning. Thus the use of classical or classically inspired letters was as much about sculptors linking themselves to their peers as it was about making clear associations with antiquity. In this sense they called attention to their personal contribution to the shared work recovering the glory of antiquity and inserted themselves into a narrative and group framework that had elements both contemporary and ancient.

■

Questions of audience and reception are also fundamental when considering the ways signatures conveyed information. In most cases, it appears that sculptors were not signing primarily for the populace at large but rather for their peers in artistic, scholarly and literary circles. The evidence, provided by the ways in which artists consistently copied the signatures of their peers, illustrates that they were in fact reading and reacting to fellow artists' statements of authorial presence. Signatures' lettering also supports the notion that sculptors, in signing their works, were addressing primarily an audience of their artist and humanist peers. As much as the use of Roman letterforms in the fifteenth and sixteenth centuries was a nod to prevailing trends, it was also a choice that took audience into account. This idea of selecting a particular lettering style for a particular audience was something with which people of the period would have been familiar. Since the late thirteenth century, letter-writers were supposed to have command of at least three different types of script for different types of letters (and thus different audiences/recipients).[34] In the second half of the sixteenth century the Italian writing master Giovanni Francesco Cresci noted that different types of correspondence could require different types of scripts, and in some cases scripts were reserved for different languages; e.g., one script for vernacular, another for Latin.[35] The situation for writing on sculpture

33. It also might suggest they were directly involved in the manual execution of the signature, which might not have been the case for the dedicatory inscription.
34. David Ganz, "'Mind in Character': Ancient and Medieval Ideas about the Status of the Autograph as an Expression of Personality," in *Of the Making of Books: Medieval Manuscripts, Their Scribes and Readers*, ed. P.R. Robinson and Rivkah Zim (Aldershot: Scolar Press, 1997), 293.
35. Ganz, "Autograph," 293–94. See also Giovanni Cresci, "Il perfetto cancellaresco corsivo," in *Scribes and Sources: a Handbook of the Chancery Hand in the Sixteenth Century*, trans. A.S. Osley (London: Faber and Faber, 1980), 119.

in the form of epigraphy and signatures was likely no different, and lettering was used to signify, among other things, the presence of an author who made a choice about lettering and a reader to whom that choice was directed.[36]

Given this component to lettering, content and audience, it is probable that part of the reason behind the use of ancient letterforms and tropes in the Renaissance was to address the metaphorical audience of antiquity. In doing so, sculptors were signifying their correspondence with the artists to whom they aspired. This sort of imaginary dialogue developed by fifteenth-century sculptors was not without precedent; not surprisingly, its origins are in the roots of humanistic thought. Petrarch, in the previous century, wrote letters to ancient authors like Cicero,[37] claiming, "I wrote to him as a friend of my own years and time, regardless of the ages which separated us."[38] Signing a work with OPVS DONATELLI or SANSVVINVS FLORENTINVS / FACIEBAT in Roman capitals seems to be a means of initiating a similar dialogue with the ancients, only in stone or metal rather than on paper. In many cases these artists were using signatures as another means of collapsing the distance between their own period, the value of which was not guaranteed, with that of antiquity, which was enshrined in the minds of Renaissance artists and humanists.

This sort of dialogue with antiquity has precedents in the Middle Ages. The tenor of the conversation changes by the fifteenth century, but there is an interesting comparison found in some twelfth-century signatures and artist inscriptions. Several sculptors from the period proudly declared their art to be "modern" and implied a slightly different juxtaposition with the "ancient." The sculptor Guillelmus, on his pulpit from 1158–61 originally in Pisa Cathedral, signed: *hoc Guillelmus opus praestantior arte modernis//quattuor annorum spatio [temporibus fecit]// sed do(mi)ni centum decies sex mille duobus.* ("Guillelmus, distinguished in modern art, made this work in a period of four years, finishing in the year of our lord 1162.")[39] As Dietl has illustrated, the use of the term *modernus*, in this and other cases, implies a comparison with and victory over the art of antiquity.[40] In other instances twelfth-century signatures and inscriptions compared their artists to Daedalus for their skill or ingenuity, lofty praise since Daedalus was considered the inventor of sculpture and architecture and the ideal representation of artistic achievement. Occasionally the comparison was even improved upon by claiming

36. Dario A. Covi has noted how important context and subject matter are for painted inscriptions. See his *The Inscription in Fifteenth Century Florentine Painting* (New York: Garland, 1986).
37. A.J. Minnis, *Medieval Theory of Authorship: Scholastic Literary Attitudes in the Later Middle Ages*, 2nd ed. (Philadelphia: University of Pennsylvania Press, 1988), 211–17.
38. *Francisci Petrarcae epistolae de rebus familiaribus*, ed. Fracassetti, trans. Cosenza, Praefatio, i, 25 (Chicago: University of Chicago Press, 1910), x–xi; noted and discussed in Minnis, *Medieval Theory*, 211–12.
39. Dietl, "*In arte peritus*," 89–90.
40. Dietl, "*In arte peritus*," 90.

the modern artist's superiority to his antique model.[41] As with fifteenth- and sixteenth-century signatures, antiquity is a foil with which to interact — only the details of the interaction have changed. Rather than positioning themselves in opposition to the artists of antiquity, the sculptors of the Renaissance chose instead to fashion themselves as their spiritual descendents.

Perhaps not surprisingly, one of the exceptions to this situation is Michelangelo. His signature on the St. Peter's *Pietà* is executed in an epigraphic style that is recognizably un-classical and old-fashioned compared to contemporary examples, and therefore highly personal. Michelangelo's anachronistic lettering highlights the importance that signatures' formal elements could have for Renaissance sculptors' identities. Aileen Wang has noted the lettering's similarity to that used by Donatello,[42] although this is true only for those works prior to his *Gattamelata*. It is more accurate to state that the letters on the *Pietà* look back to the Florentine sans-serif epigraphic style used in the first half of the fifteenth century by nearly all Tuscan sculptors, though most notably by Ghiberti and Donatello. Even the choice of abbreviation — a superscript line with a hump — is a feature that appears regularly in inscriptions from the first three quarters of the fifteenth century and earlier. Donatello used it (Fig. 9), and it can be seen in a number of Florentine inscriptions from the early Renaissance.[43] But by 1499, when Michelangelo was signing his *Pietà*, this style of lettering and abbreviation had been passé in Rome for over two decades.[44]

41. On Daedalus topoi, see Dietl, "*In arte peritus*," 114–21; also Dietl, *Die Sprache der Signatur*; and "Dädalus-Topoi in *Künstlerinschriften des 12. Jahrhunderts*," 186–208.

42. Wang, "Michelangelo's Signature," 458–59, notes the signature's lettering is especially close to the style used by Donatello. I would argue for a broader relation to fifteenth-century sculptors in the Florentine circle, including both Donatello and Ghiberti. Interestingly, all of the elements of this signature also appear in the papal bull of Sixtus IV from 14 July 1475 confirming the primacy of the Lateran Basilica, currently displayed at the Lateran. The most notable difference is that the papal bull lettering is more classically Roman than Michelangelo's Florentine letterforms.

43. Wang, "Michelangelo's Signature," 454–55, notes that this is not a feature commonly found in classical inscriptions, and thus she believes it to be derived from writing rather than epigraphy. Though it is true that this is not a common element of classical epigraphy, it does appear frequently in medieval and early Renaissance epigraphy. Inscriptions with this sort of abbreviation include Donatello's tomb of Pope John XXIII in the Florence Baptistery; Donatello and Michelozzo's Brancacci monument in S. Angelo a Nilo, Naples; Luca della Robbia's Federighi monument in Sta. Trinità and his Cantoria in Sta. Maria del Fiore, both in Florence; the Medea Colleoni monument by Amadeo in Bergamo; the inscription on the scroll held by the figure of Justice on Nicola Pisano's Siena Duomo pulpit; the inscription on the facade of Sta. Maria Novella; and Giovanni Pisano's signature on the Pisa Duomo pulpit. It appears several times in Giovanni Pisano's signature for the Pisa Duomo pulpit, where it replaces an N in IOHANIS, the same letter Michelangelo replaced.

44. True Roman-revival capitals that closely followed or were based on ancient models begin to appear in the second half of the fifteenth century. Among the most notable contributors to the development and refinement of Roman letterforms was the sculptor Andrea Bregno. By the end of the 1470s the style of lettering pioneered by Bregno was being widely used and imitated in Rome. See especially Starleen K. Meyer and Paul Shaw, "Towards a New Understanding of the Revival of Roman Capitals

In choosing to inscribe his name in this manner, Michelangelo is calling attention to an earlier epigraphic and sculptural tradition. The use of such a personal style allowed the young artist to express both his individuality as well as his identification not with his contemporaries but rather with the great Florentine sculptors who came before him. For an artist who famously claimed to have had no teacher in sculpture this was an important component of his identity construction.[45] Had Michelangelo signed using then-current Roman capitals it would have been a nod to contemporaries, or possibly a mark of association with them, both of which were anathema to Michelangelo. Thus the appropriation of old-fashioned lettering is just as significant as Michelangelo's use of the imperfect verb *faciebat* or his placement of the signature on a strap running between the breasts of the Virgin. By rejecting contemporary norms for lettering and decorum, and thus rejecting larger ideas about a common identity centered around the emulation and recovery of antiquity, Michelangelo called attention to his desire to be considered entirely on his own terms. Instead, he chose to portray himself — via lettering as well as through the affirmation FLORENT — as a proudly Florentine sculptor set apart from all other living sculptors. That Michelangelo's signature was able to make such claims is testament to the profound statements that even formulaic signatures and styles could convey; indeed, if the signatures and lettering styles of his peers did not carry so much significance, his rejection of them for a personal style would have been far less meaningful. Such a move would have been uncharacteristic for an artist as concerned with self-presentation as Michelangelo, and thus it is only reasonable to assume that in both content and style the signature on the *Pietà* — like all signatures from the period — proclaimed authorship and identity via a complex set of interactions with tropes both old and new.

The fact that sculptors were consistently addressing other artists and humanists via their signatures may help to explain why the Renaissance examples lose their self-laudatory content. Decorum and social mores also likely played a role, and fourteenth-century factors, which are as yet unclear, must have been influential given the trend's origins in that century, but another aspect was the rise of literature on artists.[46] Prior to the fifteenth century, signatures and artist inscriptions were among the only places sculptors could hope to be enshrined in

and the Achievement of Andrea Bregno," in *Andrea Bregno: Il senso della forma nella cultura artistica del Rinascimento*, ed. Claudio Crescentini and Claudio Strinati (Florence: Maschietto, 2008), 276–331.
45. See, e.g., Ascanio Condivi, *La vita di Michelangelo*, ed. Liana Bortolon (Milan: Arnoldo Monditori Editore, 1965), esp. 8-10. On Michelangelo's creation of his image, see Aileen June Wang, "Michelangelo's Self-Fashioning in Text and Image" (Ph.D. diss., Rutgers University, 2005).
46. Print culture in general seems to have influenced or altered notions of authorship; see, e.g., Cynthia J. Brown, "Text, Image, and Authorial Self-Consciousness in Late Medieval Paris," in *Printing the Written Word: The Social History of Books, Circa 1450–1520*, ed. Sandra Hindman (Ithaca: Cornell University Press, 1991): 103–42.

writing. The beginnings of art-historical literature in the quattrocento changed this, as artists began to be mentioned in literary and textual sources. Ghiberti's treatise is from this century, as is Manetti's biography of Brunelleschi, which may be considered the first true artist's biography.[47] In 1456 the humanist author Bartolomeo Fazio included painters and sculptors — such as Ghiberti and Donatello — in his *De viris illustribus*, alongside "Poets, Orators, Lawyers, Physicians, Private Citizens, Captains, [and] Princes."[48] The north Italian humanist Gregorio Correr dedicated three of his poems to the Veronese sculptor Antonio Rizzo (c.1440–99), even referring to him by his profession: *Antonium Riccium Sculptorem*.[49] Baldassare Castiglione made the sculptor Gian Cristoforo Romano one of the courtiers in his *Il libro del cortegiano*.[50] And of course by the mid-sixteenth century Vasari's *Lives* completely transformed the ways artists and sculptors could hope to be immortalized through literature. Perhaps the presence of ever more outlets for textual expression caused a decrease in primacy given to signatures, as sculptors realized that inscriptions, rooted in a single copy in stone or metal, were no longer the best or the only option for self-promotion; the written and then the printed word offered a type of exposure that could carry an artist's name far beyond the confines of a particular work. Thus in the fifteenth and sixteenth centuries the expanded role of one form of textual communication left a significant and lasting mark on another form of writing, as sculptors increasingly sought to insert themselves into a cultural, artistic and literary sphere potentially more durable and permanent than even stone or bronze.

■

47. Catherine M. Soussloff, *The Absolute Artist: The Historiography of a Concept* (Minneapolis: University of Minnesota Press, 1997), 43–44. Soussloff claims it is the "first text in the genre of the biography of the artist because it can be characterized by models, topics, tropes, and structure that pertain uniquely to the genre" (43); and later that it "contains virtually all of the elements that can be associated with the better-known biographies by Vasari of a century later" (44).

48. Pisanello, who worked as a medalist, is also included, though it is as a painter rather than as a sculptor. See Baxandall, *Giotto and the Orators*, 104–9; the original Latin can be found on 163–68.

49. I am grateful to Heather Nolin for this information; see Giovanni Degli Agostini, *Notizie istorico-critiche intorno la vita, e le opere degli scrittori viniziani* (Venice: Simone Occhi, 1752), 1:132, no. xiv. For information on the texts' disappearance, see Wiebke Pohlandt, "Antonio Rizzo," *Jahrbuch der Berliner Museen* n.s. 13 (1971): 163 n. 165.

50. Baldassare Castiglione, *Il Cortegiano*, ed. Vittorio Cian (Florence: G.C. Sansoni, 1894), Google ebook. Noted in Francis Ames-Lewis, *The Intellectual Life of the Early Renaissance Artist* (New Haven: Yale University Press, 2000), 61.

Fig. 1. Lorenzo Ghiberti, *St. John the Baptist*, c.1412–15, Orsanmichele, Florence. Photo: Sarah Wilkins.

Fig. 2. Wiligelmo, inscription from the facade of the Modena Duomo, twelfth century. Photo: author.

Fig. 3. Donatello, *Judith and Holofernes*, c.1455, Palazzo della Signoria, Florence. Photo: author.

Fig. 4. Niccolò Lamberti, *St. Mark*, c.1408–15, Museo dell'Opera del Duomo, Florence. Photo: Sarah Wilkins.

Fig. 5 (A, above, B, below). Lorenzo Ghiberti, North Doors, 1403–24, Florence Baptistery. Photo: author.

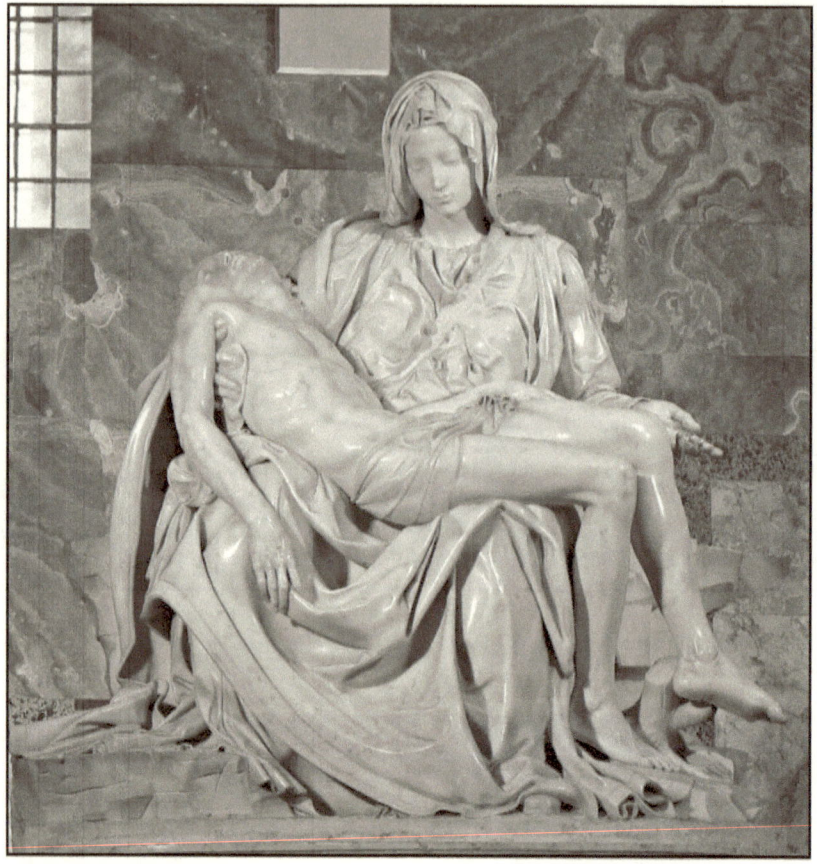

Fig. 6. Michelangelo Buonarroti, *Pietà*, 1497–99, St Peter's, Rome. Photo: Stanislav Traykov.

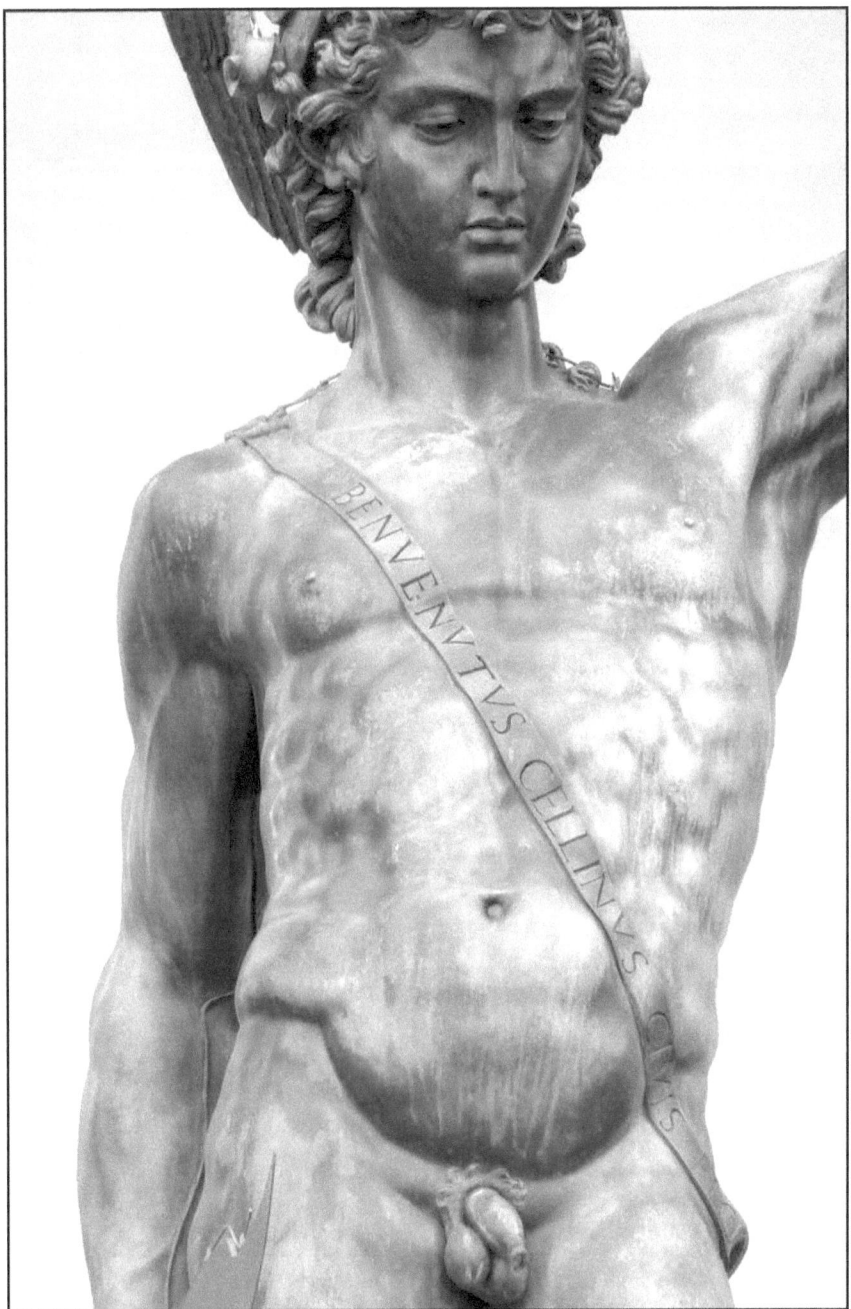

Fig. 7. Benvenuto Cellini, *Perseus*, 1545–53, Loggia dei Lanzi, Florence. Photo: author.

Fig. 8. Piero di Niccolò Lamberti and Giovanni di Martino da Fiesole, *Mocenigo Tomb*, 1423, SS. Giovanni e Paolo, Venice. Photo: author.

Fig. 9. Donatello, *Pecci Tomb*, 1426, Siena Duomo. Photo: Francesco Bini.

BRONZINO, GIAMBOLOGNA & ADRIAEN DE VRIES
INFLUENCE, INNOVATION AND THE *PARAGONE*

MEGHAN CALLAHAN

In 1553 Giambologna (1529-1608), a native of Douai, Flanders, arrived in Florence.[1] Having been apprenticed with the sculptor Jacques de Broeucq (c.1505-84) in Antwerp, he made his way to Rome and then to Tuscany. While it seems that he initially planned to remain in Florence for only a few years, commissions from Grand Duke Cosimo I de' Medici (1519-74) led to a permanent position at the Medici court. Giambologna's northern origins distinguished him from Florentine artists, and while he became immensely successful in Florence, during his first years in the city as a newcomer he would have needed to demonstrate his knowledge of both classical antiquity and contemporary Italian art.

Examining Giambologna's small bronzes in the context of contemporary Florentine art makes it apparent that Bronzino was an important influence. The Fleming seems to have used Bronzino's painting *Venus with Cupid and a Satyr* as inspiration for the figure of the satyr in his bronze *Reclining Nymph/Venus with Satyr,* executed with the help of Adriaen de Vries (c.1546 or 1556-1626).[2] (Figs. 1, 2) Until now Bronzino's painting has been overlooked as a source for Giambologna and de Vries.

This essay is a small thank you to Sarah Blake McHam for her inspiring teaching and unflagging encouragement. I would also like to thank the Independents Group of the Association of Art Historians for their generous grant for images, and Heather Hess and Patricia Wengraf for helpful comments.

1. Michael Cole, *Ambitious Form: Giambologna, Ammanati and Danti in Florence* (Princeton: Princeton University Press, 2011), 33, dates his arrival between 1556 and 1558. Michael Bury, "Benedetto Vecchietti, Patron of Giambologna," *I Tatti Studies* 1 (1985): 24, believed Giambologna arrived in the city in about 1551/52. Charles Avery, *Giambologna: The Complete Sculpture* (London: Phaidon, 1987, reprt. 2000), 16, gives the date of 1553, citing Elisabeth Dhanens, *Jean Boulogne: Giovanni Bologna Fiammingo, Douai 1529 – Florence 1608. Bijdrage tot de studie van de kunstbetrekkingen tussen het graafschap Vlaandereden en Italie* (Brussels, Paleis der Academiën, 1956), 295, but she discusses various dates for Giambologna's arrival on pp. 33-34, concluding that he arrived about 1553. I agree with the 1553 date, see my "Giambologna's Rented House," *The Burlington Magazine* 155 (January 2013): 29-30.
2. Adriaen de Vries' birthdate is unknown. Rosemarie Mulcahy, "Adriaen de Vries in the Workshop of Pompeo Leoni," in *Adriaen de Vries 1556-1626,* exh. cat. Amsterdam, Rijksmuseum, 12 December 1998-14 March 1999; Stockholm, Nationalmuseum, 15 April-20 August 1999; Los

A SCARLET RENAISSANCE ■

Giambologna, like all artists, drew influences and inspiration from a variety of sources, including the classical sculpture of his predecessors and the drawings, paintings and sculptures of his contemporaries.[3] Both Bronzino and Giambologna used an antique marble known as Cleopatra or Ariadne, versions of which are now in the Vatican and the Museo Archeologico in Florence, for the composition of their respective figures of a *Venus* in the painting and sculpture discussed here (Fig. 3). Bronzino's painted citation of the antique model engaged him and the viewer in the *paragone*, prompting the question of whether sculpture or painting was the nobler art and opening a discourse with the antique by questioning whether modern artists could surpass the ancients. Giambologna continued the *paragone* debate with his nod to Bronzino's painting, while at the same time creating a comparison between his contemporary small bronze sculpture and the antique marble.

Bronzino and Giambologna were both well aware of the *paragone*. In 1547 Benedetto Varchi (1502/3–65) gave a lecture to the Accademia Fiorentina in which he resurrected Leonardo da Vinci's question of whether painting or sculpture was the nobler art, which became known later as the *paragone*.[4] He then solicited artists' opinions, including that of Bronzino, and had the text of his lecture and the artists' responses printed in 1550. In 1584, in *Il Riposo*, Raffaello Borghini included a summary of the debate as fictionally discussed by Baccio Valori and Girolamo Michelozzi at Bernardo Vecchietti's Villa Il Riposo.[5] Vecchietti was Giambologna's great patron, and Borghini frequented his studio, so the sculptor surely was aware of the debate.[6]

Giambologna's use of Bronzino's painting invites comparisons not only between painting and sculpture but also between Flemish and Florentine, antique and modern, and text and image. Giambologna's engagement with the *paragone* and Bronzino's paintings does not need to be seen solely as rivalrous competition, or one-upmanship, but as an example of the Flemish

Angeles, J. Paul Getty Museum, 12 October 1999–9 January 2000 (Zwolle: Waanders Publishers, 1998), (hereafter *Adriaen de Vries 1556–1626*), 48, 293, published a letter of 1586 from Gaspar del Castillo to Juan de Ibarra, the secretary of works to Philip II, in which he describes de Vries as "thirty years of age," suggesting he was born in 1556, but he was probably mistaken. The birthdate of 1546 comes from a portrait medal inscribed "ADRIAENVS. BATAVS.HAGENSIS. AETATIS SVE ANO 81" thought to have been made to commemorate his death in 1626. See Vienna, Kunsthistorisches Museum, Munzkabinett, Inv. Nr. 12.146bss, as in *Adriaen de Vries 1556–1626*, 42 n. 2 for bibliography; and Lars Olof Larsson, *Adriaen de Vries: Adriaenvs Fries Hagiensis Batavs 1545–1626* (Vienna: Werlag Anton Schroll 1967), fig. 3.
3. Cole, 39 makes a similar point for Flemish artists in Rome.
4. Deborah Parker, *Bronzino: Renaissance Painter as Poet* (Cambridge: Cambridge University Press, 2000), 83, 202 n. 6 for a useful summary of writers on the *paragone*.
5. Raffaello Borghini, *Il Riposo* (Florence: Giorgio Marescotti, 1584), 1:42–46.
6. On Vecchietti and Giambologna see Bury.

artist continuing a tradition of citations in art to engender comparisons and discussion by artists and patrons.[7]

Bronzino was painter at the Medici court when Giambologna arrived in Florence, and the two must have met on more than one occasion, perhaps at a meeting of the Accademia del Disegno, of which both were members.[8] From the 1530s until 1564 Bronzino provided the Medici court with portraits, altarpieces and secular paintings.[9] He was also a prolific poet and member of the Accademia Fiorentina.

Giambologna had his first documented commission in Florence in 1558, when he sculpted a coat of arms for the Palazzo di Parte Guelfa.[10] He probably came by the work through the influence of Bernardo Vecchietti (1514–90), who housed the artist and convinced him to stay in Florence.[11] As art advisor to the Medici, Vecchietti introduced Giambologna to Francesco de' Medici (1541–87) who allowed him to enter the competition for the *Neptune* statue in Piazza della Signoria. Although unsuccessful in that bid, Giambologna was commissioned in 1560/61 for *Samson Slaying a Philistine* for a fountain in the Casino de' Medici.[12] A series of large-scale commissions followed, including the *Fountain of Neptune* in Bologna in 1562. In 1572 Grand Duke Cosimo I sent Giambologna to Rome with Bartolomeo Ammanati and Giorgio Vasari to gather records of antiquities.[13] Cosimo I's son Ferdinando commissioned Giambologna for the equestran monument to his father, and it was installed in Piazza della Signoria in 1594.[14] Throughout these years Giambologna and his studio also produced small-scale bronzes that were sent throughout Europe as diplomatic gifts and were eagerly sought after by collectors.

While recent studies have emphasized the dialogue between sculptors in sixteenth-century Florence, that between painters (other than Michelangelo) and sculptors is less often studied.[15] Artists who worked at the small court

7. A similar situation has been proposed for Bronzino and Francesco Salviati at the Medici court, see Janet Cox-Rearick, "Friendly Rivals: Bronzino and Salviati at the Medici Court, 1543–48," *Master Drawings* 43.3, *Sixteenth-Century Florentine Drawings* (Fall 2005): 309.
8. For recent biography and bibliography see the essays in *Bronzino: Artist and Poet at the Court of the Medici* (hereafter *Bronzino: Artist and Poet*), ed. C. Falciani, A. Natali, exh. cat., Florence, Palazzo Strozzi, 24 September 2010–23 January 2011.
9. See Massimo Firpo, "Bronzino and the Medici" in *Bronzino: Artist and Poet*, 92.
10. Avery, *Giambologna*, 18.
11. See Bury.
12. Op. cit. Now London, Victoria and Albert Museum.
13. Op. cit., 26.
14. Sarah Blake McHam, "Giambologna's Equestrian Monument to Cosimo I: The Monument Makes the Memory," in *Patronage and Italian Renaissance Sculpture*, ed. Kathleen Wren Christian and David J. Drogin (Burlington, VT: Ashgate, 2010), 195–221.
15. See Cole on Giambologna, Ammanati and Danti. For a fifteenth-century example see Arnold Victor Coonin, "The Interaction of Painting and Sculpture in the Art of Perugino," *Artibus et Historiae* 24.47 (2003): 103–20.

of Florence were aware of one another's work, yet no one has fully examined Bronzino's influence on Giambologna. James Holderbaum noted the effect of Bronzino's *Resurrected Christ* in the Guadagni Chapel in the church of SS. Annunziata in Florence on Giambologna's *Resurrected Christ* in the Duomo of Lucca, and Bronzino's painted portrait of the Medici court dwarf Morgante on the bronze *Morgante Riding a Sea Creature* by Giambologna and Cencio della Nera[16] (Figs. 4, 5). Bronzino's double-sided painting, executed before 1553, depicts *Morgante* seen from the back on the verso and frontally on the recto.[17] Holderbaum suggested that with *Morgante Riding a Sea Creature*, Giambologna was engaging Bronzino in the *paragone* by crafting a small bronze of the same subject.[18] This seems even more likely for Giambologna's small standing bronze *Morgante* holding a wine cup in his right hand now at the Bargello[19] (Fig. 6). The Bargello standing *Morgante* is believed to be the same one listed in the 1588 inventory of the Casino di S. Marco, used at that time by Ferdinando de' Medici.[20]

Prior to restoration, Bronzino's *Morgante* also held a wine cup, as earlier notions of modesty led to the dressing of the dwarf with ivy garlands to

16. James Holderbaum, *The Sculptor Giovanni Bologna*. Outstanding Dissertations in the Fine Arts (New York: Garland, 1983), 200–201 n. 5, noting the Guadagni Chapel and Santissima Annunziata comparison may have come from "...the papers of the late Friedrich Kriegbaum" to which he was granted access by Professor Ludwig Heydenreich. Holderbaum remarked that Giambologna would later have his burial chapel next to the chapel housing Bronzino's painting. For the painting see Maurizia Tazartes, *Bronzino* (Milan: Rizzoli Skira, 2003), 178. On *Morgante* see James Holderbaum, "A Bronze by Giambologna and a Painting by Bronzino," *The Burlington Magazine* 98.645 (December 1956): 442.
17. For the recently restored painting see *Bronzino: Artist and Poet*, 215–17, cat. no IV.7, the entry by Sefy Hendler. For discussion of the painted and bronze versions of *Morgante* by Bronzino and Giambologna as honoring the dwarf Morgante as a natural marvel and as a reflection of Cosimo I as ruler see Gabriella Jasin's essay in this volume.
18. Holderbaum, "A Bronze by Giambologna," 439–45, discusses the seated *Morgante* and notes Bronzino's interest in the *paragone* but does not address the small standing *Morgante*, for which see *Giambologna 1529–1608: Sculptor to the Medici*, ed. Charles Avery and Anthony Radcliffe, exh. cat. Edinburgh, Royal Scottish Museum, 19 August–10 September 1978; London, Victoria and Albert Museum, 5 October–16 November 1978; Vienna, Kunsthistorisches Museum 2 December 1978–28 January 1979 (hereafter *Giambologna 1529–1608*), 103, cat. no. 52, the entry by Anthony Radcliffe. See also Manfred Leithe-Jasper and Patricia Wengraf, *European Bronzes from the Quentin Collection*, exh. cat., New York, The Frick Collection, 28 September 2004–2 January 2005 (hereafter *European Bronzes*), 162–65, cat. no 14; *Giambologna: Gli dei gli eroi*, ed. Beatrice Paolozzi Strozzi and Dimitrios Zikos, exh. cat. (Florence, Museo Nazionale del Bargello 2006) (hereafter Strozzi and Zikos), 352, cat. no. 5.
19. Inv. 72B, h. 12.1 cm. *Giambologna 1529–1608*, 103, cat. no. 52, the entry by Anthony Radcliffe, the cast in which Morgante is blowing a *cornetto* (Victoria and Albert Museum, London, inv. no. 65-1865). For other casts see *European Bronzes*, 162–65, cat. no 14, and Strozzi and Zikos, 352, cat. no. 5.
20. Maria Grazia Vaccari, "Di e da Giambologna: La collezione del Bargello," in Strozzi and Zikos, 348.

hide his nudity and transform him into *Bacchus* or *Silenus*. It is possible this restoration was influenced by Giambologna's small bronze *Morgante* with a wine cup. As revealed through cleaning completed prior to 2010, Bronzino's original painting shows Morgante frontally on the recto with an owl perched on his raised right hand, and on the verso holding a string of dead birds in his right hand, as if he had returned from fowling.[21] The wide-legged stances in the painting and the bronze *Morgante* are similar but not the same, as the painted *Morgante* stands with his legs slightly straighter than the bronze version. The painting was displayed in the Palazzo Vecchio in the "…small room above the receiving room of the new rooms of the Guardaroba."[22] Giambologna certainly would have seen this painting, and his standing *Morgante* may be interpreted as the recently arrived sculptor's reaction to Bronzino's painting: unlike the Florentine painter, who was limited by two sides of the canvas, the sculptor is able to depict the dwarf fully in the round, perceived instantly by any viewer who could pick up the statuette in his or her hand.

Bronzino's double-sided *Morgante* has been seen as a response to Varchi's request for letters from artists on the *paragone*.[23] Bronzino began his written response with seven points in favor of sculpture, but he did not finish the counter argument for painting, perhaps preferring to have his art speak for him.[24] Sefy Hendler noted that in describing the benefits of sculpture in his letter to Varchi, Bronzino "…stresses that [sculpture] allows one to 'move around a figure', making it possible to discover how the different 'views' segue and complete each other in space."[25] In his double-sided portrait of *Morgante*, Bronzino includes different views yet could not escape the canvas's two dimensionality. How was the viewer to see both sides? Hendler proposes that Bronzino's portrait "originally had quite an unusual frame" without further description.[26] Lorenzo Bini Smaghi stated in reference to the *paragone* that Bronzino's portrait of *Morgante* was "a picture intended to be placed in the centre of the room as though it were a sculpture," although he unfortunately provides no documentation.[27] What is clear is that the viewer must be able either to walk around Bronzino's painting in order to appreciate the entire

21. Hendler in *Bronzino: Artist and Poet*, 217.
22. Ibid. Hendler, citing Touda Ghadessi Fleming, "Identity and Physical Deformity in Italian Court Portraits, 1550–1560, Dwarves, Hirsutes and Castrati," (Ph.D. diss., Evanston, IL. Northwestern University, 2007), noted that the painting had a wide audience because this was the room to which foreign visitors were brought when they came to Florence.
23. On Varchi's request see Parker, 83, 202 n. 6.
24. Holderbaum, "A Bronze by Giambologna," 442, suggested that Bronzino abandoned writing his response to Varchi's question in order to paint the Morgante, also cited by Hendler in *Bronzino: Artist and Poet*, 217.
25. Hendler in *Bronzino: Artist and Poet*, 217.
26. Ibid.
27. Lorenzo Bini Smaghi, first introductory essay in *Bronzino: Artist and Poet*, unpaginated.

work or be able to turn the painting over — a difficult trick as the painting measures 150 x 98 cm, or roughly 5 x 3 feet. The weight and bulk of a framed painting of this size would mean that it would either have to be freestanding or hinged to a wall so it could be moved to see both sides in succession. Giambologna's bronze response to Bronzino's painting demonstrated that with sculpture such problems were removed.[28]

Similarly, Giambologna replied to Bronzino's *Reclining Venus with Cupid and a Satyr* by modifying a small bronze of a reclining nude woman that had been sent to Cardinal Ferdinando de' Medici as a gift from his brother Francesco I in 1584.[29] Bronzino's painting had been commissioned by Alamanno Salviati while in Florence, probably about 1553–55. When Alamanno died in 1571, his son Jacopo inherited it. Upon Jacopo's death in 1584, the painting was sent to the family in Rome.[30] Vasari described "...a Venus with a Satyr nearby, so beautiful that she seems truly to be Venus, the goddess of beauty."[31] Despite the central placement in the composition, the Cupid failed to draw Vasari's attention, and he did not mention it. In the painting a grinning satyr with his right hand raised and open approaches Venus and Cupid and appears to climb onto the bed on which she rests. The satyr supports his body with his left hand in which he grips his pipes.

In the same year that Bronzino's painting was sent to Rome, Cardinal Ferdinando de' Medici received the bronze statuette of "...a nude woman asleep" that has been associated with Giambologna's bronze *Reclining Nymph/Venus*.[32] Neither the satyr nor the medium is mentioned in the letter, but the model is the only sleeping woman known in Giambologna's oeuvre.[33] In 1588 the inventory taken in the Villa Medici in Rome included "2 two metal figures of a Venus asleep and a satyr who is looking at her with a black painted wooden base."[34] This bronze has been associated with that now in the Quentin

28. Giambologna may also have been responding to Vasari's citation of Daniele da Volterra's double-sided painting of *David and Goliath* (now Paris, Louvre) made in conjunction with a terracotta statuette of the same group (now lost) that Holderbaum, "A Bronze by Giambologna," 441, discusses in the context of Bronzino's painting.
29. On the bronze, see Dhanens, 187.
30. The painting became part of the Colonna family collection when Caterina Zeffrina Salviati married Fabrizio Colonna in 1718. See Andrea Baldinotti in *Bronzino: Artist and Poet*, 212–13, cat. no. IV.6, citing earlier bibliography. The painting was described in Jacopo Salviati's 1583 inventory. See also A. Fazzini, "Collezionismo privato nella Firenze del Cinquecento: L'«appartamento nuovo» di Jacopo di Alamanno Salviati," *Annali della Scuola Normale Superiore di Pisa* 22.1 (1993): 191–224.
31. "...una Venere con un Satiro appresso, tanto bella che par Venere veramente, Dea della bellezza." Giorgio Vasari, *Le Vite de' più eccellenti pittori scultori e architettori*, ed. Rosanna Bettarini and Paola Barocchi (Florence: Studio per Edizioni Scelte 1987), 6:235.
32. "...una femmina nuda in atto di dormire." See Dhanens, 187.
33. Keutner in *Giambologna 1529–1608*, 118.
34. "...2 figurette dua dimetallo di una Venere che dorme et un satiro che la sta guardando con base di ligname tinto di nero." *European Bronzes*, 134 cat. no. 11 with previous bibliography.

Foundation Collection, which does not currently have a satyr but does have two holes in the base that were added after casting to affix a satyr.[35]

In Giambologna's bronze, Bronzino's satyr is reversed. He raises his left arm and opens his left hand. His right arm is lowered, hovering over Venus' thigh. This compositional change is probably due to the model of the woman having been created before the addition of the satyr. Keeping the extended right arm, as in Bronzino's painting, would have disturbed the composition. Instead, the satyr's pose is ingeniously adapted to that of the sleeping woman, and he appears to have crept onto the base of the chaise longue. Giambologna did not include Bronzino's Cupid, as there was no room for it on the model, and he was not in any case reproducing the painting.

Giambologna's cast featuring the satyr is documented first in Dresden in 1587, when Emperor Christian I of Saxony had an inventory of his collection made.[36] There has never been any debate that the sleeping nude woman is by the hand of Giambologna, but differences in the modelling and color of the satyr in the cast in Dresden led Martin Raumschüssel to attribute the satyr to Adriaen de Vries.[37] The musculature, handling of the facial features and expression of the satyr all point to de Vries' hand (Figs. 7, 8). The bend of the satyr's legs and the contoured waist are also similar to those elements in a *Crouching Gladiator* attributed to de Vries.[38] It is possible that the darker tone of the satyr was intended to provide a similar contrast between the skin colors of the nude woman and the satyr as in Bronzino's painting, but it should also be noted that the satyr was cast separately from the *Venus*. The model proved popular, and there are about eighteen known casts with satyrs and two single satyrs that have been ascribed to Giambologna and his shop, as well as six known casts of the single *Venus*.[39]

35. Ibid.
36. *European Bronzes*, 134–36, with previous bibliography.
37. *Von allen Seiten schön: Bronzen der Renaissance und des Barock* (hereafter *Von allen Seiten schön*), ed. V. Krahn, exh. cat., Berlin, Altes Museum, 31 October 1995–28 January 1996 (Heidelberg: Edition Braus, 1995), 370–71, cat. no. 115; 372–73, cat. no. 116 for the single satyr in Dresden, Grunes Gewölbe; see also A. Scherner, in *Princely Splendor: The Dresden Court 1580–1620*, ed. Dirk Synram and Antje Scherner, exh. cat. Hamburg, Museum für Kunst und Gewerbe, 10 June–26 September 2004; New York, The Metropolitan Museum of Art, 26 October 2004–30 January 2005; Rome, Fondazione Memmo, Palazzo Ruspoli, 1 March–29 April 2005 (hereafter *Princely Splendor*), 274, no. 148.
38. *Von allen Seiten schön*, 372–73, no. 116, citing Manfred Leithe-Jasper, *Renaissance Master Bronzes from the Collection of the Kunsthistorisches Museum in Vienna*, exh. cat., (Washington, DC: National Gallery of Art, 1986), 160–62, no. 39; 163–65, no. 40, *Crouching Gladiator II*, attributed to Adriaen de Vries, possibly after 1600.
39. See the chart in *European Bronzes*, 136. Some casts are now missing their satyrs. There are many later copies of the model that are not included in the chart.

Giambologna could easily have seen the Salviati painting or a drawing of it, as he knew the family since before 1579 when he began work on the Salviati Chapel in Florence. The painting may also have been known to Francesco and Ferdinando de' Medici, as they were related to the Salviati via their grandmother Maria Salviati, who had married Giovanni delle Bande Nere.[40] Maria was the sister of Francesco and Ferdinando's great uncle Alamanno Salviati, who had commissioned the painting. Jacopo Salviati was Ferdinando's first cousin once removed. The Medici could easily have known of, or seen, the painting in either Florence or in Rome, where Ferdinando de' Medici was living when the painting was sent down after Jacopo's death.

Adriaen de Vries is documented in Giambologna's studio in 1580 (1581 modern style), when on March 3 of that year "Master Adriaen the Flemish goldsmith" received silver to make two crucifixes from Giambologna's models as per the elder sculptor's directives.[41] He is recorded in Florence again in 1585 when the bronze founder Fra Domenico Portigiani, who often worked with Giambologna, cast a "group of small figures" for him.[42] This might have been a model of de Vries' own design, or he may have sent the figures under the direction of Giambologna.[43] De Vries might have arrived in Florence via Milan, as he is believed to have been in that city around 1578–80, based on the bronze statue of *Bacchus Wearing a Silenus Mask*, most likely modeled by de Vries and probably cast by Andrea Pellizzone.[44] It is not clear how de Vries came to be working with Giambologna, but there was a large Flemish community in Florence where they may have first made contact. The extent of Adriaen's role in the workshop is not yet fully clear, nor is whether he remained in Florence for the entire span of the five years 1580–85.

In March of 1586 de Vries moved to Milan to work with Pompeo Leoni on bronzes to be sent to Spain for the high altarpiece of the Escorial.[45] Adriaen stayed there for two years and by March of 1589 he was in Turin working for Carlo Emanuele I, the duke of Savoy. In 1590 he was in Prague at Emperor Rudolf II's court, but this apparently led to diplomatic problems between the duke and emperor, who both wanted to employ de Vries. Five years later de

40. For the Salviati family tree see Pierre Hurtubise, OMI, *Une famille-témoin: Les Salviati* (Vatican City: Biblioteca Apostolica Vaticana, 1985): annexes B, C.
41. Lars Olof Larsson, *Adriaen de Vries: Adriaenvs Fries Hagiensis Batavvs 1545–1626* (Vienna: Werlag Anton Schroll, 1967), 11, 19 n. 1; Frits Scholten, "Adriaen de Vries, Imperial Sculptor," in *Adriaen de Vries 1556–1626*, 15, 42 n. 30.
42. Lars Olof Larson, "Die niederländischen und deutschen Schüler Giambolognas," in *Giambologna 1529–1608*, 59, 62 n. 6. See also *Adriaen de Vries 1556–1626*, 15, 42 n. 31; and *European Bronzes*, 132 n. 24.
43. *Adriaen de Vries 1556–1626*, 15, Scholten believed it was de Vries' model.
44. Patricia Wengraf, "A Bronze Bacchus Wearing a Silenus Mask, Made for Antonio Londonio," *The Burlington Magazine* 153 (January 2011): 13–21.
45. For this and the following see *Adriaen de Vries 1556–1626*, passim.

Vries went to Rome, where he received a commission from the city of Augsburg for two fountains. In 1601 Rudolf II appointed Adriaen as court sculptor, and he continued to take foreign commissions until his death in 1626.

De Vries must already have been a full-fledged goldsmith when he arrived in Florence as he was referred to as "master," although where he received his training is unknown.[46] Suggestions of what inspired Giambologna to instruct Adriaen de Vries to add a satyr to his composition of the *Reclining Venus/Nymph* have included the woodcut depicting a nymph and satyr in the *Hypnertomachia Poliphili* published in Venice in 1499,[47] Titian's *Pardo Venus* at the Louvre[48] and Correggio's *Venus, Satyr and Cupid* at the Louvre.[49] All derive from depictions of satyrs surprising, unveiling or attacking nymphs on antique cameos or vases that remained in circulation or were rediscovered during the Renaissance. It is possible that by adding the figure of a satyr both Bronzino and Giambologna were trying to inject an extra erotic charge of voyeurism to the figure of a nude woman.[50]

Charles Avery noted a "striking similarity" between Giambologna's group and Titian's painting, with the satyr reversed, but questioned whether or not the master could have known about the painting, which remained in Venice until 1564, and suggested that Giambologna may have used a drawing or engraving as a source.[51] The placement of the satyr at the end of the nymph's body, the lowered arm crossing over her legs and the tilt of his head in Titian's painting and the bronze are quite similar, but the liveliness of the satyr in Bronzino's composition and the way in which he enters the scene is much closer to the vivacity found in de Vries' little satyr. Giambologna's previous use of Bronzino's paintings also suggests the Florentine source instead of the Venetian.

46. *Adriaen de Vries 1556–1626*, 13. It has been suggested that his brother in law, the goldsmith Simon Adriaensz. Rottermont (1547–1614) trained him as an apprentice in The Hague.
47. Among others see Anthony Radcliffe and Nicholas Penny, *The Art of the Renaissance Bronze, 1500–1650: The Robert H. Smith Collection* (London: Philip Wilson, 2004), 192–95, no. 32, the entry by Marietta Cambereri.
48. Charles Avery, *Jean Bologne: La Belle endormie*, trans. Nicole Candelier (Paris: Galerie Piltzer, 2000), 48.
49. Sybille Ebert-Schiffer, "Giambolognas "Venus und Satyr": Ein erotisches Staatsgeschenk aus Italien," *Dresdener Kunstblätter* 4 (2004): 234.
50. On Bronzino see Cox-Rearick in *Venere et Amore: Michelangelo e la nuova bellezza ideale/ Venus and Love: Michelangelo and the New Ideal of Beauty*, exh. cat., ed. F. Falletti, J.K. Nelson, Florence, Accademia di Firenze, 26 June – 3 November 2002 (Florence: Giunti, 2002) (hereafter *Venere et Amore*), 210; and Robert W. Gaston, "Sacred Erotica: The Classical "Figura" in Religious Painting of the Early Cinquecento," *International Journal of the Classical Tradition* 2.2 (Fall 1995): 254. On Giambologna and the erotic see Ebert-Schifferer.
51. Avery, *Giambologna*, 48.

A SCARLET RENAISSANCE ■

Giambologna's reason for adding a small satyr to the *Reclining Venus/Nymph* is unknown, as is why he chose de Vries to model it. The inspiration to add a satyr could have come from de Vries, but as an assistant in Giambologna's shop, he would not have been allowed to modify compositions without the master's approval. Although Giambologna is credited with the conception and execution of the majority of models that came out of his shop, other sculptors' innovations must have been welcomed and used.[52] It has been suggested that adding the satyr was de Vries' idea, as the satyr is much smaller than the Venus and appears to be an "afterthought."[53] The satyr was modelled by de Vries, but he would have done so under the direction of Giambologna, whose previous interest in and use of Bronzino's paintings as sources suggests that he decided to add the satyr to create a comparison between his work and that of the Florentine, fostering the *paragone* debate between the two.

In using Bronzino's painting as a model Giambologna (and de Vries by extension) entered into the *paragone* discussion and opened avenues for further discussions among viewers. The first was with the antique, with which Bronzino had already invited comparisons by evoking the composition of the antique *Sleeping Ariadne*.[54] There were at least four versions of antique marbles of the *Sleeping Ariadne* known in Rome in the sixteenth century.[55] During the Renaissance the snake bracelet around her left arm led viewers to interpret the statue as the dying Cleopatra, and then as Ariadne abandoned by Theseus on the island of Naxos.[56] As the statue formed part of a fountain, it was also suggested that it represented a sleeping nymph who guarded sacred waters. The Maffei family in Parione owned the version now in the Vatican. In 1512 it entered the possession of Julius II and was installed as a fountain in the Belvedere.[57] Angelo Colucci and Hans Goritz had copies made of the

52. Avery, *Giambologna*, 48.
53. Avery, *Giambologna*, 49.
54. Bronzino was also inspired by Pontormo's nude women at the Medici Villa at Castello among other sources. See *Venere et Amore*, 208–10, no. 34, the entry by Janet Cox-Rearick.
55. *Villa Medici: Il Sogno di un cardinale Collezioni e artisti di Ferdinando de' Medici*, exh. cat., ed. Michel Hochmann, Accademia di Francia a Roma 18 novembre 1999–5 marzo 2000 (Rome: Edizioni di Luca, 1999, hereafter *Villa Medici*), 168–69, cat. no. 17; "Statua di Arianna dormiente, cosidetto Cleopatra," the entry by Carlo Gasparri. See also Phyllis Bober and Ruth Rubinstein, *Renaissance Artists & Antique Sculpture* (London: Harvey Miller and Oxford University Press, 1986), 113–14, no. 79. The Vatican statue is a second-century CE Roman copy of a Hellenistic Pergamene work from about 200 BCE. Images of sleeping nude women of course were popular throughout the fifteenth and sixteenth centuries in Florence and Venice. See Millard Meiss, "Sleep in Venice: Ancient Myths and Renaissance Proclivities," *Proceedings of the American Philosophical Society* 110.5 (October 27, 1966): 348–82.
56. For a theoretical view on the "naming" of the sculpture see Leonard Barkan, *Unearthing the Past: Archaeology and Aesthetics in the Making of Renaissance Culture* (New Haven: Yale University Press, 1999), 233–47.
57. Bober & Rubinstein, *Renaissance Artists*, 114.

fountain for their gardens by the mid 1520s.[58] When the Salviati family in Rome purchased Hans Goritz' property in 1527, his copy is thought to have joined their collection.[59]

Cardinal Ferdinando de' Medici purchased his version in 1572 from the estate of Cardinal Ippolito d'Este.[60] The statue was previously owned by the Bufalo family, who had the missing head and arm replaced by an unknown sculptor in the first half of the sixteenth century, using that of the Vatican *Ariadne* as a model.[61] Although the Vatican version is best known to scholars today, it has been noted that Ferdinando's *Ariadne* would have been visible to a wider audience as it was displayed in a pavilion on the edge of Ferdinando's garden.[62] Bronzino may have been inspired by Salviati's copy of the *Ariadne*, while Giambologna may have looked at Ferdinando's marble in addition to Bronzino's painting.

In adding a cupid and a satyr to his painted composition, Bronzino enlivened the antique sculptor's composition. He changed the direction of her legs by crossing the top leg over the bottom. Bronzino challenged his predecessor by adding striking colors, introducing contrasts among the woman's creamy white flesh, Cupid's rosy tones and the swarthy satyr. The golden curls of Cupid and the woman's hair are echoed in the gold details of the bow, arrow, jewel and quiver worn by Cupid. Bronzino awakened the woman, who teasingly holds Cupid's bow away from him while she lies on green and blue sheets. Bronzino further addressed the *paragone* debate by including the figure of Cupid seen from behind while Venus is shown supine, to "…enhance the three-dimensionality of the composition, challenging the art of sculpture."[63] The position of the satyr also added to this challenge as his view of the pair simultaneously encompasses the front of Venus and the back of Cupid.[64]

58. I thank Rebecca Compton for generously sharing sections of her unpublished article, forthcoming in *Sixteenth Century Journal*, on Bronzino's painting, and for the reference to Phyllis Pray Bober, "The Corysiana and the Nymph Corycia," *Journal of the Warburg and Courtauld Institutes* 40 (1977): 223–39.
59. Rebekah Compton believes Bronzino's composition was inspired by the antique sculpture in Jacopo Salviati's possession in Rome. See note 58 above.
60. *Villa Medici*, 168. Now Florence, Museo Archeologico Nazionale, inv. 13728. Christina of Sweden owned another variation, which is now in the Prado. See also Kathleen Wren Christian, *Empire without End: Antiquities Collections in Renaissance Rome, c. 1350–1527* (New Haven: Yale University Press, 2010), 179, 281–86, fig. 178, who refers to the statue as *Cleopatra* in context of the del Bufalo collection.
61. Ibid. This head was replaced in the nineteenth century, see *Villa Medici*, 170, cat. no. 18.
62. Ibid.
63. Baldinotti in *Bronzino: Artist and Poet*, 212 citing Maurice Brock, *Bronzino* (Paris: Flammarion, 2002), 235.
64. Baldinotti has this reversed in the above-cited text.

A SCARLET RENAISSANCE ■

In his bronze response Giambologna took up the implied challenge to the antique and to sculpture posed by Bronzino. Instead of having the woman's legs cross at the shins, as in the antique marble, Giambologna enhanced the figure's sensuality by portraying her with open legs, the knees bent and the right foot extended invitingly over the edge of the base; bringing out the sculpture's tactile qualities.[65] He reversed the arm over Venus' head from right to left. Instead of copying the marble's left arm that supports her head with her cheek on her hand, the Fleming extended her right arm to rest between her legs, with her hand gathering loose folds of drapery, further enhancing contrasts of texture. At the same time, he opened up Bronzino's composition, moving Venus from her side to her back, and releasing the supportive right arm shown in Bronzino's painting to form a languid pose between her legs. He closed the woman's eyes, making a new comparison to the antique *Dead Amazon* (also known as the *Dead Gaul*) once in the collection of Alfonsina Orsini in the Palazzo Medici in Rome.[66] As Giambologna conversed with the antique through his small bronze, he simultaneously opened a discourse with painting and with Bronzino's previous painted challenge to the antique and sculpture.

Giambologna's challenge to Bronzino and the antique was further enhanced by the composition of de Vries' satyr. Unlike Bronzino's satyr, who can only be seen from the front, de Vries' satyr can be seen from the back, sides and front, depending on the position of the bronze and the viewer. The open pose of the satyr in Bronzino's painting is enhanced in the small bronze by the actual physical space between the satyr and the Nymph/Venus. The tilted head and raised open hand impart movement to the painted and bronze satyrs; further suggested in the bronze by the inclusion of the satyr's legs and hooves hanging off the edge of the base (Fig. 9). While the satyr's lower legs are hidden in Bronzino's composition, his use of the pink curtain behind the satyr highlights the movement behind the satyr's approach as the viewer imagines him having just pushed the curtain aside.

Not only did de Vries, possibly using a sketch model by Giambologna, evoke the pose of Bronzino's painted satyr, he also added an antique citation by using the model of the Torso Belvedere.[67] The nipped-in waist, strong musculature and powerful thighs of the satyr echo the large fragment that had been known in Rome since the late 1430s and copied and completed by numerous artists. Adriaen would cite the torso again in about 1607 for his bronze *Christ in Distress*, in which he also directly quoted Dürer's *Christ in*

65. On the theme of tactile erotic qualities of sculpture see Stephen Campbell, "Eros in the Flesh: Petrarchan Desire, the Embodied Eros and Male Beauty in Italian Art, 1500–1540," *Journal of Medieval and Early Modern Studies* 35 (2005): 641–44.
66. Bober and Rubinstein, *Renaissance Artists*, 179–80, no. 143. The sculpture is in the Museo Nazionale in Naples.
67. *Princely Splendor*, no. 149, 275, the entry by A. Scherner.

Distress woodcut of 1511.⁶⁸ While it is unclear if de Vries made a trip to Rome during his time in Florence, it is possible; and he was documented in Rome in 1594/95. The prevalence of drawings, reductions and completions of the Belvedere Torso by Renaissance artists suggest that he certainly would have known of it prior to his documented trip.

The addition of the satyr in Bronzino and Giambologna's compositions could also lead to comparison with ancient texts, as it may be interpreted as *Jupiter and Antiope*.⁶⁹ Ovid's *Metamorphoses* includes the story of how the beautiful Antiope was noticed by Jupiter, who took the form of a satyr, raped her and left her.⁷⁰ She was then abducted by Epopeus, the king of Sicyon, and eventually gave birth to twins. The possibility of multiple interpretations of an image would have pleased Giambologna, who famously designed the marble *Rape of the Sabines* with no fixed theme in mind. The marble group was unveiled in January 1583 in the Loggia dei Lanzi, Florence. The title and theme were decided after the completion of the work, when Raffaello Borghini suggested it might represent the story of the Sabine women being carried off by the Romans as told by Livy.⁷¹ While beginning a sculpture without an intended theme was unusual, such ambiguity was not unusual for Giambologna, as demonstrated by another two-figured group sent to Ottavio Farnese, the duke of Parma. In a letter of 13 June 1579, Giambologna noted that the duke was free to interpret the subject of the two-figured group as he wished: "...the two above-mentioned figures that can suggest the Rape of Helen and maybe of Proserpina or one of the Sabines: chosen to display wisdom, and the study of art, they are each 1½ braccia [89.6 cm] high."⁷² Giambologna's focus was much less the subject of his sculptures than whether or not a client would find the composition appealing.

Giambologna's foreign status may also have contributed to his interest in the Florentine Bronzino's compositions. It has frequently been noted that Giambologna added "Belga" to his signature to distinguish himself as Flemish rather than Bolognese.⁷³ Specifying one's origin was not unusual for late

68. *Adriaen de Vries 1556–1626*, no. 19, 162–63.
69. Avery, *Giambologna*, 4, noted that the sculpture was never described this way although it was a likely subject. A cast after Giambologna at Windsor Castle has a plate with the title "Jupiter et Antiope" affixed to what looks like a French eighteenth- or nineteenth-century base. See Courtauld Institute of Art, no. 276, negative no. B 69/557, at the Warburg Institute, London.
70. Ovid, *Metamorphoses*, trans. A.D. Melville (Oxford: Oxford University Press, 1986), 6:110–11.
71. Livy, *The History of Rome*, I.9.
72. Capobianco in Strozzi and Zikos, 166, no. 4, citing G. Filangieri di Candia, "Due bronzi di Giovanbologna nel Real Museo Nazionale di Napoli," *Napoli Nobilissimi* VI, 2 (1897): 20–21, for the letter. For the full text of the letter see Dhanens, 343–44, "*Le due predette Fig. che possono inferire il rapto d'Elena et forse di Proserpina o, d'una delle Sabine: eletto per dar campo alla saggezza, et studio dell'arte, sono alte ciascuna br 1½.*"
73. See among others, Patricia Wengraf, "Zur Bedeutung der "signaturen" an Giambolognas Marmor- und Bronzefiguren," in *Giambologna: Triumph des Koerpers*, exh. cat., Vienna, Kunsthistorisches

A SCARLET RENAISSANCE ■

Renaissance Florence, Bronzino declared his birthplace in his signature in the lower left corner of *Reclining Venus with Cupid and Satyr*, "A· BRONZ· FIORE·F". Giambologna was one of many Flemings and Germans working in the Florentine court in the 1550s and competing with native artists for commissions. Willem Danielsz. van Tetrode (c.1525-80), known in Florence as "Guglielmo Fiammingo," assisted Cellini from 1548 to 1551 on the *Perseus*.[74] Tetrode was also responsible for most of the restoration work on *Ganymede*, although Cellini claimed in his autobiography to have transformed the antique marble fragment into the young boy.[75] After working in Rome and Florence, Tetrode returned to the North where he is last documented in Delft in March 1568.

Tetrode's departure may have opened some commissions for Giambologna. There were other Flemish sculptors working in Florence at the time, but their names and works have yet to be fully documented and revealed and Giambologna was the most successful among them. Flemings also worked as goldsmiths, tapestry designers and weavers and painters at the Medici court, but Giambologna was the only high ranking Flemish sculptor at court.[76] When the Flemish Pietro Francavilla (1548-1615) arrived in Florence, Giambologna hired him as a collaborator, and Francavilla later disseminated Giambologna's style abroad.[77] Giambologna did not have to distinguish himself so much from other Flemish artists as from Florentines.[78] It is logical that he would look to the work of the established Bronzino, as well as to his contemporary

Museum, 27 June-17 September 2006 (Vienna: Kunsthistorisches Museum, 2006), 102-39. For sculptors' signatures between 1450 and 1550 see David Boffa's essay in this volume.

74. Anna Maria Massinelli, *Bronzetti e Anticaglie dalla Guardaroba di Cosimo I: Mostre del Museo Nazionale del Bargello* 18 (Florence: Museo Nazionale del Bargello, 1991), 88; and *Benvenuto Cellini: Opere non esposte e documenti notarili. Mostre del Museo Nazionale del Bargello* 3, ed. D. Trento (Florence: Museo Nazionale del Bargello, 1984), 62, record that Tetrode was paid by Cellini for working on *Perseus* from 20 August 1548 to 21 June 1550. On Tetrode see also *Willem van Tetrode: Sculptor (c. 1525–1580)/ Guglielmo Fiammingo Scultore*, ed. Frits Scholten, exh. cat., Amsterdam, Rijksmuseum; New York, The Frick Collection (Zwolle: Waanders Publishers, 2003).

75. Massinelli, *Bronzetti*, 88.

76. On Flemish goldsmiths see C.W. Fock, "Goldsmiths at the Court of Cosimo II de' Medici," *The Burlington Magazine* 114.826 (1972): 11-17; for weavers see Lucia Meoni, *Gli arazzi nei musei fiorentini: La collezione medicea, catalogo completo* I. *La manifattura da Cosimo I a Cosimo II (1545-1621)* (Livorno: Sillabe, 1998), 35-119. Meoni noted that after 1554 the tapestry workshops begun by Cosimo were directed by Florentine masters who had been trained by the Flemings. On Pieter de Witte, also known as Pietro Candido, see Kurt Steinbart, "Pieter Candid in Italien," *Jahrbuch der Preuszischen Kunstsammlungen* 58 (1937): 67, 71; and *Pieter de Witte/Pietro Candido: Un pittore del cinquecento tra Volterra e Monaco*, exh. cat., Volterra, Palazzo dei Priori, 30 May-8 November 2009, (Milan: Silvana Editoriale, 2009).

77. Ethan Matt Kavaler, "Review of *Ambitious Form: Giambologna, Ammanati, and Danti in Florence* by Michael Cole (Princeton: Princeton University Press, 2011)," in *Historians of Netherlandish Art, Review of Books*, http://www.hnanews.org/hna/bookreview/current/sixteenth6.html. See also Avery, *Giambologna*, 225-26.

78. For Giambologna in context with Florentine sculptors see Cole.

sculptors. Using Bronzino's paintings as inspiration for compositions and subjects of his bronzes allowed Giambologna to prove himself current with the work of one of the most important Florentine painters while retaining his identity as a Flemish sculptor.

By having de Vries model the satyr, Giambologna not only demonstrated his knowledge of the antique and Bronzino's composition but also added an alternative to his original composition of a sleeping woman. Bronze casts of the *Reclining Nymph/Venus* were available either with or without a satyr, and patrons could choose which they preferred. One of the reasons that Giambologna created small bronzes was because they could be produced by others under his supervision and easily sold and transported.[79] This is made evident by his refusal to sculpt in marble for Duke Francesco Maria II della Rovere. When the duke had his agent Simone Fortuna ask Giambologna if he could create two marble statuettes, Giambologna refused. Fortuna told Francesco in a letter that although Giambologna was too busy at the time, he was perfectly willing to send the duke something in bronze,

> ...and to give them [to you] finished, he said before a year's time...because once the models were made of wax or clay, that he can quickly do himself, at the same time he can order the moulds, the gesso, and to have them cleaned after by the goldsmiths, that he keeps on hand precisely for his Highness, for whom most recently he did the Twelve Labours of Hercules of a height of half a *braccio* [29.2 cm] so stupendously, that everyone says they have never seen such a beautiful thing, and that [neither] Michelangelo nor Apelles would have known how to do it so well.[80]

Sculpting in marble was time-consuming, and Giambologna was not very good at it.[81] Furthermore, marble carving had the reputation of being less "dignified" than painting or modelling, due to the physical labor required by the artist, as had been noted by Leonardo da Vinci in his *Treatise on Painting*,

79. Avery, *Giambologna*, 236, views the "virtual mass-production of some of Giambologna's examples" as "creat[ing] a demand outside the confines of Italy" and see also p. 139 in which he refers to the "mass-production" of bronzes in Giambologna's studio.
80. Dhanens, 345, letter dated 27 October 1581 from Fortuna to the duke: "*Ma se V. E. le volesse di bronzo (come vuole il gran Duca tutte le cose piccole) in tal caso promette di servir ottimamente, et darle finite, disse prima in un anno, ma per mio amore s'ingegnerà di darle in sei et al più in otto mesi, perchè fatti i modelli di cera o di terra che si fan presto di sua mano, darà al medesimo tempo a far le forme, il gesso, et a ripulirle poi a gli orefici, che tiene aposta per sua Altezza, per la quale ultimamente ha fatto le XII forze d'Hercole di grandezza di mezzo braccio così stupendamente, che ogni uno dice no potersi veder cosa più bella, et che Michelagnolo [sic] nè Apelle haverebbero saputo far tanto.*"
81. On Giambologna as a modeler rather than carver see Cole, 33–34.

which although unpublished was known to many artists.[82] Bronzino revived this view of marble carving in his letter to Varchi, noting that sculptors often:

> ...put forward their much publicized difficulty that they cannot add to but only remove, and that it is very tiring to practice their art because they have hard stone for material, the painters answer — I say — that if sculptors mean the physical effort of chiselling, this does not make their art nobler, but rather it diminishes its dignity, because the more the arts are exercised with manual and physical exertion, the closer they are to the mechanical crafts, and consequently, the less noble they are...but if one means mental effort, [the painters] say that not only painting is equal, but far surpasses it, as will be explained below.[83]

■

Giambologna's reputation as a great modeler and sculptor in bronze would have allowed him to use Bronzino's words to his advantage. He was not in the company of the manual laborers criticized by Bronzino and his fellow painters, because his assistants did the heavy work. Giambologna's wax models, designed with little visible effort (in a fine example of *sprezzatura*), were the opposite of the working process in carving described by Bronzino. While physically Giambologna's hand was far removed after the wax model was finished, he considered all his works to be "his" or by "his hand," whether cast by Domenico or Zanobi Portigiani or finished by Antonio Susini or Pietro Tacca.[84] Michael Cole has noted that in the 1594 statue depicting Grand Duke Ferdinando I in Arezzo, Giambologna credited himself with the design and Francavilla with the execution: "IOANNES BONONIA I/

82. See Jean Paul Richter, "History of the 'Trattato della Pittura'," in *Leonardo's Writings and Theory of Art*, ed. Claire Farago, 5 vols. (New York: Garland, 1999), 4:315. See also Cole, 143-57 on Giambologna and the treatise.

83. Parker, 113, citing Bronzino, "Lettere di artisti a Benedetto Varchi," in *Scritti d'arte del Cinquecento*, Paola Barocchi, ed., 3 vols. (Milan: Ricciardi, 1971), 1:502, her modified translation of the letter in McCorquodale, *Bronzino*, 162, which I have also modified. "...*dove gli scultori adducano la difficoltà tanto divolgata, cioè di non poter porre, ma solo levare, et essere gran fatica a far tale arte per avere le pietre dure per subbietto; rispondono — dico — che, se vogliono dire della fatica del corpo circa lo scarpellare, che questo non fa l'arte più nobile, anzi più preso toglie dignità perchè quanto l'arti si fanno con più esercizio di braccia o di corpo, tanto più hanno del meccanico, e per conseguente sono manco nobili; ma se vorranno dire della fatica dell'animo, dicono che non solo la pittura gli è uguale, ma la trapassa di gran lunga, come si dira più di sotto.*" See also Cole, 33-34.

84. In 1605 Giambologna wrote to Belisario Vinta, the secretary of state of Grand Duke Ferdinando I (1549-1609), "...*un mio allievo chiamato Antonio Susini, ha gitato nelle mie forme di molte statuette per mandare in Allamagna; quali sono delle più belle cose che si possino havere dalle mie mani.*" For the text see Dhanens, 371-72.

PETRUS FRANCAVILLA BELGIAE F."[85] Cole states "...the trade-off for this division of credit was the constant suspicion that there was really *nothing* to be seen of Giambologna's hand."[86] The interest in collecting and preserving models in the sixteenth century, as theorized by Cole, reflected a concern with design (*disegno*) and the hand of the artist.[87] Giambologna's models were widely collected in his lifetime and it seems that he used them in order to promote himself as an additive rather than reductive sculptor and as a designer rather than a manual laborer.[88] It was vital that Giambologna was seen as the designer, as the only part of a bronze that Giambologna "touched" was the wax model, which disappeared during the lost wax casting process. His sketch-models were preserved precisely to retain evidence of his hand.[89]

The business aspects of Giambologna's bronze production is often overlooked, as scholars have been more interested in assigning authorship of the casts to the master or one of his many assistants.[90] Charles Avery noted that while there are very few contemporary bronze reductions of monumental marble groups that Giambologna had designed for the Medici, there are several models, including the *Reclining Nymph/Venus* that were "reproduced in large numbers by Antonio Susini...and Giambologna or Susini were evidently permitted to enjoy the financial rewards."[91] Despite Simone Fortuna's portrayal of Giambologna in his letter to the duke of Urbino on 27 October 1581 as a man who was "...not greedy at all, as one can tell by his being so poor..." who only wanted "...glory and to rival Michelangelo,"[92] Giambologna expected and asked for gifts from the grand duke in addition to his monthly salary.[93] It is still unclear how much he earned from the small bronzes that his workshop produced, and it would be a useful avenue for future research. Seen from an economic position, by having Adriaen de Vries model a satyr to be added to the existing model of the *Reclining Nymph/Venus*, Giambologna created

85. Cole, 34. He translates the inscription: "Giovanni Bologna invented [this], Pietro Francavilla of Belgium made it" and compares it to the manner in which prints were signed.
86. Cole, 34–35.
87. Cole, 21–25.
88. Ibid.
89. See Avery, *Giambologna*, 236; and Cole 21–25.
90. Avery, *Giambologna*, 236, touches on this when he notes the "virtual mass-production" of some of Giambologna's models. See Avery, p. 225, where he discusses modern interest in discerning the hands of assistants and followers, such as Francavilla, Pietro Tacca, Adriaen de Vries among others.
91. Avery, *Giambologna*, 235.
92. Dhanens, 345. See also Avery, *Giambologna*, 251.
93. Michelangelo also presented himself as uninterested in money, but as has been demonstrated by Rab Hatfield, *The Wealth of Michelangelo* (Rome: Edizioni di Stori e Letteratura, 2002), he was a canny investor and very wealthy. On Giambologna's requests for money and real estate see Dimitrios Zikos "Giambologna's Land, House and Workshops in Florence," *Mitteilungen des Kunsthistorischen Institutes in Florenz* 46.2/3 (2002): 366–67.

two options on the same theme for potential clients. The *Reclining Nymph/ Venus* alone could be interpreted in light of the antique Roman source, or the long tradition of images of reclining nude women, while the version with satyr could be read as a nod to the antique and/or in comparison with such contemporary paintings as those by Correggio, Titian and, more specifically, Bronzino.

Giambologna was not the only Fleming in Florence using Bronzino's paintings as source. The painter Peter de Witte (also known as Pieter Candido) also reworked elements of Bronzino's compositions.[94] Giambologna seems to have been the only Flemish sculptor to make such direct references. Giambologna's specific citations of Bronzino's subjects and compositions demonstrate the Fleming's much deeper involvement in studying the Florentine's paintings than a generalized adherence to the Florentine *zeitgeist*. Competition between living artists and the memory of their predecessors as evidenced through artistic citations was not always negatively tinged with rivalry but also demonstrated respect and praise. Giambologna's use of Bronzino's compositions for his small bronzes allowed the northern artist to demonstrate his knowledge of Florentine painting and insert himself and his work into the contemporary theoretical discussions of the *paragone* that fascinated the Medici court and its artists.

■

94. Steinbart, 67, 71.

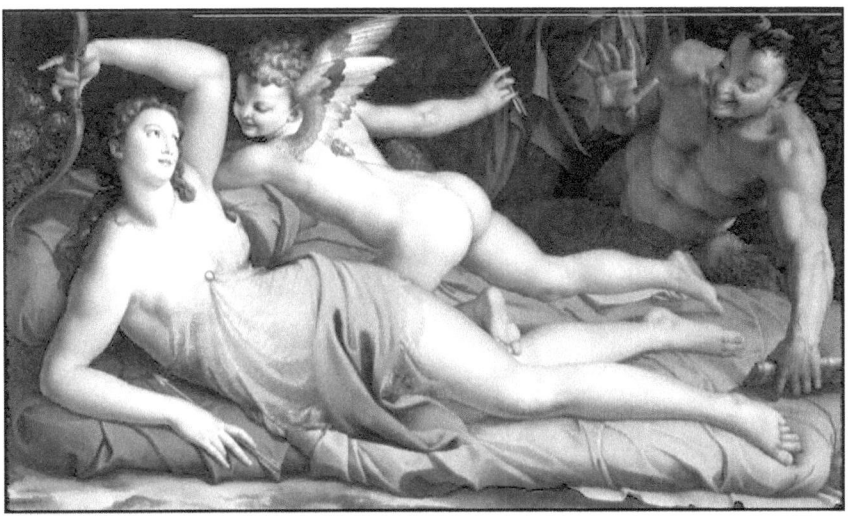

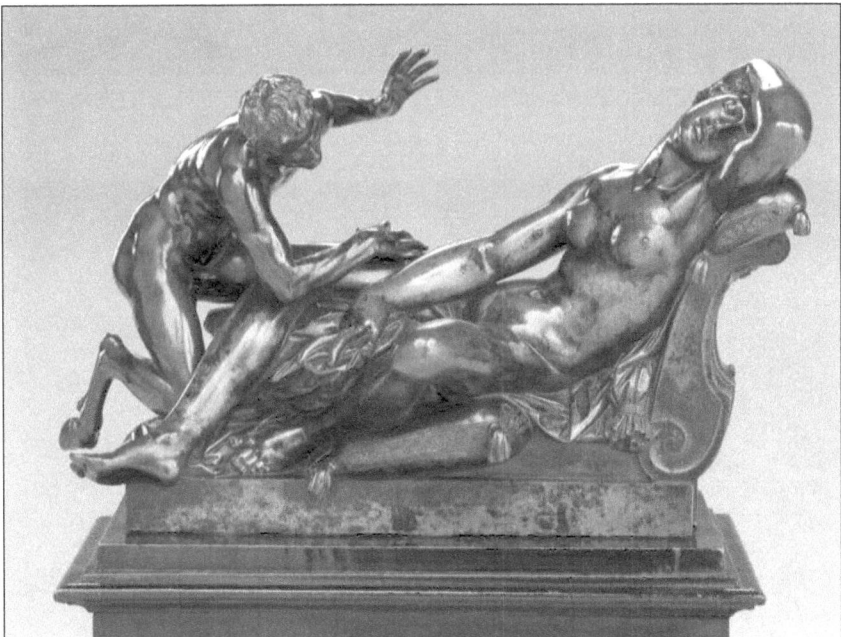

Fig. 1 (above). Agnolo Bronzino, *Venus with Cupid and a Satyr*, c.1553–55. Oil on panel, 135 x 231 cm, inv. Salviati 1756, no. 66. Rome, Galleria Colonna. Photo used with permission of the Galleria Colonna.
Fig. 2 (below). Giambologna, *Reclining Nymph/Venus with Satyr*. Bronze, h. 31.4 cm, l. 34 cm., Inv. no. IX 34, Grünes Gewölbe, Staatliche Kunstsammlungen Dresden, photo: Jürgen Kapinski.

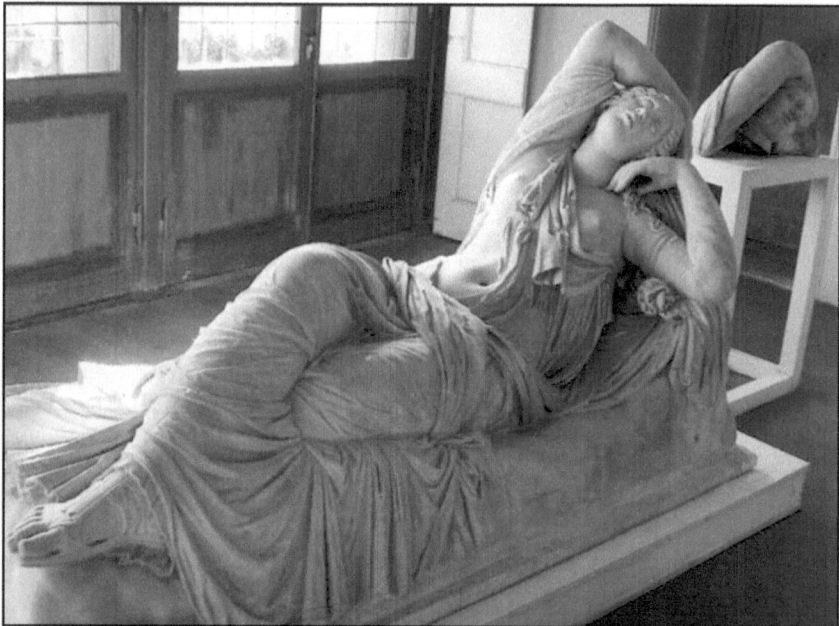

Fig. 3 (above). *Sleeping Ariadne*. Marble, h. 1.23, l. 2.27, inv. 13728. Florence, Museo Archaeologico.

Fig. 4 a, b (below). Bronzino, *Morgante*. Oil on canvas, 150 x 98 cm, inv. 1379, no 1836. Florence, Galleria Palatina. © 2012 Photo: Scala, Florence. Courtesy of the Ministero Beni e Atti. Culturali.

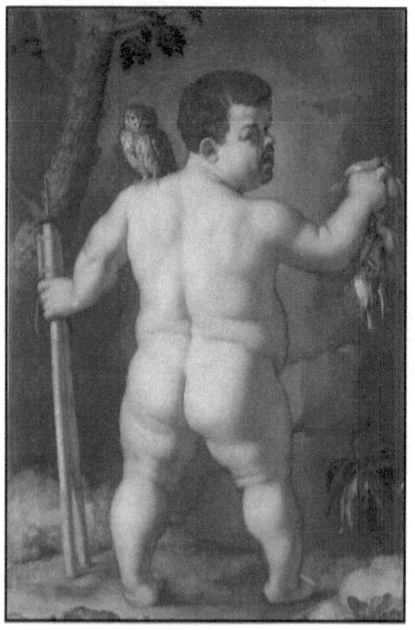
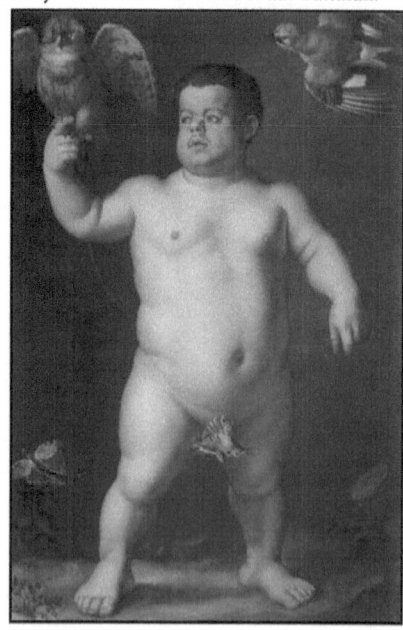

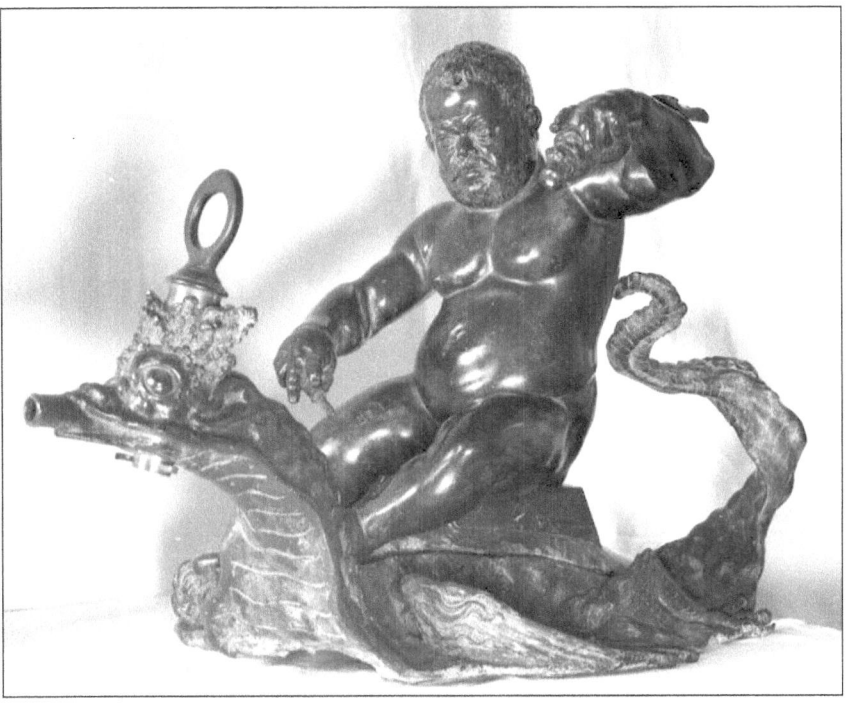

Fig. 5 (above). Giambologna, *Morgante Riding a Dragon*. Bronze, inv. Bronzi e placchette, n.9, h 36.5 cm. Florence, Bargello. © Soprintendenza Speciale per il Polo Museale Fiorento, Gabinetto Fotografico, Ministero Beni e Atti. Culturali.

Fig. 6 (right). Giambologna, *Morgante*. Bronze, h. 13.7 cm, inv. 72B, Florence, Bargello. © Soprintendenza Speciale per il Polo Museale Fiorento, Gabinetto Fotografico, Ministero Beni e Atti. Culturali.

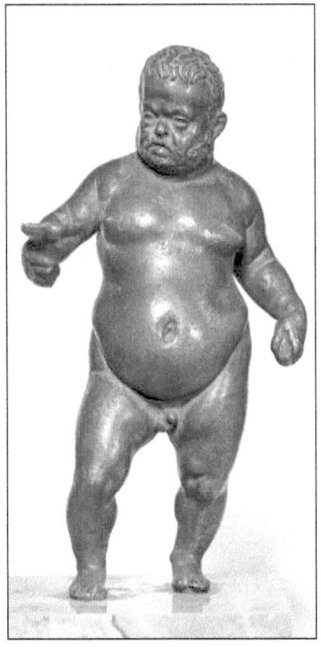

A SCARLET RENAISSANCE

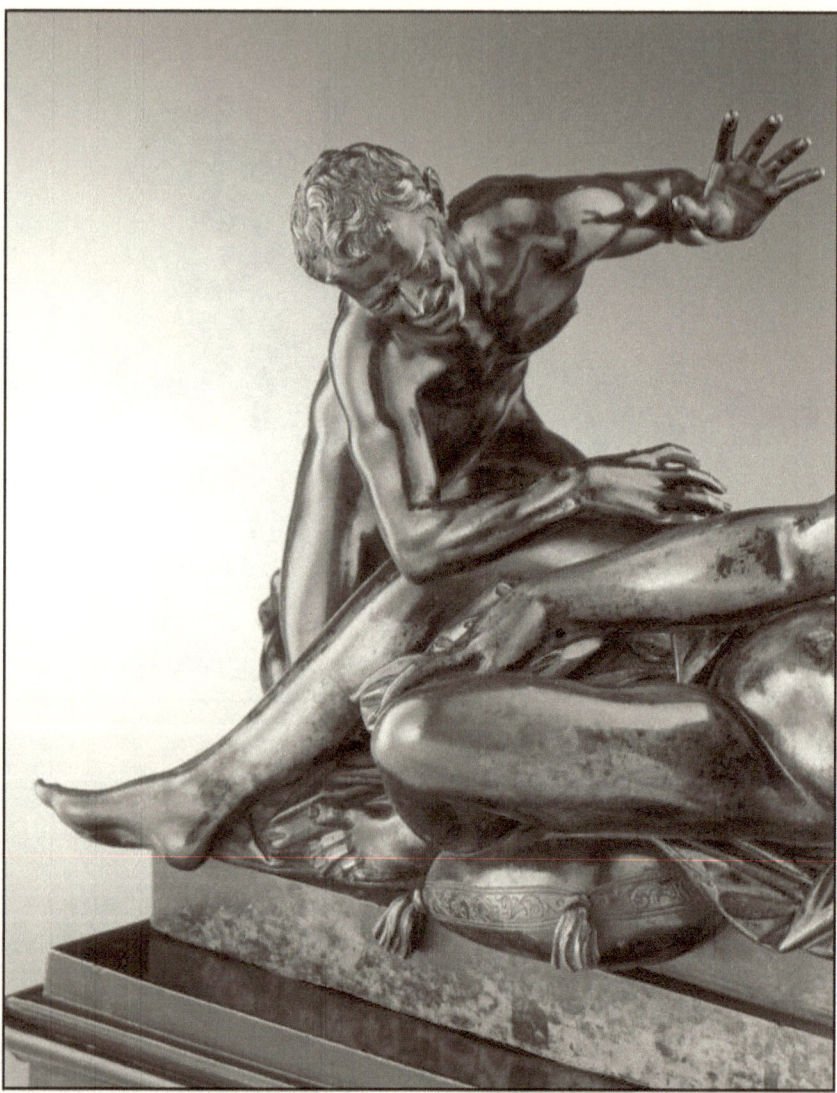

Fig. 7. Giambologna, *Reclining Venus with Satyr*, detail. Grünes Gewölbe, Staatliche Kunstsammlungen, Dresden. Photo: Arrigo Copitz.

Fig. 8. Adriaen de Vries, *Satyr*. H. 18.7 cm, inv. no. IX 14. Grünes Gewölbe, Staatliche Kunstsammlungen Dresden. Photo: Jürgen Kapinski.

Fig. 9. Giambologna, *Reclining Venus with Satyr*, detail. Grünes Gewölbe, Staatliche Kunstsammlungen, Dresden. Photo: Arrigo Copitz.

THE SPIRIT OF WATER
RECONSIDERING THE *PUTTO MICTANS* SCULPTURE IN RENAISSANCE FLORENCE
ARNOLD VICTOR COONIN

A commonly misunderstood iconographical type from Renaissance Italy is that of a male youth who appears to be urinating — often with evident glee.[1] Such images survive in a variety of media, including sculptures of marble, clay and bronze, major fresco decorations, the marginalia of illuminated manuscripts,[2] nielli,[3] *deschi da parto*[4] and as smaller figures integrated within architectural embellishments.[5] In short, the micturating youth was a common and popular subject in the Italian Renaissance. This study analyzes sculptures found in central Italy, particularly Florence, many of which formed part of

I am pleased to dedicate this paper to Sarah McHam, knowing that she will appreciate both its humor and seriousness. I especially thank David Boffa and Alison Luchs for their help with earlier drafts.

1. While acknowledging a certain degree of arbitrariness, "urinate" in this essay will refer to figures expelling bodily waste while "micturate" will normally refer to passing fluid as a symbolic act. Two important articles came to my attention after this essay was largely finished, and I have tried to acknowledge their contributions in the notes. Our respective studies overlap throughout, albeit with different emphasis. An essay highlighting gender issues and sexuality appears by Patricia Simons, "Manliness and the Visual Semiotics of Bodily Fluids in Early Modern Culture," *Journal of Medieval and Early Modern Studies* 39 (Spring 2009): 331–73. A separate article on related themes appears by Marilyn Aronberg Lavin, "Art of the Misbegotten: Physicality and the Divine in Renaissance Images," *Artibus et Historiae* 60 (2009): 191–244. In general, my essay is in sympathy with Lavin, and though my study overlaps considerably with that of Simons, our interpretations differ respectfully but considerably.
2. Augusto Campana, "'Pueri mingentes' nel quattrocento," in *Friendship's Garland: Essays Presented to Mario Praz on his Seventieth Birthday*, ed. Vittorio Gabrieli (Rome: Edizioni di Storia e Letteratura Roma, 1966), 31–42.
3. A.M. Hind, *Nielli, Chiefly Italian of the XV Century: Plates, Sulphur Sasts and Prints Preserved in the British Museum* (London: British Museum, 1936).
4. See Jacqueline M. Musacchio, *The Art and Ritual of Childbirth in Renaissance Italy* (New Haven: Yale University Press, 1999).
5. For example, the Porta della Mandorla in Florence. Another well-discussed example is in the Tempio Malatestiano in Rimini in the so-called Chapel of the Liberal Arts. Agostino di Duccio designed if not executed the figure c.1455–57 and would have been familiar with the type from his stays in Florence.

fountains. These sculptures were numerous enough that a cursory survey finds at least a dozen extant examples from the fifteenth and sixteenth centuries. In addition, many versions from later centuries clearly rely on the Renaissance prototypes.

Despite the frequent appearance of micturating youths in a variety of Renaissance imagery, there is ambivalent scholarly explanation for these particular figures' meaning and little regard for their development over time in the context of Italian Renaissance sculpture.[6] The tendency has perhaps been to look away more than to overlook, since the iconography might seem uncomfortable to the modern viewer and its subject dismissed as more scatological than scholarly.[7] Yet cursory dismissals of these images ignore their significance within the context of the period's broader visual culture. We need to recognize both the humor and the seriousness of the images if we are to understand them properly.

The iconographical type of the micturating youth was an important one, whose fifteenth-century roots betray its debt to contemporary trends in humanistic culture. The exposed human penis has long denoted ideas of power, fertility and even immortality.[8] During the Renaissance increased attention in the visual arts was given to the Christ child's penis, as analyzed so revealingly by Leo Steinberg.[9] Concurrently, the micturating youth remained an extremely popular image for over a century, even as new artists, patrons and viewers contributed to subtle shifts in its appearance, iconography and reception.

The modern scholar faces many problems concerning these sculptures, not least of which is simply what to call them. The subject is rarely described in English, since the available terminology sounds either too clinical or too

6. Previous studies of the so-called *putto mictans* have been more general and either ignore or misinterpret the meaning of this specific action. See the encyclopedic discussion by Waldemar Deonna, "Fontaines antropomorphes: La femme aux seins jaillissants et l'enfant 'mingens'," *Genava* 6 (1958): 239–96; and the informative examples by Guy Schoutheete de Tervarent, "L'origine des fontaines anthropomorphes," *Bulletin de la classe des Beaux-Arts de l'Academie Royale de Belgique* 38 (1956): 122–29.

7. On modern responses to urine and art see Jonathan Weinberg, "Urination and its Discontents," in *Gay and Lesbian Studies in Art History*, ed. Whitney Davis (London: Hayworth Press, 1994), 225–43.

8. Daniel Rancour-Laferriere, "Some Semiotic Aspects of the Human Penis," *Versus: Quaderni di studi semiotici* 24 (1979): 37–82; and John Clark, *Looking at Lovemaking: Constructions of Sexuality in Roman Art, 100 B.C. – A.D. 250* (Berkeley: University of California Press, 2001). Also see Lavin, "Art of the Misbegotten."

9. According to Steinberg, such a display of Christ's sexuality was a vital proof of God's humanity. See Leo Steinberg, *The Sexuality of Christ in Renaissance Art and in Modern Oblivion*, 2nd ed. (Chicago: The University of Chicago Press, 1996), especially 45ff. For a response to Steinberg see Carolyn Bynum, *Fragmentation and Redemption: Essays on Gender and the Human Body in Medieval Religion* (New York: Zone, 1992).

crude using words such as *urinating, micturating, peeing* or *pissing*. In Italian the subject might be called a *Putto Pissatore* (pissing putto). In German *Pissmännchen* (little piss man) has been used. Often the figures are referred to in Latin — presumably to add an air of distanced dignity — whereby we find *Putto Mictans* (from *micturio* — to make water or urinate) and *Puer Mingens* (*puer* being child and *mingens* from *mingo* — to make water). The Dutch *Manneken Piss* normally refers to a later example in Belgium (also called *Petit Julien* in French).[10] Common to all modern attempts to name the type is a focus on the action of the figure, that is, his passing of water. In contrast, a more fruitful approach to these Renaissance figures may be to consider their meaning. Doing so enables one to appreciate the figures' significance in the context of their production, reception and function, and (with due regard to the dangers of overstating linguistic determinism) might enable modern scholars to reassess these works with fresh eyes.

The title offered here for this sculptural type is *spiritello d'acqua*, or "water sprite," a concept that owes much to the brilliant study, *Inventing the Renaissance Putto*, by Charles Dempsey. In this illuminating book, the author explains that in Renaissance art the beings traditionally called *putti* (or related variants, such as *amori, amorini, genii, genietti, eroti, cupidi* and *bambini*) can more accurately be termed *spiritelli* or "sprites." Dempsey discerns different types of sprites; he categorizes the main examples into natural, vital and animal. They populate early Renaissance art with ubiquity in both religious and secular contexts. These are spiritual beings, the root of whose name (*spirito* or latin *spiritus*) refers to a movement of air or breath (the sense of which survives in words like *respiration* and the now obsolete *spiration*).[11]

10. Dutch for "little piss man." This study is about the Italian tradition, which is distinct from the northern. Still, one may reference the famous passage describing a banquet at Lille for Philip the Good, duke of Burgundy, in 1454 at which stood a statue of a naked boy micturating rose water. The most famous extant example in the North is that in Brussels, with the present image by Jerome Duquesnoy (1619), which reportedly replaces a statue originally in place as early as 1377. Related examples exist in other cities. In northern Renaissance art, urination is often depicted as a more base or comic act. See Deonna, "Fontaines antropomorphes"; Tervarent, "L'origine des fontaines"; and Catherine Emerson, "Are You Taking the Piss(e)? Early Appearances of the Urinating Boy in the Low Countries and Northern France," in *Grant risee? The Medieval Comic Presence*, ed. Adrian P. Tudor and Alan Hindley (Turnhout: Brepols, 2006), 31–47. For a popular but untrustworthy account see Georges Dubosc, *Manneken Piss et fontaines ubérales* (1925), available in Freeware text: http://www.bmlisieux.com/normandie/dubosc06.htm; also see Marc Lanval, *L'Enigme du Manneken-Pis* (Brussels: Editions du Laurier, 1953).

11. Charles Dempsey, *Inventing the Renaissance Putto* (Chapel Hill and London: University of North Carolina Press, 2001), 40ff; and review by Sarah Blake McHam in *Studies in Iconography* 24 (2003): 248–51. Also see Charles Dempsey, "Donatello's *Spiritelli*," in *Ars naturam adiuvans: Festschrift für Matthias Winner zum 11. März 1996*, ed. Victoria von Flemming and Sebastian Schütze (Mainz am Rhein: P. von Zabern, 1996), 50–61.

Sprites are depicted in acts that might seem mischievous, but they are innocent beings and we must remember that "because the putto is an infant, or epitome of guileless innocence, it is the perfect vehicle to manifest the uncontrollable and irrational bodily sensations that are spurred by powerful feelings such as fear, beauty, sexual arousal or love at first sight."[12] Accordingly, the most notable of these sprites — the *spiritello d'amore* — is the one associated with Cupid and love.[13]

The sculptures featuring the micturating sprite can be better understood within this perceptual framework, in which the sprites represent tangible embodiments of what are typically abstract concepts. The term *spiritello d'acqua* indicates the figure's significance, and is more appropriate than any of the titles that describe its action. Depending on context, these water sprites bear various connotations of good health, good fortune, love, fertility, abundance and wealth. To be sure, they were also meant to bring a smile, a chuckle or an elicitation of joy to the original viewer and should continue to do so today without sheepishness or disgust.

In the quattrocento, the representation of sprites was rekindled with a frequency not seen since antiquity, and with much greater variety. It has been well established that classical precedents of the micturating youth do exist, especially on Bacchic sarcophagi and the occasional single figure.[14] But what emerges in the Renaissance is new and distinct.

To Donatello goes the principal credit for reinventing the theme of the putto — and by extension the sprite — in a way that is consequential and not merely decorative.[15] While previous manifestations were more ornamental, Donatello endowed the figures with meaning derived from and critical to the works' greater context. As Sarah McHam has explained, "Donatello's great innovation was to make the putti active participants in the narrative drama, either as border figures who elaborate its meanings, or as its principals."[16] The first such *spiritelli* are generally considered Donatello's free-standing figures produced for the Siena Baptistery font (c.1429–34).[17] They are highly animated and joyful embodiments of music and

12. Ibid.
13. Dempsey, "Donatello's *Spiritelli*," 52.
14. See especially See Deonna, "Fontaines antropomorphes"; and Tervarent, "L'origine des fontaines." As discussed by Deonna, other related types feature Hercules, Silenus and Hermaphrodites micturating. Also see Lavin, "Art of the Misbegotten," 201.
15. On Donatello's representations of sprites see the erudite discussion by Ulrich Pfisterer, *Donatello und die Entdeckung der Stile 1430–1445* (Munich: Hirmer Verlag, 2002), esp. 133ff.
16. McHam, review of Dempsey, 249.
17. See discussion in Dempsey, *Inventing the Renaissance Putto*; and McHam, review of Dempsey. On the *spiritelli* for the Siena font see John Pope-Hennessy, *Donatello* (New York: Abbeville Press, 1993), 86; and idem, *Italian Renaissance Sculpture*, 4th ed. (London: Phaidon, 2000), 352. Also see Francesco Caglioti, "Donatello e il Fonte Battesimale di Siena: Per una rivalutazione dello 'Spiritello danzante' nel Museo Nazionale di Firenze," *Prospettiva*, 110/111 (2003-2004): 18–29.

dancing celebrating the sacred rite of Baptism. The sculptor further explored related ideas with figures on the Cavalcanti Altar in Sta. Croce, Florence, and through the dancers on the external pulpit of Prato Cathedral and his Cantoria in Florence Cathedral. Dempsey labels the latter figures s*piritelli del suono* and explains that they "are neither celestial...nor infernal, neither angels...nor devils, but the essence of a pure and irresistible sensation of innocent joy that makes the pulse beat faster."[18]

Brunelleschi, working with his close friend Donatello, designed the first Renaissance *spiritelli d'acqua* for Florence Cathedral in 1432[19] (Fig. 1). These are two winged sprites in high relief that adorn the lavabo in the north sacristy of the duomo. Conceived by Brunelleschi in 1432, they were executed by his pupil Buggiano and finished by 1440.[20] The sprites, seated atop a large water pouch, each straddle a spout from which water issues forth between their legs in a highly suggestive manner. The act seems tantamount to urinating but it is a pure water that issues from beneath celestial beings, in a manner playful and mirthful but necessarily innocent and devoid of indecency.

A second lavabo, in the south sacristy, makes similar reference, though even more assertively (Fig. 2). Begun by Buggiano in 1442 and finished by Pagno di Lapo in 1445, the lavabo features nude winged sprites standing behind their respective urns where a spout is located just below the level of the penis. A degree of humor and lightheartedness is clearly evident, but it is not debased humor. The figures are spirits of purity and cleanliness; and their act, which puns with the emission of bodily waste, has as its core purpose the sharing of a spiritual essence in a joyous form that should elicit a pleasing if teasing response from the viewer. There is no question that they were conceived as *spiritelli*, as confirmed by the commissioning documents.[21]

Contemporary descriptions of the *spiritello d'acqua* figures provide a means of understanding their actions within a fifteenth-century context. The author of the Anonimo Magliabechiano describes the north lavabo "con putti che gettono acqua."[22] They are described similarly by Antonio Billi,[23] the Codice Strozziano[24]

18. Dempsey, *Inventing the Renaissance Putto*, 45–46.
19. See Margaret Haines, *The Sacrestia delle Messe of the Florentine Cathedral* (Florence: Cassa di Risparmio di Firenze, 1983), 124–26. Also see *Atti del Convegno su Andrea Cavalcanti detto il Buggiano: Buggiano Castello, 23 giugno 1979*, ed. Comune di Buggiano (Buggiano: Comune di Buggiano, 1980).
20. See Haines, *The Sacrestia delle Messe*; and Giancarlo Gentilini, "Una perduta 'pila' del Brunelleschi, due del Buggiano e alcune altre acquasantiere fiorentine del primo Quattrocento," in *Atti della giornata di studio sul tema: Le vie del marmo. Aspetti della produzione e della diffusione dei manufatti marmorei tra Quattrocento e Cinquecento* (Florence: Giunti, 1994), 61–67.
21. Lavin, "Art of the Misbegotten," 198.
22. *L'Anonimo Magliabechiano*, ed. A. Ficarra (Florence: Fiorentino Editore, 1968), 75.
23. "Quelli bambini che gettano acqua," Antonio Billi, *Il Libro di Antonio Billi*, ed. F. Benedettucci (Rome: De Rubeis, 1991), 34–35.
24. Reference to the two sprites in the north sacristy as "bambini in ditto lavacro che gettano acqua." See Pope-Hennessy, *Italian Renaissance Sculpture*, 344.

and Vasari.²⁵ The operative verb in all these descriptions of the action is *"gettare"*: to spout, flow, cast (forth), gush, fling, hurl, throw, etc.²⁶ The verb *gettare* is again used by Vasari when describing the *spiritello d'acqua* fountain sculpture by Pierino da Vinci: "...egli facesse un fanciullo per quell'acquaio, che gettasse dal membro virile."²⁷ There is also mention of a lost *spiritello d'acqua* made by Andrea Verrocchio for the Medici villa at Careggi, as recorded by the sculptor's brother, Tommaso, in a list of works allegedly made for the Medici family and for which payment was still owed as of January 27, 1495/96. The work, specified for Careggi, is listed as "una fighura di marmo che gietta acqua."²⁸

The linguistic evidence in these references helps clarify the action of the lavabo sprites, which is reinforced by how they are presented: they spout water (not urine), which implicitly or explicitly exits from pure bodies. Such a display in the cathedral — and in the sacristy, no less, where the lavabo serves for "the ritual ablution of the celebrant's hands before mass"²⁹ — indicates not just the acceptability of such a motif but the relevance, as well. These are spiritual and uncorrupted streams of water that ultimately flow from a source of purity.

The meaning and function of the lavabo sprites is crucial for understanding subsequent *spiritello d'acqua* sculptures, since the latter are imbued with similar connotations, especially as they move from ecclesiastical to secular spaces. Such lavish adornment of these interior water sources was new to the Renaissance and the embellishment logically migrated quickly from church to secular spaces. Scant archaeological evidence remains in situ, but descriptions and the extant objects themselves indicate that they probably resided in the domestic sphere.³⁰

25. In referencing Buggiano: "il quale fece l'acquaio della sagrestia di Sta. Reparata, con certi fanciulli che gettano acqua." Giorgio Vasari, *Le vite de' più eccellenti pittori scultori ed architettori*, ed. Gaetano Milanesi (Florence: Sansoni, 1878–85): 2:383–84.
26. See the *Vocabolario degli Accademici della Crusca*: GETTARE, e GITTARE [Rimuover da se, con men violenza, che non è trarre. Lat. iacere, emittere]. http://vocabolario.signum.sns.it. While description of the action is relatively consistent over time, the figure itself is more commonly termed a *spiritello* in the fifteenth century, while the sixteenth century varies considerably (*bambini, putti*, etc.) indicating diluted spiritual associations as explained below.
27. Vasari-Milanesi, *Le Vite*, 6:121–22. As discussed below, this statue is generally identified as the example now in Arezzo, Museo Civico.
28. Dario Covi, *Andrea del Verrocchio: Life and Work* (Città di Castello: L.S. Olschki, 2005), doc.
28. Also listed by Bertha Harris Wiles, *The Fountains of Florentine Sculptors and Their Followers from Donatello to Bernini* (Cambridge, MA: Hacker, 1933), 139. According to Vasari, a related Medici work, also lost, was made by Antonio Rossellino for the Medici palace: "Fece nel palazzo de'Medici la fontana di marmo che è nel secondo cortile; nella quale sono alcuni fanciulli che sbarrano delfini che gettano acqua." This variant type, with dolphins spouting water, is discussed below. See Vasari-Milanesi, *Le Vite*, 3:93–94.
29. Haines, *The Sacrestia delle Messe*, 28.
30. See Attilio Schiapparelli, *La Casa Fiorentina* (Florence: Sansoni, 1908), 80–86; Marta Ajmar and

The *spiritelli d'acqua* engage in an action devoid of taint or scandal. There is innocent humor, to be sure, but neither mockery nor insolence. Like the Renaissance viewer, we must recognize evident joy, wittiness and playfulness, without aversion or intimations of impertinence. Related images from domestic contexts help to establish the meaning of the act of micturition and its positive iconographic associations in general, and only a brief notice of these suffice to make the point. For example, the reverse of a *desco da parto* of 1428, attributed to Bartolomeo di Fruosino, shows a nude and squatting child in the act of micturition[31] (Fig. 3). He is not an actual child but a representation of idealized infancy. An inscription around the edge of the object, partly obscured, may be roughly translated as:

> May God give health to every woman who gives birth and to the child's father... may [the child] be born without fatigue or danger. I am a baby who lives on a [rock?]...and I make pee of silver and gold.[32]

The obverse shows a birthing scene. The scenes complement each other by juxtaposing the newborn with imagery of a healthy child's emission of silver and gold, the most valuable of material substances. In effect, what he passes is a stream of wealth and good fortune sure to characterize the child's (and hence the family's) bright future.[33] Furthermore, a peeing newborn is a living newborn; and when it first urinates, like crying, it is an emphatic indication that the baby has evaded death.

Other images of micturition are frequently found in the context of love, marriage and fertility. Another *desco da parto* from the workshop of Apollonio di Giovanni and now in the North Carolina Museum of Art, Raleigh,[34] shows two naked boys, one of whom micturates on poppy pods held by the other. Poppy plants appear on other *deschi di parto* and have close associations with fertility due to their numerous seeds. That we have a metaphor is confirmed by the obverse of the object, which shows an allegorical scene of the Triumph

Flora Dennis, *At Home in Renaissance Italy* (London: V&A Publishing, 2010), 38–39 and 284–87. Also see Lavin, "Art of the Misbegotten," 200.
31. See *Art and Love in Renaissance Italy*, ed. Andrea Bayer (New York: Metropolitan Museum of Art, 2008), 66 and cat. 69 (fig. 54).
32. Translation adapted from that in *Art and Love...*, 152 and 321.
33. Support is found in the description of a fountain in a poem by Luigi Pulci written for Lorenzo de' Medici the elder, of 1446 which again features a spiritello who links the material and spiritual using water. See Luigi Pulci, *Il driadeo di Luca Pulci al magnifico Lorenzo de Medici: Poema scritto nell'anno 1446* (Naples: A. Trani, 1881). http://www.archive.org/stream/ildriadeodilucap00pulcuoft/ildriadeodilucap00pulcuoft_djvu.txt
34. *Art and Love*, cat. 72.

of Chastity. Taken together, the *desco's* two images declare that this chaste marriage will be blessed with health and abundant fertility.[35]

There are other nuances to the *spiritello d'acqua* sculptures to be sure. These may include allusions to topics astrological, cosmological, folkloric and mythological.[36] For example, Aquarius literally means water-carrier, and he could be depicted either pouring water from a vessel or expressing water from his body in an act of micturition.[37] The water he passes defines his cosmic being. Neptune[38] and Hercules[39] were also shown similarly micturating as expressions of power and achievement.

There are many related fountain types, too numerous to list here, that feature putti or sprites in various poses, the most common being the *spiritello* holding a fish or dolphin. Verrocchio's example, now in the Palazzo Vecchio, is the most famous of many and was originally made for the Medici villa at Careggi under the patronage of Lorenzo the Magnificent.[40] Female analogues to the male *spiritello d'acqua* exist and often feature water issuing forth from exposed breasts. This imagery is seen in many fountain designs, including a version

35. A more emphatic use of micturition to link love and fertility is in the noteworthy painting in the Metropolitan Museum of Art by Lorenzo Lotto showing Venus and Cupid, which has been convincingly related to marriage poems, or epithalamia. Cupid is decidedly not urinating on Venus (the fluid is not urine and never touches her body) but rather micturating the fertile and life-giving fluids contained within the body that issue forth (*gettare*) in the context of love and marriage. See Keith Christiansen, "Lorenzo Lotto and the Tradition of Epithalamic Paintings," *Apollo* 124 (1986): 166–73; and *Art and Love*, cat. 148. Valuable and appropriate nuances are added by Simons, "Manliness and the Visual Semiotics."

36. As suggested by Middeldorf in *Giorgio Vasari: Principi, letterati e artisti nelle carte di Giorgio Vasari*, ed. Laura Corti, Margaret Daly Davis, Charles Davis and Julian Klieman, exh. cat., (Florence: Edam, 1981), viii, 20, 265, and fig. 320. Also see the discussion and abundant bibliography in Britta Kusch-Arnhold, *Pierino da Vinci* (Münster: Rhema, 2008), 105–11.

37. In his commentary on the Pierino figure, Middeldorf, *Giorgio Vasari*, suggests the possibility of astrological and other aspects that might be explored, even speculating on Aquarius as the birth sign of the commissioner, which is doubtful. On the iconography of astrology see the bibliography in Ewa Śnieżyńska-Stolot, *Astrological Iconography in the Middle Ages: The Decanal Planets*, trans. Joanna Komorowska (Kraków: Jagiellonian University Press, 2003).

38. An engraving for a fountain attributed to Zoan Andrea (c.1480–85, possibly after a design by Mantegna) features Neptune with three sprites. Two of the sprites pour water from a vessel and simultaneously micturate into the lower basin. See *Early Italian Engravings from the National Gallery of Art*, ed. Jay A. Levenson, Konrad Oberhuber and Jacquelyn L. Sheehan (Washington: National Gallery of Art, 1973), no. 100; and Adam von Bartsch, *Le Peintre-Graveur* (Vienna: Kessinger, 1802–21), 13:303, no. 15. Also see Bertha Harris Wiles, *The Fountains of Florentine Sculptors and Their Followers from Donatello to Bernini* (Cambridge, MA: Harvard University Press, 1933).

39. A *Hercules Mingens* was drawn several times by Baccio Bandinelli (examples in the British Museum, Biblioteca Ambrosiana and the Musée du Louvre); and a *Hercules Mingens* statuette appears in the *Portrait of Andrea Odoni* by Lorenzo Lotto.

40. Good discussion is found in Dario Covi, *Andrea del Verrocchio*, 98–105; and Jack Freiberg, "Verrocchio's *Putto* and Medici Love," in *Medieval Renaissance Baroque: A Cat's Cradle for Marilyn Aronberg Lavin*, ed. David A. Levine and Jack Freiberg (New York: Italica Press, 2010), 83–101.

described and illustrated in the *Hypnerotomachia Poliphili*: "...three nude Graces, made from fine gold [...]. From the nipples of their breasts there flowed thin streams of water looking like rods of refined silver, polished and striated, as if it had been distilled from the white pumice of Taracone."[41] Like the male *spiritello d'acqua*, these are in essence images of fecundity and life.[42]

The present study argues that the fluid emitted by the sprites under discussion is not actually urine in the sense of human waste, but a pure and vital water emitted from spiritual beings. Thus we find a print of an ideal fountain in which sprites stand with linked arms while micturating into a basin below. Additional sprites playfully bathe in the fountain's water, with one catching the emission both in a bowl and in his mouth. This proves the innocent nature of both actions (emitting and catching) and underscores the purity of the sprite's water. A similar event is described in the *Hypnerotomachia Poliphili* as discussed below. The fluid here is a substance that is demonstrably potable and protective.[43] Again, the emphasis is on playfulness and humor, to pique the senses and bring a smile; the sprites are naughty but not malicious. They bring levity without indecorousness

We must duly recognize, to be sure, that in the human male both urine and semen pass through the penis, and this sexual association to the Renaissance and modern viewer is undeniable. An image of micturition might indeed bear sexual innuendos and even subtle reference to ejaculation.[44] The Renaissance mind was certainly attuned to such suggestion through both imagery and wordplay. But it is important that *spiritelli* and *putti* are necessarily prepubescent and free of sexual implications; they are oblivious to and incapable of actual ejaculation, and thus overtly risqué or sexual associations are largely inappropriate when dealing with the imagery under discussion here.

That urine might indicate the state of one's health is self-evident, and urinalysis is still employed as one of the most widespread and useful diagnostic tools in medicine. Its practice goes at least as far back as the earliest civilizations of Egypt and the Ancient Near East.[45] In the history of medicine

41. Francesco Colonna, *Hypnerotomachia Poliphili*, trans. Joscelyn Godwin (London: Thames and Hudson, 1999), 89–90.
42. On the female types see especially Deonna, "Fontaines antropomorphes"; and Tervarent, "L'origine des fontaines." On connections between urination and lactation in the North see Emerson, "Are You Taking the Piss(e)?"
43. This engraving, probably Ferrarese, is titled by Hind, "Fountain of Cupids." Hind, *Nielli, Chiefly Italian*, E.III.20.
44. Both Lavin and Simons provide valuable discussion.
45. For the following discussion see Henry S. Wellcome, *The Evolution of Urine Analysis: An Historical Sketch of the Clinical Examination of Urine* (London and New York: Burroughs Welcome and Company, 1911); and Giovanni Cau, "Urologhi, uromanti, uroscopi e la matula," *Rivista di storia delle scienze mediche e naturali* 18.9 (1927): 244–59. Also see more recently Nancy G. Siraisi, *Medieval and Early Renaissance Medicine: An Introduction to Knowledge and Practice* (Chicago and London:

one may trace the importance given to urinalysis through Hippocrates, Galen, Theophilus and others. The ancient authors analyzed features such as color, consistency, sediment, odor and volume. Taste was also employed, for example, to detect the sweetness that might indicate what we now know as diabetes. The classical authors were full of advice on how to use urine medicinally. Pliny advises it for gout and skin diseases. Dioscorides suggests drinking one's own urine as an antidote for snake venoms and scorpion stings. To be sure, techniques involving urinalysis and practical usage became more refined during the Middle Ages and Renaissance and could prove quite effective.

Female urine, for example, was widely believed (correctly) to indicate fertility and pregnancy, though its trustworthiness was debated in the Italian Renaissance.[46] The concept is found at least as early as ancient Egypt c.1350 BCE and can be traced, however unevenly, through classical culture up to the present.[47] The general idea was to distribute a woman's urine on certain types of plants and if the plant flourished then she was believed to have conceived. Though this practice is not as reliable as modern pregnancy tests, experiments have proven the method to have some degree of accuracy.

Artists and their patrons were well aware of the implications and uses of urine. Leonardo da Vinci owned a copy of a treatise on urine analysis written by Montagnana, the famous Italian physician, in 1487.[48] Another well-known medical treatise, by Johannes de Ketham, was published in Venice in a Latin edition of 1491 and in Italian in 1494 as *Fasiculo de medicina*. It contains illustrations of uroscopy (the visual analysis of urine) and even a conveniently consultable urine chart.

Urinalysis is more frequently depicted in Renaissance art than commonly realized, as is the vessel used by doctors to collect and examine the urine, which was most often a *matula*.[49] The *matula* was normally made of transparent glass, with a bulbous shape that often mimicked the bladder and allowed for careful collection and inspection. It was transported by use of cylindrical baskets, usually made of wicker. The relief on the Florence Campanile illustrating the art of medicine, attributed to Andrea Pisano, is perhaps the

University of Chicago Press, 1990); and related discussion in Jeff Persels, "Taking the Piss out of Pantagruel: Urine and Micturition in Rabelais," *Yale French Studies* 110 (2006): 137-51.

46. See Rudolph M. Bell, *How to Do It* (Chicago and London: The University of Chicago Press, 1999), 71ff.

47. J. Burstein and G.D. Braunstein, "Urine Pregnancy Tests from Antiquity to the Present," *Early Pregnancy: Biology and Medicine* 1 (1995): 288-96.

48. Bartolomeus Montagnana, *Tractatus de urinarum iudiciis* (Padua: Cerdo, 1487). See Ladislao Reti, "The Two Unpublished Manuscripts of Leonardo da Vinci in the Biblioteca Nacional of Madrid – II," *The Burlington Magazine* 110.779 (Feb. 1968): 81-91.

49. See Cau, "Urologhi, uromanti."

most public image showing uroscopy[50] (Fig. 4). The scene shows a doctor, seated before his assistants, examining a urine sample in a *matula*, while two female patients wait with their respective samples in wicker baskets. The highly visible location of this image indicates the normalcy of the practice.[51] Furthermore, Saints Cosmas and Damian were commonly seen in Florence due to Medici associations, and they often hold a *matula* or other such vessel as used in their role as doctors.[52]

Urine was not just used diagnostically but also as a remedy in extracts or balms.[53] Female urine was believed especially good for leprosy. The antiseptic quality of urine was duly recognized during the Renaissance (urine normally being sterile when it exits the healthy body), as in the famous episode described in the autobiography of Benvenuto Cellini when the artist daringly escapes from the Castel Sant'Angelo. He recounts: "I was quite exhausted, and had, moreover, flayed the inside of my hands, which bled freely. This compelled me to rest awhile, and I bathed my hands in my own urine."[54]

50. A later sculpture depicting urinalysis is in Pistoia at the Ospedale del Ceppo and attributed Santi Buglioni. The scene shows a patient with two doctors, one of whom takes his pulse and the other holds the urine jar and bleeding staff. See Giancarlo Gentilini, *I della Robbia: La scultura invetriata nel Rinascimento* (Milan: Cantini, 1992), 427.

51. The location of this image is interesting since apparently a convenient public spot to seek bladder relief during the Renaissance was the area between the cathedral and the campanile. See Douglas Biow, *The Culture of Cleanliness in Renaissance Italy* (Ithaca: Cornell, 2006), esp. 15–16 and 86–87. Laws prohibiting individuals from urinating in public places indicate that people were frequently doing just that, even in this prestigious corner of the city. The sign of a cross was considered an effective deterrent to dissuade people from urinating on the city walls or those of private homes. See Biow, 86–87 and 206 n.72. Architects certainly understood the need to provide places for hygienic evacuation, and such is recognized in the drawings or writings of Leon Battista Alberti, Francesco di Giorgio and Leonardo da Vinci, among others. See Alberti, *On the Art of Building in Ten Books*, trans. Joseph Rykwert, Neil Leach and Robert Tavernor (Boston: MIT Press, 1988), 151. Examples of Renaissance latrines still exist in Florence in the Palazzo Vecchio and the Palazzo Davanzati. See Schiaparelli, *La Casa Fiorentina*, 87–88 for latrines. Alternate names are *latrine, cessi, private, agiamenti, guardarobe, luoghi comuni, necessarí*. The painter Pietro del Donzello, a follower of Perugino, was hired in 1506 to paint images of two saints on the campanile precisely to discourage such practice: "…perchè non vi si pisci." See Biow, 194 n. 49; and Arnold Victor Coonin, "New Documents Concerning Perugino's Workshop in Florence," *Burlington Magazine* 141.XXX (February 1999): 100–104.

52. An image by Fra Angelico from the San Marco Altarpiece shows *The Healing of Justinian by Saint Cosmas and Saint Damian* and includes a vessel used to collect urine hanging on the patient's headboard inside a container. These more generic urine bottles used every day were typically called an *orinale* or *vaso urinaceo*. They were kept in a case (called a *vesta*), usually straw or wicker baskets, and hung by the bedside so as not to have to leave the bed to urinate at night. Both men and women used such vessels, and they appear frequently in inventories and in images. See Peter Thornton, *The Italian Renaissance Interior, 1400–1600* (London: Abrams, 1991).

53. Cau, "Urologhi, uromanti," 253–54.

54. Benvenuto Cellini, *The Autobiography of Benvenuto Cellini*, trans. John Addington Symonds (New York: P.F. Collier, 1910), 228.

A SCARLET RENAISSANCE ■

Urine had useful properties if considered as a purely chemical substance. Artists were particularly aware of this, since both human and animal urine had long been used in various industries, especially those dependent on pigments and color. Dyers in the Middle Ages commonly used human urine in the manufacture of dyes (such as blues, blacks and browns), as is frequently specified in recipes found in the *Plictho* by Giovanventura Rosetti, published in Venice in 1548 as the first comprehensive source on the subject.[55] Pigments for painters could also be made from urine, including lead white and red lake. Cennino Cennini reports that some artists grind red lake with urine, while warning that the mixture, "soon becomes offensive."[56]

Theophilus, writing in the early twelfth century, describes using urine for diverse purposes, including making pigments (folium and salt green), glass making, cementing and coloring gold and even hardening tools. He adds, "Tools are also made harder by hardening them in the urine of a small red-headed boy than by doing so in plain water."[57] It is unclear why smaller redheads offered better results but let us not argue with apparent success.

Sculptors well understood these properties of metals, and bronze founders since antiquity knew that urine could be employed to quickly alter the patination of bronze (since stale urine yields ammonia). In this context there is also a niello engraving featuring a sprite micturating on the whetstone of a knife grinder.[58] Contrary to suggestions that there are sexual innuendos in the image, including sodomy, the print means nothing of the sort.[59] The winged being is simply a sprite, whose bodily water augers practical good fortune for this common artisan, much like the red-headed boy recommended by Theophilus.

■

The *spiritello d'acqua* sculptures under discussion here thus emerged in Florence in a society receptive to such imagery and from among a group of artists familiar with the cathedral's two sacristy lavabos and the creative circle of Brunelleschi and Donatello (including their associates Buggiano and

55. See Giovanventura Rosetti, *The Plictho: Instructions in the Art of the Dyers which Teaches the Dyeing of Woolen Clothes, Linens, Cottons, and Silk by the Great Art as well as by the Common*, trans. Sidney M. Edelstein and Hector C. Borghetty (Cambridge, MA: MIT Press, 1969).
56. Cennino Cennini, *The Craftsman's Handbook*, trans. Daniel V. Thompson, Jr. (New York: Dover, 1960), chap. 44.
57. Theophilus, *On Divers Arts*, trans. John G. Hawthorne and Cyril Stanley Smith (Chicago: University of Chicago Press, 1963), esp. 95.
58. Hind, *Nielli, Chiefly Italian*, no. 278.
59. My interpretation here respectfully disagrees with that of Simons, "Manliness and the Visual Semiotics," 348ff.

Michelozzo). Their original placements are long lost but it is probable that most formed part of fountains or acquaii as part of the Renaissance home.[60] Acquaii often had single heads as decorative features, and an inventory of the property of Lorenzo il Magnifico describes one example with "due teste che ridono sopra l'acquaio [della] sala grande terrena."[61] The sense of joy is important, and it is interesting that these laughing heads (probably sprites) are listed along with several works by Desiderio da Settignano, responsible for the inimitable bust of the *Laughing Boy* in Vienna[62] and whose studio produced at least one of the extant figures to be discussed below. The sprites complemented other such objects commissioned for weddings, new homes, the birth of children and the general celebration of family.[63]

These micturating water sprites can be loosely grouped into three principal types defined by their respective poses — contrapposto, uncovering and cache-sexe. The earliest datable examples — also the most numerous to survive — are of the contrapposto type, which were popular in the middle of the fifteenth century (Fig. 5). In this basic composition the *spiritello* stands in relaxed contrapposto; the right hand is at the right thigh, holding drapery aside, while the left hand comes across the body to hold the penis between thumb and forefinger. The figures all bear a playful, even mischievous, smile, an attribute of sprites in general, and they glance up at the viewer with chin slightly buried in the neck. Drapery falls off the left shoulder and bunches at the waist while clinging closely to the torso. With one significant exception, there are few major differences in these extant statues notwithstanding the proclivities of their respective sculptors.

The example in the Musée Jacquemart-Andrè (Fig. 5) is the earliest datable example to survive and is probably closest to an original prototype.[64] It may

60. See especially Schiapparelli, *La Casa Fiorentina*; and Ajman and Dennis, *At Home in Renaissance Italy*. Published heights of these sculptures vary somewhat by catalogue but are generally listed between 50 and 100 cm (about 20–40 inches). Most of these sculptures bear clear evidence of having been used as fountains, though it is almost impossible to determine at what point plumbing was actually installed.

61. Gentilini in *Desiderio da Settignano*, 30 and 46 n. 25.

62. Most recently catalogued in *Desiderio da Settignano*, 164–67; and *The Renaissance Portrait from Donatello to Bellini*, ed. Keith Christiansen and Stefan Weppelmann (New Haven: Yale University Press, 2011), 156–57. On the type see Arnold Victor Coonin, "Portrait Busts of Children in Quattrocento Florence," *Metropolitan Museum Journal* 30 (1995): 61–71.

63. Jacqueline Marie Musacchio, *Art, Marriage, and Family in the Florentine Renaissance Palace* (New Haven: Yale University Press, 2009).

64. See the catalogue entry by Françoise de la Mourèyre-Gavoty, *Sculpture Italienne. Institut de France – Paris – Musée Jacquemart-André* (Paris: Les Presses Artistiques, 1975), no. 43. Its face resembles those of sprites in early works by Donatello and Michelozzo, especially the dancing figures in relief on the external pulpit in Prato. Its similarities are such that it has been attributed directly to Michelozzo. See especially Antonio Natale, *L'umanesimo di Michelozzo* (Florence: SPES, 1980), 48; following C. Del Bravo, review of F. de la Mourèyre-Gavoty, *Sculpture Italienne*, in *Antichità*

be reasonably dated c.1445–55 and attributed to an assistant of Bernardo Rossellino (possibly Buggiano). The author of a similar *spiritello* in the Louvre (Fig. 6) was undoubtedly one of the carvers, associated with Desiderio da Settignano, who produced the roundels that decorate the exterior frieze of the Pazzi Chapel at Sta. Croce and made this work c.1450–60.[65]

The dating and general attributions of these sculptures are important because their sculptors seem fully aware of both the earlier figures from the two lavabos as well as other contributions of their more famous forebears, especially Donatello and Brunelleschi. The *spiritello* figures are still vital and full of the playfulness and joyfulness expected when good fortune and good health are invoked. As variants become more popular over time the significance of style and iconography are both diluted, as in the example in the Bardini Museum (Fig. 7) which seems more crass in every way.[66]

Viva 3 (1975): 65–66. The body and drapery, however, suggest a later execution, informed by the more supple and sensuous descriptions of cloth found in the respective studios of Bernardo and Antonio Rossellino, and even an awareness of Desiderio da Settignano. The closest analogy to contemporary figures is with the putti that surmount the tomb of Leonardo Bruni in Sta. Croce. These were carved by an assistant of Bernardo Rossellino, at one time identified as the mature Buggiano, though without universal acceptance. See Anne Markham Schulz, *The Sculpture of Bernardo Rossellino and his Workshop* (Princeton: Princeton University Press, 1977), 49–51. Schulz (103) also notes a prior attribution to Buggiano by Dorothy B. Graves. Pope-Hennessy, *Italian Renaissance Sculpture*, 370–71, unequivocally disagrees with the Buggiano attribution. The Sta. Croce faces are not as square as Buggiano's sacristy sprites but their general physiognomy is similar. The putti on the Bruni tomb do differ from each other, and the Musée Jacquemart-Andrè *spiritello d'acqua* shares similarities with each. The affinities of the museum's statue with a participant in the Rossellino studio is compelling enough to confirm a date near the execution of the Bruni tomb (c.1444–51) and does not resonate stylistically in later works by Bernardo Rossellino or in the sculpture of the Chapel of the Cardinal of Portugal, largely the work of Antonio. My proposed dating is about a decade earlier than that of Mourèyre-Gavoty (1455–60).

65. The Pazzi frieze was executed by a group of sculptors probably guided by the virtuoso hand of Desiderio da Settignano; the young Benedetto da Maiano would have been among them, as well as other sculptors whose names remain elusive. The author of the Louvre *spiritello d'acqua* belongs to this anonymous but intriguing group. Many of the faces on this frieze have a distinctive pear-shaped head, with a particularly large cranium relative to the jaw. They bear an unconvincing smile that conveys more sadness than joy. The roundel numbered 19 in Ida Cardellini, *Desiderio da Settignano* (Milan: Edizioni di comunità, 1962) is just one example whose face resembles that of the Louvre *spiritello*. In both, the hair is carved in low relief with little volumetric mass besides a clumping at the middle of the forehead. They share a distinctively large forehead that narrows considerably near the eyes, and the face puffs out again at the cheeks. Many folds of skin congregate around the lower lip and chin, and the facial expression is generally more subtle and subdued relative to other examples. Support for Benedetto's training in Desiderio's shop is found in Doris Carl, *Benedetto da Maiano*, 2 vols. (Turnhout: Brepols, 2006).

66. See the catalogue entry by Lusanna in *Il museo Bardini a Firenze*, ed. Enrica Neri Lusanna and Lucia Faedo (Milan: Electa, 1986), no. 193 as "Scultore Fiorentino (metà XV secolo)." The entry notes another smaller version in the Louvre. Relative to the other examples, its torso is more flatly executed and the details of the face exaggerated to the point of misshapenness. The eyes

Furthermore, in an example in the Musée de la Chartreuse in Douai (Fig. 8) we have a slight variant in which the figure bears a unique headdress festooned with fruit and foliage.[67] This addition makes the figure a pastoral type, more closely associated with the classical sprites that accompany Bacchus and less of a specifically Christian or more generally spiritual ideal.[68]

The final example of the contrapposto type is a marble by Mino da Fiesole, who creates a unique and forceful variation on the by now well-established theme[69] (Fig. 9). Mino reverses the contrapposto and replaces the conventional drapery with loose wrappings akin to swaddling cloth. Mino's figure has a less impish expression, and looks emphatically upwards with chin aloft rather than buried. Most significantly, Mino adds new attributes by way of wings and a flaming torch supported by the right arm.

The mixture of flame and water is purposeful and transforms the sprite into a being associated with love.[70] By trope and tradition, fire ignites the passions. Water, rather than extinguishing the flames, is warmed by them. It is a concept Shakespeare most famously expressed in the first ten lines of his sonnet 153:[71]

> Cupid laid by his brand, and fell asleep:
> A maid of Dian's this advantage found,
> And his love-kindling fire did quickly steep
> In a cold valley-fountain of that ground;
> Which borrow'd from this holy fire of Love

are extremely narrow and the mouth inexpertly excavated to create a simple cavity rather than an organic form. The head is so severely downturned and the chin buried so deeply that the neck is hardly discernable from the front. Still, it is an important example that further establishes the popularity of the type and the range of its production in studios both leading and derivative, bringing us to the third quarter of the fifteenth century.

67. See Louis Gonse, *Les chefs d'oeuvres des Musées de France: Sculpture* (Paris: Baranger, 1904), 173. Also see Foucques de Wagnonville Amédée, *Catalogue des oeuvres de peinture et de sculpture, des objets d'art et de curiosité légués au musée de Douai* (Douai: Musée de Douai, 1877), n. 265; and Leroy Stéphane, *Catalogue des peintures, sculptures, dessins et gravures du Musée de Douai* (Douai: Oscar Duthilloeuil, 1937), n. 863.

68. See, for example, Titian's *Bacchanal of the Andrians* where a putto micturates at the feet of a nude, sleeping nymph. For more sexually suggestive interpretations see Anthony Colantuono, *Titian, Colonna and the Renaissance Science of Procreation* (Farnham, Surrey and Burlington VT: Ashgate, 2010), 119–24. Also see Simons, "Manliness and the Visual Semiotics," 356ff.

69. See Gianni C. Sciolla, *La scultura di Mino da Fiesole* (Turin: Giappichelli, 1970), n. 16; and Franz Wickhoff, "Ein Pissmännchen von Mino da Fiesole," *Zeitschrift für bildende Kunst* 24 (1889): 198–200. The statue is generally dated c.1470–75.

70. For further discussion of the flame see Dempsey, "Donatello's *Spiritelli*," 14; and *Inventing the Renaissance Putto*, esp. 86ff.

71. For a summary of commentary see Carl D. Atkins, *Shakespeare's Sonnets: With Three Hundred Years of Commentary* (Madison, NJ: Fairleigh Dickinson University Press, 2007), 374–77. The final four lines comprise a typical inversion that only reinforce the theme.

A SCARLET RENAISSANCE ■

> A dateless lively heat, still to endure,
> And grew a seething bath, which yet men prove
> Against strange maladies a sovereign cure.
> But at my mistress' eye Love's brand new-fired,
> The boy for trial needs would touch my breast;
> I, sick withal, the help of bath desired,
> And thither hied, a sad distemper'd guest,
> But found no cure: the bath for my help lies
> Where Cupid got new fire — my mistress' eyes.

In Mino's statue the mixture of flame and water vividly encompasses the essence of love and desire in the most salubrious of ways. It is, in effect, the most original statement of the contrapposto type and the only example to substantially extend its iconographic potential. If one posits a domestic context, it is a statue that emphatically promotes visually the idea of love linked with health, fertility and abundance — familial messages the patrons of such sculptures were eager to promote.

The second type of *spiritello d'acqua* showing micturition may be called uncovering.[72] In these images the sprite normally lifts his shirt to reveal the penis and allow his emission to flow unobstructed. They look down with concentration as if discovering with a sense of wonder what they can do.[73] There are some classical sculpted prototypes for this pose, including a well-known example in the Louvre.[74] Donatello also provided a precedent with a micturating putto seen in a detail from his bronze relief showing the Bacchic treading of grapes that makes up one side of the triangular base of his *Judith and Holofernes*.

The two best known independent examples of this pose from the fifteenth century are a bronze in Vienna and a terracotta in Berlin.[75] The Vienna

72. A term more commonly used in classical art is the "Anasyrma" pose, or a lifting of skirts. This emphasizes the symbolic, apotropaic, or revealing nature of the gesture. The term "flashing" would imply a more sexual nature. Anasyrma is most commonly associated with images of women.
73. I thank Alison Luchs for help clarifying the features and description of this pose.
74. See a classical prototype illustrated in Tervarent, "L'origine des fontaines," fig. 11 (Deonna, "Fontaines antropomorphes," fig. 119) with notice of other examples. A closely related classical type is the Ithyphallic Hermaphrodite Anasyrma, an example of which is in the Louvre. A drawing after Rubens is discussed and illustrated in Marjon van der Meulen, *Rubens' Copies after the Antique*, 3 vols. (London: H. Miller, 1995), cat. 53.
75. The bibliography of the bronze and terracotta versions overlaps. Gentilini, *I della Robbia*, 361, discusses the terracotta in the context of Girolamo della Robbia; and the attribution to Girolamo is retained in the catalogue entry by Alfredo Bellandi, *I Della Robbia e l'arte nuova della scultura invetriata*, ed. Giancarlo Gentilini (Fiesole: Giunti, 1998), 4.10, 303-4. I prefer an attribution to Andrea della Robbia in the 1480s. See Allan Marquand, *Andrea della Robbia and His Atelier* (Princeton: Princeton University Press, 1922), 2:184-85, no. 335. On the bronze in Vienna see Manfred Leithe-Jasper, *Renaissance Master Bronzes from the Collection of the Kunsthistorisches Museum* (Vienna: Smithsonian Institution, 1986), 68-69. Leithe-Jasper argues that it is earlier. Bode, *The*

bronze (Fig. 10), datable c.1453–64, is the earlier image. Its original context is unknown, but the bronze medium and its piping suggests a conspicuous setting as part of a larger fountain design. It was not conceived as a seated figure, though it has often been displayed as such.[76] Instead, the figure was supported in the back so it could lean over much like the positioning of the painted sprite in the right corner of Titian's famous *Bacchanal of the Andrians*. Stylistically, the Vienna sprite shows close analogies to bronze figures from the workshop of Vittorio Ghiberti, especially the three heads from the architrave on the south portal of the Florence Baptistery. I have attributed the modeling of those to Antonio Rossellino, who likely modeled this figure as well.[77]

A sprite in Berlin (Fig. 11) is only slightly later than the Vienna bronze and is roughly datable to the 1480s. It is here attributed to Andrea della Robbia, who was responsible for many of the most admired images of youth in the Renaissance, including the roundels of the Ospedale degli Innocenti, where swaddled infants in relief still grace the building's facade.[78]

Italian Bronze Statuettes of the Renaissance, new edition, James David Draper (New York: M.A.S. de Reinis, 1980), catalogued the bronze (CLXVII) as Venetian, c.1570. The revised index by James Draper more plausibly ascribes it to Vittorio Ghiberti, c.1465–75. Also see Leo Planiscig and Ernst Kris, *Kunsthistorisches Museum: Sammlungen für Plastik und Kunstgewerbe* 3. *Ausstellung-Kleinkunst der italienischen Frührenaissance* (Vienna: Kunsthistorisches Museum, 1936), 6, no. 11.

76. I thank Claudia Kryza-Gersch for confirming that the figure stood while being supported in the back. There exists a bronze in the Bargello Museum, Florence which I have seen only in photographs. It appears to be a similar to the Vienna bronze in most superficial aspects and further suggests a similar stance for the Vienna sculpture. A copy of the Vienna bronze appears on the web in the collection of the Manor House, Curry Mallett in Somerset, England.

77. Arnold Victor Coonin, "Vittorio Ghiberti and the Frame of the South Doors of the Florence Baptistery," *Sculpture Journal* 18.1 (2009): 38–51; and idem, "*Dopo Lorenzo:* On the Ghiberti Family Workshop," *Italian Art, Society, and Politics: A Festschrift for Rab Hatfield*, ed. Barbara Daimling, Jonathan K. Nelson and Gary M. Radke (Florence: Syracuse University Press, 2007), 83–98. The two sculptors were from families with a close professional relationship and the Vienna *spiritello d'acqua* was produced coincident with the time in which Bernardo and Antonio Rossellino were collaborators on the south Baptistery door overseen by Vittorio Ghiberti (1453–64). Also see Coonin, "New Documents." The same period saw Antonio taking the lead on the spectacular carving of the tomb of the Cardinal of Portugal in S. Miniato al Monte (1461–66). One may note a good comparison to the Christ child in the tondo of the S. Miniato monument, with the signature lock of hair falling at the center of the forehead, the baby-fat cheeks and idiosyncratic smile. Antonio Rossellino was a sculptor acutely aware of artistic precedents and this interpretation of the *spiritello d'acqua* in its seated pose harkens directly back to the first such sprites in the north sacristy of Florence Cathedral. Antonio, however, was not a specialist in bronze casting, and the figure was thus probably modeled by Antonio Rossellino and cast by Vittorio Ghiberti.

78. Marquand ascribes the figure to the atelier of Andrea della Robbia. Andrea also created impressive busts of the young Christ and Saint John the Baptist, Madonna and Child reliefs, and a plethora of sprites, cherubs and angels that populate his endlessly inventive larger creations. The Berlin terracotta complements well the general features found in many of these figures of youth, with their spiraling hair and friendly faces.

A SCARLET RENAISSANCE ■

A unique element in this fountain figure is that the sprite stands over an Iris, a flowering plant with deep iconographical significance, especially in Florence. The plant may have been inserted into the composition for practical reasons, especially for support, but its iconography emphasizes the general idea of fertility and growth, not unrelated to the common custom of pouring urine on plants to test for pregnancy.[79] As noted above, a flourishing plant confirmed conception. The Iris root was also commonly used for medicinal and gastronomic purposes.

The Iris seen here is the *Iris germanica*, which along with its white-flowering cousin (*Iris florentina*) was strongly associated with the city of Florence as the *giglio fiorentino*.[80] The same flower appears in many paintings of the time, including Botticelli's *Primavera* and the *Portinari Triptych* by Hugo van der Goes. From the *Ricettario fiorentino* (1499) we learn that the flower could be expected to be picked in April and was thereby a potent symbol of spring, with all the positive connotations of fertility and health therein.[81] The Berlin *spiritello d'acqua* thus bore civic and political connotations about a healthy Florentine state in addition to its other positive attributes.

The myriad messages of good fortune and abundance, as expressed through the micturating *spiritello d'acqua*, would largely be lost in the following century. By the end of the sixteenth century, Raffaello Borghini describes a *spiritello d'acqua* in a fountain carved by Valerio Cioli as part of sculptural decorations at the Medici Villa di Pratolino c.1569–84. He states: "and a little boy is in the corner lifting his shirt in front of him as if to jokingly urinate."[82] There is no mention of any other meaning to the statue. Here we have indication that the humorous nature of the image is still operative but the scatological aspect has grown stronger than the metaphysical. This evolution is best observed in a third and most suggestive compositional type.

79. Burstein and Braunstein, "Urine pregnancy tests."
80. For this discussion see *The Flowering of Florence: Botanical Art for the Medici*, ed. Lucia Tongiorgi Tomasi and Gretchen A. Hirschauer, exh. cat. (Washington: National Gallery of Art, 2002), 23.
81. *Nuovo riceptario composto dal famosissimo Chollegio degli eximii doctori dell'arte et medicina dell'inclita città di Firenze* (Florence: Compagnia del Dragho, 1499), fol. 1-0b as cited in *Flowering of Florence*, 104 n. 19.
82. R. Borghini, *Il Riposo* (Florence: Marescotti, 1584), trans. Loyd H. Ellis (Toronto: University of Toronto, 2008), 291. The original, *Il Riposo di Raffaello Borghini*, ed. Giovanni Gaetano Bottari (Florence: Kessinger Publishing, 1730), 490, reads, "un fanciullino, che alzatasi la camicia dinanzi, quasi scherzando piscia." Reputedly, the figure can be seen at the entrance to the villa as depicted in the Giusto Utens lunette, painted 1599. See Wiles, 97. A bronze statuette once attributed to Cioli (now lost) apparently depicted the young Bacchus micturating. For this image see Staatliche Museen zu Berlin, *Dokumentation der Verluste: Skulpturensammlung*. Band VII. *Skulpturen, Möbel*, ed. Lothar Lambacher, et al. (Berlin: SMB, 2006), 172 n. 7166. It is a rather crass version that conflates various themes.

The final compositional type, a *cache-sexe*, becomes most popular in the sixteenth century and provides the last major variation on the theme of the micturating *spiritello d'acqua*. In the *cache-sexe* pose the sprite covers his penis with a mask (usually a satyr's mask) and micturates through it.[83] Buggiano's second pair of sprites from the south sacristy of Florence Cathedral essentially used urns as a sort of *cache-sexe*, thus establishing the type early on. The pose probably evolves from similar compositions without a mask. An illustrated example is described in the *Hypnerotomachia Poliphili* (Fig. 12). Poliphilo ventures to fetch water from a fountain featuring two nymphs that support a little boy described thus:

> The nymphs held the child's garment up so as to uncover him up to the waist or navel; and the child held his little member with both hands, pissing cold water into the hot bath, to make it tepid.

Since water instead of urine emerges, this allows Poliphilo to add the following episode in perfectly good humor:

> No sooner had I set one foot on the step to reach the falling water, than the little Priapus lifted his penis and squirted the freezing water in my hot face, so that I fell back instantly on my knees. At this, such a high and feminine laughter echoed around the hollow dome that as I recovered, I too began to laugh fit to die.

Poliphilo registers laughter rather than disgust, realizing the playful nature of the work, especially after noting the fountain's inscription of "Geloiastos" variously translated as "he who causes laughter" or "the most mirthful one" or simply "trickster," all of which indicate jest or buffoonery, which confirms the relative innocence of the sprite and his action.[84] Humor is an essential element in this type and becomes even more important when the mask is added.

The mask necessarily affects the meaning of the water sprite, making the protagonist more mischievous and even naughty, if harmless. The mask serves a dual role in covering the penis but also calling attention to it in a way that is

83. The term comes from Dempsey, *Inventing the Renaissance Putto*. On the mask see Idem, "Lorenzo's 'ombra'," in *Lorenzo il Magnifico e il suo mondo*, ed Gian Carlo Garfagnini (Florence: Olschki, 1994), 341–55; and Dempsey, "Donatello's *Spiritelli*." Also see the ample discussion of these types in Kusch-Arnhold, *Pierino da Vinci*.

84. The inscription above the fountain reads: ΓΕΛΟΙΑΣΤΟΣ. I thank scholars Kenny Morrell and David Sick for their assistance with its meaning. According to Morrell, it is related to the Greek word (γελοῖος, ΓΕΛΟΙΟΣ), which means "laughable," "amusing," or "absurd." The form ΓΕΛΟΙΑΣΤΟΣ is unusual, however. The masculine noun, γελοιαστής, is attested in ancient Greek and means "jester" or "buffoon." According to Sick, the inscription could also refer to the observer, as "he who is mockable." I use translations found in Colantuono, *Titian, Colonna*, 120; and Simons, "Manliness and the Visual Semiotics."

playful and suggestive though not necessarily sexual. Dempsey highlights the intended humor and says of such sprites, "They are only childish hobgoblins hiding their true natures behind fright masks, scarecrows used to frighten other children. The mask pretends to cover something tremendous and terrifying, but which is really nothing."[85] The child too, with his exaggerated smile, pretends to be causing mischief but is only issuing water that is purifying rather than soiling.[86]

By general consensus, the most accomplished extant version of the *cache-sexe* type is a sculpture in Arezzo attributed to Pierino da Vinci[87] (Fig. 13). In this example, the sprite stands almost nude, with legs spread wide, and with only a bit of drapery crossing his left shoulder. He thrusts his pelvis slightly forward to better project his water through the mask. The sprite holds the mask tight to his body with fingers pulling back the cheeks of the satyr's mouth and exaggerating the sense of terror with implied discomfort. It could be the sculpture described by Vasari in his biography of Pierino:

> ...ed appunto avendo fatto allora fare un acquaio di pietra per Cristofano Rinieri, dette a Piero un pezzetto di marmo, del quale egli facesse un fanciullo per quell' acquaio, che gettasse acqua dal membro virile. Piero prese il marmo con molta allegrezza, e fatto prima un modelletto di terra, condusse poi con tanta grazia il lavoro, che 'l Tribolo, e gli altri feciono coniettura che egli riuscirebbe di quegli che si truovano rari nell' arte sua.[88]

The Arezzo sculpture is generally considered to be one of Pierino's earliest works, c.1540–45. Indeed, it is a sculpture decidedly sixteenth-century in both style and in its iconographical development. The more innocent and ideal connotations of issuing water, while not completely lost, are now altered in a way consistent with the *maniera* of the cinquecento, with greater theatrics, and with a sophisticated but less high-minded intellect implied.

There exist at least three notable copies of this statue, progressively more base and exaggerated in style, that bring us into the seventeenth century.

85. Dempsey, *Inventing the Renaissance Putto*, 112.
86. A late fifteenth-century engraving, probably Venetian, shows an elaborate fountain of love in which shield-bearers micturate into a mixing with water that flows from masks. See Hind, *Early Italian Engraving*, E.III.2. Another fountain of love appears on a maiolica plate dated 1513. In this example satrys micturate into the waters below. See *Art and Love*, cat. 4.
87. See especially Kusch-Arnhold, *Pierino da Vinci*; and Middeldorf, *Giorgio Vasari: Principi*. Also see an earlier discussion by Ulrich Middeldorf, "Additions to the Works of Pierino da Vinci, 1928," in *Raccolta di scritti* (Florence: Spes, 1979), 1:52–53; and *Museo Statale d'arte medievale e moderna in Arezzo* (Florence: Cassa di risparmio di Firenze, 1987), 29 n. 24. On Pierino also see *Pierino da Vinci: Atti della giornata di studio*, Vinci, Biblioteca Leonardiana, 26 maggio 1990, ed. Marco Cianchi, Comune di Vinci (Firenze: Becocci, 1995).
88. Vasari-Milanesi, *Le Vite*, 6:121–22.

They are figures apparently made for an audience for whom the original connotations of the water sprite no longer resonate so loudly. The closest version chronologically and thematically to Pierino's is that in the Musée de la Chartreuse, Douai (Fig. 14), which bears a supporting tree trunk uncomfortably inserted between the sprite's legs.[89] The final two versions of this type are known from the art market: a version in Milan that has been attributed to Matteo Ferrucci, and dated c.1600[90] and a sculpture in Venice by a follower of Pierino da Vinci as late as the early seventeenth century.[91] Both are bastardizations of the type, the former being too cartoonish and the latter too mature to convincingly evoke the true essence of the sprite.

The viewers of these images would have had little reason to connect the imagery with the first sacristy figures from which they ultimately derived. By this point these origins and their more idealized associations were all but lost. The sprites, which ultimately became more scatological and crass in reference, are the progenitors of the garden variety copies one can easily acquire today. They may evoke a chuckle but offer little by way of positive ideals, which conjured health, wealth, fertility, good fortune and even love. In effect, by the end of the Renaissance the more ideal, much less the spiritual, connotations of the micturating *spiritello d'acqua* had been all but played out.

■

89. For this and the following copies see comprehensive entries and previous bibliography in Kusch-Arnhold, *Pierino da Vinci*, nos. 4.1, 4.2 and 4.3. The version in Douai is catalogued in Foucques de Wagnonville, *Catalogue*, n. 266 ; and Leroy, *Catalogue des peintures*, n. 864. It is a mid-sixteenth-century work in grey sandstone that has been optimistically attributed to Giambologna but is more likely by an anonymous sculptor copying Pierino's famous example. This lively sprite retains the same mischievous smile but there are some obvious iconographic differences, especially the replacement of drapery with a tree trunk inserted between the figure's legs. The tree trunk does have pastoral connotations and associations with Bacchus, but in this case was probably inserted for structural reasons. It is a rather awkward and inelegant design with less detail overall and a more angular and geometric composition than its predecessor.

90. Kusch-Arnhold, *Pierino da Vinci*, no. 4.2, citing C. Pizzorusso, "Matteo Ferrucci: *Puer Mingens*," *Spunti per conservare* (Milan: Galleria Nella Longari, 2001), 46–49. The sculptor fashioned the figure after the Arezzo example and made unflattering changes in the proportions, moving away from the classical ideal with a more squat and less elegant portrayal. The mask has also been changed and appears more architectural, though the playfulness remains.

91. See Alessandro Parronchi, "Alcuni inediti," *Pierino da Vinci: Atti della giornata di studio* (Vinci: Comune di Vinci, 1995), 31–34; and Kusch-Arnhold, *Pierino da Vinci*, no. 4.3. As in Perino's version, on which it is based, the figure holds a traditional satyr mask and bears conventional drapery across the chest and down the back. The main distinctions of this example are the apparent age of the sprite and the more subdued character of his smile. This is no longer the exuberant image of child-like innocence the sprites traditionally embody. This child is older, with little of the playful impishness of previous examples and ultimately appealing to different sensibilities than the original examples had confidently assumed.

A SCARLET RENAISSANCE ■

Fig. 1 (left). Lavabo, Florence Cathedral, North Sacristy. Designed by Brunelleschi 1432, executed by Buggiano by 1440.

Fig. 2 (below). Lavabo, Florence Cathedral, South Sacristy. Begun by Buggiano 1442, finished by Pagno di Lapo in 1445.

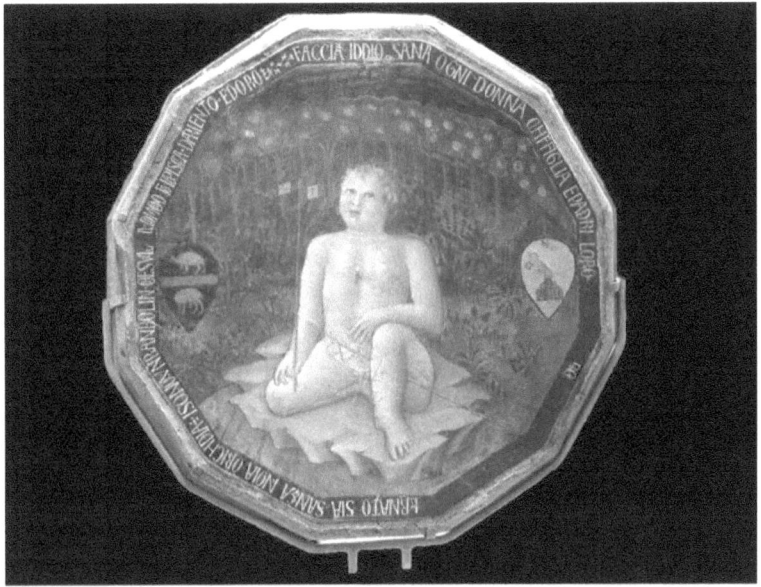

Fig. 3 (above). Desco da Parto, attributed to Bartolomeo di Fruosino, 1428. New York, Private Collection.

Fig. 4 (below). Relief with scene of Urinalysis. Andrea Pisano. From Campanile, Florence. Florence, Museo dell' Opera del Duomo.

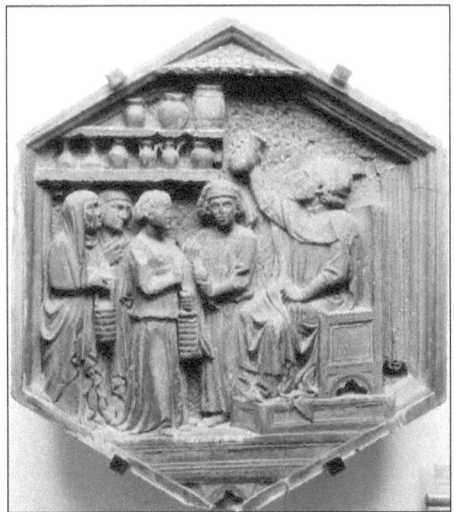

A SCARLET RENAISSANCE ■

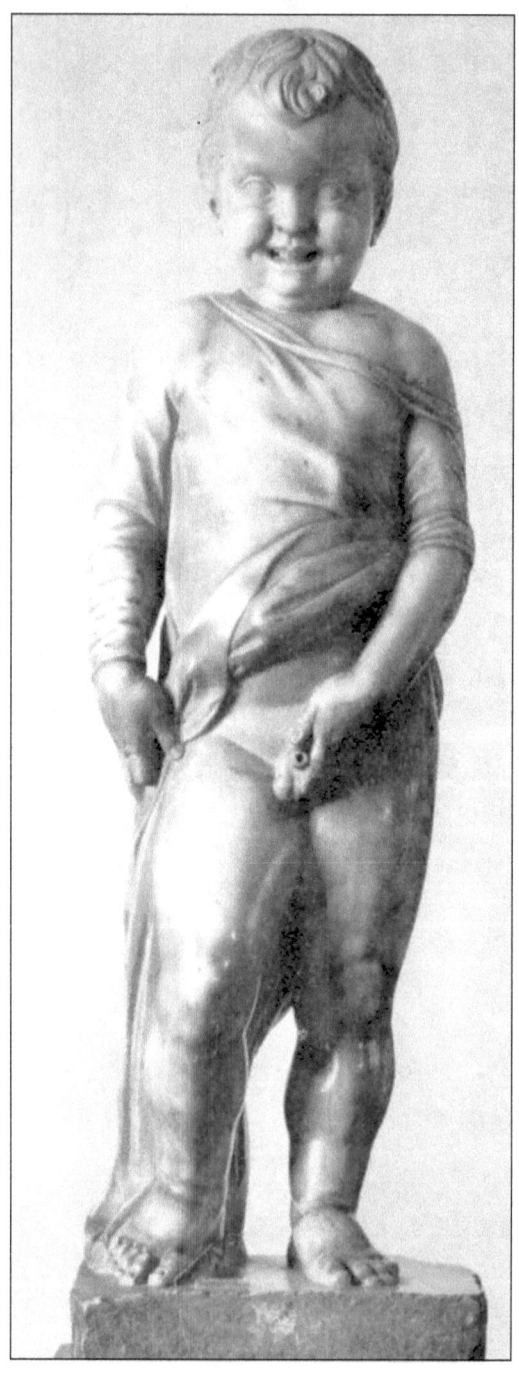

Fig. 5. *Spiritello d'acqua*, c.1445–55. Attributed to an assistant of Bernardo Rossellino (possibly Buggiano). Paris, Musée Jacquemart-Andrè.

Fig. 6 (above right). *Spiritello d'acqua*, c.1450–60. Attributed to a participant on the Pazzi Frieze. Paris, Louvre.

Fig. 7 (bottom). *Spiritello d'acqua*, third quarter fifteenth century. Anonymous Sculptor. Florence, Bardini Museum.

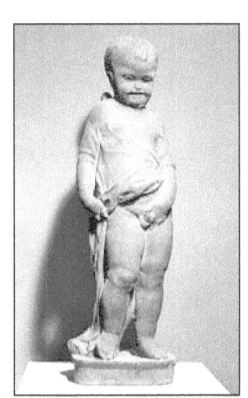

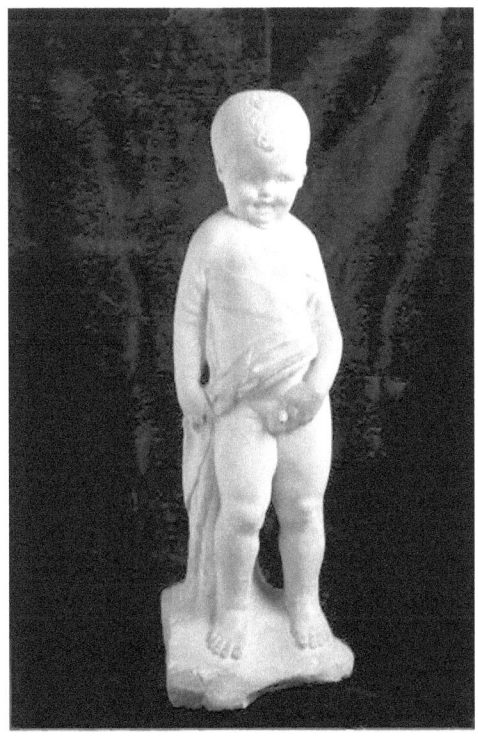

A SCARLET RENAISSANCE

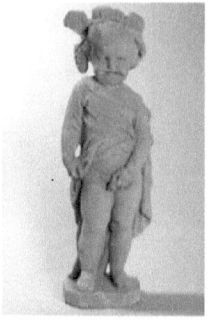

Fig. 8 (top left). *Spiritello d'acqua,* third quarter fifteenth century. Anonymous Sculptor.
Douai, Musée de la Chartreuse.

Fig. 9 (bottom left). *Spiritello d'amore,* Mino da Fiesole, c.1470–75. Florence, Bargello.

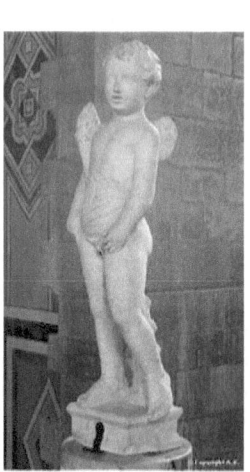

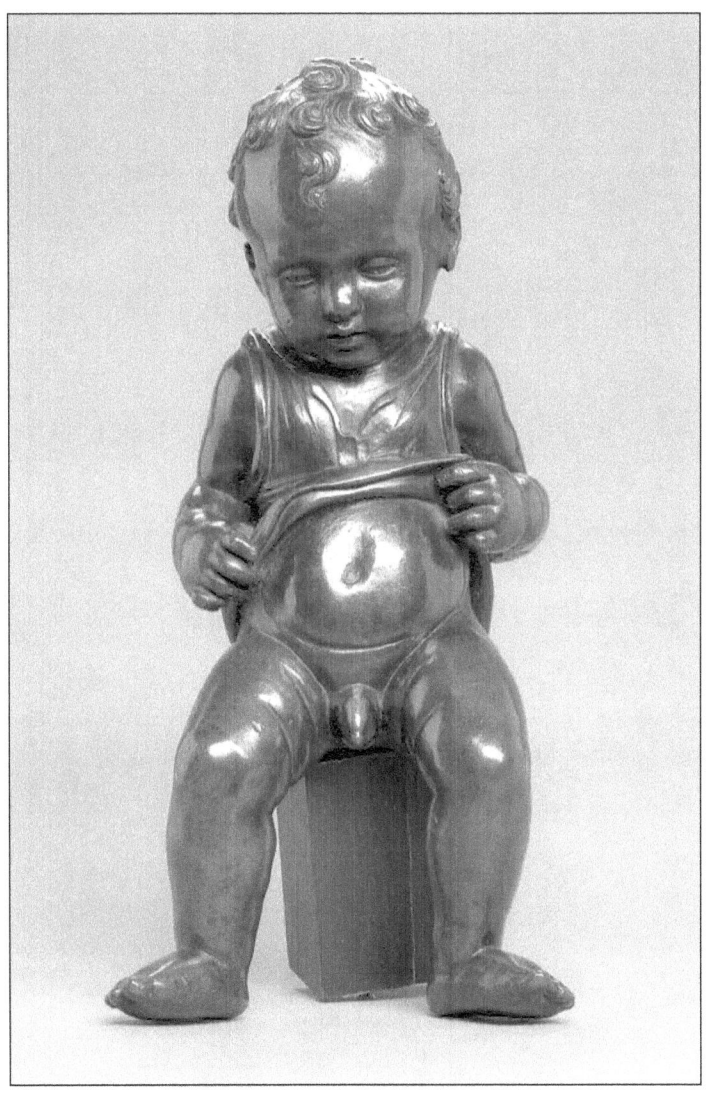

Fig. 10 (above). *Spiritello d'acqua*. Designed by Antonio Rossellino; cast by Vittorio Ghiberti, c.1453–63. Vienna, Kunsthistorisches Museum.

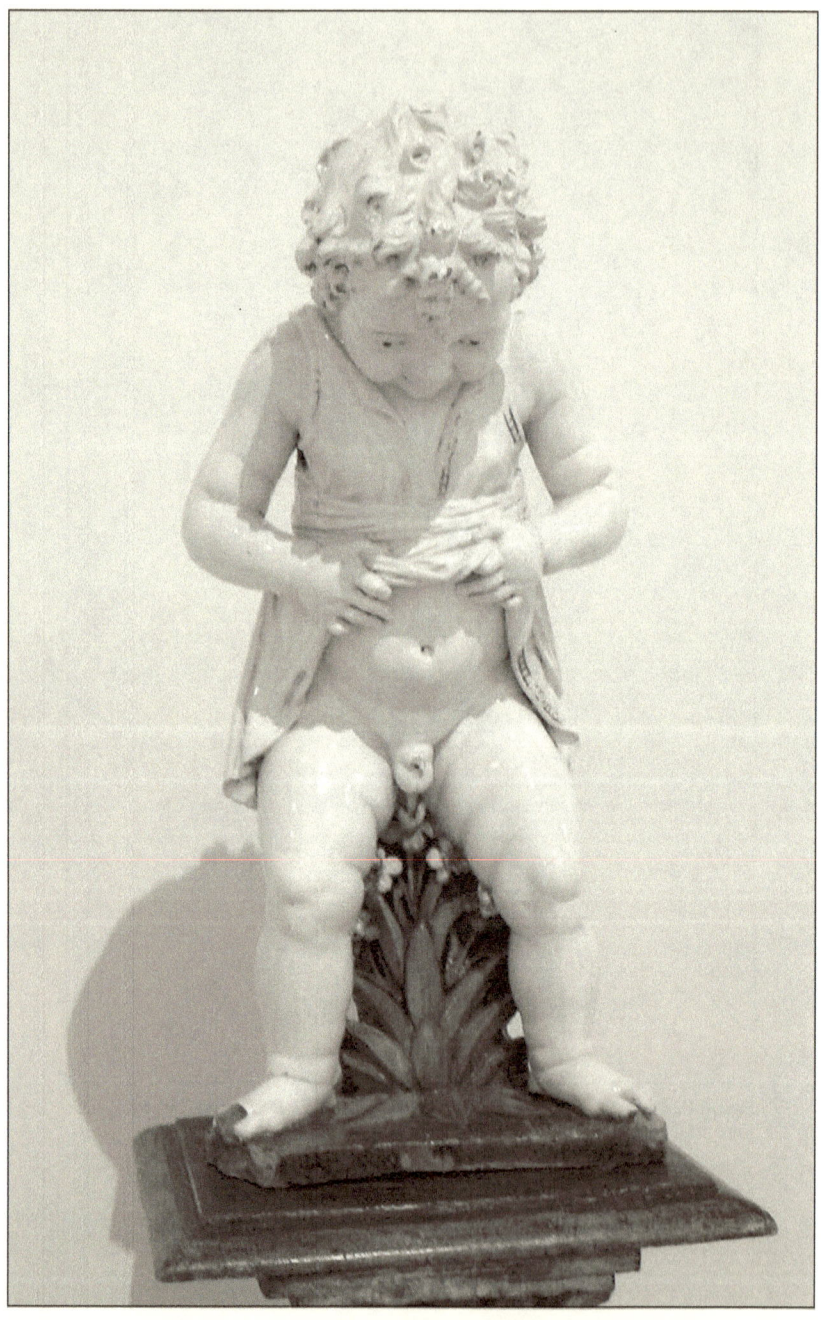

Fig. 11 (right). *Spiritello d'acqua*. Andrea della Robbia, 1480s. Berlin, Staatliche Museen.

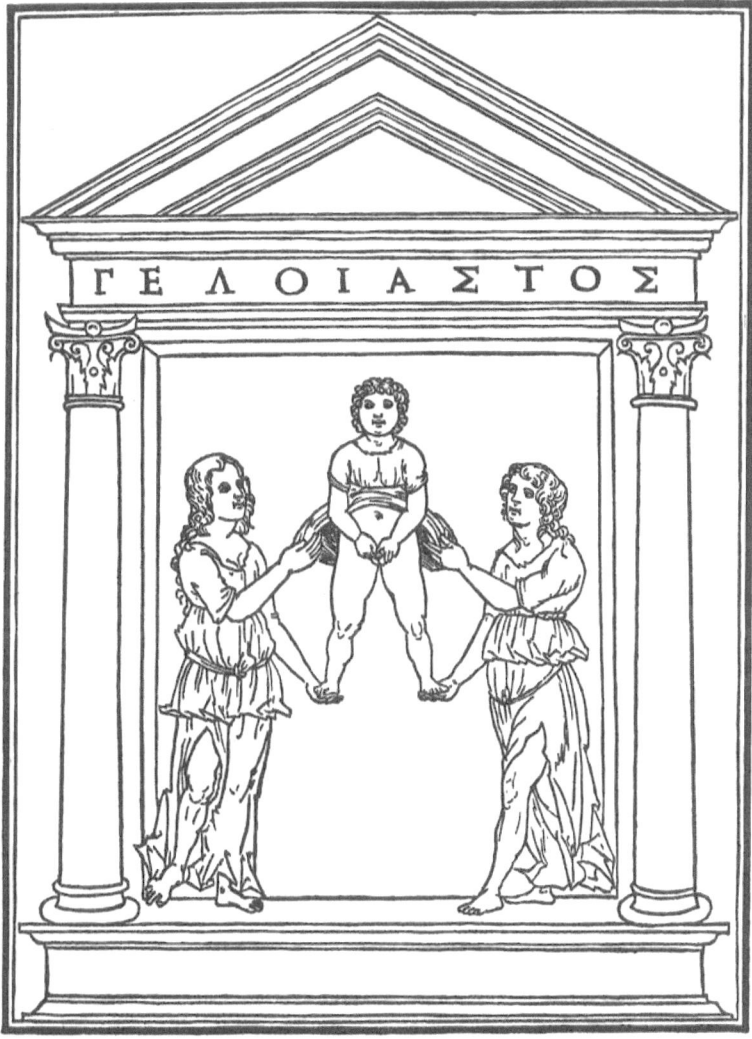

Fig. 12. Geloiastos Fountain Sculpture. From Francesco Colonna, *Hypernotomachia Poliphili* (Venice: Aldus Manutius, 1499), p. 85.

A SCARLET RENAISSANCE

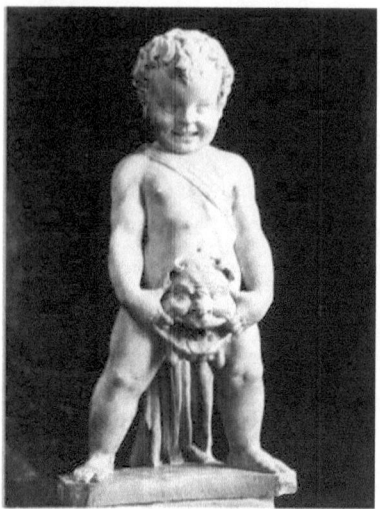

Fig. 13 (top). *Spiritello d'acqua*. Pierino da Vinci, c.1540–45. Arezzo, Museo Statale d'arte medievale e moderna.

Fig. 14 (right). *Spiritello d'acqua,* mid-sixteenth century. Douai, Musée de la Chartreuse.

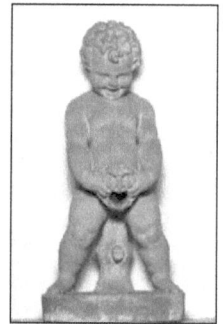

FROM MEDALIST TO SCULPTOR
LEONE LEONI'S BRONZE BUST OF CHARLES V
KELLEY HELMSTUTLER DI DIO

Leone Leoni responded to his first invitation to the court of Charles V with great enthusiasm, writing, "I almost believe that it may be true, that I am beginning to be successful, to be taken seriously and [...it makes me] want to make coliseums, colossal statues, tombs, [and] obelisks, as if possessed or worse!"[1] Leoni's ambitions are clear, and manifest his intent to produce large-scale sculptures. Prior to this moment, Leoni, who had trained as a goldsmith, had only produced medals and other small-scale objects. In many ways, his entrance into court marked an important change in his career. The emperor awarded Leoni financially, raised him to the rank of noble, made him an imperial knight, consented to his proposal for an equestrian monument and commissioned portrait medals, portrait busts and life-sized portrait statues.[2] Charles's sister, Queen Mary of Hungary, was likewise impressed with Leoni's abilities in portraiture and commissioned framed marble reliefs of Charles V and Isabel, marble busts and full-length marble and bronze portrait statues. Not only did Leoni wish to make larger-scale objects, he specifically sought to create sculptures that were unprecedented in their form and that challenged the achievements in sculpture of the ancients as well as his contemporaries.

I am deeply indebted to Prof. McHam for many things, not least of which is for introducing me to Leone Leoni's work in a seminar on public sculpture in the Renaissance in the fall of 1994. Prof. McHam then encouraged me to examine his life and sculptures in my dissertation, which I undertook with her guidance. Her enthusiasm for the discipline, her profound knowledge of Renaissance sculpture and her steadfast support of her students continue to inspire me as a teacher and scholar. I also wish to thank Michael Cole for his excellent suggestions, which improved this essay in important ways.

1. Letter from Leoni to Antoine Perrenot de Granvelle, dated November 1, 1548. Published by Eugéne Plon, *Les maîtres italiens au service de la maison d'Autriche: Leone Leoni, sculpteur de Charles-Quint, et Pompeo Leoni, sculpteur de Philippe II* (Paris: Plon et cie., 1887), appendix III, no. 30.
2. For Leoni's social position and his strategies for elevating himself, see Kelley Helmstutler Di Dio, *Leone Leoni and the Status of the Artist at the End of the Renaissance* (Farnham, Surrey and Burlington, VT: Ashgate, 2011). For the economic costs and social profits of his self-fashioning, see idem, "Signs of Success: Leone Leoni's Signposting in Sixteenth-Century Milan," in *The Patron's Payoff: Economic Frameworks for Conspicuous Commissions in Renaissance Italy*, ed. Jonathan Nelson and Richard Zeckhauser (Princeton: Princeton University Press, 2009), 149–65.

Leoni's skill and ambition were perfectly suited to the Habsburgs' needs for sculpture.

While Leoni's full-length statues were lauded and were important sources for sculptures produced in Italy, Spain and the Netherlands, his smaller-scale sculpture, namely his portrait busts, reliefs and medals, more immediately and widely disseminated his artistic ideals.[3] The form and iconography of Leoni's portrait busts of the imperial family and high-ranking members of the Habsburg regime became the necessary point of reference for other sculptors working for a similar clientele throughout Europe. Here I shall focus on Leoni's most ambitious (and also the earliest) bust: the bronze *Bust of Charles V* (Figs. 1 and 2), now in the Museo Nacional del Prado, Madrid.[4]

An elaborate base supports the three-quarter length figure of the emperor. The head of the emperor is turned towards his left shoulder and his hair, brows and beard are meticulously delineated. The curls of the hair extend from the back of the head towards the forehead, in a way that suggests an association with Augustan portraits.[5] The strong brow provides sockets for the slightly bulging eyes and the lines underneath and to the sides of the eye hint at the sitter's age. The aquiline nose and the jawline protrude more or less as they were described by Charles's contemporaries and in other portraits of him. The head sits on a high collar; a ruff around the neck and then a patterned gorget lead the eye to the collar of the Golden Fleece that encircles the trim of the gorget. On one shoulder plate there is a medallion with Victory holding a palm. The other shoulder likewise bears a medallion, but a sash, which goes from the shoulder across the figure and ties at the termination of the bust on the lower-right side of the figure, covers it. The cuirass is decorated with stripes of foliated ornament that is interrupted at the center of the chest with

3. Among Leoni's large-scale sculptures, the *Charles V and Fury* (Museo Nacional del Prado, Madrid) was the only one that seems to have served as the source for multiple sculptures, including *Ferrante Gonzaga and Envy* (by Leone and Pompeo Leoni, Guastalla, c.1560–94); Simone Moschino's *Apotheosis of the Duke of Parma Alessandro Farnese* (c.1600, originally Palazzo Farnese, now in the Reggia di Caserta); Jacques Jonghelinck, *The Duke of Alba conquering Deceit* (1571, destroyed); Jonghelinck's *Mars* of his *Seven Planets* series (now Palacio Real, Madrid); and the figure of Faith in the *Tomb of Fernando de Valdés* (c.1568, Colegiata de Sta. María la Mayor, Salas, Oviedo).

4. Previous studies of the bust include Irving Lavin's important articles on Renaissance busts: "Bernini's Death," *Art Bulletin* 54 (1972): 158–86; idem, "On the Sources and Meaning of the Renaissance Portrait Bust," *Art Quarterly* 33 (1970): 207–26; repr. in Sarah Blake McHam, ed., *Looking at Italian Renaissance Sculpture* (Cambridge: Cambridge University Press, 1998), 60–78; and idem, "On Illusion and Allusion in Italian Sixteenth-Century Portrait Busts," *Proceedings of the American Philosophical Society* 119 (1975): 353–62. See also Michael Mezzatesta's chapter on the bust in his "Imperial Themes in the Sculpture of Leone Leoni" (Ph.D. diss., New York University, 1980); and W. Cupperi, "Autorisierte Herrscherbildnisse des Leone Leoni: Die Bronzebüsten Karls V, in Madrid, Wien und Windsor Castle," in *Drei Fürstenbildnisse: Meisterwerke der* Repraesentatio Maiestatis *der Renaissance* (Dresden: Staatliche Kunstsammlunger, 2008), 26–38."

5. Mezzatesta, "Imperial Themes," 95.

an oval image of the *Risen Christ*, modeled after Michelangelo's sculpture in Sta. Maria sopra Minerva in Rome. From the shoulder, the armor terminates at the end of the pauldron and emphasizes the subtle counter-balance of the shoulders so that the arms seem to be in movement. The *contrapposto* of the head, torso and shoulders further animates the sitter.[6]

The bust is not arbitrarily truncated mid-torso like most busts; instead the figure terminates at the end of the breastplate. Furthermore, the bust is supported not by a traditional turned or architectural socle but by an eagle flanked by a male and a female statuette that are supported by dolphin-like sea creatures. The eagle's head turns strongly to the right, and by the curve of its head repeats the curve of the end of the breastplate. Its strong breast faces the viewer, as do its crouching legs, broad tail, and talons. The talons curve over the thin octagonal base and frame the central part of the inscription, which follows the line of the base: IMP. CAE. CAROLVS. V. AUG. The eagle's wings are not visible from the front; instead they curve behind the male and female figures of Mars and Bellona (or Minerva). The figures support themselves by resting their elbows on the eagle's shoulders.

The male figure bends his left arm and its position, resting on the eagle's shoulder causes his shoulder to protrude. His right arm holds up the emperor's breastplate, just beneath the place where the sash is knotted. Mars's head turns toward the viewer, but his body is in profile when the viewer stands in front of the bust. Mars has a thin, muscular frame, which rests on the back of a sea creature. His left leg is bent, and his foot crosses behind the calf of his right leg. He wears a helmet, but no other ornament identifies him.

On the emperor's left side is the female figure, which also wears a helmet. Her curls fall beyond the helmet towards her bare shoulders. Like the male figure, she rests her elbow on the shoulder area of the eagle: her shoulder is thus pronated, and from the front, the viewer sees the profile of her youthful nude body. She crosses her right leg over her left and is seated on the back of a sea creature. Her position, like the male's, invites the viewer to see the sculpture from the side. From the side, the rest of their bodies are visible, as are the wings of the eagle and the heads of the sea creature. From this view, the signature, which goes vertically down the support and reads: LEO. P[ATER] POMPE.[IVS] F[ILIUS]. ARET[INI] F[ECERVNT], or "Leoni (and) Pompeo, Aretines, made this".[7]

The ensemble is meticulously finished and has its beautiful original light-brown patina. The textural contrasts between the eagle and the nude figures

6. For a discussion of Leoni's bronzes and Renaissance concepts regarding "life-like" sculptures, see my *Leone Leoni*, 79–105, with further bibliography.

7. The double signature of Leone and Pompeo Leoni refers to the fact that while Leone was likely responsible for the majority of the figure, Pompeo completed it after he transported the figure from the Leoni's workshop in Milan to the court in Madrid.

and the armor and the head of the emperor are done with exceptional skill. Truly, this bust is a *tour de force* of Renaissance bronze techniques. It is an admirable display of Leoni's skills in working on a larger scale while he maintained the meticulous attention to detail and inclusion of miniature decoration and imagery, more typical of the work of goldsmiths and medalists.

Stylistically, Leoni met the expectations of his patron by providing an idealized likeness of him. The identity of the sitter is as immediately recognizable today as it was then; and Leoni wrote, "there is not a hair different between the bust and the man."[8] Of course, Leoni's claim is not entirely true: he wisely chose not to show all of the physical defects that plagued Charles. However, his statement does imply that it was important to him to include a good deal of detail, to increase the believability of the likeness and to demonstrate his skill.

Leoni did much more than record the emperor's likeness. In both the presentation of the sitter and the figurative decoration of the base, Leoni transformed the *all'antica* bust type into something entirely original and meaningful that would more fully convey the intended associations between Charles V and the great ancient Roman emperors. The message of Charles' descendance from the great Roman emperors could be perceived with great immediacy because of the context of its display and because of the formal characteristics of the bust. Though the intended placement of the bust when it was commissioned remains unclear, the bust was eventually incorporated into the royal collections in Spain, where it was displayed alongside multiple series of ancient Roman emperors. Particularly in the Spanish context, busts immediately recalled Roman imperial portraits, because that was the most prevalent sculpted form of portraiture of the ancients extant in Spain. Leoni amplified those imperial associations by including armor and the figures that support the bust, which further identify Charles and as emperor.

As for the presentation of the sitter, Leoni's newly conceived form proposed a solution to a problem that had vexed Renaissance sculptors: namely, how to indicate the whole person of the sitter while using a truncated form.[9] Irving Lavin surmised that "Leoni's empty cuirass is a visual pun, which suggests that the bust not only 'contains' the sitter, whom the viewer inevitably imagines *in toto*, but is also a self-contained object, a commemorative monument in its own right."[10] Leoni thus developed an innovative way to negotiate the truncated form of the bust: the inclusion of the breast and shoulder plates of

8. Letter from Leone Leoni to Ferrante Gonzaga, June 29, 1549, Giuseppe Campori, *Gli Artisti italiani e stranieri negli stati estensi* (Rome: Multigrafica editrice, 1855), I.
9. Jennifer Montagu studied this problemmatic aspect of portrait busts and Baroque experiments with various solutions in her recent article, "Busts and their Bases," *The Sculpture Journal* 20 (2011): 155–61.
10. Irving Lavin, "Bernini's Death," *Art Bulletin* 54 (1972): 177.

the suit of armor "completely dissimulate the amputation of torso and arms; and this empty shell which the mind fills with the spirit of the man, does not rest on an abstract base, but is carried aloft in apotheosis by the imperial eagle and two allegorical figures."[11] Leoni may have known Francesco da Sangallo's *Bust of Giovanni delle Bande Nere* (Museo Nazionale del Bargello, Florence, late 1520s), in which the armored torso of the sitter terminates at the junction between the breastplate and the fauld.[12] In that case, however, there is no base; the torso rests directly on the plinth.

Leoni pulled from his experience as a goldsmith and medalist, and he incorporated stylistic elements similar to those in objects produced by northern Italian goldsmiths and medalists in the same decades he was making the bust. This expertise allowed him to conceive of an entirely original approach to the truncation of the figure and for the form and decoration of the base. Thus Leoni did not hide his experience with goldsmithery, though it was that background that had evidently caused his detractors (whether real or perceived) to question his ability to execute large-scale works. Instead, in this bust, he showed off those skills, through the inclusion of the small figures of the support and the incredibly high level of detail in the eagle's feathers, the decoration of the armor, the features of the sitter and his new approach to the termination of the figure.

Though Leoni declared that with his early Habsburg commissions he wished to show that he had "another spirit than that of a medalist," he relied on his medallic production as he conceived of the new form for the bust.[13] In fact, Leoni's truncation of the torso parallels his experimentation with the truncation of figures in his portrait medals. In the introductory chapter of his catalogue on Italian medals in British collections, Philip Attwood remarked on a connection between the formal changes in later sixteenth-century medals, where the truncations follow the border of the medal, and busts from the same period, where horizontal bases had been supplanted by the *all'antica* type set on a socle.[14]

Here, I would like to briefly explore this connection more specifically in regard to what Leoni does in his medals and busts. In fact, Leoni may have been responsible for this change in conception; other medalists and sculptors reutilized Leoni's inventions. In his medals before 1548, Leoni terminated the figure either at the terminus of the neck or collarbone, such as in the medal of Baccio Bandinelli or the one of Paul d'Anna,[15] or in some cases he formed

11. Lavin, "Illusion and Allusion," 360
12. Mezzatesta, "Imperial Themes," 85.
13. The letter was published by Plon, *Les maîtres italiens*, 362–63 n. 21.
14. Philip Attwood, *Italian Medals c.1530–1600 in British Public Collections* (London: The British Museum Press, 2003), 1:14.
15. Attwood, *Italian Medals*, plates 1 and 3.

a diagonal truncation that followed from the shoulder to mid-chest. In those cases, he tried to foreshorten the figure, and turn it at a three-quarters angle to show the breastplate. These attempts had rather awkward results because the figure is not convincingly foreshortened, such as the early Charles V medals and the Andrea Doria medal (1541, Fig. 3, left).[16] But beginning with his medal for Prince Philip in 1548 (Fig. 4), Leoni positioned the figure so that the head is in strict profile, but the torso is turned almost completely towards the viewer. In addition, he included a much greater expanse of the torso, terminating the figure at the waistline (or slightly above). He used that terminus and position of the sitter in his subsequent imperial medals, such as the ones of Danaë, 1551; Charles V, 1549; Isabel, 1549; Ferdinand I, 1551; and Maximilian, 1551.[17] Leoni likewise experimented with the relationship between the border of the medal and the figure. In most of these examples he maintained the beaded or smooth, incised line at the edge of the medal, including the area beneath the bust. In the medals of the duke of Sessa, 1560; Michelangelo, 1560; Ferrante Gonzaga, 1555/6[18], for example, the figure interrupts the line.[19] In sum, Leoni was clearly concerned about how to express the sitter *in toto* and negotiate the figure's termination and join its base in a way that would not detract from, and potentially would add to, the figure's effectiveness, and he was simultaneously exploring new solutions in the years he was working on the imperial busts.

Leo Planiscig dealt with the figures of Leoni's base as examples of his smaller-scale work. Based on their style, he related other statuettes and other small objects to Leoni's oeuvre.[20] Jeremy Warren has noted the similarity of Leoni's decoration of fabric and armor in the imperial portraits with the decoration of objects commonly produced by goldsmiths and suggested that perhaps Leoni (or someone in his circle) made the candlestick in the Fortnum Collection, Ashmolean Museum, Oxford.[21] Leoni's familiarity with

16. Attwood, *Italian Medals*, plates 1 and 4.
17. Attwood, *Italian Medals*, plates 6, 9 and 10.
18. Attwood, *Italian Medals*, plates 12, 14, and 15.
19. Leoni's medals served as models for Jacopo Trezzo's, as seen in his medals of Prince Philip (1555) and Mary I of England (1554). Pompeo Leoni (Don Carlos, 1557, Ercole d'Este, 1554), Annibale Fontana and other Lombard medalists also followed Leoni's model. Attwood, *Italian medals*, plates 21 and 31.
20. Based on the small figures included under the bust, Leo Planiscig, "Bronzi minori di Leone Leoni," *Dedalo* 7 (1927): 544–67, attributed multiple bronze statuettes to Leoni, including *Triton and Turtle* (Berlin, R. Weininger Collection); *Neptune* (Vienna, S.E.G. Auriti Collection); *Triton* (Vienna, Kunsthistorisches Museum); *Candlestick Holder with a Figure of Venus* (London, Victoria and Albert Museum); *Dolphin with a Putto* (Vienna, collection of Prince Liechtenstein); *Prisoner* (Vienna, Kunsthistorisches Museum); *Neptune* (private collection); a huge vase with masks in a private collection; an amphora (Paris, Louvre); and a large cup in the Castello Sforzesco, Milan. A door pull in the Cleveland Museum of Art (1994.114) has also been attributed to Leoni.
21. Jeremy Warren, *Renaissance Master Bronzes from the Ashmolean Museum, Oxford: The Fortnum Collection* (Oxford: Daniel Katz Ltd. and the Ashmolean Museum, 1999), 102.

the production of these sorts of objects, in particular with inkstands and andirons (objects commonly produced by goldsmiths) produced in northern Italy in the sixteenth century informed his conception of the base. Another example of this sort of object is a bronze andiron attributed to Tiziano Aspetti (Metropolitan Museum of Art, New York). As in Leoni's bust, the supporting element has been entirely transformed into a space for figural decoration of very high relief and meticulous ornamental detail. Two similar examples are in the National Gallery of Art, Washington. The first is a north Italian inkstand from c.1530 (Fig. 5) that may have originally served as a base for a statuette. It includes two satyr figures on each side of the tripod base.[22] Their placement and positioning are certainly reminiscent of the figures on the base of Leoni's bust. The second is a Venetian andiron (Fig. 6) that dates from the middle of the seventeenth century, but is based on a mid-sixteenth-century design.[23] It consists of a richly decorated three-tiered scrolled base with figures, fantastical ornament, garlands, bucrania and masks. Again, the support has been entirely transformed from a simple socle or tripod base to an important visual component of the whole.

As he conceived the innovations in his bust of Charles V, Leoni was clearly aware of his rival Benvenuto Cellini's bronze bust of his patron, Cosimo I, which was completed in 1547, just one year before Leoni began his. Both artists, after starting their careers as goldsmiths and medalists, were determined to demonstrate their ability to work on larger-scale sculptures. Though their work was lauded, there was a stigma about working on a smaller scale.[24] In his brief discussion of Cellini's *Perseus*, Vasari wrote, "it was certainly an amazing thing, since Benvenuto had practiced for many years making small figures, to be able to make such a large figure with such excellence."[25]

Leoni wrote that with the commission for Charles V he wished to prove his detractors wrong and show them that he had "another spirit than that of a

22. Another object which has the same altar pedestal with crouching satyr figures on the left and right is the Pricket Candlestick (originally a perfume burner), Paduan workshop, second quarter of the sixteenth century, now in the Robert H. Smith Collection, National Gallery of Art. Washington. It was published in Anthony Radcliffe and Nicholas Penny, *Art of the Renaissance Bronze 1500-1650* (London: Philip Wilson Publishers, 2004), cat. 3.

23. Both the north Italian *Inkstand Incorporating Altar Pedestal* and the Venetian *Andiron with a Figure of Venus* from the National Gallery of Art, Washington, were published in Penny, "The Evolution of the Plinth, Pedestal and Socle," *Art of the Renaissance Bronze*, 466–67.

24. For the lackluster status of goldsmiths and their art in the sixteenth century, see Marco Collareta, "Benvenuto Cellini ed il destino dell'oreficeria," in *Benvenuto Cellini: Kunst und Kunsttheorie im 16. Jahrhundert*. ed. Alessandro Nova and Anna Schreurs (Cologne: Böhlau Verlag, 2003), 161–70.

25. "E certo fu maraviglia che, essendosi Benvenuto esercitato tanti anni in far figure piccole, ei condusse poi con tanta eccellanza una statua così grande." Giorgio Vasari, *Le vite*, 2nd ed. XX vols. (Florence: Giunti, 1568), 2:874. Thanks to the work of Paola Barocchi, the full text of both editions of Vasari's *Lives* are found at www.memofonte.it/autori/giorgio-vasari-1511-1574.html.

medalist."²⁶ Vasari said in his life of Leoni that he had moved on to do larger sculptures that were "of greater importance than medals."²⁷

Cellini had first shown off his skills in larger-scale sculptures with his bronze bust of Cosimo I, in which the duke is shown in armor. It surely is not a coincidence that Leoni's first attempt was his armored portrait of Charles V.²⁸ The *"statua armata,"* as both artists called their busts, allowed the two artists to maximize their backgrounds in working on the small scale. This is seen in the minute detail, high level of finish and precision, and the handling of the decorative aspects of the armor in both busts. Leoni, in his desire to outdo his rival, conceived of a treatment of the base that would be entirely innovative and allowed him to include further examples of his technical acumen in both the large and the small scale.²⁹

Leoni's peers and predecessors had been experimenting with the possibilities for form and meaning in supports. While the medieval bust with no base had remained in fashion, artists throughout Italy had begun experimenting with a more archeologically accurate *all'antica* bust. The *all'antica* bust derived its formal characteristics from Roman busts, not medieval ones.³⁰ The contrast can be seen in the fifteenth-century example by Mino da Fiesole, the *Bust of Piero de' Medici* (Bargello, Florence, 1453), which follows the medieval reliquary-bust form, and in the *all'antica* sixteenth-century form seen in Michelangelo's *Bust of Brutus* from 1539–40 (Bargello, Florence). The difference in the treatment of the termination in the *all'antica* type was that it was rounded and required elevation on a socle. In the sixteenth century, the most common forms of socles were turned or architectural ones.

Thomas Martin has demonstrated that the *all'antica* type started with artists in the Paduan/Venetian ambient, namely with Antico and, perhaps most especially, with Simone Bianco (c.1490–1555).³¹ Alessandro Vittoria continued to experiment with the bust and socle format and most often used what Nicholas Penny termed as "the spreading scrolled tablet socle." He used variations of it throughout his career.³² He manipulated the socle and its relationship to the bust so that the sitter appeared more dynamic

26. Plon, *Les maitres*, 362–63 n. 21.
27. "...in opere di maggiore importanza che le medaglie non sono." Vasari, *Le vite*, 2:840.
28. Michael Cole explored the relationship between Cellini's *Bust of Cosimo I* and Leoni's *Bust of Charles V* and the *"statua armata"* more deeply in his essay, "Under the Sign of Vulcan," in *Bronze: The Power of Life and Death* (Leeds: Henry Moore Institute, 2005), 36–52.
29. For more on Cellini and Leoni's rivalry, see Di Dio, *Leone Leoni*, chapter 3.
30. For the form and meaning of Renaissance busts, see Irving Lavin's articles, cited in note 3 above.
31. Thomas Martin, *Alessandro Vittoria and the Portrait Bust in Renaissance Venice: Remodeling Antiquity* (Oxford: Clarendon Press, 1998), 5–11.
32. Nicholas Penny, "The Evolution of the Plinth, Pedestal and Socle," in *Collecting Sculpture in Early Modern Europe*, ed. Nicholas Penny and Eike D. Schmidt (Washington: National Gallery of Art, 2008), 468.

and animated. For example, the socles of the busts of Doge Nicoló da Ponte (1578–85, Galleria del Seminario, Venice); Giambattista Ferretti (1557, Musée du Louvre, Paris); Marcantonio Grimani (1565, S. Sebastiano, Venice) and Benedetto Manzini (1561, Galleria Giorgio Franchetti alla Cà d'Oro, Venice) are all asymmetrical so that they appear as if they have been squashed by the weight and the movement of the busts.[33]

Leoni's solution to the problem of how to manage the base of the bust was the most dramatic and visually compelling, and it maximized the potential for the base as a site for imagery. In doing so Leoni transformed the base from a static, functional form into an active participant in the meaning communicated by the bust. While the bust was an obvious evocation of a standard Roman imperial portrait type, Leoni's inclusion of the eagle and allegorical figures at the bottom of the bust alluded to the apotheosis of the emperor, which, of course, was also quite standard Roman imperial iconography. More specifically, the figures of Mars and Bellona, both gods of war in Roman mythology, signaled imperial military might. The eagle was multivalent: it was a symbol from the Habsburg's heraldry, it was the bird of Jupiter, god of justice and king of the gods, and it was a standard Roman symbol for apotheosis. Joining together the Risen Christ on Charles' breastplate, the collar of the Golden Fleece and the active positioning and intensity of the expression of the sitter, the message was clear: Charles uniquely possessed the military strength and Christian devotion necessary to conquer his foes, and his achievements would be rewarded in heaven. His victory at Mühlberg was proof of his role as supreme defender of the faith. He descended from the great ancient Roman emperors, but because of his piety he trumped even them — just as Leoni could be compared to the ancients but trumped them and his peers with his achievements in sculpture.

The bust of Commodus as Hercules in the Capitoline Museum, Rome, seems like the closest precedent. However, this particular bust was not known until 1874. The bronze bust of Paul III by Guglielmo della Porta (1546, Museum für Kunst und Gewerbe, Hamburg) has also been cited as a source for Leoni's composition.[34] The pope's elaborate mantle is covered in relief sculptures of Peace, Justice, Victory and Abundance. The base includes two male nude reclining figures (prisoners or river gods), but they did not support the bust as Leoni's do. There is also a medal of Lodovico III Gonzaga by Bartolommeo Melioli (1444, National Gallery of Art, Washington) in which a mound of trophies supports the portrait and the arms are truncated at the level of the cuirass, as in Leoni's.[35] It is not known with certainty if Leoni knew either of these, but he may have.

33. See Martin, *Alessandro Vittoria*, 56–63.
34. Mezzatesta, "Imperial Themes," 76; and Rosario Coppel Aréizaga, *Museo del Prado: Catálogo de la Escultura de Época Moderna. Siglos XVI-XVII* (Madrid: Museo del Prado, 1998), cat. 12.
35. Mezzatesta, "Imperial Themes," 75.

A SCARLET RENAISSANCE

There may well have been other Roman or even contemporary busts of this type that Leoni could have known, but it appears that Leoni's concept, particularly his effective and cohesive use of subsidiary supporting figures that amplify the symbolic meaning of the bust, may have been an entirely new one for the Renaissance viewer. His contemporaries' experiments in central Italy with pedestals of large-scale sculptures as an area for figurative decoration were important for Leoni's invention. Baccio Bandinelli and Cellini had used richly decorated pedestals for larger sculptures, but they were rectangular in plan. The base of Cellini's *Perseus* (1545–54, Piazza della Signoria, Florence) is composed of niches, bronze statuettes and a bronze narrative panel. Bandinelli's base for his statue of Giovanni delle Bande Nere (1540, Piazza S. Lorenzo, Florence) includes narrative panels, as did Bandinelli's plan for the base of the monument to Andrea Doria in Genoa (c.1528–38, drawing now in the Louvre, Paris). Leoni's conception is entirely different. The bronze bust of Charles V, for example, is supported by a sculptural group — the allegorical figures and eagle, which in turn rest on a very narrow horizontal octagonal strip. The form and significance of the base is entirely transformed in Leoni's hands.

Leoni's engagement with the technical and theoretical issues with which sculptors in central Italy were grappling is further indicated in the multiple viewpoints the bust is intended to have. The position of Charles's head, turning to the left, invites the viewer around the side of the sculpture, where, a fuller view of the emperor's visage and the entirety of the nude supporting figure and the remainder of the eagle on the base can be seen. The thin octagonal base beneath further encourages the viewer to move around the bust.[36] Leoni thus had to approach the design of the bust in a way that would provide multiple interesting viewpoints. To strive for this in his first bust firmly indicates the ambitions he had for this early monumental work.

As mentioned earlier, Leoni's bronze *Bust of Charles V* was incorporated into the royal sculpture collections along with the other sculptures Leoni produced for the Habsburgs, and they were displayed alongside series of busts of Roman emperors, statuettes and large-scale sculptures that Philip II and Philip III acquired through inheritance and state gifts.[37] Among these were

36. The bust is unfinished in the back, which suggests its intended placement against a wall.
37. Leoni's Habsburg portraits remained in Pompeo Leoni's studio until after his death in 1608. They were then moved to storage in the Alcázar, then to Aranjuez, then to the Buen Retiro. At Aranjuez and the Buen Retiro, Leoni's sculptures were displayed in the same spaces as the multiple series of ancient Roman imperial busts (originals and copies) that were part of the royal collections. For the display of the sculptures, see José Luis Sancho, "La escultura de los Leoni en los jardines de los Austrias," *Los Leoni* (Madrid: Museo del Prado, 1998), 66ff; Rosario Coppel, "La colección de escultura en bronce bajo el reinado de los Austrias," in *Brillos en Bronce: Colecciones de Reyes* (Madrid: Patrimonio Nacional, 2011), 15–34; and Kelley Helmstutler Di Dio and Rosario Coppel

three series of busts of Roman emperors that also included busts of modern rulers, including three of Charles V, three of Philip II and one of Don Carlos. Thus, the *paragone* Leoni had aimed for — for his works to be compared to the ancients and his contemporaries — was fulfilled through this manner of display, just as it created a *paragone* between Charles and Philip and the best ancient rulers.

Several major figures in the Habsburg government and their allies outside of Spain sought out copies of Leoni's imperial sculptures directly from the artist; others had local artists produce sculptures that were similar to them in form and style.[38] In the 1550s, the duke of Alba, Don Fernando Álvarez de Toledo, commissioned from Leoni a portrait bust of himself, one of Charles V (Fig. 7, which is a copy of Leoni's original bronze bust) and one of Prince Philip (all three busts are now in Windsor Castle). In these examples, the bases are further reduced versions of the original, basically they form a block with an inscription. However, in the bust of Philip, Leoni experimented with a swath of drapery at the terminus of the figure, and he continued the line of the figure more subtly than the elaborated "apotheosis" base of the bronze Charles V bust.

Leoni also made Cardinal Antoine Perrenot Granvelle a bronze copy of the same bronze bust of Charles V (Kunsthistorisches Museum, Vienna), one of Mary of Hungary (also Kunsthistorisches, Vienna) as well as a bust of Granvelle (lost). The bust of Charles V is an duplicate of the original. Leoni also made copies of the bust of Charles V and a bust of Philip II (a reduction of the full-length bronze portrait) for Vespasiano Gonzaga. Other copies of the Charles V bronze bust now in Gaasbeek; National Gallery of Art, Washington; and the Patrimonio Nacional have unknown provenances but indicate the popularity of this bust.[39]

Rudolf II acquired the copy of the bronze bust of Charles V that Leoni made for Granvelle. Rudolf had Adriaen de Vries, who had worked with Leoni on the Escorial project, make a bust of him as a pendant for it in 1603 (now in the Kunsthistorisches Museum, Vienna). The base figures and eagles of de Vries' bust closely imitate Leoni's base figures: a full cuirass is included,

Areizága, *Sculpture Collections in Early Modern Spain* (Farnham, Surrey and Burlington, VT: Ashgate, 2013). For the relationship between Leoni's portrait busts in the royal collection and the taste for sculpture in Spain, see my essay, "Leone Leoni's Habsburg Portraits and the Taste for Sculpture in Spain," in *El arte de los Leoni* (Madrid and Brussels: Museo del Prado and Brepols, forthcoming).
38. In addition to the examples given below, I would add that Baccio Bandinelli's 1558 bronze bust of *Cosimo* I (Museo Nazionale del Bargello, Florence), especially in its low termination below the waistline, suggests his awareness of Leoni's bust. On the other hand, the bust rests directly on the termination of the torso; it does not rest on a decorated base of any sort, which may point to Francesco da Sangallo's bust of *Giovanni delle Bande Nere* (Bargello) as his source.
39. Coppel Aréizaga, *Museo del Prado*, cat. 12.

and the head is turned. De Vries also used this composition for his bust of Christian II of Saxony (Prague, 1603; Skulpturensammlung, Staatliche Kunstsammlungen, Dresden). Clearly, Leoni's bust of Charles V continued to be seen as an important exemplum of the representation of power.

Some Italian patrons commissioned busts to be made with some of the same compositional features as Leoni's Habsburg busts. These include the bust of Giacomo Maria Stampa, c.1553 by an unknown sculptor (Fig. 8, Walters Museum, Baltimore) and the busts of Ludovico Vistarini (Museo Civico, Lodi) and Alessandro Grassi (Fig. 9, Palazzo Borromeo, Isola Madre), both c.1555–65 and attributed Angelo Marini. These three busts terminate in richly decorated socles with allegorical figures flanking the central socle. The one of Giacomo Maria Stampa has very large figures of slaves and tall socle. In fact, the base is one-half the height of the total scultpure and thus appears as important as the sitter in the meaning of the bust. The unknown sculptor of the bust clearly followed Leoni's example then amplified even further the importance and potential significance of the decoration of the base. In the bust of Alessandro Grassi, the allegorical figures and other decorative details of the base are compressed into the tall rectangular space. The figures are shown holding up a turned socle that supports a small horizontal strip. A decorative border of figures, a mask and cloud-like flourishes transition to the deeply carved folds in the drapery on the sitter's torso. The sculptor (Marini?) has more firmly structured the base as an independent sculptural/architectural group and incorporated more decorative detail than Leoni did. The busts of Gabrio Serbelloni (Fig. 10) and Giovanni Antonio Serbelloni of c.1565, by an unknown sculptor,[40] though they have more subdued turned socles as the bases, nevertheless reflect Leoni's style in the meticulous detail of the armor and facial features of the sitters and in the greater extension of the torso.

Leoni came to the court with great ambition but little actual experience with large-scale sculpture. When he conceived of the design for the bust of Charles V, he pulled from his training and deep knowledge of the production of small-scale objects one of the most innovative and visually compelling busts of the sixteenth century. His skill and creative approach to the truncation, allowing an understanding of the figure *in toto*, to the positioning of the sitter, to the meticulous depiction of the facial features, hair, armor and the figures of the base work together to imbue the figure with life and dynamism while simultaneously recording Charles' roles as emperor and defender of the Catholic faith.

■

40. Both are in private collections and, as far as I am aware, have not been previously published.

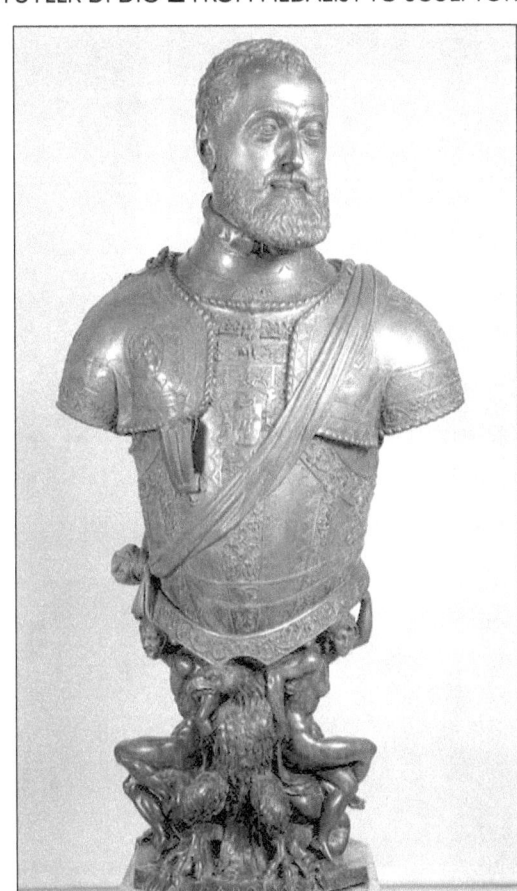

Fig. 1 (right). *Bronze Bust of Charles V.* Museo del Prado.

Fig. 2 (below). Base of the *Bronze Bust of Charles V.* Museo del Prado.

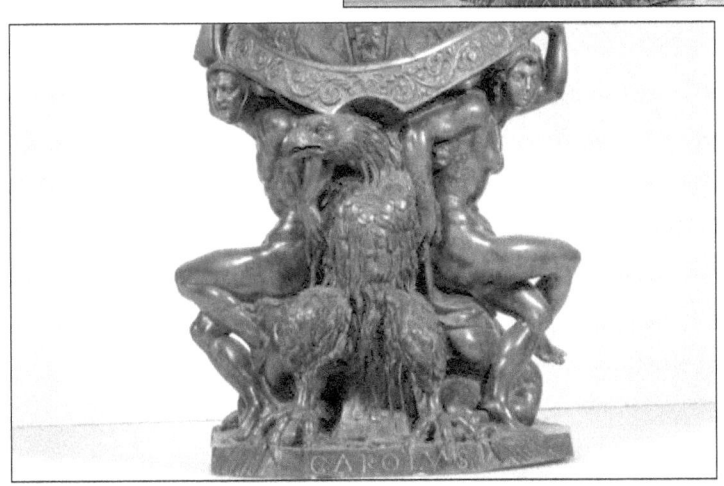

A SCARLET RENAISSANCE

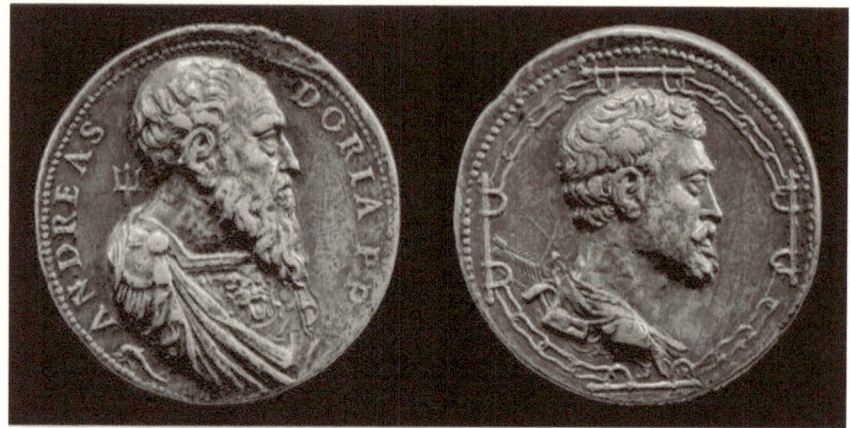

Fig. 3 (above). Leoni, Doria/self-portrait medal, 1541. British Museum.

Fig. 4 (below). Leoni, Philip II medal, 1548. British Museum.

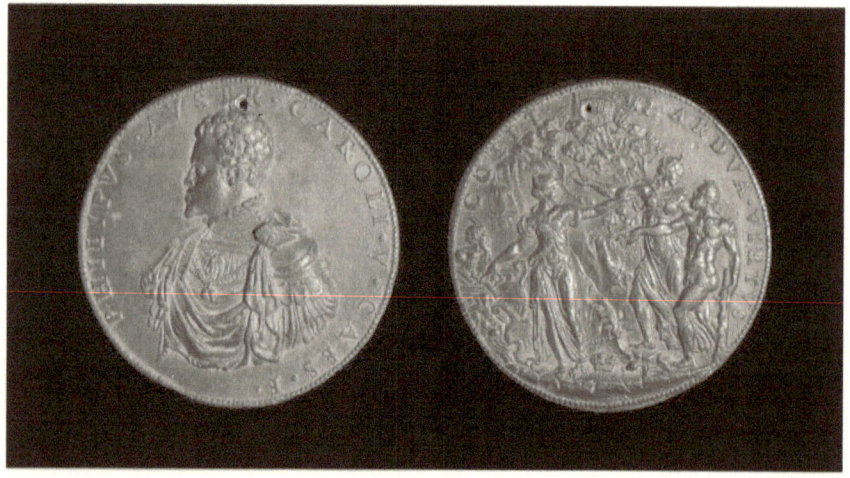

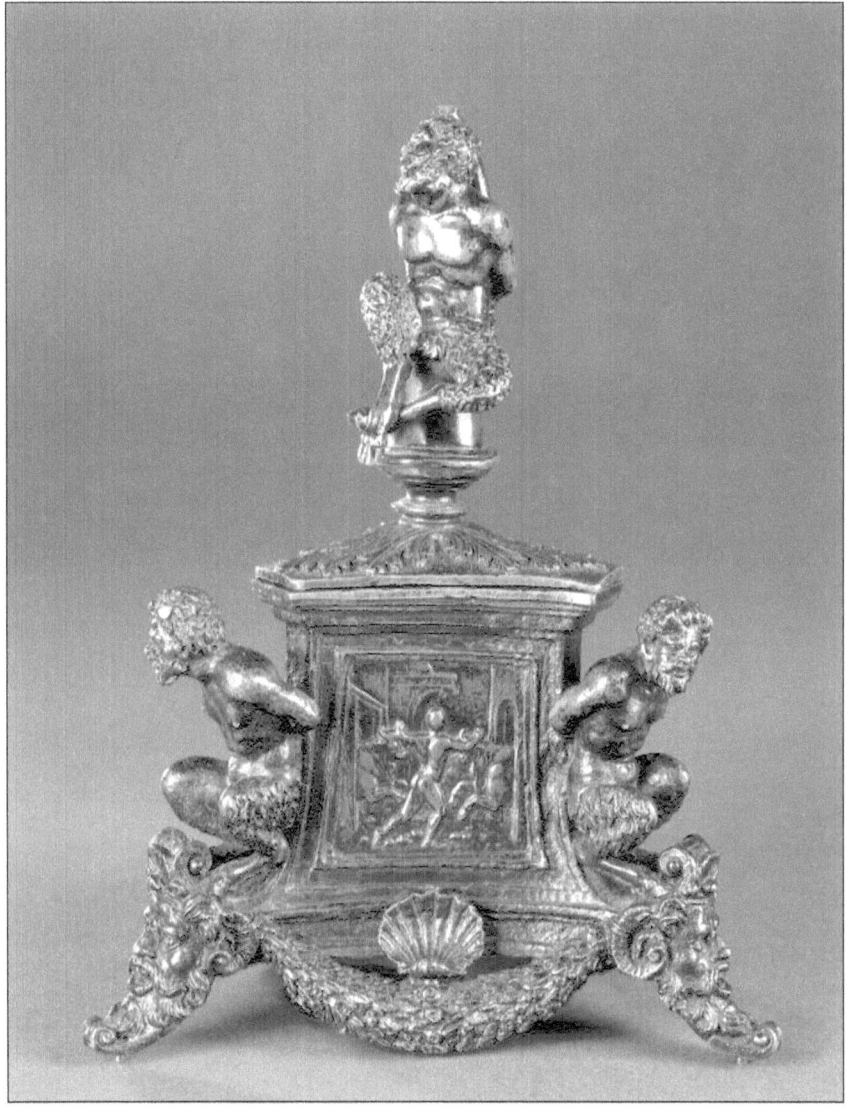

Fig. 5. North Italian inkstand, National Gallery of Art, Washington, DC.

A SCARLET RENAISSANCE

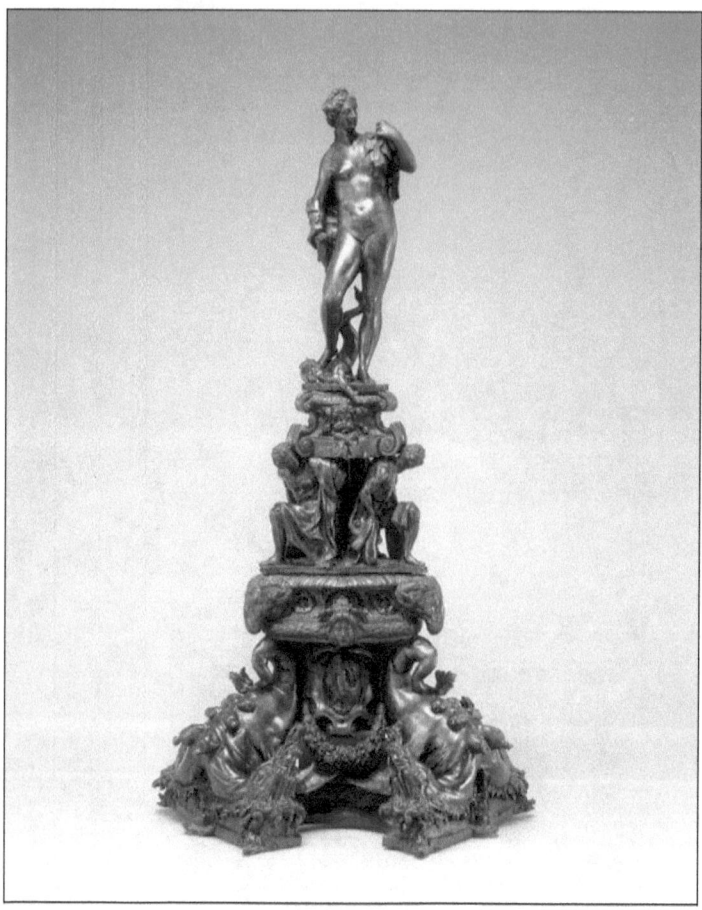

Fig. 6. Venetian andiron, mid-17th c. after a 16th c. design.
National Gallery of Art, Washington, DC.

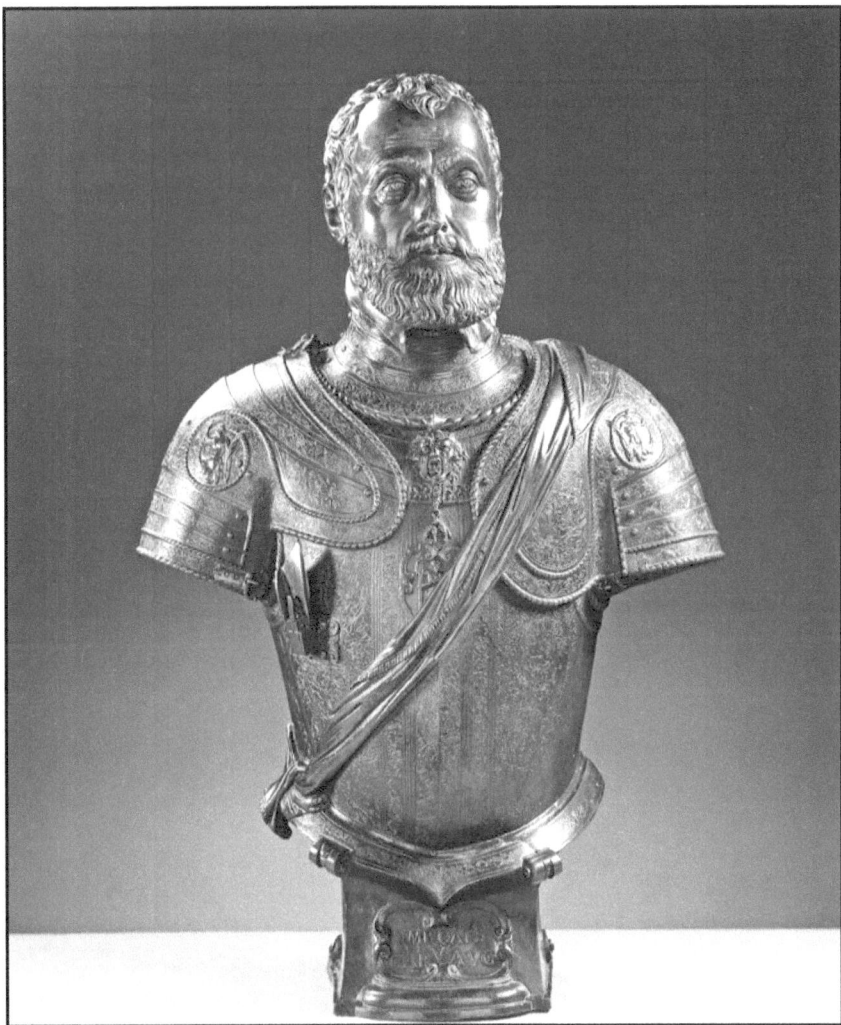

Fig. 7. Leoni, *Bust of Charles V,* 1550s. Windsor Castle.

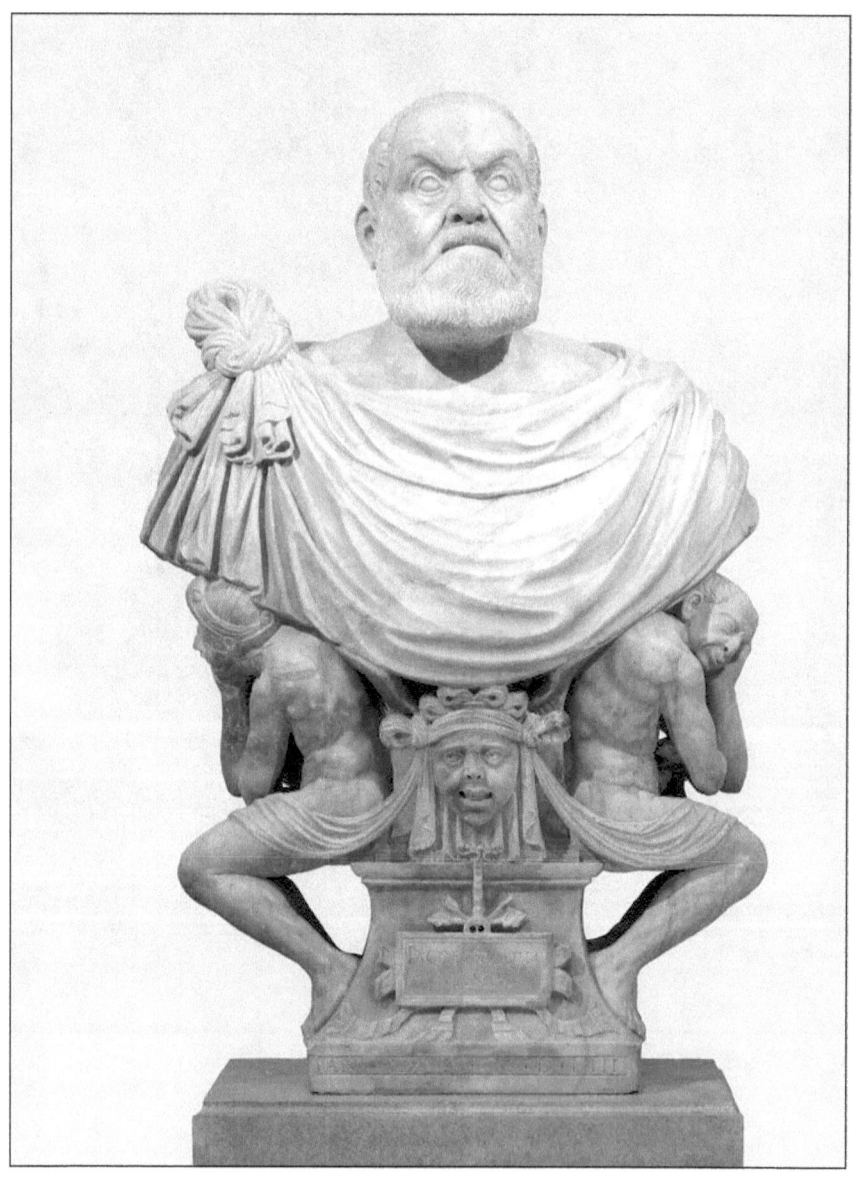

Fig. 8. Unknown sculptor, *Giacomo Maria Stampa*, c. 1553. Walters Museum, Baltimore, MD.

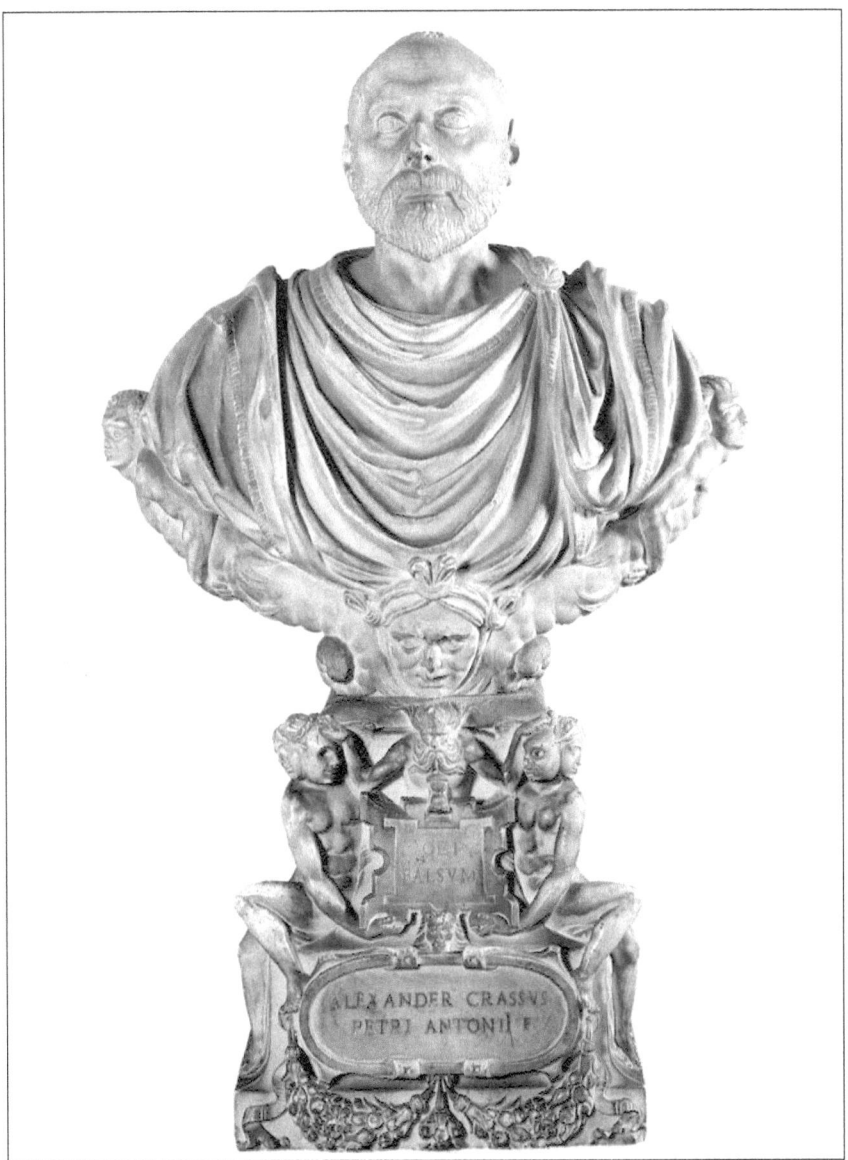

Fig. 9. Angelo Marini, *Bust of Alessandro Grassi*, c.1555–65. Palazzo Borromeo, Isola Madre (Photo: Copyright Renzo Dionigi, with permission).

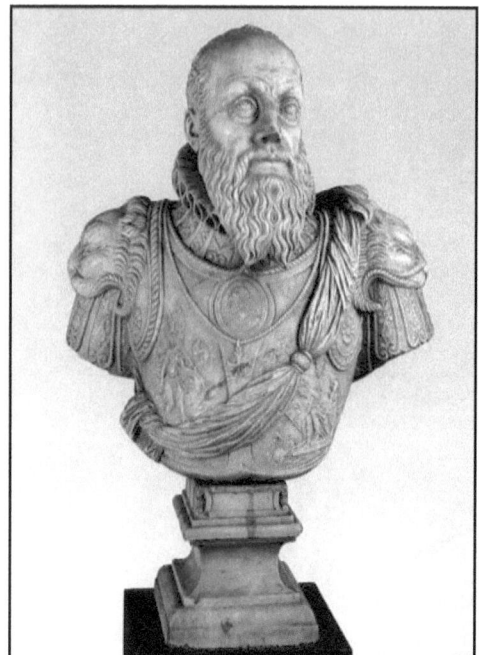

Fig. 10. Unknown sculptor, *Gabrio Serbelloni*, c.1560. Private collection. (Photo: Copyright Renzo Dionigi, with permission).

"CIVITAS FLORENTI[A]E"
THE NEW JERUSALEM
AND THE *ALLEGORY OF DIVINE MISERICORDIA*

PHILLIP EARENFIGHT

> Come, blessed of my Father,
> inherit the kingdom prepared
> for you from the foundation of the world.
> Matt. 25:34

The view of Florence in the early fourteenth-century *Allegory of Divine Misericordia*, located in what was once the residence of the Misericordia (now the Museo del Bigallo), is perhaps the best-known image of the late medieval city (Fig. 1). The *Allegory* presents a group of buildings packed within the city walls, which bear the inscription "CIVITAS FLORENTI[A]E (City of Florence)." The crenellated walls lead to a large fortified portal that is decorated with four shields bearing insignias identified with the city. In the center of the city is the Baptistery; to its right appear the rising facade of the Duomo of Sta. Maria del Fiore, the remains of the basilica of Sta. Reparata, and the beginnings of the Campanile. Built of gleaming white, green and red marbles, these structures stand out against a background of buildings made of darker materials. They include Sta. Maria Novella, S. Lorenzo, Sta. Maria Maggiore, the Palazzo del Podestà, the Badia, the Palazzo della Signoria, and Sta. Croce.[1]

This representation of Florence appears in virtually every study of the city's urban development, where it is regarded as the first attempt to render the general nature and effect as well as numerous features of the city during the age of Dante and Giotto.[2] It is particularly a favorite among architectural historians

[1]. This study is drawn from my dissertation, "The Residence and Loggia della Misericordia (Il Bigallo): Art and Architecture of Confraternal Piety, Charity, and Virtue in Late Medieval Florence" (Rutgers University, 1999), which I prepared under the thoughtful guidance of Sarah McHam, to whom I am most grateful. I thank Victor Coonin for his careful editing of this essay and to the anonymous reader who provided helpful comments and corrections.. Regarding the location of the buildings in the fresco, see Marvin Trachtenberg, *The Campanile of Florence Cathedral: "Giotto's Tower"* (New York: New York University Press, 1971), 151 n. 1.

[2]. Giovanni Fanelli, *Firenze: Architettura e città*, 2 vols. (Florence: Vallecchi, 1973), 2:22.

who have focused on every detail of this precisely dated representation of the city.[3] But despite its popularity, the meaning of the city view within the *Allegory* has not been the object of thorough study (Fig. 2). Typically, scholars consider the view from the perspective of the fresco's patron, the Compagnia di Sta. Maria della Misericordia, one of the largest charitable confraternities in the city, and show how it illustrates the Misericordia's responsibilities to the city and its citizens.[4] While this is certainly accurate, there is evidence that the view of Florence plays a more prominent role in the fresco's iconography than has been recognized.[5] Through an analysis of the fresco's imagery and numerous inscriptions, this study argues that the view of Florence is at once an image of the contemporary city and a reference to the New Jerusalem. Moreover, this study demonstrates how the location of the fresco enabled viewers to compare the painted image of Florence with its real counterpart and to project concepts of the divine city onto the real city. This interpretation is the first to focus on the image of the city within the fresco's iconography and to show how it relates to the actual city it represents.

■

The *Allegory of Divine Misericordia* was painted in 1342 for the Compagnia di Sta. Maria della Misericordia. The Misericordia was one of many lay religious confraternities formed in the late Middle Ages to promote an apostolic life among the laity in an increasingly worldly society.[6] Its origins in the mid-

3. Howard Saalman, "Sta. Maria del Fiore: 1294–1418," *Art Bulletin* 46 (1964): 472 n. 6; Trachtenberg, *Campanile*, 151 n. 1.
4. On the fresco, see Giovanni Poggi, I.B. Supino and C. Ricci, "La Compagnia del Bigallo," *Rivista d'arte* 2 (1904): 189–202; Howard Saalman, *The Bigallo: The Oratory and Residence of the Compagnia del Bigallo e della Misericordia in Florence* (New York: New York University Press, 1969); Hanna Kiel, *Il Museo del Bigallo a Firenze* (Milan: Electa, 1977); William R. Levin, *The Allegory of Mercy at the Misericordia in Florence: Historiography, Context, Iconography, and the Documentation of Confraternal Charity in the Trecento* (Lanham, MD: University Press of America, 2004); and Phillip Earenfight, "Catechism and Confraternitas on the Piazza S. Giovanni: How the Misericordia Used Image and Text to Instruct its Members in Christian Theology," *The Journal of Religious History* 28 (2004): 64–86. Regarding the history of the confraternity, see Levin, *Allegory of Mercy*, 21–29.
5. Levin, *Allegory of Mercy*, 31–32, notes that the artist's task was to represent the "*idea* of the city of Florence" and that the image of the city "communicated the notion that Florence was totally under the omnipotent protection of the Lord's mercy."
6. On lay piety during the late Middle Ages, see Lester Little, *Religious Poverty and the Profit Economy in Medieval Europe* (Ithaca: Cornell University Press, 1978); in Florence see Marvin Becker, "Aspects of Lay Piety in Early Renaissance Florence," in *The Pursuit of Holiness in Late Medieval and Renaissance Religion*, ed. Charles Trinkaus and H. Oberman (Leiden: E.J. Brill, 1974), 177–99; Ronald F.E. Weissman, *Ritual Brotherhood in Renaissance Florence* (New York: Academic Press, 1982); Blake Wilson, *Music and Merchants: The Laudesi Companies of Republican Florence* (Oxford: Oxford University Press, 1992); and John Henderson, *Piety and Charity in Late Medieval Florence* (Oxford: Oxford University Press: 1994), 1–73.

duecento remain poorly documented; however, the surviving evidence suggests that the Misercordia may have been one of several lay pious groups organized or inspired by the Dominican friars at Sta. Maria Novella.[7] Members of the confraternity (*confratelli*) assembled regularly to perform acts of charity and devotion for the love of God and their neighbors and the salvation of their souls. Among their charitable duties, the Misericordia *confratelli* provided food and clothes to the poor, acted as agents for *innocenti* and, most notably, transported and buried the city's indigent dead. While we can infer much about the Misericordia's general character through its similarity to other better-documented confraternities of this era, nothing is known about the Misericordia's membership, officers, early history and day-to-day operations during the duecento and early trecento. Indeed, the oldest surviving institutional documents and records of the confraternity date from 1351 — more than a century after its founding. While the loss of what must have been a substantial body of documentation does not permit an exact recording of the institution's growth over time, the Misericordia appears to have acquired a degree of importance in the early trecento, since we know from other sources that in 1321 the confraternity acquired a highly prized strip of land on the Piazza S. Giovanni, immediately opposite the Baptistery's south portal where it established what would become one of the most important confraternal residences in the city (Fig. 3).[8] Nearly three decades later, the Misericordia's financial resources increased dramatically in the aftermath of the plague of 1348. Matteo Villani notes that a windfall of plague-related bequests to the Misericordia amounted to a remarkable 25,000 lire, which suggests that the confraternity had, for some time, cultivated a following of benefactors.[9] With

7. On the history of the Misericordia, see in particular Luigi Passerini, *Storia degli stabilimenti di beneficenza e d'istruzione elementare gratuita della città di Firenze* (Florence: Le Monnier, 1853), 440–82; Ugo Morini, *Documenti inediti o poco noti per la storia della Misericordia di Firenze (1240–1525)* (Florence: Archiconfraternità della Misericordia, 1940); William Levin, "Studies in the Imagery of Mercy in Late Medieval Italian Art" (Ph.D. diss., University of Michigan, 1983), 330–50; idem, "'Lost Children,' A Working Mother, and the Progress of an Artist in the Florentine Misericordia in the Trecento," *Publications of the Medieval Association of the Midwest* 6 (1999): 34–84.

8. Prior to 1321 it is unclear where the confraternity members met. Presumably they, like the members of most confraternities, secured access to an altar in one of the city's churches or friaries. The use of such an altar was probably discontinued when the Misericordia established its residence near the Baptistery where, one assumes, it designated space for the confraternity's private devotion. For the document, see Florence, Archivio di Stato, *Carte Strozziane, Magliabecchiana*, Cl. XXXVII, cod. 300, c. 132 (formerly in the Biblioteca Nazionale Centrale, Florence). See Robert Davidsohn, *Forschungen zur älteren Geschichte von Florenz*, 4 vols. (Berlin: Ernst Siegfried Mittler, 1896–1908), 4:397; Poggi et al., "La Compagnia del Bigallo," 189–202, at 194 n. 1; and Saalman, *Bigallo*, 44.

9. Matteo Villani, *Cronica*, ed. F. Dragomanni, 2 vols. (Florence: Sansone Coen, 1846), 1:vii: "...e per somigliante modo fu lasciato a una nuova Compagnia chiamata la Compagnia della Misericordia tra mobili e possessioni il valore di più di venticinque mila fiorini d'oro." Also noted in Passerini, *Storia*, 447; Torricelli, *La Misericordia*, 5; and Levin, "Studies in the Imagery of Mercy," 336, 426

its newfound riches the Misericordia expanded its residence on the Piazza S. Giovanni by acquiring the adjoining corner lot where it built its now well-known gothic loggia/oratory (Fig. 4).[10] The Misericordia enjoyed sole use of its enlarged facilities until 1425, when the Florentine government forced it to merge with another confraternity, the financially desperate Compagnia di Sta. Maria del Bigallo. In the cinquecento, the Misericordia ended the merger and relinquished the site, which has since been known as the Bigallo and more recently the Museo del Bigallo.[11]

THE ALLEGORY IN SITU

Although documents related to the commission for the *Allegory of Divine Misericordia* do not survive, the fresco was evidently painted by a close follower of Bernardo Daddi on the western wall of what was once the deep, narrow entrance hall of the confraternity's initial residence on the Piazza S. Giovanni.[12] As a reconstruction illustrates, the fresco was originally visible from the Piazza S. Giovanni through the once spacious entrance hall opening (Fig. 5). The exact function of the entrance hall remains undocumented; however, given its access to the piazza and the Misericordia's mission to serve the urban lay population, one is led to regard this semi-public space as a place from which charity was distributed and where devotional ceremonies were performed. This seems likely when one recalls that the confraternity's move to the highly visible and civic oriented Piazza S. Giovanni represented a significant commitment to the city's life and identity. Indeed, its site on the

n. 398. The construction of the Misericordia's loggia and oratory appears to have led Villani to conclude that the Misericordia was a relatively new company. John Henderson, "Piety and Charity in Late Medieval Florence. Religious Confraternities from the Middle of the Thirteenth Century to the Late Fifteenth Century" (Ph.D. diss., Westfield College, University of London, 1983), 139, reads Villani's use of the phrase "una nuova compagnia" as an indication of the Misericordia's relative importance to the larger Orsanmichele.

10. Renovations of the residence in the eighteenth century fundamentally altered our experience of the fresco. The most important change was the construction of an exterior facade, which consolidated the initial residence and the neighboring building behind a uniform elevation and walled off access to the residence from the piazza. In addition to the exterior facade, an interior wall was built across the depth of the hall, dividing the space into two halves. The front half preserves what remains of the original entrance hall, while the back half was gutted to accommodate a new interior stairway. The interior wall not only divided the space into two parts, but it also cut through a series of inscriptions that were painted to the left of the *Allegory*. Fortunately, restorers maintained the inscriptions and attached them to the new wall, in the corner next to the main image of the *Allegory*. See Saalman, *Bigallo*, and Fig. 6.

11. The Misericordia remains active to this day, operating the city's highly visible ambulance service, which is headquartered nearby, in a small square immediately to the south of the Campanile.

12. Richard Offner, *A Critical and Historic Corpus of Florentine Painting* (New York: New York University Press, 1930–58), sec. III, 3:159–63.

Piazza S. Giovanni was one of the most prominent of any confraternity in the city, rivaling even that of the much larger and wealthier Compagnia di Sta. Maria d'Orsanmichele, which performed its ceremonial activities in the city's communal grain loggia.[13] Thus, the modern viewer standing before the *Allegory* must exercise considerable imagination to reconstruct the original experience of looking at the fresco, perhaps over an altar, with the Baptistery, Campanile and Duomo visible just beyond the entrance (Fig. 6). It is with this reconstructed experience in mind that one turns to the fresco to understand its meaning and function within this semi-private, semi-public space in Florence.

THE ICONOGRAPHY OF THE *ALLEGORY*

As scholars have recognized, the *Allegory of Divine Misericordia* concerns the role of *misericordia* (mercy) in human salvation, particularly as it applies to the mission of the confraternity.[14] Such a theme was appropriate for the Misericordia whose members were compelled to heed Christ's example and perform acts of mercy for their neighbors. This theme is proclaimed prominently through an inscription from Matthew 21:35 which appears at the top of the fresco (Fig. 7):

> VENITE BE/NEDICTII PAT/RIS MEI PO/SSIDETE
> PARATUM / VOB[IS] REGNUM/A COSTITUTI/ONE MUNDI
> Come, blessed of my Father, inherit the kingdom prepared for you from the foundation of the world.

To appreciate fully the relevance of this text to members of the Misericordia and its significance to the fresco's iconography, it is useful to consult the entire passage from Matthew, which relates Christ's description of the means of salvation at the Last Judgment:

> When the Son of Man comes in his glory, escorted by all the angels, then he will take his seat on his throne of glory. All the nations will be assembled before him and he will separate men one from another as the shepherd separates sheep from goats. He will place the sheep on his right hand and the goats on the left. Then the King will say to those on his right hand, "Come, blessed of my Father, inherit the kingdom prepared for you from the foundation of the world. For I

13. Regarding Orsanmichele and the Misericordia see Phillip Earenfight, "Sacred Sites in Civic Spaces: The Misericordia and Orsanmichele in Post-Plague Florence," in *The Historian's Eye: Essays on Italian Art in Honor of Andrew Ladis*, ed. Hayden B.J. Maginnis and Shelley E. Zuraw (Athens: Georgia Museum of Art, 2009), 15-32.
14 Poggi, "La Compagnia del Bigallo," 204-6; Offner, *Corpus of Florentine Painting*, 159-63; Kiel, *Museo del Bigallo*, 118; Levin, "Studies in the Imagery of Mercy," 11-36.

was hungry and you gave me food; I was thirsty and you gave me drink; I was a stranger and you made me welcome; naked and you clothed me, sick and you visited me, in prison and you came to see me." Then the virtuous will say to him in reply, "Lord, when did we see you hungry and feed you...?" And the King will answer, "I tell you solemnly, in so far as you did this to one of the least of my brothers, you did it to me." Next he will say to those on his left hand, "Go away from me, with your curse upon you, to the eternal fire prepared for the devil and his angels. For I was hungry and you never gave me food...". Then it will be their turn to ask, "Lord, when did we see you hungry...?" Then he will answer, "I tell you solemnly, in so far as you neglected to do this to the least of these, you neglected to do it to me." And they will go away to eternal punishment, and the virtuous to eternal life.[15]

Seen within the context of Matthew's full text, the inscription at the top of the fresco articulates the principle that those who perform acts of mercy for their neighbors will (i) earn the mercy of the Lord, (ii) gain salvation at the Last Judgment and (iii) enter the kingdom of God. This study will consider these three elements, demonstrating how each segment of Matthew's text corresponds to key aspects of the fresco's imagery, focusing in particular on the kingdom of God and how it relates to the image of the city of Florence represented at the bottom of the fresco.

THE ROLE OF MERCY IN SALVATION

There are numerous references in the fresco to the role of mercy in salvation. Foremost is the image of the Agnus Dei that appears in the center of the fresco's upper border. The image of the lamb pouring forth its blood to wash away the sins of humanity and enable salvation embodies the concept of mercy and its role in salvation. For members of the Misericordia, the Agnus Dei was the model on which their charitable mission was based. In imitation of Christ's mercy and self-sacrifice for humanity, members of the Misericordia showed mercy and gave of themselves for their neighbors. The position of the Agnus Dei proclaims that the theme of mercy and salvation is central to the fresco's iconography, and by extension, the work of the Misericordia.

The theme of mercy and self-sacrifice is further echoed by the image of the pelican in her piety, which appears in the diamond motif to right of the Agnus Dei. This image illustrates a mother pelican pecking at its breast so as to offer its blood as food for her chicks. This symbol of self-sacrifice is frequently nested atop images of the Crucifixion where it translates the complex theological notion of Christ's self-sacrifice into a simple, albeit

15 Matt. 25:31–46.

misunderstood, observation in nature.[16] Its appearance next to the Agnus Dei complements, enhances and enriches the theme of the fresco.

Immediately below the Agnus Dei is the imposing figure of Divine Misericordia who wears a tiara inscribed with the identifying label "MISERICORDIA DOM[INI]." Her mantle displays eleven medallions, some with text, others with text and images. The top three medallions present biblical inscriptions that emphasize the importance of *misericordia* in salvation. The one on the left reads "BEA/TI MISERIC/ORDES Q[UONIAM] M/MISERICORDI/AM CONSEQUENTUR (Blessed are the merciful; for they shall obtain mercy)."[17] It suggests that those who are merciful and give of themselves to their neighbors will ultimately experience salvation. The one in the center reads "MISER/ICORDIA DEI/PLENA EST/TERRA (The earth is full of the mercy of the Lord)."[18] This reference is particularly relevant in light of the image of Florence below Divine Misericordia, and suggests that the city — by virtue of the confraternity's activities — is full of the mercy of the Lord. The medallion on the right acts as a reminder to the members of the confraternity and reads: "MISERI/CORDIA ET VER/ITAS NON TE D/ESERANT CIRC/UNDA EAS GU/TURI TUO (Let not mercy and truth forsake thee: bind them about thy neck)."[19] The lower eight medallions include inscriptions and small narrative images that represent the Acts of Mercy (providing food to the hungry, drink to the thirsty, etc.). For example, the top left medallion of this group of eight illustrates two men seated at a table; the text above them reads, "EXU/R[I]VI & DEDIS/TIS M[IHI] MA[N]DUCA/RE (I hungered, and you gave me to eat)."[20] Reiterating the text of the lower eight medallions

16. The pelican acquired its symbolic meaning during the Patristic age through a pseudoscientific interpretation that aimed to explain what observers perceived to be the pelican's curious practices regarding its young. According to the *Physiologus* and its popular descendants, the vernacular bestiaries, the pelican loves its chicks, but as they grow, they peck at their parents' face causing the father bird to kill them. The pelican mourns the loss of the chicks for three days; then, the mother pecks her own breast until it bleeds, allowing her blood to revive her dead offspring. By analogy, the mother pelican spilling her blood to revive her dead chicks became a symbol for Christ spilling his blood for the salvation of humanity. On the pelican in her piety, see Levin, *Allegory of Mercy*, 58–61. The image of the pelican is balanced by a similar image of a stork protecting its chicks from serpents, which symbolizes Christ's victory over evil. On the stork, see Levin, *Allegory of Mercy*, 65.
17. Matt. 5:7.
18. Ps. 33:5.
19. Prov. 3:3.
20. The second medallion illustrates two men, one raising a cup to drink; the text reads, "SITI/VI ET DEDI/STIS MIC[H]I BIB/ERE (I was thirsty and you gave me drink)." The next pair opens with a man who stands before a building, inviting another man to enter; the text reads, "HOSPE[S] / ERA[M] & COLLE/GISTIS ME (I was a stranger, and you took me in)." It is followed by a scene of one man handing a garment to a naked man; the text reads, "NUD/US ERAM/[ET] [CO]OPERUISITIS/ME (I was naked, and you clothed me)." The third pair opens with two men conversing, the one on the right has a bandaged head; the text reads, "INFI/RMUS ERA/M & VISITAST/IS ME (I was

are a series of single-word phrases that flank Divine Misericordia and read: "VISITO/POTO/CIBO... (I visit/I give drink/I feed...). These inscriptions provided members of the Misericordia with easy to learn catechetical phrases and devotional chants to remind them of their charitable duties.[21]

In sum, the medallions and the texts that decorate and flank Divine Misericordia illustrate how the members were to imitate Christ by showing mercy and giving of themselves to their neighbors. Through the texts and images Divine Misericordia figuratively and literally embodies the virtue of brotherly love and self-sacrifice exemplified by Christ, the Agnus Dei. Taken in conjunction with Matthew's inscription at the top of the fresco, the representation of the Acts of Mercy in text and image provide the means for salvation at the Last Judgment. As these various examples demonstrate, there are several aspects in the fresco that illustrate the role of mercy in salvation.

THE LAST JUDGMENT

There is considerable evidence that the fresco illustrates aspects of the second element: the Last Judgment. The most striking example is the inscription from Matthew at the top of the fresco. While the text appears only occasionally in the arts of the Middle Ages, it is always within the context of the Last Judgment.[22] For the purposes of this study, two examples will illustrate this point.

The first example is found in the interior ceiling mosaics of the Florentine Baptistery where the text appears as part of the large Last Judgment scene.

sick and you visited me)." Its pair shows one man speaking to another who is jailed behind bars; the text reads, "IN CAR/C[ERE] ERAM & VE/NISTI[S] AD ME (I was in prison and you came unto me)." The final pair illustrates related scenes; on the left, several men carry the wrapped body of a corpse; the text reads "NULLUS/DE MISE/RICORDIA/DEI DE/SPERE/T (Let no one despair of the mercy of God)." To the right, figures in a funeral procession carry a coffin with the Misericordia's coat of arms, a cross dividing the letters "F" and "M." The text reads, "[PRO] MISERICORDIA DEI MI [SERE]RE SUR [SU]M (For the mercy of God on high, have mercy)." During the late Middle Ages, Matthew's canonical six acts of mercy increased to seven with the addition of burying the dead. On the seventh act of mercy, see Levin, *Allegory of Divine Mercy*, 46–47; for the sake of symmetry, the artist represented the Misericordia's particularly noted responsibilities — burying the dead — twice.

21. The other four inscriptions are: REDIMO (I set free); TEGO (I cover), COLLIGO (I gather together), CONDO (I bury). On how these texts were used, see Earenfight, "Catechism and *Confraternitas*."

22. Examples include the Last Judgment fresco in the nave vault at Idensen (Lower Saxony); Walters Art Museum, MS 500, fol. 23r; Cambridge, Johns College, MS 231, fol. 22v; Cambridge, Fitzwilliam Museum, MS 330; New York, Morgan Library, MS 649, fol. 7r; London, Victoria and Albert Museum, 253.67; Trier, Stadtbibliothek, 1709 (*Liber Aureus* of Prüm), cover; Florence, Gallerie dell'Accademia, 442 (Bernardo Daddi); New York, Metropolitan Museum of Art, 1975.1.99; Conques, Sainte Foy, tympanum sculpture; Saint Denis, west facade central portal; Vatican, Pinacoteca, no. 526; and Boulogne, Bibliothèque de la Ville, Augustine, *De civitate Dei*, MS 53, fol. 73.

The text is written on a scroll held by an angel who appears below and to the left of Christ and who leads the elect in the direction of the portal to the New Jerusalem (Fig. 8). The scroll illustrates the same text from Matthew that appears in the *Allegory of Divine Misericordia*: "VENITE BENEDICTI PATRIS MEI/POSSIDET PARATUM (Come, Blessed of my father, inherit [the kingdom] prepared [for you])." Located only steps away from the entrance to the Misericordia's residence, it is inconceivable that members of the confraternity and the fresco painter of the *Allegory* were not thoroughly acquainted with what was the most important and prominent representation of the Last Judgment in the city.[23] As in the Misericordia fresco mosaic, the inscription in the mosaic is part of a Last Judgment scene and associated specifically with the elect.

A second example appears in an early duecento panel representing the Last Judgment, which was painted for an oratory in the church of Sta. Maria in Campo Marzio in Rome and now in the Pinacoteca Vaticana (Fig. 9).[24] The panel is divided into five registers: the top register represents the Majestas Domini; the second register illustrates Christ behind an altar flanked by angels and Apostles; the middle register includes images of salvation on the left, while scenes of four of the Acts of Mercy (providing food/drink to the hungry/thirsty, visiting the imprisoned, and clothing the naked) appear on the right; the fourth register represents the resurrection of the dead; the bottom register represents the New Jerusalem on the left and hell on the right. The text from Matthew appears on a scroll held by an angel to the right of Christ, which reads, "VENITE BENEDICTI PATRIS MEI POSSIDET PARATUM (Come, blessed of my father, inherit [the kingdom] prepared [for you])." Although separated by a few registers from the elect who appear in the New Jerusalem, the placement of the scroll on Christ's right indicates that the text is directed to the elect.

As these examples demonstrate, this text from Matthew was not only reserved for images of the Last Judgment, but more specifically it was associated with the elect who are about to enter the New Jerusalem. This is significant because the appearance of this text in the *Allegory* not only defines the image within the context of the Last Judgment, but it identifies the devotees flaking Divine Misericordia as the elect, those, as the text above them states,

23. Another example appears as at the top of a painted cross by Bernardo Daddi now in the Galleria dell'Accademia in Florence. In this scene, Peter extends a hand to an angel and the elect. The angel holds a scroll with the inscription: "Venite Benedi (come Blessed)." See Giorgio Bonsanti, *Galleria dell'Accademia: Guide to the Gallery and Complete Catalogue* (Boston: Sandak, 1992), 88–90.

24. Wolfgang Volbach, *I dipinti dal X secolo fino a Giotto: Catalogo della Pinacoteca Vaticana* (Rome: Liberia Editrice Vaticana, 1979), 1:17–21; Edward B. Garrison, *Italian Romanesque Panel Painting: An Illustrated Index* (London: Courtauld Institute of Art, University of London, 1998), no. 615; Carlo Pietrangeli, *Paintings in the Vatican* (Boston: Little, Brown, 1996), 27.

who are "blessed of my Father [to] inherit the kingdom prepared...from the foundation of the world." That we are to read the devotees as the elect is reinforced by an early fourteenth-century illumination from a manuscript of Augustine's *De civitate Dei* in the Bodleian Library (Fig. 10).[25] In an historiated letter "G" from the verso of the manuscript's opening folio, Christ appears above censor-swinging angels, the Madonna della Misericordia, and the elect who flank her in devotion.[26] The illumination represents the Last Judgment with Christ as judge at the top and the elect below.[27]

The similarity of the Bodleian illumination to the *Allegory* fresco is striking. In both works, the top central image represents a figure of self-sacrifice: in the Bodleian illumination, Christ bears his wounds and appears among angels holding symbols of the passion, while in the *Allegory*, we find the theologically equivalent image of the Agnus Dei pouring forth its blood. In both works censor-swinging angels pay homage to their object of mercy; in the Bodleian image this is the Madonna della Misericordia, while in the fresco it is an abstract personification of the same principle — Divine Misericordia.[28] In

25. Oxford, Bodleian Library, Augustine, *De civitate Dei*, MS 691, fol. 1v; *Illuminated Manuscripts in the Bodleian Library, Oxford,* compiled by Otto Pächt and John J.G. Alexander (Oxford: Oxford University Press, 1973), pl. LXIV, 3:639.
26. The visual similarity of the figure of Madonna della Misericordia in the illumination to Divine Misericordia in the fresco suggests that the two images are related. On confraternities relying on existing iconographic formulas, such as the Madonna della Misericordia, the Madonna of Humility and the Flagellation of Christ, see Ellen Shiferl, "Caritas and the Iconography of Confraternal Art," *Studies in Iconography* 14 (1995): 210. On the origins and development of the Madonna della Misericordia, see Christina Belting-Ihm, "Sub matris tutela": *Untersuchungen der Vorgeschichte der Schutzmantel-madonna* (Heidelberg: Carl Winter Universitätsverlag, 1976) ; Nancy J. Hibbard, "*Sub Pallio*: The Sources and Development of the Iconography of the Virgin of Mercy" (Ph.D. Diss., Evanston, IL: Northwestern University, 1984); and Levin, *Allegory of Divine Mercy,* 36–37.
27. Augustine uses *"civitas"* to imply the Church in a universal sense, as both a commonwealth and community under God. In biblical texts it is applied to Jerusalem, the church of the Old Covenant, the Heavenly or New Jerusalem, or the Church perfect. Regarding Augustine and the role of mercy in salvation see *De civitate Dei,* 21:27. However, as the first and only illumination in the manuscript, the image of the elect can also stand as the *civitate Dei,* not just the city but the citizens of God. Indeed, the opening text that both shapes and flanks the illumination suggests as much: "Gloriosissimam civitatem Dei sive in hoc temporum cursu" (The glorious city of God is my theme in this work). Typically, an historiated initial for a late medieval *De civitate Dei* manuscript represents the author holding models of the two cities, in this instance the city of God is suggested by the elect and the Madonna della Misericordia. For example, see Cambridge, MA, Harvard College, Typ 228 H, fol. 1v.
28. There is a distinction to be made between the two: the Madonna della Misericordia is the Virgin of Mercy; she protects her devotees who seek mercy under the safety of her protective mantel; Divine Misericordia is a personification of an abstract virtue. Divine Misericordia does not protect her devotees nor does she intercede physically on their behalf; rather, she bears images and texts that compel her devotees to perform such acts. One earns salvation not simply through devotion but also through performing merciful acts in the urban environment. Such an emphasis on the civic-oriented, active life would have been appropriate to members of the confraternity,

both works, the elect is represented by members of society who clasp their hands in a gesture of submission and self-sacrifice.[29] The dependency of the image of Divine Misericordia on the Madonna della Misericordia type is important, particularly since the latter occasionally appears in scenes of the Last Judgment, occupying the space to Christ's right. This not only confirms our view that the devotees flaking the Madonna della Misericordia are the elect, but it also gives evidence that they represent what Augustine called the community or commonwealth of God, the *civitate Dei*.[30] As these works demonstrate, the devotees before Divine Misericordia represent the elect who will inherit the "kingdom prepared for them." But what of that kingdom and what role might the image of Florence play in this equation?

THE KINGDOM OF GOD/NEW JERUSALEM AND FLORENCE

In considering the kingdom of God, the New Jerusalem, and the representation of Florence, it is important to establish precisely what defined the image of the New Jerusalem. While many of the images of the New Jerusalem are characterized by a walled, often bejeweled, city, there are other qualities that are just as important. To consider their features, we return to the Vatican Last Judgment panel to focus on the small scene of the New Jerusalem (Fig. 9). The image appears in the lower-left corner of the panel and illustrates the walled city of the New Jerusalem with two donors. Inside the center of the city appears the Virgin with arms outstretched in the orant position. Flanking the Virgin on either side are two saints; the elect face her in adoration.[31] The appearance of the Virgin in or above the New Jerusalem represents the notion that the city is filled with the mercy of the Lord.[32] However, this formula is flexible and Christ, the Agnus Dei, or even Ecclesia may appear in this space

who sought to participate directly in their own personal salvation and to serve the civic body. By following the example she promotes, her devotees earn salvation and their place among the elect; see Levin, *Allegory of Divine Mercy*, 36–37.

29. In the Bodleian manuscript, the society is made up exclusively of bishops, royalty and clergy and thus reflects the patrons who commissioned the illumination. In contrast, the Misericordia fresco displays a broad sector of the Florentine citizenry, which is appropriate given the confraternity's wide-ranging membership. For the figures flanking Divine Misericordia, see Levin, *Allegory of Divine Mercy*, 33–36. It should be noted that Levin regards the figures as citizens of Florence, but not necessarily the elect. On the clasped hand gesture of prayer and its meaning within the fresco, see Levin, *Allegory of Divine Mercy*, 38–41.

30. Examples of this format include a late duecento panel in the Pitcairn Collection and a page from a trecento choral book in Perugia. The Pitcairn panel was originally in Sta. Maria inter Angelos, Spoleto. See Hibbard, "Sub Pallio," pl. 118. Regarding the Choral Book, MS 9, fol. 2v, Biblioteca del Duomo, Perugia, see Belting-Ihm, "*Sub matris tutela*," pl. XXIIa.

31. As Belting-Ihm and others have shown, this form of the Virgin Orant is the basis for the Madonna della Misericordia in the Byzantine world. Belting-Ihm, "*Sub matris tutela*," pl. XIII, b.

32. Rev. 22:3.

above the city and convey the notion of the city filled with mercy. It is this feature, the presence of the mercy of the Lord — either as Christ, the Lamb or the Virgin — that defined the image of New Jerusalem. Representations of the New Jerusalem in any of these ways are numerous and can be found in a variety of illustrated *Apocalypse*, *De civitate Dei*, and *Bible moralisée* manuscripts as well as in monumental frescos.[33] Of the manuscript illuminations, those from a *Bible moralisée* in the Nationalbibliothek in Vienna represent both the Christ and the Agnus Dei type and appear in a mandorla above the walled New Jerusalem.[34] On a larger scale, a New Jerusalem fresco with Christ and the Agnus Dei appears in the church of S. Pietro in Civate.[35] Closer in date and context to the Misericordia's fresco is the Last Judgment from the abbey church at Pomposa.[36] In this painting the New Jerusalem appears to the left of Christ and is topped by a medallion with the image of the Agnus Dei, signifying that it is filled with the mercy of the Lord.[37] As these examples make clear, the image of the New Jerusalem is defined as a walled space filled with the mercy of the Lord, signified by the presence, symbolic or otherwise, of the Virgin, Christ or the Lamb of God in or above the city.

Returning to the *Allegory*, we find an important parallel in the image of the city of Florence, which appears directly below Divine Misericordia and the Agnus Dei, which fill the city and its citizens with the mercy of the Lord. This notion is further emphasized by the text of the medallion on Divine Misericordia's cope, which reads, "The earth is full of the mercy of the Lord." Taken within the apocalyptic context of the inscription from Matthew with its overt reference to the kingdom of God and the presence of the elect, the viewer is compelled to associate the said kingdom with the image of Florence. By a process of substitution, the devotees and their city under the Agnus Dei and Divine Misericordia become the elect and the New Jerusalem, respectively.

33. Manuscript examples include Prague Cathedral, Chapter Library, MS A.VII, fol. 1v; Prague, University Library, MS XXIII.C.124, fol. 168v; Eton College, Library, MS 177, fol. 56r; Bibliothèque de la Ville, Cambrai, MS 386, fol. 43r; and Valenciennes, Bibliothèque Municipale, MS 99, fol. 38r; Boulogne, Bibliothèque de la Ville, 53, *De civitate Dei*, fol. 73r; Oxford, Bodleian Library, MS 352, fol. 13r; and Oxford, Bodleian Library, MS Laud. Misc. 469, fol. 7v. Mural examples include the abbey church, Saint-Chef-en-Dauphiné, Isere; and abbey of S. Pietro al Monte, Civate, Lecco. See also Bianca Kühnel, *From the Earthly to the Heavenly Jerusalem: Representations of the Holy City in Christian Art of the First Millennium* (Freiburg im Breisgau: Herder, 1987), 137–38; and idem, ed., *The Real and Ideal Jerusalem in Jewish, Christian and Islamic Art*, being *Jewish Art* 23/24 (1997/98).
34. MS 1179, fol. 244r. See Alexandre de Laborde, *La Bible Moralisée Conservée à Oxford, Paris et Londres*, 5 vols. (Paris: Société française de reproductions de manuscrits à peintures, 1911–27), 4, pl. 696.
35. C.R. Dodwell, *The Pictorial Arts of the West 800–1200* (New Haven: Yale University Press, 1993), 182–83.
36. Mario Salmi, *Abbazia Pomposa* (Rome: La Libreria dello Stato, 1937), fig. 392.
37. This example is interesting in light of the image of Florence in *Allegory of Divine Misericordia*, because this view appears to include a reference to the abbey church in the right corner of the city's walls.

The detailed view of Florence, with its representation of several identifiable buildings, would appear to be at odds with a symbolic interpretation of the city within the fresco's iconography. This apparent contradiction is resolved in Augustine's writings on the earthly city and its celestial counterpart:

> Thus we find in the earthly city a double significance: in one respect it displays its own presence, and in the other it serves by its presence to signify the heavenly city.[38]

That the image of Florence represents both the real city and signifies the celestial, eternal city is also indicated by the inscription that appears on the city's walls. While the words "CIVITAS FLORENTIE" provide a simple, literal description of the real "City of Florence," the term "CIVITAS" can be read not only as "city" but community or people of God.[39] This concept, noted earlier, was most explicitly stated by Augustine and further considered by other writers including Aimon of Halberstadt who, in his commentary on Apocalypse 21:1, writes:

> this city is the holy Church, which is called *civitas* for these reasons, that it has many inhabitants, it extends to the four quarters of the earth, and above all it is the dwelling place of God.[40]

Within the context of the *Allegory* fresco, the elect are the commonwealth of God, the *civitas Dei*, which is made concrete by the image of Florence below.

Further evidence that the portrait of Florence is both a portrait of the city and a reference to the New Jerusalem appears in the inscription found at the base of the fresco, which reads:

> OMNIS MISERICORDIA FACIET LOCUM UNICUIQUE/SECUNDUM MERITUM OPERUM SUORUM ET SECUNDUM INTELLECTUM PEREGRINATIONIS ILIUS/ANNO D. MCCCXLII DIE II. MENSIS SEPTEMBRIS

38. Augustine, *De civitate Dei*, XV, ch. 2. See also Ernst Kantorowicz, *The King's Two Bodies: A Study in Medieval Political Theology* (Princeton: Princeton University Press, 1957), 87; and Frugoni, *A Distant City*, 24. That those responsible for the fresco's iconography were familiar with the works of Augustine cannot be doubted. The scholastic nature of the fresco's iconography and the degree of theological sophistication required to create it suggests that it could only have come from an individual or individuals well versed in scripture and, no doubt, the writings of the Church Fathers. In light of the Misericordia's possible connections to the Dominicans, it may be that the iconography of the *Allegory of Divine Misericordia* was drafted by someone associated with the friars at Sta. Maria Novella.
39. Throughout *De civitate Dei*, Augustine speaks of the city in terms of its citizens.
40. Aimon of Hallberstadt, *Expositio in Apocalypsim* 7:21 (PL 117:1199–1200).

All Mercy may make a place for each and every one according to the merit of his work and according to the understanding of the pilgrimage; in the year of the Lord 1342 the second day of the month of September.[41]

The first two lines of the inscription are based on Ecclesiastes 16:15, which concerns the notion that everyone shall be treated according to his or her deeds and understanding of his or her pilgrimage towards salvation. In the Apocalyptic context of the fresco, the "pilgrimage" is the progress toward the New Jerusalem and the "work(s)" are acts of mercy. This notion of a pilgrimage is echoed by Augustine:

> Scripture tells us that Cain founded a city, whereas Abel, as a pilgrim, did not found one. For the city of the saints is up above, although it produces citizens here below, and in their persons the city is on pilgrimage until the time of its kingdom comes.[42]

Thus, the image of "CIVITAS FLORENTIE" within the context of Matthew's description of the Last Judgment and filled with the mercy of the Lord signifies by its presence the heavenly city — the New Jerusalem.

By substituting a generic view of the New Jerusalem with a specific view of "CIVITAS FLORENTIE," those who designed the fresco drew attention to Florence the responsibility of the Misericordia to the city and its citizens. The confraternity's prominent location on the Piazza S. Giovanni represented a major commitment to and identification with Florence and its people.[43] That the Florentine identified their city with the New Jerusalem is by no means unique. The notion that cities identified their urban center with the New Jerusalem was widespread throughout the Middle Ages. Although the earthly Jerusalem had special claim as the terrestrial counterpart to the New Jerusalem, and therefore its image was particularly influential in shaping that

41. Although the year (1342) has been accepted as a reliable date for the fresco, no one has commented on the date "2 September." Unfortunately, no evidence has surfaced to suggest what significance this day connotes. It does not appear to coincide with a feast day or event associated with the Misericordia, and there are no references to the date in any of the surviving company documents. Perhaps it records the date of an event that led to the commissioning of the fresco. If so, we do not know what that event was.

42. *De civitate Dei*, XV, ch. 1. See also Frugoni, *A Distant City*, 24. Augustine also dedicates an entire chapter, XXI, ch. 27, to the role of mercy in salvation, drawing heavily from Matthew's account.

43. The unprecedented interest in representing specific buildings, several in the course of construction, can be accounted for by the fact that throughout the period in question, the Piazza S. Giovanni was the focus of one of the city's most important urban redesign projects. In light of its location next to the Baptistery and in full view of the city's physical transformation, it is easy to imagine the Misericordia enhancing its fresco's iconography and increasing its relevance to its members and the citizens they served by inserting such documentary features as the construction of the new Duomo and Campanile.

of the New Jerusalem, the concept was adopted by numerous medieval cities.[44] Fueled by an emerging sense of civic identity, medieval writers produced early *laudes civitatum* in which they drew parallels between their respective cities and the New Jerusalem.[45] Such ideas penetrated a city's identity to a remarkable level. As Chiara Frugoni notes:

> The model of the heavenly Jerusalem did not remain a merely literary image, fit to adorn the commentaries and text of the churchmen, but was, as far as possible, applied to the real world. All strove visually to make out this concept of the "divine city," fundamental to them, in the very structures of their churches, in the layout of their cities — in sum, in the corporeal concreteness of what lay about them.[46]

The attraction and power of the New Jerusalem was also bound with the earthly Jerusalem where Christ lived and died.[47] The incorporation of the objects and references to the earthy Jerusalem imparted a sacred character to one's city and made Christ's life, death, and the promise of salvation immediate, local and personal.[48] In this way, one's city became the Holy Land, a site of pilgrimage, home to relics and miracles, and the ultimate city, the New Jerusalem. Such material evidence of the divine provided a city with protection, power, attractions and identity in the here and now and the promise of salvation in the hereafter.[49]

That the Florentines saw their city as the New Jerusalem has been well demonstrated.[50] For example, in 1339, an anonymous Florentine chronicler

44. Kantorowicz, *The King's Two Bodies*, 83–84, 234; and idem, "The King's Advent and the Enigmatic Panels in the Doors of Sta. Sabina," *Art Bulletin*, 26 (1944): 209–10; Chiara Frugoni, *A Distant City: Images of Urban Experience in the Medieval World*, trans. William McCuaig (Princeton: Princeton University Press, 1991), 56–58.
45. Frugoni, *Distant City*, 56–61; see also, J.K. Hyde, "Medieval Descriptions of Cities," *Bulletin of the John Rylands Society* 48 (1966): 308–40.
46. Frugoni, *Distant City*, 27.
47. Frugoni, *Distant City*, "...because of the emotional investment directed toward Jerusalem in the hearts of the faithful, topography is reabsorbed into theology, and the celestial city is projected onto the actual earthly one..." 20. See also, Pierre Levedan, *Représentations des villes dans l'art du Moyen Age* (Paris: Vanoest, 1954): 12.
48. Frugoni, *Distant City*, 27; Richard Trexler, *Public Life in Renaissance Florence* (Ithaca: Cornell University Press, 1980), 1–8; 46–73; idem, "Ritual Behavior in Renaissance Florence: The Setting," *Medievalia et Humanistica: Studies in Medieval and Renaissance Culture* 4 (1973): 125–44; and Felicity Ratté, "Significant Structures: Architectural Imagery in Tuscan Painting of the Thirteenth and Fourteenth Centuries" (Ph.D. diss., New York University, 1995), 179.
49. Patrick Geary, *Furta Sacra: Theft of Relics in the Central Middle Ages* (Princeton: Princeton University Press, 1978), 87–107.
50. Donald Weinstein, "The Myth of Florence," in *Florentine Studies: Politics and Society in Renaissance Florence*, ed. Nicolai Rubinstein, (Evanston: Northwestern University Press, 1968), 15–44; and Marvin Trachtenberg, "Scénographie urbaine et identité civique: Réflexion sur la Florence du

ignored the fact that the city had fifteen gates and described the city as having only twelve in order to compare it to the New Jerusalem as described in the Apocalypse.[51] On Palm Sunday the city was ceremonially transformed into the city of Christ's Passion, beginning with a procession that started at the former cathedral of S. Lorenzo and progressed through the Porta Episcopi to the Baptistery and Duomo in imitation of Christ's entry into Jerusalem.[52] Indeed, the city's most important "ancient" building — the Baptistery — called to mind for late medieval citizens the Temple of Jerusalem.[53] The Baptistery's importance is highlighted in the *Allegory* by its central position in the city view.[54] Within the fresco's iconography the Baptistery is not merely a recognizable landmark and symbol of civic pride, it represents Ecclesia. To quote Augustine, it is "the house of the Lord, the city of God, which is the holy Church...built in every land by men believing in God...."[55] Furthermore, the water of baptism complements the blood of sacrifice and together they form the two components of Ecclesia.[56] This idea is made visible in the fresco through the precise alignment of the Agnus Dei, the figure of Divine Misericordia, and the Baptistery along the composition's vertical axis. Thus,

Trecento," *Revue de l'art* 102 (1993): 14–15. See also, Charles T. Davis, "Topographical and Historical Propaganda in Early Florentine Chronicles and in Villani," *Medievo e Rinascimento* 2 (1988): 33–51.
51. *Florentie Urbis et Reipublice Descriptio*, Archivio di Stato, Lucca, Biblioteca, n. 936, c. 105 and following; reprinted in Carl Frey, *Loggia dei Lanzi zu Florenz* (Berlin: Wilhelm Hertz, 1885), 119; see also Hermann Bauer, *Kunst und Utopie: Studien über das Kunst- und Staatsdenken in der Renaissance* (Berlin: Walter de Gruyter, 1965), 9 n. 37; Trachtenberg, "Scénographie urbaine," 15; and Frugoni, *Distant City*, 27.
52. Robert Davidsohn, *Storia di Firenze*, 8 vols. (Florence: G.C. Sansoni, 1956–65) 1:1064; Davis, "Topographical and Historical Propaganda," 40.
53. Carol H. Krinsky, "Representations of the Temple of Jerusalem Before 1500," *Journal of the Warburg and Courtauld Institutes* 33 (1970): 1–19; Kühnel, *From the Earthly to the Heavenly Jerusalem*; idem, *Real and Ideal Jerusalem*; Hayden B.J. Maginnis, "Places Beyond the Seas: Trecento Images of Jerusalem," *Source: Notes in the History of Art* 14 (1994), 1–8; and Ratté, "Significant Structures," 101; Eloise Angiola, "'Gates of Paradise" and the Florentine Baptistry," *Art Bulletin* 60 (1978): 245.
54. Krinsky, "Representations of the Temple of Jerusalem Before 1500," 1–19; Maginnis, "Places Beyond the Seas," 1–8.
55. Augustine, *De civitate Dei*, 8.24.2.
56. John 19:34 describes how when the crucified Christ was pierced by the centurion's lance, blood and water poured from his side. The Church Fathers interpreted the blood and water as symbols of Baptism and the Eucharist, two sacraments that signified the Church, which is born like a second Eve from the side of another Adam. On the relationship of baptism to *misericordia*, see the baptismal font (c.1230–50) in Hildesheim Cathedral where the image of a snake appears in conjunction with an image of *misericordia* and an inscription that reads: "To those defiled by crime, baptism is a work of piety." See Robert Freyhan, "The Evolution of the Caritas Figure in the Thirteenth and Fourteenth Centuries," *Journal of the Warburg and Courtauld Institutes* 11 (1948): 68–86, in particular, 70; Katzenellenbogen, *Virtues and Vices*, 49; and Levin, "Studies in the Imagery of Mercy," 69–71. Taddeo Gaddi's image of *Ecclesia* (Crucifixion, Refectory, Sta. Croce, Florence) is shown pouring water over a child in one hand while holding a chalice of wine in the other. The reliefs of the Acts of Mercy on the west portal of the Parma Baptistery suggest the same association between *misericordia* and baptism.

the Baptistery, Divine Misericordia, and the Agnus Dei represent the Lord's mercy in the city and signify the New Jerusalem.[57]

The *Allegory of Divine Misericordia* was not the only trecento fresco in Florence to identify the city with the New Jerusalem. In Andrea di Bonaiuti's *Way of Salvation* for the chapter house at Sta. Maria Novella, the artist placed the Duomo of Sta. Maria del Fiore in the lower left corner of the composition, directly below the entrance to heaven and the elect (Fig. 11).[58] Although the new Duomo rests on the composition's earthly level, its dome enters the Celestial City, which it symbolizes. As with the image of the Baptistery in the *Allegory*, the Duomo, in this variation on the Last Judgment, represents both Ecclesia and the New Jerusalem.[59] However, what makes the comparison between the *Allegory* and the *Way of Salvation* compelling is that they define their respective patrons, the Misericordia confraternity and the Dominican Order, as the means to salvation at the Last Judgment with Florentine buildings representing the New Jerusalem.[60] It is not coincidental that a mendicant order and a charitable confraternity would have been interested in images that

57. According to Rev. 21:22: "...there was no temple in the city since the Lord God Almighty and the Lamb were themselves the temple...." While some manuscript illuminators and fresco painters upheld this description of the New Jerusalem, many artists nevertheless included ecclesiastical structures in their representations of the celestial city.

58. In general, see Julian Gardner, "Andrea di Bonaiuto and the Chapter House Frescoes in Sta. Maria Novella," *Art History* 2 (1979): 107–38. Since the frescos predate the completion of the Duomo, it necessarily represents a projected view of its finished condition.

59. Frugoni, *A Distant City*, 24–25.

60. Until the end of the trecento, the Baptistery was *the* architectural symbol of the city of Florence on a terrestrial and celestial level. However, as the new Duomo grew to overwhelming proportions, its future dome emerged as the new symbol of the city and its connection to the New Jerusalem. Although the Baptistery always remained central to the Florentines, by the quattrocento the Duomo had become the architectural symbol of Florence and a symbolic link to the New Jerusalem. See Taddeo Gaddi's *Meeting at the Golden Gate* in the Baroncelli Chapel at the Franciscan convent of Sta. Croce, where a projected appearance of Sta. Maria del Fiore with its dome stands as the Temple of Jerusalem. The Palazzo dell'Arte dei Giudici e Notai ceiling fresco (1366) further demonstrates how the Florentines associated their city with the divine city and the Last Judgment. See David Friedman, *Florentine New Towns: Urban Design in The Late Middle Ages* (Cambridge, MA: MIT Press, 1988), 202–3. The fresco represents a schematic diagram that denotes the relationship of guilds to the Florentine government within the context of the city's exterior walls and symbols of the city's principal civic institutions. This image was undoubtedly influenced by representations of the New Jerusalem, which often appeared appropriately on the undersides of domes or vaulted spaces. By decorating its ceiling as if it were the vault of a religious structure and adopting such iconographic forms as the New Jerusalem, the Arte dei Giudici e Notai defined Florence under guild rule as the Heavenly City. Such an image surely aimed to provide theological justification to consular rule, which of course was otherwise absent as the prevailing notions of theocratic rule were based a priori on a monarch, not on a guild government. Such an example appears on the narthex vault at the church of S. Pietro in Civate. Other examples include the vault fresco at the abbey church, Saint-Chef-en-Dauphiné, Isere; and the church of Jirí, Castle, Prague. In general see, Kühnel, *From the Earthly to the Heavenly Jerusalem*.

integrate the city's urban fabric within a spiritual context. As is well known, the mendicants and confraternities aimed to address spirituality within an urban environment.[61]

The conclusion that the view of Florence in the *Allegory of Divine Misericordia* is both a representation of the city as an urban fabric and a representation of the city as the New Jerusalem raises significant implications regarding how Florentines and others originally experienced and comprehended the fresco. Since the fresco was positioned in a way that enabled the viewer to compare the painted city with the real city, concepts imbedded in the painting could easily have been projected onto reality. Thus, as one viewed the fresco and deciphered its allegorical meaning, arriving at the notion that Florence was blessed through the actions of the Misericordia and is the New Jerusalem, that idea was projected onto the real city and its citizens.[62]

Seen within the physical context of the Misericordia's entrance hall, the *Allegory* presented members of the confraternity with an image that defined the vital role of mercy in salvation at the Last Judgment and demonstrated how, through the *confratelli's* charitable actions, they filled the city with the mercy of the Lord, thereby identifying their fellow citizens with the elect and Florence with the New Jerusalem.

THE *ALLEGORY OF DIVINE MISERICORDIA*: FUNCTION AND CONTEXT

With the foregoing interpretation in mind, we return to the fresco's function and context in the Misericordia's entrance hall on the Piazza S. Giovanni. As noted earlier, the fresco occupies a position within the entrance hall, at a point towards the front, but not so far forward that it would have been subjected to the elements. Moreover, it is located rather high on the wall, with the lower margin located well above the heads of even the tallest *confratelli*, and its upper margin reaching all the way to the timbered ceiling. From this position, the fresco was best viewed within the entrance hall area. However, given the open nature of the space, one would have been able to see it from the piazza and it would have caught the attention of visitors as they stepped into the hall.

Regarding the fresco's function, it must have served in part to provide members of the Misericordia with an image that served a catechetical role, one that helped convey the essentials of Christian theology to members of the

61. Little, *Religious Poverty*.
62. A similar situation occurs in Ambrogio Lorenzetti's frescos for the Palazzo Pubblico in Siena. But there, the viewer would have projected ideas in the painting onto a view of the surrounding landscape of the Sienese *contado*, which is visible through the windows at the back of the room. See Deborah Leuchovius, "Notes on Ambrogio Lorenzetti's *Allegory of Good Government*," *Rutgers Art Review* 3 (1982): 29–35; Ute Feldges-Henning, "The Pictorial Programme of the Sala della Pace: A New Interpretation," *Journal of the Warburg and Courtauld Institutes* 35 (1972): 159–60.

confraternity.[63] This function was complemented by the design of the fresco, with its mnemonic features and an integrated use of image and text. Thus, on one level, the fresco conveyed to visitors and passers-by the charitable nature of the confraternity, its association with mercy and its identity and role in Florence.

On another level, it is possible that that the fresco also functioned as an altarpiece. Although there is no record or physical evidence of an altar having been in the entrance hall during the period prior to the completion of the new loggia and oratory in the 1360s, at which time such activities are known to have taken place in the space, it is difficult to imagine that the entrance hall did not in some way serve as an oratory during this initial period. Considering that the confraternity's move to the Piazza S. Giovanni represented a commitment to the city's urban population and civic identity, it would be unusual if it did not capitalize on its prominent site and perform its religious services within view of the public, much as the Compagnia di Sta. Maria d'Orsanmichele did within the communal grain loggia located only a few blocks away.[64] The fresco is located at such a height to accommodate an altar and a celebrant before it. From a liturgical point of view, the eucharistic theme of the fresco would have been appropriate. Moreover, the composition, with its emphatically iconic design, would have served well as a focal point for the celebration of the Eucharist, devotional exercises and reciting the various catechetical texts inscribed on the fresco. Indeed, the numerous clasped-hand gestures in the fresco may have compelled the viewer to respond in like manner. Although the subject of Divine Misericordia would have been unique among altarpieces, it shares many qualities with the Madonna della Misericordia for which there are numerous examples in the altarpiece format.

Regarding the fresco's proximity to the Piazza S. Giovanni, the fresco represents a remarkable response to the urban environment where it was meant to be viewed. As noted above, the nature of the entrance hall enabled the viewer to consider the image of the city and the iconography of the fresco within the context of the piazza. The fresco compels the viewer to relate the imagined city with the real city. This dialogue between the painted and the real urban fabric was inspired not only by the fresco's iconography but also by the dramatic building projects that were taking place on the Piazza S. Giovanni during the course of the late duecento and trecento. From their site opposite the Baptistery's south portal, members of the Misericordia had a clear view of the vast transformation of the Piazza S. Giovanni that was taking place at that time. This transformation included the destruction of the Ospedale di S. Giovanni Evangelista and the old cathedral of Sta. Reparata, the

63. Earenfight, "Catechism and *Confraternitas.*"
64. On competition between Orsanmichele and the Misericordia, see Earenfight, "Sacred Sites in Civic Spaces."

complete redesign of the piazza, the construction of the new Duomo of Sta. Maria del Fiore and the Campanile, as well as decorative programs for the Baptistery.[65] However, the Misericordia was not merely a silent witness to this process; rather, it grew over the course of the trecento to become the single most important land owner and builder to shape the piazza's southern flank. For the confraternity to incorporate an urban view of the city that centers on the piazza in a fresco that celebrates and defines the confraternity's mission in the city signifies the impact of the urban development on the Misericordia and how it perceived its place in society. It is not coincidental that one of the earliest large-scale urban views of Florence should have been commissioned by a civic-oriented institution that was establishing itself on one of the city's most significant experiments in urban planning. The Misericordia was dedicated to serving the city's population; it came to represent charity in the city and consequently expressed a civic orientation in way unlike any other confraternity in the city. Indeed, no other confraternity, not even Orsanmichele, identified itself with the city as explicitly as the Misericordia. The *Allegory* underscores the confraternity's identification with Florence through the city's most important architectural monument, the Baptistery of S. Giovanni. Evidence of this identification with the commune and its symbols suggests that the Misericordia saw itself as an emblem of the city's charity.

CODA: THE SYMBOL OF THE TAU

A study of the symbol of the *tau* ("T") that appears prominently on the center of Divine Misericordia's conical head covering provides a way to draw together a number of the ideas introduced in this iconographic interpretation of the *Allegory*. The mystical meaning associated with the *tau* has a rich and complex history; however for our purposes a few key features shall suffice.[66] Most importantly, the *tau* is the last character of the Hebrew alphabet and the symbolic equivalent to the Greek *omega* (Ω). Although the *tau* holds a significant place in Christian symbolism, it appears only once in the Vulgate in Ezekiel's terrifying and symbolically charged vision of the destruction of Jerusalem. After being shown the sins that were taking place in the city, Ezekiel is informed of the ensuing punishment (Ezek. 9:1-6):

> "Come here, you scourges of the city, and bring your weapons of destruction."
> Immediately six men advanced from the upper north gate, each holding a deadly

65. On the piazza's design and significance in the city's urban plan, see Trachtenberg, *Dominion of the Eye*, 27–85.
66. On the history of the symbolism of the *tau*, see H. Rahner, "Antenna crucis, v: Das mystische Tau," in *Zeitschrift für katholische Theologie* 75 (1953): 385–410; in brief, see John Fleming, "The Scribe of the Tau," in his *From Bonaventure to Bellini: An Essay in Franciscan Exegesis* (Princeton: Princeton University Press, 1982), 99–128; and Levin, "Studies in the Imagery of Mercy," 874–99, 907.

weapon. In the middle of them was a man in white, with a scribe's inkhorn in his belt. They came in and halted in front of a bronze altar. The glory of God of Israel rose off the cherubs where it had been and went up to the threshold of the Temple. He called the man in white with a scribe's ink horn in his belt and said, "Go all through the city, all through Jerusalem, and mark a tau on the foreheads of all who deplore and disapprove of all the filth practiced in it." I heard him say to the others, "Follow him through the city, and strike. Show neither pity nor mercy; old men, young men, virgins, children, women, kill and exterminate them all. But do not touch anyone with a tau on his forehead."

On the basis of Ezekiel's prophecy, a number of the symbolic associations of the *tau* can be outlined. First, the *tau* was a symbol of God's favor and protection. Such an association is verified by its meaning in Hebrew as a symbol of justice.[67] Indeed, it was used in Jewish funerary art of the Roman period to identify the elect who would receive eternal life. Because of the close relationship between the Jews and Christians, the association of the *tau* with the elect passed easily from one group to the other. Such a migration was bolstered by other symbolic associations that the cross-shaped *tau* possessed. Although the *tau* (T) and the *chi* (X) are phonetically unrelated and only visually similar, at least by the third century Christians were associating the *tau* with the *chi*, when they came to signify Christ's self-sacrifice on the cross and the means to salvation. The meaning of the *tau* was thus fully articulated in the western empire by Tertullian (c.160–c.220):

> Sending advance notice, therefore, and accordingly, also making the connection with the suffered Christ, he prophesied correctly that the just will suffer in the same way as he, the Apostles, and respectively, all the faithful, signed, that is, with that distinctive mark, concerning which Ezekiel [says]: "The Lord says unto me: Go through the midst of the gate, through the midst of Jerusalem, and give a Tau mark upon the foreheads of the men." This is, namely, the letter Tau of the Greeks, and now our "T," a type of the Cross, to which extent he portended the future, upon our foreheads before the true catholic [Heavenly] Jerusalem.[68]

Tertullian connects the *tau* and the passage from Ezekiel with Revelation and interprets the mark of the *tau* as a symbol of the elect of Christ and the destruction of Jerusalem as a prefiguration of the Last Judgment.[69] Moreover, the association of the *tau* with Christ's cross connects this symbol of salvation with self-sacrifice. Tertullian also adds that the early Christians made the

67. Levin, "Studies in the Imagery of Mercy," 884.
68. Tertullian, *Adv. Marcionem*, III.22 (PL 2:381); Levin, "Studies in the Imagery of Mercy," 887.
69. Tertullian, *De corona*, III (PL 2:99); Levin, "Studies in the Imagery of Mercy," 888.

sign of the *tau* on their foreheads to assert their claim that they were the elect who would inherit the Heavenly Jerusalem. In this sense, the man in white linen who marks the elect with the *tau* symbolizes the Lord, whose self-sacrifice enabled salvation and formed the model on which Christians base their own self-sacrifice. The *tau* is a symbol of the Lord's divine *misericordia* and the promise of a New Jerusalem to the elect at the Last Judgment. By imitating the Lord's self-sacrifice through acts of *misericordia*, members of the confraternity are implicitly marked with the symbol of the *tau* and will survive the destruction of the Last Judgment and enjoy salvation in their heavenly city, the New Jerusalem (in this instance, Florence). By placing the symbol of the *tau* on the headpiece of Divine Misericordia, the artist came as close as possible to marking her forehead with the *tau*, as noted in Ezekiel.

As this discussion of the *tau* demonstrates, the fresco's iconography is based on the three key aspects as outlined in the book of Matthew: the role of mercy in salvation, the Last Judgment and the New Jerusalem. Considering the complexity of the image and its iconography, it would be helpful to know who was responsible for its design. Although one can assume that at least some members of the Misericordia helped design the painting, its subtlety suggests that individuals with a high degree of theological sophistication were deeply involved. In light of the close association between the early confraternities and the mendicant friars, the Misericordia's apparent relationship to the Dominicans, and the fresco's overtly catechetical nature, it is likely that a friar, perhaps a member of the Dominican Order, helped design the fresco's iconography. Such involvement would signify the degree to which the mendicant emphasis on urban lay piety had been embraced and articulated by members of the city's lay confraternities.

■

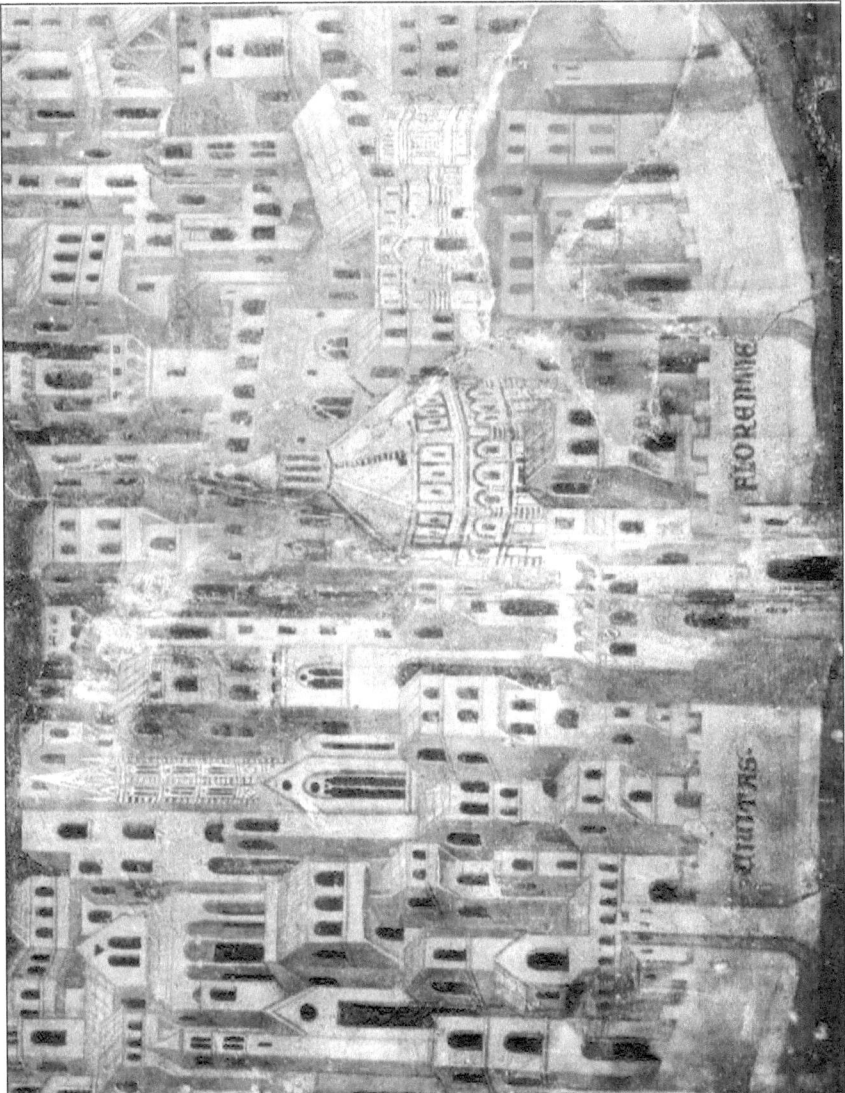

Fig. 1. Follower of Bernardo Daddi, *Allegory of Divine Misericordia* (detail), 1342. Residence of the Compagnia di Sta. Maria della Misericordia, presently the Museo del Bigallo, Florence (Alinari/Art Resource).

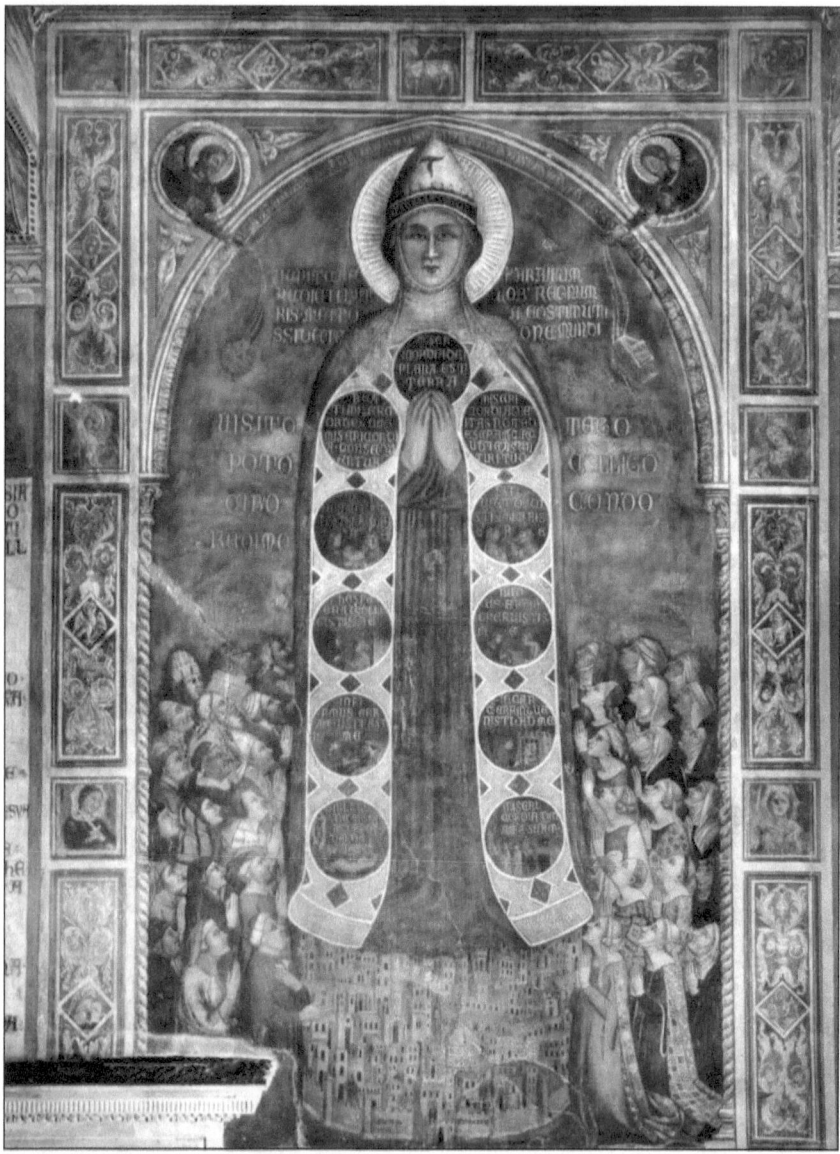

Fig. 2. Follower of Bernardo Daddi, *Allegory of Divine Misericordia*, 1342. Residence of the Compagnia di Sta. Maria della Misericordia, presently the Museo del Bigallo, Florence (Alinari/Art Resource).

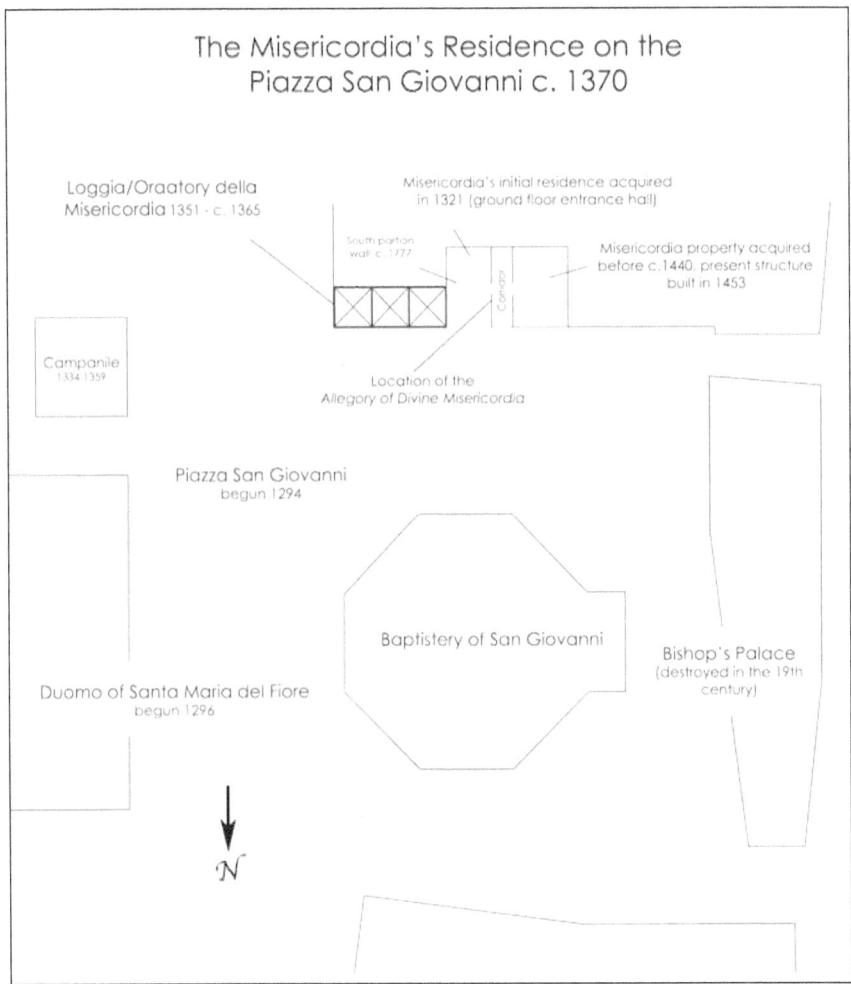

Fig. 3. Plan of the Piazza S. Giovanni (author).

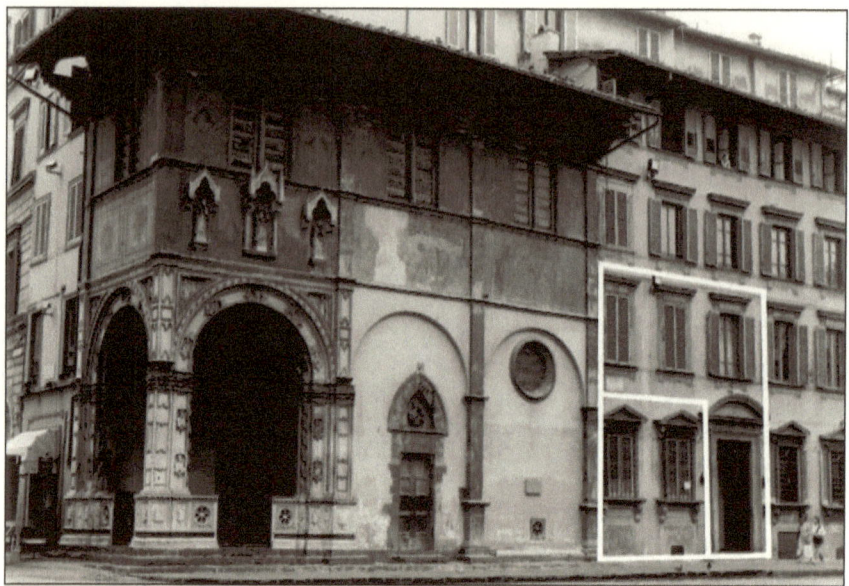

Fig. 4 (above). Alberto Arnoldi, Loggia/Oratory and Residence of the Compagnia di Sta. Maria della Misericordia (presently the Museo del Bigallo), Florence. Left: loggia/oratory (begun 1351); right: residence/entrance hall (before 1321, with eighteenth-century revetment). Original entrance opening indicated in white (author).

Fig. 5 (below). Reconstruction of Loggia/Oratory and Residence of the Compagnia di Sta. Maria della Misericordia with the *Allegory of Divine Misericordia* (H. Saalman, *Bigallo*, xii, with author additions).

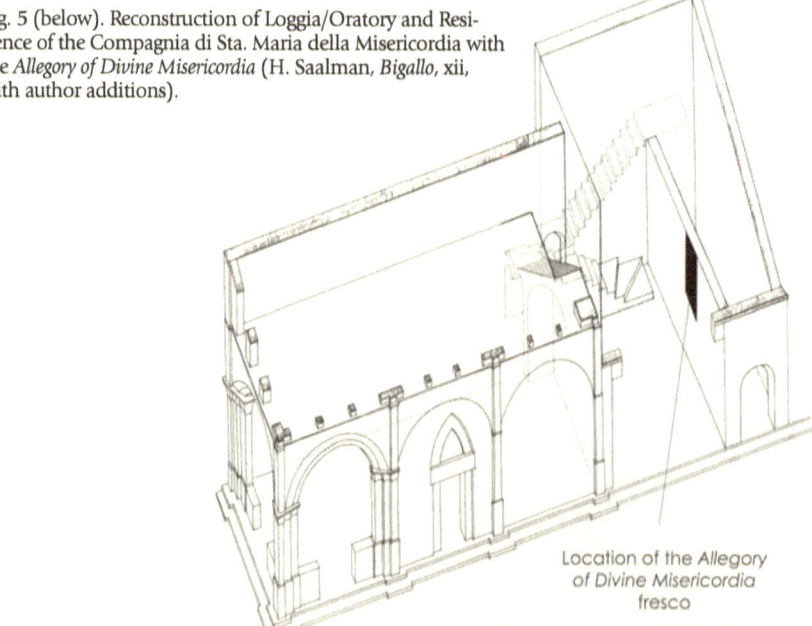

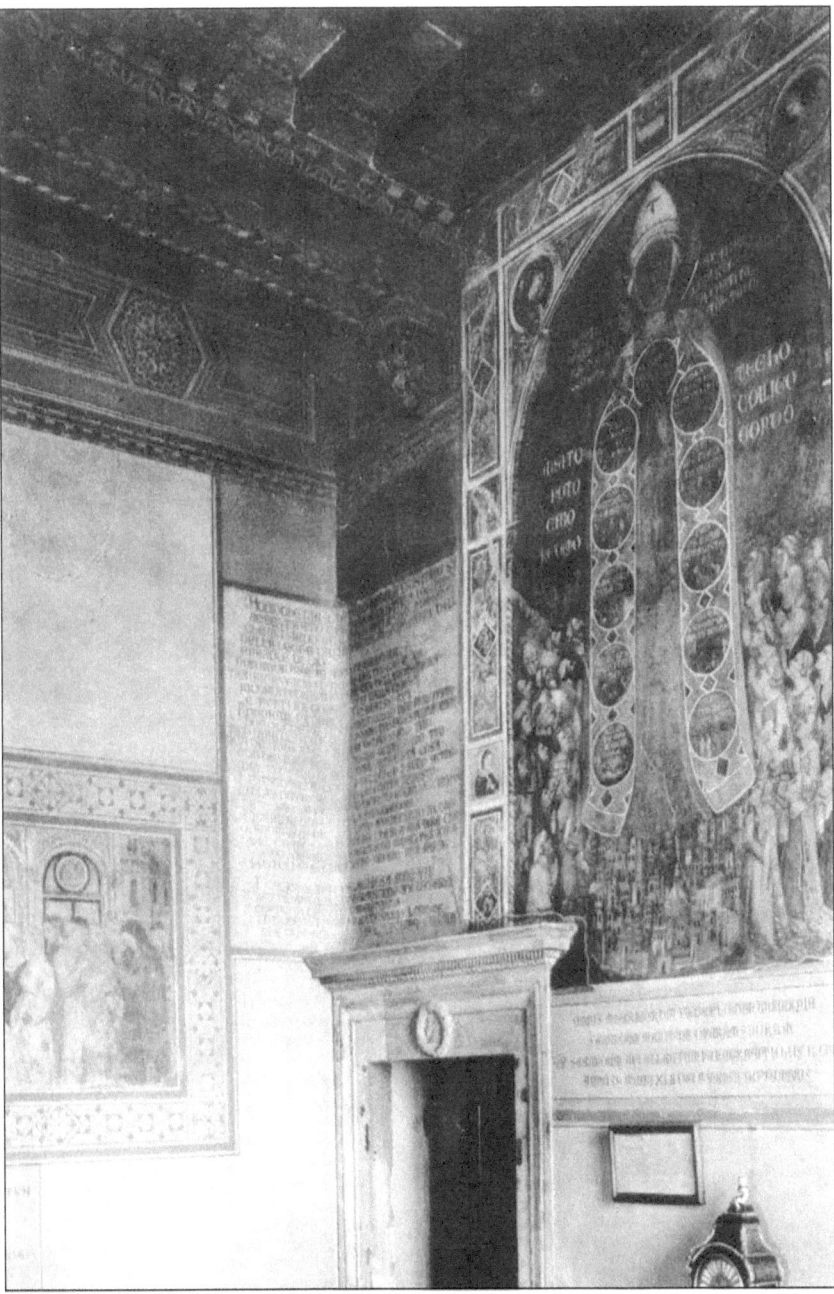

Fig. 6. Interior of the Entrance Hall showing the *Allegory of Divine Misericordia*, residence of Compagnia della Misericordia (presently the Museo del Bigallo), Florence (H. Saalman, *Bigallo*, ill. 11).

A SCARLET RENAISSANCE

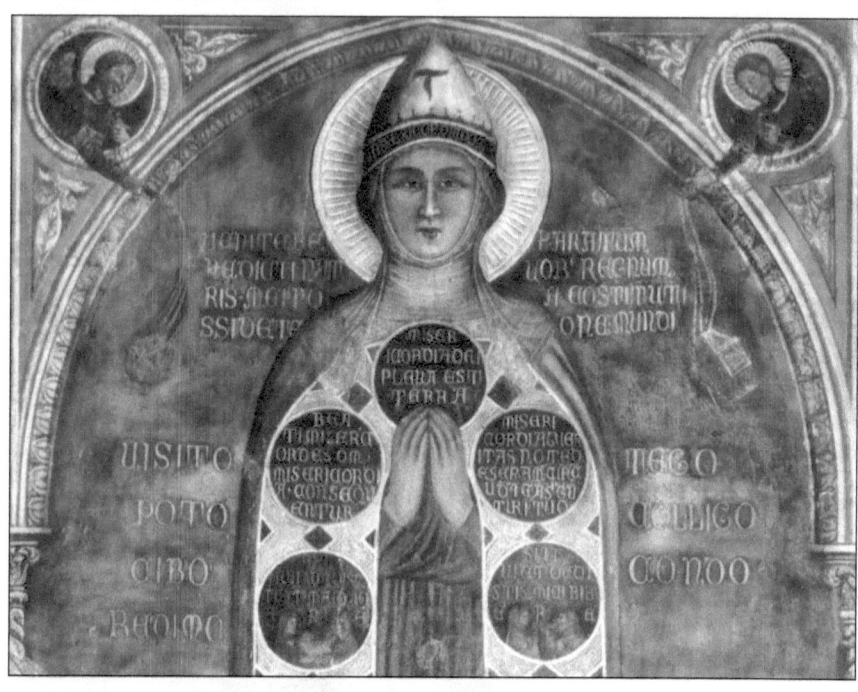

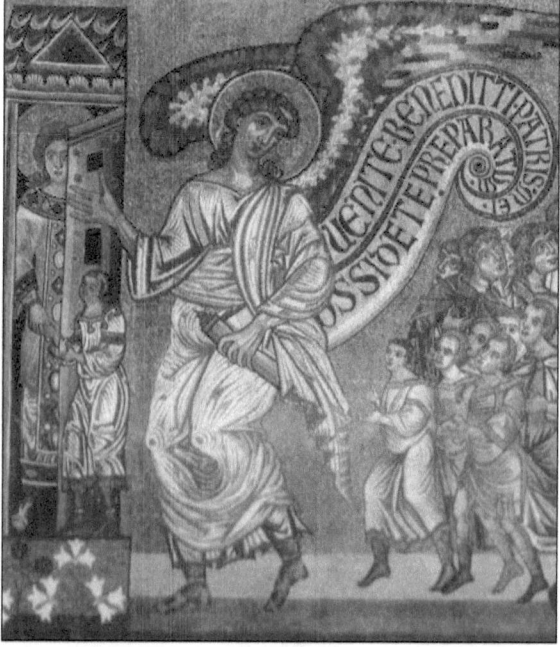

Fig. 7 (above). *Divine Misericordia*, detail of Fig. 2.

Fig. 8 (left). *Last Judgment* (detail), Baptistery, ceiling, mosaic, late thirteenth century, Florence (Alinari/Art Resource).

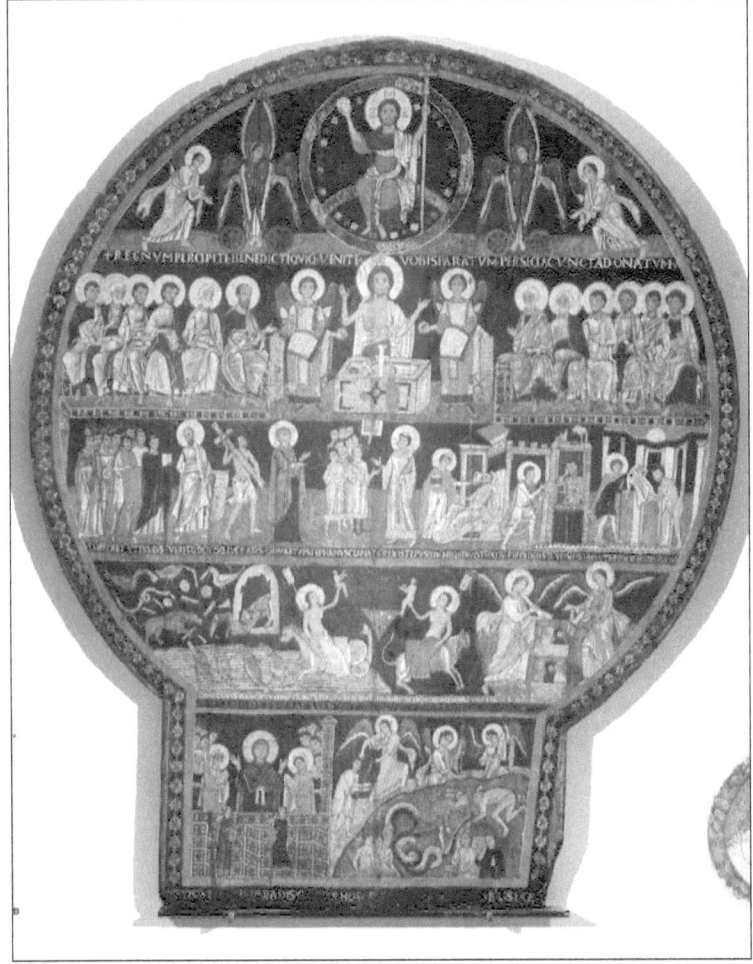

Fig. 9. *Last Judgment*, tempera on panel, early thirteenth century. Rome, Vatican, Pinacoteca, #526 (Alinari/Art Resource).

Fig. 10. *Last Judgment*, Augustine, *De civitate Dei*, early fourteenth century, Oxford, Bodleian Library, MS. Bodl. 691, fol. 1v.

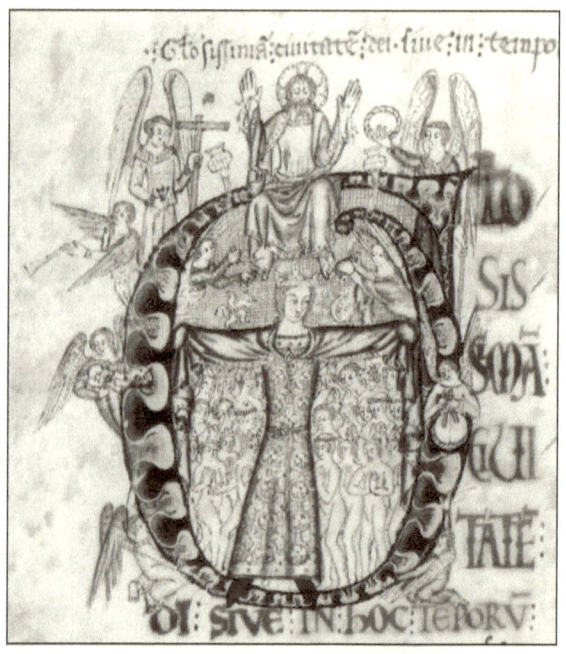

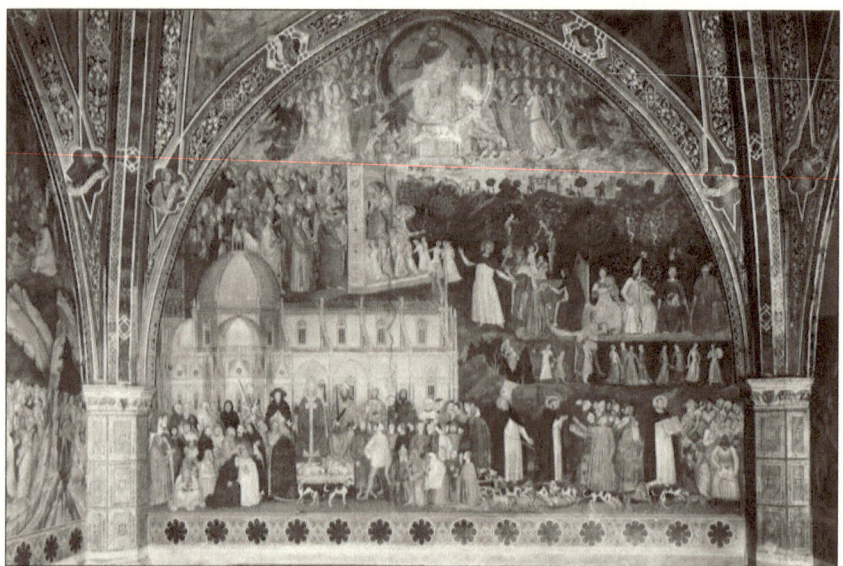

Fig. 11. Andrea di Bonaiuti, *Way of Salvation*, begun 1365, chapter house, Sta. Maria Novella, Florence (Alinari/Art Resource).

GOD'S ODDITIES AND MAN'S MARVELS
TWO SCULPTURES OF MEDICI DWARFS
GABRIELA JASIN

Between the years 1561 and 1564, Cosimo I de' Medici (1519–74) commissioned two fountain sculptures from Valerio Cioli da Settignano (1529–99), an artist of little fame.[1] These fountains were destined for Cosimo's newly acquired estate in Florence, the Pitti Palace, and more specifically for the Boboli Gardens.[2] These marble sculptures are life-size portraits of two well-known dwarfs who were at Cosimo's court. An unabashedly naked Morgante (Fig. 1) straddles a turtle and raises his right hand in a gesture of power, while Pietro Barbino (Fig. 2), timid and modestly draped, clasps a fish in his right hand.

The following paper explores the traditional representation of dwarfs previous to Cioli's sculptures and the way in which Cioli's sculptures depart from this tradition. Instead of relegating the value of Cioli's sculptures to the realm of humor, as is often the case, an alternative context will be established that assigns significant new meaning to Cioli's sculptures. More specifically, I propose that the Boboli Gardens functioned for Cosimo I as a macrocosmic *kunst und wunderkammer* or cabinet of curiosities. The political significance of these garden sculptures thus became reflections of Cosimo I and his aspirations as the founder of a new Florence, and more broadly, of a new Etruscan/Tuscan state.

The traditional scholarly assessment of Cioli's dwarf fountains emphasizes their place in the realm of the humorous and grotesque. For Bertha Harris Wiles, Cioli's dwarfs anticipated such seventeenth-century works as Romolo del Tadda's three Boboli sculptures based on designs by Jacques Callot (1592–1635), who was known for his caricatures of dancing fools and hurdy-gurdy players. Harris acknowledged that Cioli's sculptures lack the overtly grotesque style of Callot and thus assigned value in their satire of classical motifs.[3] While this assessment

1. Billie Gene Thompson Fischer, "The Sculpture of Valerio Cioli, 1529–1599." (Ph.D. diss., Ann Arbor: University of Michigan, 1976), 120.
2. The most recent comprehensive work on the Boboli Gardens is *Boboli 90: Atti del Covegno Internationale di studi per la salvaguardia e la valorizzanzione del giardino*, presented in Florence, March 9-11, 1989, 2 vols. (Florence: Edifier, 1990).
3. Bertha Harris Wiles, *The Fountains of Florentine Sculptors and their Followers from Donatello to Bernini* (New York: Hacker Art Books, 1975), 100. See also Paul Barolsky, *Infinite Jest: Wit and Humor in Italian Renaissance Art* (Columbia: University of Missouri Press, 1978), 143.

is fair, Cosimo I must have prized these sculptures for reasons beyond the satire of classical motifs.

The earliest description of Cioli's fountains appears in Giorgio Vasari's 1568 edition of *Le Vite*. Vasari wrote that Cioli made several sculptures as ornamentation for a great ducal room in the Pitti Palace and at the same time:

> ... [Cioli made] of marble, the statue of the dwarf Morgante, nude; that which is so beautiful and so similar to the successful truth that perhaps there has never been seen another monster so well made and constructed with such diligence similar to nature and to reality....[4]

Vasari praised the statue of Morgante for its beauty and it similarity to the "successful truth," claiming that he had not seen another monster so well made, constructed with such diligence similar to nature. As for the standing dwarf, Barbino, Vasari praised the character of the dwarf himself, for his good nature, intelligence and wit.

The dwarf Braccio di Bartolo, called Morgante, is known to have been in the Medici entourage from at least the 1540s until 1594.[5] In 1555, Cosimo I granted Morgante a ducal privilege in which he is defined as "the dwarf of our ducal palace and our most beloved servant."[6] There is also unfortunate evidence that Morgante suffered humiliation and physical abuse at the hands of certain courtiers.[7] Morgante also served as *uccellatore*, or "bird-catcher." Hunting was a privileged pastime of the nobility, and Morgante played an important role in it. One can imagine the intimacy that was shared between Cosimo I and his dwarf, as it was recorded that the two spent many an afternoon together, hunting birds

4. "di marmo, la statua di Morgante nano, ignuda; la quale e tanto bella e cosi simile al vero riuscita, che forse non e mai stato veduto altro mostro cosi bien fatto ne condotto con tant diliggenza simile al naturale e proprio,..." Giorgio Vasari, *Le Vite de'piu eccellenti pittori, scultori ed architettori sccitte da Giorgio Vasari, pittore aretino*, ed. Gaetano Milanesi (Florence: G.C. Sansoni, 1906), 7:639.

5. Braccio di Bartolo's nickname is derived from the poem by Luigi Pulci begun about 1461 at the request of Lucrezia Tornabuoni, mother of Lorenzo the Magnificent. The poem is a retelling of the Orlando epic, into which Pulci injected an element of humor. The giant Morgante is transformed into a comic hero whose nature contrasts with the roguery of the demi-giant, Marguette. See Fischer, *The Sculpture of Valerio Cioli*, 124.

6. *Bronzino: Artist and Poet at the Court of the Medici*, ed. Carlo Falciani and Antonio Natali, exh. cat. (Florence: Mandragora, 2010), 214. For a more general analysis of the phenomenon of dwarves at the Medici court see Touba Ghadessi Fleming, "Identity and Physical Deformity in Italian Court Portraits, 1550–1650: Dwarves, Hirsutes, and Castrati." (Ph.D. diss., Evanston, IL: Northwestern University, 2007).

7. As first cited from the Archivio di Stato di Firenze by Detlef Heikamp, "Il nano Morgante: Tentativo di un ritratto," in *Giambologna: Gli dei, gli eroi. Genesi e fortuna di uno stile europeo nella scultura*, ed. Beatrice Paolozzi Strozzi and Dimitrios Zikos, exh. cat. (Florence: Museo Nazionale del Bargello, 2006), 286-93, at 287.

at the Medici villa in Castello and in the Boboli Gardens.[8] Cioli's portrait shows Morgante completely nude, and his body is described with great rolls of fat, twisted legs and crimped flesh in the thighs. His mouth is open, as if in mid-speech and his head is turned slightly to the right. His right hand is extended in gesture and his left hand rests on his waist. Morgante is shown about four feet tall, which was probably his actual size. The smooth surface of his body contrasts with the shell of the turtle, which is patterned.

Like Morgante, the dwarf Pietro Barbino enjoyed life in the Medici court and was listed in a Medici retinue of 1586. Vasari lovingly described Barbino as "a dwarf, ingenious, well-read, and of gentle spirit, a favorite of our duke."[9] Barbino's portrait shows him as a standing figure in slight *contrapposto*. Barbino's misshapenness is largely restricted to his stunted legs, although the arms appear slightly shorter than normal. His right hand holds a fish, while his left clasps a bit of drapery over his left shoulder. Barbino looks down slightly with a rather wistful expression on his face. The head of Pietro does not look like that of a jester but could be a portrait of a court secretary or some other official, a position which Barbino might have filled from time to time.[10]

Both portraits were most likely completed between 1561 and 1564,[11] and the most salient feature shared between them is their derivation from classical prototypes. Morgante's position astride a turtle can be seen as a transformation of the classical equestrian portrait or even Silenus astride his donkey, and his gesture might be interpreted as Neptune calming the seas. Barbino's stance finds a parallel in Michelangelo's *David*, and his possession of a fish might be a transformation of a standard motif in antique garden decoration: the putto with a goose or with a dolphin. While the two dwarfs lend themselves to comic spectacle, particularly in their satire of classical types, their marble, life-size portraits merit further exploration.

Court dwarfs were seldom an independent subject of artistic representation prior to 1500. Their elevation from group representation to isolated portrait may have depended on the nobility's increased recognition of the dwarf as a court fool and more generally, as a cherished member of the court. Cherished for his ability to dispel melancholy and bolster self-confidence in the master

8. Falciani and Natali, *Bronzino*, 214.
9. Vasari-Milanesi, 7:639. "...e parimente gli ha fatto condurre la statua de Pietro detto Barbino, nono ingegnoso, letterato e molto gentile, favorito dal Duca nostro...."
10. Fischer, *The Sculpture of Valerio Cioli*, 129.
11. The approximate dates of the two works may be determined by Valerio's arrival in Florence in 1561 and Vincenzo Borghini's letter to Cosimo of November 4, 1564. In suggesting sculptors to execute the allegories for Michelangelo's tomb, Borghini excludes Cioli because he, among others, "has had statues from your Excellency." Unless Borghini was thinking of the antique restorations that Cioli had done, he was likely referring to one or both dwarf fountains. See Fischer, *The Sculpture of Valerio Cioli*, 120.

of the house, the dwarf as court fool was described as a prized "possession" and a valuable article in court inventories.[12] As early as 1480, documents record that dwarves and jesters were exchanged among the courts of Italy to lighten moods and relieve illness.[13]

The earliest depictions of dwarfs in the Renaissance are included in group portraiture or in representations of court spectacle. Seen by contemporaries as similar to a mistress's lap-dog, or the lord's hunting dog, the dwarf was essentially depicted as a human pendant to his owner. One of the few quattrocento portraits of a dwarf is that of the court fool, Scocola, whom Francesco Cossa (1436–78) included in the fresco at the Palazzo Schifanoja in 1470 at Ferrara. In this group portrait representing the month of April, Duke Borso d'Este offers Scocola a coin, perhaps as a reward for his praiseworthy wit and humor. The taller figures in the background serve as foils to the dwarf and to the hunting dogs placed directly at Scocola's side.

A fresco by Andrea Mantegna executed between 1465–74 in the Camera Picta of the Castello at Mantua also places a dwarf within a group portrait. In a fresco representing Ludovico and Barbara Gonzaga holding court, a female dwarf is inserted between two full-grown men and is partially hidden by the train of her mistress. A parallel is created both visually and metaphorically between this diminutive lady-in-waiting and the hunting dog beneath the duke's chair, as she is only inches taller than her canine companion. Starn and Partridge have adduced that the central position and insistent gaze of the dwarf must have been a standing family joke.[14] Even still, this little lady, perhaps keenly aware of her value, is the only figure who confronts her audience with a wise and knowing stare.

Cosimo I and his son, Francesco I, also followed the practice of including their court dwarfs in group portraits. Several commemorative prints dating to the later half of the sixteenth century depict the courtly processions of Cosimo I. In Cosimo's return to the palace after his coronation, Morgante and Barbino appear amongst the duke and his courtiers. Additionally, in a roundel on the ceiling of the Palazzo Vecchio painted by Giorgio Vasari, Cosimo is featured designing the Cosmopoli for the island of Elba. Cosimo's advisors and architects surround him, and in the foreground the dwarf Morgante's portrait bust appears, giving the viewer an over-the-shoulder glance. Under the direction of Francesco I, mannerist

12. It was an unfortunate fact that dwarfs were considered property and were inventoried as such. The attitudes toward dwarfs expressed above reflect only those of the sixteenth century and are certainly not appropriate or current today.
13. For example, in 1480, Eleanora d'Este wrote a letter of apology to Bona di Savoya, saying that she had detained her jester, Cacagno, longer than arranged "per nostra recreatione." E. Tietze-Conrat, *Dwarfs and Jesters in Art*, 45.
14. Randolf Starn and Loren Partridge, *Arts of Power: Three Halls of State in Italy, 1300-1600* (Berkeley: University of California Press, 1992), 95. For an elaborate description and interpretation of the Camera Picta, see the chapter entitled, "Room for a Prince: The Camera Picta in Mantua," 81–135.

sculptor Giambologna (1529–1608) executed a bronze relief on the north side of the base of Cosimo's equestrian monument. In this coronation spectacle, Giambologna inserted the dwarf Morgante conversing with another courtier.[15] Both Morgante and Barbino appear in Medici group portraits, affirming the high esteem in which these court dwarfs were held.

Cosimo's interest in his court dwarfs was likely more than an appreciation of buffoonery and comic relief. The Renaissance patron, well represented by Cosimo I de' Medici, attempted to harness and contain the wonders of the world in an environment closer to home. Artists and patrons alike searched for natural wonders in their own "backyard." The depiction of dwarfs or any other human anomaly was a source of scientific interest and aesthetic wonder for both artist and patron, as well as an indication of a patron's privilege in "possessing" such a rare and singular human.

By the second half of the sixteenth century, the revival of classical learning that flourished in Renaissance Florence included an intensified interest in and collecting of concrete and observable phenomena in the natural world. Europeans most often considered natural wonders as examples of God's ingenuity and wisdom. Less frequently, they described them as cases of "nature erring."[16] Human prodigies, dwarfs and other natural anomalies became the subject of art and poetry and were discussed extensively in natural histories during the late fifteenth and sixteenth centuries. The discovery and interest in certain ancient texts held particular significance in this Renaissance vogue for the marvelous. Perhaps the most influential ancient text was Pliny's *Historia Naturalis*, which is a scientific encyclopedia divided into thirty-seven books.[17] First published in Italian in 1469 and in forty-six editions by 1550, Pliny's text contained a wealth of information for the Renaissance reader. Of particular interest here is Pliny's belief in *ingegnosa natura*, or natural wonders. Pliny describes in detail the fabulous races of the world, from the continent of Europe to that of Africa. Some of these natural wonders are purely mythological, such as the Cyclops, centaurs, satyrs.[18] Others were humans that displayed abnormalities and disfigurements. For example, Pliny described a dog-headed man from the Simian Mountains and a race whose heads grow

15. For current studies on this equestrian monument, see Sarah Blake McHam, "Giambologna's Equestrian Monument to Cosimo I: The Monument Makes the Memory," in *Patronage and Italian Renaissance Sculpture*, ed. Kathleen Christian and David Drogin (Burlington, VT: Ashgate, 2010), 195–222; Mary Weitzel Gibbons, "Cosimo's *Cavallo*: A Study in Imperial Iconography," in *The Cultural Politics of Duke Cosimo I de'Medici*, ed. Konrad Eisenbichler (Burlington: Ashgate, 2001), 77–102. See also Meghan Callahan's essay above in this collection.

16. Joy Kenseth, "The Age of the Marvelous: An Introduction," in *The Age of the Marvelous*, ed. Joy Kenseth, exh. cat. (Hanover, NH: Hood Museum of Art, 1991), 33.

17. For a comprehensive study on the influence of Pliny on Italian Renaissance culture, consult Sarah Blake McHam's forthcoming book, *Pliny and the Artistic Culture of the Italian Renaissance*.

18. *The Age of the Marvelous*, 220.

in their breasts rather than from their necks. He also described a race with enormous ears and a colony of hairy women. Last, but certainly not least, Pliny described the encounter with a race of pygmies in Africa. Although an amalgamation of truths, half-truths and myth-making, all of the marvelous races that Pliny discussed in *Historia Naturalis* hold something in common: they were natural phenomena at which to marvel.

Not surprisingly, the popularity of Pliny's tales prompted zoologists in the mid-sixteenth century to include natural marvels and monsters in their own texts. Moreover, the encounter with the New World at the end of the fifteenth century fueled an increasing interest in the appearance and behavior of those races that were far from Eurocentric ideas of the "normal human." *Liber Chronicarum*, a history of the world developed and published under the auspices of Hartmann Schedel in 1493, directly transcribed and illustrated those unusual races described by Pliny. Konrad Lycosthene's *Prodigiorum ac ostentorum chronicon* of 1557 documented the known animals since antiquity and those animals that are both mythological and marvelous, such as satyrs and frog-headed babies.[19]

Human-made marvels were equally important to patron and artist in the late Renaissance. Works of art were particularly appreciated if they rivaled the creative power and ingenuity of God himself. Aristotle's *Rhetoric* expressed the necessity of an element of surprise in the arts (particularly poetry and prose), for it provided many justifications of wonder as desired aesthetic goal.[20] Artists and their work, particularly during the Mannerist period, were praised for their *ingegno*, which was analogous to God's creative power.[21] The ability to invent and fashion the new was considered to be an expression of this *ingegno* and thus an occasion to marvel. Artists who could transform a canvas or a block of marble into creations that rivaled and surpassed nature and who could simultaneously infuse these works with wit, humor and surprise were ranked as geniuses. Thus, the artist of the sixteenth century was constantly attempting to surpass God's own *ingegno*. And, *artificialia*, just as *naturalia*, was particularly valued as marvelous if they was exceptional and distinctive in its invention.[22]

Cosimo I's court painter, Agnolo Bronzino (1503–72), executed a portrait in 1553 that elucidates this intentional rivalry with God's genius and the

19. W.B. Ashworthe, "Remarkable Humans and Singular Beasts," in *The Age of the Marvelous*, 120.
20. *The Age of the Marvelous*, 219.
21. Kenseth, "An Introduction," in *The Age of the Marvelous*, 38.
22. On the rivalry between art and nature, see for example, P. Findlen, "Jokes of Nature and Jokes of Knowledge: The Playfulness of Scientific Discourse in Early Modern Europe," *Renaissance Quarterly* 42 (1990): 292–331; Martin Kemp, "Wrought by No Artist's Hand: The Natural, the Artificial, the Exotic and the Scientific in some Artifacts from the Renaissance," in *Reframing the Renaissance* ed. Claire Farago (New Haven and London: Yale University Press, 1995), 177–96.

desire to surpass it (Fig. 3). Bronzino's portrait is a double-sided, full-length portrait of a figure, so that the front and backside of the sitter can be seen on the front and back of the canvas, respectively. James Holderbaum was the first who attributed the execution of this unique portrait as a polemic in the *paragone* argument, a topic that was introduced by Benedetto Varchi a few years earlier.[23] A double-sided portrait would therefore be used to illustrate the painter's ability to present multiple views of a subject and the passage of time. Ultimately, Bronzino's portrait was meant to promote the superiority of painting over sculpture. Because Bronzino's portrait is in a monumental and formal format, the sitter must have been cherished as well; it is none other than the dwarf Morgante. Parts of this unique portrait were overpainted with the attributes of Silenus and of Bacchus, thereby concealing its exceptional qualities. Consequently, art historians had all but ignored this portrait until recent restoration revealed its original state.

Restoration has uncovered that Bronzino initially painted Morgante in his role as *uccellatore*, or bird-catcher to the duke. Instead of emphasizing his comedic role as court fool, Bronzino portrayed Morgante as a noble hunter, surrounded by an owl (*Athene noctua*), a Eurasian jay (*Garrulus glandarius*) and monarch butterflies (*Danaus plexippus*).[24] Like the marble fountains by Cioli, Bronzino's portrait is not a parody, nor is Morgante a source of ridicule. While recent scholarship emphasizes the role this work might have played in the *paragone* debate, it is worth noting that Bronzino's portrait of Morgante provided an opportunity to showcase Cosimo's prized dwarf as an important figure in Medici court life and as a natural wonder that was "collected" like the butterflies included in Bronzino's portrait. Rivaling both the art of sculpture and God himself, Bronzino memorialized the dwarf, Morgante, in this rare and ingenious double-sided portrait. And in doing so, Bronzino departed from the tradition of inserting the court dwarf in a group portrait, thereby creating the first full-length portrait of a dwarf under Medici patronage.

The dwarf Morgante was also the subject of several bronze statuettes executed by Giambologna in the 1580s for Cosimo's son, Grand Duke Francesco. According to Avery, the model is known in a few variants: one in which Morgante blows the *cornetto* that he holds in his right hand while supporting himself with a stick held on his left, another in which he is personified as a Bacchic figure, with a wine cup in his right hand and a bunch of grapes in his left and, most significantly, the last in which Morgante is riding a dragon (Fig. 4).[25]

23. James Holderbaum, "A Bronze by Giambologna and a Painting by Bronzino," *The Burlington Magazine* 98 (1956): 441–42; see also Falciani and Natali, *Bronzino*, 214; and Callahan essay above.
24. Falciani and Natali, *Bronzino*, 214.
25. Charles Avery, *Giambologna: The Complete Sculpture* (Mount Kisco, NY: Moyer Bell, 1987), 103. Avery states this variant to be Bacchus; however, I hesitate to do so and prefer to place him in a more inclusive category that acknowledges his resemblance to a satyr figure or Silenus.

Giambologna's final variant, *Morgante on a Dragon*, was a collaborative effort. Cencio della Nera created the model of the dragon upon which Morgante sits. The entire ensemble was made to surmount a fountain in a garden created for Francesco on a terrace on top of the Loggia de'Lanzi.[26]

The earliest recorded example of Giambologna's other bronze variants of Morgante is a gilt version in Copenhagen, which was inventoried in the Danish royal cabinet of curiosities in 1673.[27] Samuel Quicchelberg was the first to define this type of collection in 1565 as the *kunst und wunderkammer* or the cabinet of curiosities, and this early form of museum was the most characteristic expression of the period's fascination with the unusual or extraordinary.[28] As Adriana Turpin notes, the *kunst und wunderkammer* is traditionally associated with northern collections, but the great variety of rare natural and man-made objects in the Medici collections, particularly under the direction of Cosimo I, suggests that this association requires modification.[29]

Meant to evoke the appearance of an early museum, the *kammer* brings together a wide variety of natural and artificial objects to marvel, creating a microcosm of the world in "one closet shut."[30] Because a bronze statuette of Morgante was found in a Dutch cabinet of curiosities, one may speculate that the Medici placed their version(s) in a similar room. The Uffizi, which was planned by Vasari under the aegis of Cosimo I and was intended as an administrative building, seems a likely repository for Giambologna's statuettes. In 1581, under the patronage of Cosimo's son, Francesco I, the decision was made to house the Medici's art collection in the Uffizi's upper loggia. The *Tribuna*, an octagonal room within the Uffizi, functioned as a temple for all the arts, both natural and man-made.[31] Paintings lined all the walls and at eye level, and an ebony shelf with drawers full of medals and small precious objects surrounded the chamber. The shelves were adorned with statuettes, including those by Giambologna, and on a painted plinth, which has now

26. *Giambologna 1529–1608: Sculptor to the Medici*, ed. Charles Avery and Anthony Radcliffe, exh. cat. (London: The Council, 1978), 101.
27. We also know that a bronze Morgante was on display — or at least inventoried in the Casino de' Medici in 1588, although not specifically in a cabinet of curiosities. See Maria Grazia Vaccari, "Di e da Giambologna: La collezione del Bargello," in *Giambologna: Gli dei gli eroi*, 348. I would like to thank Meghan Callahan for calling this to my attention.
28. Samuel Quicchelberg, *Incriptiones vel Tituli Theatri Amplissimi complectectentis rerum universitatis singulas materias et imagines eximias*…(Munich: Ex Officina Adami Berg typographi, 1565).
29. Adriana Turpin, "The New World collections of Duke Cosimo I de'Medici and their Role in the Creation of a *Kunst-* and *Wunderkammer* in the Palazzo Vecchio," in *Curiosity and Wonder from the Renaissance to the Enlightenment*, ed. R.J.W. Evans and Alexander Marr (Ashgate: Burlington, 2006), 64.
30. Kenseth, "A World of Wonders in One Close Shut," in *The Age of the Marvelous*, 83.
31. For a firsthand account of those paintings and objects within the *Tribuna* during the seventeenth century, see Michael McCarthy, "The Drawings of Sir Roger Newdigate: The Earliest Unpublished Record of the Uffizi," *Apollo* 134 (Sept. 1991): 159–68.

disappeared, were different species of stuffed birds and fish accompanied with rare stones and shells.[32] Unlike northern collections, the *Tribuna* was characterized by an absence of specialization and by the juxtaposition of nature and artificial objects. Francesco reassembled all reality in miniature and, thereby, symbolically reclaimed dominion over the natural and artificial world.[33] To imagine the presence of Giambologna's bronze statuettes of dwarfs in the *Tribuna*, the Medici gallery of wonders, is not difficult.

While the *Tribuna* was not realized until the patronage of Cosimo's son (and successor), during Cosimo's patronage we witness a similar phenomenon, which shares an underlying ethos with the *kunst und wunderkammer*. This phenomenon is the emergence of the garden as a place of wonderment, and it is in this context that Cioli's dwarfs should be understood. The playful competition between art and nature was as pervasive in the Renaissance garden as it was in the cabinet of curiosities.[34] Just as in a room of wonder, the collector was able to place himself in the center of his own fashioned universe.[35] Thus, the experience of the manifold forms of nature and objects fashioned by hand glorified the owner and signaled his preeminence among men.[36] Some Renaissance gardens are explicit in their reference to the marvelous. Vicino Orsini (1523-83), owner and creator of the Sacro Bosco at Bomarzo, explicitly communicates this message through an inscription in the garden that reads: "You who have traveled the world wishing to see great and stupendous marvels, come here where there are horrendous faces, elephants, lions, bears, orcs and dragons."[37]

Although not as programmatic as the Sacro Bosco, the Boboli Gardens exhibit all those elements that constitute an arena of the marvelous and a microcosm of the world. As an extension of the Pitti Palace, the Boboli Gardens were created to glorify their owner through their diversity and accumulation of objects. We know that Cosimo I was an avid collector of antiquities, art and natural oddities.[38] Cosimo's keen interest in botanical curiosities is

32. Luciano Berti, *The Uffizi* (Florence: Becocci Editore, 1971), 8.
33. Giuseppe Olmi, "Science – Honour – Metaphor: Italian Cabinets of the Sixteenth and Seventeenth Centuries," in *The Origins of Museums: The Cabinet of Curiosities in Sixteenth- and Seventeenth-Century Europe*, ed. Oliver Impey and Arthur MacGregor (Oxford: Clarendon Press, 1985), 5-16.
34. Claudia Lazzaro, *The Italian Garden: From the Conventions of Planting, Design, and Ornament to the Grand Gardens of Sixteenth-Century Central Italy* (New Haven: Yale University Press, 1990), 8-19.
35. Mark S. Weil, "Love, Monsters, Movement and Machines: The Marvelous in Theaters, Festivals and Gardens," in *The Age of the Marvelous*, 169.
36. Kenseth, "A World of Wonders in One Close Shut," 85.
37. Weil, "Love, Monsters, Movement and Machines," 170.
38. Francis Haskell and Nicolas Penny, *Taste and the Antique: The Lure of Classical Sculpture, 1500-1900* (New Haven: Yale University Press, 1981), 54.

also evident, as he was the founder of the botanical gardens at Pisa and the Giardino Botanico de'Simplici in Florence.[39]

Cosimo's interest in botany and in collecting both natural and human-made wonders met fruitfully at the Boboli Gardens. Giusto Utens's lunette vista of the Pitti Palace and the Boboli Gardens (Fig. 5) documents the principal features of the gardens in place by 1599. The first documented work on the gardens, in May 1550, was the planting of fir, cypress, holm oak and laurel trees on the slopes around the lawn. In the 1550s and 60s, the gardens to the left of the palace in Utens' view was being cultivated. A thrushery for hunting (Morgante's realm) was constructed in 1554 high on the hill. In the late 1550s, Vasari built the fishpond at the edge of the property in the left foreground of Utens' lunette. This pond became the lower story of Bernardo Buontalenti's grotto that featured on its facade Baccio Bandinelli's statues of *Ceres* and *Apollo*, representatives of nature and art, respectively. Cosimo's son, Francesco, would see the completion of Buontalenti's *Grotto Grande*. A thousand asparagus plants were brought to the gardens 1563, followed by saffron crocus.[40] And perhaps the dwarf fruit trees that Cosimo planted were in place by that time as well. Equally important within these decades, Cosimo added several antique, mythological and genre statues and fountains to the gardens.[41]

This eclectic accumulation of artificial and natural wonders at the Boboli Gardens was instigated by Cosimo I and advanced by his son, Francesco. The Boboli Gardens, a repository for a princely collection, functioned as an outdoor cabinet of curiosities in which the boundaries between art and nature were consciously maintained and simultaneously collapsed. Valerio Cioli's fountains of Morgante and Barbino, destined for the Boboli, were surely prized as marvels by a sixteenth-century audience. As a matter of subject, the dwarf had overt implications as a wonder of nature and as a product of God's ingenuity on earth. The dwarf's representation, separate from group portraiture, and virtually unprecedented, thus exemplifies the *ingegno* of the artist. Just as the Giambologna statuettes were appropriate for the *Tribuna*, so Cioli's fountains of the dwarfs were appropriate in the Boboli Gardens. It is not difficult to see their placement in the Boboli as an effort on Cosimo's part to enhance his extraordinary, unique and diverse accumulation of objects.

I also contend that the humorous Morgante and the thoughtful Barbino were mouthpieces, if not reflections, of Cosimo himself. More specifically, Morgante and Barbino reflect Cosimo's desire to style himself as the founder of a new

39. For a monographic study on the gardens at Pisa, see Fabio Garbari et al., *Giardino dei Simplici: L'Orto botanico di Pisa dal XVI al XX secolo* (Pisa: Casa de Risparmio, 1991).
40. Francesco Gurrieri and Judith Chatfield, *Boboli Gardens* (Florence: Editrice Edam, 1972), 71.
41. These statues include, but are not limited to, the antique *Hercules and Antaeus*, Stoldo Lorenzi's *Fountain of Neptune*, Giambologna's *Oceanus Fountain*, Baccio Bandinelli's peasant (executed by Giovanni Fancelli). For a complete list of works, see Gurrieri and Chatfield, *Boboli Gardens*.

Etruscan/Tuscan state. Morgante on his amphibious steed and the standing Barbino yield yet other layers of meaning because of their heroic medium. Wiles asserted that Cioli used marble to draw attention to the sculptures' reference to classical motifs. "Classical inspiration would also explain Cioli's unfortunate use of the ideal medium of marble in his genre figures. The more pictorial bronze is better adapted to such subjects."[42] Had Cioli used bronze (a more costly medium than marble), the portraits of Morgante and Barbino probably would have been smaller than life size. Therefore, the use of marble must have been a conscious decision on the part of Cioli and his patron, and certainly this choice depended on more than "classical inspiration." Although small in size in real life, Morgante and Barbino grow in stature and in status because of their marble life-size representations. This idealization must have aroused a chuckle and provoked contemplation among Cosimo's visitors to the gardens.

As previously noted, the Morgante statue has various possible antique sources as his inspiration. Billie Gene Thompson Fischer speculated on the possibility for yet another source behind Morgante's creation that enhances the idea of the interchangeability of the dwarf and the grand duke of Tuscany. A bronze statuette of a man on a turtle is listed in a Medici inventory of 1574, and the ultimate source for this motif appears on a number of engraved gems and other small objects all of Italian provenance. All of these perhaps derived from a metope of the sixth-century Greek temple of Hera at Foce del Sele at Paestum.[43] Some examples show the man kneeling on a turtle, but the relief at Paestum and an Etruscan bronze mirror from the third century BCE depict the man seated on the turtle's shell. The Etruscan mirror is now in Florence, and it is possible that it was in the Medici collection in the sixteenth century. Even if this were not the case, the proliferation of the motif on small objects, particularly on Etruscan and Roman Republican gemstones and private seals, suggests that a court artist could have been familiar with the image.

On a gemstone with the motif of a man riding a turtle (Fig. 6), as well as on the other antique objects, the youthful rider seems to be a hero of some kind. He holds a branch with fruit towards which the turtle turns his head, thereby keeping his head above water and following the desired direction of his rider. One plausible hypothesis is that the hero is Phalanthos, the founder of a new colony in Italy.[44] Richter discussed this possible identification and concluded that if the

42. Harris, *The Fountains of Florentine Sculptors*, 100.
43. Paola Zancani Montuoro and U. Zanotti-Bianco, *Heraion alla Foce del Sele II* (Rome: Libreria dello Stato, 1954), 301–15.
44. Gisela M.A. Richter, *Catalogue of Engraved Gems, Greek, Etruscan, and Roman, Metropolitan Museum of Art New York* (Rome: L'Erma di Bretschneider, 1956), 96, no. 433. The gemstone is a moss agate. Eleven other examples of this motif are cited: a black skyphos in Palermo, a bronze handle on a vase, a bronze mirror, and eight engraved gems.

turtle-rider is not Phalanthos, he is a native Italian hero whose legend, closely related to that of Phalanthos, has been lost. Richter's hypothesis is compelling because all the examples of this theme are found in Italy.

Expanding on Fischer's identification of this motif and Richter's hypothesis about its meaning, I contend that the "founder motif" of a man riding a turtle could very well have been an inspiration for the Morgante fountain, particularly when the nature of Cosimo's aspirations as a ruler is understood. Cosimo was intent on styling himself as the creator of a new Etruscan/Tuscan state, particularly during the decade when Cioli executed his dwarf fountains. As already noted, Cosimo I was an avid collector of antiquities, and like his ancestor, Lorenzo the Magnificent (1449–92), had a special interest in those artifacts of Etruscan (native Italian) provenance.[45] Soon after his marriage to Eleanor of Toledo in 1539, Cosimo set about a diligent search for traces of the ancient Etruscans, making extensive exacavations at Chiusi, Arezzo and other Etruscan sites. Among the celebrated finds were a bronze statue of Minerva found near Arezzo in 1541, the *Chimera*, also found near Arezzo in 1554, and the *Orator*, found near Lake Trasimene in 1566.[46]

A group of Cosimo's cultural advisors further developed this interest in the Etruscan heritage of Florence. These *literati* revived the *mito etrusco*, the myth of the Etruscan, rather than Roman, origins of Florence. This myth became entrenched in 1541, with the founding of the Accadamia Fiorentina.[47] In this particular learned circle, the origins of art and language were inextricably linked to the native Italian civilization of the Etruscans. In 1546, the duke's librarian, Pierfrancesco Giambullari (1495–1555), wrote and dedicated a text to Cosimo on the history and language of Tuscany. *Il Gello* was intended as a scholarly demonstration of the Etruscan source of the Tuscan tongue and of

45. For an account of the *mito etrusco* of Florence and the Etruscan revival under the Medici, see Marina Martelli, "Il 'mito' Etrusco nel principato mediceo: Nascita di una coscienza critica," *Specimen* 6 (1980): 1–8; Giovanni Cipriani, *Il mito etrusco nel rinascimento fiorentino* (Florence: Leo S. Olschki, 1980); Andre Chastel, *Art et Humanisme à Florence au temps de Laurent le Magnifique* (Paris: Presses Universitaires de France, 1959), 69–71; A. D'Alessandro, "*Il Gello* di Pierfrancesco Giambullari: Mito e ideologia nel principato de Cosimo I," in *La nascita della Toscana: Dal convegno di studi per il IV centenario della morte di Cosimo I de' Medici* (Florence: Leo S. Olschki, 1980), 73–104; Henk Th. Van Veen, *Cosimo I de'Medici and his Self-Representation in Florentine Art and Culture*, trans. Andrew P. McCormick (Cambridge: Cambridge University Press, 2006); and Michael Sherberg, "The Accademia Fiorentina and the Question of the Language: The Politics of Theory in Ducal Florence," *Renaissance Quarterly* 56 (Spring, 2003): 26–55.
46. G.F. Young, *The Medici* (New York: Random House, 1910), 567.
47. Janet Cox-Rearick, "Pontormo, Bronzino, Allori, and the lost 'Deluge' at San Lorenzo," *The Burlington Magazine* 134.1069 (April 1992): 247.

Etruscan civilization as "la verissima origine della Toscana."[48] Tuscany was the birthplace of Italian culture, inhabited before the Greeks and the Romans.[49]

Cosimo wanted an association drawn between him and his venerable Etruscan ancestors. This connection was particularly important in light of Cosimo's claim as the founder and ruler of what was once ancient Etruria, the site of the highest civilization in Italy prior to the founding of Rome. After Cosimo's victory over Siena in 1557, his duchy had been rounded out to include twelve towns – Florence, Fiesole, Siena, Arezzo, Pisa, Cortona, Volterra, Pistoia, Borgo San Sepolchro, Montepulciano, Prato and Livorno – restoring, if not exactly in territory, at least in number, the "dodice prime colonie degli Hetrusci."[50] In 1569, Cosimo was crowned grand duke of Tuscany, recognizing his territorial conquests and their unification. By representing himself as a descendant of the Etruscans and as the founder of a new Etruria, Cosimo asserted the primacy of his reign and the importance of his accomplishments.

It seems that Cosimo I had already established his association with the Roman founding of Florence. The glory of Cosimo's Florence, primarily founded and inhabited by Etruscans, was brought to greater glory by the citizenship conferred upon the city by the Roman triumvirate — or so Cosimo would have us believe. In addition to Etruscan references, Cosimo appropriated Augustan imagery to bolster his association with "founder" mythology of the new Florence and Tuscan state. It was not unusual for Cosimo to allude to several myths and motifs as a means of propaganda, even those that are seemingly at odds with each other. The ceiling program for the Salone del Cinquecento in the Palazzo Vecchio, specifically the *Foundation of Florence* and the central *tondo*, confirmed not only the venerable Etruscan heritage shared by the Florentines but also the Roman citizenship conferred upon them.

On 3 March 1563, Giorgio Vasari presented Duke Cosimo de' Medici with his first design for the decoration of the ceiling of the Salone del Cinquecento

48. Pierfrancesco Giambullari, *Il Gello di M. Pierfrancesco Giambullari Accademico Fiorentino* (Florence, 1546), 48, as cited by Kurt W. Forester, "Metaphors of Rule: Political Ideology and History in the Portraits of Cosimo I de' Medici," *Mitteilungen des Kunsthistorichen Institutes in Florenz* 15 (1971): 82.

49. Several scholars have noted Cosimo's dependence on the symbolism of Hercules both as a ruler and founder of Florence and the greater state of Tuscany. See Nicolai Rubenstein, "Vasari's Painting of the 'Foundation of Florence' in the Palazzo Vecchio," in *Essays in the History of Architecture Presented to Rudolf Wittkower*, ed. Douglas Fraser et al. (London: M. Levine, 1967), 64–73; and L.D. Ettlinger, "Hercules Florentinus," *Mitteilungen des Kunsthistorichen Institutes in Florenz* 16 (1972):119–42.

50. Leandro Alberti, *Descrittione di tutta Italia* (Bologna, 1550), 22, as cited in Forester, "Metaphors of Rule," 82.

in the Palazzo Vecchio.[51] After several designs and modifications, the central panels of the ceiling included the foundation of Florence under the second triumvirate of 43 BCE and the amplification of Florence by Charlemagne. These images flanked a tondo containing the apotheosis of Cosimo crowned by the personified city of Florence.

Primary consideration should be given to the image of the foundation of Florence and the central tondo. In the foreground of Vasari's painting, we see the triumvirs — Octavianus, Antonius and Lepidus — completing the foundation of the colony with the conferment of its standard. The triumvir nearest to the onlooker and occupying the most prominent place in the pictorial plane is identified as Octavianus by the Capricorn with the globe and rudder that appears on many of Augustus' coins. The Capricorn was Augustus' astrological sign as well as that of Duke Cosimo, who, in an attempt to fashion himself as the "new" Augustus, had used it as an emblem in countless artistic commissions, particularly during the 1560s.[52] The prominent position of Octavianus reflects his leading role in the founding of the colony and by association, extends to Cosimo's foundation of Tuscany that is celebrated in the panels devoted to his conquest of Siena in 1555. If this association were not explicit enough, the inscription surrounding the tondo in which Cosimo appears as the "Divus Augustus" leaves no room for equivocation. The inscription reads: SPQF OPTIMO PRINCIPE. CONSTITVTA CIVITATE. AVCTO IMPERIO. PACATA ETRVRIA. (The Senate and the people of Florence. The best prince. The state established. The realm enlarged. Etruria pacified.)[53] In light of Cosimo's interest in native Italian founder imagery, of his Etruscan heritage and of Vasari's program for the Salone del Cinquecento, Valerio Cioli's *Morgante* works convincingly as a reflection of Cosimo's political aspirations.[54]

51. From the outset, the advisor to the decorative program of Salone del Cinquecento, Vincenzo Borghini (1515–80) and the painter, Vasari, rejected the legendary tradition that Florence had been founded on the order of Julius Caesar. Poliziano (1454–94) had previously introduced the theory of the foundation of Florence by the Roman triumvirate based on a newly discovered *Libri regionum*. Poliziano's theory had gained acceptance among Italian humanists and historians. As evidence of the relationship between the Etruscans and the Romans as proposed by Poliziano, the theater on the Capitol, which was erected in 1513 for the celebration of the conferment of Roman citizenship on Giuliano de' Medici, contained a series of historical paintings that were meant to extol the close relationship between the Etruscans and Romans. Through written descriptions, Borghini was aware of these images, particularly that of the foundation of Florence, and may even have derived some subject matter from them for the painting in the Palazzo Vecchio. See Rubenstein, "Vasari's Painting," 66.
52. For numerous examples of Cosimo's appropriation of Augustan imagery, see Janet Cox-Rearick, *Dynasty and Destiny in Medici Art* (Princeton: Princeton University Press, 1984).
53. Cox-Rearick, *Dynasty and Destiny*, 281.
54. While scholars tend to see most of the fountains and statuary at the Boboli Gardens as lacking a political agenda and unity, there is evidence to the contrary. See Maria Ann Conelli, "Boboli Gardens: Fountains and Propaganda in Sixteenth-century Florence," *Studies in the History of Gardens & Designed Landscapes* 18 (winter 1998): 300-316.

There is other evidence that establishes a link between the turtle-riding Morgante, the fish-toting Barbino, and the duke of Tuscany. As Fischer observed, the turtle figures prominently in an emblem of Cosimo I, in which the slow-moving animal is harnessed with a sail, thereby becoming a representation of an Augustan motto, *Festina lente* or "make haste slowly." The implication is that a prince would use prudence to study matters of state and, once he reached a decision, would execute it promptly. Shortly before the ceiling of the Palazzo Vecchio was started, Vasari had painted a full-length portrait of the duke in which this Augustan emblem was employed.[55] The portrait was strategically placed at the entrance to the rooms of Leo X, the largest and most important rooms in Cosimo's suite in the palazzo.[56] In it, Cosimo stands with the sword of victory in one hand and the baton of dominion in the other. He is surrounded by shields, one of which carries the image of the turtle with the sail. Significantly, Vasari associates this portrait with the event of the victory over Siena, explaining that the chiaroscuro below it represents the building of "la fortezza di Siena."[57]

In addition to the turtle and sail, a dolphin entwined around an anchor also served as a symbol for Cosimo's motto, *Festina lente* (Fig. 7).[58] The dolphin, regarded since ancient times as the swiftest of sea creatures, is hampered by the weight of the anchor, and thus, like the tortoise and sail, signifies prudence.[59] Pietro Barbino, pendant to Morgante, holds a fish, rather than a dolphin, yet the symbolic meaning of Barbino's hand holding the fish can be interpreted as equivalent to that of the dolphin held back by the anchor.[60]

Another artistic commission under Duke Cosimo substantiates this connection between Barbino and Cosimo's personal *impresa*. In 1555, nearly a decade earlier than the dwarf portraits commissioned from Cioli, Cosimo I ordered the construction of two aqueducts to bring water to the city of Florence. To celebrate this accomplishment, fountains were to be erected in

55. The emblem, in fact, appears in countless paintings decorating the Palazzo della Signoria. See Cox-Rearick, *Dynasty and Destiny*.
56. Cox-Rearick, *Dynasty and Destiny*, 280.
57. Ibid.
58. For a thorough study of dolphins in art, see Charles Avery, *A School of Dolphins* (New York; and London: Thames and Hudson, 2009).
59. Fischer, *The Sculpture of Valerio Cioli*, 132.
60. In the same years that Cioli was working on *Pietro Barbino*, Bartolomeo Ammannati was completing *The Fountain of Juno* for Cosimo I. This work was completed in 1563 and was originally destined for the central south wall niche of the Sala Grande in the Palazzo Vecchio. Ultimately, Cosimo's son, Ferdinando placed it in the Boboli Gardens in 1589. The sculptural group consisted of six figures, one of which was the personification of Prudence. Ammannati's *Prudence* is personified by a youthful, nude male who stands in contrapposto and holds an anchor around which a dolphin winds its tail to form the impresa of Augustus. Perhaps Ammannati's *Prudence* inspired Cioli's *Barbino*. They look strikingly similar, although *Barbino* lacks the anchor because it is Barbino who restrains the fish, acting like the anchor. See Conelli, "Boboli Gardens," 307–11.

and around the Palazzo Vecchio. Among several commissions awarded for that purpose was the design by Vasari and its execution in porphyry by Francesco del Tadda of a new base for Andrea del Verrocchio's *Putto with a Dolphin*. This sculpture, created by Verrocchio eight years earlier, was Cosimo's choice to replace Donatello's *David*. When *David* moved to the palazzo in 1495, it had become a symbol of the victory of the Florentine Republic over the Medici.[61] Corinne Mandel suggests the replacement of David with Verrocchio's *Putto with a Dolphin* underscores Cosimo's interest in expunging any vestiges of Republican symbolism and in installing an equally potent symbol of his Medici heritage and rule.[62] Mandel successfully connected Verrocchio's *Putto with a Dolphin* to Cosimo's emblem signifying *Festina lente*, relying on the idea that much like the anchor, the putto restrains the speed of the dolphin, thereby creating the idea of temperance and prudence.[63] The similar classical motif shared between Cioli's standing dwarf and Verrocchio's putto cannot be mere coincidence. Barbino, like Verrocchio's putto, restrains the slippery fish, and like Verrocchio's sculpture, is symbolic of Cosimo's Augustan motto, *Festina lente*.

By 1574, at the death of Cosimo I, the scattered territories of Florence had grown in number and become consolidated into a larger state; the government had been reorganized from the ground up and was in the service of aristocratic power; and Tuscany had been restored to prominence among the Italian states. Only under the aegis of Cosimo III over a century later, did the eclectic and encyclopedic nature of the sixteenth-century Medicean collections become classified more systematically. Cosimo III's interest in the exotic and marvelous was obviously expressed in a menagerie built in 1677 in the Boboli Gardens. This small zoo and the animal keeper's house were located in what now is known as the Limonaia. A wall surrounded the area, the facade of which had eight iron-barred windows through which the

61. See John T. Paoletti, "The Bargello David and Public Sculpture in Fifteenth-Century Florence," in *Collaboration in Italian Renaissance Art*, ed. Wendy Stedman and John T. Paoletti (New Haven: Yale University Press, 1978), 99–108; and for a thorough record of the movements of Donatello's *David* within the Palazzo Vecchio, see Francesco Caglioti, *Donatello e i Medici: Storia del David e della Giuditta* (Florence: Leo S. Olschki, 2000).

62. Corrine Mandel, "Verrocchio's *Putto with a Dolphin*: The Metamorphosis of a Medicean Symbol," in *Italian Echoes in the Rocky Mountains: Papers from the 1988 Annual Conference of the American Association for Italian Studies*, ed. Sante Matteo et al. (Provo, UT: American Association for Italian Studies, 1990), 95–109. It might also be significant that the putto with a dolphin is a well-known motif used by Augustus to claim divine lineage to Venus, and by extension, to Aeneas, the mythological founder of Rome. It is well documented that Augustus fashioned himself as the "new" Aeneas, just as Cosimo I was intent on presenting himself as the "new" Augustus and the "new" founder of Etruria. For Cosimo, the putto with a dolphin may have had Augustan/Aenean associations as well.

63. Mandel, "Verrocchio's *Putto with a Dolphin*," 97.

animals could be viewed. The animals were housed in separate enclosures, and one of them was reserved for stuffed specimens.[64] In 1757, Cambiagi records that in the zoo "were rare animals from distant lands, kept in various compartments."[65] The building was decorated to reflect the rare and curious creatures within: the external walls are patterned and enriched with sponge-like rocks and mosaic work, antique urns and fragments, together with marble statuary, both ancient and modern. It is no surprise then that the Morgante fountain, and possibly the Barbino fountain, stood like sentinels in niches at the entrance of the zoo. Cioli's fountains of Morgante and Barbino stood as prime examples of God's oddities and human marvels, as well as reflections of Medici aspiration. They found a comfortable and accommodating spot at the Medici menagerie and greeted visitors there until its transformation into a orangerie in 1785.[66]

■

64. Gurrieri and Chatfield, *Boboli Gardens*, 17–63.
65. Maria Simari, "Menageries in Medicean Florence," in *Natura Viva in Casa Medici*, ed. Marilena Mosco, exh. cat. (Florence: Centro Di, 1985).
66. Gurrieri and Chatfield, *Boboli Gardens*, 63.

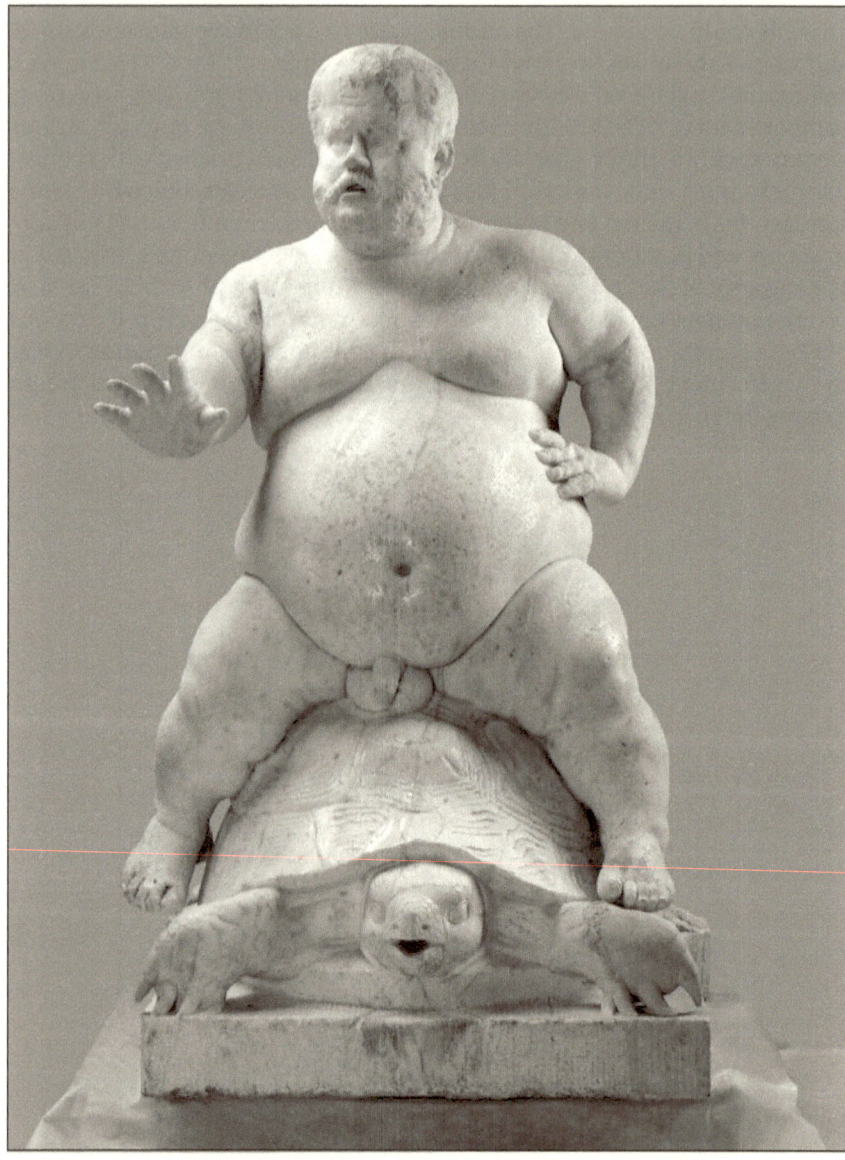

Fig. 1. Valerio Cioli, *Morgante*. Boboli Gardens, Florence, Italy. Credit: Kunsthistorisches Institut in Florenz—Max-Planck-Institut.

Fig. 2. Valerio Cioli, *Pietro Barbino*. Boboli Gardens, Florence, Italy. Credit: Kunsthistorisches Institut in Florenz—Max-Planck-Institut.

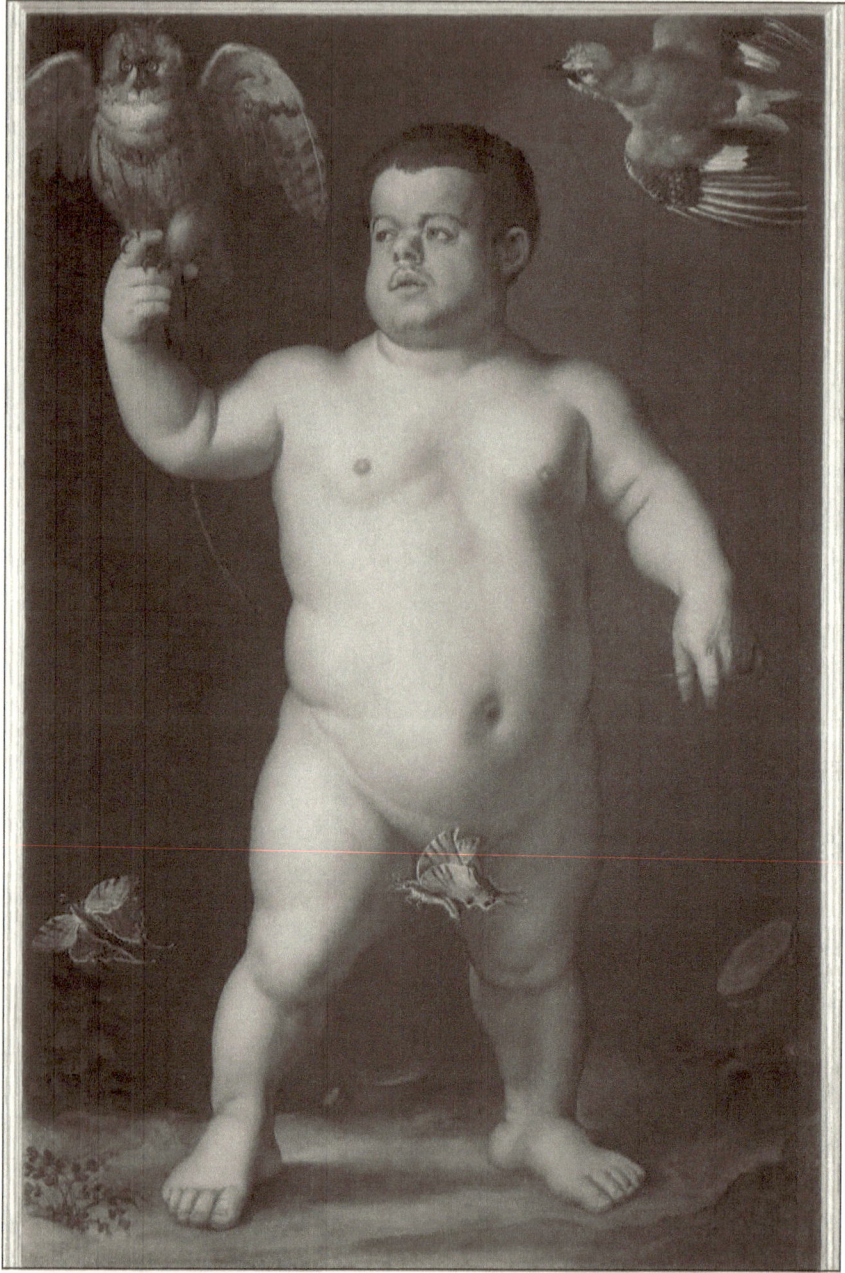

Fig. 3. Agnolo Bronzino, *Nano Morgante*. Uffizi Gallery, Florence, Italy. Photo: Scala, Florence. Courtesy of the Ministero Beni e Atti. Culturali.

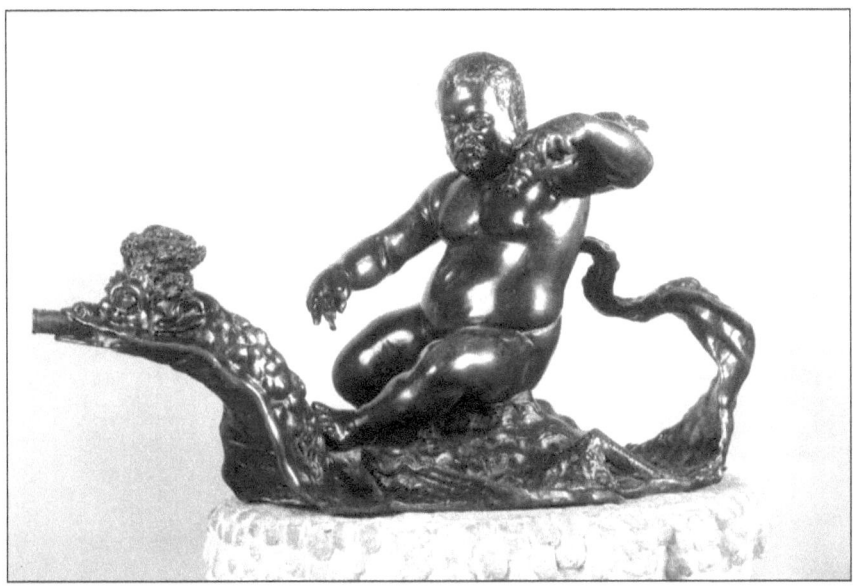

Fig. 4. Giambologna, *The Dwarf Morgante Riding on a Dragon*. Walters Art Museum, Baltimore, Maryland Credit: Wikimedia Commons, Walters Art Museum.

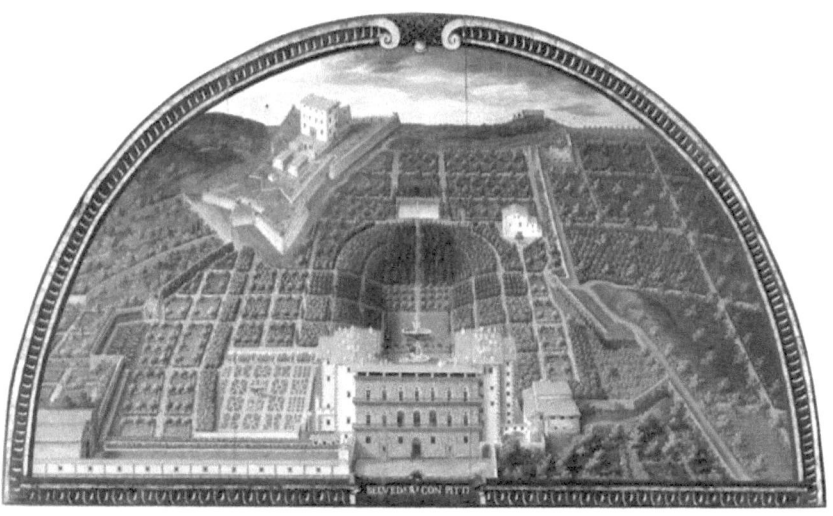

Fig. 5. Giusto Utens, *Pitti Palace and Boboli Gardens, ca. 1599*. Lunette from Museo Firenze com'era, Florence, Italy Credit: Wikimedia Commons, transferred from en.wikipedia.

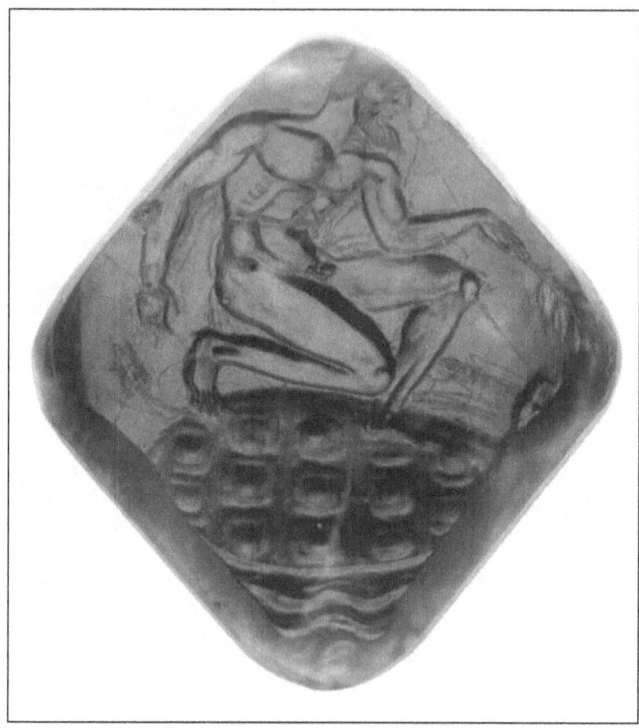

Fig. 6 (above). Moss Agate Ringstone, *Man Riding a Tortoise*. The Metropolitan Museum of Art, New York, New York Credit: The Metropolitan Museum of Art. Source: Art Resource, NY.

Fig. 7 (right). Aldus Manutius, *Festina Lente*. Imprint and motto. Credit: Wikimedia Commons, Arminiuzz.

MEDICI CONTINUITY, IMPERIAL TRADITION AND FLORENTINE HISTORY
PIERO DE' MEDICI'S *TABERNACLE OF THE CRUCIFIX* AT S. MINIATO AL MONTE

LINDA A. KOCH

The ornate tabernacle that Piero di Cosimo de' Medici (1416–69) commissioned in 1447 to house the miraculous crucifix of S. Giovanni Gualberto at S. Miniato al Monte in Florence has been recognized as a pivotal monument within the artistic patronage of the city's most powerful family (Fig. 1). First, the *Tabernacle of the Crucifix*, together with another tabernacle that he sponsored contemporaneously at SS. Annunziata for a miraculous *Annunciation*, signaled Piero's emergence as an independent patron outside the family home. It established Piero's mark for the first time in the sacred, public spaces of Florence, until then the domain of his father, Cosimo (1389–1464).[1] Second, the tabernacle introduced a kind of sumptuous, ornate decoration not associated with Cosimo's public commissions. It also incorporated the first major display of family and personal devices — notably the diamond ring, three feathers, motto SEMPER and Piero's Falcon impresa — that would later be used in a variety of family contexts.[2]

John Paoletti argued that Piero's flourish of patronage activity in the later 1440s, which also included an unsuccessful attempt to take over the decoration of the main altar at Florence Cathedral, responded to his father's wishes, was undertaken on behalf of the family and might be understood as a kind of "dynastic transfer of power from father to son." He suggested that Cosimo, then in his 60s, may have felt it wise to introduce his elder son and intended

1. The two tabernacles were Piero's only independent commissions. Subsequently he worked within the structure of corporate patronage. See John T. Paoletti, "… *ha fatto Piero con volontà del padre…*: Piero de' Medici and Corporate Commissions of Art," in *Piero de' Medici, 'Il Gottoso' (1416–1469): Kunst im Dienste der Medicieer/Art in the Service of the Medici*, ed. Andreas Beyer and Bruce Boucher (Berlin: Akademie Verlag, 1993), 211–50, esp. 222–26. For a detailed discussion of both tabernacles, see Wolfgang Liebenwein, "Die 'Privatisierung' des Wunders: Piero de' Medici in SS. Annunziata und S. Miniato," in *Piero de' Medici*, 251–90.
2. E.H. Gombrich, "The Early Medici as Patrons of Art," in *Norm and Form: Studies in the Art of the Renaissance* (London: Phaidon, 1966), 35–57 at 48; Francis Ames-Lewis, "Early Medician Devices," *Journal of the Warburg and Courtauld Institutes* 42 (1979): 122–43.

successor in the field of "visual propaganda," which had become an important vehicle for underpinning the political power of this merchant banking family in the city.[3] The commission at S. Miniato extended the Medici family's influence across the Arno to the great Romanesque basilica on the southern hill overlooking Florence.[4] At S. Miniato, as at the Annunziata, Piero continued his father's practice of taking control of altars and their attendant cults in the sacred precincts of the city through generous patronage, though uniquely he associated himself in both venues with miracle-working images.[5]

Scholarship on the *Tabernacle of the Crucifix* has largely focused on Piero's taste for rich or "princely" ornament, his "privatization" of miraculous images, and his inclusion of several new Medici devices.[6] What has been missing is an explanation of how these aspects of Piero's patronage at S. Miniato play into a larger coordinated program, including the deeper meanings embedded in the tabernacle's form and decoration, how the monument relates thematically to the Romanesque church in which it stands, and how its iconography relates to and informs its main function — to preserve an old medieval crucifix purported to have miraculously nodded its head to a local saint named Giovanni Gualberto in the eleventh century.

Certainly, there are factors that hamper study of the tabernacle. Little documentation exists for either the tabernacle or the church of S. Miniato during this period. Except for two brief notices regarding the commission dating June 27, 1447 and June 10, 1448, most of the contemporary documents of the Arte di Calimala, the guild in charge of the church that granted Piero permission to erect the structure, are lost.[7] In addition to the lacuna of written documentation for activities at the church, the crucifix of Giovanni

3. Paoletti, "...ha fatto," 222–26. On Cosimo's poor health and his concerns with death, see the assessment by Dale Kent, *Cosimo de' Medici and the Florentine Renaissance* (New Haven and London: Yale University Press, 2000), 138–41, at 242.

4. Cosimo, however, had patronage obligations at the church of S. Salvatore al Monte just below S. Miniato until c.1458. See Kent, *Cosimo*, 80, 107, 356, 434 n. 11.

5 See John T. Paoletti, "Strategies and Structures of Medici Artistic Patronage in the 15th Century," in *The Early Medici and their Artists*, ed. Francis Ames-Lewis (London: Berkbeck College, 1995), 29–36.

6. Ames-Lewis, "Early Medician Devices"; and Liebenwein, "Die 'Privatisierung'."

7. Transcriptions of the documents for the tabernacle, preserved in the MS of Sen. C. Strozzi, are found in Giovanni F. Berti, *Cenni storici per servire di guida ed illustrazione alla basilica di S. Miniato al Monte* (Florence: Tipografia Baracchi, 1850), 151; Giorgio Vasari, *Le vite de' più eccellenti pittori, scultori, e architettori*, ed. Karl Frey (Munich: G. Müller, 1911), 234; and Francesco Gurrieri Luciano Berti and Claudio Leonardi, *La basilica di S Miniato al Monte a Firenze* (Florence: Cassa di Risparmio di Firenze, 1988), 119–20. Miranda Ferrara and Francesco Quinterio, *Michelozzo di Bartolommeo* (Florence: Salimbeni, 1984), 244, asserted that no documents relative to the tabernacle exist at the monastery of S. Miniato. The lacuna of Calimala records for this period, with the exception of those copied by Sen. Strozzi (see n. 8), are the result an eighteenth-century fire, as explained in Richard Krautheimer, *Lorenzo Ghiberti*, 2 vols. (Princeton: Princeton University Press, 1970), 2:362.

Gualberto is no longer preserved in the tabernacle. It was removed in 1671 and transferred to the church of Sta. Trinita.[8]

Today the tabernacle displays a set of trecento panels attributed to Agnolo Gaddi that includes standing figures of St. Giovanni Gualberto and St. Minias (the latter of whom is the church's patron and namesake) and smaller panels with scenes from Christ's life. Although there has been debate about when the panels were placed in the tabernacle, it seems logical, as Liebenwein argued, that they were installed in the tabernacle upon its completion as a cover for the miraculous crucifix.[9] The brilliant panels assembled within a gilded framework would have put an appropriate finishing touch on the new and sumptuous enclosure for the crucifix. While painted crosses in Italy were not typically preserved behind such covers, the reputation of the crucifix of S. Giovanni Gualberto as a miraculous image explains its special treatment. The "veiling" of miraculous images was customary in late medieval and Renaissance Florence. Just as with other modes of enshrinement of these images, such as their enclosure behind grilles, their "veiling" served to distance worshippers from them, thus enhancing their cultic powers. Clergy would ritually unveil them on feast days and for other special occasions.[10]

Despite the crucifix's removal in the seventeenth century and scant documentation for the church in the mid-quattrocento, there are visual and historical sources that can lead us to a fuller understanding of the tabernacle. Investigation of artistic models for the monument's design, as well as consideration of S. Miniato's history and decoration, yields insights into the tabernacle's meaning and Piero's strategies for the promotion of continuous Medici authority. This study argues that the tabernacle's most

8. Berti, *Cenni storici*, 64.
9. Liebenwein, "Die 'Privatisierung'," 275, proposed that the head was visible for daily viewing (presumably exposed in the spot where the Ascension panel is located) while the entire crucifix would be open to view on special occasions. That it was installed in the tabernacle only after the crucifix's removal in 1671 to fill the gap left there, see Walter and Elizabeth Paatz, *Die Kirchen von Florenz*, 5 vols. (Frankfurt am Main: Vittorio Klostermann, 1952–55), 4:280 n. 143, who, nevertheless, proposed (233) that in a different arrangement the panels decorated the altar before the tabernacle was erected. See also Bruce Cole, *Agnolo Gaddi* (Oxford: Clarendon Press, 1977), 52–53. Miklòs Boskovitz's review of Bruce Cole, *Agnolo Gaddi*, in *Art Bulletin* 60 (1978): 707–11, esp. 709.
10. Liebenwein, "Die 'Privatisierung'," 275, 290 n. 11, cites a Florentine law of 1435 aimed at limiting exposure of the Virgin of Impruneta because "sacred objects...are normally respected and held in greater reverence if they are rarely seen," while excessive exposure of them might diminish their power and devotion to them. Written sources confirm that in the fifteenth century restrictions were placed on access to the Virgin of the Annunziata, for which Piero had provided his other tabernacle, and on the viewing of other sacred objects. See Richard C. Trexler *Public Life in Renaissance Florence* (Ithaca and London: Cornell University Press, 1980), 98–99. Recently on the veiling of miracle-working images in Florence, see Meghan Holmes, "Miraculous Images in Renaissance Florence," *Art History* 34 (2011): 432–65, esp. 439–45, 453, 455–57.

important visual model was a sarcophagus with imperial associations in Byzantine Ravenna but that its design and symbolism concomitantly allude to the Holy Sepulcher in Jerusalem. Furthermore, it will be shown that Piero's emulation of Christian imperial traditions that historically had aimed at dynastic statements, including emperors' historical role as the protectors of the Cross of the Crucifixion, are crucial for understanding the tabernacle's program. Finally, I will suggest that Piero de' Medici, in constructing a universal significance for a local miracle-working image, not only promoted his family but significantly enhanced and dignified the crucifix's cult at the church of S. Miniato al Monte.

THE TABERNACLE OF THE CRUCIFIX IN SITU: LOCATION, FORM AND CULT

The *Tabernacle of the Crucifix*, attributed by Vasari to Michelozzo, rises prominently in the nave of S. Miniato just before the crypt and elevated presbytery (Fig. 2). A classicizing barrel-vaulted structure, it was built over the old Romanesque altar, which was shifted ninety degrees from a horizontal position to a lengthwise arrangement to accommodate the tabernacle's depth (Fig. 3).[11] The old altar underlies and forms the central support for the current mensa of red marble, or *rosso antico*, which is further supported at its extremities on Ionic colonettes. The tabernacle rests in front on unfluted Composite columns and in the back on fluted Corinthian pilasters engaged into the rear wall enclosure (Figs. 1, 4). The richly carved marble arches at front and back of the canopy terminate in leafy scrolls, the fronts of which display small balls alluding to the Medici *palle*. The extrados of the arches carry oak-leaved garlands tied with ribbons. The glazed-terracotta roof by Luca della Robbia is decorated with a pattern of green, mauve and white scales; while the inner ceiling, also in Della Robbia glazed terracotta, consists of octagonal blue-and-white rosette-filled coffers. The entablature frieze and the entire back side of the tabernacle are incrusted with white and dark green marble (Figs. 4, 5).

Integrated into this rich profusion of ornament are several Medici devices. The canopy's green, mauve and white scales represent the Medici livery colors (Fig. 6). Repeated in series along the inner and outer friezes of the entablature in marble intarsia is the diamond ring with three feathers intertwined with a fluttering banderole bearing the motto "SEMPER." Dominating the upper lunette on the back side is a white marble relief with Piero's impresa of the falcon clutching a diamond ring and banderole again inscribed SEMPER (Fig. 7). The diamond ring is also found repeated throughout the iron grille that encloses the holy precinct on three sides (Fig. 1).[12] Both the diamond ring

11. Paatz, *Die Kirchen*, 4:232–33.
12. For the Medici emblems displayed on the tabernacle see also Francis Ames-Lewis, "Early Medici

and the motto SEMPER have implications for continuity, the significance of which will be enhanced through our investigation of the tabernacle's program. Following a stipulation of the Arte di Calimala in the June 1448 document, the eagle emblem of the Calimala crowns the summit of the arch at front and back. This document suggests some tension between the guild and Piero regarding the display of insignia.[13]

The so-called crucifix of S. Giovanni Gualberto, for which the tabernacle was created, is a large medieval painted image of Christ on the Cross that today is very dark due at least in part to heavy repainting. Although difficult to date, it is probably of the twelfth or thirteenth century, much later than the miracle is reported to have occurred.[14] According to Giovanni Gualberto's legend, one day while still a young man he encountered the murderer of his relative on the road into Florence. As the enemy, asking for mercy, fell to his knees and made the sign of the cross with his arms, Gualberto pardoned him and then went inside the church. As he knelt before the crucifix, it nodded its head in approval of the mercy he had shown. The miracle of the moving crucifix triggered Gualberto's conversion to the religious life. He entered the monastery at S. Miniato and later went on the found the Vallombrosan Order.[15]

Little is known for certain about the cult of the miraculous crucifix at S. Miniato before Piero commissioned his tabernacle. Early versions of Giovanni Gualberto's *vita* do not even locate the miracle at S. Miniato, only at a church.[16] Only with the Vallombrosan *vita* of c.1310 did the miracle's association with S. Miniato, where Gualberto began his religious calling, become established. Shortly thereafter

Devices," *Journal of the Warburg and Courtauld Institutes* 42 (1979): 122–43; and Liebenwein, "Die 'Privatisierung'," 277–79.

13. The bronze eagles were executed by Maso di Bartolommeo in early 1449. For the relevant expenses from his *Libro di Ricordi*, see Allan Marquand, *Luca della Robbia* (Princeton: Princeton University Press, 1914; repr. New York: Hacker Art Books, 1972). On the reluctance of the Arte di Calimala to allow Piero to display his and his family's insignia, see Linda A. Koch, "Power, Prophecy, and Dynastic Succession in Early Medici Florence: The Falcon Impresa of Piero di Cosimo de' Medici," *Zeitschrift für Kunstgeschichte* 73 (2010): 507–38, esp 515; also Liebenwein, "Die 'Privatisierung'," 277, who noted that Piero had been a member of the Calimala since 1439.

14. For a discussion and illustration of the crucifix of S. Giovanni Gualberto, with references to earlier sources, see Cristina de Benedictis, "La pittura del duecento e del trecento in S. Trinità," in *La Chiesa di Santa Trinità*, ed. Giuseppe Marchini and Emma Michelletti (Florence: Cassa di Risparmio di Firenze, 1987), 89, illustration p. 93, fig 62.

15. On Giovanni Gualberto and his legend, see *Bibliotheca Sanctorum* 6 (Rome: Istituto Giovanni XXIII nella Pontificia Università Lateranense, 1965), 1012–32; A. Degli' Innocenti, "Le vite antiche di Giovanni Gualberto: Cronologia e modelli agiografici," *Studi medievali* 25 (1984): 31–91. For a list of the *vite* from the eleventh to the fifteenth century and painted images of the saint, especially of the fourteenth and fifteenth centuries, see also *Iconografia di S. Giovanni Gualberto: La pittura in Toscana*, ed. Anna P. Rizzo (Vallombrosa and Florence: Ed. Vallombrosa, 2002).

16. *Bibliotheca Sanctorum* 6:1115–16; Paolo di Re, *Giovanni Gualberto nelle fonti dei secoli XI-XII: Studio critico, storico, agiografico* (Rome: Nuova grafica artigiana, 1974), 24–25.

Giovanni Villani, in his *Chronicle of Florence* (before 1348), not only placed the miracle at S. Miniato but also situated Gualberto's encounter with his enemy very near the church ("assai presso della chiesa di S. Miniato al Monte"). Villani did not, however, specifically mention the preservation of a miraculous crucifix at the church. He only described the miracle as "an open miracle seen by all."[17] Nor did Villani describe a cult following for the crucifix. That he did not mention any special devotion to the crucifix marks a contrast to his treatment of other miraculous images in Florence, such as the Virgin at Orsanmichele, where he not only described an "open miracle" but also told of the many pilgrims who came to venerate the image.[18] His silence on the crucifix at S. Miniato suggests that its cult developed only later in the trecento. The earliest mention of the crucifix is from 1384, when chronicles describe how it was carried in procession from S. Miniato through Florence to the cathedral to celebrate the city's victory over Arezzo.[19]

The absence of documentation for the cult of the crucifix at S. Miniato has left open the question of the crucifix's location in the church before Piero's intervention in 1447. It seems unlikely, as some have suggested, that it was kept in the crypt and transferred out of this location only upon completion of the tabernacle.[20] The crypt had always been dedicated to the relic cult of the church's patron, St. Minias, whose altar still occupies a central position there, directly below the high altar in the elevated presbytery.[21] It seems more likely, as others

17. Giovanni Villani, *Cronica*, 4 vols., ed. F.G. Dragomanni (Florence: S. Coen, 1844–45; repr., Frankfurt: Minerva G.M.B.H, 1969), 1:156–57: "aperto miracolo, veggenti tutti."
18. Villani, *Cronica*, 479. On the probable beginnings of the cult of the Annunciation fresco at SS. Annunziata in the 1340s, see Megan Holmes, "The Elusive Origins of the Cult of the Annunziata in Florence," in *The Miraculous Image in the Late Middle Ages and Renaissance*, ed. Erik Thunø and Gerhard Wolf (Rome: L'Erma di Bretschneider, 2004), 97–121. On Florence's miracle-working Virgins, see Richard C. Trexler, "Florentine Religious Experience: The Sacred Image," *Studies in the Renaissance*, 19 (1972): 7–41, at 11; and, more recently, Hayden B.J. Maginnis, *The World of the Early Sienese Painter* (University Park: Pennsylvania State University Press, 2001), 165–67. Most recently on miracle-working images in Florence see Holmes, "Miraculous Images."
19. Felicity Ratté, "Creation of a Cult Image: The Crucifix of S. Giovanni Gualberto in Fourteenth-Century Florence" (Forthcoming). See also the chart on the relative chronology of the development of image cults in Florence in Holmes, "Miraculous Images," 434.
20. Among those assuming that the crucifix was kept in the crypt are Giuseppe Richa, *Notizie storiche delle chiese fiorentine*, 10 vols. (Florence: Pietro Gaetano Viviani, 1754–62; repr., Rome: Multigrafica Editrice, 1972), 3:171; Berti, *Cenni storici*, 64; Liebenwein, "Die 'Privatiersung'," 271. Similarly unsupported by documentation are observations that the crucifix was placed in the tabernacle in either 1448 or 1466. Richa, 172, proposed c.1466; Paatz, *Die Kirchen*, 5:366, suggested 1448 or 1466; Liebenwein, "Die 'Privatisierung'," 272, upheld the 1466 date, despite the tabernacle's completion by 1452 at the latest.
21. Calimala documents between the years 1335 and 1342 indicate expenses to embellish the altar of St. Minias for celebration of the cult, including the installation of an iron grille around it. It it enticing to connect a document of the same date with the miraculous crucifix, but the wording is too vague and, again, the location not specified: "Paghisi fior. 8 soldi 25 per l'accrescimento della croce della chiesa di S. Miniato." For the documents, see Vasari-Frey, *Le vite*, 321–22. Further on the promotion of St. Minias's cult in this period see note 24 below.

have presumed, that the crucifix was located on the old Romanesque altar in the center of the nave just before the entrance to the crypt where the tabernacle was erected.[22] Its traditional location here is supported by the wording of the 1447 document: "L'altare del Crocifisso possa essere ornato da un cittadino grande che si offerirà un tabernacolo di grande apparenza e spesa."[23]

Whatever the relative popularity of the Gualberto crucifix may have been among the miraculous images of Florence, the invigoration of its cult may well have been the ostensible reason for Piero's tabernacle commission. The challenge of promoting a holy cult at the church of S. Minato, located far from the city center, is evident from the only-partially successful efforts to increase pilgrimage and devotion to the relic cult of St. Minias in the trecento.[24] Still, the duty of Florence's civic institutions to "maintain and augment" holy objects and images, and the recognition by these institutions that the value attached to holy objects by honorable families increased the value of these objects in the minds of the faithful, may have played a role in the Calimala's acceptance of Piero's offer to provide a "tabernacle of great beauty and expense" and, even, to include his family's insignia.[25] It was within the context of a generous and expensive embellishment to the church and crucifix cult that Piero, I will argue, simultaneously promoted both his family's authority and his own future control over Florentine government after his father's death.

AN IMPERIAL MODEL IN RAVENNA

Fundamental to our elucidation of the tabernacle's program is the identification of an important model for the structure's design. As a canopy supported on columns and pilasters placed over a free-standing altar, it descends, of course, from ciboria of the type found in the medieval churches of Rome. At the same time, with its back wall closed to support an image, it has precedents in earlier shrines for miraculous images, such as Orcagna's Orsanmichele Tabernacle (1355–66). Despite these typological prototypes, the closest visual parallels for the barrel-vaulted structure at S. Miniato are found in the former imperial city of Ravenna. The tabernacle bears a striking resemblance

22. For example, Paatz, *Die Kirchen*, 4:232–33, 279; Cole, *Agnolo Gaddi*, 52; Francis Ames-Lewis, "Art in the Service of the Family: The Taste and Patronage of Piero di Cosimo de' Medici," in *Piero de' Medici*, 207–20, at 207.
23. See above, n. 6.
24. On efforts to promote the cult of St. Minias through the relics and decorative program at S. Miniato during the Middle Ages, see Scott B. Montgomery, "*Quia Venerabile Corpus Redicti Martyris ibi Repositum*: Image and Relic in the Decorative Program of S. Miniato al Monte," in *Images, Relics, and Devotional Practices in Medieval and Renaissance Italy*, ed. Sally J. Cornelison and Scott B. Montgomery (Tempe, AZ: ACMRS, 2006), 7–25.
25. On the interplay of Florence's civic institutions, honorable families and the faithful in assuring devotion to holy images and objects, see Trexler, *Public Life*, 93–99.

to a group of antique Christian sarcophagi unique to that city and its vicinity characterized by semi-cylindrical lids and rectangular chests framed with classically-derived architectural members. Notably, a few examples of these "architectural sarcophagi" possess lids decorated with a pattern of scales, just as found on the vaulted roof of the S. Miniato tabernacle.[26]

While the scale-covered, barrel-vaulted sarcophagus type as a whole could have provided a point of reference for Piero and his artists, one particular scale-covered sarcophagus was no doubt the single most important model. This is the example located in the right-hand niche of the cruciform chamber known as the Mausoleum of Galla Placidia (Fig. 8).[27] This tomb, both finely carved and imposing in scale, not only displays crosses on its front but also possesses a combination of architectural and decorative features that have remarkable correspondences in the tabernacle. In addition to the scales on its lid, fluted Corinthian pilasters frame the corners of the sarcophagus chest. Although simplified from their classical precedents, they find parallels in the pilasters framing the tabernacle's rear wall (Figs. 4, 5). Further, although the sarcophagus lacks the full classicizing entablature found in the tabernacle, such an entablature is suggested by a molded lintel partially supported by the pilasters that runs along the top of the chest. Finally, the guilloche pattern decorating the lower border of the sarcophagus lid is echoed by the repeated pattern of intertwined ribbons bearing Piero's motto that runs along the inner and outer friezes of the tabernacle (Figs. 6, 8).

This sarcophagus, one of three tombs occupying the niches of the Mausoleum of Galla Placidia, was admired by one of Cosimo de' Medici's closest friends, the ecclesiastical humanist and champion of Christian antiquity, Ambrogio Traversari (1386–1439), who visited Ravenna in December 1433.[28] In his *Hodoeporicon*, the written account of his travels, Traversari described it, writing: "Nearby we saw a little sanctuary building containing a remarkable royal tomb of dazzling white marble and having a lid covered with scales."[29] Traversari

26. On the sarcophagus type, including the assertion that it is geographically limited to Ravenna and environs, see Marion Lawrence, *The Sarcophagi of Ravenna* (Rome: L'Erma di Bretschneider, 1970), 1–2, 29. To my knowledge only two scholars have noted this resemblance and did so only in passing: Ferrara and Quinterio, *Michelozzo*, 244 ("The estradosso in multicolored scales derived from the covers of romano-byzantine sarcophagi"); and Lorenzo Gnocchi, "Le preferenze artistiche di Piero di Cosimo de' Medici," *Artibus et Historiae* 18 (1988): 41–78, at 48. I made the observation independently.
27. On the sarcophagus in the mausoleum of Galla Placidia, see Lawrence, *Sarcophagi*, 33–35.
28. On Traversari's friendship with Cosimo, see Charles Stinger, *Humanism and the Church Fathers: Ambrogio Traversari (1386–1439) and Christian Antiquity* (Albany: State University of New York Press, 1977), 30–34. For Traversari's influence on artistic matters in Florence, idem, "Ambrogio Traversari and the 'Tempio degli Scolari' at S. Maria degli Angeli in Florence," in *Essays Presented to Myron P. Gilmore*, 2 vols. (Florence: La Nuova Italia, 1978), 1:271–86.
29. "Aediculam prope fanum vidimus, sepulcra Regum ex marmore candido ingentia, habentem,

was more explicit as to its "royal" occupant in a letter to his humanist friend in Florence, Niccolò Niccoli (1364–1437): "a tabernacle [the mausoleum] near the temple [S. Vitale] preserves the magnificent tombs of white marble of Augusta Placidia and Valentinian the Elder."[30] Throughout the Middle Ages and Renaissance the scale-covered sarcophagus was held to be the tomb of Emperor Valentinian III, the son of Galla Placidia. It was in Valentinian's place that Placidia ruled as regent in Ravenna beginning in 425 CE. The sarcophagus in the niche opposite the entrance was believed to be the tomb of the empress herself, while the sarcophagus in the left niche, not mentioned by Traversari, was thought to be that of her second husband, Constantius III.[31]

While Traversari may have stimulated the Medici family's interest in the mausoleum, Cosimo and the young Piero could have visited the Adriatic city themselves.[32] In fact, most educated Florentines would already have been well aware of Ravenna's prestigious past as capital of the western empire and Byzantine outpost from histories of Florence. In his *Chronicle*, Villani had proclaimed that "the city of Ravenna in Romagna...was the greatest and most famous city of Italy next to Rome."[33] Leonardo Bruni's *History of Florence* (completed in 1416), a copy of which is recorded in Piero de' Medici's library, abounds with historical details about Ravenna and the emperors associated with that city.[34] Bruni himself had visited Ravenna in 1410. Of Galla Placidia and the Theodosian dynasty to which she belonged Bruni wrote, "Galla

squamatis operculis." From Alessandro Dini-Traversari, *Ambrogio Traversari e i suoi tempi* (Florence: Seeber, 1912), appendix: *Hodoeporicon*, 102. For the full account of his visit to Ravenna, see 101–4. In Italian translation, see Ambrogio Traversari, *Hodoeporicon*, ed. and trans. Vittorio Tamburini (Florence: Leice le Monnier, 1985), 193-97.

30. "Sacellum fano propinquum, Placidiae Augustae, et Valentiniani Senioris sepulcra magnifica servat ex marmore candido." Quoted from *Ambrosii Traversarii Generalis Camaldulensium aliorumque ad ipsum*, 2 vols. (Florence: Caesarco, 1759; repr. Bologna: Forni, 1968), 2:421. In the same letter he mentions several Christian emperors, including Theodosius, Placidia and Charlemagne. A large portion of the letter is quoted in Michael Baxandall, *Giotto and the Orators: Humanist Observers of Painting and the Discovery of Pictorial Composition, 1350–1450* (Oxford: Clarendon Press, 1971), 152-54.

31. Traversari appears to have erred in calling the scale-lidded sarcophagus the tomb of the elder Valentinian, Galla Placidia's grandfather. Some modern scholars have identified it as that of Honorius, Galla Placidia's half-brother, also mistakenly. Medieval and Renaissance writers consistently refer to it as Valentinian's. For Concorreggio, see Corrado Ricci, "Il Sepolcro di Galla Placidia in Ravenna," *Bolletino d'arte* 7 (1913): pt. 1, 389-418 at 390ff; and Desiderio Spreti (1414–74), in his history of Ravenna (c.1460; first published 1489): *Desiderii Spreti Libri III:* I. De amplitudine, II. de vastione, et III. de instauratione urbis Ravennae (Venice: Guerraea, 1588), 8.

32. Cosimo and Piero may have visited Ravenna in 1433/34 on their way into exile in Venice. Earlier, in a letter of Dec. 30, 1430, Cosimo mentioned his plan to take the road by Ravenna on his way to Venice. See Janet Ross, *Lives of the Early Medici, as Told in Their Correspondence* (Boston: R.G. Badger, 1911), 17.

33. Villani, *Cronica* I, for example, 87–89, 94.

34. Francis Ames-Lewis, *The Library and Manuscripts of Piero di Cosimo de' Medici* (New York and London: Garland, 1984), 289.

A SCARLET RENAISSANCE ■

Placidia...was taken in marriage by King Athaulf. After his death...she was married to Constantius, a remarkable man, to whom she bore Valentinianus, the next emperor after Honorius."[35] For Florentines and other Renaissance visitors, then, the mausoleum and its sarcophagi would have resonated with Christian imperial and dynastic associations.

THE CULT OF SPOLIA AND IMITATION

In modeling the *Tabernacle of the Crucifix* at S. Miniato on an imperial monument in Ravenna, Piero and his artists followed a well-known medieval tradition.[36] The imitation of monuments from Ravenna, as well as the extraction of actual spolia from the city, was a practice that had been inaugurated by the Lombards and Charlemagne.[37] Even before his coronation as Holy Roman emperor, Charlemagne (771–814) had his new palace chapel at Aachen modeled after the church of S. Vitale in Ravenna.[38] Moreover, as reported by his biographer, Einhard, the king brought columns and marbles from Rome and Ravenna in order to build the "basilica," citing the unavailability of suitable materials elsewhere.[39] Charlemagne also took statues and other ornaments from Ravenna, including a gilded equestrian thought to represent the Ostrogoth king Theodoric (489–526), who had been given the imperial regalia by the Byzantine emperor Zeno.[40]

Charlemagne's appropriation of the forms and materials of Ravenna's monuments, as well as his transport of columns from Rome, was charged with political symbolism.[41] It was part of a larger strategy by which he claimed

35. Leonardo Bruni, *History of the Florentine People*, 3 vols. (Cambridge: Harvard University Press, 2001), 1:54. That Bruni visited Ravenna, see Girolamo Mancini, *Vita di Leon Battista Alberti* (Rome: Bardi, 1971), 324, citing "Leonardi *arretini*," esp. 9, lib. III.
36. On Piero's strict supervision of commissions, see Gombrich, "Early Medici," 47.
37. On the Lombards and Ravenna, see Angiola M. Romanini, et al., *L'arte medievale in Italia* (Milan: Sansoni, 1996), 161ff; and Carla Giovannini and Giovanni Ricci, *Le città nella storia d'Italia: Ravenna* (Bari: Laterza, 1985), 90.
38. Günther Bandmann, *Mittelalterliche Architektur als Bedeutungsträger* (Berlin: Gebr. Mann, 1985), 105ff; Carol Heitz, *L'architecture religieuse carolingienne: Les formes et leurs fonctions* (Paris: Picard, 1980), 68, 71.
39. Einhard, *The Life of Charlemagne*, trans. S.E. Turner (Ann Arbor: University of Michigan Press, 1985), 54.
40. Charlemagne's confiscation of building materials and statuary from Ravenna was mentioned by Spreti, *Desiderii Spreti Libri iii*, 9; see also Donald Bullough, *The Age of Charlemagne* (New York: Putnam, 1966), 149. On Theodoric, see Giovannini and Ricci, *Ravenna*, 39ff; and Paolo Verzone, *The Art of Europe: The Dark Ages from Theodoric to Charlemagne* (New York: Greystone Press, 1968), 46ff.
41. On the political significance of the cult of spolia and imitation, see Lucilla del Lachenal, *Spolia: Uso e reimpiego del antico dal III al XIV secolo* (Milan: Longanesi, 1995), 15, 47, 109ff.; Dale Kinney, "The Concept of Spolia," in *A Companion to Medieval Art: Romanesque and Gothic in Northern Europe*, ed. Conrad Rudolph (Malden and Oxford: Blackwell Publishing, 2006), 233–52; with special consideration of papal Rome, see Karl Noehles, "Die Kunst der Cosmaten und die Idee der Renovatio Romae," in *Festschrift Werner Hager*, ed. Günter Fiensch and Max Imdahl (Reckinghausen:

succession from the Byzantine and earlier Roman emperors and signaled the transfer of empire northward to the Franks. Concomitantly, in the literature of the Carolingian court, Aachen was proclaimed the new Constantinople and the new Rome. Charlemagne's visual display vis-à-vis Ravenna and Rome promoted both the legitimacy of his imperial rule in the West and the notion of dynastic continuity. It worked hand-in-hand with the formulation by his court of a genealogy that traced his lineage back to Constantine the Great. Charlemagne was hailed as the new Constantine in an act of genealogical mythmaking that imitated the practice of the Byzantine emperors themselves.[42] The claims of legitimacy and dynastic continuity that these artistic and literary strategies advanced served successive Holy Roman emperors in perpetuating the idea, if not the reality, of an *Imperium Romanum* in the West. Many followed in Charlemagne's footsteps making politically symbolic journeys to Ravenna and sometimes despoiling the city's monuments. The last imperial depredations on record are those of Frederick II in 1240.[43]

However, two centuries later, in late 1448 or early 1449, Sigismondo Malatesta, lord of Rimini, had his soldiers strip the precious colored marbles from the walls of Sant' Apollinare in Classe outside Ravenna and cart them back home. In Rimini they were used in the redecoration of the church of S. Francesco, now known as the Malatesta Temple, which Sigismondo was having transformed into a monument intended, at least in part, to glorify himself and his family.[44] Notably, Sigismondo's spoliation at Ravenna occurred just at the time Piero's tabernacle was being created. Sigismondo was on good terms with the Medici and it is not unlikely that he and Piero communicated about their respective commissions around this time.[45] Yet Piero did not use spolia from Ravenna in the tabernacle but employed the alternate time-honored means of making meaningful reference to Ravenna — imitation.[46]

Bongers, 1966), 17–37, esp. 23 for Charlemagne.
42. Marie Tanner, *The Last Descendent of Aeneas: The Hapsburgs and the Mythic Image of the Emperor* (New Haven: Yale University Press, 1993), 82, 186, 197, 271 n. 27.
43. On the spoliation of Ravenna's monuments by Frederick and other Holy Roman emperors, see Giovannini and Ricci, *Ravenna*, 1–3, 90. A surviving document recording Frederick II's visit to the Mausoleum of Galla Placidia in 1231 includes mention of three sarcophagi. See Corrado Ricci, "Il Sepolcro," 400.
44. Corrado Ricci, *Il Tempio Malatestiano* (Milan and Rome: Bestetti & Tumminelli, 1925), 210–14; Charles Mitchell, "An Early Christian Model for the Tempio Malatestiano," *Intuition und Kunstwissenschaft: Festschrift für Hanns Swarzenski*, ed. Peter Bloch et al. (Berlin: Gebr. Mann, 1973), 427–38. Marilyn Aronberg Lavin, "Piero della Francesca's Fresco di Sigismondo Pandolfo Malatesta before St. Sigismund: ΘΕΩΙ ΑΘΑΝΑΤΩΙ ΚΑΙ ΤΗΙ ΠΟΛΕΙ," *Art Bulletin* 56 (1974): 345–74.
45. On April 7, 1449, Sigismondo wrote to Piero's brother, Giovanni de' Medici, regarding an artist working in the St. Sigismund Chapel at S. Francesco in Rimini. See Ricci, *Tempio*, 214.
46. On resorting to imitation to invoke the antique where spolia was not available, see Noehles, "Die Kunst," 24ff. Yet the Medici had access to porphyry and serpentine in Rome and Florence, for which see Andreas Beyer, "Funktion und Repräsentation: Die Porphyry Rotae der Medici," in

Admittedly, the rich coloration and varied materials employed in the *Tabernacle of the Crucifix* differentiate Piero's monument from the scale-covered sarcophagus itself, which Traversari took care to describe as "of dazzling white marble." It is likely, however, that Piero wished the tabernacle to emulate the rich coloration of the well-preserved mosaics, polychrome marbles and stucco ornament in the Mausoleum of Galla Placidia as a whole.[47] Lorenzo Gnocchi suggested that Piero was inspired by aspects of the rich ornament of Ravenna's interiors for the decoration of his lost studiolo in the Medici Palace, executed by Luca della Robbia in the 1450s.[48] In the fifteenth century the Mausoleum of Galla Placidia had an altar with a mensa of porphyry, following the practice of Byzantine court ceremonial. Piero may have provided the slab of *rosso antico*, a frequent substitute for porphyry, that still serves as altar table within the tabernacle at S. Miniato today.[49]

Piero's strategy, like Sigismondo's, can be understood in relation to a broader phenomenon of the period — lesser authority figures, such as dukes and princes, at least nominally still subject to the German emperor, who emulated the imperial topos to bolster their legitimacy and prestige. Not unlike Sigismondo, the Medici were concerned with establishing the legitimacy and continuity of their leadership in Florence, where they had no hereditary right.[50] Adrian Randolph has argued that the Medici sought to imply their own legitimacy through display of the multivalent diamond ring (seen for the first time in the tabernacle's frieze and in the falcon impresa on back), whose varied associations included marital and monarchical ones.[51] The early Medici aspired to be the equals of the Italian princes with whom they had formed relations, and they seem to have understood as well as any the power of art to speak through visual analogy. The allusions in Piero's tabernacle to the Christian imperial sarcophagus in Ravenna could symbolically lend an

Piero de' Medici, 151-68.
47. In the fifteenth century the lower walls of the mausoleum may have displayed polychrome marbles different from the *giallo antico* seen today. The walls once displayed stucco ornament. The sarcophagus believed to be Galla Placidia's may have been faced with colored marble or metal. See Ricci, "Il Mausoleo," 17-19.
48. Gnocchi, "Le preferenze," 48-54.
49 Ricci, "Il Mausoleo," 392. The altar in the *Tabernacle of the Crucifix* has been called porphyry, but to this author's eye appears to be *rosso antico*.
50. On the illegitimacy of Medici power in the fifteenth century, see E.H. Gombrich, "The Early Medici as Patrons of Art," in *Norm and Form: Studies in the Art of the Renaissance* (London: Phaidon, 1966), 35; and Alison Brown, "Platonism in Fifteenth-Century Florence," in *The Medici in Florence: The Exercise and Language of Power* (Florence: Leo S. Olschki and Perth: University of West Australia, 1992), 215-45 esp. 216-17. For the issue of legitimacy as a concern for quattrocento Italian princes, see Anthony Grafton, *Leon Battista Alberti: Master Builder of the Renaissance* (New York: Hill and Wang, 2000), 8, 10.
51. Adrian W.B. Randolph, "Engaging Symbols: Legitimacy, Consent, and the Medici Diamond Ring," in *Engaging Symbols: Gender, Politics and Public Art in Fifteenth-Century Florence* (New Haven and London: Yale University Press, 2002), 108-37.

aura of legitimacy to Medici control of Florence while implicating the future succession of Piero within the Medici line.

THE TABERNACLE, S. MINIATO AND FLORENTINE "*ROMANITAS*"

It is probably not coincidental for the tabernacle's design and program that the church of S. Miniato al Monte benefited from imperial patronage in the Middle Ages. The first documentary record of a church of St. Minias, though not mentioned by Villani or any Florentine writer before the sixteenth century, concerns a donation made in 783 by Charlemagne for the soul of his wife, Hildegard.[52] Other documents confirm that before Florence became an independent commune other Holy Roman emperors made donations to S. Miniato and took the church under their protection. Perhaps the best known instance of imperial patronage was that of Henry II celebrated in Villani's *Chronicle*. Villani explained how, in 1013, Henry II and his wife, Empress Gunegonda, helped finance the construction of "the great and noble church of marble which is there now in our times" at the urgent request of Florentine Bishop Hildebrand. He goes on to state how "they presented and endowed the said church with many rich possessions in Florence and in the country, for the good of their souls, and caused the said church to be repaired and rebuilt of marbles, as it is now."[53]

I have previously argued that the church's history of imperial patronage helps to explain the design of the royal burial chapel of the Cardinal of Portugal, begun in 1460 off the left aisle of S. Miniato. I attempted to show that it took the Mausoleum of Galla Placidia as the principle model for its architectural form and rich decoration.[54] In that case, the imitation of an imperial monument can be explained by the fact that the young Portuguese prince, who died in Florence in 1459, was not only related to the king of Portugal but also to the Holy Roman emperor at the time, Frederick III (r.1440–93). It is more extraordinary that Piero had tapped the imperial mausoleum a full decade earlier and that his tabernacle sat close by in the nave of S. Miniato when the cardinal's chapel was erected.[55]

52. Giancarlo Setti, ed. "Regesto dell'abbazia fiorentina di S. Miniato al Monte," *La Graticola Mensile di s. Lorenzo* 4.7-8 (1976): 117–35, esp. 119. For the document, see also Luciana Mosiici, ed., *Le carte del monastero di S. Miniato al Monte (secoli IX–XII)* (Florence: Leo S. Olschki, 1990), 410–11.
53. Villani, *Cronica*, 79; for the English translation, see *Villani's Chronicle*, 37. On the chronology of the church, which was actually begun after 1014, see Walter Horn, "Romanesque Churches in Florence: A Study in Their Chronology and Stylistic Development," *Art Bulletin* 25 (1943): 112–31, esp. 124–25.
54. Linda A. Koch, "The Early Christian Revival at S. Miniato al Monte: The Cardinal of Portugal Chapel," *Art Bulletin* 78 (1996): 527–55.
55. For a proposal that Piero may have had a hand in the cardinal's chapel, see Martina Hansmann, "Die Kapelle des Kardinals von Portugal in S. Miniato al Monte: Ein dynastisches Grabmonument aus der Zeit Piero de' Medicis," in *Piero de' Medici*, 291–316.

A SCARLET RENAISSANCE ■

The significance of S. Miniato's history of imperial patronage for the program of Piero's tabernacle is suggested by another feature of its decoration, namely the falcon impresa enclosed within a tondo on the monument's back side (Fig. 7). The falcon clutching a diamond ring and banderole with the motto SEMPER was, I have proposed elsewhere, inspired by a large imperial eagle cameo of the first century CE. The cameo's importance, however, is not just that it was an imperial source for Piero's impresa, but that it is believed to have decorated the ambo of Henry II in Aachen Cathedral (of which Charlemagne's palace chapel forms part) during the Middle Ages. Having been handed down through the centuries, the imperial cameo was inserted into the ambo as spolia to promote Henry's legitimacy as emperor.[56]

The prestige of S. Miniato al Monte, while certainly due in part to its imperial patronage, was linked more broadly with the Roman heritage of Florence and her self-identity as "a little Rome." The Roman foundation of Florence had been emphasized by all Florentine writers since the earliest chronicles, and her architecture reflected this important heritage.[57] The church of S. Miniato's temple-like facade (completed in the thirteenth century) and its interior are strongly classicizing, a characteristic of the broader Florentine Romanesque style (Fig. 2). The green-and-white marble incrustation is a medieval adaptation of the polychrome marble revetment of classical Roman buildings. S. Miniato's aura of *"Romanitas"* is heightened by the presence on the interior of some antique Roman columns and capitals, actual spolia from ancient buildings in and around Florence.[58] That S. Miniato was perceived by Florentines in terms of Florence's Roman heritage is supported by the building's close stylistic affinity with the Baptistery, whose construction date is not recorded, but which local writers insisted had been a Roman Temple of Mars later re-dedicated to John the Baptist.[59] That both Filippo Brunelleschi and Leon Battista Alberti combined elements from S. Miniato and the Baptistery in their architectural designs is evidence that they closely associated the two buildings.[60]

56. Koch, "Power, Prophecy," 515–16. For the eagle cameo as spolia and Henry II's need to assert his legitimacy, see Karen Rose Matthews, "Expressing Legitimacy and Cultural Identity through the Use of Spolia on the Ambo of Henry II, *Medieval Encounters* 5 (1999): 156–83.
57. In addition to Villani, *Chronica*, and Bruni, *Istoria*, see Donald Weinstein, "The Myth of Florence," in *Florentine Studies: Politics and Society in Renaissance Florence*, ed. Nicolai Rubinstein (Evanston, IL: Northwestern University Press, 1968), 15–44 at 21; Charles T. Davis, "Topographical and Historical Propaganda in Early Florentine Chronicles," *Medioevo e rinascimento* 2 (1988): 33–51; and Stefano U. Baldassarri and Arielle Saiber, eds., *Images of quattrocento Florence: Selected Writings in Literature, History, and Art* (New Haven: Yale University Press, 2000), 3–11, 12–17, 18–24.
58. Gurrieri, Berti, Leonardi, *La basilica*, 28, with further bibliography.
59. Antonio Paolucci, ed., *Il Battistero di S. Giovanni a Firenze (The Baptistery of S. Giovanni Florence)*, 2 vols. (Modena: F.C. Panini, 1994).
60. See Howard Saalman, *Filippo Brunelleschi: The Buildings* (University Park, PA: Pennsylvania

Florentines also associated S. Miniato with the founding of Christianity in Florence. Following his martyrdom in the city during the persecutions of Decius in the third century, St. Minias carried his head across the Arno and up to the hill where the present building sits.[61] A church dedicated to the saint stood on the spot before Charlemagne's donation in 783. Notwithstanding the elevated presbytery that accommodates the unusually large crypt for Minias' relics, the simple three-aisle church plan resembles that of an early Christian basilica (Figs. 2, 9). Thus, its design elements spoke of both the Roman and Christian history of Florence. Bruni, who promoted Florence's foundation during the Roman Republic, nevertheless treated Florentine history as part of the universal history of Rome that included its continuation under the Christian emperors. He gave due attention to Ravenna's important role as temporary capital of the empire and as Byzantine outpost.[62] Though rarely mentioned, the architecture of Ravenna directly influenced Tuscan Romanesque architecture, including its method of arcading as seen at S. Miniato.[63]

Scholars have noted how the *Tabernacle of the Crucifix* is assimilated formally to the church of S. Miniato but have stopped short of seeing the assimilation as particularly meaningful.[64] Yet the tabernacle's visual echoes of the larger building endow Piero's monument with an aura of the latter's history and patronage, in the same way that Ravenna's monuments were tapped for symbolic purposes. Beyond the fact that the tabernacle's barrel-vault echoes proportionally the many round arches throughout the church presbytery, it is notable that both the intarsia frieze carrying the Medici devices of the diamond ring, feathers, and motto "SEMPER" and the entire the back side of the tabernacle take up the dichromatic scheme of dark green, or *verde di Prato*, and white marble found throughout the basilica (Figs. 5, 6).[65] In addition, the tabernacle's front columns and rear engaged pilasters are carefully attuned to the organization of structural elements in the larger church where freestanding columns, as well as columns engaged into piers, run along the nave, while pilasters frame the apse at the eastern end (Fig. 2). Also, the arrangement of the tabernacle's richly carved capitals — Composite in front and Corinthian at the back — follows the disposition of capitals in the larger church (Figs. 1, 4). The

University Press, 1993), 75–76; and Robert Tavernor, *On Alberti and the Art of Building* (New Haven: Yale University Press, 1998), 99–106.
61. Villani *Cronica*, 77–79; Montgomery, "*Quia Venerabile Corpus*," 11–12.
62. Bruni, *Istoria* 1, 1-141.
63. Rolf Toman, ed., *Romanesque: Architecture, Sculpture, Painting* (Cologne: Könemann, 1997), 74. In 1026 the Bishop of Arezzo send his architect to Ravenna to study S. Vitale. Elements of that building's design were incorporated into the cathedral of Arezzo.
64. For example, Liebenwein, "Die 'Privatiersung'," 273.
65. The facade, apse, presbytery and altars of S. Miniato employ actual marble intarsia and relief, while the nave's upper walls and arches are painted with geometric ornament in imitation of the two-tone marble scheme. See Gurrieri, Berti and Leonardi, *La basilica*, 31.

Composite order consistently appears closer to the west entrance, the place of the laity, and the Corinthian toward the east and thus the place of the high altar and clergy.[66] Finally, each of the four capitals is unique in design, echoing the variation among those in the church while not precisely replicating any one. The tabernacle's varied capitals are no doubt intended to suggest spolia, echoing the actual spolia present in the medieval church.[67] The effort of patron and artists to make connections between the tabernacle and church go beyond these key "imitative" features. Actual fragments of *verde di Prato*, that is, spolia from the church, are incorporated into the tabernacle. Long ago Paatz observed that actual Romanesque marble fragments were used: six ornamented slabs were inserted into the flooring beneath the tabernacle, and a border was formed from fragments on the upper back side (Figs. 5, 7). Moreover, the original intarsiated Romanesque altar penetrates through and forms the lower half of the tabernacle's back side, also becoming a kind of spolia.[68] The upper half of the back wall was newly created so as to fuse old with new.

The assimilation of the tabernacle's design to the medieval church and the incorporation of actual spolia from it must be understood as part of a program of meaningful reference that merged Florentine history with the history of imperial Ravenna and the larger Christian empire. Thus, while he operated within the accepted structures of religious patronage in Republican Florence, Piero de' Medici linked himself and his family with the patronage traditions of both Byzantine and Holy Roman emperors. As Alison Brown has emphasized, in spite of Florence's official republicanism, the city had developed its own rhetoric of imperium and remained, like the principalities of Italy, technically subject to the emperor.[69]

THE IMPERIAL CROSS CULT AND THE CRUCIFIX OF S. GIOVANNI GUALBERTO

It remains to explain how the tabernacle's program as elucidated thus far relates to its function of housing the crucifix of S. Giovanni Gualberto. One key may be the central role played by the Cross in the Christian imperial tradition. Constantine the Great's legendary vision of the Cross, and his subsequent victory over Maxentius at the battle of the Milvian Bridge under

66. John Onians, *Bearers of Meaning: The Classical Orders in Antiquity, the Middle Ages, and the Renaissance* (Princeton: Princeton University Press, 1988), 103–4, 141–46.
67. That the variety of capitals in the tabernacle was intended to give the illusion that here, as in the rest of the church, remnants were employed was suggested by Fedele Tarani, *La Basilica di S. Miniato al Monte: Guida storica-artistica* (Florence: Tipografia Arcivescovile, 1909), 57.
68. For the original observation that the Romanesque altar penetrates through and forms the lower back side of the tabernacle, see Paatz, *Die Kirchen*, 4:2–233, 278 nn. 135–37.
69. Alison Brown, "The Language of Empire," in *Medicean and Savonarolan Florence: The Interplay of Politics, Humanism, and Religion* (Turnhout: Brepols, 2011), 247–62.

this sign in the early fourth century, not only established the Cross as an eternal symbol of the Roman Empire but linked for all time the continuity of the empire with Christian salvation history.[70] The centrality of the Cross in imperial contexts following Constantine is evident in the fifth-century Mausoleum of Galla Placidia where it is the overriding leitmotif of the entire monument. A cross hovers in the star-filled sky of the mausoleum's vault, a probable allusion to Constantine's vision as it simultaneously expresses the causal link between Christ's sacrifice and triumph and man's redemption following Christ's return. In the lunette mosaics above the entrance and on the wall opposite, the Good Shepherd and St. Lawrence also carry large crosses. The scale-covered sarcophagus also displays crosses — two appear under triumphal arches, a triumphal arch-cum-cross combination that, incidentally, was echoed by a frontal view of the tabernacle in S. Miniato at the time the crucifix was displayed inside (Figs. 2, 8). Significantly, too, the mausoleum's ground plan itself forms a cross through its deep transept-like niches, or arms, which in turn echo the shape of the church of Sta. Croce, or "Holy Cross," to whose narthex it was still attached in the fifteenth century.[71] Sta. Croce was one of several churches Galla Placidia built in Ravenna during her regency to promote the continuity of the Theodosian-Valentinian Dynasty and the legitimacy of her rule in the West.[72]

In Florence, Cosimo de' Medici may have begun to link the message of dynasty within his family to the veneration of the cross in the early 1440s with the *Crucifixion* fresco in the antechamber to his cell at the monastery of S. Marco. There, kneeling in adoration of the Crucified Christ in the company of the Virgin Mary are the namesake saints of the Medici: Cosmas (Cosimo), Peter Martyr (Piero) and John the Evangelist (Giovanni di Cosimo). While the depiction of kneeling figures before the cross is certainly linked in this context with the art and devotional practices of the Dominicans at S. Marco, Francis Ames-Lewis, nevertheless, recognized an important reference to dynastic succession in the Medici line.[73] For the ambitious Medici, references to dynasty were not infrequently linked with the desire for the continuity of political control of Florence. Piero's own sponsorship of the *Tabernacle of the*

70. Tanner, *Last Descendent*, 183–88; on this theme see also the classic studies by Norman Cohn, *Pursuit of the Millennium* (London: Secker and Warburg, 1957); and Bernard McGinn, *Visions of the End: Apocalyptic Prophecy in the Middle Ages* (New York: Columbia University Press, 1979)
71. Further on the architecture of the mausoleum and its connection to the church of Sta. Croce, see Koch, "Early Christian Revival," 539–41.
72. Piero Piccinini, "Immagini d'autorità a Ravenna," in *Storia di Ravenna*, ed. Domenico Berardi, et al., 3 vols. (Venice: Marsilio, 1990–96), 2.2:33–77, esp. 33ff.
73. On the *Crucifixion* fresco at S. Marco and its dynastic messages, see Francis Ames-Lewis, "Art in the Service of the Family: The Taste and Patronage of Piero di Cosimo de' Medici," in *Piero de' Medici*, 207–20, at 213–14. On Dominican imagery at S. Marco, see William Hood, *Fra Angelico at S. Marco* (New Haven: Yale University Press, 1993).

Crucifix later in the same decade most certainly combines the message of his devotion to the cross with dynastic references of a political nature.

The tabernacle at S. Miniato can be associated with an important practice of the Christian emperors intended to promote the perpetuation of the Roman Empire until the Last Days — the preservation and protection of the Cross itself, particularly the relic of the True Cross. The tradition began with the legendary discovery and proving of the True Cross by Constantine's mother, Helen, who thereafter had the relic placed in a chapel at the church of the Holy Sepulcher in Jerusalem. Later taken as spoils by the Persian King Chosroes, the Cross was recovered by Emperor Heraclius, who returned it to Jerusalem. Another chapel associated with Heraclius's deed was dedicated in Jerusalem to the exaltation of the Cross.[74] Heraclius's heroic recovery of the Cross from the infidel spurred an important provision in the prophecies surrounding the legend of the Last World Emperor — his final charge in preparing for the Last Days was to journey to Jerusalem and recover the Holy Sepulcher. Then, either at Golgotha or the Mount of Olives, depending on the particular prophecy, he would remove his crown and render the empire to Christ.[75]

Carolingian court literature promoted Charlemagne's association with the Cross as part of the larger effort to claim the new emperor's legitimate succession from the Byzantine emperors. Charlemagne is reported to have received a lance from heaven containing a relic of the Cross and, echoing Constantine, to have had a vision of the Cross that anticipated his victory over the heathens at Regensburg. According to another legend Charlemagne journeyed to Jerusalem to recover the Cross and the Holy Sepulcher. There, the Greek emperor gave him relics of the Passion, including wood and nails of the Cross.[76] Although Charlemagne did not actually go to Jerusalem, he did receive relics of the Passion, which he used to establish Aachen as a pilgrimage center in imitation of the holy sites in Jerusalem, the most prestigious of all pilgrimage cities.[77]

The legend of the True Cross itself was consolidated and popularized in the late-medieval West in Jacobus de Voragine's *Golden Legend*.[78] Florentines would have been familiar with the legend and, therefore, with the emperors' role as champion of the Cross, not only through Jacobus de Voragine's well-known text but also from Agnolo Gaddi's monumental fresco cycle depicting the

74. Barbara Baert, *A Heritage of Holy Wood: The Legend of the True Cross in Text and image* (Leiden and Boston: Brill, 2004), ix, 1–53, 133–93.
75. Baert, *Heritage*, 152–53; Tanner, *Last Descendent*, 150; Amnon Linder, "The Myth of Constantine in the West: Sources and Hagiographic Commemoration," *Studi medievali* 16 (1975): 43–75, esp. 52.
76. Tanner, *Last Descendent*, 44.
77. Heitz, *L'architecture religieuse*, 69–70; Tanner, *Last Descendent*, 42, 263 nn. 34, 44.
78. Jacobus de Voragine, *The Golden Legend: Readings on the Saints*, trans. W.G. Ryan, 2 vols. (Princeton: Princeton University Press, 1993), 1:277–84, 2:168–73.

legend in the choir of the Franciscan church of Sta. Croce (1388–92).[79] The continued popularity of the legend of the True Cross in the mid-fifteenth-century is attested by the major cycle begun in 1447 for the church S. Francesco in nearby Arezzo and completed by Piero della Francesca.[80]

Piero's provision of a tabernacle for the crucifix of Giovanni Gualberto echoes the Christian imperial tradition of preserving the Cross. Although the Florentine crucifix was neither a relic of the True Cross nor an actual relic at all, there are factors to explain how it could have been perceived as analogous to both.[81] First, its assumed connection with an event that occurred in the eleventh century endowed the image and the wood panel on which it was painted with a perceived antiquity that made it comparable to a relic.[82] Moreover, the reputation of the crucifix of Giovanni Gualberto as a miraculous image provided another basis for associating it with the True Cross, whose very "proving" depended on its miracle-working powers. While its initial "proving" was effected by the miracle of the resurrection of a youth, Jacobus de Voragine's account of the True Cross includes other miracles including one notable for its similarity to the miracle of the crucifix of Giovanni Gualberto. Jacobus de Voragine recounts how a young notary, who was ordered to worship the demons and to deny Christ, refused. Instead, he made the sign of the cross. Later when he went into Sta. Sophia with his master before an image of Christ, the master noticed that the image had its eyes on the notary, following him as he moved, as approval for his devotion.[83] In the legend of Giovanni Gualberto it was the "sign" of the cross by his relative's murder that was the catalyst for Gualberto's visit to the church where the crucifix nodded to him.[84] Both tales feature the theme of devotion to the cross and, importantly, moving miraculous images of Christ.[85]

79. Marilyn Aronberg Lavin, *The Place of Narrative: Mural Decoration in Italian Churches, 431–1600* (Chicago: University of Chicago Press, 1990), 99–118, for Gaddi's cycle. Gaddi's cycle at Sta. Croce lacks the Constantinian episodes. Lavin explains this in light of Florence's alliance with Charles V (1364–80) of France, who strongly identified himself with Charlemagne.

80. Lavin, *The Place of Narrative*, 167.

81. On the relationship between relics and images in the West, see Hans Belting, *Likeness and Presence: A History of the Image before the Era of Art*, trans. Edmund Jephcott (Chicago: University of Chicago Press, 1994), 194–97; 297–310. For the relationship of images and relics in Florence, see Sally J. Cornelison, "When an Image is a Relic: The St. Zenobius Panel from Florence Cathedral," in *Images, Relics, and Devotional Practices in Medieval and Renaissance Italy*, ed. Sally J. Cornelison and Scott B. Montgomery (Tempe, AZ: ACMRS, 2006), 95–113; and Holmes, "Miraculous Images," esp. 447, 449.

82. On images and the aesthetic of archaism, see Holmes, "Miraculous Images," 442, 457.

83. Jacobus de Voragine, *Golden Legend*, 284.

84. The miracle of the cross was the trigger for Giovanni Gualberto's conversion to the religious life. For Gualberto's life and legend, see above n. 15.

85. On moving crucifixes, see Richard C. Trexler, "Being and Non-Being: Parameters of the Miraculous in the Traditional Religious Image," in *The Miraculous Image*, 15–27; on moving images more generally, see Holmes, "Miraculous Images," 435, 439, 447–48.

There is reason to argue, too, that Piero's tabernacle for the crucifix of Giovanni Gualberto was actually intended to allude to the Holy Sepulcher in Jerusalem. Some evidence is provided by the notable parallels between the tabernacle's location and the placement of altars dedicated to the Holy Cross in the naves of Carolingian and Romanesque churches. These "altars of the Cross" typically held Cross and other Passion relics and were often adorned with a painted or mosaic image of the Crucified. They were located not just in the nave but exactly in the middle of the church, precisely the location of the crucifix altar and tabernacle at S. Miniato al Monte (Fig. 9). In this regard S. Miniato possesses an arrangement more common in the churches of northern Europe than in Italy.[86] Of particular significance in the North was the Carolingian church of St. Riquier at Centula, the abbey church of Charlemagne's son-in-law, the poet courtier Angilbert, where, for the first time, the liturgy followed that used in Jerusalem. Carol Heitz argued that the image of the Crucifixion there was part of a larger arrangement intended to re-create the Holy Sepulcher.[87] The Holy Sepulcher and Golgotha had been conceptually linked as the Church of the Holy Sepulcher in Jerusalem was also known to contain the summit of Golgotha. Thus, the sites of the Crucifixion, Entombment, and Resurrection were geographically and symbolically connected in recreations in the West.[88] Altars of the Cross were especially associated with veneration of the Cross on Good Friday. Notably, a modern source claims that, according to an ancient custom, on Good Friday of every year at S. Miniato al Monte the "porta santa" was thrown open and the crucifix exposed in the church.[89] It is probable that Piero's tabernacle and the miraculous crucifix it contained were especially associated with Good Friday observances.[90]

That the *Tabernacle of the Crucifix* was not only to be associated with the veneration of the Cross on Good Friday, but also, more specifically, intended

86. Georg Humann, "Zur Geschichte der Kreuzaltäre," *Zeitschrift für Christliche Kunst* 6 (1983): 74–82; and Günter Bandmann, "Zur Bedeutung der Romanischen Apsis," *Wallraf-Richartz-Jahrbuch* 15 (1953): 28–46, esp. 39.
87. Heitz, *L'architecture religieuse*, 51–59.
88. Colin Morris, *The Sepulcher of Christ and the Medieval West, from the Beginning to 1600* (Oxford: Oxford University Press, 2005), 85–89, 107–19.
89. Setti, "Regesto," 118. That the crucifix was venerated on Good Friday was also mentioned by Emiliano Lucchesi, O.S.B., *Il Crocifisso di S. Giovanni Gualberto el lo Stendardo della Croce di S. Francesco di Sales* (Florence: Gualandi, 1937), 10.
90. On the veneration of the Cross on Good Friday, and as part of the Holy Week celebration in Italy, see Augustine Thompson, O.P, *Cities of God: The Religion of the Italian Communes 1125–1325* (University Park, PA: The Pennsylvania State University Press, 2005), 323-26. On the relationship between Cosimo de' Medici's tomb and Good Friday and Holy Week liturgy at S. Lorenzo, see Susan McKillop, "Dante and *Lumen Christi*: A Proposal for the Meaning of the Tomb of Cosimo de' Medici," in *Cosimo de' Medici, 1389–1464: Essays in Commemoration of the 600th Anniversary of Cosimo de' Medici's Birth*, ed. Francis Ames-Lewis (Oxford: Clarendon Press, 1992), 280–83.

to evoke the tomb of Christ, or Holy Sepulcher in Jerusalem, is suggested by its sarcophagus-inspired form. Beyond it sepulchral resonances, the barrel-vaulted shape provided the triumphal-arch motif referring to Christ's triumph over death through his Resurrection. Thus the tabernacle and the crucifix within it made reference to the main liturgical events of Christ's Passion at Jerusalem: the Crucifixion, Entombment and Resurrection. Admittedly, the tabernacle does not attempt to recreate the Holy Sepulcher's actual appearance as would Alberti's Rucellai Chapel at S. Pancrazio, completed a decade later. Piero's tabernacle is merely allusive and symbolic, not unlike many recreations of the Holy Sepulcher in the West.[91]

As much as the tabernacle echoes the scale-covered sarcophagus in Ravenna, it departs from that model in its proportions. Rather than extending long and horizontally like its model, the tabernacle's ground plan forms an exact square. This is suggestive for, in John's Apocalyptic vision, Jerusalem takes the form of a square.[92] In this regard, the *Tabernacle of the Crucifix* at S. Miniato has an important precedent in an earlier quattrocento Florentine monument, Masaccio's fresco of the *Holy Trinity* (c.1425–28) in Sta. Maria Novella (Fig. 10). Scholars have shown that the perspective construction of Masaccio's illusionistic architecture also projects into an exact square forming a tabernacle, or tomb-like vaulted space. Among these scholars is Ursula Schlegel, who years ago linked the two quattrocento monuments in her attempt to explain the symbolism of the *Trinity's* unusual architectural setting. She suggested that the setting alludes illusionistically to a Golgotha Chapel as created in some medieval churches, and that God the Father stands on the rood-loft, the screen wall that gives onto the choir in these churches. For comparison, she cited the arrangement at S. Miniato, where she recognized an altar of the Cross set before the rood-screen (Figs. 1, 2). For Schlegel, both the *Trinity* and the ensemble at S. Miniato recreate a Holy Place in Jerusalem following the tradition of western medieval churches.[93] If the *Tabernacle of the Crucifix* does refer obliquely to the Holy Sepulcher, then it appears to have had a close precedent Masaccio's fresco.

The importance of Holy Sepulcher iconography in Florence was closely related to the city's self-identity as Jerusalem. For Florentines, the traditional symbolism of a church as a manifestation on earth of the Heavenly Jerusalem could not be separated from the civic and, indeed, political ideology of their city as Jerusalem. This civic identity was of particular relevance during Holy

91. Morris, *Sepulcher of Christ*, 61–67. See also the classic study by Richard Krautheimer, "Iconography of Medieval Architecture," *Journal of the Warburg and Courtauld Institutes* 5 (1942): 1–33.
92. Nigel Hiscock, *The Symbol at Your Door: Number and Geometry in Religious Architecture of the Greek and Latin Middle Ages* (Burlington, VT: Ashgate, 2007), 191.
93. Ursula Schlegel, "Observations on Masaccio's *Trinity* Fresco in Santa Maria Novella," *Art Bulletin* 45 (1963): 19–33.

Week celebrations including, of course, Good Friday.[94] If the tabernacle at S. Miniato takes an indirect approach to Holy Sepulcher imagery compared with Alberti's Rucellai Chapel for Giovanni Rucellai, both structures do share an important feature — the intarsiated green-and-white marble geometric ornament. With this type of display, both monuments link the Holy Sepulcher with Florentine tradition and, thus, with the dual identity of Florence as both Jerusalem and "a little Rome."[95]

A related aspect of the tabernacle's meaning depends on its location in S. Miniato. With the crucifix of S. Giovanni Gualberto displayed inside, both crucifix and tabernacle would be seen in perfect alignment with the apse mosaic of the *Maiestas Domini* in a Heavenly Paradise (Fig. 2). When the crucifix was on view, the message would have been clear that God's kingdom is only accessible through the sacrifice and triumph of Christ. Not incidentally, mosaics representing the *Maiestas Domini* could be found in the imperially sponsored churches of Ravenna, which in the fifteenth century still included S. Giovanni Evangelista, also built by Galla Placidia. The *Maiestas Domini* was also the subject of the dome mosaic in Charlemagne's palace chapel in Aachen.[96] In those contexts, the Christ in Majesty image spoke of the power relationship of the emperors with the heavenly ruler from whom they derived their authority and to whom the Last Emperor would render his crown in the Last Days. At S. Miniato, Piero strategically placed his falcon impresa on the tabernacle's upper back side where it directly confronts the *Maiestas Domini* across the presbytery's space (Figs. 4, 7).[97]

The facade-like rendering of the tabernacle's reverse directly below the falcon, with its central door-like structure, reiterates the theme of the accessibility of God's kingdom, this time through the "porta celeste" or doorway to heaven (Fig. 5). The geometric intarsia design of this door-like scheme not only reflects the church's interior decoration, in particular the arched entryway into the crypt but also the church's marble facade with its arches offering the passage way to salvation (Fig. 11). The design on the upper half of the tabernacle's back has at

94. On Florence as prominent among the Italian city-states that expressed their self-identity as Jerusalem during the late Middle Ages in their architecture, see Wolfgang Braunfels, *Mittelalterliche Stadtbaukunst in der Toskana* (Berlin: Verlag Gebr. Mann, 1966), 134–39. On Florence in particular, see also Marvin Trachtenberg, *Dominion of the Eye: Urbanism, Art, and Power in Early Modern Florence* (Cambridge: Cambridge University Press, 1997). On these cities and their churches as images of the Heavenly Jerusalem come down to earth, see Thompson, *Cities of God*, 26. Further on the importance of the Holy Sepulcher and Jerusalem in Florentine architecture and literature, see Kent, *Cosimo*, 188.
95. For the argument that Alberti also designed the *Tabernacle of the Crucifix*, see Gabriele Morolli, "Sacelli: I tempietti marmorei di Piero de' Medici. Michelozzo o Alberti?" in *Michelozzo: Scultore e Architetto (1396–1472)*, ed. Gabriele Morolli (Florence: Centro Di, 1998), 131–70, esp. 140–47.
96. Ernst Günther Grimme, *Der Dom zu Aachen: Architektur und Ausstattung* (Aachen: Einhard-Verlag, 1994), 42–46.
97. On the connections between Piero's falcon impresa and the *Maiestas Domini* mosaic, see further Koch, "Power, Prophecy," 524–27.

its center a Greek cross, borrowing the motif located at the apex of the pediment on the church's upper facade.[98] The back of the tabernacle would have been seen by worshippers returning from the crypt after venerating the relics of St. Minias. With this arrangement, then, Piero associated himself and family with not one but two cults at S. Miniato.[99] Indeed, as we have noted, Medici emblems evoking continuity permeate the tabernacle and the grille that encloses it, suggesting the family's protection of the crucifix, if not control of its cult. While the Benedictine Olivetan monks of S. Miniato presided over liturgical rites at both the nave and crypt altars, on a symbolic level Piero implicated himself and his family as perpetual protectors of the Cross in the tradition of the Christian emperors.[100]

Piero's embellishment of the nave altar of S. Miniato al Monte with an ornate tabernacle certainly dignified the miraculous crucifix of S. Giovanni Gualberto and may have encouraged a greater cult following. In appropriating a local miracle-working image that had its own legend, Piero found it useful to enhance its inherent associations with the True Cross and the traditional links of nave altars with Holy Sepulcher and Jerusalem symbolism. Allusions to the Holy Sepulcher and Jerusalem were overlaid onto a canopy inspired by a sarcophagus in Ravenna that possessed both Christian and imperial associations. This was surely done with the awareness that Ravenna and every capital of the Christianized empire before and after, including Constantinople and Aachen, had recreated itself not only as a New Rome but also as a New Jerusalem, making itself a pilgrimage destination with Passion and True Cross relics and altars devoted to the Holy Cross.[101] At S. Miniato, Piero emulated the practice of the Christian emperors who had claimed legitimate and continuous dynastic succession by attaching themselves to the cult of spolia and imitation and devoting themselves to the cult of the Cross. Within the established structures of patronage in republican Florence, Piero de' Medici promoted his pretensions to rightful succession from his father, Cosimo, and the acceptance of continuous Medici leadership in Florence.

■

98. Liebenwein, "Die 'Privatisierung'," 279, noted the door-like appearance of the tabernacle's back side.
99. For the cult of St. Minias focused on the crypt, see Montgomery, "*Quia Venerabile Corpus*," 8, 16–22.
100. On Benedictine Olivetan monks, who had lived at S. Miniato since 1373, see Thomas J. Loughman, "Spinello Aretino, Benedetto Alberti, and the Olivetans: Late Trecento Patronage at S. Miniato al Monte," (Ph.D. diss., Rutgers University, 2003).
101. For Aachen, see Heitz, "L'architecture religieuse carolingienne," 74–76; for Constantinople as Jerusalem, see Morris, *Sepulcher of Christ*, 59.

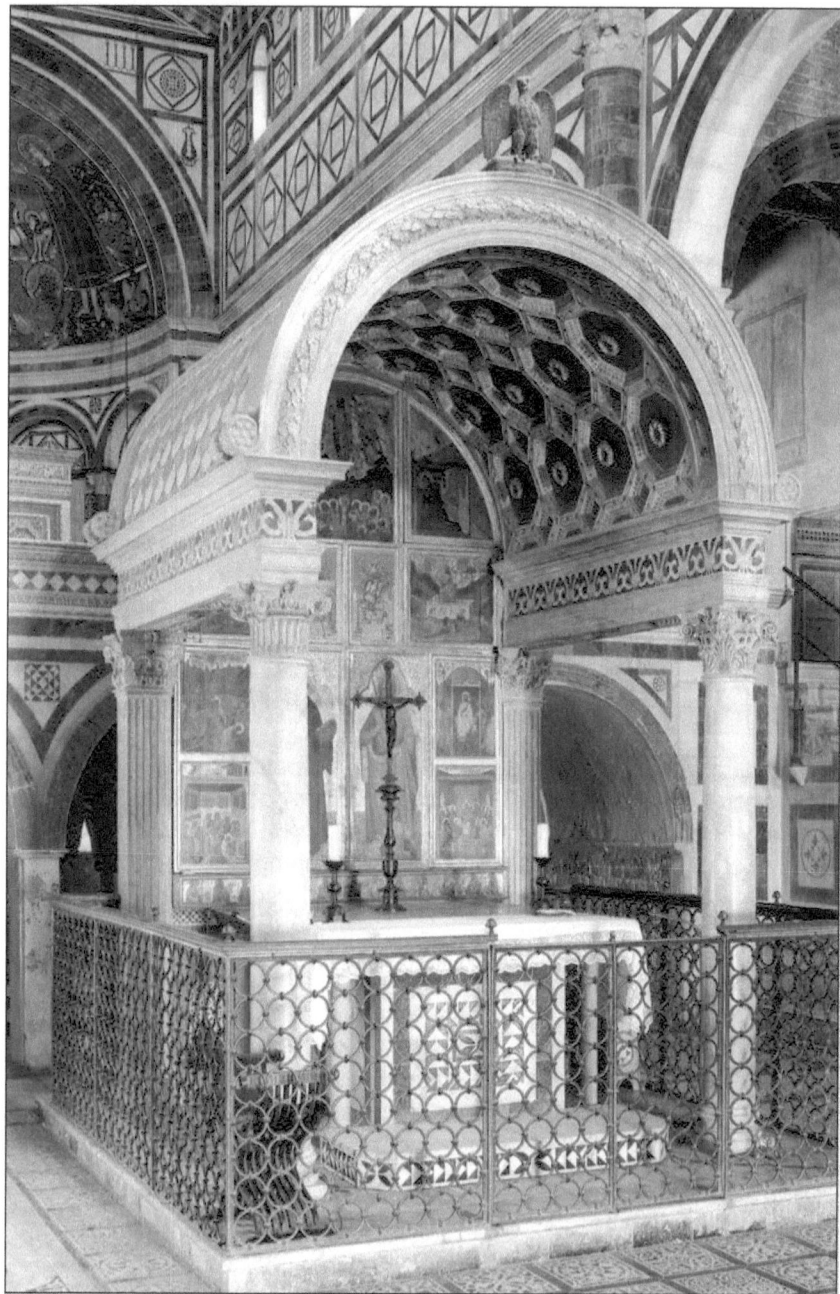

Fig. 1. *Tabernacle of the Crucifix*. S. Miniato al Monte, Florence. Photo: Conway Library, The Courtauld Institute of Art, London.

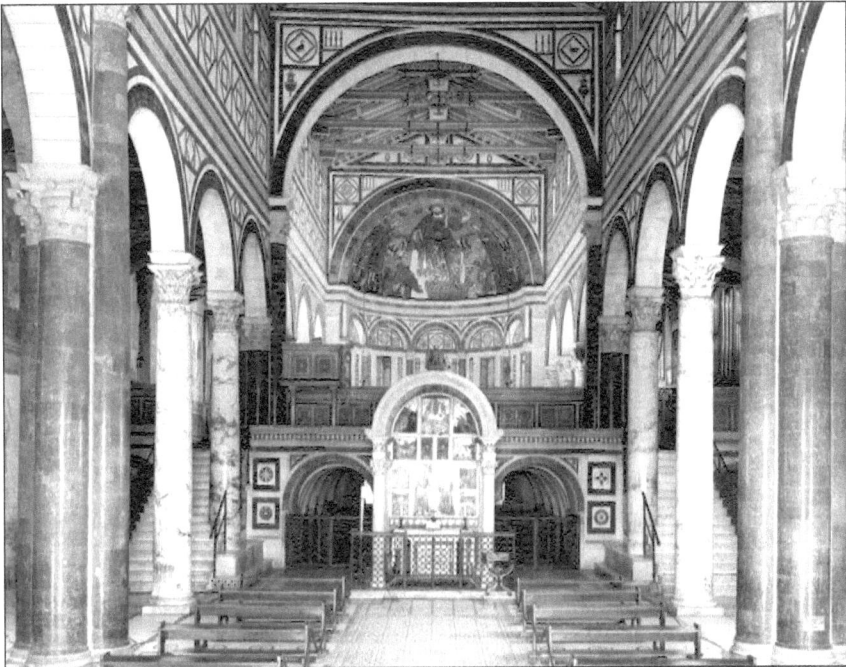

Fig. 2 (above). Interior view of nave toward altar. S. Miniato al Monte, Florence. Photo: Alinari / Art Resource, NY.

Fig. 3 (below). Altar of the *Tabernacle of the Crucifix*. S. Miniato al Monte, Florence. Photo: Conway Library, The Courtauld Institute of Art, London.

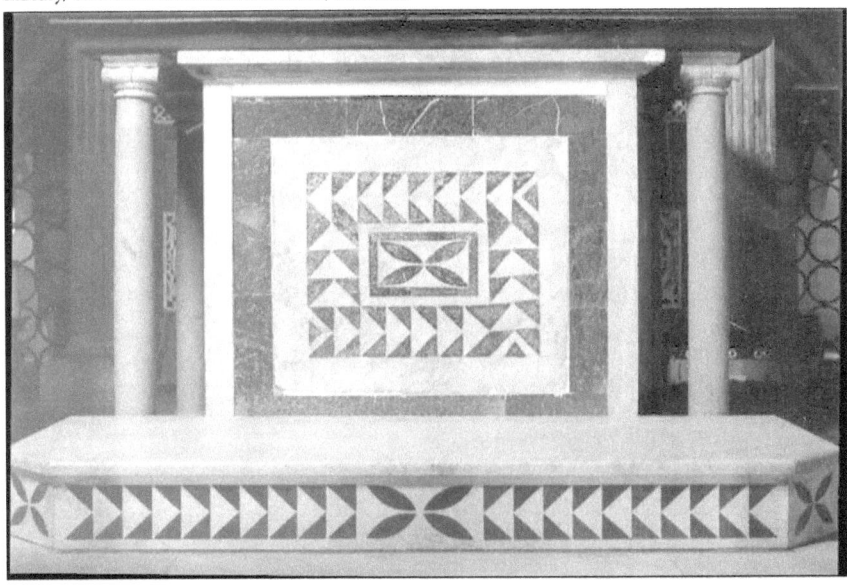

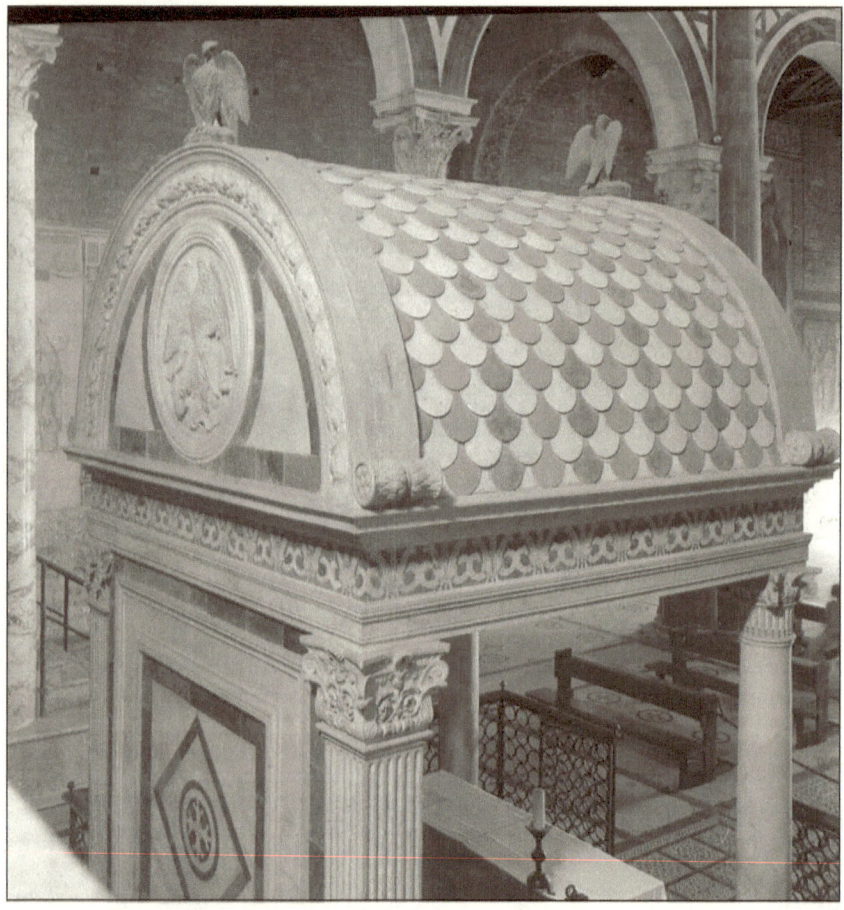

Fig. 4. *Tabernacle of the Crucifix*. S. Miniato al Monte, Florence. Photo: Conway Library, The Courtauld Institute of Art, London.

Fig. 5. *Tabernacle of the Crucifix*, back side. S. Miniato al Monte, Florence. Photo: Conway Library, The Courtauld Institute of Art, London.

Fig. 6. *Tabernacle of the Crucifix*, canopy. S. Miniato al Monte, Florence. Photo: Alinari / Art Resource, NY.

Fig. 7 (top). Falcon Impressa, *Tabernacle of the Crucifix*. S. Miniato al Monte, Florence. Photo: Conway Library, The Courtauld Institute of Art, London.

Fig. 8 (center). Scale-covered sarcophagus. Mausoleum of Galla Placidia. Ravenna, Italy. Photo: Alinari / Art Resource, NY.

Fig. 9 (below). Plan. S. Miniato al Monte, Florence. Photo: From *Dieci secoli per la basilica di San Miniato al Monte*, eds. F. Gurrieri et al. (Florence: Edizioni Polistampa, 2007), p. 13.

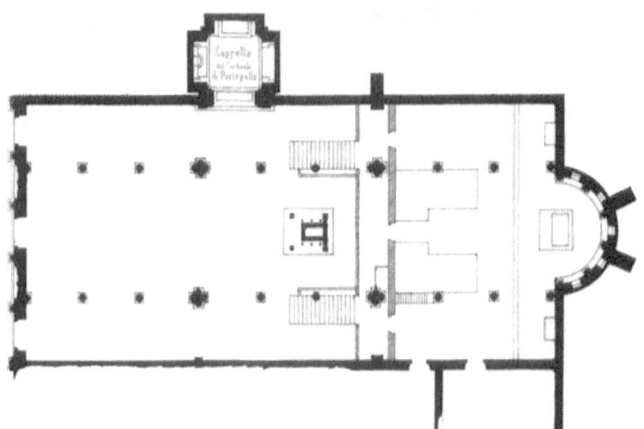

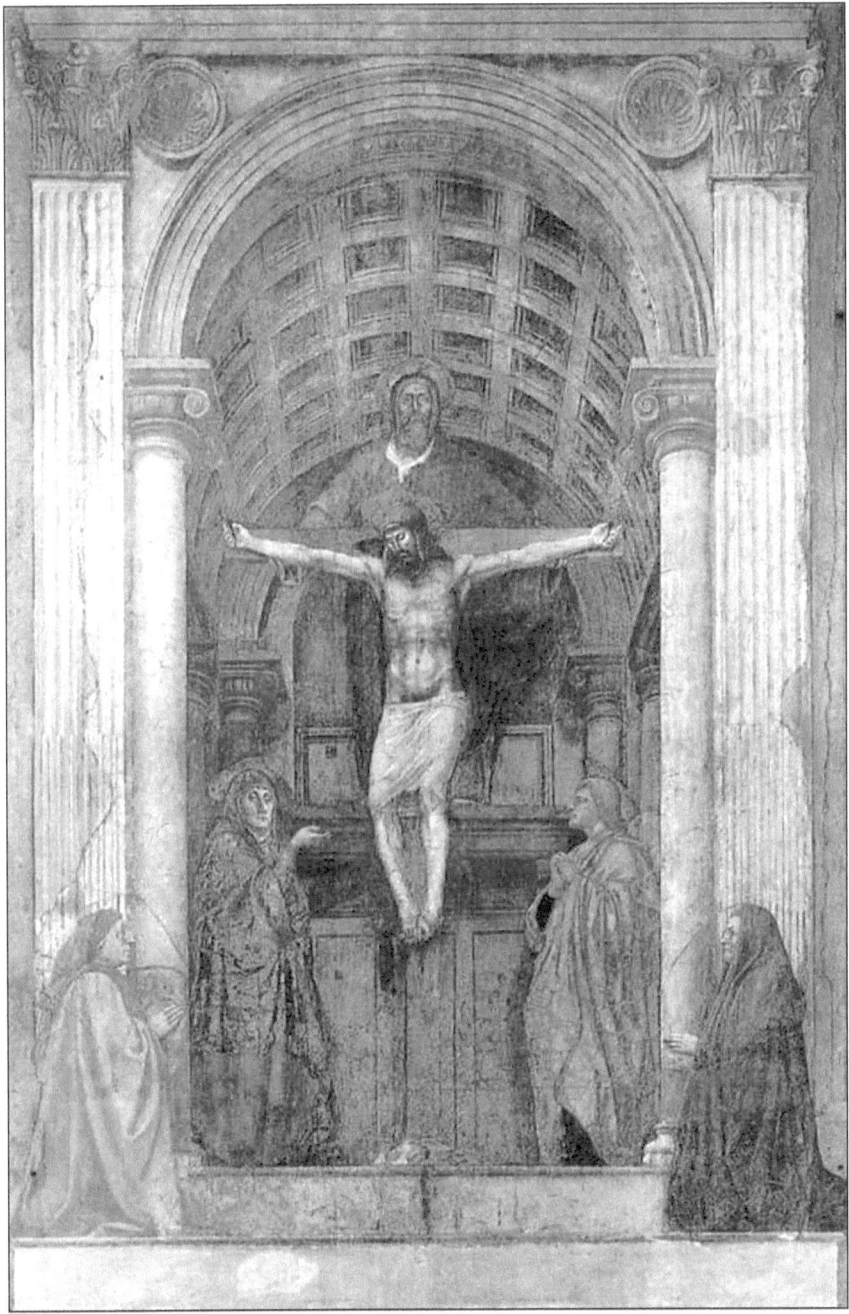

Fig. 10. Masaccio, *Holy Trinity* (1425–28). Sta. Maria Novella, Florence. Photo: Wikimedia.

A NEW INTERPRETATION OF PAOLO VERONESE'S *SAINT BARNABAS HEALING THE SICK*

HEATHER R. NOLIN

Soon after the conclusion of the Council of Trent in 1563, Paolo Veronese painted two altarpieces for the Secular Canons at S. Giorgio in Braida in Verona: the *Martyrdom of Saint George* (Fig. 1) and *Saint Barnabas Healing the Sick* (also known as *The Miracle of Saint Barnabas*, Fig. 2).[1] Scholars generally agree that the *Martyrdom of Saint George* was among the first works of art to respond to the council's final decree that renewed the veneration of saints and asserted their effectiveness as intercessors.[2] Consequently, it is one of the most

1. Most scholars date *The Martyrdom of Saint George* to 1566 based upon stylistic and circumstantial evidence. See Filippa M. Aliberti Gaudioso, "14. Paolo Veronese, *Martirio di S. Giorgio*," in *Veronese e Verona*, ed. Sergio Marinelli (Verona: Fedrigoni, 1988), 222; and Sergio Marinelli, "La Pala per l'Altar Maggiore di S. Giorgio in Braida," in *Nuovi studi su Paolo Veronese*, ed. Massimo Gemin (Venice: Arsenale, 1990), 323–32. The artist was supposed to have returned to Verona in 1565 to marry Elena Badile, the daughter of his teacher, Antonio Badile, who had died six years earlier. Elena and Paolo married in the church of Sta. Cecilia on 29 April 1566: Arch. S. Cecilia, *Computum ecc.* as cited by P.M. Tua, "Per un elenco delle opere pittoriche della scuola veronese prima di Paolo," *Madonna Verona* 6 (1912): 67 n. 5. William R. Rearick, ed. *The Art of Paolo Veronese, 1528–1588* (Washington: National Gallery of Art; New York: Cambridge University Press, 1988), 89, expanded the bracket dates of the painting's completion to between 1549–50 and 1568. Some scholars consider the *Saint Barnabas Healing the Sick* to be a contemporary of the *Martyrdom of Saint George*, supporting a date of 1566. See Terisio Pignatti, *Veronese*. Profili e saggi di arte veneta (Venice: Alfieri, 1976), 132 n. 62; and Percy H. Osmond, *Paolo Veronese: His Career and Work* (London: Sheldon Press, 1927), 54. Others date the *Saint Barnabas* to as early as 1560–62 or as late as 1569. Florence Ingersoll-Smouse, "L'oeuvre peint de Paul Véronèse en France," *Gazette des beaux-arts* 16.2 (1927): 227, dates the painting to 1560–62. Paola Marini, "15. Paolo Veronese, *S. Barnaba Guarisce gli Ammalati*," in Marinelli, *Veronese e Verona*, 233, dates it to after 1567 based upon stylistic comparisons with the lost *Piscina probatica*, which Carlo Ridolfi, *Le meraviglie dell'arte: Ovvero le vite degli illustri pittori veneti e dello stato*, 2 vols. (Berlin: Grote'sche Verlagsbuchhandlung, 1648; repr. 1914–24), 1:340, dated to 1567, and for its stylistic similarities between these two paintings and Tintoretto's *San Rocco Comforted by Angels* (1567) in the Scuola di S. Rocco. Rearick, *Art of Paolo Veronese*, 99–100 n. 5 stated the style of the preparatory drawing of the *Seated Nude* suggests the final painting is closer to 1569. See note 9 below.

2. Twenty-fifth session, 4 December 1563: "…[A]ll bishops and others who hold the office of teaching…instruct the faithful diligently in matters relating to intercession and invocation of the saints, the

studied post-Tridentine altarpieces and the work of art given the majority of attention in art-historical literature related to S. Giorgio in Braida.[3] By contrast, Paolo Veronese's second altarpiece depicting St. Barnabas healing the sick of Cyprus armed only with the Gospel of Matthew has received far less scholarly

veneration of relics, and the legitimate use of images, teaching them that the saints who reign together with Christ offer up their prayers to God for men, that it is good and beneficial suppliantly to invoke them and to have recourse to their prayers, assistance and support in order to obtain favors from God through His Son, Jesus Christ our Lord, who alone is our redeemer and savior…[L]et the bishops diligently teach that by means of the stories of the mysteries of our redemption portrayed in paintings and other representations the people are instructed and confirmed in the articles of faith, which ought to be borne in mind and constantly reflected upon; also that great profit is derived from all holy images, not only because the people are thereby reminded of the benefits and gifts bestowed upon them by Christ, but also because through the saints the miracles of God and salutary examples are set before the eyes of the faithful, so that they may give God thanks for those things, may fashion their own life and conduct in imitation of the saints and be moved to adore and love God and cultivate piety…. If any abuses shall have found their way into these holy and salutary observances, the holy council desires earnestly that they be completely removed, so that no representation of false doctrines and such as might be the occasion of grave error to the uneducated be exhibited…such zeal and care should be exhibited by the bishops with regard to these things that nothing may appear that is disorderly or unbecoming and confusedly arranged, nothing that is profane, nothing disrespectful, since holiness becometh the house of God." From Henry Joseph Schroeder, *Canons and Decrees of the Council of Trent* (St. Louis, MO and London: B. Herder, 1941), 215–17.

3. For the *Martyrdom of Saint George*, see Giorgio Vasari, *Le vite de'più eccellenti pittori, scultori ed architettori* (1568, repr. Florence: G.C. Sansoni, 1962), 6:363–64; Raffaello Borghini, *Il Riposo, in cui della pittura, e della scultura si favella, de' piu illustri pittori, e scultori, a delle piu famose opere loro si fa mentione, e le cose principali appartenenti a dette arti s'insegnano* (Florence: Marescotti, 1584), 561; Giacomo Filippo Tomasini, *Annales canonicorum secularium Sancti Georgii in Alga* (Udine: N. Schiratti, 1642), 257; Ridolfi, *Le meraviglie*, 319; Pietro Caliari, *Paolo Veronese* (Rome: Forzani e c, tipografi del Senato, 1888), 72–73, 366; M. Marini, *L'opera completa del Veronese* (Milan: Rizzoli Editore, 1968), 108–9, cat. 18; Pignatti, *Veronese*, 131–32, cat. 61; Sergio Marinelli, ed. *Veronese e Verona* (Verona: Fedrigoni, 1988); Terisio Pignatti and Filippo Pedrocco, *Veronese* (Milan: Electa, 1995), 1:255–56; Marinelli, "La Pala," 201–5, 19–21, cat. 7–8, 13; Aliberti Gaudioso, "Paolo Veronese," 222–30, cat. 14; Terisio Pignatti and Filippo Pedrocco, *Veronese: Catalogo completo dei dipinti* (Florence: Cantini, 1991), 1:168, cat. 81; and 2:255–56, cat. 153 for full bibliography; Michele Di Monte, "La Morte Bella: Il Martirio nella Pittura di Tiziano, Tintoretto e Veronese," *Venezia Cinquecento* 9.17 (1999): 91–179; and Richard Cocke, *Paolo Veronese: Piety and Display in an Age of Religious Reform* (Aldershot, UK and Burlington, VT: Ashgate, 2001), 23–25, 35, 42, 65, 94–5, 102–3, 105–7, cat 19. Some important examples of scholastic analysis of Veronese's *Martyrdom of Saint George* in the context of Trent are Marinelli, "La Pala"; Richard Cocke, "Venice, Decorum and Veronese," in *Nuovi Studi su Paolo Veronese*, 241–55; Peter Humfrey, "Altarpieces and Altar Dedications in Counter-Reformation Venice and the Veneto," *Renaissance Studies* 10.3 (1996): 371–87. Examples of the emphasis placed upon Veronese's altarpiece over all others in the church can be found in Giuseppe Trecca, *La Chiesa de S. Giorgio in Braida a Verona* (Verona: Eurotipo, 1930; repr. 2000); and Pierpaolo Brugnoli, *La Chiesa di S. Giorgio*, vol. 5, Collana. "Le Guide" (Verona: Vita Veronese, 1954). See Heather R. Nolin, "Uniting Faith and Image: The Collective Visual Identity of the Congregation of Secular Canons and Its Expression in the Artistic Commissions at S. Giorgio in Braida (1441–1668)" (Ph.D. diss., Rutgers University, 2011) for bibliography of all the works of art in the church.

analysis.[4] This is possibly because it portrays a highly unusual narrative that inspired few imitations, its date of completion and original location are subject to debate, and the canons' precise motive for commissioning it is unknown. Other evidence not previously considered, however, suggests that the canons commissioned the St. Barnabas in mid- to late-1566 to reaffirm in their minds the efficacy and authority of their mission of reform in the face of Pope Pius V's mounting suspicion and his aggressive post-Tridentine initiatives enacted soon after his election in January of that year.[5] Reconsideration of documentary and physical evidence seems to indicate that the canons carefully selected the altarpiece's iconography and placement within the church to reinforce this message.

Scholars have previously concluded that the canons choose the *Golden Legend* as the narrative source for Veronese's altarpiece of St. George.[6] The text also supplied the literary source for the St. Barnabas altarpiece, although the saint's life and vocation can be found in the Bible as well.[7] Barnabas was born in Cyprus and consequently became the island's patron saint. During his life he was known for his wisdom, patience and devotion to the poor. He traveled widely together with his companion Saul (who would become St. Paul), including to Antioch where the pair converted many of the residents.

4. For the *Saint Barnabas Healing the Sick*, see Borghini, *Il Riposo*, 4:561; Tomasini, *Annales*, 257; Ridolfi, *Le meraviglie*, 1:305; Lodovico Moscardo, *Historia di Verona* (Verona: Andrew Rossi, 1668), 120; Bartolomeo dal Pozzo, *Le vite de' pittori, degli scultori et architetti veronesi*, Italica gens; n. 73 (Bologna: A. Forni, 1718), 240; Giovan Battista Lanceni, *Ricreazione pittorica, o sia notizia universale delle pitture nelle chiese, e luoghi pubblici della città, e diocese di Verona*, vol. 6, Collana di opere veronesi inedite o rare (Verona: Centro per la Formazione Professionale Grafica, 1720; repr., 1986), 200; Scipione Maffei, *Verona illustrata*, 5 vols. (Verona: J. Vallarsi e P. Berno, 1731), 3:175; Caliari, *Paolo Veronese*, 72-73, 277, 390; Osmond, *Paolo Veronese*, 55, 110; Ingersoll-Smouse, "L'oeuvre peint," 212, 227-28; Pignatti, *Veronese*, 132; Marini, "Paolo Veronese," 231-36; Rearick, *Art of Paolo Veronese*, 99-100 n. 50; Jean Martineau and Charles Hope, eds., *The Genius of Venice 1500-1600* (London: Royal Academy of Arts, Weidenfeld and Nicolson, 1983), 235 n. 136; Pignatti and Pedrocco, *Veronese*, 2.1:267-68 n. 170; Richard Cocke, *Veronese* (London: Chaucer Press, 2005), 85; and Hans Dieter Huber, *Paolo Veronese: Kunst als soziales System* (Munich: W. Fink, 2005), 173-74.

5. Pius V's predecessor, Pope Pius IV (r.1559-65) was responsible for the lag between the council's conclusion in 1563 and the enactment of the decrees of Trent. Michael A. Mullett, *The Catholic Reformation* (London and New York: Routledge, 1999), 111. Despite his contribution to the successes at Trent, Pius IV did not personally take up the reins of reform and continued to practice nepotism and to conduct himself more like a secular prince than the head of the Church. With Pius V's election in January 1566, the papacy and the Church once again resumed the mission of reform and implementation of the council's decrees. His advocacy for monastic reform was rooted in his own values since he himself had begun his ecclesiastical career as a Dominican friar and maintained strict personal piety as he attained higher ranks in the Church. See Mullett, *The Catholic Reformation*, 113-14.

6. Cocke, *Veronese*, 85; and Jacobus de Voragine, *The Golden Legend: Readings on the Saints*, trans. William Granger Ryan (Princeton: Princeton University Press, 1993), 238-42.

7. Jacobus de Voragine, *The Golden Legend*, 318-21; and Acts 14:14.

A SCARLET RENAISSANCE ■

God then spoke to them both, saying they must continue their apostolate beyond that city. God instructed Saul to go to Jerusalem and Barnabas to return to his native island. Once back on Cyprus Barnabas began healing the sick. Barnabas, aided by his cousin John Mark, who is traditionally identified as St. Mark the Evangelist, cured the infirm by placing the Gospel of St. Matthew upon their heads and reading its verses.[8] It is because of this miracle that Barnabas came to be venerated for his powers to heal.

The moment Barnabas restored health to the infirm using the Gospel of St. Matthew is the scene Veronese illustrated in his altarpiece for the canons. The drama unfolds outdoors in front of a small round temple of the Corinthian order. Barnabas wears a belted dark blue tunic with contrasting orange lining. His form is monumental and fills the center third of the canvas. St. Mark also wears a similar dark blue tunic. He stands behind and holds up the bare-chested crippled man whose discarded crutch in the foreground alludes to his imminent cure.[9] With St. Mark supporting the man, Barnabas is able to place Matthew's Gospel on his head. An older woman with a blue turban stands behind this group of three men and holds a lighted four-wick candle. The large candle is not needed to illuminate the scene because it appears to take place in the full light of day, as the blue sky and shadows cast by the columns and Barnabas's book indicate. Veronese may have included the candle as a metaphor for the crippled man's miraculous recovery — the candle appears to sprout from the open text and a breeze from the left suddenly stirs its flames. On the far right of the canvas, another sick person in the arms of a bearded man in red awaits Barnabas' intervention. A young black boy in the lower left of the composition holds an unlit candle in his hand.[10] He looks across to the second sick figure and appears to be readying the candle for the moment Barnabas restores this man's health.

The Secular Canons who commissioned Veronese to paint this subject were members of the Congregation of S. Giorgio in Alga that was named for the island in the Venetian lagoon where its founding members established their mother church. They were major players in the reform movements of northern

8. Joseph MacRory, "St. Mark," in *The Catholic Encyclopedia*, ed. D.G. Schultenover (Middletown, CT: American Library Association, 2005); and Acts 12:25. Barnabas became so identified with Matthew's gospel on account of this deed that when Barnabas's remains were unearthed in Cyprus, the evangelist's hand-written copy was said to have been among the saint's bones. See Jacobus de Voragine, *Golden Legend*, 322.
9. A drawing of *A Seated Nude Young Man, Looking Upwards and Seen from Below, and a Detail of the Legs of Another Figure* is a preparatory study for the figure of the infirm. See the figure in Rearick, *Art of Paolo Veronese*, n. 50. This drawing was auctioned in 2006 for $39,000. See Sotheby's New York Old Master Drawings Sale N08161, 25 January 2006, lot 47.
10. A drawing in the Louvre of the *Head of a Negro Boy* is the preparatory drawing for this figure. See the figure in Rearick, *Art of Paolo Veronese*, n. 51.

Italy in the years leading up to the Reformation and the Council of Trent.[11] They believed reform was best achieved by returning to the fundamental ideals and canonical teachings of the Church. Part of their strategy to transform the clergy and monastic life in general was to formulate an artistic program that reinforced their spirituality and came to embody the visual identity of the nascent religious organization.[12]

As I have argued elsewhere, Angelo Correr, the future Pope Gregory XII, most likely founded the Secular Canons' organization in 1402.[13] Consequently, the canons had a strong spiritual connection to Rome and the papacy, and their loyalty only grew over the next century as former members filled the ranks of the Curia, such as when Gabriele Condulmer was elected as Pope Eugenius IV in 1431.[14] But fundamentally the canons' allegiance was to Venetian authority. The congregation was a secular Venetian organization and tied politically to the capital, the location of their administrative center and the hometown of

11. Giorgio Cracco, "La Fondazione dei Canonici Secolari di San Giorgio in Alga," *Rivista di Storia della Chiesa in Italia* 13 (1959): 70–88; and Silvio Tramontin, "Canonici Secolari di San Giorgio in Alga," in *Dizionario degli Istituti di Perfezione*, ed. Guerrino Pelliccia and Giancarlo Rocca (Rome: Edizione Paoline, 1975), 154–58.

12. Nolin, "Uniting Faith and Image," 135–59. Gabriele Neher and Michael Douglas-Scott have used a similar approach in their respective studies of the art in the canons' churches of S. Pietro in Oliveto in Brescia and the Madonna dell'Orto in Venice. See Gabriele Neher, "Moretto and the Congregation of S. Giorgio in Alga 1540–1550: Fashioning a Visual Identity of a Religious Congregation," in *Fashioning Identities in Renaissance Art*, ed. Mary Rogers (Aldershot, UK and Brookfield, VT: Ashgate, 2000), 131–47; Michael Douglas-Scott, "Pordenone's Altar-Piece of the Beato Lorenzo Giustiniani for the Madonna dell'Orto," *Burlington Magazine* 130.1026 (1988): 672–79; Michael Douglas-Scott, "Art Patronage and the Function of Images at the Madonna dell'Orto in Venice under the Secular Canons of S. Giorgio in Alga circa 1462–1668" (Ph.D. diss., University of London, 1995); and Michael Douglas-Scott, "Jacopo Tintoretto's Altarpiece of St. Agnes at the Madonna dell'Orto in Venice and the Memorialisation of Cardinal Contarini," *Journal of the Warburg and Courtauld Institutes* 60.1026 (1997): 130–63.

13. Nolin, "Uniting Faith and Image," 97–115. For additional information about Angelo Correr and his pontificate as Gregory XII, see Edoardo Piva, "Venezia e lo scisma durante il pontifico di Gregorio XII (1406–1409)," *Nuovo Archivio Veneto* 13 (1897): 135–58; Dieter Girgensohn, *Venezia e il primo veneziano sulla cattedra di S. Pietro: Gregorio XII 1406–1415*, trans. Pietro Pavanini (Venice: Centro Tedesco di Studi Veneziani, 1985); Richard P. McBrien, *Lives of the Popes: The Pontiffs from St. Peter to John Paul II* (San Francisco: Harper, 1998), 252–53; and Gherardo Ortalli, "Gregorio XII," in *Enciclopedia dei papi*, ed. Massimo Bray (Rome: Istituto della Enciclopedia Italiana, 2000), 584–93.

14. For additional information about Gabriel Condulmer and his pontificate as Eugenius IV, see Alfredo Monaci, "Una notizia inedita sulla vita di Gabriele Condulmer (Eugenio IV)," *Miscellanea di storia e cultura ecclesiastica* 4 (1906): 425–26; Cracco, "La Fondazione dei Canonici Secolari," 73–5; idem, "L'introduzione dei Gesuati in Vicenza nella prima metà del Quattrocento," *Rivista di Storia della Chiesa in Italia* 11 (1957): 407 n. 2; Joseph Gill, *Eugenius IV: Pope of Christian Union* (Westminster, MD: Newman Press, 1961); Paul De Vooght, "Eugéne IV," in *Dictionnaire d'Histoire et de Géographie Ecclésiastiques*, ed. R. Aubert and É. Van Cauwenbergh (Paris: Letouzey and Ané, 1963); Denys Hay, "Eugenio IV, papa [Gabriele Condulmer]," in DBI (Rome: Istituto della Enciclopedia Italiana, 1993), 43:496–502; and Denys Hay, "Eugenius IV (Gabriele Condulmer)," in *Enciclopedia dei papi* (Rome: Istituto della enciclopedia italiana, 2000), 2:634–39.

their founder, Angelo Correr, and many of their brethren, including Gabriele Condulmer. Furthermore, the Venetian Republic believed it had jurisdiction over ecclesiastics because its power over Rome was ordained from its inception as demonstrated with the appointment of the Venetian Secular Canon Lorenzo Giustiniani as the first patriarch of Venice and head of the Venetian see in 1451.[15]

The Secular Canons had always managed to balance delicately these dual allegiances, but beginning in 1566 this status quo was threatened by Pope Pius V (r.1566–72). Not long after his election, he took steps to enforce the Council of Trent's edicts that necessitated more centralized control of the Church in order to protect against heresy. This included regulating the religious orders — especially the secular ones — by bringing them within his purview. The pope's zeal resulted in a bull of 17 November 1568 that obligated the Canons to relinquish their secular status by taking monastic vows and adopting the Rule of St. Augustine, thus designating them as regular canons, and to sever their organizational ties to Venice.[16] It was against this backdrop of changing political and religious

15. The Servite friar Paolo Sarpi in his *Sopra l'officio dell'Inquisizione* of 1613 articulated this belief in the early seventeenth-century. See also Ludwig Freiherr von Pastor, *The History of the Popes, from the Close of the Middle Ages* (St. Louis, MO: B. Herder, 1923), 4:92, 25:112; Paolo Prodi, "The Structure and Organization of the Church in Renaissance Venice: Suggestions for Research," in *Renaissance Venice*, ed. J.R. Hale (London: Faber, 1973), 410–11, esp. n. 9; Gaetano Cozzi and Michael Knapton, *Storia della Repubblica di Venezia: Dalla guerra di Chioggia alla riconquista della Terraferma* (Turin: Utet Libreria, 1986); Gaetano Cozzi and Giuseppe Gullino, *La chiesa di venezia tra riforma protestante e riforma cattolica. Contributi alla storia della chiesa di Venezia* (Venice: Edizioni Studium Cattolico Veneziano, 1990); and Michael A. Mullett, "Counter-Reformation or Catholic Reformation Revisited," *History Review* 38 (2000). For Lorenzo Giustiniani, see Bernardo Giustiniani, *Vita Beati Laurentii Iustiniani Venetiarum Proto Patriarchae* (1475, repr., Rome: Officina Poligrafica Laziale, 1962); Daniele Rosa, *Summorum, sanctissimorumque pontificum illustrium virorum piorumque patrum de Beati Laurentii Iustiniani Venetiarum patriarchae vita sanctitate ac miraculis testimoniorum centuria*, 1st ed. (Venice: Apud Sanctum Gryllum, & Fratres, 1614); Tomasini, *Annales*, 14–19; Silvio Tramontin, *San Lorenzo Giustiniani nell'arte e nel culto della Serenissima* (Venice: Studio Cattolico Veneziano, 1956); Giovanni Mantese, "San Lorenzo Giustiniani priore del monastero di sant'Agostino in Vicenza," in *Studi in onore di Federico M. Mistrorigo*, ed. Aristide Dani and Luciano Rossi (Vicenza: Rumor, 1956), 719–56; Antonio Niero, *San Lorenzo Giustiniani: Protopatriarca di Venezia nel V centenario della morte, 1456-1956* (Venice: F. Ongania, 1959); Pietro La Fontaine, *Il primo patriarca di Venezia: Vita popolare di S. Lorenzo Giustiniani*, 3rd ed., vol. 1. Collana biografica (Venice: Studium Cattolico Veneziano, 1960); Antonio Niero, *I patriarchi di Venezia: Da Lorenzo Giustiniani ai nostri giorni* (Venice: Studium Cattolico Veneziano, 1961), 21–22; Oliver M.T. Logan, "The Ideal of the Bishop and the Venetian Patriarchate: c.1430–c.1630," *The Journal of Ecclesiastical History* 29.4 (1978), 415–50; Antonio Niero, ed. *L'immagine di San Lorenzo Giustiniani nell'arte: Documenti di cultura e vita religiosa nel suo tempo. Venezia, Chiesa di S. Stae (10 ottobre–4 dicembre 1981)* (Venice: Comune, Musei Civici, 1981); Silvio Tramontin, ed. *Venezia e Lorenzo Giustiniani* (Venice: Comune-Ufficio Affari Istituzionali Patriarcato, 1985(?)); Patricia H. Labalme, "No Man but an Angel: Early Efforts to Canonize Leonardo Giustiniani (1381–1456)," in *Continuità e discontinuità nella storia politica, economica e religiosa: Studi in onore di Aldo Stella* (Vicenza: Neri Pozza, 1993).

16. The bull is reproduced in Tomasini, *Annales*, 537–40 and Luigi Tomassetti et al., eds., *Bullarum, diplomatum et privilegiorum sanctorum romanorum pontificum taurinensis*, 25 vols. (Turin: Augustae Taurinorum, 1857–72), 7:725s. It has been assumed that the priests took monastic vows from the

supervision that the canons rethought the decoration of the transept of their church and commissioned Veronese to paint the *Saint Barnabas* altarpiece.

Saint Barnabas Healing the Sick is now housed at the Musée des Beaux Arts in Rouen where it has been since 1803.[17] A nineteenth-century copy of the painting hangs today above the right (south) transept altar (Fig. 6) in S. Giorgio in Braida. This is where Napoleon found the original before removing it from the church in 1797.[18] However, evidence suggests that the canons commissioned the painting for the altar opposite the one upon which Napoleon found Veronese's painting: under the organ on the left (north) side of the transept ("E" in Fig. 3 and Fig. 5) where Moretto da Brescia's *Saint Cecilia and Female Saints* (Fig. 4) had hung since 1540.[19]

Raffaello Borghini, when he discussed the artist's oeuvre in his *Riposo* of 1584, is the first to refer to both of Veronese's paintings in S. Giorgio in Braida.[20] He stated that the *Martyrdom of Saint George* was on the high altar yet did not specify the exact location of the St. Barnabas altarpiece. Carlo Ridolfi in his *Le meraviglie dell'arte* of 1648 is the earliest to describe the *Saint Barnabas* in a specific location within the church.[21] He wrote that the painting was "under the organ." In 1718, Bartolomeo Dal Pozzo confirmed in his *Le vite de' pittori* that the *Saint Barnabas* altarpiece was there too.[22] Upon closer inspection of his

inception of their organization in 1402, and they have been mistakenly referred to as the Regular Canons of S. Giorgio in Alga or the Augustinian Congregation of S. Giorgio in Alga. See Gabriele Neher, "Moretto and Romanino: Religious Painting in Brescia 1510-1550. Identity in the Shadow of La Serenissima" (Ph.D. diss., University of Warwick, 1999), 115.

17. Inv. D 803-17.

18. Napoleon ordered the original canvas removed from its stretcher and folded for transfer to the Louvre in Paris on 18 May 1797; it arrived there on 27 July 1798. He also had Veronese's *Martyrdom of Saint George* taken down from above the high altar. Both paintings were displayed in the Louvre and greatly influenced French painters, especially Delacroix, who made copies of these and other paintings plundered from Italy. See Pierre Rosenberg, "Fragonard à Vérone. Fragonard et Véronèse," *Verona Illustrata* 2 (1989): 89-91. The *Martyrdom* returned from its French sojourn in 1815 and was re-hung in its original frame where one can see it today. Napoleon also took scores of paintings, sculptures, antiquities, books and manuscripts, and various curiosities and natural materials from all over Italy. See *Catalogo de' capi d'opera di pittura, scultura, antichità, libri, storia naturale, ed altre curiosità transportate dall'Italia in Francia* (Venice: Antonio Curti, 1799), XVII for complete list of plundered items. The *Saint Barnabas* was listed in the catalogue as "S. Barnaba che legge l'Evangelico sopra il capo d'un malato" and as by the school of Paolo Veronese.

19. This premise has been put forth before, but the reasons why the canons would have made this change have never been addressed. See Richard Cocke, *Veronese's Drawings: A Catalogue Raisonné* (Ithaca, NY: Cornell University Press, 1984), 235 n. 136; and Marini, "Paolo Veronese," 231.

20. "In Verona entro la chiesa di S. Giorgio vi sono di sua mano due tavole: quella dell'altar maggiore, dimostrante il martirio di San Lorenzo [sic]: e quella, dove si vede un miracolo di San Bernaba." Borghini, *Il Riposo*, 4:561.

21. "Sotto l'organo è S. Barnarda Apostolo collocato nel seno d'una Tribuna, che risana un'infermo leggendovi sopra l'Evangelo, e vi assistono huomini e donne con torchi in mano, che fanno oratione; altri conducono infermi al Santo, acciò gli risani." Ridolfi, *Le meraviglie*, 1:305.

22. "Sotto l'Organo sinistro è S. Barnaba Apostolo collocato nel seno d'una Tribuna, che risana

text one finds Dal Pozzo's account reproducing Ridolfi's description of 1584 almost exactly, except that Dal Pozzo specified the painting was "under the *left* organ." In 1668, the same year the canons' organization was suppressed, Ludovico Moscardo wrote his *Historia di Verona* in which he stated that the painting was in place on the south side of the transept "under the choir" and Moretto's canvas was opposite it.[23] An inventory taken of the church that same year confirms this arrangement.[24] Yet it is worth noting what two nineteenth-century chroniclers had to say about the original location of the looted painting. Both Giovan Battista Da Persico in 1820 and Carlo Belviglieri in 1898 noted that at the time of their writing Moretto's *Santa Cecilia* was "under the organ" on the north of the church. But more importantly they concurred that at some point before Veronese's *Saint Barnabas* was taken to France, it had replaced Moretto's painting.[25]

An inscription in the cloister supports my suggestion that Veronese painted the St. Barnabas altarpiece for the altar under the organ on the church's left aisle. The inscription lists all the altars that were consecrated in S. Giorgio in Braida in either 1536 or 1543, but it does not mention an altar under the cantoria on the right (south) side of the church.[26] It is not mentioned because one probably

un'infermo leggendovi sopra l'evangelo, e n'assistono huomini, e donne con torci in mano che fanno oratione. Altri conducono Infermi al Santo, acciò li fisani." Dal Pozzo, *Le vite*, 241.

23. On 7 December 1668, Pope Clement IX authorized the suppression of the Congregation of Augustinian Canons from S. Giorgio in Alga. (ASVat, Fondo Veneto II, 1, fol. 252r.) At the same time, the pope suppressed the Gesuati and the Augustinian Friars from S. Gerolamo in Fiesole. (ASVat, Fondo Veneto I, 1, 246r.) This was done, in part, to help finance Venice's ongoing war with the Turks, specifically the doomed siege of Candia that ended in 1669 with Venice's loss of the strategically important island of Crete. Tramontin, "Canonici Secolari," 158. "...Questa Chiesa di S. Giorgio si ritrova adorata di maravigliose pitture, che oltre la sua Architettura la rendono insigne per gli eccellenti huomini, che vi hanno operato, trà quali fù Paolo Caliari Veronese, che vi dipinse la Palla dell'Altar maggiore, & quella, che è sotto al Choro: il Romanin Bresciano dipinse le porte dell'organo, sotto al quale si vede una bellissima palla del Moretto pur'anche'esso Besciano...." Moscardo, *Historia di Verona*, 120.

24. ASVat, Fondo Veneto, 3, 257r: "All'Altar di S. Cecilia nel corpo della Chiesa a' Cornici Evangelii Pala dell'istotta Santa, et altre Sante in Tela." ASVat, Fondo Veneto, 3, 260r: "Altare di S. Barnaba che vien Mer il p.o a`cornu Evangelii [sic] / Pala di Paulo Veronese in tela dal med. Santo, e molte figure di grandissimo stima, e prezzo."

25. "...sotto l'organo, recente lavoro del Calido, veneziano, so ha la Vergine col Bambino, le ss. Lucia, Cecilia, ec. coll'epigrafe: Alexander Morettus Brix. MDXL Moretto, come ognun sa, fù soprannome del Bonvicino. Questa tavola fù sustituita a qualla di s. Barnaba, originale di Paolo, non ritornataci da Parigi." Giovanni Battista Da Persico, *Descrizione di Verona e della sua Provincia*, 2 vols. (Verona: Società tipografica editrice, 1820-21); 2:92-93. "Sotto l'organo, la bellissima tavola colle Sante Lucia, Cecilia, Caterina, Barbara, Agnese, è opera di Alessandro Del Moretto [Bonvicino] bresciano [1540], porta scritto il nome e l'anno. Questa tavola fu sustituita a quella di S. Barnaba di Paolo Caliari, rapita, e non più tornata da Parigi." Giovanni Belviglieri, *Guida alle chiese di Verona* (Verona: F. Apollonio, 1898), 72.

26. V. CAL MAIAS M.D.XXXVI / AD DEI OPT MAX GLORIAM EIVSQ. MARTY GEOR. ÆDE HANC

did not exist in 1543. Physical evidence suggests the original cloister entrance was in this location instead. An arched doorway is still visible in the narrow hallway behind the altar containing the copy of Veronese's painting (Fig. 8). Though it is unknown exactly when the opening was walled up, the canons may still have accessed the cloister through this entrance in 1603 when a door decorated with an image of St. George by Paolo Farinati may have covered it.[27]

The St. Barnabas altarpiece itself holds clues to its original location. Veronese seems to have tailored his composition so that the altarpiece would appear united with its intended location (Fig. 7). If the *Saint Barnabas Healing the Sick* were in situ under the organ on the left (north) side of the transept, the painting's internal architecture and light source would have conformed to the surrounding architecture and the church's natural and spiritual illumination. The unfluted columns in Veronese's painting would mimic the smooth ones on the altar under the organ even though they are capped with Corinthian

/ ALTARIAQ. III E QVIB. DVO POSTEA LOCIS AMOTA FVERE / RELIQVVM TITVLO MICH. GAB. RAPH. CETEROR. Q. ANG. IO. / MATH. GIB. EPS. VERON. ALIA IX SEPTENNIO POST DIONYS. / GRÆC. CHIRON. ET MILOPOT. ANTISTES MAXIMUM EIVSD. / MARTY ET APOST PET ET PAVLI AB ORGANI LATERA I / VIRG. ET MARTY CÆCILIE CHA., AGN. ET LVCIÆ II BEAT. LAVR. / PROTOPATR. VENET. ZEN. SYL. MART. PONT. III SANCTISS / TRINIT. SEB. Q. ET ROCHI IIII LAV. STEPH. VINC. ET CHRISTOPH. / MAVRTY V VRSULÆ ET SOC. PRID. CAL. AVG. ET MOX IIII / NO. HÆC E REGIONE OMN. APOST. INDE ANT. BENED. MAV. ET / BERN ABB POSTREM MARIÆ MAGD. MARTHÆ FRATR. Q. / LAZ. PRÆSVLES AMBO PIIS CONSECRARVNT / ANSELMO CANERIO VERON PRIORE MERITISS. English translation by Ryan Fowler: "On 27 April 1536, for the glory of God most high and mighty and his martyr George, Gian Matteo Giberti consecrated this church and three altars of which two of these were moved afterwards from their places and in the name of the Angels Michael, Gabriele and Raphael. In the seventh year afterwards [on 31 July 1543] Dionysius, bishop of Chaeronea in Greece and Milopotamos, [consecrated] another nine [altars], the largest of them [i.e., the high altar] [in the name of] the same martyr [George] and Apostles Peter and Paul; on the side of the organ [i.e., the left side] the first [altar] to the Virgins and martyrs Cecilia, Catherine, Agnes and Lucy; the second to Beatus Lorenzo [Giustiniani] first patriarch of Venice, S. Zeno and St. Silvester the martyred pope; the third to the Holy Trinity and Sts. Sebastian and Roche; the fourth to the martyrs Sts. Lawrence, Stephen, Vincent and Christopher; the fifth to St. Ursula and her retinue. The second of August [Dionysius the bishop also consecrated] on the other side [of the nave, an altar] to all the Apostles; thence to [the altar dedicated to] Sts. Anthony, Benedict, Maurice and Abbot Bernard; the last [altar] to Mary Magdalene, Martha and her brother Lazarus. Anselmo Canerio of Verona most praise-worthy prior."

27. The canons commissioned Farinati to paint *Multiplication of the Loaves and Fishes,* one of the large canvases in the chancel, in 1600. An entry in Paolo Farinati's *Giornale* confirms he painted this canvas for the canons. But on 15 November 1603 the artist recorded that the sacristan, Don Matio Bruno, commissioned him to paint a panel for the door of the church, which he decorated with an image of St. George. "Sa Zorzo. Fato sula portela, a la porta di la iesia e l'à mandà a tor il padre don Matio Bruni segrestan ali 15 novembre 1603, su la qual li è un San Zorzo." Paolo Farinati, *Giornale*, Civiltà veneziana. Fonti e testi, 8. Serie 1: Fonti e documenti per la storia dell'arte veneta, 5 (1573–1606) (Florence: Leo S. Olschki, 1968), 166. Lionello Puppi, who published and edited Farinati's *Giornale* in 1968, noted that the panel was for the front door of the church. But perhaps "la porta di la iesa" was the door that lead into the church from the cloister.

instead of Ionic capitals. The painted shadows would appear to be cast by light coming from the direction of the high altar and the windows of the apse. In this way, the miracle of St. Barnabas would have appeared to have been taking place within the altar, just beyond the limit of the picture plane.

Veronese seems to have experimented with unifying his painting and its surroundings in this way while working out the composition for his earlier *Saint George* altarpiece for S. Giorgio in Braida's high altar.[28] A drawing of *The Apotheosis of Saint George* thought to be Veronese's second iteration of his composition shows the artist incorporating elements from new high altar frame designed by Michele Sanmicheli, which had the effect of making the action appear to take place within a fictive extension of the altar frame's concave colonnade.[29] Vasari saw the architectonic frame soon after its completion in 1563 and described it in his 1568 *Vite*:

> ...[it] bends to make a niche and is of the Corinthian order with composite capitals, double columns in full relief with pilaster strips behind them. Similarly, the pediment above, that covers everything, also bends with great skill following to the niche below, and it has all the trappings that cap that order.[30]

Both Sanmicheli's real and Veronese's fictive architectures have Corinthian capitals atop plain columns. The dentilated entablature seen in the upper left corner of the *Apotheosis* is derived from the cap of the entablature in the altar frame. Had Veronese used this drawing as the model for his final altarpiece, George's ascension would have appeared to take place just beyond the picture plane but within the confines of the high altar's row of columns.

Compositions of other paintings in the church also suggest that Veronese's St. Barnabas altarpiece was intended for the position then occupied by Moretto's on the left (north) side. Bernardino India painted two pair of

28. While Cocke has noted that the fictive architecture in the drawing of *The Apotheosis of Saint George* — which is thought to have been Veronese's second conception of his final altarpiece — was meant to accord with the real architecture of the high altar of S. Giorgio in Braida (the altarpiece's intended location), no scholar until now has ever proposed that Veronese intended the fictive architecture in the *Saint Barnabas* to harmonize with the architecture of the altar under the organ and the light coming from the windows surrounding the high altar.

29. The drawing is now in a private Roman collection. See Sergio Marinelli, "13. Paolo Veronese, Apoteosi di S. Giorgio," in Marinelli, *Veronese e Verona*, 219–21; Aliberti Gaudioso, "Paolo Veronese," 222; Rearick, *Art of Paolo Veronese*, 79; and Marinelli, "La Pala," 329.

30. "Questo'opera, dico, la quale va girando secondo che fa la nicchia, è d'ordine corintio con capitelli composti, colonne doppie di tutto rilievo, e con i suoi pilastri dietro. Similmente il frontespizio, che la ricopre tutta, gira anch'egli con grande maestria, secondo che fa la nicchia, e ha tutti gli ornamenti che cape quell'ordine." Giorgio Vasari, *Le opere di Giorgio Vasari: Il resto delle vite degli artefici, l'appendice alle note delle medesime, l'indice generale e le opere minori dello stesso autore*, vol. 2 (Florence: D. Passigli, 1838), 850.

figures flanking both transept altars in the early 1560s: on the left are martyrs tentatively identified as Sts. Fermo and Rustico, (Figs. 9a & b); on the right are Sts. Pope Gregory I and Jerome (Figs. 10a & b).[31] The left pair of martyrs appear as if they are engaging with the figures in Moretto's canvas (Fig. 5), their gazes are directed toward the Virgin and Child in nimbus in the upper register, unlike the other side of the transept where neither Sts. Gregory I nor Jerome (Fig. 6) engages with the painted imagery between them: Gregory looks toward the high altar and Jerome looks heavenward. This suggests that an altarpiece was absent when these lateral paintings were commissioned and supports the notion that the doorway to the cloister occupied the space there instead. Since St. Pope Gregory I embodied Pope Gregory XII, the founder of their congregation, and St. Jerome was the erudite protector of scholars, and retrospectively after Trent the author of one of the only authorized version of the Bible, these divine protectors of the canons would have been appropriate sentinels guarding their private quarters.[32]

One final piece of evidence in the *Saint Barnabas* altarpiece suggests the painting was meant to hang under the organ and facing the cloister door (Fig. 7). The iconography of the St. Barnabas altarpiece, and many other works of art in S. Giorgio in Braida, highlights the canons' erudition and use of canonical texts in their liturgy.[33] In Veronese's altarpiece, Barnabas holds the Gospel of St. Matthew and uses it to heal the sick as the canons used the Gospels and other texts to reform the clergy and to instruct the populace. The belief that salvation is attainable through study of scripture, especially the Gospels, was a key component of the canons' reform strategy and one of the devotional models emphasized by the Council of Trent.[34] But the inclusion of this text in

31. These identifications were made by Brugnoli, *La Chiesa di S. Giorgio*, 5, 38. However, Saverio Dalla Rosa, "Catastico: Delle pitture e scolture esistenti nelle chiese e luoghi pubblici situati in Verona," ed. Sergio Marinelli and Paolo Rigoli (Verona: Istituto Salesiano "San Zeno" Scuola Grafica, 1803-4; repr. 1996), 218, facsimile of MS. 1008, BCVr, thought the left martyr was St. George; and Trecca, *La Chiesa de S. Giorgio in Braida a Verona*, 51, thought Tiberius, brother of Cecilia, was on left and that St. Valeriano, husband of St. Ursula, was on the right.

32. Humfrey, "Altarpieces," 377-78; and Nolin, "Uniting Faith and Image," 51-56, 97-115. See also Elizabeth Pilliod, "Alessandro Allori's 'The Penitent Saint Jerome'," *Record of the Art Museum, Princeton University* 47.1 (1988): 2-26; and Eugene F. Rice, *Saint Jerome in the Renaissance* (Baltimore: The Johns Hopkins University Press, 1985), for Jerome's significance in the Renaissance. Imagery of Jerome pervaded the congregation's churches. The most well-known example being Parmigianino's *Vision of Saint Jerome* painted in 1527 for S. Salvatore in Lauro, Rome and now in the National Gallery in London. See Mary Vaccaro, "Documents for Parmigianino's 'Vision of St Jerome'," *The Burlington Magazine* 135.1078 (Jan. 1993): 22-27.

33. One example of many is Sigismondo de Stefani's *Martyrdom of Saint Lawrence* of 1563. Open texts of all four Gospels dominate its upper register.

34. Cracco, "La Fondazione dei Canonici Secolari," 81. Council of Trent, Session XVIII, 26 February 1562. See Schroeder, 215-17.

this altarpiece's iconography further implies that the altarpiece was intended to hang on the north side of the transept under the organ.

Contemporary descriptions of church interiors, and specifically those concerning S. Giorgio in Braida, often used the terminology "à Cornu Evangelii" and "à Cornu Epistolae" to describe the position of objects in the church.[35] This nomenclature derives its meaning from the location on or near the altar of the church where specific liturgical activities took place.[36] The canons read the Gospels from the left side of the altar. In this context, it follows logically that the canons would have placed Veronese's painting "à Cornu Evangelii" or on the left side of S. Giorgio in Braida's high altar because St. Barnabas' divine remedy for curing the sick was St. Matthew's Gospel.

But why would the canons in 1566 want to remove Moretto's painting from under the organ, especially since Moretto completed it only in 1540 and included the patron saint of music, St. Cecilia, and her companions? It was not unusual for the canons to relocate art (and other movable goods, such as books) within the walls of a single church or from one church to another.[37] Though the practice of moving paintings was not unique, the canons' system was highly unusual because they sometimes moved an altarpiece not long after it was completed to ensure their churches' iconographic programs always expressed their most pressing religious concerns. This seems to have been the case with both of Veronese's paintings for S. Giorgio in Braida.

While scholars agree that the *Martyrdom of Saint George* hanging above the high altar in S. Giorgio in Braida today was created after the Council of Trent's December 1563 decree, it has been speculated that the canons commissioned Veronese as early as 1550.[38] He was probably asked to paint a replacement for

35. For example, the 1668 inventory of S. Giorgio in Braida. See ASVat, Fondo Veneto II, doc. 1, fol. 259r.
36. "À Cornu" literally means "on the horn" and describes the side of the altar in relation to the cross over the altar. See Augustin Joseph Schulte, "Altar Horns," *The Catholic Encyclopedia*. Therefore, "à Cornu Evangelii" is on the side of the altar where the Gospels were read, i.e. "on the left side of the church." Similarly, "à Cornu Epistolae" translates to "on the right side of the church" because it is on the side of the altar where the Epistles were read.
37. Another example of when the canons moved a work within the church is at the Madonna dell'Orto where they repeatedly relocated Gentile Bellini's banner of Lorenzo Giustiniani. The canons also moved objects from one church to another, such as when the canons from S. Giorgio in Alga took Girolamo da Santacroce's *Giustiniani* altarpiece from the Madonna dell'Orto or when the Veronese canons switched Francesco Torbido's altarpiece in S. Giorgio in Braida with Girolamo dai Libri's altarpiece in Sant'Angiolo in Monte. Nolin, "Uniting Faith and Image," 264–68.
38. Three preliminary sketches dating to c.1550–52 are believed to represent the first iteration of Veronese's altarpiece. All three drawings are reproduced in Marinelli, "La Pala," 326–28, figs. 260–62. The first is a drawing in the Louvre (Cabinet des Dessin, n. 4839) thought to be Paolo Farinati's copy of Veronese's first altarpiece. The second drawing in the Uffizi (Gabinetto dei Disegni, n. 12845 F) is of George slaying the dragon and is paired with another drawing in the Louvre (Départment des arts graphique, n. 4816) of the Madonna and Child with Sts. Peter and Paul. The last two drawings are considered studies for the bottom and top sections of the altarpiece. Rearick, *Art of Paolo Veronese*,

Gian Francesco Caroto's *San Giorgio and the Princess*, which may have hung above the high altar for just fifteen years, because by 1550 its iconography may have been considered too profane.[39] Furthermore, its composition may have been outmoded, it may have suffered extensive, yet unspecified damage, and plans may have been underway to replace the existing altar frame with Sanmicheli's new design.[40] Whatever the reason, Caroto's canvas was probably removed from S. Giorgio in Braida sometime between 1552 and 1569 and relocated to the church of S. Giorgio in Marega, where it was first documented and where it remains today.[41] The previously discussed *Apotheosis* from 1564

36–38, dates these three drawings to 1550. Marinelli, "La Pala," 324, dates them to 1551–52. Cocke, *Veronese's Drawings*, 348 and 78, rejected both the study of George and the dragon and the Madonna and Child as by Veronese. The drawings roughly correspond to Caroto's composition and duplicate his imagery, including the saint slaying the dragon and the Virgin and saints in the upper register. These similarities suggest the canons did not originally ask Veronese to change the altarpiece but to make it in his own style. His composition so closely resembled Caroto's painting, however, that it has been suggested as the reason his first version was rejected. See Aliberti Gaudioso, "Paolo Veronese," 222. A drawing universally accepted as Veronese's study for the final canvas of the *Martyrdom of Saint George* shares figures in common with a drawing in Rotterdam dated 1564 is now in the Getty. See Cocke, *Veronese's Drawings*, 134–35, fig. 53.

39. Giuliana Ericani first attributed the *San Giorgio and the Princess* to Caroto. See Giuliana Ericani, "29. Francesco Caroto, S. Giorgio e la Principessa," in Marinelli *Veronese e Verona*, 266–73; and idem, "La Pala," 323–32, for analysis and image. This painting has never been documented above S. Giorgio in Braida's high altar. It shows the saint mounted on horseback and slaying the dragon while the princess flees towards the city in the background. The iconographic choice of a battle scene between the warrior saint and the dragon emphasizes George's role as soldier defending against evil and as protector of Catholic orthodoxy — a fitting reference for the canons whose mission was to battle corruption within the Church.

40. Scholars had come to accept without further confirmation Vasari's attribution of the church to Michele Sanmicheli: "riuscì contro l'opinione di molti, i quali non pensarono che mai quella fatica dovesse reggersi in piedi per la debolezza delle spalle, che avea: le quali furono poi in guisa da Michele fortificate, che non si ha più di che temere." (Vasari, *Vite* 29, 6:355–64.) Pierpaolo Brugnoli was the first to attribute the frame to Sanmicheli and to date it to the interval between 1536, the year Bishop Giberti consecrated four altars in the church, and 1543 when the rest of the altars were dedicated. Pierpaolo Brugnoli, "Qualche aggiunta al catalogo delle opere di Michele Sanmicheli," *Architetti Verona: Ordine degli architetti della Provincia di Verona* 1.11 (July 1961): 21. Only since 1995, when Maria Beltramini published her discovery of a contract written in 1557 between the prior of S. Giorgio in Braida, Domenico Savallo, and a team of "talia piera" and "murari" for the completion of the "salizon de la nostra chiesa...fatto secundo li disegni fatti per messer Michel da S. Michel Inzignere," has Sanmicheli's involvement in the second phase of construction at S. Giorgio in Braida been firmly proven. See ASVat, Fondo Veneto II, 832, unnumbered folio dated 2 October 1557 as quoted in Maria Beltramini, "Sanmicheli e la Chiesa di San Giorgio in Braida a Verona," in *Michele Sanmicheli: Architettura, linguaggio e cultura artistica nel Cinquecento*, ed. Lionello Puppi, Howard Burns and Christoph Luitpold Frommel. Documenti di architettura (Milan and Vicenza: Electa, 1995), 106.

41. Caroto's painting arrived at the church of S. Giorgio in Marega di Bevilaqua (Marega is a village two miles from Bevilaqua in the Veronese province), sometime before 10 May 1569. On that date Agostino Valerio, bishop of Verona, visited the church. He ordered the repainting and relining of the altarpiece above the high altar because it was in such bad condition. This is the first and only

was probably Veronese's second version of the new altarpiece. It is thought that the canons decided a scene of George's martyrdom was more fitting given the dedication of the altar and the Council of Trent's requirements for devotional images.[42]

Unlike Caroto's canvas, Moretto's painting was likely not removed because it no longer conformed to decorum but because its location was especially significant for the canons for two reasons: the altar on the left transept was probably closest to the former location of the hospital of St. Barnabas once administered by the canons, and the altar faced the entrance to the cloister and would therefore be the first image the canons' saw when they emerged from the cloister.

Imagery of St. Barnabas was unusual in the sixteenth century.[43] For the canons, however, it held special significance — evoking their previous relationship with the charitable hospital of St. Barnabas.[44] The hospital had been linked with the church of S. Giorgio in Braida at least since the twelfth century. At that time the two institutions were physically close: the hospital is described as in the "burg" of S. Giorgio in Braida, that is, in the same parish;

known mention of the painting in the documents. See AAVr, vol. XIII, c. 390: "repingatur palla altaris maioris. Ematur tela coperienda dicta palla" as cited by Ericani, "Francesco Caroto," 267.

42. Aliberti Gaudioso, "Paolo Veronese," 226. Maurice E. Cope, *The Venetian Chapel of the Sacrament in the Sixteenth Century*. Outstanding Dissertations in the Fine Arts (New York: Garland, 1979), 212–13, makes the point that the Eucharist was the most appropriate subject for a high altar. Yet the altar in S. Giorgio in Braida had been dedicated since at least 1536 to Sts. Peter and Paul and St. George, the titular saint of both the church and the canons' religious organization. Therefore, it seems likely that the canons wanted to retain this dedication. However, they did decorate the chancel's lateral walls with scenes that alluded to the Eucharist: they commissioned Felice Brusasorci to paint a large canvas of *The Fall of Manna from Heaven* around 1600 and Paolo Farinati to its pendant, *The Multiplication of Loaves and Fishes*, which he completed in 1603.

43. Only a few examples of this episode survive. In addition to the nineteenth-century copy in S. Giorgio in Braida by an unknown artist, there is one in Pommersfelden (curatorial records at the Musée des Beaux-Arts, Rouen) and another that was on the Venetian art market in 1960 but whose current location is unknown. (Soprintendenza per il patrimonio storico artistico ed etno-antropologico per le province di Verona, Vicenza e Rovigo. Scede di catalogo generale, 51791). The Musée des Beaux-Arts in Rouen also has in their collection a watercolor copy of this painting made by Delacroix in 1834 (curatorial records at the Musée des Beaux-Arts, Rouen). In 1720, an altarpiece by Michel Angelo Prunati of the same subject, and possibly a copy of Veronese's painting, was in the church of the Confraternità di S. Alessio. It is unknown if this canvas is either the Pommersfelden one or the one available in 1960. See Lanceni, *Ricreazione Pittorica*, 6.1:195: "vi sono due altari oltre il Maggiore in uno la Natività del Vergine: Opera di Antonio Baroni. Nell'altro S. Barnaba in atto di benedire un Infermo: Opera di Michel Angelo Prunati."

44. Marini, "Paolo Veronese," 231. The organization was also known as the Hospital of the Paupers of Christ and was dedicated to both the Virgin Mary and to St. Barnabas. See Giuseppe Tommasi, *Storia dello Spedale de' SS. Alessio, Barnaba, e Concordia* (Verona: Dionigi Ramanzini, 1774); Vittorio Fainelli, *Storia degli ospedali di Verona: Dai tempi di San Zeno ai giorni nostri* (Verona: Ghidini e Fiorini, 1962); and Alessandro Pastore, ed. *L'Ospedale e la città: Cinquecento anni d'arte a Verona* (Verona: Cierre, 1996).

as well as institutionally close, with S. Giorgio in Braida holding several of the hospital's documents for safekeeping.[45] Pope Eugenius IV issued a decree on 20 December 1446 granting the Secular Canons of S. Giorgio in Braida sole custody of the hospital.[46] This gave them full control of the organization and they soon began serving the physical needs of the local community while continuing to tend to their spiritual ones inside the church.

The canons possessed the hospital for only a little more than half a century, unfortunately, because a fire damaged it in 1516 during the War of the League of Cambrai.[47] The following year, the Venetians intentionally destroyed what remained to make way for new city walls to be built as part of Venice's initiative to improve the fortifications on the *terrafirma*.[48] The ruined hospital provided ready building materials for the construction of the Porta S. Giorgio not far from the facade of the church, completed by 1525 as shown by an inscription on the exterior of the gate.[49] Moreover, before the hospital of Saint Barnabas was destroyed to make way for the new Venetian walls in 1517, it was adjacent to the church on the Borgolecco di S. Giorgio and may have been attached to the church.[50] This fact further supports the hypothesis that the canons placed the canvas of St. Barnabas' miracle on the left (north) side of the transept because the altar was among those closest to the hospital's former site. Thus, by choosing St. Barnabas as a subject of Veronese's altarpiece, the canons revived their connection to this charitable organization and reminded themselves and those in the Curia of a part of their successful mission of reform: their commitment to doing good works and to assisting the Veronese people with their spiritual and physical needs as associated with their stewardship of the hospital.

Two specific elements in the painting — the color of the garb worn by the main figures and the presence of St. Mark — would have spoken directly to

45. ASVat, Fondo Veneto I, 7454, 7463 as cited in Sue Brotherton, "San Giorgio in Braida in the Changing World of Verona, 1050-1200" (Ph.D. diss., University of Pennsylvania, 1992), 279.
46. ACNV XVI, bulla Eugenii IV, dat. Romae a. I, 1446, XIII Kal. Ian. (20 dicembre) eseguita con bulla di Martino V, dat. Romae a. S. P. an. I. 1447 XIII Kal. Feb. (20 gennaio) as cited in Pio Cenci, "L'archivio della Cancelleria della Nunziatura Veneta," in *Miscellanea Francesco Ehrle: Scritti di storia e paleografia*. Studi e Testi (Vatican City: Biblioteca Apostolica Vaticana, 1924), 299 n. 7.
47. "L'Ospitale di San Barnaba fu incendiato, con tutto il borgo di San Giorgio, il 16 agosto del 1516 dalle milizie straniere per ordine del Conte da Cariati." Fainelli, *Storia degli ospedali*, 185; and Pier Zagata, *Cronica della citta' di Verona* (Verona: D. Ramanzini, 1745), I, 183.
48. Fainelli, *Storia degli ospedali*, 156.
49. Erik Johan Langenskiöld, "Michele Sanmicheli: Was He the Architect of the Porta di S. Giorgio in Verona?" *Palladio* 10 (Jan.-June 1960): 49; and Paul Davies and David Hemsoll, *Michele Sanmicheli* (Milan: Electa, 2004).
50. A document dated 13 October 1176 recorded the location of an unknown object as "su le porticu hospitalis sancti Georgis in Braida." (AA.VV., *Arch. di S. Martino d'Avesa*, rot. n. 8 orig. as cited by Fainelli, *Storia degli ospedali*, 50.)

the canons and are worth noting in light of the painting's intended message to the canons and the Curia. The Secular Canons were especially devoted to the Virgin Mary as their protector and intercessor. The ecclesiastical garb that Pope Gregory XII permitted them to wear on 27 January 1407 reflected their duty to her.[51] The color of their skullcaps and habits was the dark blue of the Virgin's mantle, and it was the reason the canons were known as the *Celestini* or *Turchini* (*turchino* means dark blue in Italian). Veronese painted St. Barnabas wearing the dark blue tunic, or *turchino*, that mimic the canons' ecclesiastical garb and invoked their mission as priests.[52]

In Veronese's painting, St. Mark, patron saint of Venice, helps St. Barnabas perform his miracle and also wears the *turchino* of the canons as if to show solidarity with them. Venice and the Secular Canons had relied upon each other since the early 1400s. As Venice was better able to secure its territories on the mainland with the help of the Secular Canons, their congregation was able to expand and to reform monasteries on the mainland because of the favorable political conditions in the newly-acquired towns. The canons' congregation quickly became Venice's secret weapon in securing hegemony in its growing mainland domain, prompting the Venetian Senate to call it the city's "Trojan Horse."[53] Therefore, St. Mark's presence in the St. Barnabas altarpiece was a visible way for the Secular Canons to express their continued loyalty to Venice before their bonds to the city were forcibly weakened after 1568 by Pope Pius V's edict. This important association also seems to help in the dating the altarpiece to before that year.

As argued here, Veronese's *Saint Barnabas Healing the Sick* was painted for the altar under the organ that was opposite the entrance to the cloister on the left (north) side of the church (Fig. 9 & E in Fig. 4) and replaced Moretto's altarpiece. The importance of this commission to the canons is suggested by their choice of artists, since at that time Veronese was at the pinnacle of his career and, in addition to the *Martyrdom of Saint George* for the high altar of S. Giorgio in Braida, had painted the altarpiece and predella panels for the high altar of S. Giorgio in Alga, the canons' mother church in Venice.[54] The

51. Gill, *Eugenius IV*, 18. For an image of their habits, see Filippo Buonanni, *Ordinum religiosorum in ecclesia militanti catalogus, eorumque indumenta in iconibus expressa, & oblata Clementi XI. Pont. Max* (Rome: Antonii de Rubeis, 1706), plate 8, or reproduction in Tramonti, "Canonici seculari," 156.

52. This ensemble closely resembles that worn by Francesco Montemezzano's figure of Mary Magdalene in his altarpiece of the *Noli Me Tangere* painted for the canons' church in 1578/80. This makes it very likely that the canons made the creative decision to dress the saints in such a way.

53. ASV, *Senato, Secreta*, reg. 26, fol. 31v: "ex quo sicut ex equo troiano multi clari et in ecclesiam dei et magni viri prodierunt" as cited and reproduced in Labalme, "No Man but an Angel," 18 n. 9.

54. The canons seem to have favored Paolo Veronese and considered it a great honor to have his art above their altars because, in addition to these two paintings in Verona, Veronese painted the altarpiece and predella panels for the high altar of S. Giorgio in Alga, the canons' mother church

placement and iconography of the St. Barnabas altarpiece strongly suggests that the canons were the primary audience. It would have been the first image they saw when they emerged from their private quarters into the body of the church, and in this capacity as their church "frontispiece" it spoke directly to the canons and reminded them of their mission. This would have been reinforced by the dress of miracle-working St. Barnabas and St. Mark in robes of dark blue that mimicked the canons' vestments. The presence of Barnabas also invoked the hospital that the canons had been the final caretakers of before its destruction and reminded them of their connection to that pious institution. It seems probable that Veronese produced this altarpiece not long after the Council of Trent promulgated their last decree in 1563 but before Pope Pius V's decree of 1568 forcing the canons to become avowed priests. It is noteworthy that for their second canvas for S. Giorgio in Braida the canons chose as the subject the particular episode of St. Barnabas healing the sick, not a scene of his martyrdom by stoning, nor that of his mission of preaching in Antioch, nor as intercessor between the worshipper and Christ or Mary above in the heavenly realm — all also suitable imagery in light of the requirement imposed by the 1563 decree of the Council of Trent. Rather, the portrayal of St. Barnabas as an heroic and earthly figure in the act of healing the sick with the Gospel of Matthew and being helped by St. Mark, patron saint of Venice, alludes to the relationship of the canons and their mission of reform with the support of the Venetian Republic.

■

in Venice, probably around 1570-80. The altarpiece showed St. George disputing before Emperor Diocletian, and the three predella panels showed scenes from St. George's life. See Tomasini, *Annales*, 227-28. These paintings, along with the rest of the contents of the church, library and monastery of S. Giorgio in Alga, were destroyed in a fire that broke out on 11 July 1716. See Flaminio Corner, *Ecclesiae venetae antiquis monumentis: Nunc etiam primum editis illustratae ac in decades distributae*, 18 vols. (Venice: Jo. Baptistae Pasquali, 1749), 6:76; and Flaminio Corner, *Notizie storiche delle chiese e monasteri di Venezia, e di Torcello, tratte dalle chiese venezian, e torcellane* (Padua: Stamperia del Seminario, G. Manfre, 1758), 505.

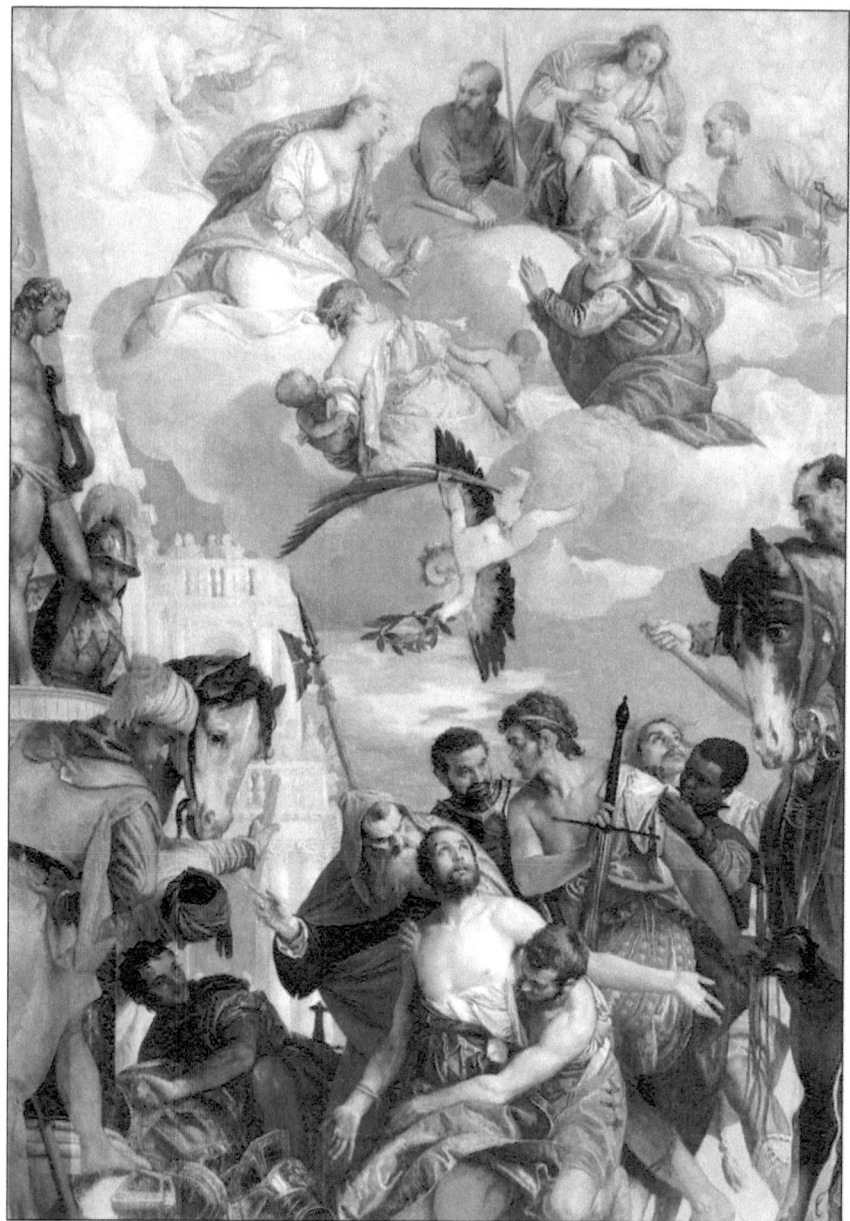

Fig. 1a (above). Paolo Veronese, *Martyrdom of Saint George*, 1566, oil on canvas, 426 x 305 cm. S. Giorgio in Braida, Verona. Public domain.

Fig. 1b. (facing page). *Martyrdom of Saint George* in situ. Photo: author.

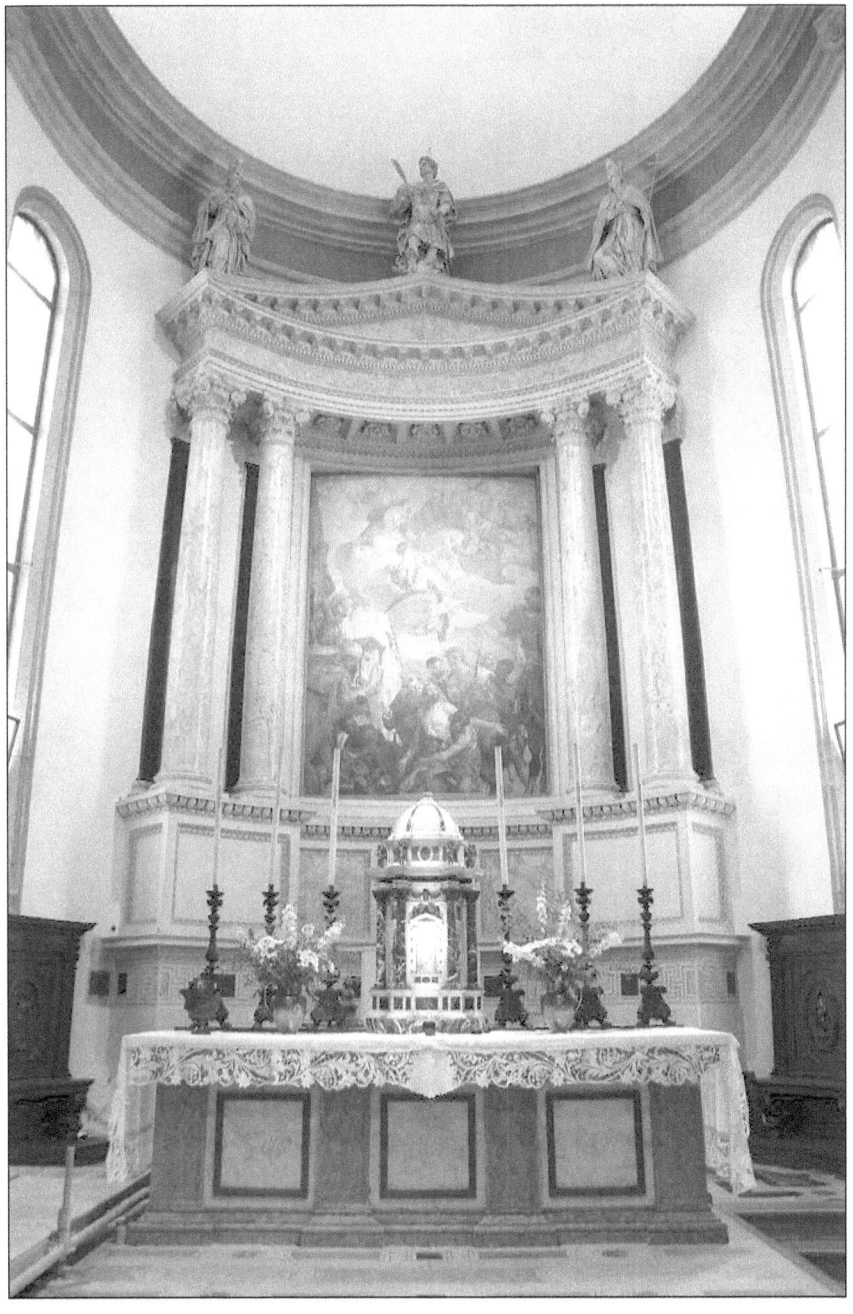

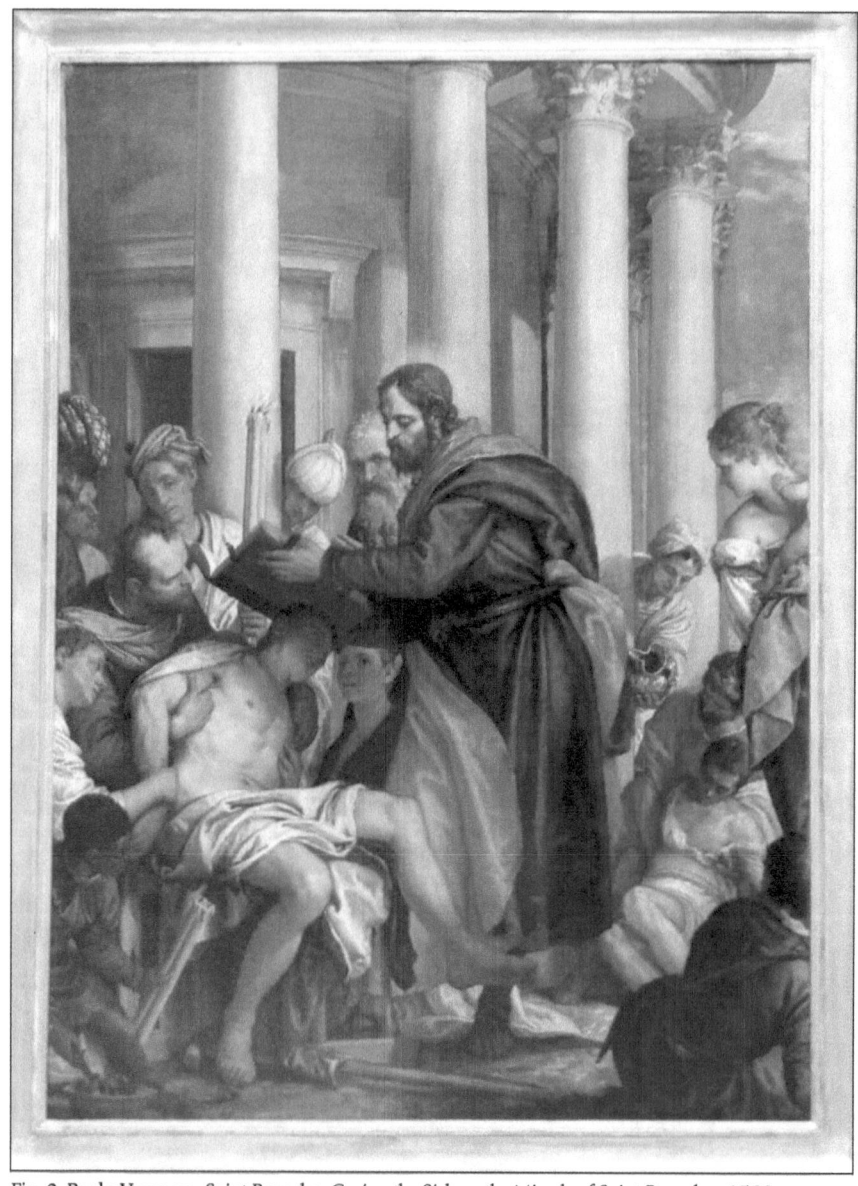

Fig. 2. Paolo Veronese, *Saint Barnabas Curing the Sick* or *the Miracle of Saint Barnabas*, 1566, oil on canvas, 260 cm x 193 cm, Musèe des Beaux-Arts, Rouen (inv. D 803-17; ex-S. Giorgio in Braida, Verona). Photo: author.

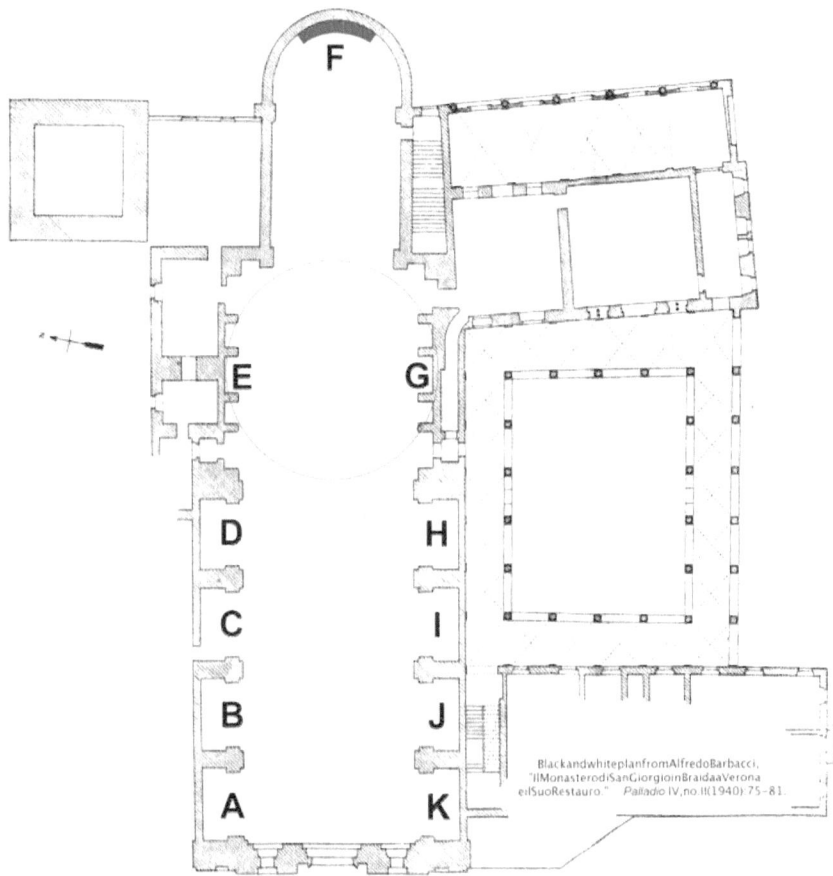

Fig. 3. Plan of S. Giorgio in Braida's altars, the saints to whom they were dedicated (according to the cloister inscription) and dates consecrated. Black and white plan taken from Alfredo Barbacci, "Il Monastero di San Giorgio in Braida a Verona e il Suo Restauro." *Palladio* 4.2 (1940): 75-81.

A: St. Ursula and her retinue (1543)
B: Sts. Lawrence, Stephen, Vincent and Christopher (1543)
C: Holy Trinity and Sts. Sebastian and Roche (1543)
D: Lorenzo Giustiniani, and Sts. Zeno and Pope Silvester (1536 and 1543)
E: Virgins Sts. Cecilia, Catherine, Agnes and Lucy (1543)
F: Sts. George, Peter and Paul (1504 and 1543)
G: No recorded consecration
H: Michael, Gabriele, Raphael and the Angels (1536)
I: St. George (1536); all the Apostles (1543)
J: Sts. Anthony, Benedict, Maurice and Abbot Bernard (1543)
K: Mary Magdalene, Martha and her brother Lazarus (1543)

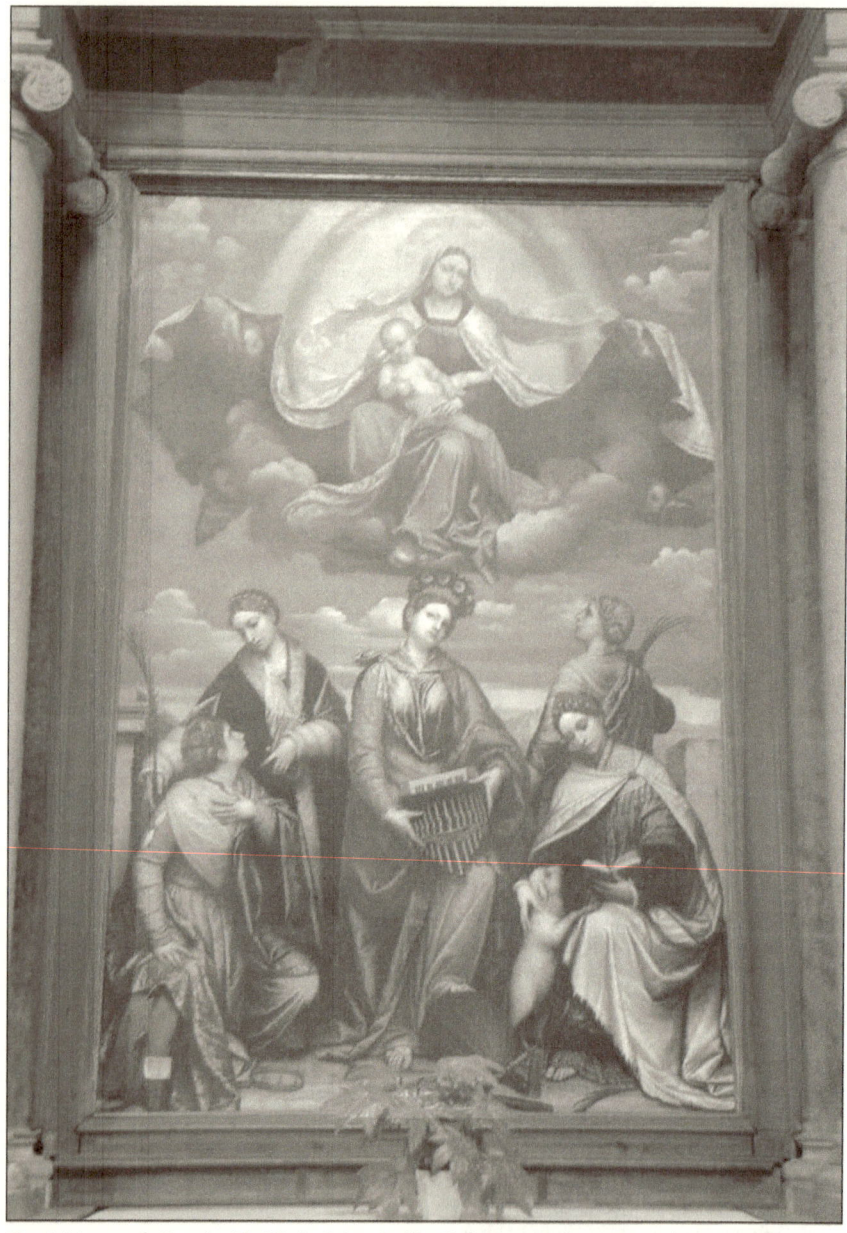

Fig. 4. Moretto da Brescia, *The Virgin Saints Cecilia, Catherine, Agatha, Agnes and Lucy,* 1540, oil on canvas, 288 x 193 cm. S. Giorgio in Braida, Verona. Photo: author.

Fig. 5 (above). North (à Cornu Evangelii) side of the transept of S. Giorgio in Braida. Location of the organ. Photo: author.

Fig. 6 (below). South (à Cornu Epistolae) side of the transept of S. Giorgio in Braida. Location of the cantoria. A nineteenth-century copy of Veronese's *Saint Barnabas Healing the Sick* now hangs above the altar. Photo: author.

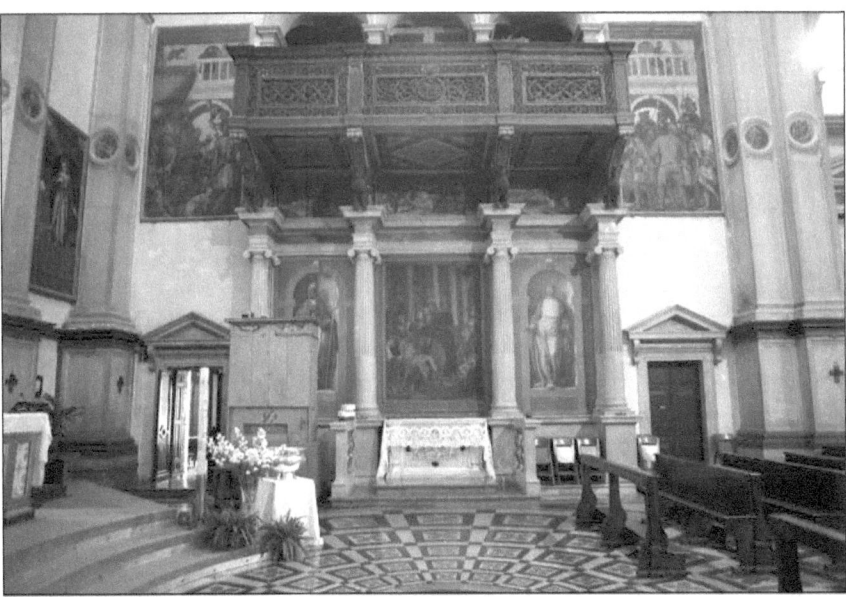

A SCARLET RENAISSANCE

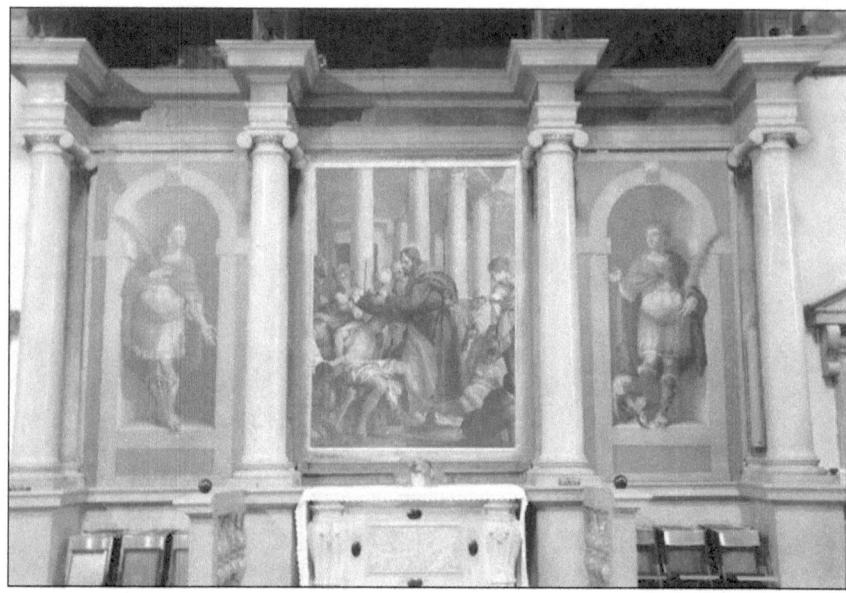

Fig. 7. Reconstructon of Veronese's *Saint Barnabas Healing the Sick* "à Cornu Evangelii" or on the left of the church under the organ. Photo: author.

Fig. 8. Evidence of the original cloister entrance. This walled-up doorway is located directly behind the church altar shown at the center of Fig. 6 and marked as "G" in Fig. 3. Photo: author.

Fig. 9a (left). Bernardino India, *Martyred Saint* (Fermo or Cecilia's brother or husband?), 1560s, oil on canvas, 325 x 170 cm. S. Giorgio in Braida, Verona.

Fig. 9b (below). Bernardino India, *Martyred Saint* (Rustico or Cecilia's brother or husband?), 1560s, oil on canvas, 323 x 168 cm. S. Giorgio in Braida, Verona.

Images 9a and 9b used with the permission of the Ministero per i Beni e le Attività Culturali, Soprintendenza per i Beni Storici e Artistici ed Etnoantropologici per Verona, Vicenza e Rovigo.

Fig. 10a (left). Bernardino India, *Pope Saint Gregory*, 1560s, oil on canvas, 326 x 176.5 cm. S. Giorgio in Braida, Verona.

Fig. 10b (below). Bernardino India, *Saint Jerome*, 1560s, oil on canvas, 324 x 172 cm. S. Giorgio in Braida, Verona.

Images 10a and 10b used with the permission of the Ministero per i Beni e le Attività Culturali, Soprintendenza per i Beni Storici e Artistici ed Etnoantropologici per Verona, Vicenza e Rovigo.

MEDICI POWER AND TUSCAN UNITY
THE CAVALIERI DI SANTO STEFANO AND PUBLIC SCULPTURE IN PISA AND LIVORNO UNDER FERDINANDO I

KATHERINE POOLE

In 1562 Cosimo I de' Medici (r.1537–64) founded the Cavalieri di Santo Stefano, a chivalric brotherhood modeled after one of the most famous of the Christian knightly orders, the Knights of Malta.[1] The order, housed in Pisa, was comprised of members from the most influential aristocratic families in Tuscany, and operated as a navy defending the Catholic Church and the Catholic countries rimming the Mediterranean against the increasing threat of the Ottoman Empire. It was not until the reign of Cosimo's son Ferdinando I (r.1587–1609), however, that the Medici rulers made their role as grand masters of their Christian knightly order one of the most prominent markers of grand-ducal identity, employing the iconography of the Cavalieri to proclaim their power and prestige in commissions throughout their Tuscan empire.[2]

A special thank you to Sarah Blake McHam for the invaluable support, wisdom and guidance she has provided me over the years. I could not have asked for a better art historical mentor and role model and this essay would not have been possible without her.

1. Key sources for the history of the order include Gino Guarnieri, *I cavalieri di Santo Stefano nella storia della marina italiana (1562–1859)*, 3rd ed. (Pisa: Nistri-Lischi Editori, 1960); Cesare Ciano, *Santo Stefano per mare e per terra: La guerra mediterranea e l'ordine dei cavalieri di Santo Stefano dal 1563 al 1716* (Pisa: ETS, 1985); Franco Angiolini, *I cavalieri e il principe: L'ordine di Santo Stefano e la società toscana in età moderna* (Florence: Edifir Edizioni, 1996); Angiolini, "L'ordine di Santo Stefano: La storia plurisecolare," in *Pisa dei Cavalieri*, ed. Clara Baracchini (Milan: Franco Maria Ricci, 1997), 7-19; Rodolfo Bernardini, *Breve storia del Sacro Militare Ordine di S. Stefano Papa e Martire dalla fondazione a oggi e dell'istituzione dei Cavalieri di S. Stefano* (Pisa: ETS, 1995); and Bernardini, *L'istituzione dei Cavalieri di Santo Stefano: Origine, sviluppo, attività* (Pisa: ETS, 2005). One of the earliest and most comprehensive sources concerning the exploits of the order is Fulvio Fontana, *I pregi della Toscana nell'imprese più segnalate de' cavalieri di Santo Stefano* (Florence: Miccioni & Nestenus, 1701), written during the reign of Cosimo III (r.1670–1723) and dedicated to the Medici grand duke.

2. On Ferdinando, the fundamental study of the history of Tuscany under the Medici grand dukes is Jacopo Riguccio Galluzzi, *Istoria del Granducato di Toscana sotto il governo della Casa Medici...* 5 vols. (Florence: Gaetano Cambiagi, 1781); volume 3 covers the reign of Ferdinando. Graziella Silli, *A Court at the End of the 16th Century: Artists, Men of Letters, Scientists at the Court of Ferdinand I* (Florence: Alinari, 1928) remains the sole monograph on Ferdinando's reign, although Suzanne B. Butters has written extensively on his tenure as a cardinal and his patronage in Rome. See Butters, "Contrasting

A SCARLET RENAISSANCE ■

Ferdinando's commission of two colossal, free-standing, public portrait sculptures, Pietro Francavilla's *Monument to Cosimo I* (1594–1600) (Fig. 1) and Giovanni Bandini and Pietro Tacca's *Monument to Ferdinando I* (1595–1626) (Fig. 2), for the Medici-controlled cities of Pisa and Livorno respectively, attests to two critical — and largely unexplored — aspects of grand-ducal patronage. The first is Ferdinando's skillful construction of a potent ruling identity for the Medici dynasty through imagery tied to the Cavalieri di Santo Stefano. The second concerns how the use of this iconography and the placement of these sculptures in two of the Medici subject cities articulated the crucial message of Medici grand-ducal policy to the Tuscan populace; they were an integral part of a powerful land and sea empire as well as key players in the fight against the Ottoman "other," a strategy cleverly calculated to promote Tuscan unity and pride while disguising the loss of individual liberty and republican identity.

The approval by Pope Pius IV (r.1559–65) of the foundation of the Order of Santo Stefano was an indication of Cosimo's growing political and territorial power, as well as of his esteemed place within the Church.[3] In creating his own chivalric brotherhood, a privilege previously reserved for royalty, Cosimo followed the model of two of the most prestigious Christian knightly orders, the Order of St. John of Jerusalem, more popularly known as the Knights of

Priorities: Ferdinando I de' Medici: Cardinal and Grand Duke," in *The Possessions of a Cardinal*, ed. Mary Hollingsworth and Carol M. Richardson (University Park, PA: The Pennsylvania State University Press, 2010), 185–225; Butters, "Ferdinando de' Medici and the Art of the Possible," in *The Medici, Michelangelo, and the Art of Late Renaissance Florence* (New Haven and London: Yale University Press, 2002), 66–75; Butters, "Le Cardinal Ferdinand de Médicis," in *La Villa Médicis*, ed. André Chastel and Philippe Morel (Rome: Académie de France à Rome, 1991), 170–97; and Butters, "'Magnifico, non senza eccesso': Riflessioni sul mecenatismo del Cardinale Ferdinando de' Medici," in *Villa Medici: Il sogno di un cardinale. Collezioni e artisti di Ferdinando de' Medici*, ed. Michel Hochmann (Rome: De Luca, 1999), 22–45. A number of recent exhibition catalogues, including Mina Gregori, ed., *Fasto di corte: La decorazione murale nelle residenze dei Medici e dei Lorena*, 2 vols. (Florence: Edifir, 2005–6); Gabriella Capecchi, et al., *Palazzo Pitti: La reggia rivelata* (Florence: Giunti, 2003); and Mina Gregori and Detlef Heikamp, eds., *Magnificenza alla corte dei Medici: Arte a Firenze alla fine del Cinquecento* (Milan: Electa, 1997), offer the most thorough overviews of Ferdinando's Florentine patronage as grand duke.

3. Although authorized by Pius IV in October 1561, the official foundation date of the Order of Santo Stefano was January 9, 1562. On February 1, the pope issued a papal bull confirming the order and approving its statutes. The consecration of the order and the conferring of the title of grand master on Cosimo took place in Pisa a month later on March 15. The annexation of Siena in 1559 appears to have been in part the impetus for Cosimo to begin a full-scale campaign to gain a knightly order. That Cosimo had begun secret negotiations with the papal court concerning the foundation of the order shortly after the Treaty of Câteau-Cambrésis gave possession of Siena to Florence is clear from Cosimo's correspondence to the Florentine ambassador to Rome during the fall of 1561. Paul W. Richelson suggests that Cosimo began discussing the formation of the order even earlier, in 1560 on a visit to Rome during which Pius IV made Cosimo's second eldest son, Giovanni, a cardinal: *Studies in the Personal Imagery of Cosimo I de' Medici, Duke of Florence* (New York: Garland, 1978), 148. On the birth of the order, see Bernardini, *Breve storia*, 15–18; and Angiolini, "L'ordine di Santo Stefano," 7.

Malta, and the Order of the Golden Fleece, the crusading order founded by the dukes of Burgundy, of which he himself was a member. The two orders influenced Cosimo in everything from the guiding statutes of the Cavalieri to the robes worn by the members.[4]

The official reason for the creation of the Order of Santo Stefano, confirmed in the founding statutes, was to assist the Christian powers of Europe in their crusade against the Ottoman Empire. By extension, the order was to defend Christianity from the spread of Islam, mirroring the mission of the Orders of Alcantara and Calatrava, the chivalric brotherhoods founded in Spain and Portugal during the Middle Ages to fight the Muslim populations of the Iberian Peninsula.[5] The Cavalieri vowed to combat the Ottoman encroachment throughout the Mediterranean by plundering enemy vessels and enslaving their crews, attacking coastal settlements and liberating Christian prisoners, patrolling the seas from the Barbary Coast in North Africa to as far east as the Levant.[6]

The Cavalieri di Santo Stefano would first prove their military might in 1571, when they sailed as part of the victorious papal fleet at the battle of Lepanto, considered the greatest victory of the united forces of Christendom against the Ottoman Empire. Following Ferdinando's ascension to the role of grand master in 1587, the Cavalieri would experience a series of significant military triumphs in quick succession. This string of successes culminated in the two greatest land assaults in the history of the order, the capture of Preveza, an Ottoman stronghold in northwestern Greece, and the siege of Bona, the Tunisian coastal city that served as the principal naval base of the Barbary corsairs, who terrorized the seas during the sixteenth and seventeenth centuries. In both instances, the Cavalieri captured hundreds of prisoners while liberating an equivalent number of Christian slaves.[7]

Cosimo's motivations for the creation of the Order of Santo Stefano were far more complex than the stated mission in the statutes suggests. The Medici desire to defend Christian territories from Ottoman rule stemmed not solely from religious fervor but also from the fiscal need to maintain navigational routes and profitable commercial interests in the Mediterranean, a necessity for Florence, a city with a mercantile economy heavily dependent on trade with other European ports.[8] In addition, the foundation of the order was one of Cosimo's most brilliant acts of statecraft. His public embrace of Christian

4. Bernardini, *Breve storia*, 35.
5. Angiolini, "L'ordine di Santo Stefano," 7.
6. Guarnieri, *Cavalieri*, 14–15, 42; and Riccardo Ciuti, *Pisa Medicea: Itinerario storico artistico tra cinque e seicento* (Pisa: Felici, 2003), 26–27.
7. On specific military actions undertaken by the Cavalieri: Guarnieri, *Cavalieri*, 127–47; Bernardini, *Breve storia*, 40–62; and Angiolini, "L'ordine di Santo Stefano," 16–17.
8. Guarnieri, *Cavalieri*, 13–15.

crusade, reflective of the dominant cultural and ideological climate of Europe at the time, gained the Medici papal approval and prestige abroad, specifically with prominent Catholic powers like Spain and France. The desire for a knightly order devoted to the defense of the Catholic faith was a blatant attempt to ingratiate himself with the pope during the same years that he doggedly pursued the title of grand duke, an honor he finally received in 1569 from Pius IV's successor, Pius V (r.1566–72).[9]

Furthermore, Cosimo's definition of the order's membership as pan-Tuscan and aristocratic surely was aimed at convincing the most influential families of his fledgling Tuscan state to forget their loss of power and independence at the hands of the Medici dukes by joining in the order's mission against a common foe, the Ottoman "infidel." As Franco Angiolini notes, the order effectively eliminated rivalries and self-interests, halted fighting among the aristocratic families, and most importantly, inextricably bound the Tuscan elite to the Medici dynasty, defusing any challenges to their ruling power.[10]

On the surface, the choice of St. Stephen as the patron saint of Cosimo's new knightly order appears unusual.[11] The martyred pope was a relatively minor saint and furthermore, he had no pre-existing connection to Pisa, the city that housed the order, which could be exploited. However, Cosimo's choice of a papal saint to represent his chivalric brotherhood allowed him to illustrate his reverence for the ecclesiastical office, and like the foundation of the order itself, was clearly part of Cosimo's relentless campaign to secure the grand-ducal title.

The principal reason for the choice of Santo Stefano was owed to the saint's fortuitous feast day, August 2, a date coinciding with the two crucial military triumphs of Cosimo's reign, Montemurlo and Marciano. The newly crowned duke defeated a group of Florentine exiles, the so-called *fuorusciti*,

9. It is likely for this same reason that Cosimo initiated the renovation of the two principal mendicant churches in Florence, Sta. Maria Novella and Sta. Croce, during the early 1560s, years that coincided with the last session of the Council of Trent. Many churches, Sta. Maria Novella and Sta. Croce included, retained a form designed to serve liturgical practices that the council deemed outmoded. As Marcia B. Hall has shown, Cosimo was able not only to demonstrate his commitment to post-Tridentine reform, but also to lead the way in said reform, setting an example that other monastic churches would be compelled to follow. See her *Renovation and Counter-Reformation: Vasari and Duke Cosimo in Santa Maria Novella and Santa Croce, 1565–1577* (Oxford: Clarendon Press, 1979). Regarding Cosimo's receipt of the grand-ducal title, see Furio Diaz, *Il Granducato Di Toscana: I Medici* (Turin: UTET, 1987), 188–91.

10. Angiolini, "L'ordine di Santo Stefano," 7.

11. Little is known about the life of St. Stephen, the pope (not to be confused with the more well known St. Stephen, the first martyr). He is believed to have been Roman by birth and is said to have served as archdeacon to Pope Lucius I. Following the death of Lucius in early 254 CE, Stephen was then elected pope himself. He died August 2, 257 CE. The primary source on Stephen's life is Jacobus de Voragine, *The Golden Legend of Jacobus de Voragine*, trans. William Granger Ryan, 2 vols. (Princeton, NJ: Princeton University Press, 1993), 2:39.

and their French supporters at Montemurlo in 1537, foiling a coalition that had wished to remove him from office. In 1554, the battle at Marciano in Val di Chiana became the critical turning point for the Florentines in their war against Siena. Both victories were key successes in Cosimo's struggle for dynastic and political legitimacy. The first solidified his position as ruler of Florence, while the second led to the conquest of a longtime Tuscan rival and the establishment of the Tuscan grand duchy.[12]

The early August feast day also coincided with the most noteworthy triumph of the great Roman Emperor Augustus, the defeat of Marc Antony at Actium. Cosimo's natal horoscope was strikingly similar to that of Augustus, an exalted astrological destiny that the duke had exploited since his rise to power in 1537.[13] The victory at Montemurlo fulfilled the promise of Cosimo's natal horoscope and confirmed that his political power was predestined and divinely sanctioned. This military triumph became the basis for some of the Medici ruler's most effective propaganda in both literature and art, and the belief in his Augustan destiny and an imminent golden age in Tuscany were strengthened by his success at Marciano on that same date seventeen years later.[14] Thus, by choosing St. Stephen as the patron saint of his knights, Cosimo permanently linked the order with his Augustan destiny, implying that its foundation was, like his military victories, divinely sanctioned.

Cosimo selected Pisa,[15] a Florentine possession since 1405 and a courtly retreat for the Medici rulers since the mid-fifteenth century, as the permanent base of his order.[16] Cosimo then chose to transform a piazza that for centuries

12. It was following the defeat of Siena that Cosimo began his vigorous pursuit of the title of grand duke of Tuscany for himself and his heirs.
13. See Janet Cox-Rearick, *Dynasty and Destiny in Medici Art: Pontormo, Leo X, and the Two Cosimos* (Princeton, NJ: Princeton University Press, 1984), 256–58, on the conflation of Actium/Montemurlo/Marciano by Cosimo. Cox-Rearick and Claudia Rousseau, "Cosimo I de 'Medici and Astrology: The Symbolism of Prophecy" (Ph.D. diss., Columbia University, 1983), are the key sources for Cosimo's use of his auspicious natal horoscope in his creation of personal imagery/propaganda. Also invaluable for understanding Cosimo's formation of an Augustan identity are Kurt W. Forster, "Metaphors of Rule: Political Ideology and History in the Portraits of Cosimo I de' Medici," *Mitteilungen des Kunsthistorischen Institutes in Florenz* 15.1 (1971): 85–88; and Richelson, *Personal Imagery of Cosimo*, 25–78.
14. Rousseau, "Cosimo and Astrology," 370, convincingly argues that there is good reason to believe that Cosimo delayed the Marciano battle for the sake of this serendipitous "coincidence."
15. On Pisa the most recent, comprehensive source is Alberto Zampieri, ed., *Pisa nei secoli: La storia, l'arte, le tradizioni*, 4 vols. (Pisa: ETS, 2002); see also Giuseppe Caciagli, ed., *Pisa*, 4 vols. (Pisa: Colombo Cursi Editore, 1970–72); Emilio Tolaini, *Pisa* (Rome-Bari: Editori Laterza, 1992); and for the Medici era, Ciuti, *Pisa Medicea*.
16. In 1441, Cosimo il Vecchio (1389–1464) established a residence in the city from which to oversee his commercial interests in the Pisan territories. Under Cosimo I, the city, due to its mild climate, served as the official winter residence of the grand dukes, in effect becoming the capital of the Medici state from December to February. In this capacity, Pisa hosted a number of important Medici ceremonial

had contained the most important civic structures in the city, converting the Palazzo degli Anziani, which had originally served as the civic headquarters of the chief public bodies of the Pisan Republic, into the main residence for his knights.[17] As with the Piazza Signoria and Palazzo Vecchio in Florence, the former center of Pisan independent government became a Medici showplace, purged of all communal connotations. Yet as Paul Richelson notes, this loss of Pisan identity was cleverly disguised as a privilege, suggesting that Cosimo had favored the Pisans above his other subject cities by selecting their city to house his order.[18] Furthermore, the presence of the sea-faring Cavalieri di Santo Stefano in the former civic center of Pisa, a city with a proud maritime tradition due to its position near the mouth of the Arno River, surely rekindled a certain sense of communal pride. Cosimo had chosen Pisa as the site for his order due to this pre-existing maritime tradition.[19] In helping Pisa to reclaim some aspect of the naval dominance the city had possessed during the golden age of its republic, Cosimo further softened the blow of subjugation. In addition, the Pisans had played a prominent role in planning and executing the First Crusade (1096–99), the military expedition focused on recapturing Jerusalem from Muslim rule. Pisa's close ties to this celebrated Christian victory lent legitimacy to the Medici duke's own crusade against the Muslims.[20]

events throughout the year, from triumphal entries to receptions for Medici brides, as well as lavish celebrations in the winter months for Christmas, New Year's and Carnevale. These events were an integral part of the construction of Medici identity in Pisa. See Giovanna Gaeta Bertelà and Annamaria Petrioli Tofani, eds., *Feste e apparati medicei: Da Cosimo I a Cosimo II. Mostra di disegni e incisioni*, exh. cat. (Florence: Leo S. Olschki, 1969), 209–14; and Angelo Solerti, *Musica, ballo e drammatica alla Corte medicea dal 1600 al 1637: Notizie tratte da un diario; con appendice di testi inediti e rari* (Florence: R. Bemporad and Figlio, 1905), 28–40. On Pisa as the winter residence of the Medici court, see Maria Teresa Lazzerini and Riccardo Lorenzi, "La sede della corte," in *Livorno e Pisa: Due città e un territorio nella politica dei Medici*, exh. cat., ed. Mario Mirri (Pisa: Nistri-Lischi e Pacini, 1980), 276–87; and Corinna Vasic Vatovec, "La residenza dei Medici a Pisa nel Cinquecento," in *Architettura a Roma e in Italia, 1580–1621*, ed. Gianfranco Spagnesi (Rome: Centro di Studi per la Storia dell'Architetttura, 1989), 2:17–26.
17. Ewa Karwacka Codini, *Piazza dei Cavalieri: Urbanistica e architettura dal medioevo al novecento* (Florence: Cassa di Risparmio, 1989), 7. Karwacka Codini is the authoritative source on the piazza. See also sections on the palace in Leon George Satkowski, *Giorgio Vasari: Architect and Courtier* (Princeton, NJ: Princeton University Press), 67–74; and Claudia Conforti, *Giorgio Vasari architetto* (Milan: Electa, 1993), 191–208.
18. Richelson, *Personal Imagery of Cosimo*, 149 n. 14.
19. Bernardini, *Breve storia*, 37. Due to Pisa's unique status as "second city of the duchy," Cosimo and Ferdinando both lavished considerable attention on it, promoting cultural, agricultural and economic renewal through a variety of civic projects. The grand dukes' devotion to the restoration of Pisa's maritime identity was of particular interest. See Ciuti, *Pisa Medicea*, 18–25, 61–79; and Caciagli, *Pisa*, 1:180–224. In addition to the foundation of the Order of Santo Stefano, the Medici constructed a new shipbuilding yard, the Arsenale Mediceo, and built two canals, the Canale dei Navicelli and Canale di Ripafratta, in order to connect Pisa to Livorno and to Lucca respectively and to allow for quicker and safer traffic between the Tuscan ports.
20. On Pisa's involvement in the First Crusade, see Michael Matzke, "Pisa, l'arcivescovo Daiberto

The foundation of the Order of Santo Stefano was the key event precipitating the transformation of Pisa into a critical site of Medici patronage during the grand-ducal period. Both Cosimo and Ferdinando were actively involved in the shaping of the Piazza dei Cavalieri and its surrounding structures, commissioning paintings and sculpture for both interior and exterior spaces. Additionally, the popularity of imagery connected to the Cavalieri di Santo Stefano in Medici commissions throughout Tuscany, beginning with Ferdinando's reign, made Pisa unique among cities of the *dominio*. No other "peripheral" city had such a prominent role to play in shaping grand-ducal iconography.

The second site of Cavalieri activity was Livorno, located south of Pisa along the Tyrrhenian coastline. Florence had purchased the small fishing village from Genoa in 1421 with the intention of developing a commercial port on the site.[21] During the fifteenth century, Pisa provided sea access for the landlocked Florence, but its harbor had steadily silted up over the years, making navigation increasingly difficult.[22] A new Medici port was clearly necessary.

The enlargement and modernization of the port at Livorno began in earnest during the reign of Cosimo, and the Medici subsequently shifted the majority of the grand duchy's maritime activity away from Pisa. The town, founded by Francesco to complement the harbor, was completed during the reign of Ferdinando, and it is under his leadership that the port truly flourished, experiencing an astonishing rate of growth and prosperity.[23]

The policies established by Ferdinando made Livorno particularly attractive to both merchants and settlers. The grand duke's tax incentives encouraged trade, while several proclamations issued in the early 1590s fostered immigration to the port city. The most important of these laws, passed in 1593, established Livorno as a refuge for marginalized groups, offering them political and religious freedom. Directed specifically towards foreign merchants, the decree resulted in immense economic benefits for the grand duchy. It facilitated trade with countries throughout the western Mediterranean and the Levant, as well as Africa, India and even the Ottoman Empire. By the end of the sixteenth century, Livorno was one of the most active ports in the Mediterranean.[24]

e la I crociata," in Marco Tangheroni, ed., *Pisa e il Mediterraneo: Uomini, merci, idee dagli Etruschi ai Medici* (Milan: Skira, 2003), 145–49.

21. On Livorno: Cornelia Joy Danielson, *Livorno: A Study in 16th Century Town Planning in Italy* (Ann Arbor, MI: University Microfilms International, 1987); Giacinto Nudi, ed., *Livorno: Progetto e storia di una città tra il 1500 e il 1600* (Pisa: Nistri-Lischi e Pacini, 1980); Dario Matteoni, *Livorno* (Rome-Bari: Laterza, 1985); and Gino Guarnieri, *Livorno Medicea: Nel quadro delle sue attrezzature portuali e della funzione economica-marittima. Dalla fondazione civica alla fine della dinastia medicea (1577–1737)* (Livorno: Giardini, 1970).

22. Danielson, *Livorno*, 10.

23. Ibid., 2; see 130–74 on the reign of Ferdinando overall.

24. Ibid., 113–15, 192; Diaz, *Il Granducato*, 301–3; and Cesare Ciano, "La politica Marinara," in *La*

A SCARLET RENAISSANCE ■

Despite the increasing importance of Livorno, Pisa retained its critical role within the Medici maritime empire due to the presence of the Order of Santo Stefano within the city. Thus, a dual port system evolved in Tuscany over the course of the sixteenth century, reflecting the two sides of Medici maritime policy. Pisa became the ceremonial port, the religious and academic base for the Order of Santo Stefano, while Livorno served as the working port, the principal site of mercantile commerce and shipbuilding, and home to the Cavalieri fleet. The importance of Pisa and Livorno as key sites of power for the Medici grand dukes is clearly reflected in Ferdinando's decision not only to commission artworks for two of the most important and highly visible public sites within these cities — the Piazza dei Cavalieri in Pisa and the mouth of the harbor at Livorno — but also in his choice of colossal portrait statues for these locations.

The Medici had long patronized public sculpture, appreciating the prestige of emulating antique precedents. Following his return to Florence in 1587 to assume his position as grand duke of Tuscany, Ferdinando quickly revealed a penchant for dynastic and absolutist imagery as well as a preference for public sculpture. His first large-scale commission upon inheriting the grand-ducal title, Giambologna's *Equestrian Monument of Cosimo I* for Florence's geographic and political heart, the Piazza della Signoria, clearly illustrates his keen understanding of the power of public art.[25] In addition to the equestrian monument, between the years 1587 and 1601 Ferdinando commissioned an additional five full-length, free-standing, public portrait sculptures for highly visible locations in Florence and other prominent subject cities throughout the grand duchy, the two monuments in Pisa and Livorno among them.[26]

The campaign of visual propaganda mounted by Ferdinando in the late sixteenth century clearly owes a debt to his father, a prolific patron. However,

corte, il mare, i mercanti, exh. cat. (Florence: Electa, 1980), 115. The full text of the 1593 proclamation — ASF, Lor., Reggenza n.650 ("Privilegi concessi ne' X di Giugno 1593 al Porto di Livorno a favore de' Mercanti Stranieri" — is published in Guarnieri, *Livorno Medicea*, 261–68. Livorno remained an important commercial center throughout the seventeenth and eighteenth centuries, despite the progressive decline of the Tuscan navy and the acquisition of the most profitable trade routes by Dutch and English ships. It continued to serve as the preferred port for Western merchants destined for the Levant and Eastern ships bound for the western Mediterranean and northern Europe; see Ciuti, *Pisa Medicea*, 28.

25. See Mary Weitzel Gibbons, "Cosimo's Cavallo: A Study in Imperial Imagery," in *The Cultural Politics of Duke Cosimo I de' Medici*, ed. Konrad Eisenbichler (Aldershot, UK and Burlington, VT: Ashgate, 2001), 77–102. In 1601 Ferdinando would commission his own equestrian monument from Giambologna and his assistant Pietro Tacca for the Piazza SS. Annunziata in Florence.

26. The critical source on the colossal portrait statue in the Renaissance remains Virginia Bush, *Colossal Sculpture of the Cinquecento* (New York: Garland, 1976). Chapter 5 provides a concise overview of Medici commissions, esp. 179–205, and Bush, 192, singles out Ferdinando as the patron who provided the colossal portrait statue with its "definitive form."

Ferdinando's predilection for public sculpture also must be attributed in part to his presence at the papal court for almost twenty-five years (1563–87) where he served as a cardinal from age fourteen to thirty-eight. In Rome, Ferdinando had first-hand access to ancient sculptures, and he became an enthusiastic collector of antiquities, an activity that continued following his return to Florence.[27]

In addition, as a cardinal Ferdinando had witnessed the artistic strategies utilized by the Roman Catholic Church to promote itself and unify the faithful during the years it was combating serious threats from both the Protestants and the Ottoman Empire.[28] As argued by Mustafa Soykut, following the fall of Constantinople in 1453, the Muslim threat became a crucial ideological weapon used by the papacy to reassert its power and to divert attention from schisms in Europe and the Church, uniting the Christian community once more under the authority of Rome.[29]

Ferdinando's familiarity with church propaganda clearly served him well as a ruler in the secular sphere. By the time Ferdinando came to power in 1589, the Florentine grand duchy included twelve principal subject cities: Florence, Siena, Pisa, Fiesole, Arezzo, Cortona, Volterra, Pistoia, Borgo San Sepolcro, Montepulciano, Prato and Livorno.[30] Employing a strategy analogous to that of the Catholic Church, Ferdinando utilized the iconography of the Cavalieri

27. Butters, "Ferdinando de' Medici and the Art of the Possible," 67–73.
28. In 1573, Ferdinando had been one of three cardinals chosen by Pope Gregory XIII for a provisional committee that became the Congregation for the Propagation of the Faith ("Congregatio de Propaganda Fide," often called the Propaganda), a church body dedicated to fostering the spread of Catholicism through missionary work, in 1622 under Pope Gregory XV. On the Propaganda, see Raphael Hung Sik Song, *The Sacred Congregation for the Propagation of the Faith* (Washington, DC: Catholic University of America Press, 1961); and the *New Catholic Encyclopedia*, 2nd ed. (Detroit: Thomson, Gale, 2003), 11:749–52 (the 1913 edition identifies the three cardinals, including Ferdinando, by name, 12:456, a detail omitted from the most recent edition).
29. Mustafa Soykut, *Image of The "Turk" In Italy: A History of The "Other" In Early Modern Europe, 1453–1683* (Berlin: Schwarz, 2001).
30. Although the majority of the *dominio* was acquired during the republican period prior to grand-ducal rule, Cosimo's conquest of Siena and its dependencies in 1559 represented a crucial turning point for the Medici as they gained unchallenged authority over the better part of Tuscany. The importance of the *dominio* in early modern state formation and the dynamics of center/periphery is the subject of a number of recent historical studies that provide useful models for an evaluation of patterns of Medici art patronage during the grand-ducal period and for understanding the cultural repercussions of regional rule and the emergence of the territorial state. See Thomas W. Blomquist and Maureen F. Mazzaoui, eds., *The "Other Tuscany": Essays in the History of Lucca, Pisa, and Siena During the Thirteenth, Fourteenth, and Fifteenth Centuries* (Kalamazoo, MI: Medieval Institute Publications, Western Michigan University, 1994); Elena Fasano Guarini, "Center and Periphery," in *The Origins of the State in Italy: 1300–1600*, ed. Julius Kirshner (Chicago: The University of Chicago Press, 1995), 74–96; William Connell and Andrea Zorzi, eds., *Florentine Tuscany: Structures and Practices of Power* (Cambridge: Cambridge University Press, 2000); and Paula Findlen et al., eds., *Beyond Florence: The Contours of Medieval and Early Modern Italy* (Stanford: Stanford University Press, 2003).

to unify his *dominio*, evoking the shared mission of all Tuscans, the defense of the Catholic Church and the true faith against the Ottoman infidel. Just as Cosimo's foundation of the Order of Santo Stefano had facilitated the initial integration of the former Tuscan communes into the modern grand-ducal state, united under one supreme ruler and with a unified identity, Cavalieri imagery became a crucial vehicle for Ferdinando's "conversion" of the subject cities into a Medici empire. The monumental public portraits of Cosimo in Pisa and Ferdinando in Livorno confirm Randolph Starn and Loren Partridge's dictum that, "works of art commissioned by the powerful...were strategic instruments, tactical weapons, technical machines of government no less than armies, laws, institutions, and taxes."[31]

The *Monument to Cosimo I*, commissioned by Ferdinando for the Piazza dei Cavalieri in Pisa, was completed by Pietro Francavilla after a design by his master, Giambologna.[32] Occupying the lowest point in the piazza, it is visible from each of the principal entrances onto the square. The position of the buildings ringing the space assists in directing the visitor's gaze towards the sculpture and its backdrop, the Palazzo dei Cavalieri, the former town hall of the Pisan Republic, re-structured to house Cosimo's knightly order.[33]

The marble statue was the culmination of the decorative program initiated by Cosimo to drain the space of any lingering Pisan identity. The facade of the palace is covered with a complex *sgraffito* program, conceived of and largely completed during Cosimo's reign. It was subsequently embellished with sculptures during Ferdinando's tenure, most prominently portrait busts of the Medici grand dukes. The Medici commissions in the Piazza dei Cavalieri

31. Randolph Starn and Loren Partridge, *Arts of Power: Three Halls of State in Italy, 1300–1600* (Berkeley: University of California Press, 1992), 259.

32. Francavilla completed the figural portion in 1596, and the monument was installed in 1600 following the completion of the accompanying fountain. Key bibliography on the monument includes Dario Simoni, "Sulla statua di Cosimo I de' Medici a Pisa," in *Miscellanea storico letteraria a Francesco Mariotti nel cinquantesimo anno della sua carriera tipografica* (Pisa: E. Pacini nella Stamperio del Mariotti, 1907), 63–66; Herbert Keutner, "Über die Entstehung und die Formen des Standbildes im Cinquecento," *Münchner Jahrbuch der bildenden Kunst* 7 (1956): 163–64; Stefano Renzoni, "Fontana con la statua di Cosimo I (Cat. B.ii.6)," in Mirri, *Livorno e Pisa*, 369–71; Roberto Paolo Ciardi et al., *Scultura a Pisa tra quattro e seicento* (Pisa: Cassa di Risparmio, 1987), 146–48; Karla Langedijk, *The Portraits of the Medici, 15th–18th Centuries*, 3 vols. (Florence: Studio per Edizioni Scelte, 1981–87), 1:478–80; Bush, *Colossal Sculpture*, 201; and Karwacka Codini, *Piazza dei Cavalieri*, 26–32.

33. As previously noted, the critical source on the piazza and its buildings is Karwacka Codini, *Piazza dei Cavalieri*; a concise summary of this material is found in Karwacka Codini and Paul Daniel Fisher, "La Piazza dei Cavalieri," in Zampieri, *Pisa nei secoli*, 65–121. See also Mario Salmi, "Il palazzo e la piazza dei Cavalieri," in *Il palazzo dei Cavalieri e la Scuola Normale Superiore a Pisa* (Bologna: Nicola Zanichelli, 1932), 3–57; Clara Baracchini, ed., *Pisa dei Cavalieri* (Milan: Franco Maria Ricci, 1997); and Stefano Sodi and Stefano Renzoni, *La chiesa di S. Stefano e la piazza dei Cavalieri* (Pisa: ETS, 2003).

clearly reflect the consummate skill of Cosimo in employing art to serve his ruling agenda. They also testify to the similar abilities of Ferdinando, who successfully carried on his father's artistic torch while refining and reshaping the iconography of Medici rule to suit his own purposes, most significantly with his employment of iconography related to the Order of Santo Stefano.

Father and son transformed the piazza into a highly visible and public stage for the display of Medici power, and more specifically, the strength and glory of their fledgling maritime empire and their brave Christian knights. Over the course of the sixteenth and seventeenth centuries, it became the most important ceremonial space for the enactment of the order's rituals.[34] It was the site of the grand procession held during the triennial meeting of the Capitolo Grande, the entire membership of the Cavalieri,[35] and the location where the grand master of the Order of Santo Stefano welcomed his knights home from battle. The frescos depicting the "Fasti Medicei" at the Medici Villa della Petraia, show Ferdinando's son, Cosimo II (r.1609–21), presiding over just such a triumphal procession held on April 1, 1609 to celebrate the order's great victory, the conquest of Bona in 1607.[36] The Piazza dei Cavalieri was also the space where the grand-ducal court received important guests. Future Medici grand duchess Christine of Lorraine visited the piazza as part of her months-long voyage — escorted by members of the Order of Santo Stefano — from her home country of France to Florence for her 1589 wedding to Ferdinando.[37] Through Francavilla's sculpture, Cosimo remained grand master in perpetuity, forever presiding over this important space and the ceremonies and celebrations enacted within it.

Cosimo is depicted as a victorious military leader, in full armor with a sword strapped at his side, and he once gripped a commander's baton in his right hand (Fig. 3). The grand duke's right foot rests atop a dolphin, a stance

34. Satkowski, *Vasari*, 71.
35. For a detailed description of the ritual procession held in the piazza during the triennial meeting of the Capitolo Generale see Fulvio Fontana, *Le glorie immortali della sacra, ed illusstriss.ma [sic] religione de S. Stefano, tanto nelle armi quanto nelle lettere* (Milan: Sirtori, 1706), 17–19.
36. On the ceremony in honor of the victory at Bona, see Stefano Renzoni, "Pisa tra mita e storia nelle feste granducali cinque-seicentesche," in *La festa, la rappresentazione poplare, il lavoro: Momenti della cultura e della tradizione in territorio pisano, XVI–XIX sec.*, exh. cat. (Pisa: Giardini, 1984), 87; and Franco Paliaga, "Feste e ceremonie organizzate dall'Ordine nel periodo Mediceo" in *Le imprese e i simboli: Contributi alla storia del Sacro Militare Ordine di S. Stefano P. M. (Sec. Xvi–Xix)* (Pisa: Giardini, 1989), 245.
37. For an example of the types of celebrations held in honor of important Medici guests in Pisa, see the festival book detailing the visit of Christine of Lorraine in Giovanni Cervoni, *Descrizione delle pompe e feste fatte ne la città di Pisa per la venuta de la S. Madama Christina de l'Oreno Gran Duchessa di Toscana. Nella quale si contano l'entrata, la battaglia navale, la battaglia del Ponte, la luminaria, i fuochi artificiali, le squadre, gli habiti, l'imprese, i motti, e loro significati, con tutte l'altre cose, e con tavola* (Florence: Marescotti, 1589).

virtually identical to the *Fountain of Neptune* in Bologna (1563-66), and the *Oceanus Fountain* (c.1571-76, Fig. 4) in the Boboli Gardens of the Palazzo Pitti in Florence. Both were completed by Giambologna, with the latter also commissioned by the Medici.[38] The dolphin was an appropriate accoutrement for monuments dedicated to rulers of the sea, and the formal correspondence to Neptune and Oceanus undoubtedly served to remind viewers of Cosimo's maritime prowess.

In addition, a low fountain with a small shell-shaped basin stands in front of the base that supports the figure of the grand duke.[39] Just as the prominent presence of Ammannati's *Fountain of Neptune* in the Piazza della Signoria in Florence signaled the success of Cosimo's newly constructed aqueduct in that city, the fountain in the Piazza dei Cavalieri similarly celebrated the completion of a six-kilometer-long aqueduct by the Medici grand dukes in Pisa.[40] In Florence, the figure of Neptune, a stand-in for Cosimo, advertised the grand duke's ability to provide his citizens with fresh water and to command the seas.[41] In Pisa, the allegorical guise is lifted and a beneficent Cosimo is shown delivering water to the citizens himself. It is no longer Neptune, but a contemporary, human ruler, who controls the waters.

While the *Monument to Cosimo I* clearly proclaims the growing power of the Medici sea empire, additional iconographic details allude to another vital aspect of Cosimo's ruling identity, that of Christian crusader (Fig. 5). Around his neck, Cosimo wears the collar of the Order of the Golden Fleece, the chivalric brotherhood whose membership included the most prominent men in Europe.[42] The insignia, an announcement of Cosimo's prestige and political position, was a standard attribute in nearly every portrait of the grand duke following his investiture in the order in 1545, including his official ruling portrait painted by Bronzino that same year.

However, emblazoned on the breastplate of Cosimo's armor and dwarfing the dangling ram is the large eight-pointed cross of the Order of Santo Stefano.

38. The resemblance to these earlier fountains was first noted by Ciardi, *Scultura a Pisa*, 148. See also the article by Meghan Callahan in this volume.
39. On the fountain, see Karwacka Codini, *Piazza dei Cavalieri*, 26-29. In Francavilla's original design for the fountain, the water flowed directly from the mouth of the dolphin into the basin below. In the final version, engineering complications instead dictated that the water be channeled through the fantastic creature known as "il gobbo" (hunchback).
40. The construction of the aqueduct was begun by Cosimo but remained unfinished until the renewal of the project by Ferdinando in the early 1590s. See Ciuti, *Pisa Medicea*, 105-8; and Karwacka Codini, *Piazza dei Cavalieri*, 31-32.
41. The authoritative source on the *Fountain of Neptune* is Felicia Else, "Water and Stone: Ammannati's Neptune Fountain as Public Ornament" (Ph.D. diss., Washington University, 2003).
42. See *La Toison d'Or: Cinq siècles d'art et d'histoire*, exh. cat. (Brussels: Administration Communale, 1962) for a complete listing of every member inducted into the order from its inception in the fifteenth century.

The base of the monument also advertises Cosimo's role as the founder of his own chivalric maritime order. It is embellished with the *stemma* of the grand master on the front and a red cross to match that on his breastplate decorates the back.[43]

This explicit association of the first Medici grand duke with the office of grand master of the Order of Santo Stefano was largely a creation of Ferdinando, as Cosimo rarely employed the iconography of the Cavalieri during his lifetime.[44] Cosimo's interest in asserting his inclusion in the Order of the Golden Fleece over that of his own order is not entirely surprising. The creation of the Order of Santo Stefano did ally Cosimo with the pope and other powerful Catholic sovereigns in defense of the Church, and its foundation surely helped secure the title of grand duke. And yet, while it was a coup to have founded his own knightly order, the Order of Santo Stefano was a regional organization composed mainly of aristocratic Tuscans, some of whom had their nobility bestowed by the Medici, and thus were considered "upstarts."

In contrast to his father, Ferdinando flaunted his identity as grand master of the Order of Santo Stefano, both in Florence and in the *dominio*. As seen with Cosimo's association with the Order of the Golden Fleece, the depiction of a Christian ruler as a warrior for the true faith had become a standard representation of power in the Counter-Reformatory climate of late sixteenth- and early seventeenth-century Europe.[45] The desire to promote himself as a crusading knight no doubt was owed in part to Ferdinando's former status as a cardinal as well. It also was a fitting identity for a ruler who emulated the celebrated medieval knight Godfrey of Bouillon, one of the leaders of the First Crusade, the first Latin Christian lay ruler of Jerusalem (1099–1100) and hero of Tasso's popular sixteenth-century epic *Gerusalemme Liberata*. Godfrey was a distant relative of Ferdinando's wife, Christine of Lorraine, and following their marriage in 1589, Ferdinando considered Godfrey a member of the

43. The two inscriptions on the base also reference the order. The left inscription records the year of the monument's completion: "FERDINANDO MED./MAG. DVCE ETR. ET/ORD. MAG. MAGIST./III FELICITER/DOMINANTE/ANNO DOMINI/MDXCVI" (While Ferdinando de' Medici was ruling happily as the third grand duke of Tuscany and grand master of the order in the year of our Lord 1596"). The inscription on the right proclaims Ferdinando's role in the commission honoring his father: "ORDO. EQ. S. STEPH./COSMO MEDICI M/ DVCI ETR. CONDITORI/ET PARENTI SVO/GLORIOSISS. PERP./MEM. C. STATVAM E/ MARMORE COLLO/CAVIT" ([he] set up this statue for the perpetual memory of Cosimo de' Medici, the grand duke of Tuscany, the founder of the Order of the Knights of St. Stephen and his most glorious parent). Inscription text: author's on-site visit in October 2005; all translations by Dr. Andrew Fenton.
44. For the few works of art completed during Cosimo's lifetime that celebrate his role as founder of the Order of Santo Stefano, see Richelson, *Personal Imagery of Cosimo*, 147–62.
45. Franco Angiolini, "I principi e le armi: I Medici granduchi di Toscana e gran maestri dell'ordine di S. Stefano," in *Il "Perfetto Capitano": Imagini e realtà (secoli XV–XVII)*, ed. Marcello Fantoni (Rome: Bulzoni, 2001), 184–85.

Medici dynasty. Throughout his reign, Ferdinando employed imagery and iconography that closely associated himself with the brave crusading warrior. Godfrey inspired Ferdinando's drive to reclaim the Holy Sepulcher in Jerusalem and transport it to Florence, one of the founding missions of the Order of the Golden Fleece that the grand duke co-opted as a Medicean crusade.[46]

Ferdinando had good reason to celebrate his position as not just knightly crusader but as head of the Order of Santo Stefano specifically. The Cavalieri achieved their greatest victories over the Ottoman Empire — Preveza and Bona — and accrued fame throughout Europe under his leadership. In addition, by foregrounding his family's role as knights of the Church in his commissions, Ferdinando could forcefully declare Medici hegemony at key sites in the subject cities while simultaneously exploiting the putative pan-Tuscan unity forged by his father through the foundation of the Order of Santo Stefano.

The recurrence of the colossal portrait sculptures conspicuously emblazoned with the emblems of the Cavalieri di Santo Stefano and their prominent, public placements suggests that Ferdinando perceived the imagery as successful and an effective way to communicate with the Tuscan populace. He tempered the blatant absolutism of his commissions clearly announcing Medici domination by inviting viewers, many of whom would have been knights themselves, to see in these portrait sculptures of the grand dukes not just images of authority, but also shared Christian pride and glory. Thus, while the decision to present Cosimo as the grand master of the Order of Santo Stefano was certainly the result of the monument's location in front of the order's primary residence and church, the formal choices also clearly reflected the artistic and ruling agenda of the patron, Ferdinando.

In the mid-1590s, Ferdinando commissioned the large-scale standing portrait sculpture of himself for the port of Livorno, the second crucial site of Medici sea power and Cavalieri activity. The *Monument to Ferdinando I* ultimately was the shared project of two sculptors, Giovanni Bandini (1540-99) and Pietro Tacca (1577-1640), who produced the colossal marble portrait of Ferdinando and the bronze "Quattro Mori" (Four Moors) respectively.[47]

46. On Ferdinando's identification with Godfrey of Bouillon: Nadia Bastogi, "La villa della Petraia," 87-97; and "Sala di Bona," 103-9, both in Gregori, ed., *Fasto di Corte*; Stefania Vasetti, "I fasti granducali della Sala di Bona: Sintesi politica e culturale del principato di Ferdinando I," in Capecchi, *Palazzo Pitti*, 228-39; and Massimiliano Rossi, "Emuli di Goffredo: Epica granducale e propaganda figurativa," in *L'arme e gli amori: La poesia di Ariosto, Tasso e Guarini nell'arte fiorentina del Seicento*, ed. Elena Fumagalli, Massimiliano Rossi and Riccardo Spinelli (Livorno: Sillabe, 2001), 32-42.

47. Key bibliography for the monument in Livorno includes Cesare Venturi, "Il monumento livornese dei 'Quattro Mori'," *Liburni civitas* 7 (1934): 213-51; Simonetta Taccini, "I Quattro Mori," in Nudi, *Livorno*, 282-84; Gigetta dalli Regoli, "La produzione artistica destinata alle strutture livornesi: Committenza granducale e opere promosse dalle istituzioni locali," in Nudi, *Livorno*, 270-73; Keutner, "Über die Entstehung," 158-60; Guarnieri, *Cavalieri*, 120-23; Bush, *Colossal Sculpture*, 201-2; Langedijk, *Portraits of the Medici*, 1:131-32, 2:748; Danielson, *Livorno*, 199-205;

Bandini's marble colossus, begun in 1595, was completed in 1599. Following Bandini's death in April of that same year, the sculpture was transported to Livorno, where it was to remain uninstalled for almost twenty years. In 1602, Ferdinando consulted with Pietro Tacca about the addition of four bronze slaves to Bandini's standing portrait, and a letter written by Tacca on February 6, 1607, indicates that the sculptor was studying the anatomy of prisoners from the galleys at Livorno and making wax casts in preparation for designing the "mori."[48]

The grand duke did not live to see the installation of the Livorno monument. It was completed several decades after Ferdinando's death under the guidance of his son, Cosimo II, and his grandson, Ferdinando II (r.1621–70). The marble colossus was erected with great ceremony on May 29, 1617, but Tacca's four bronze slaves were not put in place until 1626, at which time decorative panels of *pietre dure* also were added to the monument's base and bronze "trofei barbareschi" (now lost) were positioned at the feet of Ferdinando.[49]

Mirroring the *Monument to Cosimo I* in the Piazza dei Cavalieri in Pisa, Bandini's Ferdinando brandishes a commander's baton and wears contemporary armor, with the distinctive cross of the Order of Santo Stefano clearly visible on the breastplate (Fig. 6). The monument provided the grand duke — and former cardinal — with an opportunity to proclaim publicly his own status as a victorious Christian warrior. Just as with Francavilla's Cosimo in the Piazza dei Cavalieri, this emphatic declaration of knightly identity is not surprising, given the sculpture's placement at the main port where the Tuscan fleet was moored. It was originally installed just outside the city gates at one end of the Via Ferdinanda, facing the open sea, and thus visible to each ship arriving at the Medici port (Figs. 7, 8).[50]

and Jessica Mack-Andrick, *Pietro Tacca: Hofbildhauer der Medici (1577–1640). Politische Funktion und Ikonographie des frühabsolutistischen Herrscherdenkmals unter den Grossherzögen Ferdinando I, Cosimo II und Ferdinando II* (Weimar: VDG, 2005), 145–54.

48. Taccini, "I Quattro Mori," 283. I concur with Taccini that Tacca's letter of February 1607 combined with the delay in installing Bandini's sculpture supports the theory that Ferdinando had always intended to include slaves on the Livorno monument and that it was not unveiled in 1599 because it was incomplete.

49. Ibid. In 1641, two bronze fountains, originally intended to flank the monument, were installed in Piazza SS. Annunziata in Florence, possibly due to hydraulic problems in Livorno.

50. In 1888, the monument was moved a short distance from its original location to Piazza Giuseppe Micheli, facing the same direction but slightly elevated and farther from the water, in order to protect it from the sea. On the rich history of the Livorno monument post-seventeenth century, see Venturi, "Monumento livornese," 235–42. Of particular interest is the fate of the monument after the liberation of Livorno by Napoleonic decree in 1798. General Sextius Miollis, Napoleon's Tuscan commander whose troops occupied the city, urged the commune to tear down the "monumento della tirannide, che insulta l'umanità," advocating the replacement of the figure of Ferdinando with an allegorical figure of virtue, but the retention of the slave figures, transformed into vices. The French decision to abandon Livorno in July 1799 put an end to Miollis' plan.

A SCARLET RENAISSANCE

The *Monument to Don Juan of Austria* completed in Messina in 1572 by Andrea Calamech is often cited as a main inspiration for Bandini's colossus in Livorno. Don Juan (1547-78), son of Holy Roman Emperor Charles V, served as the general of the Spanish fleet in the Mediterranean and as the supreme commander of the Christian League's fleet at Lepanto. As Cornelia Danielson notes, he was therefore an especially suitable model for Ferdinando, who like Don Juan was a princely knight devoted to conquering the infidel. Not only are the formal similarities of the two monuments striking, the location within their respective cities are related as well; like Ferdinando, the *Monument to Don Juan* also was installed at one end of the main thoroughfare in Messina (Via Austria) and faced the port.[51]

However, a detail conspicuously lacking from the Calamech statue is the presence of the four bronze slaves chained to the base of the Livornese monument (Figs. 9, 10). The inclusion of these captives situates the *Monument to Ferdinando I* within a sculptural tradition of rulers crushing a chained foe, including such works as Leone Leoni's *Charles V and Fury Restrained* (1549-55). The use of prisoners on the base of a colossal sculpture is derived from antique models, the most famous example being the *Equestrian Monument to Marcus Aurelius* in Rome, which originally had a barbarian figure crouching under the horse's front leg (now lost).[52] The chained prisoner figures created for the equestrian statue of the French king Henry IV (r.1589-1610) for the Pont Neuf in Paris (destroyed in 1792), likely served as an additional inspiration for Ferdinando, given that the commission was completed by Tacca and Giambologna's workshop during the same period they worked on the Livorno monument.[53]

Tacca's "Quattro Mori," symbols of the war booty captured by the Cavalieri di Santo Stefano, surely were intended to associate the Medici ruler with these sculptural traditions, and yet, there was a very real component to Ferdinando's triumph missing from the aforementioned works. Human trafficking was a key tactical element in the holy war raging between Christians and Muslims in the Mediterranean during this period, with each side zealously committed to enslaving their "godless" enemy and by extension weakening their opponent. The slave trade also became a critical source of labor, most prominently as oarsmen for the massive galleys that formed the backbone of the Mediterranean navies of both Christians and Muslims.[54]

51. Danielson, *Livorno*, 200-202.
52. Bush, *Colossal Sculpture*, 173; and Michael Mezzatesta, "Marcus Aurelius, Fray Antonio De Guevara, and the Ideal of the Perfect Prince in the Sixteenth Century," *Art Bulletin* 66.4 (1984): 621.
53. Taccini, "Quattro Mori," 283.
54. Critical sources for the Mediterranean slave trade during the early modern period include Salvatore Bono, *Schiavi musulmani nell'Italia moderna: Galeotti, vu' cumpra', domestici* (Naples: Edizioni Scientifiche Italiane, 1999); Bono, *Corsari nel Mediterraneo: Cristiani e musulmani fra guerra, schiavitu' e*

As previously stated, the Order of Santo Stefano emulated its more famous crusading brothers, the Knights of Malta, in numerous ways, including their enthusiastic involvement in the slave trade. During Ferdinando's reign, Livorno was one of the principal slaving centers of Christendom, and it grew rich supplying slaves to the French, Venetians and Genoese, among others.[55] The first quarter of the seventeenth century was the most active period of slave capture in the history of the Order of Santo Stefano. The order's galleys transported close to 2,000 Turkish slaves to Livorno in 1605 alone. In September 1607, the greatest single capture of slaves by the Medici knights occurred during the order's land assault on the fortified city of Bona, a principal naval base of the Barbary pirates on the North African coast. It was considered the most significant victory in the history of the Order of Santo Stefano, and 1500 slaves were seized.[56]

Thus, the *Monument to Ferdinando I* is set apart from its predecessors by its acknowledgment of the very real and vibrant slave trade at the port of Livorno. Ottoman and African slaves were unloaded as war booty from the Cavalieri ships and put to work at the port not far from where Ferdinando, the "Domatore dei Mori,"[57] towers over Tacca's chained captives. In addition, the monument was located not only at the harbor entrance but also near the so-called *bagno*, an immense structure completed in 1602 to house slaves as well as *forzati* (convicted criminals) and *buonevoglie* (free men, often debtors) during their stints at port.[58]

commercio (Milan: A. Mondadori, 1993); Peter Earle, *Corsairs of Malta and Barbary* (London: Sidgwick & Jackson, 1970); Stephen Clissold, *The Barbary Slaves* (New York: Barnes & Noble, 1992); Robert C. Davis, *Christian Slaves, Muslim Masters: White Slavery in the Mediterranean, the Barbary Coast, and Italy, 1500–1800* (London & New York: Palgrave Macmillan, 2003); Davis, "The Geography of Slaving in the Early Modern Mediterranean, 1500–1800," *Journal of Medieval and Early Modern Studies* 37.1 (2007): 57–75; and Davis, *Holy War and Human Bondage: Tales of Christian-Muslim Slavery in the Early-Modern Mediterranean* (Santa Barbara, CA: Praeger/ABC-CLIO, 2009).
55. See Earle, *Corsairs*, 178; and Davis, "Geography of Slaving," 65–66.
56. See Bono, *Schiavi musulmani*, 54–62, on this period of slave seizure by the Cavalieri; and Guarnieri, *Cavalieri*, 457–68, who reproduces the "Registro delle Prede," a record of the order's conquests and booty spanning the years 1568 to 1688 that was originally contained in the Archivio di Stato in Pisa but destroyed by fire during WWII.
57. Guarnieri, *Cavalieri*, 15. According to Bernardini, *Breve storia*, 50, Ferdinando received this nickname owing to the great successes of the Cavalieri during his reign.
58. A second *bagno* eventually became necessary and was built outside of town to accommodate the growing numbers of captives held at Livorno. The original *bagno* was in use into the nineteenth century and finally was razed during the Fascist era. On the site today is the Livorno city hall; Davis, *Holy War*, 177–78. On the Livornese *bagno*, see Vittorio Salvadorini, "Il Bagno delle Galere," in Nudi, *Livorno*, 189–90; Lucia Frattarelli Fischer, "Nella città dei Mori: La schiavitù a Livorno in età moderna," *Storia e dossier* V (1990), 41–43; Matteoni, *Livorno*, 39–40; and Enrico Vincenzini, *Livorno corsara: Storie di corsari, galeotti e nazioni: 1494–1784* (Livorno: Nuova Fortezza, 1996), 47–53.

In fact, the "Quattro Mori" were modeled after two of the more than 2,000 slaves living in the Livornese *bagno* during the first quarter of the seventeenth century, a "youthful, strong, sturdy and well-muscled" Algerian named Morgiano and an older Moroccan slave from Salé named Ali.[59] The individualized faces and realistically muscled bodies of the four slaves — one African and three of Turkish descent — reflect Tacca's studies from life. In direct contrast to the statue of Ferdinando, an idealized icon of absolutist power rather than a flesh-and-blood individual, each of the "Quattro Mori" reacts to his enslavement in a personal, psychologically rich way, actively straining at the chains that bind his body or passively accepting his fate, once again underscoring the reality of the slave trade at Livorno.

A striking contrast is created through the juxtaposition of Bandini's white marble portrait of Ferdinando with the dark bronze of Tacca's "mori," a rare combination of materials that emphatically underscores the racial and religious "otherness" of the four captives. While the *bagno* contained its share of prisoners that were neither Muslim nor of African or Turkish descent, these are not the men Tacca depicted beneath the grand duke. The formal choices therefore add to the reality of the monument, while simultaneously reinforcing Tuscan superiority and the distinct divide between victor and enslaved, Christian and infidel. To my knowledge the Livorno monument is the only Renaissance "prisoner" group to mix media in such a dramatic fashion, and no other "conquest" monument is positioned so prominently in a public space frequented by those it depicts in bondage. The captives seized by the Cavalieri during their raids on the Barbary Coast and throughout the Ottoman-controlled Mediterranean worked on a number of the urban renewal and development projects initiated by the Medici grand dukes at Livorno,[60] mere feet from their sculpted – and chained – doppelgangers.

Through its display of the human spoils of religious conflict, frozen in chains for eternity, the *Monument to Ferdinando I* served as a forceful declaration of the grand duke's vast maritime empire and his ruthless military power, specifically his enslavement of his Ottoman enemies. Visible to each vessel entering the Medici harbor, Bandini's sculpted Ferdinando warned potential

59. Venturi, "Monumento livornese," 216–17. On the life of a slave at the port of Livorno and aboard the ships of the Order of Santo Stefano, in addition to Bono, *Schiavi musulmani*, see Cesare Ciano, " Gli schiavi ed i forzati nella Livorno medicea," *Rivista di Livorno* 9 (1959): 22–26; Frattarelli Fischer, " Nella città dei Mori," 40–43; and Algerina Neri, *Uno schiavo inglese nella Livorno dei Medici* (Pisa: ETS, 2000). Neri recounts the travails of William Davies, a Protestant barber-surgeon from London. In 1598, after running afoul of the Inquisition while aboard an English vessel, Davies was imprisoned in the *bagno* in Livorno and forced into hard labor, spending three years working on the construction projects in progress at the port and then six back-breaking years rowing on the grand-ducal galleys. Davis, *Holy War*, 175–80, also covers the plight of Davies in detail.

60. See Bono, *Schiavi musulmani*, 356–58, on various projects completed at the port using forced labor.

aggressors of the naval prowess of the grand duchy and alerted prisoners to the fate that awaited them in Livorno. The statue of the grand duke also welcomed the victorious ships of the Order of Santo Stefano as they returned to port, and to this audience the inclusion of Tacca's "mori" was a pointed visual reminder of the "other" that united all Tuscans as Christian warriors. Just as Cosimo forever commanded the Piazza dei Cavalieri, presiding over celebrations of knightly achievement and power, the pendant sculpture of Ferdinando controlled the harbor even after his death, reminding each knight as he boarded the order's galleys of his principal mission, to defend the true faith from the infidels, in the service of his Medici grand master.

Ferdinando's calculated choice of site and medium for the imposing public portrait monuments of himself and his father in Pisa and Livorno, the two crucial maritime centers of the Medici empire — as well as visual allusions to their knightly brotherhood — ensured that both he and his father would remain grand masters, and by extension defenders of the one true faith, in perpetuity. Although clearly images of Medici power and hegemony, through their emphasis on knightly identity as well as the inclusion of the clearly defined "other" in the case of Livornese slaves, these monuments celebrate the grand dukes as Christian crusaders and evoke the shared mission that united all Tuscans, the defense of the one true faith against the Ottoman infidel. Thus, the physical presence of these commissions, forceful declarations of Medici power and dominance, was tempered by inviting viewers to see in these portrait sculptures not just images of authority, but also shared Christian pride and glory. The monuments in Pisa and Livorno serve to this day as prominent and permanent reminders of the strength of the Tuscan navy and the great successes of the Cavalieri di Santo Stefano. Beyond that, they testify to Ferdinando's consummate skill as a ruler and a patron of art and his crucial, and as yet undervalued, role as architect of Medici grand-ducal identity in the expanding Tuscan empire.

■

Fig. 1. Pietro Francavilla. *Monument to Cosimo I*, 1594–1600. Marble, 17' 4" high (Cosimo: 9' 2"; base: 8' 2"). Set against the backdrop of the Palazzo dei Cavalieri, Piazza dei Cavalieri, Pisa. Photo: author.

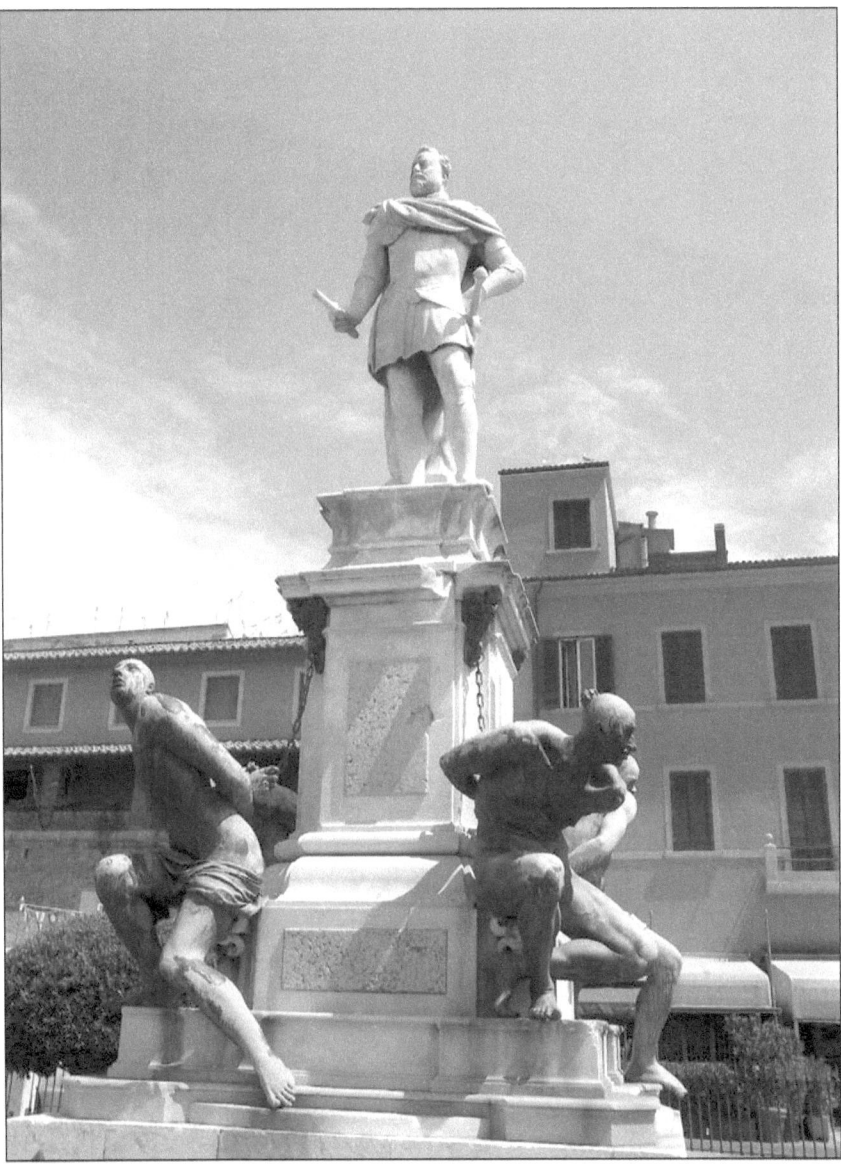

Fig. 2. Giovanni Bandini and Pietro Tacca. *Monument to Ferdinando I*, c.1595–1626. Marble and bronze, 32' 9" high (Ferdinando: 14' 4"; base: 18' 5"; "Quattro Mori": range 6' 5" to 8' 2"). Piazza Micheli, Livorno. Photo: author.

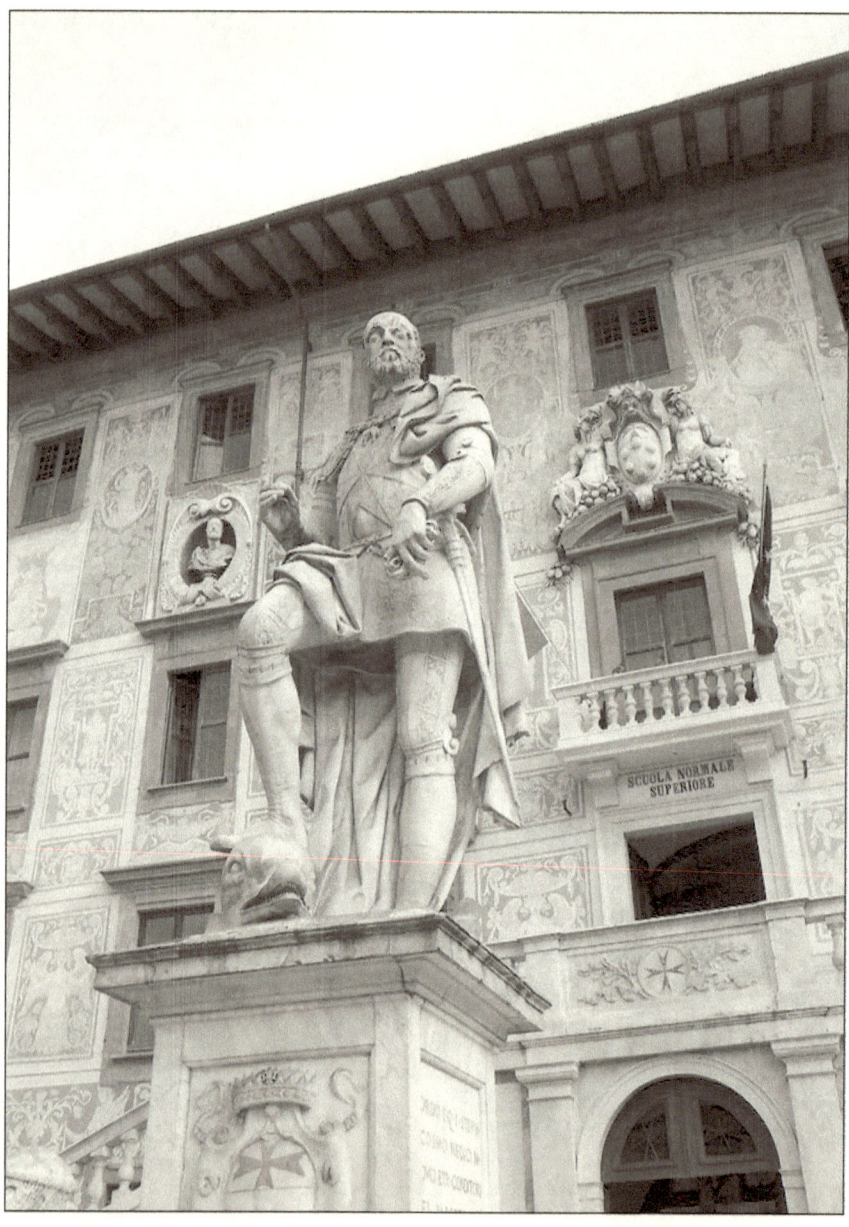

Fig. 3 (above). Pietro Francavilla. *Monument to Cosimo I*. Photo: author.

Fig. 4 (facing page). Giambologna. *Oceanus,* c.1571–76. Marble. Museo Nazionale del Bargello, Florence. Photo: author.

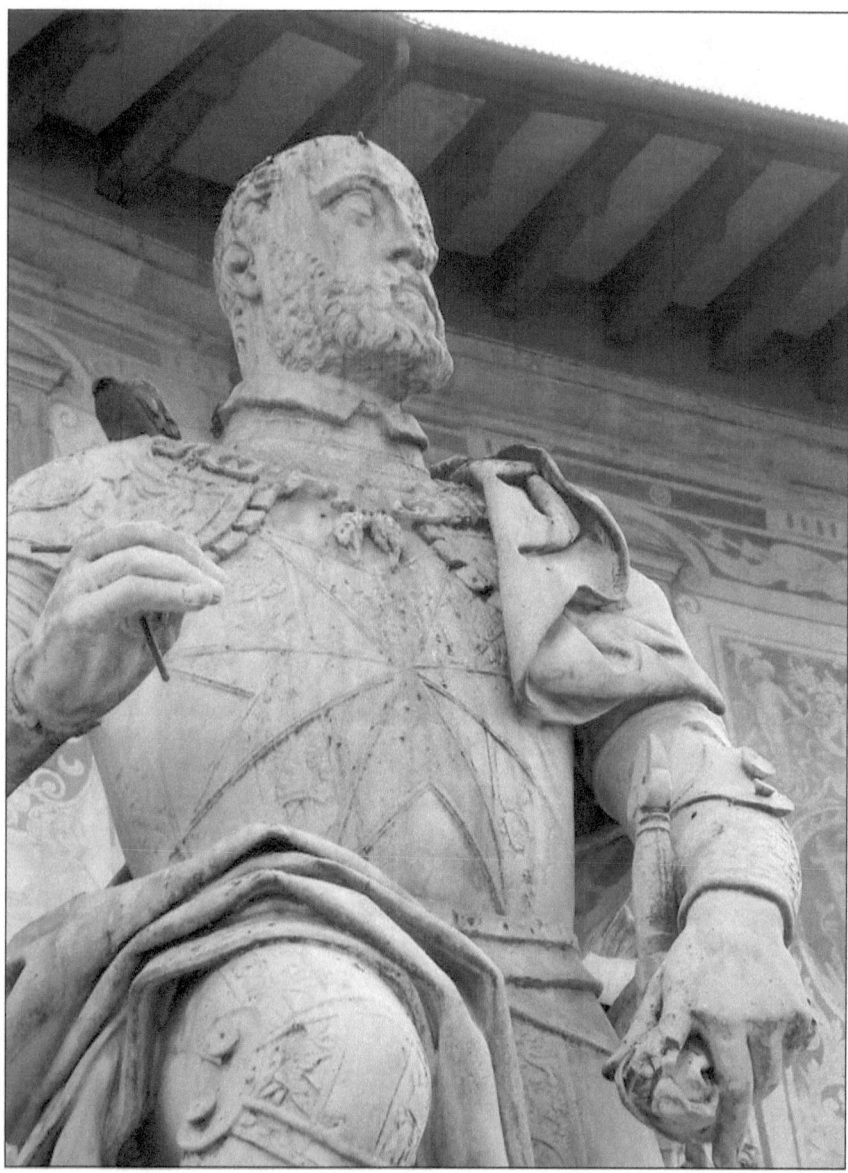

Fig. 5. Pietro Francavilla. *Monument to Cosimo I,* detail of breastplate. Photo: author.

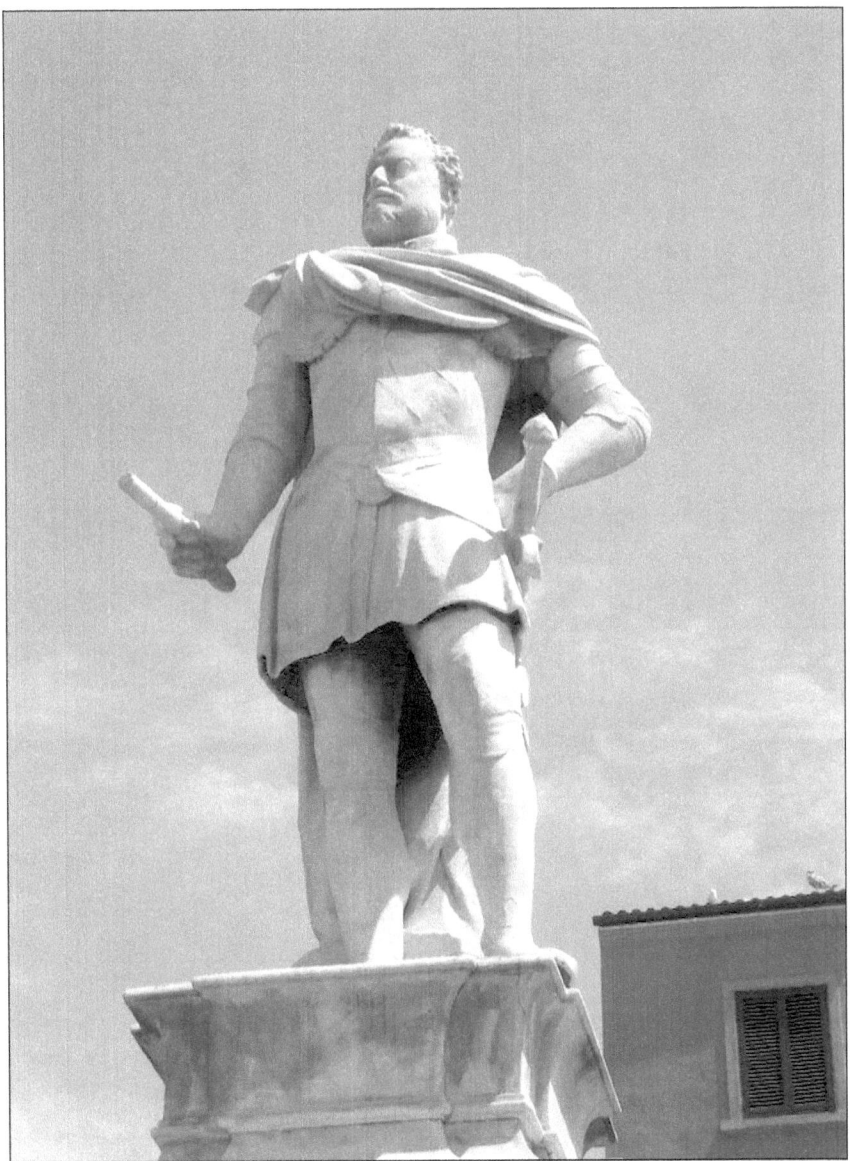

Fig. 6. Giovanni Bandini. *Monument to Ferdinando I,* detail of Bandini's colossus. Photo: author.

A SCARLET RENAISSANCE

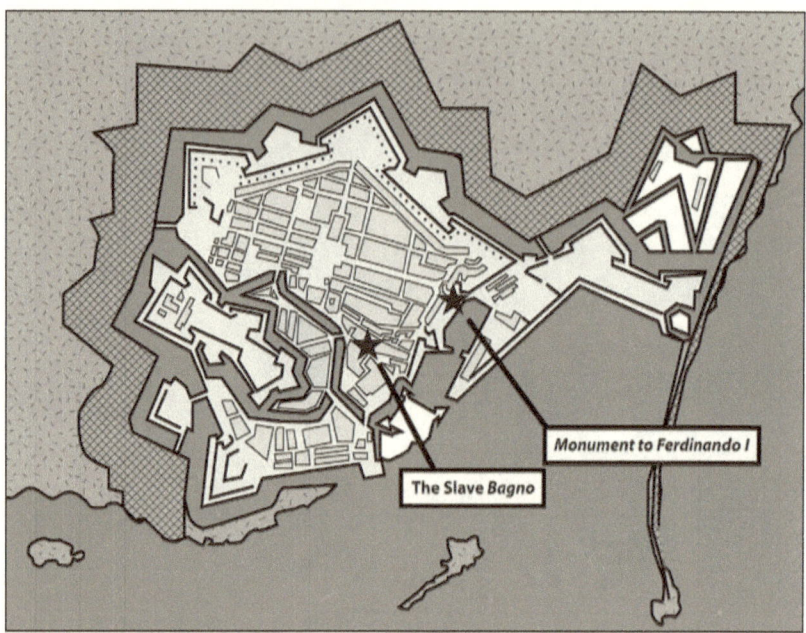

Fig. 7 (above). Plan of Livorno with the *Monument to Ferdinando I* and the slave *bagno* identified. Map courtesy of Christopher Jones.

Fig. 8 (below). Anonymous. *View of the Port at Livorno*, 17th century (post-1626). Archivio di Stato, Pisa. Photo: SCALA, Florence — courtesy of the Ministero Beni e Att. Culturali.

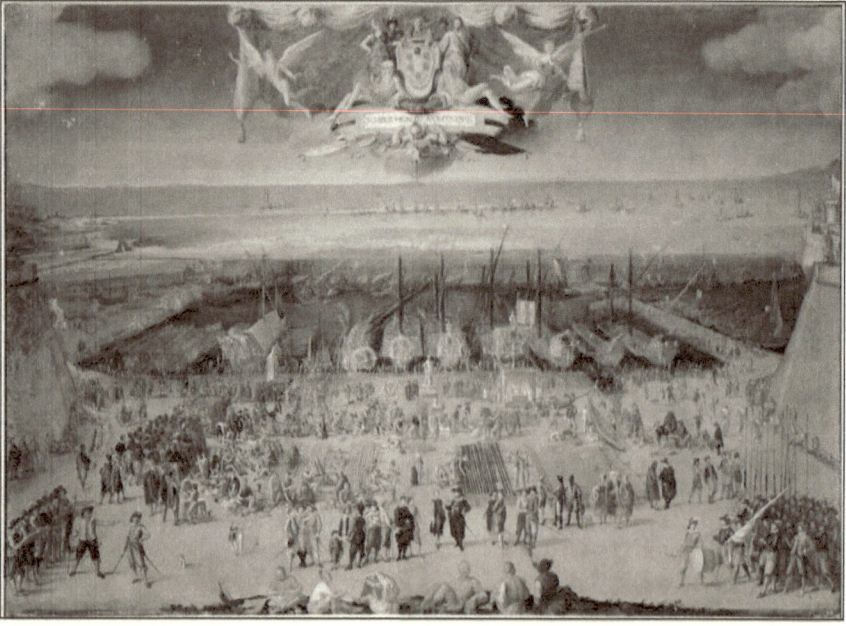

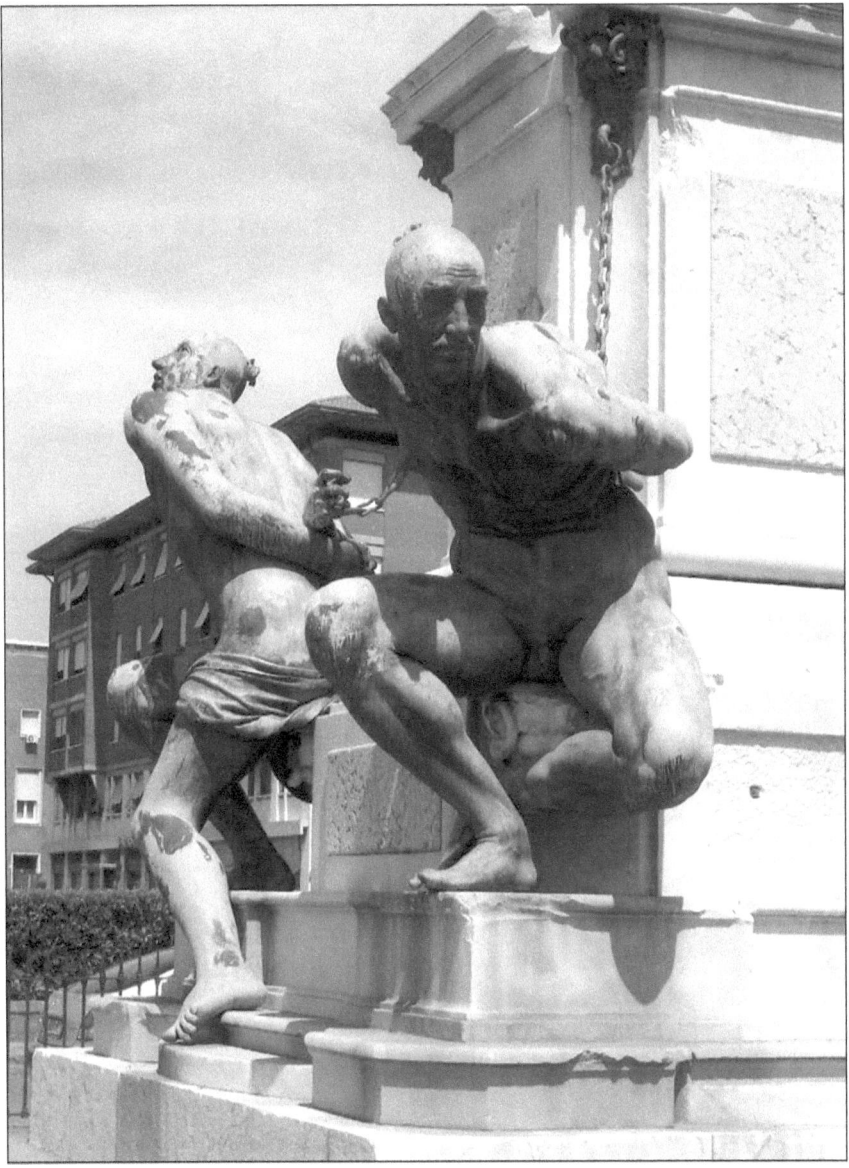

Fig. 9. Pietro Tacca. *Monument to Ferdinando I*, detail of "Quattro Mori." c.1617–26. Livorno, Piazza Micheli. Photo: author.

A SCARLET RENAISSANCE ■

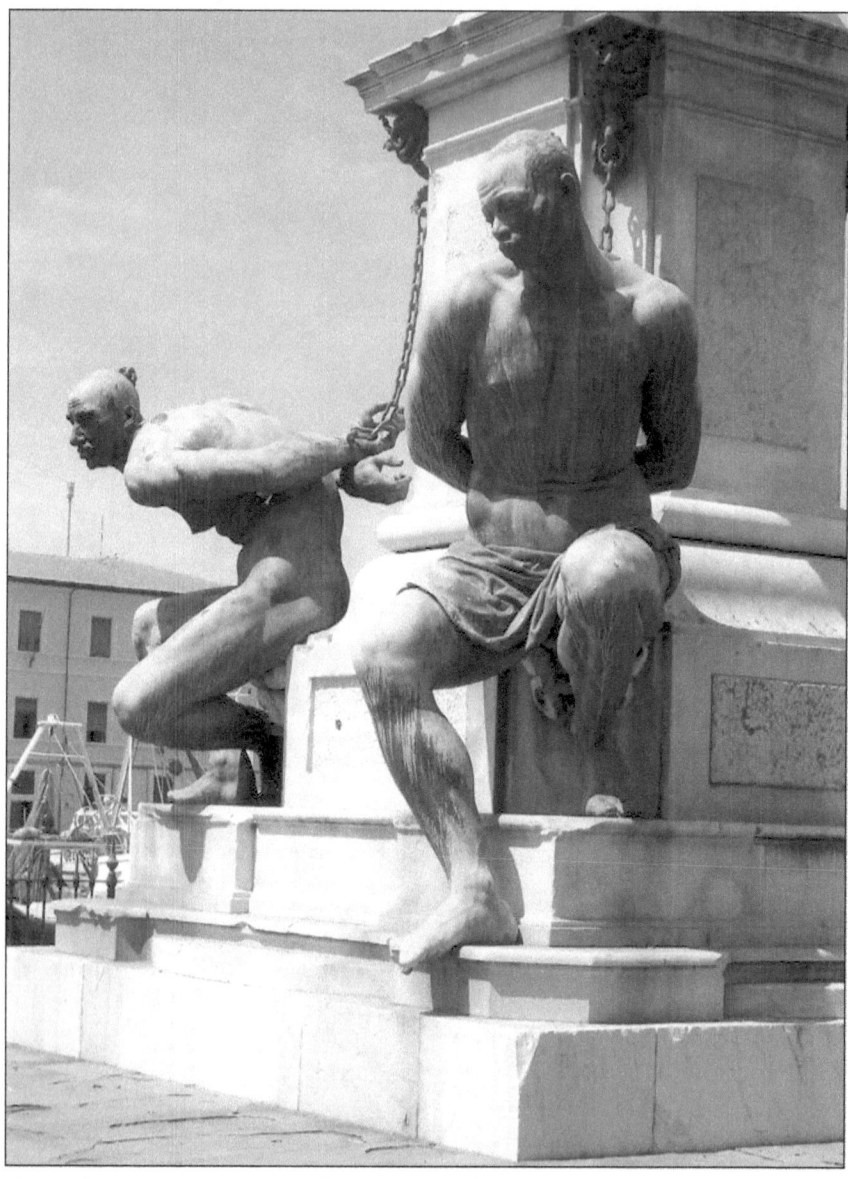

Fig. 10. Pietro Tacca. *Monument to Ferdinando I*, detail of "Quattro Mori," c.1617–26. Livorno, Piazza Micheli. Photo: author.

EMBELLISHING THE QUEEN'S RESIDENCE
QUEEN CHRISTINA OF SWEDEN'S PATRONAGE OF GIAN LORENZO BERNINI AND MEMBERS OF HIS CIRCLE OF SCULPTORS

LILIAN H. ZIRPOLO

Only recently have scholars acknowledged the contributions of Queen Christina of Sweden to the history of art collecting.[1] Few, however, admit to her involvement in the advancement of Baroque art, perhaps because a prejudice exists in Italian Baroque scholarship against the accomplishments of artistic figures from the latter part of the seventeenth century, when the queen was active commissioning works of art.[2] Having abdicated the Swedish throne in 1654 and moved to Rome in the following year, Queen Christina first resided in the Palazzo Farnese, placed at her disposition by Ranuccio II Farnese, duke of Parma. In 1659, after several relocations, she settled in the Palazzo Riario, now Corsini, on the Lungara, where she spent the last three decades of her life. From the mid-1660s she was engaged in the renovation and decoration of her residence. By then, she and Gian Lorenzo Bernini had developed a close friendship; and the sculptor acted as her artistic advisor, particularly in regards to the restoration and proper display of her ancient art collection. Bernini also provided the artists who would assist him in bringing his vision for the project to fruition.

1. The most useful sources for Christina's collecting activities are Carl Nordenfalk, ed., *Christina Queen of Sweden: A Personality of European Civilisation* (Stockholm: Nationalmuseum, 1966); Enzo Borsellino, "Cristina di Svezia collezionista," *Ricerche di Storia dell'Arte* 54 (1994): 4–16; Tomasso Montanari, "Cristina di Svezia, il cardinale Azzolino e il mercato veronese," *Ricerche di Storia dell'Arte* 54 (1994): 25–52; *Cristina di Svezia: Le colezzioni reali*, ed. Ulf Cederlöf and Susanna Le Pera Buranelli (Rome: Fondazione Memmo; Milan: Electa, 2003); Lilian H. Zirpolo, "Severed Torsos and Metaphorical Transformations: Christina of Sweden's Sale delle Muse and Clytie in the Palazzo Riario-Corsini, *Aurora. The Journal of the History of Art* 9 (2008): 29–53.
2. The notion that the late seventeenth century was an era of decline for the arts in Rome has exacerbated scholarly indifference toward these masters. While it is true that low finances during this period curtailed the production of sizeable papal commissions, artistic activity in Rome continued under the patronage of the nobility, the clergy and religious orders. Stephanie Walker, "The Sculpture Gallery of Prince Livio Odescalchi," *Journal of the History of Collections* 6.2 (1994): 189.

A SCARLET RENAISSANCE ■

In current scholarship, Bernini's role in Queen Chistina's palace renovation and ornamentation campaign goes largely unrecognized. The artists involved in the restoration of her prized ancient sculptures are seen as having worked independently rather than as part of a well-orchestrated and purposeful undertaking.[3] Most of these masters are all but forgotten in spite of the fact that in their time they were much sought after. The present study seeks to reveal this other aspect of Bernini's artistic career and give proper placement within the history of Baroque art to the sculptors involved in the commission. It also seeks to augment our understanding of Christina's art patronage and collecting efforts, which had a material effect on the course of Baroque art.

ABOUT CHRISTINA OF SWEDEN

Christina was born in Stockholm on 26 December 1626. She was the daughter of King Gustav Adolf, who died in the battle of Lützen in 1632, when she was six, and Maria Eleonora, princess of Brandenburg, who suffered from mental illness.[4] As other heiresses to European thrones, Christina received an education as if she were a male. Chancellor Axel Oxenstierna, who governed as head of the Swedish regent council until Christina reached maturity, prepared the young princess for her later monarchic duties; while Johannes Matthiae, court chaplain, later bishop, and a tolerant theologian, instructed her in philosophy, theology, mathematics, astronomy and other areas of learning.[5] By eighteen, Christina was fluent in French, German, Italian, Dutch, Latin, Greek and, of course, Swedish and had enough knowledge of Hebrew and Arabic to muddle through texts written in those languages. Later, the Duc de Guise would remark that the queen spoke "eight languages, but mostly French and that as if she had been born in Paris" and that she had more knowledge than "all our Academy and the Sorbonne put together."[6] The duke was not the first to praise Christina for her erudition. When she was only seven, Gabriel Oxenstierna, the court's high chancellor, had already recognized her intellectual prowess. In a letter he wrote to his

3. Silvia Danesi Squarzina, "La collezione di Cristina di Svezia, un Cupido reconsiderato e due inventari," in Cederlöf and Le Pera Buranelli, 51, has recognized that the restoration of ancient statues in Christina's collection took place under Bernini's supervision, as did the commissioning of modern sculptures. However, she only mentions this in one sentence, leaving much to be discussed on the subject.
4. Nordenfalk, ed., 26. On King Gustaf Adolf, see Michael Roberts, *Gustavus Adolphus* (London and New York: Longman, 1992).
5. On Christina's education, see Leif Åslund, *Att fostra en kung: Om drottning Kristinas utbildning* (Stockholm: Atlantis, 2005).
6. In Christopher Hibbert, *Rome: The Biography of a City* (New York and London: W.W. Norton, 1985), 191–93. The Duc de Guise was Henri II de Lorraine, whose memoirs were first published in Paris in 1668.

brother Axel he stated that the child demonstrated extraordinary political genius in spite of her young age.[7]

Christina ascended the throne on 8 December 1644 and immediately began efforts to attract learned individuals to her court. One of the greatest luminaries she invited to Stockholm was René Descartes. He arrived in October 1649 to instruct the queen in philosophy. Descartes reported that Christina was passionate about literature, particularly Greek, and that she had a large collection of ancient books, most of which she is known to have read.[8] Other gifted scholars at Christina's court were the German philologist Johan Freinsheimus, the Dutch scholar of Latin Nicolaas Heinsius, and the Frenchman Gabriel Naudé, a physician, free thinker and, at one time, librarian to both cardinals Armand Richelieu and Jules Mazarin of France. Also at her court were Raphael Trichet Du Fresne, who published the first edition of Leonardo's treatise on painting and dedicated it to the queen; and Pierre Bourdelot, a physician learned in art who advised Christina on her collection.[9]

THE ROAD TO ROME

In spite of the fact that Christina interacted daily with the learned men at her court and that she had created for herself an environment well suited for her inquisitive nature, she drew little satisfaction from her role as the Swedish monarch. The strict Lutheranism she was expected to uphold was inhibiting her free thinking, and her daily royal obligations were interrupting her efforts to satisfy her insatiable appetite for knowledge. For her, Catholic Rome, at the time the center of learning and culture, would provide a more intellectually-stimulating environment, unencumbered by royal duties.[10]

7. Sven Stolpe, *Christina of Sweden*, trans. Alec Randall and Ruth Mary Bethell (New York: Macmillan, 1966), 4; Nordenfalk, ed., 30; Hugh Honour, "Queen Christina of Sweden as Art Collector," *Connoiseur* 163 (1966): 9.
8. Descartes died the following year due to either influenza or pneumonia, most likely brought on by Stockholm's cold and damp climate, especially at five in the morning when he and Christina met in her studio. Prior to his death, Descartes and Christina spoke of establishing an academy, the statutes of which he had compiled at her request. The Cartesian Academy held its first meeting in February 1650, on the first Sunday after Descartes' funeral. Stolpe, 120–21; Nordenfalk, ed., 47–48, 205; Honour, 9. On Descartes and Christina, see Jean François de Raymond, *La Reine et le Philosophe: Descartes et Christine de Suède* (Paris: Lettres modernes, 1993).
9. The prominent mathematician and geometrician Blaise Pascal; Samuel Bochart, a philosopher, theologian and orientalist who spent a year at court studying Christina's Arabic texts; and Claude Saumaise (called Salmasius), who taught at Leiden and published political and theological treatises, were also at her court. Nordenfalk, ed., 204–10; Stolpe, 128–29.
10. Scholars have devoted a great deal of energy to examining the possible reasons for Christina's abdication. Since they are inconsequential to this study, I have only made general statements on the topic. For a more in-depth examination, see Gunnar Hägglund, "La regina Cristina: Passaggi e soggiorni nelle Marche," in *Cristina di Svezia e Fermo: Atti del Convegno internazionale "La regina Cristina di Svezia,*

A SCARLET RENAISSANCE ■

Consequently, on 6 June 1654, Christina abdicated the throne, leaving her cousin Karl Gustav as her successor. After a grand tour of various northern cities, including Hamburg, Utrecht and Brussels, her public conversion to Catholicism in Hofkirche at Innsbruck, and then stays in Venice, Mantua, Ferrara, Bologna and Urbino, among other Italian cities, Christina entered Rome with great pomp through the Porta del Popolo on 25 December 1655.[11]

Christina brought to Rome the precious manuscripts she had acquired while in Sweden from the collections of Cardinal Mazarin, the French councilor Alexandre Petau, the bibliophiles Hugo Grotius and Gerard Vossius, the Dutch Rabbi Manasse ben Israel and the orientalist Gilbert Gaulin, among others. Consisting of approximately six thousand printed volumes and two thousand manuscripts, this collection was considered one of the most significant of Europe at the time.[12] She also brought her art collection, then valued at the exorbitant figure of thirty million francs. Included in this group were several hundred paintings, one hundred bronze, marble and alabaster statuettes, and seventy tapestries.[13] These objects represented only a limited number of the works from the Swedish royal collection.[14] She only took the sixteenth-century Italian paintings, leaving

il cardinale Decio Azzolino jr e Fermo nell' arte e la politica della seconda metà del seicento. Tenuto a Fermo nell'Auditorium di San Martino nei giorni 3 e 4 ottobre 1995, ed. Vera Nigrisoli Wärnhjelm (Fermo: Fondazione Cassa di Risparmio di Fermo, 2001), 42–43, with further bibliography.

11. Pope Alexander VII sent Lucas Holste, his internuncio, Vatican librarian and himself a convert, to officiate at Christina's conversion ceremony, which took place on 21 November 1655. On Christina's journey from Stockholm to Rome and ensuing celebrations, see Galeazzo Gualdo Priorato, *Historia della Sacra Real Maestà di Cristina Alessandra regina di Svetia* (Rome: Reu. Camera Apostolica, 1656); Sforza Paravicino, *Descrizione del primo viaggio fatto a Roma dalla Regina di Svezia Christina* (Rome: Bulzoni, 1838); Torgil Magnuson, *Rome in the Age of Bernini*, vol. 2 (Stockholm: Almqvist & Wiksell International, 1986), 147–51.

12. Most of the manuscripts were French medieval missals, Bibles, illuminated prayer books and all the texts of the Church Fathers and medieval theologians. Several were philosophical works and humanist transcriptions produced in Rome. Botticelli's illustrations of Dante's *Divine Comedy*, a thirteenth-century Latin translation of Aristotle's *Nichomachean Ethics* and a French version of Marco Polo's *Voyages* (these last two in Stockholm, Kungliga Biblioteket) were also in her collection. Most of these texts are now housed at the Vatican. The printed volumes were dispersed between 1745 and 1747. See Christian Callmer, "Queen Christina's Library of Printed Books," in *Analecta Reginensia: Queen Christina of Sweden, Documents and Studies*, ed. Magnus von Platen, vol. 1 (Stockholm: Kungl. Boktryckeriet P.A. Nordstedt & Söner, 1966), 59–73; Alfred Neumann, *The Life of Christina of Sweden* (London: Hutchinson, 1935), 264; Nordenfalk, ed., 47–48, 530–31, 539–40; *Cristina di Svezia: Mostra di documenti vaticani. Biblioteca vaticana, ottobre 1966* (Vatican City: Tip. Poliglotta Vaticana, 1966).

13. Carlo Pietrangeli, *Le collezioni private romane attraverso i tempi* (Rome: Fratelli Palombi, 1985), 13; Borsellino, "Cristina di Svezia," 7.

14. A large number of the paintings owned by Christina were from the collection of Rudolph II, seized when Prague fell to the Swedes. Rudolph had recently enriched his collection with the works looted from the Gonzaga Palace in Mantua. Some other works in Christina's possession had been plundered from the convents and palaces of Prague and the galleries of Monaco. The priceless cargo arrived in Stockholm on 14 April 1649. Magnus Olausson, "13 Juglio 1648: La conquista de quartiere di Malá Strana a Praga," in Cederlöf and Le Pera Buranelli, 133.

behind the works by the northern masters.[15] A letter Christina penned on 22 May 1652 to Paolo Giordano II Orsini, duke of Bracciano, from Sweden, explains her actions. In it she expressed her preference for Italian artists, remarking that she would "give away the lot [of northern masters] for a couple of Raphaels, and I think that even that would be paying them too much honor."[16]

It is not completely clear how Christina developed a preference for Italian art. However, channels of contact between the Swedish court and the rest of Europe had been established long before Christina assumed the throne, which would have provided information on the latest artistic developments throughout the continent.[17] Visitors at her court also might have influenced her in this regard. Gabriel Naudé had studied medicine in Padua and, while in Mazarin's service, had travelled through Europe to procure volumes for the cardinal's library.[18] Raphael Trichet Du Fresne and Pierre Bourdelot explored Rome together, and they were both in contact with Cassiano dal Pozzo. Further, Du Fresne corresponded with Cardinal Francesco Barberini, dal Pozzo's employer.[19] Indeed, Christina herself wished to become one of dal Pozzo's correspondents. A letter she penned to Nicolaas Heinsius on 1 May 1652 when the scholar was about to embark on a trip through Italy divulges this, as well as the fact that she had great interest in corresponding with other Italian cultural figures:

> As regards to your sojourn as a whole, make it as long or as short as you deem necessary for the service you are to render me. It will be a great service you do me if you can arrange for me to correspond with Mr. del Pozzo and some other prominent persons.[20]

15. On her way to Rome, she sent Albrecht Dürer's *Adam* and *Eve* (both in Madrid, Prado) as gifts to the king of Spain and Hans Holbein the Elder's *Spring of Life* (Lisbon, Museum of Art) to the king of Portugal. Holbein the Younger's portrait *of Sir Thomas More* (New York, Frick Collection) is the only northern work she kept for herself. Nordenfalk, ed., 419, 505–6.

16. "... ma io vi giuro che li darie tutti per un paro di quadri di Raffaello e credo di farli anche troppo honore." The letter was accompanied by a painting by Titian that Christina sent to Orsini as a gift. Martin Olin, "La Regina Cristina collezionista di opere d'arte," in Cederlöf and Le Pera Buranelli, 160; English trans. in Francis Haskell, *Patrons and Painters: A Study in the Relations Between Italian Art and Society in the Age of the Baroque* (London: Chatto & Windus, 1963), 97; Honour, 9. For Christina's correspondence with Orsini, see Carl di Bildt, "Cristina di Svezia e Paolo Giordano II duca di Bracciano," *Archivio di Società Romana di Storia Patria* 29 (1906): 5–32. See also Magnuson, 22; Stolpe, 148.

17. Hans Henrik Brummer, "The *editio princeps* of Leonardo Da Vinci's *Treatise on Painting* Dedicated to Queen Christina," in *Leonardo's Writings and Theory of Art*, ed. Claire J. Farago (New York: Garland, 1999), 461.

18. Jack A. Clarke, *Gabriel Naudé: 1600–1653* (Hamden: Archon Books, 1970), 76.

19. Du Fresne wrote to Cardinal Barberini in 1652 informing him of an academy he and Queen Christina had established in Sweden. Brummer, "The *editio princeps*," 464, 468.

20. Magnus Olaf Celsius, *Bibliothecae regiae Stockholmensis historia brevis et succinta* (Stockholm: L. Salvii, 1751), 60; English translation in Brummer, "The *editio princeps*," 464. On Heinsius, Christina and dal Pozzo, see Franz Felix Blok, *Nicolaas Heinsius in dienst van Christina van Sweden* (Delft: Ursulapers, 1949).

A SCARLET RENAISSANCE ■

THE PALAZZO RIARIO RENOVATIONS

To celebrate Christina's triumphant entry into Rome and prior to placing his Palazzo Farnese at the queen's disposition, the duke of Parma commissioned Carlo Rainaldi to embellish the palace's façade with the arms of Christina, Sweden and the papacy. Stucco figures that personified virtues and Old Testament scenes alluding to the queen's conversion to Catholicism and her persona were also included. In 1656, the plague spread to Rome from Naples and other parts of Italy and, so Christina left the city.[21] She traveled to France where she remained until 1658, save for brief visits to Pesaro and Fano in 1656 and 1657. Upon her return to Rome, she first resided in the Palazzo Rospigliosi-Pallavicini on the Quirinal, then owned by Cardinal Jules Mazarin.[22] Then, in 1659, Christina rented the Palazzo Riario, where she remained until her death in 1689 (Fig. 1).[23]

When Christina moved into her final residence, she made a number of modifications to both the exterior and interior so the building would reflect the dignity of her high social standing, as well as to provide proper spaces to display her art collection and to host concerts, theatrical productions and academic meetings.[24] The architect she hired to carry out the work was Camillo Arcucci, Francesco Borromini's pupil. Arcucci died in 1667 and was replaced by his adopted son Giuseppe Brusati.[25] During the renovations, the queen

21. Nordenfalk, ed., 276, cat. no. 622–23; 282, cat. no. 638.
22. Nordenfalk, ed., 299.
23. The lease was signed by Cardinal Decio Azzolino, her good friend and liaison with the Vatican, and is housed in the Archivio di Stato di Roma, Not. A. C. Olimpiades Petruccius, 1659, vol. 5924, c. 10 ss. The owner of the palace then was Ferdinando Riario. See Enzo Borsellino, *Palazzo Corsini alla Lungara: Storia di un cantiere* (Fasano: Schena Editore, 1988), 29; Mariella Piacentini, "Disegni inediti di Palazzo Riario (poi Corsini) alla Lungara," *Studi Romani* 45 (1997): 303; Tomaso Montanari, "Il Cardinale Decio Azzolino e le collezioni d'arte di Cristina di Svezia," *Studi Secenteschi* 38 (1997): 191.
24. The only evidence of the *palazzo*'s early appearance prior to Christina's renovations is found in the *vedute* of Rome rendered in mid- to late-sixteenth century by Antonius van den Wyngaerde (1552–53), Ugo Pinard (1555), Etienne Du Pérac (1577) and Antonio Tempesta (1593). These engravings are all included in Amato Pietro Frutaz, *Le Piante di Roma*, 3 vols. (Rome: Istituto di Studi Romani, 1962). See Borsellino, *Palazzo Corsini alla Lungara*, 26–27; and Piacentini, 302 n. 3. There is also a painting by an anonymous artist dating to sometime after 1612, now housed in the Museo di Roma in the Palazzo Braschi. For the dating of this painting, see Nordenfalk, ed., 319, cat. no. 734.
25. According to Christina's *libro di conti*, Arcucci received payments for his services from 1664 to 1666. Giuseppe Brusati collected payments from 1669 to 1679. Biblioteca Comunale di Jesi, Archivio Azzolino, vol. V, cc. 588v, 591 r, 593, v, 595, 597v, 598v, 604 v. See also Borsellino, *Palazzo Corsini alla Lungara*, 31 n. 37. Though Camillo and Brusati are no longer well known, they had a distinguished career worth examining. Camillo had already worked on the Casino Riario for Ferdinando Riario c.1640. He assisted Francesco Borromini in the Oratory of St. Philip Neri in 1651–67 and was responsible for the design of the Palazzo Gottifredi-Grazioli built in the 1650s, the Palazzo Pio of 1650–67 and the monastery of Sta. Maria in Campo Marzio of 1656–66. From 1658 until his death

lived in the Casino Riario, where the art, books and other precious objects she brought from Sweden were kept while work on the palace continued.[26]

The most significant change made to the palace's exterior was the closing off of the main doorway facing the Via Lungara and its relocation to the north side (Fig. 2). A forecourt in front of the new entrance where a *giardino segreto* had stood was then added. An imposing gate, reached from the Via Lungara, provided the entrance to the forecourt. The gate featured rusticated compound piers that supported an attic and scroll at either side to connect it visually to the shorter masonry wall. The attic was then adorned with two stylized pyramids, each surmounted by a sphere, similar to the decorative forms found in the Porta del Popolo through which Christina had entered Rome officially. The garden rising toward the Janiculum could be accessed from the forecourt through another entry strategically lined with the main gate. This second gate was a simplified version of the first, with narrower compound piers, scrolls and stylized pyramids surmounted by spheres. The attic, however, was omitted.[27] The work was carried out sometime after 1664.[28]

in 1667, he also worked on the Palazzo Spada and from 1663 on the Spada Chapel in the Chiesa Nuova, dedicated to St. Charles Borromeo. Brusati worked on the Palazzo Falconieri in Via Giulia in 1648 and assisted Camillo in 1666 in the monastery of Sta. Maria in Campo Marzio, which resulted in their developing such a close relationship that Camillo adopted Brusati. From 1667 until 1675, Brusati also worked in the Palazzo Spada, and from 1668 to 1679 on the Spada Chapel in the Chiesa Nuova. In 1673–76, he was charged with the Falconieri Chapel in S. Giovanni dei Fiorentini, and in 1680 he was appointed Sottomaestro delle Strade, a charge he fulfilled until 1684. See Piacentini, 305–6. On Arcucci and Brusati, see Anna Maria Corbo, "Giuseppe Brusati Arcucci," in DBI 14 (Rome: Istituto della Enciclopedia italiana, 1972), 696–97; Lionello Neppi, *Palazzo Spada* (Rome: Editalia, 1975), 207 n. 4; David Buttler, "Orazio Spada and His Architects: Amateurs and Professionals in Late Seventeenth-Century Rome," *The Journal of the Society of Architectural Historians* 53.1 (1994): 61–79.

26. Hans Henrik Brummer, "Two Works by Giulio Cartari," *Konsthistorisk Tidskrift* 36 (1967): 110. These objects were in storage in Hamburg until 1661 when they were shipped to Rome. On 19 November 1661, Torquato di Montaiuto, Florentine ambassador to Rome, wrote to Cardinal Carlo de Medici: "In più ricca forma si sente che il signor cardinale Azzolino riduca il Palazzo de' Riarii per la regina, nel quale, essendovi fatti molti nobili acconcimi, sono arazzi, pitture e libri singolarissimi, et si aspettano ogni giorno 30 cavalli da carrozza per Sua Maestà, dei quali si dicono grande cose." Archivio di Stato di Firenze, MP 5249, 810r–v, letter of 19 November 1661. See Montanari, "Cristina di Svezia," 193. The casino was to the west of the Riario property, toward the Janiculum. It stood on the site until 1895 when it was demolished to make way for the Piazza Giuseppe Garibaldi.

27. The entryway to the garden from the forecourt already existed when Christina rented the Palazzo Riario. According to 1645 and 1697 surveys, this entryway was moved so it would line up with the main gate, and the marble statuary that adorned it was removed as was its iron gate, which was replaced with wood. Biblioteca Comunale di Jesi, Archivio Azzolino, b. 211, c. 573 r–v, c. 544r (a. 1645); 571v–572r (a. 1697). Piacentini, 309 n. 26, 310 n. 30.

28. In 1664, the *stuccatore* Marcantonio Beraglio was paid for stucco work carried out "alli due portoni che uno verso strada e l'altro che entra nel giardino," which means that the main entrance to the palace was still in use in that year. Biblioteca Comunale di Jesi, Archivio Azzolino, vol. V, 588r.; Borsellino, *Palazzo Corsini alla Lungara*, 32; Enzo Borsellino, *Palazzo Corsini, Roma* (Rome: Istituto Poligrafico e Zecca dello Stati, 2002), 17.

A forecourt was not a common part of Roman domestic architecture, though the villas Farnesina and Borghese do include this feature. The exterior renovations made to the Palazzo Riario were most likely based on French models Christina had seen and experienced during her stay in France. In fact, Figure 2 shows that the Riario garden, which Christina also had remodeled, was also a French type composed of hedges carefully pruned to form complex interlaced arabesques occupying the parterres. Fountains, an aedicule and a nymphaeum punctuated the landscape design.[29]

In the palace's interior, Christina had some wall partitions removed to accommodate her Sala dei Svizzeri (to be used by the Swiss Guards placed at her disposition by the pope) on the piano terra (Fig. 3, nos. 41–42), a salone on the piano nobile (Fig. 4, no. 23) and a library on the upper story (Fig. 4, nos. 36–37).[30] On the piano terra, the portico that led to the garden cortile was closed off and the space transformed into a sumptuous bathroom (Fig. 3, facing nos. 46–47) which, according to the archival documentation, was built in 1670 and included two marble basins and niches filled with statuary.[31] Christina used the rooms on this level to display her collection of ancient art, which will be the focus of the discussion in the last sections of this essay. On the piano nobile, the Sala dei Palafrenieri that faced the formal garden and cortile was extended toward the main stairway and converted into the Camera dell' Udienze Solenni (Fig. 4, no. 10). Christina's bedroom, the Sala dell' Alcova (Fig. 4, no. 15), was created by removing a partition between two rooms that were connected by a doorway. Two Corinthian columns were added

29. Christina had engaged the services of the French landscape architect André Mollet to work for her in the royal gardens in Stockholm. Mollet published *Le Jardin de Plaisir* in 1651 in Stockholm and dedicated it to Christina, a treatise that was to deeply influence the field of gardening. On the title page, Mollet included the following inscription to describe himself: "Maistre des Jardins de la sérénissime Reine de Suède." Reginald Theodore Blomfield, *The Formal Garden in England* (New York: The Macmillan Company, 1901), 56–57. Mollet came from a family of well-known gardeners, and he was also active in London where he worked for King Charles I and Queen Henrietta Maria, and later Charles II; and in the Netherlands where he worked for Frederik Hendrik, prince of Orange. On Mollet, see Evelyn Cecil, *A History of Gardening in England* (Whitefish: Kessinger Publishing, 2006); Laurence Pattacini, "André Mollet, Royal Gardener in St. James's Park, London," *Garden History* 26.1 (1998): 3–18. It is possible that Christina added the forecourt to her palace to emphasize its new identity as a place of cultured retreat and leisure, similar to the Villa Borghese and Villa Farnesina, though there is no concrete evidence to confirm this.

30. Biblioteca Comunale di Jesi, Archivio Azzolino, vol. V., c. 550r; Borsellino, *Palazzo Corsini alla Lungara*, 33 and n. 46.

31. There was also a *stanziolo* in the bathroom with "due caldaie murate con tutti li condotti, che portano l'acqua alli suddetti Bagni con suoi sportelli in ferro." Archivio di Stato di Roma, Bellus, a. 1698, vol. 941, c. 609r; a. 1699, vol. 943, c. 885v; a. 1696, vol. 934, c. 499; a c. 676r; Borsellino, *Palazzo Corsini alla Lungara*, 33 n. 45. The expenses incurred in the building of the bathroom are recorded in the Biblioteca Comunale di Jesi, Archivio Azzolino, b. 211, c. 595r-v. See Piacentini, 311 n. 31.

to support an ornate architrave.[32] Across from her bedroom was the Stanza dei Quadri (Fig. 4, no. 13) where her prized Venetian mythologies hung. The upper story is where the greatest structural changes were made. A series of contiguous rooms facing the cortile were opened up to form a second gallery for the display of the remaining paintings in Christina's collection (Fig. 4, no. 28), a Cappellone (Fig. 4, no. 27), and a Coro di Musici (on the landing).[33]

In 1660, Christina traveled to Hamburg where she remained until 1662, and four years later she returned to that city for a second visit that lasted until 1668.[34] During her absence, Cardinal Decio Azzolino, her liaison with

32. These two rooms used to create Christina's bedroom were decorated in the second half of the sixteenth century with frescos inspired by those in Emperor Nero's Domus Aurea, commissioned by Cardinal Alessandro Riario, who then lived in the palace (1565-85). They are still in situ and depict the stories of Moses (to the north toward the cortile) and Solomon (to the south toward the Porta Settimiana), with *all'antica* grotesques enframing the narratives. The artist who rendered these fresco decorations is unknown, though the style bears an affinity to the paintings of the Zuccari brothers. Borsellino, *Palazzo Corsini alla Lungara*, 26. Borsellino, *Palazzo Corsini, Roma*, 15 has suggested that the artist in charge of these fresco decorations may have been Vitruvio Alberi, who is mentioned in a contract dated 1581, though, as Borsellino indicates, the document may be referring to work in the Palazzo Riario at Caprarola. Alberi is best known for his frescos in the Palazzo Altemps, executed in the late 1580s-early 1590s, especially in the heavily damaged Sala della Stufa and Sala delle Prospettive Dipinte. He executed these in collaboration with Pasquale Cati. See, Touring Club Italiano, *Guida d'Italia: Roma* (Milan: Touring Club Italiano, 1999), 387. The Sala dell'Alcova is where Christina died, the event commemorated with a plaque above one of the doorways that reads: "LA REGINA CRISTINA DI SVEZIA MORÌ IL 19 APRILE 1689 'SONO NATA LIBERA VISSI LIBERA MORIRÒ LIBERATA' - DROTTING CHRISTINA AV SVERIGE AULED I DETTA RUM DEN 19 APRIL 1689 'JAG FÖDDES FRI, LEUDE FRI OCH SKALL DÖ FRIGJORD' CHRISTINA." Borsellino, *Palazzo Corsini, Roma*, 111.

33. It was in this upper story of the palazzo that Christina's theatrical and musical productions took place. The removal of walls to create larger, more imposing spaces, unfortunately caused some structural weaknesses, as evidenced by the fact that a pilaster in the Camera dell' Udienze Solenni had to be reinforced in 1665. Reinforcements were also made to the ceiling in the salone of the piano terra. Biblioteca Communale di Jesi, Archivio Azzolino, vol. V, c. 550 r; Borsellino, *Palazzo Corsini alla Lungara*, 33 n. 46; 34 n. 47; Borsellino, *Palazzo Corsini, Roma*, 19. In 1697-99, after Christina's tenure, reinforcements had to be made to the Cappellone as well. Biblioteca Communale di Jesi, Archivio Azzolino, vol. V, cc. 551v-552v; Archivio di Stato di Roma, Bellus, a. 1699, vol. 943, c. 890v. Records on the original renovation of the Cappellone and Coro dei Musici are in Biblioteca Communale di Jesi, Archivio Azzolino, b. 211, c. 551v, 552 r (a. 1697). Records on the original work in the Camera dell' Udienze are in the Biblioteca Communale di Jesi, Archivio Azzolino, vol. V, c. 590v; Piacentini, 314 n. 36-37. For an examination of the Stanza dei Quadri and its contents, see Veronica Biermann, "The Virtue of a King and the Desire of a Woman? Mythological Representations in the Collection of Queen Christina," *Art History* 24.2 (April 2001): 213-30.

34. Her purpose was to try to collect her pension from the Swedish government. Her banker and mediator, Diego Texeira, was based in Hamburg. He died in 1666, and Christina appointed his son Manoel to succeed him as her banker and representative. The 1660-62 trip included a stop in Stockholm to attend the funeral of Charles X Gustavus (d.1660). Montanari, "Il Cardinale," 191; Nordenfalk, ed., 352. Gunnar Hägglund, "La regina Cristina: Passaggi e soggiorni nelle Marche," in Nigrisoli Wärnhjelm, 41-56 discusses Christina's travels outside of Rome, including Hamburg and Stockholm, as well as her stays in Fano and Pesaro in 1656 and 1657 to escape the bout of

the papacy, oversaw the work in the Palazzo Riario.[35] From 1660 to 1664, Azzolino corresponded with various agents in Venice and Holland charged with procuring sumptuous fabrics, crystals, mirrors and tapestries for the decoration of the palace.[36] A letter dated 1 August 1661 sent by Torquato di Montauto, the Florentine ambassador to Rome, to Cardinal Carlo de' Medici indicates that by then work on the garden had begun,[37] suggesting that at the time there was great interest in the courts of Europe in Christina's palace renovations.[38]

plague in the papal city. On Christina's relations with Sweden after her move to Rome, see Marie-Louise Rodén, "Queen Christina's Relationship to Sweden after her Abdication of 1654," *Nouvelles de la République des Lettres* 1 (1991): 113-30.

35. Decio was also charged with obtaining a retinue for Christina's Roman court. He hired trustworthy individuals from his hometown of Fermo, including Cesare Macchiati, Christina's personal doctor until 1675; Lorenzo Adami, her captain of the guard until 1668 and Decio's cousin; Lorenzo's brothers Domenico and Ignazio, who acted as her page and *scudiero* respectively (Ignazio was promoted to lieutenant of Christina's Swiss Guard in 1680); Romolo Spezioli, a distant relative of Decio who took over as Christina's physician in 1675; and Romolo's brother, Giovanni Antonio Spezioli who acted as Christina's *capellano*. See Vera Nigrisoli Wärnhjelm, "I Fermani alla corte della regina Cristina di Svezia," in Nigrisoli Wärnhjelm, 105-21.

36. Montanari, "Il Cardinale," 194-95 and docs. 3-5, 7 in his *Appendice Documentaria*. These include a letter by Cardinal Azzolino to Johan Philip Silfvercrona, Christina's agent in the Hague, dating to c.1660, regarding tapestries ordered for the Palazzo Riario; a letter also dating to c.1660 by the cardinal to Girolamo Rota, her agent in Venice placing an order for damask fabrics; and a letter of 1664 Rota addressed to Azzolino regarding some mirrors. On Christina's tapestries, see Carl Nordenfalk, "Queen Christina's Roman Collection of Tapestries," in Platen, 266-95.

37. "Nel palazzo che tiene in affitto la regina di Svezia nella Lungara vi si lavora di continuo e si riducono in delizie gli orti che vi erano, per il vicino ritorno di Sua Maestà." Archivio di Stato di Firenze, MP 5249, 321r; Montanari, "Il Cardinale," 193 n. 20.

38. Having revamped her home, Christina again surrounded herself with intellectuals. Her palazzo became a meeting place for artists, literati, scientists and musicians, and from these gatherings several academies evolved, including the Accademia Reale Christina established in 1674. Among its members were the naturalist Giovanni Alfonso Borelli; the astrologue Giovanni Domenico Cassini; and the poets Alessandro Guidi, Vincenzo da Filicaia and Benedetto Menzini. Cardinal Giovanni Francesco Albani, later Pope Clement XI, was also a member. The proceedings of the Accademia Reale are in the Vatican Library (Inv. No. Cod. Ottobon. 1744), as is a register with signatures of its twenty-seven members. Both can be read in their entirety in Michele Maylender, *Storia delle Accademie d'Italia*, vol. 4 (Bologna: L. Cappelli, 1929), 394-417. This academy then became the Accademia degli Arcadi after Christina's death and held its first meetings at the Palazzo Riario in her honor. It still exists today. Christina also acted as protector of the Accademia dei Misti in Orvieto and the Accademia degli Stravaganti in Rome. In 1677, Giovanni Giustino Campini founded the Accademia dell' Esperienza under Christina's patronage, the purpose of which was to discuss problems of physics and mathematics. Campini was professor of astronomy in Bologna in 1650 and made a series of important discoveries on the rotation of the planets and their satellites, recording them in a treatise now at the Vatican Library (Inv. No. Vat. Lat. 11757). He also devised a new telescope and advised Christina on the observatory she set up in her home in 1663. Neumann, 263; Nordenfalk, ed., 376-78. See also Girolamo Graziani, *Historia della Regina di Svetia* (Modena: B. Soliani, 1656).

LILIAN H. ZIRPOLO ■ EMBELLISHING THE QUEEN'S RESIDENCE

THE QUEEN AND THE SCULPTOR

Christina met Bernini on the day of her official entry into Rome through the Porta del Popolo, which earlier, under Alexander VII's patronage, the artist had refurbished for the occasion. He had also designed the carriage the queen rode in as she passed through this ceremonial gate.[39] After the procession, Count Raimondo Montecuccoli, diplomat in the Austrian Hapsburg's service, introduced Christina to Bernini. Bernini said to her in a modest tone, "If there is anything bad it is mine," referring to the carriage, to which she responded: "Then there is nothing of yours." [40]

Christina's first visit to Bernini's studio did not take place until 1662, the year she returned from Hamburg. The fact that she had been abroad for most of the late 1650s and early 1660s had provided little opportunity for earlier encounters with the sculptor. On the occasion of the queen's visit, Bernini was working on the statue of *Constantine the Great*, intended to be placed at the foot of the Scala Reggia in the Vatican. He received Christina in his crude work clothes as he believed it to be the most worthy attire for a virtuoso of his station to wear in the presence of the queen. She understood the implication and reverently fingered his smock to indicate her appreciation for his art.[41] The two eventually developed a close friendship, based on the respect and admiration they felt for each other, as well as their mutual interest in mystical philosophy.[42]

A letter Christina penned on 11 April 1675 to the Venetian procurator, Angelo Morosini, conveys clearly that she held Bernini in high esteem. In it she noted that:

39. The carriage was made of silver with elaborate detailing that included the Vasa coat-of-arms, belonging to Christina's family, and other heraldic motifs. It was lined with sky-blue velvet trimmed with silver braiding to match the exterior. Bernini designed the chair Christina sat in as she dined with Pope Alexander VII as well. Georgina Masson, *Queen Christina* (New York: Farrar, Straus & Giroux, 1969), 250; idem, "Papal Gifts and Roman Entertainment in Honour of Queen Christina's Arrival," in Platen, 245; Rudolf Wittkower, *Bernini: The Sculptor of the Roman Baroque* (London: Phaidon, 1997), 269; Domenico Bernini, *Vita Del Cavalier Gio. Lorenzo Bernino* (Rome: Rocco Bernabò, 1713), 103; Nordenfalk, ed., 313 cat. no. 718. See also M. Fagiolo dell' Arco, *L'Effimero Barocco* (Rome: Bulzoni, 1977), 164–68; Charles Scribner, *Bernini* (New York: Harry N. Abrams, 1991), 29.

40. Masson, *Queen Christina*, 250. For sources on Christina's entry through the Porta del Popolo and her first meeting with Bernini, see Gualdo Priorato; Paravicino; Magnuson, 147–51. Count Montecuccoli (1609–80) was also a condottiere in the service of the Austrian Hapsburgs. He is best known for his defeat of the Turks in 1664 at Gotthard. On Montecuccoli, see John A. Mears, "Count Raimondo Montecuccoli: Servant of a Dynasty," *The Historian* 32.3 (1970): 392–409, with further bibliography.

41. Bernini, 104; Filippo Baldinucci, *Vita del Cavaliere Gio. Lorenzo Bernino: Scultore, Architetto, e Pittore* (Florence: Vincenzio Vangelisti, 1682), 69. See also Tod Marder, *Bernini's Scala Regia at the Vatican Palace* (Cambridge and New York: Cambridge University Press, 1997), 202; Robert T. Petersson, *Bernini and the Excesses of Art* (New York: Fordham University Press, 2002), 28; Scribner, 29.

42. Nordenfalk, ed., 313, cat. no. 718.

> I have such a high opinion of the said Bernini that I gladly take every opportunity to do him a good turn, for he has proved himself the greatest and most outstanding man in his craft who ever lived.[43]

Christina lived by those words. In 1665 she praised Bernini's design of the Louvre East Façade that Louis XIV had sought. She did this in a letter she addressed to the French monarch where she referred to the master's design as one of the most beautiful projects she had ever seen.[44] In 1670, when Luigi Bernini, Gian Lorenzo's brother, was accused of sodomizing a young boy behind the statue of *Constantine the Great*, Christina intervened on his behalf.[45] Then, sometime in the early 1670s, Christina tried to persuade Nicodemus Tessin the Younger to obtain for Bernini the Karolinska Chapel commission in Riddarholmskyrkan, Stockholm — the funerary chapel of her successor, Karl Gustav, who had died unexpectedly in 1660 of complications from pneumonia.[46] Further, when Bernini died in 1680, Christina commissioned Filippo Baldinucci to write a biography of the artist. Baldinucci, who relied heavily on the account of Domenico Bernini, Gian Lorenzo's son, published the biography in 1682, dedicating it to his patron, Christina.[47] Likewise, Bernini spoke highly of Christina to others. While in Paris, he told Paul Fréart de Chantelou, his escort, that he only knew two women who possessed great understanding of art: Madame de Lionne and the queen of

43. English trans. in Stolpe, 272; Magnuson, 345. Morosini was ambassador to Poland in 1685. See Angelo Morosini, *Relazione del Nob. Angelo Morosini: Cavalier Procurator, Ambasciatore Straodinario in Pologna* (Venice: Fratelli Visentini, 1885).
44. The letter Christina wrote to Louis XIV is in Stockholm, Riksarkivet, Azzolinosaml. 10 IV a 2. See Nordenfalk, ed., 315, cat. no. 725.
45. Luigi at the time was overseeing construction of the Scala Regia his brother had designed. The boy he attacked suffered sixteen broken bones, and Luigi was forced to flee to Naples to avoid prosecution. His possessions were seized, and he was imposed the fines of 2,000 scudi to be paid to the victim's father, and 24,000 scudi to the public treasury. These fines were eventually reduced, among other reasons, due to Christina's influence, and in 1675 Luigi was allowed to return to Rome and reclaim his possessions. Christina reportedly said: "Since sodomy today is no longer a Florentine delicacy but well nigh universal, and especially a dish of princes, so the sodomites particularly in Rome have protectors and defenders of high standing, it being a delicacy enjoyed in Rome by great and small." English trans. in James Fenton, *Leonardo's Nephew: Essays on Art and Artists* (Chicago: University of Chicago Press, 2000), 89. To reduce his brother's sentence, Bernini agreed to execute the statue of the *Blessed Ludovica Albertoni* for the Altieri Chapel in the church of S. Francesco a Ripa, which belonged to Clement X's family, free of charge. See Marder, 209 n. 173; Shelley Karen Perlove, *Bernini and the Idealization of Death: The Blessed Ludovica Albertoni and the Altieri Chapel* (University Park: Pennsylvania State University Press, 1990), 13.
46. Nordenfalk, ed., 313 cat. no. 718. Tessin the Elder obtained the commission and began work on the chapel in c.1675.
47. On the most recent debates on the priority of Bernini's biographies by Baldinucci and Domenico, see Maarten Delbeke, Evonne Levy, and Steven F. Ostrow, eds., *Bernini's Biographies: Critical Essays* (University Park: Pennsylvania State University Press, 2008).

Sweden. He added that the queen had as much knowledge of the mysteries of art as those who create it.[48]

Several works by Bernini are known to have been part of Christina's collection: a portrait bust of the queen; a head of a child crowned with a laurel wreath representing Lucilla, Marcus Aurelius' daughter, that the sculptor supposedly rendered at the age of eight;[49] a marble bust of Christ, the last work he is believed to have rendered (Fig. 5);[50] an elaborate mirror depicting *Truth Revealed by Time*;[51] and two paintings.[52] Aside from the *Salvator Mundi*, none

48. Paul Fréart de Chantelou, *Journal du voyage du Cav. Bernini en France*, ed. L. Lalanne (Paris: Gazette des Beaux-Arts, 1885), 118–19. Madame de Lionne was the wife of Hugues de Lionne, Louis XIV's *ministre d'état*.

49. Christina's collection of antiquities was purchased by Prince Livio Odescalchi from her heirs. An inventory in the Archivio Odescalchi, Rome, VB 1, fasc. 18, 1713–14, fol. 448v lists this bust as: "Testa rilevata sopra Zoccolo di Marmo bianco figurante Lucilla coronate di Lauro, e presso al Naturale opera del famoso Cav.re Bernini." This is a facsimile of II M 2, fols. 435r–448v dated in the Odescalchi archives to 1696. See Walker, "Sculpture Gallery," 201.

50. Bernini wanted to give the bust to Christina as a gift in 1680, the year of his death, but she supposedly refused it for not having a gift of equal value to give to him. Bernini then bequeathed the sculpture to the queen in his will. Bernini, 167; Filippo Baldinucci, *The Life of Bernini*, trans. Catherine Enggass (University Park and London: Pennsylvania State University Press, 1966), 66. Christina in turn bequeathed the bust to Pope Innocent XI, who passed it along to his nephew, Prince Livio Odescalchi: "Item lasciamo al Papa regnante in segno della veneratione, e della stima che noi habbiamo, come Vicario di Giesu Christo in terra, il Salvatore fatto dal Bernini." In Johann Archenholtz, *Memoires concernant Christine reine de Suede pour servir d'eclaircissement a l'histoire de son regne et principalement de sa vie privée, et aux evenemens de l'histoire de son temps civile et litéraire*... vol. 2 (Amsterdam and Leipzig: Pierre Mortier, 1751), 316. Until recently, this work was believed to be the *Salvator Mundi* in the Chrysler Museum in Virginia. The bust was listed in the Odescalchi inventory of 1713, and then it disappeared. In 1972, Irving Lavin, "Bernini's Death," *Art Bulletin* 54 (1972): 159–86, proposed the Chrysler bust to be the *Salvator Mundi* Bernini rendered for Christina. See also Wittkower, *Bernini*, cat. no. 79; Osvald Sirén, *Nicodemus Tessin d.y:s studieresor I Danmark, Tyskland, Holland, Frankrike, och Italien* (Stockholm: P.A. Norstedt, 1914), 184; Marie-Louise Rodén, "The Burial of Queen Christina of Sweden in St. Peter's Church," *Scandinavian Journal of History* 12 (1987): 66; Heinrich Brauer and Rudolf Wittkower, *Die Zeichnungen des Gianlorenzo Bernini* (Berlin: H. Keller, 1931), 178–79; Per Bjurström, "Queen Christina and Contemporary Art," in *Docto Peregrino: Roman Studies in Honour of Torgil Magnuson*, ed. Thomas Hall, Börje Magnusson and Carl Nylander (Rome: Istituto Svedese di studi classici a Roma, 1992), 21 n. 11. More recently, however, a *Salvator Mundi* in the Basilica of S. Sebastiano Fuori le Mura in Rome, previously attributed to Pietro Papaleo, an eighteenth-century sculptor from Palermo, was reattributed as Bernini's lost bust. See Irving Lavin, "La mort de Bernin: Vision de rédemption," in *Baroque vision jésuite: Du Tintoret à Rubens*, ed. Alain Tapié (Paris: Somogy; Caen: Musée des Beaux-Arts de Caen, 2003), 105–9, where he revises his previous assertion and indicates that the original bust by Bernini is the S. Sebastiano *Salvator Mundi*. See also Francesco Petrucci, "Il ritrovato busto del Salvatore di Gian Lorenzo Bernini," *Bollettino d'Arte* 88 (April–June 2003): 53–66. A third version of the bust is in the cathedral of Sées, in Orne, Normandy, which Lavin declared in his 1972 study to be a copy of the Chrysler bust.

51. On Bernini's mirror, see Lilian H. Zirpolo, "Christina of Sweden's Patronage of Bernini: The Mirror of Truth Revealed by Time," *Woman's Art Journal* 26.1 (Spring–Summer 2005): 38–43, with further bibliography.

52. Sirén, 182; Brummer, "Two Works," 125. The paintings by Bernini represented the likenesses of

of these works have been traced. Additionally, as Chantelou reported, Bernini presented one drawing a year to the queen as a gift.[53] Bernini also restored some antique works in Christina's collection. This issue will be discussed later. First, an examination on how she acquired the said collection is in order.

BUILDING A COLLECTION OF ANCIENT ART

Following the account of Pierre Chanut, French ambassador to Sweden, in his memoirs, Johann Wilhelm Archenholtz indicated in the mid-eighteenth century that Christina had brought to Rome a number of the antique pieces from the Swedish royal collection.[54] Little is known of these works, and even less of which ones were shipped to the papal city, if any. A 1652 inventory of the Swedish royal holdings enumerates 168 marble statues, yet aside from the remark that forty-eight of these objects were laying one atop the other, not much else is noted.[55]

his personal confessor and a nude male youth, respectively. Bjurström, 21 n. 8; Danesi Squarzina, 79 Appendix, It. 186–87; 84 It. 45; 86 It. 38.
53. Bjurström, 21 n. 8; Nordenfalk, ed., 313, cat. no. 718. Christina's collection of drawings included renderings by Michelangelo, Raphael, Claude Lorrain, Pietro da Cortona, Guercino, Pierfrancesco Mola, Salvator Rosa, Bernini and many others. These are now in the Teyler Museum and at the Museum der Bildenden Künste in Leipzig. On Christina's drawings and the fate of all the objects in her collection, see Carel van Tuyll van Serooskerken, "Master Drawings at the Teyler Museum," *Drawing* 10.6 (1989): 121–25; Teyler Museum, *Highlights from the Teyler Museum* (Haarlem: The Museum, 1996); Michael Mahoney, "Salvator Rosa Provenance Studies: Prince Livio Odescalchi and Queen Christina," *Master Drawings* 3 (1965): 383–89; James Byam Shaw, "I grandi disegni italiani del Teylers Museum di Haarlem," book review in *Burlington Magazine* 128 (1986): 513–14; Marcel Roethlisberger, "The Drawing Collection of Prince Livio Odescalchi," *Master Drawings* 24 (1986): 5–30. See also Carlo Pietrangeli, *Le collezioni private romane*, 137.
54. Archenholtz, 325; Ferdinand Boyer, "Les Antiques de Christine de Suède a Rome," *Revue Archeologique* 35 (1932): 255. Archenholtz was an author, publisher and one of the foremost journalists of his era. See Friedrich Ruof, *Johann Wilhelm von Archenholtz: Ein deutscher Schriftsteller zur Zeit der französischen Revolution und Napoleons (1741–1812)* (Vaduz: Kraus, 1965); Friedrich Ruof, "Johann Wilhelm von Archenholtz (1741–1812)," in *Deutsche Publizisten des 15. bis 20. Jahrhunderts*, ed. Heinz-Dietrich Fischer (Munich-Pullach and Berlin: Verl. Dokumentation, 1971), 129–39. Chanut was French ambassador to the Swedish court. He was a good friend of Descartes and acted as the intermediary in negotiations for the philosopher's employment at Christina's court. On their relationship see Jean-François de Raymond, *Pierre Chanut, ami de Descartes: Un diplomate philosophe* (Paris: Beauchesne, 1999). His memoirs are in Pierre Linage de Vauciennes, *Memoires de ce qui s'est passé en Suede, et aux provinces voisines, depuis l'année 1645 jusques en l'année 1655; ensemble le demêle de la Suede avec la Pologne, tirez des depesches de Monsieur Chanut, ambassadeur pour le roy en Suede* (Cologne: Pierre du Marteau, 1677).
55. Karl Erik Steneberg, "Le Blon, Quellinus, Millich and the Swedish Court 'Parnasus,'" in Platen, 338–39. The 1652 inventory is in the Stockhom Kungliga Biblioteket, Inv. No. S4, *Inventarium oppâ alle dhe rariteter som finnas uthi H:KMttz… konstkammar… Anno 1652* and lists altogether approximately 40,000 items, including marble sculptures, paintings, medals, ivories, ambers, porcelains, time pieces, mathematical instruments and other such items. Unfortunately, the descriptions are brief and imprecise.

Extant correspondence has yielded some useful information regarding Christina's efforts to acquire antique pieces for her collection while still occupying the Swedish throne. These documents reveal that the engraver and art dealer Michel Le Blon, Joachim von Sandrart's cousin, acted as Christina's art agent.[56] In fact, the 1652 inventory lists approximately one hundred items, mainly antiques, as having been procured by "Sieur Blom."[57] The Dutch diplomat and financier Pieter Spiering Silfvercrona and the royal chamberlain and connoisseur Mathias Palbitzki also procured artworks for Christina. In the 1652 inventory, Silfvercrona is listed as the one to have delivered the "48 large and small marble images lying one on top of the other."[58]

There is also a French translation of the inventory, titled *Inventaire des raretz qui sont dans le cabinet des antiquitez de la Serenissime Reine de Suède fait l'an 1652*, also in the Kungliga Biblioteket, Inv. No. A 4. This translation was probably made for Raphael Trichet DuFresne who did not speak Swedish and who was appointed caretaker of the royal Swedish art collection in 1652. He kept the inventory up to date until 1653 as more pieces were acquired. See Nordenfalk, ed., 428, cat. no. 1037; 329, cat. no. 1039. To complicate matters further, a devastating fire swept through the royal palace in 1697 and destroyed many of the pieces. In the Nationalmuseum in Stockholm only about a dozen busts from the royal collection remain, and two statues, *Hercules* and *Ephebos with the Head of Caracalla*, are now set in niches in the garden façade of Drottningholm Palace. There is also a statuette in marble, the *Anacreon*, at the Nationalmuseum in Stockholm, copied from Phidias' original of c.440 BCE. The *Anacreon* was listed as a *Demosthenes* in the 1652 inventory. The *Ephebos* is a Roman torso copied from an original from the fourth century BCE. The head, a portrait of Caracalla as a boy, is of a considerably later date. The *Hercules* is a copy of Lyssipus' original. The figure's head, torso and arms are antique, and the lower part of the body is a seventeenth-century addition. Among the busts are the *Head of a God* (Stockholm, Nationalmuseum; with a modern inscription identifying the figure as Plato) and a *Portrait of a Roman* (also Stockholm, Nationalmuseum), which some claim to have been owned by Rembrandt. Nordenfalk, ed., 573–79.

56. In September 1649, Le Blon wrote to the queen from the Netherlands indicating that he had purchased for her over sixty antique marble and bronze portraits and forty gold medals that had been discovered by a peasant in Flanders. He also obtained some rare ivories from Peter Paul Rubens's collection. In January 1650, he again wrote informing the queen that he had acquired an additional twenty-five marble pieces. Le Blon was of French (Valenciennes) origin, born in Frankfurt-am-Main, and a resident of Amsterdam where he died in 1656. He was appointed agent of the Swedish royal intelligence service in 1632 and masterminded Sweden's intelligence operations in Brussels, Paris and London until c.1649–50. See Platen, 339; Görel Cavalli-Björkman, Karin Sidén and Börje Magnusson, "Dutch and Flemish Art in Sweden: An Overview," *CODART Courant* 10 (2005): 20; Steneberg, 333, 338–39, 363 n. 41. See also H. de la Fontaine Verwey, "Michel le Blon, graveur, kunsthandelaar, diplomat," in *Uit de wereld van het boek*, vol. 2 (Amsterdam: Nico Israel, 1976), 103–28; Badeloch Noldus, "Loyalty and Betrayal: Artist-Agents Michel Le Blon and Pieter Isaacz, and Chancellor Axel Oxtenstierna," in *Your Humble Servant: Agents in Early Modern Europe*, ed. Marike Keblusek, et. al. (Hilversum: Verloren, 2006), 51–64.

57. Le Blon was also responsible for recruiting artists to work in Christina's court. He, in fact, is believed to have persuaded the Dutch painter David Beck, who became one of Christina's portraitists, to move to Stockholm. Nordenfalk, ed., 425, cat. no. 1025–26.

58. Silfvercrona was appointed Swedish treasury councilor and ennobled in 1636. Aside from procuring small marble sculptures for Christina, he supplied drawings by Raphael, Michelangelo and other important Italian masters, as well as ten genre paintings by Gerrit Dou, including *The Lacemaker*

A SCARLET RENAISSANCE ■

Christina's efforts to procure antiquities once she moved to Rome are considerably clearer. In 1932 Ferdinand Boyer published portions of an undated inventory in the National Archives in Paris that lists the ancient works in Christina's possession while living in Rome.[59] This document must date to 1689, the year Christina died, and must be one of the copies of her death inventory then being circulated in the courts of Europe, including France, England, Brandenburg and Modena. Coupled with contemporary accounts of Christina's activities in Rome, it has aided our understanding of how the queen amassed her impressive ancient art collection, of which over fifty pieces were large-scale and all of the highest quality.

Early accounts inform us that Christina financed excavations that yielded several major discoveries, including the Panisperna Venus unearthed at the Palace of Decius near the church of S. Lorenzo in Panisperna in 1684.[60] Other works she purchased from the Mattei, Del Drago, Clementini, Savelli and other noble families. Among these was an imposing and much admired Bacchic altar (Fig. 6) she acquired in 1662 from Francesco Chelli for 160 scudi.[61]

(destroyed by fire at Rotterdam, Museum Boymans in 1864) and *The Violinist* (London, Bridgewater Gallery). Upon her abdication, Christina returned the drawings and paintings to Silfvercrona as payment for his services. See Nordenfalk, ed., 426, cat. no. 1027; and Noldus, esp. 54–58. Palbitzki was sent by Christina in 1649 to Rome on diplomatic mission and also to purchase art. He was unable to obtain permission to ship the pieces he acquired from the papal city to Sweden. He was successful, however, in convincing the medalist Jean Parise, who was then working in Rome, to move to Stockholm and enter in the queen's service. Palbitzki was from Pomerania and was a scholar of classics and aesthetics, as well as an amateur draughtsman. In 1645–48 he was in Sicily, Egypt and Greece, where he rendered sketches of Olympia and other sites. See Steneberg, 339; Cavalli-Björkman, Sidén and Magnusson, 20; and Nordenfalk, ed., 426–27, cat. no. 1030; 426, cat. no. 1031–32.

59. Boyer, 259–67. The original document is in Paris, Archives Nationales, No. 02 1073.

60. This is recorded by Pietro Santi Bartoli, at one time Christina's librarian and antiquarian, in his *Memorie*. The excavations took place in the Via Graziosa, named after Pietro Graziosi, a local landowner. See Rodolfo Lanciani, *The Ruins and Excavations of Ancient Rome* (Boston and New York: Houghton, Mifflin, 1897), 393. Later, in 1686, Christina also financed excavations in the Baths of Diocletian and near S. Vitale in today's Via Nazionale, though these archaeological efforts did not yield any major discoveries. On Christina's excavations, see Boyer, 254–67; Robert Ricard, *Marbres antiques de Musèe du Prado à Madrid*, vol. 7 (Bordeaux: Bibliothèque de L'Ecole des Hautes Études Hispaniques, 1923); Antonio Blanco Freijeiro, *Catálogo de la Escultura: Museo del Prado* (Madrid: Museo del Prado, 1957); Xavier de Salas, "Compra para España de la collección de antiguedades de Cristina de Suecia," *Archivio Español de Arte* 14 (1940–41): 242–46. On the *Panisperna Venus*, see Miguel Ángel Elvira Barba and Stephan Schröder, eds., *Guía Escultura clásica* (Madrid: Museo del Prado, 1999), 28–29. For excavations in seventeenth-century Rome in general, see Ingo Herklotz, "Excavations, Collectors and Scholars in Seventeenth-Century Rome," in *Archives and Excavations: Essays on the History of Archeological Excavations in Rome and Southern Italy from the Renaissance to the Nineteenth Century*, ed. Ilaria Bignamini (London: British School at Rome, 2004), 55–88. Unless otherwise noted, the antiques in Christina's collection mentioned in this study are in the Prado Museum in Madrid. The reason for this is that King Philip V of Spain purchased the queen's collection in 1724 from the Odescalchi, who, in turn, had obtained it from Christina's heirs in 1692.

61. Borsellino, "Cristina di Svezia," 7–9. A number of copies of the Bacchic altar were made, attesting to its fame. The French doctor and antiquarian Jacques Spon included a seventeenth-

From the heirs of Carlo Camillo II Massimo, Christina purchased the famed Ludovisi Dioscuri (Fig. 7) in 1678 for 1,000 scudi.[62] Carlo Maratta, who had discovered that the marqués del Carpio y Heliche, Spanish ambassador to the court of Innocent XI, wished to purchase the work, sought to preserve it for the city of Rome, in the end obtaining it for Christina.[63]

century copy he saw in the Giustiniani's gardens in his *Miscellanea eruditae antiquitatis*, published in Lyon in 1685. See Antonio García y Bellido, "El puteal bàquico del Museo del Prado," *Archivo Español de Arqueología* 14.83–84 (1951): 117–54; and Barba and Schröder, 188–89. Giovan Pietro Bellori, who was Christina's librarian and antiquarian, included an engraving of the altar by Pietro Santi Bartoli in the *Admiranda romanarum antiquitatum*. On Bellori, see Kenneth Donahue, "The Ingenious Bellori," *Marsyas* 3 (1945): 781–89; Janis Bell and Thomas Wilette, eds., *Art History in the Age of Bellori* (Cambridge and New York: Cambridge University Press, 2002). On Bartoli, see Massimo Pomponi, "Alcune precisazioni sulla vita e la produzione artistica di Pietro Santi Bartoli," *Storia dell' Arte* 75 (1992): 195–225. On the relationship between Bartoli and Bellori, see Evelyna Borea, et al., eds., *L'Idea del Bello: Viaggio per Roma nel seicento con Giovan Pietro Bellori*, vol. 1 (Rome: Edizioni de Luca, 2000), 113–20, 145–51, 625–36.

62. This work is now referred to as the *San Ildefonso Group* after its location until recently in La Granja de San Ildefonso in Segovia. According to Christina's death inventory of 1689, the *Dioscuri* stood on a gilded wood pedestal decorated with a bas relief of white marble that depicted a battle scene, still in La Granja. See Boyer, 265. Boyer's article includes only the portions of the copy of Christina's inventory that list the antiquities in her collection. Giuseppe Campori, *Raccolta di cataloghi ed inventarii inediti di quadri, statue, disegni, bronzi, dorerie, smalti, medaglie, avorii, ecc. dal secolo XV al secolo XIX* (Modena: C. Vincenzi, 1870), 336–76, includes the original death inventory in its entirety, which is now housed in Rome, Archivio di Stato, Inv. No. Not. del Trib. dell' A.C. Prot. 917 Not. L. Belli. A description of the Dioscuri pedestal is also in the Odescalchi inventory of 1713–14. The entry states that the relief included nine figures on horseback and on foot battling. See Archivio Odescalchi, Rome, 1713–14, VB 1, fasc. 18, fol. 17; Walker, "Sculpture Gallery," 208, It. 92. On the pedestals in Christina's collection and later pedestals commissioned by Prince Odescalchi (mainly from Pierre Monnot) for works he purchased from her collection, see Rosario Coppel Areizaga, "Relieves que decoran los pedestales de las esculturas de la Reina Cristina de Suecia," *Archivo Español de Arte* 279 (1997): 310–15. On Camillo Massimo's collection, see Marco Buoncore, et al., *Camillo Massimo, collezionista di antichità: Fonte e materiali* (Rome: L'Erma di Bretschneider, 1996). On the purchase of Christina's collection by the Spanish monarchs, see Salas, 242–46; José María Luzón Nogué, "Isabel de Farnesio y la Galería de Esculturas de San Ildefonso," in *El Real Sitio de San Ildefonso: Retrato y escena del Rey*, ed. D. Rodríguez Ruiz (Madrid: Patrimonio Nacional, 2000), 206–12; Mónica Riaza de los Mozos and Mercedes Simal López, "La statua è un prodigio dell'arte: Isabel de Farnesio y la colección de Cristina de Suecia en La Granja de San Ildefonso," *Reales Sitios* 144 (2000): 56–67.

63. Maratta first intended to purchase the work himself and donate it to the Roman Senate to be placed in the Campidoglio. He confided his plan to Cardinal Azzolino who passed the information onto Christina. The queen, in turn, wrote to Maratta ordering him to complete the purchase on her behalf. This is according to Giovan Pietro Bellori, *The Lives of the Modern Painters, Sculptors, and Architects*, trans. Alice Sedgwick Wohl (Cambridge: Cambridge University Press, 2005), 427. Traditionally, the figures depicted in this sculpture have been identified as the Dioscuri sacrificing to Persephone. Johann Joachim Winckelmann believed that the figures, instead, represented Orestes and Pylades sacrificing to the statue of Artemis. See Nordenfalk, ed., 574, cat. no. 1476; Barba and Schröder, 144–45. The work is recorded in the Ludovisi collection in 1623 and is believed to have been unearthed in 1621–22, when construction took place in the Ludovisi estate. This was the site of the Gardens of Sallust and, therefore, rich in antiquities. See Francis Haskell and Nicholas

A SCARLET RENAISSANCE ■

Christina's *Faun with a Goat* came from the Oratorians in the Chiesa Nuova, where excavations in 1575 to build a new road resulted in the discovery of an ancient Roman sculptor's workshop. Cardinal Azzolino must have acted as the mediator in obtaining this piece for Christina as he had close ties to the Oratorians.[64] At least four of the eight antique torsos in Christina's collection that represented seated muses she obtained from Ranuccio II Farnese, duke of Parma. These fragments had been recovered at Hadrian's Villa in c.1500 and were later moved to the Villa Madama by Pope Clement VII, eventually landing in Farnese's collection.[65]

RESTORING ANTIQUITY

For the most part, conservation efforts in the Baroque era were anything but archaeologically accurate. Instead, ancient fragments were converted into whole figures, many times with new identities. Contemporary sculptors were given the task to render the missing parts should recovered ancient fragments be insufficient to complete the sculpture. Chips and scratches were then filled and surfaces cleaned and polished. The idea was to create a whole statue with the least amount of imperfections and the joining lines where the additions were made were expected to be as imperceptible as possible. So, for instance, Cardinal Scipione Borghese owned a torso of a *Dancing Faun* that Guillaume Berthelot transformed into a *Narcissus Admiring His Own Reflection* (Paris, Louvre). Similarly, Alessandro Algardi altered for the Ludovisi an ancient *Hygiaia* to produce an *Athena* by adding a head and helmet and carving an aegis into her chest (Rome, Palazzo Altemps).[66]

Penny, *Taste and the Antique: The Lure of Classical Sculpture, 1500–1900* (New Haven and London, 1981), 173. An engraving of the work by Nicolas Dorigny is included in Paolo Alessandro Maffei and Domenico de Rossi's *Raccolta di statue antiche e moderne* (Rome: Stamperia alla Pace, 1704).
64. Borsellino, "Cristina di Svezia," 10; Masson, *Queen Christina*, 350–51; Nordenfalk, ed., 574–75, cat. no. 1477; Barba and Schröder, 102–3. On the *Faun with a Goat*, see also Antonio Blanco Freijeiro, "El Fauno del Cabrito," *Archivo Español de Arqueologia* 24.83–84 (1951): 155–59. Its wood pedestal was decorated with an ancient bas relief, now in La Granja, depicting two women, a man, a child and a dog. See Walker, "Sculpture Gallery," 207 n. 76; Coppel Areizaga, 312. By 1664 Cardinal Azzolino was not only managing Christina's home, but also her financial affairs. See Rodén, "Burial of Queen Christina," 67–68.
65. In a letter Paolo Casati wrote to Christina, dated 15 December 1681, he mentions that she was granted *"Quattro tronchi di Statue delle Muse."* See Brummer, "Two Works," 110. On the discovery of the muses, see G. Hübner, "Le groupe de Muses de la Villa d'Hadrien," *Revue Archéologique* 12.4 (1908): 358–63; G. Hübner, "Detailstudien zur Geschichte der Antiken Roms in der Renaissance," *Römische Mitteilungen* 26 (1911): 288–301.
66. Miranda Marvin, *The Language of the Muses: The Dialogue between Roman and Greek Sculpture* (Los Angeles: Getty Publications, 2008), 93–97. For the Borghese *Narcissus*, see Katrine Kalveram, *Die Antikensammlung des Kardinals Scipione Borghese* (Worms am Rhine: Wernersche Verlagsgesellschaft, 1995), 201, pls. 112–13. For the Ludovisi *Athena*, see Antonio da Giuliano, *La collezione Boncompagni Ludovisi: Algardi, Bernini e la fortuna dell'antico* (Rome: Palazzo Ruspoli; Venice: Marsilio, 1992),

It was also common practice among patrons to commission modern works that could be displayed alongside their ancient sculptures as pendants, or to achieve symmetrical arrangements. In fact, Livio Odescalchi, who purchased Christina's collection from her heirs in 1692, commissioned Pierre Monnot to render a *Statue of a Faun* (1716) as a pendant to Christina's ancient *Faun with a Goat* she had obtained from the Oratorians.[67]

As a product of the era, Christina, like other patrons, wished to display her ancient works as complete pieces with identifiable subjects. These could be seen in her palace alongside modern sculptures that complemented their ancient counterparts in one form or another. Here is where Bernini and his associates came into play. As is indicated in the Odescalchi inventory, Bernini himself restored an agate and gilded bronze statue of *Caesar* for the queen by adding to it a mantle.[68] Moreover, the inventory specifies that Bernini designed the pedestal for the Bacchic altar Christina had obtained from Francesco Chelli. The pedestal was an elaborate piece "fatto à Similtudine dell'Antico." It featured carved festoons, four rams' heads and mirrors and was mounted on a swivel so viewers could move it to and fro to take in all the details of both Bernini's work and that of the ancient sculptor.[69] In addition, a cupid that stands next to the

200–203. Another example is a head and torso with emaciated limbs, believed to originally have represented a slave or fisherman, obtained by Cardinal Scipione Borghese, that was converted into the *Seneca Committing Suicide* now in the Louvre, Paris. The work is believed to have been restored by Nicolas Cordier who added arms, a thigh and a belt and placed the figure in an unhollowed reddened porphyry basin to give the impression of water mixed with Seneca's blood. The figure has since been separated from its basin. See Haskell and Penny, 26–27, 303, 305. Estelle Lingo, *François Duquesnoy and the Greek Ideal* (New Haven: Yale University Press, 2007), 11ff, discusses evidence suggesting that some collectors of the second half of the seventeenth century sought to restore their antiquities in a manner consistent with the intentions of the ancient sculptor. Bernini himself was praised for his accurate restoration of an agate figure of Caesar in the inventory of Prince Livio Odescalchi's collection he obtained from Christina's heirs. See n. 68 below.
67. Marvin, 90, 93; Walker, "Sculpture Gallery," 197.
68. "Statua il famoso Cesare con Testo, Braccia, Bastone da Commando, Messa coscia, e mezza gamba di Metallo dorato, Statua alta in tutta palmi dà Otto, e mezzo dal Collo sino sopra il ginocchio di Pietra tutto d'un' pezzo, cosa singolarissima, et unica volgarmente detta di Agata Antica di Scultore Greco, col Manto Reale di Sommo gusto fatto della med.a Pietra, mà dal Bernini con Coturni medesimamente, con cappo al Manto d'Ametista, panneggiato mirabilmente con Zoccolo d'Africano bellissimo, alto palmi Quattro, e due Terzi Scorniciato, et indorato." Archivio Odelcaschi, Rome, VB 1, fasc. 18, 1713–14, fol. 447v; Walker, "Sculpture Gallery," 204. In the Paris 1689 inventory, the piece is listed as: "1 Statua che rappresenta un Cesare con un busto e manto e stivaletti d'alabastro orientale, testa, braccia, gambe, e l'estremità dei pie didi rame dorato con una pietra amatista grossa sopra la spalla destra, d'altezza di palmi sette e mezzo." Boyer, 261. François Maximilien Misson, *Nouveau voyage d'Italie: Avec un mémoire contenant des avis utiles à ceux qui voudront faire le mesme voyage*, vol. 2 (The Hague: Henry van Bulderen, 1702), 142, described the Caesar figure as "Auguste d'albâtre oriental, transparent comme de l'ambre; la tête et les pieds de bronze doré sont des pieces ajoutées, mais le reste est fort bien conserve." In Boyer, 261 n. 1.
69. "…et una cosi Machina viene con Arte del Cav.re Bernini, sostenuta da un'Perno sopra Zoccolo,

muse Euterpe (Fig. 8), one among the group of muses found at Hadrian's Villa in Tivoli, has been attributed to Bernini.[70] The cupid, whose arms are missing, originally held two flutes.[71] His features relate to the children in Bernini's *Faun Teased by Children* (New York, Metropolitan Museum) and the tombs of Urban VIII and Alexander VII (both Rome, St. Peter's Basilica). Also Berniniesque are the contrasts of slick and coarse textures — tight hair curls and wing feathers against smooth skin — and the deliberate manipulation of light reflections on the marble surface through the various depths of carving and polish. The animated pose of the cupid, leaning back as if entranced by the inspiration that the muse of lyric poetry and music provides, is one more element that conjures up Bernini's artistic language.

The rest of the restorations and execution of complementary modern pieces were carried out by Ercole Ferrata, Giulio Cartari, Pietro Maria Balestra and Domenico Guidi — all four associates of Bernini. Ferrata restored Christina's *Faun with a Goat* and also her muses, granting the latter figures their rocky pedestals.[72] He then rendered modern statues of *Night* and *Day*, both currently in La Granja, Segovia.[73] Ferrata had acted as Bernini's assistant in 1647 in the execution of the marble decoration of the pillars of St. Peter's. In 1653, he again assisted the master on the tomb of Cardinal Pimentel at Sta. Maria Sopra Minerva, the *Cathedra Petri* commission in 1658–60, and *Elephant Carrying the Obelisk* in the Piazza di Sta. Maria Sopra Minerva in 1666–67. In addition, Ferrata executed the *Angel with the Cross* for Ponte Sant'Angelo (1667–69) and the figure of *St. Catherine* in the Cappella Chigi commission in Siena (1661–63), again under Bernini's leadership.[74]

The muses Ferrata restored were displayed in Christina's Sala delle Muse on the piano terra. The decoration of this room will be discussed below. Here, however, mention needs to be made of the *Apollo Playing the Lyre* (c.1681, Fig. 9)

che con facilità da'ogni debole Persona si gira intorno, p poter'osservare la finezza di d.o Basso relievo. Il Piedestallo è quadrato, centinato, Scorniciato con Intaglio, e Festoni, con Specchio di Giallo antico con quattro Teste di Montone fatto à Similtudine dell'Antico, dal celebre Scultore Pergamo, alto dà cinque palmi." Archivio Odescalchi, VB 1, fasc. 18, 1713–14, fols. 7–8; Walker, "Sculpture Gallery," 203.

70. Danesi Squarzina, 51–52.

71. This is known because of a rendering by Eutichio Ajello once the work arrived in Madrid. Ajello's image is in the Archivo del Museo Nacional del Prado.

72. Ferrata added the heads, arms and attributes, for example Thalia's comedy mask and Urania's globe. Maria Isabel Rodríguez López, "Iconografía de Apolo y las musas en el arte antiguo y sus pervivencias en el arte occidental," *Cuadernos de Arte e Iconografía* 13.26 (2004): 477–78.

73. Nordenfalk, ed., 487, cat. no. 1205–1206.

74. Ferrata is best known for his execution of the standing *St. Agnes on the Pyre* (c.1660) and the *Stoning of St. Emerenziana* relief (beg. 1660; completed by Leonardo Retti in 1709), both in the church of Sant'Agnese in Piazza Navona. See Rudolf Wittkower, *Art and Architecture in Italy: 1600–1750*, ed. Joseph Connors and Jennifer Montagu, vol. 2 (New Haven: Yale University Press, 1999), 124, 130, 179 n. 18; Alessandro Angelini, *Bernini* (Milan: Jaca Book, 1999), 58–59, 66.

that Christina commissioned from the Anconese sculptor Francesco Maria Nocchieri who, not surprisingly, was another follower of Bernini. The Apollo was also placed in the Sala delle Muse to provide a recreation of Parnassus.[75] Nocchieri's sculpture, which now forms part of a fountain in the gardens of the palace of Aranjuez, Spain, was as well admired as the antique works in Christina's collection. Francesco Aquila executed a print after this figure, to be included in Maffei and de' Rossi's *Raccolta di statue antiche e moderne*, along with the muses. Christina also requested that Nocchieri design her funerary monument destined for the Pantheon. He made a number of *modelli*, but in the end Christina was buried at St. Peter's and her monument was carried out by the architect Carlo Fontana, who also enjoyed Christina's patronage, and the sculptor Jean-Baptiste Theodón.[76]

Between c.1670 and 1680, Cartari restored for Christina an ancient torso to represent the Ovidian water nymph Clytie (Fig. 10). He also executed a marble bust portrait of Christina (La Granja, Patrimonio Nacional), which was displayed in the ninth chamber of the Palazzo Riario's piano terra.[77]

75. That Nocchieri was a Marchigian like Cardinal Azzolino may have ensured his participation in Christina's restoration project. On the incorporation of the *Apollo* into the fountain at Aranjuez, see C.M. Correcher, "Jardines de Aranjuez (II) Jardin del Principe," *Reales Sitios* 73 (1982): 33. A terracotta model of this figure is in the Ashmolean Museum. See Nicholas Penny, *Catalogue of European Sculpture in the Ashmolean Museum*, I: *Italian* (Oxford and New York: Oxford University Press, 1992), cat. no. 68, 88–89. Maffei and de Rossi, 104, wrote that Nocchieri used Christina's likeness to execute Apollo's facial features ("fece nel volto i lineamenti della medesima Regina"). Some have suggested that Apollo's features are those of Cardinal Decio Azzolino. See Rodríguez López, 478. The generalized features of Nocchieri's *Apollo Playing the Lyre*, which emulate those of classical statuary like the Vatican *Apollo Belvedere*, denote that the work was not meant as a portrait. Nocchieri had already executed a bust of the queen in 1656 for the senators of Rome to commemorate her visit to the Capitol (Rome, Sala dei Magistrati, Palazzo dei Conservatori) in that year. On this bust, see Giovanni Pietro Pinaroli, *Trattato delle cose più memorabili di Roma, tanto antiche come moderne*, vol. 1 (Rome: Stamperia di S. Michele a Ripa, 1725), 130.

76. Two sources indicate that Nocchieri was asked by Christina to work on her funerary monument. The first is *L'istoria degli intrighi galanti della regina Cristina di Svezia e della sua corte durante il di lei soggiorno a Roma*, ed. Jeanne Bignami Odier and Giorgio Morelli (Rome: Palombi, 1979), 180; and the second an *avviso* to Cardinal Marescotti dated 4 August 1685. See Tomaso Montanari, "La dispersione delle collezioni di Cristina di Svezia: Gli Azzolino, gli Ottoboni e gli Odescalchi," *Storia dell'Arte* 90 (1997): 251–52, 269 n. 13. On Christina's burial, see Rodén, "Burial of Queen Christina," 63–70.

77. Listed in the Odescalchi inventory as follows: "Busto di Marmo bianco della Regina Cristina di Svezia panneggiato all'Eroica, coronato di lauro di Giulio del Bernini con Zoccolo di Pietra Santa antica, massiccio, e grande sopra Piedestallo consimile al sudetto più grande del Naturale, di maniera bella, e vaga, adulate però la Regina dallo Scultore." Archivio Odelcaschi, Rome, VB 1, fasc. 18, 1713–14, fol. 436v; Walker, "Sculpture Gallery," 206 n. 65. The words "cosimile al sudetto" refer to a now-lost portrait bust of Livio Odescalchi by Pierre Monnot. Both works were displayed in the Odescalchi household on elaborate matching pedestals. Walker, "Sculpture Gallery," 197. On this bust, see Brummer, 124–27. On Cartari, see also Jacopo Curzietti, "Con disegno del Cavalier Bernino: Giulio Cartari e la decorazione della cappella Poli in S. Crisogono a Roma,"*Storia dell'arte*

Cartari was Bernini's favored pupil and he accompanied the master to Paris in 1665.[78] There, Cartari worked on a *bozzetto* for Bernini's *Bust of Louis XIV*. He entered Bernini's studio at the age of eighteen and assisted him in the rendering of the tomb of Alexander VII at St. Peter's (1674–75), the Cappella Fonseca commission at S. Lorenzo in Lucina (beg. 1660), and the *Angel with the Superscription* at Ponte Sant'Angelo (1667–69).[79]

Balestra restored Christina's Bacchic altar for which Bernini had provided the elaborate base. In 1686, Christina appointed him director of the Accademia di Scultura held at the Palazzo Riario.[80] She referred to Balestra as *il Berninetto* because his style was closely related to that of his master.[81] In fact, Balestra's *Boreas Abducted by Oreithyia* in the Großer Garten in Dresden, rendered in 1722 for Prince Elector John George III of Saxony and installed in 1728, borrows heavily from Bernini's *Pluto and Proserpina*.[82] Berniniesque features in the *Boreas* include the *serpentinata* composition, the figures' complex poses, their melodramatic gesturing and the close attention to anatomical details. Balestra made several modern sculptures for Christina as well, including an equestrian portrait of the queen trampling Envy. These works, unfortunately, have not been identified.[83]

Guidi trained first with his uncle Giuliano Finelli (who entered the Bernini workshop in 1622) in Naples, later moved to Rome (1647) and entered the studio of Alessandro Algardi, Bernini's competitor. When Algardi died in 1654, Guidi established his own studio, achieving great success. His *Lamentation over the Body of Christ* (1667–76) is in the Cappella del Palazzo del Monte di Pietà, Rome; his *Andromeda and the Sea Monster* (1694; New York, Metropolitan Museum) was intended for Francesco II d'Este, duke of Modena; and his *La Renommée* (fin. 1686;

20.120 (2008): 41–58; F. Negri Arnoldi, "Cartari, Giulio," in DBI: http://www.treccani.it/enciclopedia/giulio-cartari_(Dizionario-Biografico)/ (retrieved 15 November 2011).
78. Wittkower, *Art and Architecture in Italy*, 53; Petersson, 111.
79. Giovanna Pimpinella, *La strada verso il Paradiso: Storia di Ponte Sant'Angelo; The Road to Paradise: The History of Ponte Sant'Angelo* (Rome: Menaxa, 2009), 41, 84; Jennifer Montagu, *Roman Baroque Sculpture: The Industry of Art* (New Haven: Yale University Press, 1992), 113, 144; Wittkower, *Art and Architecture in Italy*, 130; Daniele Pinton, *Bernini: I percorsi dell'arte* (Rome: ATS Italia Editrice, 2009), 56. The Farsetti collection of terracottas by Bernini, now in the Hermitage in St. Petersburg, is believed to have come from Cartari's collection. See Fenton, 100.
80. Matteo Mancini, "La corte de Cristina de Suecia en Roma," in *Cortes del Barroco: De Bernini y Velázquez a Luca Giordano*, ed. Fernando Checa Cremades (Rome and Madrid: SEACEX, 2003), 244; Borsellino, "Cristina di Svezia," 13.
81. Roberta Perazzone, "Pietro Maria Balestra, uno scultore senese alla corte di Cristina di Svezia," in *Cristina di Svezia e Roma: Atti del simposio tenuto all'Istituto Svedese di Studi Classici a Roma, 5–6 ottobre 1995*, ed. Börje Magnusson (Stockholm: Suecoromana, 1999), 100.
82. For Dresden, Balestra also executed *Meleager Killing the Caledonian Boar* and *Venus and Cupid*. Stefano Ticozzi, *Dizionario degli architetti, scultori, pittori, intagliatori in rame ed in pietra, coniatori di medaglie, musaicisti, niellatori, intarsiatori d'ogni età e d'ogni nazione*, vol. 1 (Milan: Gaetano Schiepatti, 1830), 101.
83. Also, it was Balestra who catalogued Christina's sculptures for her 1689 death inventory. Borsellino, "Cristina di Svezia," 13.

Versailles, Neptune Fountain) went to Louis XIV.[84] More importantly for us, in 1667–69 he worked on the *Angel with the Lance* for Ponte Sant'Angelo under Bernini's direction,[85] and his *Vision of St. Joseph* (c.1694; Rome, Cappella Cornaro, Sta. Maria della Vittoria) is based on Bernini's *St. Theresa in Ecstasy* at the same church, down to the bronze rods in the background that extend the light from a hidden source. The inventories do not specify which ancient works in Christina's collection were renovated by Guidi. However, they do mention two putti, *Divine Love* and *Terrestrial Love* fighting for the victor's palm (now lost) that he executed for the queen.[86]

The scenario now becomes crystal clear: as Christina's palace was being renovated, she was occupied with augmenting her collection of antique sculptures. The sculptures obtained through purchases and excavations now needed to be made whole again. Pedestals for their proper display and accompanying modern pieces were also required. Christina called on her trusted friend, the talented Bernini, to carry out the task. To please the queen, Bernini, who by now was of advanced age and was occupied with a number of papal and princely commissions,[87] provided only the mantle for the ancient *Caesar* and the Bacchic altar's pedestal. He then distributed the rest of the work among his pupils and associates, who labored under his watchful eye. There was still more to his involvement, as will be revealed next.

THE ART OF DISPLAYING ART

Christina reserved the Palazzo Riario's piano terra for the display of her ancient statuary. These occupied nine consecutive rooms that were frescoed

84. The duke of Modena died before the work was delivered. Giuseppe Campori, *Memorie biografiche degli scultori, pittori, ec.* (Modena: Tipografia di Carlo Vincenzi, 1873), 134–36. *La Renommée* features a figure of Fame inscribing the deeds of the French king in the book of History that is supported by Chronos, who also carries a medallion that shows the profile bust of the king. Fame tramples on Envy, while at her feet are portrait medallions of Alexander the Great, Caesar and Hadrian — Louis' ancient predecessors. See Rudolf Wittkower, "Domenico Guidi and French Classicism," *Journal of the Warburg and Courtauld Institutes* 2.2 (October 1938): 188–90, esp. 189. On Guidi, see also Lione Pascoli, *Vite de' pittori, scultori et architetti moderni* (Rome: Antonio de' Rossi, 1730), 252–56.

85. Guidi was a close friend of Pietro Santi Bartoli, which no doubt gave him entrée to Christina's circle. See Wittkower, "Domenico Guidi," 188; and Cristiano Giometti, *Domenico Guidi 1625 –1701: Uno scultore barocco di fama europea* (Rome: L'Erma di Bretschneider), 2010.

86. "Statue ò siano Putti di Mano di Dom.co Guidi eccellente, scultore, quali rappresentatno l'Amor Divino, e Mondano, e contrastano p la palma alto palmi quattro, e mezzo, ed'un quarto con Piedestallo indorato alto p.mi quattro, e mezzo si Statura un'poco grande, e di gran' maniera fatti nella sua forza." Archivio Odelcaschi, Rome, VB 1, fasc. 18, 1713–14, fol. 438v. Antonio Ponz, *Viaje de España*, vol. 3 (Madrid: Aguilar, 1988), 285, saw the putti in the eighth room at La Granja in 1777. After that, the figures can no longer be traced. See Walker, "Sculpture Gallery," 209 n. 97; and Campori, 1873, 133: "… due putti che si contrastano una palma, per la regina di Svezia."

87. For example, the tomb of Alexander VII at St. Peter's, the Albertoni Chapel in S. Francesco a Ripa and the Fonseca Chapel at S. Lorenzo in Lucina.

A SCARLET RENAISSANCE ■

by Crescenzio Onofri, the pupil of Gaspard Dughet, with landscapes, referred to in the documents as *"boscareccia."*[88] The *San Ildefonso Group* and *Panisperna Venus* were placed in the eighth chamber.[89] In the seventh chamber was the *Venus Anadiomene*, a nude goddess resting her right knee on a turtle.[90] In the Stanziola del Bagno, the sumptuous bathroom created by closing off the portico that led to the garden cortile, was *Venus Bathing*, a pudica type to which Nicodemus Tessin the Younger, who visited Rome twice and enjoyed Christina's patronage, referred in his travel journal.[91] The Sala dei Svizzeri, the first chamber, housed an *Apollo*, a reclining figure identified in the Paris inventory as a Cleopatra, several fauns and the statue of a youth.[92]

88. Archivio di Stato di Roma, Bellus, a. 1699, vol. 943, c. 885v. See Borsellino, *Palazzo Corsini, Roma*, 20; Borsellino, *Palazzo Corsini alla Lungara*, 35 n. 53; and Nicola Pio, *Le vite di pittori, scultori, ed architetti,* ed. Catherine Enggass and Robert Enggass (Vatican City: Biblioteca Apostolica Vaticana, 1977), 30–31. Onofri (1632–1713) specialized in landscape paintings and was also an engraver. He worked for the Pamphili, Pallavicini, Rospigliosi and Colonna families in Rome. He moved to Florence in 1696 where he remained until his death, working for the Medici grand dukes. On this artist, see Ilaria Toesca, "G.B. Crescenzi, Crescenzio Onofri (e anche Dughet, Claude e G. B. Muti)," *Paragone* 11.125 (May 1960): 51–59.

89. The entry in the inventory for the *San Ildefonso Group* reads: "Nell' altra stanza che è l'ottava contigua — 2 Statue insigni di Castore e Poluce di marmo che stanno uniti sopra ad un zoccolo di marmo simile nude affatto alte palmi sei incirca con una statuetta di Dona nel med.o zoccolo alta palmi due e tre quarti con piedistallo di legno lavorato e indorato e nella facciata davanti un basso rilievo di marmo bianco che rappresenta una battaglia con figurine." The entry for the Panisperna Venus reads: "Nell'altra stanza che è l'ottava contigua — 1 Statua di marmo bianco insigne tutta nuda con un delfino dal canto manco alto compreso il zoccolo palmi otto." Boyer, 263–66.

90. "Nell'altra stanza che è la settima contigua — 1 Statua di Venere in atto di andare al bagno che posa il ginocchio destro sopra d'una tartaruga con panno nella sinistra e vasetto nella destra tutta nuda con suo zoccolletto di marmo bianco, come quale si dice propria del s.r. card.l Azzolini." Boyer, 265.

91. Christina's inventory describes the Venus as follows: "Nella stanziola del Bagnio che è contigua alla sudetta — 1 Statua d'una Donna nuda di marmo bianco in atto di andare al bagnio con panno in mano che si copre dal petto sino alle ginocchia alta palmi sei con un delfino attaccato a d.a statua di marmo simile." The décor of the bathroom also included a bust of a child and a statue of a youth: "1 Busto di Bambino in marmo bianco con suo peduccio bigio alto palmi uno e due terzi./1 Statua di un Giovine di marmo bianco ignudo che si appoggia ad un tronco di marmo simile con il braccio destra, alta pal. quattro e mezzo compreso il suo zoccoletto." Boyer, 266–67. Nicodemus Tessin the Younger's travel journal has proven to be priceless for the information it provides on Christina's artwork and its display. The original *Notebook from a Journey in Italy 1687–1688* is in a private collection in Stockholm (Fil. Dr. Carl David and Mrs. Carna Moselius). Its contents have been published by Sirén. Another visitor to Christina's palace was François Maximilien Misson, who traveled to Rome in 1688 and recorded his travel experiences in his *Nouveau voyage d'Italie*. See J.H. Schröder, "Om drottning Christina och hennes konstsamlingar i Rom," *Svea* 13 (1831): 414.

92. "1 Statua d'Apollo di marmo di palmi di canna dieci e un quarto, compresovi il suo zoccolo./1 Statua che rappresenta Cleopatra che sta a giacere, con il braccio dritto sopra il capo e con la mano manca alla guancia, di marmo, con suo letto, longa compreso il letto palmi dieci e mezzo, con il suo piedestallo che rappresenta una cassa di marmo bianco e bigio, con alcune figurette di

The centerpieces of the piano terra were the fifth and sixth chambers, the Sala delle Muse and Sala di Clytie, respectively, the two connected by a doorway. Though these rooms were dismantled after Christina's death and their architectural details destroyed to make way for Ferdinando Fuga's renovations in 1736 when the Corsini owned the Palazzo Riario, we have the detailed descriptions of Tessin and others that grant a reasonably accurate picture of their original appearance. We also have the plans and elevations of the Sala delle Muse Arcucci provided for his patron's approval (Fig. 11).[93]

The Sala delle Muse is where the eight seated muses in Christina's collection were kept.[94] They were arranged along the four walls to face each other.[95]

basso rilievo e con la sua facciata, che fa ornamento di marmo bianco e bigio con basso rilievo di marmo che rappresenta un Baccanalio./2 Fauni senza braccia, di marmo bianco, alti palmi dieci, compresoci il piedestallo./1 Statua d'un Giovine alta palmi nove e mezzo di marmo." Boyer, 259. The Cleopatra is in fact a recumbent Ariadne, which is how Bacchus found her on the shores of the island of Naxos. The pedestal corresponding to this figure features a bacchanal relief that further identifies her as Bacchus' consort.

93. Arcucci's rendering is part of a volume titled *Disegni di varie idee della Regina di Svezia nel Palazzo Riario alla Longara* that includes twelve pen and wash drawings of Christina's plans to renovate the Palazzo Riario. This volume is housed in the Nationalmuseum in Stockholm, Inv. No. 1045/1960. See Nordenfalk, ed., 320, cat. no. 738. For an iconographic interpretation of these two rooms and their allusions to the queen's persona, see Zirpolo, "Severed Torsos."

94. I have already discussed the implications of the presence of only eight muses in Christina's *Sala delle Muse* and of her casting herself as the ninth muse in Zirpolo, "Severed Torsos."

95. The arrangement of the sculptures to encircle Christina's throne implied that the room was the locus of learned discussion, an idea rooted in the Roman triclinium, where dining and conversation mingled and where the muses presided. The word *"triclinium"* is based on the fact that these rooms had three built-in couches arranged around a table. Each couch was large enough to accommodate three guests who reclined to take their meals and engage in conversation. The total of nine participants invoked the number of the Muses. Remains from antiquity verify that the triclinium was related to the Muses. For example, the recently discovered fresco taken from the House of the Triclinia in Moregine near Pompeii, shows Emperor Nero in the guise of Apollo and accompanied by the Muses. Discovered in 1999, this fresco was exhibited in the Field Museum in Chicago in March 2006. Another example is the floor mosaic in the triclinium of the Villa de Torre de Palma in Portugal, which depicts the same mythological characters. On the Villa de Torre de Palma, see J. Lancha and P. André, *La Villa de Torre de Palma* (Lisbon: Instituto Português de Museus, 2000). In the early modern era, it was erroneously believed that the triclinium was always built utilizing a circular or octagonal plan, so spaces meant for philosophical discourse on the arts and letters were built in emulation of the supposed ancient prototypes. Examples include Serlio's circular salon in his Odeum in Padua, Palladio's Villa Rotonda, and the elliptical salon at the Palazzo Barberini in Rome. Girolamo Teti in his *Aedes Barberianae ad Quirinalem* of 1642 specified that the Barberini salon was "especially arranged, in accord with the Muses, for the use of very wise men of letters." On this subject, see also Ronald C. Rarick, "The French Revolution and the Round Houses of Pierre-Adrien Pâris (1745–1819)," *Aurora, The Journal of the History of Art* 1 (2000): 84–85. The Sala delle Muse in the Palazzo Pio Carpi, Modena and the one at the Vatican built by Michelangelo Simonetti are octagonal. The central plan in Christina's room, with the muses, Apollo and the queen's throne arranged around the walls to create a circle of conversation, suggests the triclinium type of arrangement.

Melpomene, Muse of Tragedy, was missing from the ensemble.[96] Christina used this room as her royal audience hall and, therefore, particular attention was paid to details so as to grant a sumptuous and dramatic setting for the queen to preside over. Sixteen Corinthian columns of yellow Numidian marble carried a gilded cornice around the room and receded and advanced in response to the movements of the columns below. On the cornice itself were ancient busts of Roman emperors, strategically lined above each one of the capitals. The walls, window surrounds and all doors but one were covered with Venetian mirrors embellished with painted flowers. The door that led to the Sala di Clytie was ensconced in alabaster, while the floors were overlaid with green briquettes.[97] Nocchieri's *Apollo Playing the Lyre* stood opposite the queen's throne and canopy. The Capuan painter Francesco Graziani, called Ciccio Napoletano, frescoed the ceiling with an image of *Pegasus*[98] which,

96. A detailed listing of the Muses is in Prince Livio Odescalchi's inventories of sculptures. See Walker, "Sculpture Gallery," 212. The Muses are listed in the Paris inventory only as a group: "Nell' altra stanza che è la Quinta contigua chiamata la stanza delle Muse — 8 Muse di marmo antico a sedere, sei delle quali hanno la testa fatta di nuovo e due con faccia dell'istesso marmo... Le d.e otto muse sono d'altezza di palmi sei incirca per ciascheduna." Boyer, 261–62.

97. Misson wrote that "les seize colonnes antiques de Giallo avec les deux colonnes d'albâtre oriental, hautes de sept pieds: la plus fine agathe ne peut être plus belle." In Boyer, 262. See also Sirén, 182. The Venetian mirrors on the walls, window surrounds and doors might have also been inspired by French precedents. Catherine de' Medici created a *Cabinet des miroirs* after Henry II's death in 1559 in her Paris *appartement* (Hôtel de la Reine), consisting of 119 Venetian mirrors set into the paneling. Anne of Austria (1601–66) had a chamber of mirrors at the Louvre, where her maidservants coiffed her hair, and the chamber of the dauphin included mirrors on the walls and ceiling that featured golden borders and a background of ebony marquetry. See Sabine Melchior-Bonnet, *The Mirror: A History* (New York and London: Routledge, 2002), 26–27; David Thomson, *Renaissance Paris: Architecture and Growth, 1475–1600* (Berkeley and Los Angeles: University of California Press, 1984), 178; and S. Roche, *Miroirs galleries et cabinets* (Paris: Hartmann, 1956), 42.

98. On the *Pegasus* fresco, see Borsellino, *Palazzo Corsini alla Lungara*, 36; Luigi Salerno, *Pittori di paesaggio del seicento a Roma*, 2 vols. (Rome: Ugo Bozzi, 1977–78), 2:654; Montanari, "Il Cardinale," 218. Graziani was active during the second half of the seventeenth century and specialized in battle scenes. So, clearly, Christina hired him for the task because of his ability to render horses (and related mythological creatures) in action convincingly. Graziani arrived in Rome from Naples c. 1670. He may have been a pupil of Jacques Courtois. His *St. John the Baptist Preaching* (c.1683) is in the Cappella Cimini, S. Antonio dei Portoghesi, Rome, commissioned by Caterina Raimondi Cimini for her husband's funerary chapel. He rendered his *Penitent Mary Magdalen* for the church of Sta. Croce della Penitenza, Rome. The Barberini inventories of 1686 list a number of works by Graziani, mainly battles and marine scenes. These unfortunately have not been identified. Works by Graziani are also in the Pallavicini and Pamphili collections. See A. Serafini, "Graziani, Francesco, detto Ciccio Napoletano," DBI: http://www.treccani.it/enciclopedia/graziani-francesco-detto-ciccio-napoletano_(Dizionario-Biografico)/ (retrieved 3 November 2011). See also Filippo Titi, *Studio di pittura, scoltura et architettura nelle chiese di Roma (1674–1763)*, ed. Bruno Contardi and Serena Romano (Florence: CentroDi, 1987), 1:121, 209; 2:57, 386ff.; Luigi Salerno, in *Civiltà del seicento a Napoli*, ed. Nicola Spinosa, vol. 1 (Naples: Electa, 1984), 151, 154, 322; Loredana Lorizzo, "Nuovi documenti su Francesco Graziani detto Ciccio Napoletano e su Paolo Porpora a

along with Onofri's wall landscapes, added further visual interest to the room. This was clearly a reconstruction of the Ovidian story of Apollo and the Muses on Mount Helicon, where Pegasus' kick produced the Hippocrene Fountain, the wellspring of poetic inspiration. The green majolica floor tiles, *boscareccia* painted on the walls and flowers on the Venetian mirrors were meant to invoke the woods, grottos and "grass spangled with countless flowers" that Ovid mentioned in the *Metamorphoses* (V:250-66).[99]

This mingling of painting, sculpture and architecture with varied textures (marble, alabaster, mirrors and briquettes) and colors (white and yellow marble, green tiles, white alabaster, multi-hued flowers and frescos) strongly suggests that Bernini was the one who devised the decorative program in this room. These are the elements we also find, for example, in his Cornaro Chapel at Sta. Maria della Vittoria, Rome, where the stark white marble of the statues stands out from the colorful architectural backdrop. This backdrop is composed mainly of panels set onto the walls and an imposing aedicule above the figures, all executed in marble of every imaginable color and veining pattern. The intensity of pigments and striations enriches the emotive aspect of the main theme: the ecstatic rapture of St. Theresa as her soul unites with God. The upper portion of the walls and semi-dome feature a fresco of a heavenly glory of angels who jubilate over St. Theresa's mystical experience. The Sala delle Muse was a secular version of Bernini's opulent theatrical formulations that were meant to stimulate the senses. One can imagine the awe viewers must have felt when they first entered the Sala delle Muse — an experience not unlike that of viewers today when they first visit the Cornaro Chapel.[100]

Roma con qualche osservazione sulle dinamiche del commercio dei dipinti nel seicento," in *Saggi in memoria di Oreste Ferrari 2007*, ed. Oreste Ferrari (Naples: Electa, 2008), 57-61.

99. In Sweden Christina had already attempted to set up for herself a chamber of the Muses at the royal palace. The details of this commission are not completely clear. In 1650, approximately 2,700 cubic feet of marble were delivered to Sweden from Holland. The 1652 Swedish royal inventory lists terracotta models for the muses by the Flemish sculptor Artus Quellinus; and correspondence between Christina and her art agent Le Blon, while he was in the Netherlands procuring antiquities for the queen, also speak of Quellinus' models. Possibly Quellinus was being considered for the task of sculpting the muses, yet, in 1650, Christina had brought to Stockholm the Danzig sculptor Peter Ringering who, unfortunately, drowned a few months after arrival at court. Giuseppe Peroni, Alessandro Algardi's pupil, arrived two years later, hired by Palbitzski while in Rome. Then, Christina abdicated in 1654, and some of the marble ordered in 1650 was returned to Holland. See Steneberg, 340-45. Steneberg (344) also mentions Nicolas Cordier as having arrived in Sweden in 1650 to work for Christina. This, however, is impossible since Cordier died in 1612. Giovanni Battista Passeri, *Die Künstlerbiograhien von Giovanni Battista Passeri*, ed. Jacob Hess (Leipzig: H. Keller, 1934), 206, 317 wrote in his biography of the artists that, while in Sweden, Peroni executed a portrait of Christina in marble.

100. Such dramatic display of ancient statues in an aristocratic setting has its precedents. Carol Paul, *The Making of a Prince's Museum: Drawings for the Late Eighteenth Century Redecoration of the Villa Borghese* (Los Angeles: The Getty Research Institute), 12, discusses Scipione Borghese's Casino

A SCARLET RENAISSANCE ■

The Sala di Clytie also bears Bernini's mark in its details. The room's appellation was due to the fact that the torso restored by Cartari to represent the water nymph Clytie was here exhibited. In her new guise, the figure reclined on a pedestal and turned upward to affix her eyes on the sun, frescoed by an unknown master on the ceiling.[101] The stalks that emerged from her fingers and toes are details that prompted comparisons with Bernini's *Apollo and Daphne* (Rome, Galleria Borghese), where the nymph is seen transforming into a tree.[102] Clytie was raised from the ground by a wooden socle covered in yellow leather and dotted with stars. The moment depicted was that of her transformation into a sunflower which, as Ovid relates in the *Metamorphoses* (IV:206-73), resulted from her infatuation with the sun.[103] Again, drama, color and textures achieved through the use of various media and materials are the elements that point to Bernini's conception of the room's decorative program.

A QUEEN IN DEBT

Upon Christina's death in 1689, Cardinal Azzolino inherited her entire collection. He died two months later, and the collection passed to Azzolino's

at the Villa Borghese where Giovanni Lanfranco's fresco depicting the *Council of the Gods* (1624-25) was intended to interact with the antiquities exhibited throughout the building. The whole program linked the owner's geneaology to that of the ancient dieties and historic figures that the sculptures represented. Paul, 18, also discusses the Farnese Ceiling by Annibale Carracci (1597-1600) in the Farnese Palace, Rome, where antiquities were displayed. The fresco was intended to provide scenes from the lives of the sculpted dieties placed below, thus bringing them to life for viewers.

101. "Im sexten lag in der mitten auf einem piedestal die Clütia, antique von marmer; oben im dach wahr die Sonne gemahlet, zu fingiren wie sie darin verliebte. Sie lag in action alss wenn sie sich im girasole verwandelte, undt an den enden der finger undt zähen sahe man schon die Stämme, fast wie an der Dafne..." Tessin quoted in Brummer, "Two Works," 106-23. In the Paris inventory, Clytie is identified as Daphne: "Nella sesta stanza — 1 Statua di Daffnè giacente in atto di guardare il sole appoggiata sopra il braccio destro nuda con panneggiatura alle coscie et a una gamba longa palmi cinque con suo scoglio longo palmi quattro e un terzo e largo palmi due e due terzi." Boyer, 262-63.
102. Barba and Schröder, 170.
103. This was a rather uncommon subject in art at the time. Precedents are Poussin's *Triumph of Flora*, where Clytie is one of the many figures who form part of the goddess' entourage. She is in the middleground, partially concealed turning toward the sun while shading her eyes with her raised left arm. Isaac de Benserade's *Metamorphoses d'Ovide* of 1676, a text commissioned by Louis XIV and written in the *rondeaux* style of poetry, includes an engraving to illustrate the story of Clytie. See Brummer, 115. The nymph here stands with arms to her chest as she lovingly gazes at Apollo. The god is seated on the clouds, positioned slightly above the nymph. An ancient example is the Roman sculpture in the British Museum from c.40-50 CE (Inv. No. GR 1805.7-3.79). It presents Clytie in bust form emerging from the center of a sunflower. The figure is believed to be a portrait of Antonia, mother of Claudius, in the guise of Clytie. See A.H. Smith, *A Catalogue of Sculpture in the Department of Greek and Roman Antiquities in the British Museum*, vol. 3 (London: British Museum, 1904), 147-49, cat. no. 1599, pl. 14; B.F. Cook, *The Townley Marbles* (London: The British Museum Press, 1985), 15, fig. 9. Some scholars believe the work to be a modern rendition. See Stephanie Walker, "Clytie - A False Woman?" in *Why Fakes Matter: Essays on Problems of Authenticity*, ed. M. Jones (London: The British Museum Press, 1993), 32-40.

nephew Pompeo. With it came the responsibility of settling Christina's debts. Her banker, Manoel Texeira, her doctor, Romolo Spezioli, and her secretaries and administrators were demanding payments owed for services rendered. Also, the Danish Count Leon Wefelt sought to collect monies his father had loaned to Christina at one time.[104] A further setback for Pompeo was that Ottavio Riario, then owner of the Palazzo Riario, had decided to sue for the supposedly unauthorized renovations Christina made to the palace.[105] To liquidate debts and settle the lawsuit, in 1692 Pompeo sold Christina's collection to Prince Livio Odescalchi. The prince, in turn, set up in his palace a Sala delle Muse that mimicked Christina's to highlight his newly-obtained collection's prestigious pedigree.[106] In 1724, Philip V of Spain and his consort Isabella Farnese purchased Christina's ancient statues from Odescalchi's heirs to be displayed in their newly built palace of La Granja de San Idelfonso. With a few exceptions, the works have since been transferred to the Prado Museum in Madrid.

The sculptures may have been removed from the Palazzo Riario, and Fuga's renovations may have obliterated most of the work carried out during Christina's tenure. Nevertheless, the bits and pieces gleaned from documents and contemporary descriptions have provided enough information for us to envision the opulence of the Palazzo Riario and its contents at the time. The statues, as they now grace the Prado and La Granja, are seen out of the context Bernini envisioned and his associates actualized. Though the documents and descriptions may not attest to Bernini's role as Christina's artistic advisor, or to the involvement of his associates as a well-orchestrated effort, the visual and ancillary historic evidence is there to lead us to such conclusion.

■

104. Enrica Conversazioni, "L'archivio Azzolino conservato dal Comune di Jesi," in Nigrisoli Wränhjelm, 39.
105. Ottavio based his lawsuit on the fact that the 1659 lease stipulated that no structural alterations could be made without the owner's consent. However, as Borsellino, *Palazzo Corsini alla Lungara*, 31, stated, the extensive remodeling carried out during Christina's residence in the palace must have been known to then owner Ferdinando Riario, and he and Christina may have had some sort of verbal agreement.
106. Walker, "Sculpture Gallery," 189, 198–99.

A SCARLET RENAISSANCE ■

Fig. 1 (above). Antonio Tempesta, Pianta di Roma, detail showing Palazzo Riario, 1593.

Fig. 2 (below). Giovanni Battista Falda (attr.), Aerial view of the Palazzo Riario. Photos in the public domain.

Fig. 3. Palazzo Riario, plan, cantina and piano terra, rendered by Tommaso Corsini, based on descriptions dated 1696-97. Jesi, Biblioteca Comunale (after E. Borsellino).

Fig. 4. Palazzo Riario, plan, piano nobile and third story, rendered by Tommaso Corsini based on descriptions dated 1696–97. Jesi, Biblioteca Comunale (after E. Borsellino).

Fig. 5 (above). Gian Lorenzo Bernini, *Salvator Mundi*. Rome, S. Sebastiano Fuori le Mura, c.1679. Photo: public domain.

Fig. 6 (right). Bacchic Altar, c.50–25 BCE. Madrid, Prado Museum. Photo: Prado Museum.

Fig. 7. *Dioscuri* (San Ildefonso Group), 1st century CE. Madrid, Prado Museum. Photo: public domain.

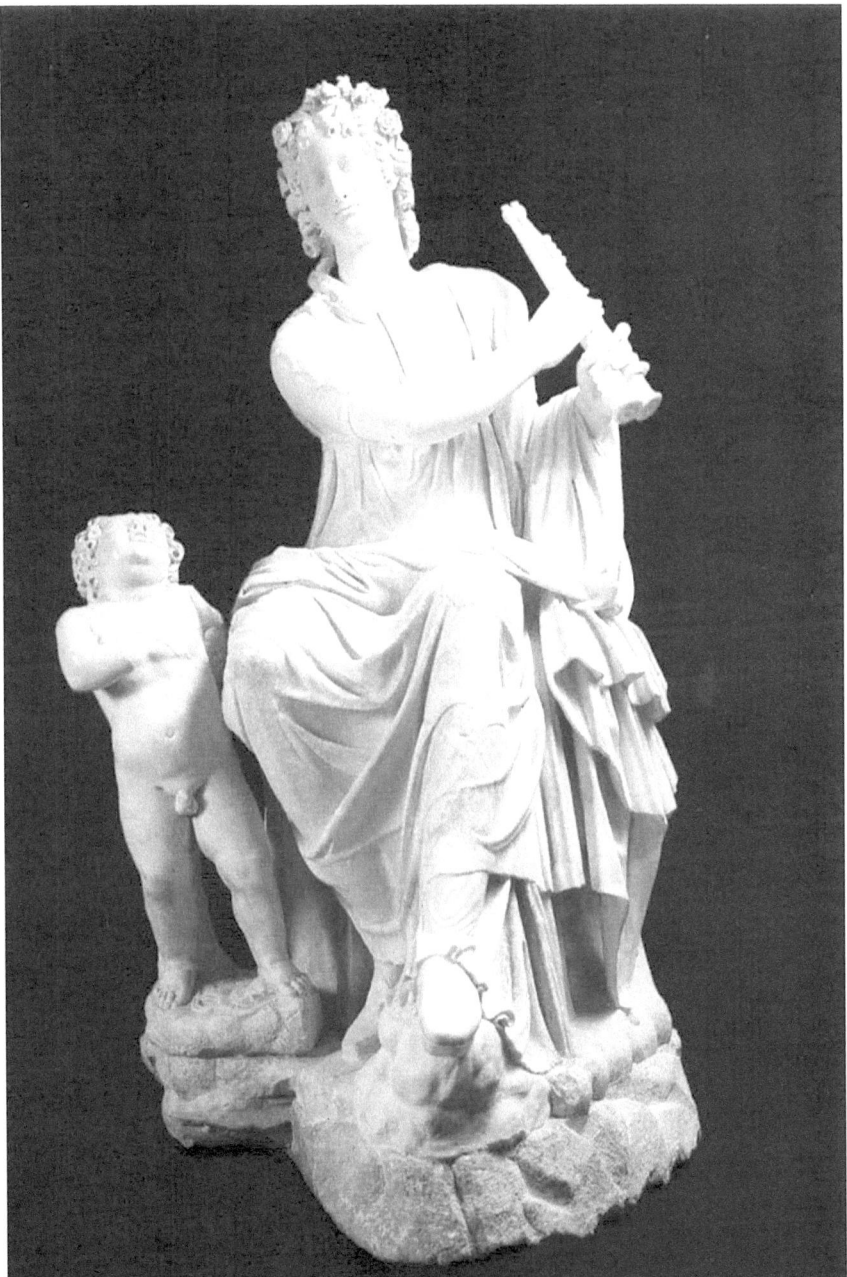

Fig. 8. *Euterpe*, Roman copy of a Greek original, c.130–40 BCE. Madrid, Prado Museum. Photo: Prado Museum.

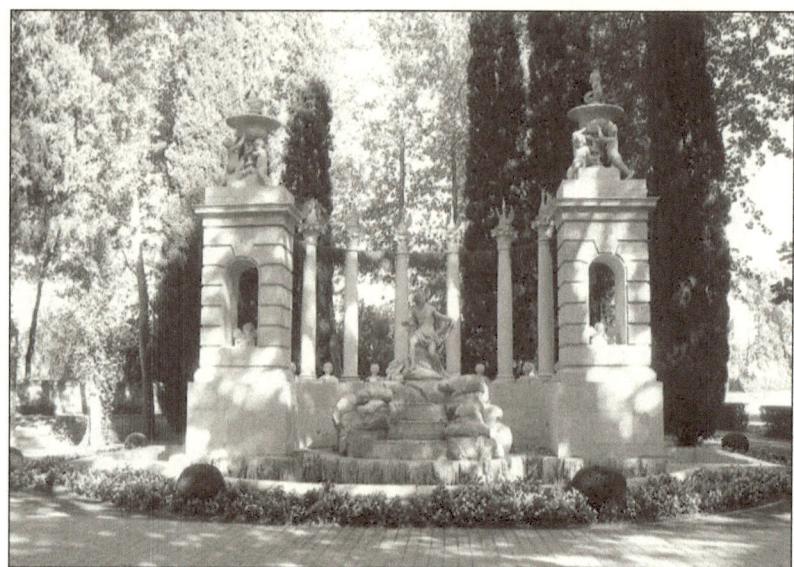

Fig. 9 (above). Francesco Maria Nocchieri, *Apollo*. Fuente Apolo Aranjuez. Photo: public domain.

Fig. 10 (below). *Clytie*, Roman copy of a Greek original, c.100 BCE, modern parts added by Giulio Cartari in 1675. Madrid, Prado Museum. Photo: Prado Museum.

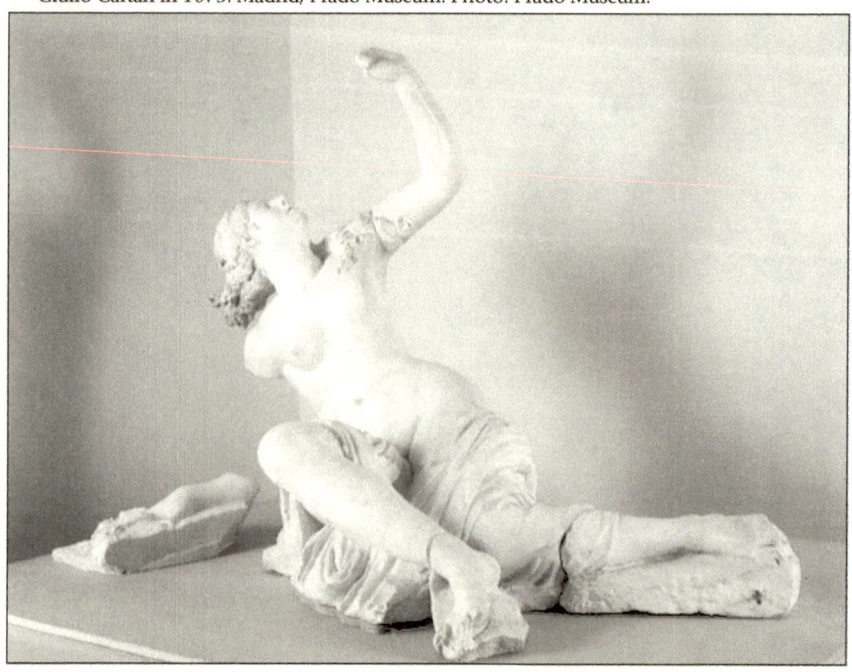

Fig. 11. Camillo Arcucci, Palazzo Riario, Sala delle Muse, plan and elevations, c.1660. Stockholm, Nationalmuseum, Inv. No. 1045/1960, fol. 10 (after C. Nordenfalk).

SARAH BLAKE McHAM
LIST OF PUBLICATIONS

BOOKS

Pliny and the Artistic Culture of the Italian Renaissance: The Legacy of the Natural History, New Haven and London: Yale University Press, 2013.

Looking at Italian Renaissance Sculpture, ed. Cambridge: Cambridge University Press, 1998; paperback edition, 2000.

A Guide to the Chapel of the Arca of St. Anthony of Padua. Padua, Edizioni Messaggero Padova, 1995 [booklet].

The Chapel of St. Anthony at the Santo and the Development of Venetian Renaissance Sculpture. Cambridge and New York, Cambridge University Press, 1994.

The Sculpture of Tullio Lombardo; Studies in Sources and Meaning. Outstanding Dissertations in the Fine Arts. New York, Garland Press, 1978.

BOOK CHAPTERS

"Antiquity as Cultural Capital in the Age of Giorgione." In *Venice in the Renaissance: Essays in Honor of Patricia Fortini Brown.* Ed. Mary Frank and Blake de Maria. Milan: Five Continents, 2012 (forthcoming).

"Giambologna's Equestrian Monument to Cosimo I: The Monument Makes the Memory." In *Patronage and Italian Renaissance Sculpture.* Ed. Kathleen Wren Christian and David J. Drogin. Aldershot, UK: Ashgate, 2010, 195–222.

"Donatello's *Judith* as the Emblem of God's Chosen People." In *The Sword of Judith: Judith Studies across the Disciplines.* Ed. Kevin R. Brine, Elena Ciletti and Henrike Lähnemann. Cambridge: Open Book Publishers, 2010, 307–24.

"Tomba come testamento: Il monumento funerario di Andrea Bregno." In *Andrea Bregno: Il senso della forma nella cultura artistica del Rinascimento.* Ed. Claudio Strinati and Claudio Crescentini. Rome: Ministero per i Beni e le Attività Culturali and Maschietto editore, 2009, 414–29.

"La tomba del doge Giovanni Mocenigo: Politica e culto dinastico." In *Tullio Lombard: Scultore e architetto nella Venezia del rinascimento. Atti del convegno di studi, Venezia, Fondazione Giorgio Cini, 4-6 aprile 2006*. Ed. Matteo Ceriana. Verona: Cierre Grafica, 2007, 81–98.

"Now and Then: Recovering a Sense of Different Values." In *Depth of Field: The Place of Relief in the Time of Donatello*. Ed. Donal Cooper and Marika Leino. Bern: Peter Lang, 2007, 305–50.

"Padua, Bassano, and Treviso." In *Venice and the Veneto*. Ed. Peter Humfrey. Cambridge University Press, 2007, 207–51.

"La Bottega dei Lombardo alla Cappella di Sant'Antonio e la teoria di Pomponio Gaurico." In *I Lombardo: Architettura e scultura a Venezia tra '400 e '500*. Ed. Andrea Guerra, Manuela Morresi, and Richard Schofield. Venice: Marsilio, 2006, 224–39.

"Erudition on Display: The 'Scientific' Illustrations in Pico della Mirandola's Manuscript of Pliny the Elder's *Natural History*." In *Visualizing Medieval Medicine, 1200-1550*. Ed. Jean A. Givens, Karen M. Reeds, and Alain Touwaide. AVISTA Studies in the History of Medieval Science, Technology and Art. Aldershot, UK: Ashgate, 2006, 83–114.

"Structuring Communal History through Repeated Metaphors of Rule: The Interior Decoration of the Palazzo della Signoria." In *Renaissance Florence: A Social History*. Ed. Roger Crum and John T. Paoletti. New York: Cambridge University Press, 2006, 104–37; paperback edition, 2008.

"La Scultura esterna di Santa Maria dei Miracoli." In *S. Maria dei Miracoli in Venezia*. Ed. Mario Piana and Wolfgang Wolters. Venice: Istituto Veneto di Scienze, Lettere, ed Arti, 2003, 123–40.

"The Role of Pliny's *Natural History* in the Sixteenth-Century Redecoration of the Piazza of San Marco, Venice." In *Diverse Approaches to the Representation of Classical Mythology in Art*. Ed. Luba Freedman and Gerlinde Huber-Rebenich. Wege zum Mythos. Ikonographische Repertorien zur Rezeption des antiken Mythos in Europa. Beiheft III. Berlin: Gebr. Mann Verlag, 2001, 89–105.

"Introduction to the Issues, Critical Methods, and Historiography Concerning Italian Renaissance Sculpture." In *Looking at Italian Renaissance Sculpture*. Ed. Sarah Blake McHam. Cambridge: Cambridge University Press, 1998, 1–17.

"Public Sculpture in Renaissance Florence." In *Looking at Italian Renaissance Sculpture*. Ed. Sarah Blake McHam. Cambridge: Cambridge University Press, 1998, 149–88.

"The Cult of St. Anthony of Padua." In *Saints: Studies in Hagiography*. Binghamton: Center for Medieval and Early Renaissance Studies, 1996, 437–66.

"Donatello's High Altar in the Santo, Padua." In *Verrocchio and Late Quattrocento Sculpture*. Ed. Steven Bule et al. Florence: Casa Editrice Le Lettere, 1992, 259-69 (revised version of following article).

"Donatello and the High Altar in the Santo, Padua." In *IL60: Essays Honoring Irving Lavin on his Sixtieth Birthday*. Ed. Marilyn Aronberg Lavin. New York: Italica Press, 1990, 75-89.

"Donatello's Tomb of Pope John XXIII." In *Life and Death in FifteenthCentury Florence*. Ed. Rona Goffen, Marcel Tetel, and Ronald G. Witt. Durham: Duke University Press, 1989, 146-73 and 232-42.

"La Decorazione cinquecentesca della Cappella dell'Arca di S. Antonio." In *Le Sculture del Santo di Padova*. Ed. Giovanni Lorenzoni. *Fonti e studi per la storia del Santo a Padova* VIII.4. Vicenza: Neri Pozza, 1984, 109-72.

ARTICLES

"Pliny's Influence on Vasari's First Edition of the *Lives*." *Artibus et Historiae* 54 (2012): 1-15.

"Reflections of Pliny in Giovanni Bellini's Woman with a Mirror." *Artibus et Historiae* 58 (2008): 157-71.

"Oedipal Palimpsest." *Source. Notes in the History of Art* 27.4 (Summer 2008): 37-46.

"Renaissance Monuments to Favourite Sons." *Renaissance Studies* 19.4 (Sept. 2005) : 458-86.

"Donatello's Bronze *David* and *Judith* as Metaphors of Medici Rule in Florence." *The Art Bulletin* 83 (March 2001): 32-47.

"La Decorazione della Cappella dell'Arca di Sant'Antonio nella Basilica del Santo, Padova, e sue relazioni coll' arte antica." *Rivista di Archeologia. Supplementi* 7. Ed. Gustavo Traversari, (Congresso Internazionale Venezia e l'Archeologia, 1988): 195-98.

"Donatello's *Dovizia* as an Image of Florentine Political Propaganda." *Artibus et historiae* 14 (1986): 9-28.

"The Cult of Mary Magdalen in FifteenthCentury Florence and its Iconography." *Studi Medievali* 3rd ser. 26.2 (1985): 685-98.

"Titian's Paduan Experience and its Influence on his Style." *The Art Bulletin* 65 (March 1983): 51-60.

"Bugiardini's Holy Family in the Indianapolis Museum of Art." *Perceptions* (Bulletin of the Indianapolis Museum of Art) 2 (1982): 7-16.

"Tullio Lombardo's DoublePortrait Reliefs." *Marsyas* 16 (1972-73): 67-86.

MISCELLANEOUS

"Florentine Art 1300–1600." Ed. Margaret King. *Oxford Bibliographies Online*. New York: University Press (forthcoming).

An Antiquity of Imagination: Tullio Lombardo and Venetian High Renaissance Sculpture. Ed. Alison Luchs. National Gallery of Art, Washington, DC, 4 July–31 October 2009. Catalog of the exhibition, essay and entry, 60–65 (with Alison Luchs), and 70–73.

"Scientific and Medical Illustrations in 15th-Century Manuscripts of Pliny the Elder's *Natural History*." *AVISTA Forum Journal* 13.2 (Fall 2003): 44–46.

Entries on Pietro, Antonio, Tullio and Sante Lombardo, *Dictionary of Art*. Ed. Jane Turner. London: Macmillan, 1996, 19:551–61.

Central Italian Sculpture, 1400–1500: An Annotated Bibliography. Boston, G.K. Hall, 1986.

REVIEWS

Alison Luchs, *The Mermaids of Venice*. Burlington Magazine. In press.

Doris Carl, *Benedetto da Maiano: A Florentine Sculptor at the Threshold of the High Renaissance*. CAA Reviews, 2008

Caroline van Eck. *Classical Rhetoric and the Visual Arts in Early Modern Europe*. Renaissance Quarterly 61.2 (Summer 2008): 526-27.

Malcolm Bull, *The Mirror of the Gods*. Renaissance Quarterly 59.1 (Spring 2006): 239–41.

The Henry Moore Institute, Leeds, *Depth of Field: The Place of Relief in the Time of Donatello*. CAA Reviews, 2005.

Charles Dempsey, *Inventing the Renaissance Putto*. Studies in Iconography 24 (2003): 248–51.

Francesco Caglioti, *Donatello e i Medici*. CAA Reviews, 2002.

Joseph Manca, *Ercole de'Roberti*. Italian Quarterly 38.149–50 (Summer-Fall 2001): 105–7.

Andrew Butterfield, *The Sculptures of Andrea del Verrocchio*. Renaissance Quarterly 52.2 (Summer 1999): 517–18.

Anne Markham Schulz, *Giammaria Mosca called Padovano: A Renaissance Sculptor in Italy and Poland*. Burlington Magazine 140.1151 (February 1999): 117–18.

Stuart Currie and Peta Motture, *The Sculpted Object 1400–1700*. Renaissance Studies 12.4 (December 1998): 586–90.

Michael Hirst and Jill Dunkerton, *Making & Meaning: The Young Michelangelo;* and William E. Wallace, *Michelangelo at San Lorenzo: The Genius as Entrepreneur. Italian Quarterly* 35.137-38 (Summer-Fall 1998): 133-37.

Paul Barolsky, *Why Mona Lisa Smiles and other Tales By Vasari;* and *Giotto's Father and the Family of Vasari's Lives. Italian Quarterly* 33.127-28 (Summer-Fall 1996): 117-20

Robert Klein and Henri Zerner, *Italian Art, 1500-1600: Sources and Documents. Italian Quarterly* 33.127-28 (Winter-Spring 1996): 128.

Leonardo da Vinci. Exhibition, Hayward Gallery, London. *Italian Quarterly* 33.127-28 (Winter-Spring 1996): 127.

Michael Levey, *The Pictures in the Collection of Her Majesty the Queen: The Later Italian Pictures. Italian Quarterly* 33.127-28 (Winter-Spring 1996): 128.

Robert Munman, *Sienese Renaissance Tomb Monuments. Renaissance Quarterly* 48.4 (Winter 1995): 902-3.

Alison Luchs, ed., *Italian Plaquettes: Studies in the History of Art. Italian Quarterly* 32.125-26 (Summer-Fall 1995): 151-52.

James Beck, *Jacopo della Quercia. Renaissance Quarterly* 46.2 (Summer 1993): 366-68.

James Beck, ed., *Raphael before Rome. Italian Quarterly* 32 (1991).

Michael Hirst, *Michelangelo and his Drawings. Italian Quarterly* 32 (1991).

Luciano Cheles, *The Studiolo of Urbino: An Iconographic Investigation. Italian Quarterly* 32 (1991).

Sheila ffolliott, *Civic Sculpture in the Renaissance: Montorsoli's Fountains at Messina. Renaissance Quarterly* 40.1 (Spring 1987): 114-16.

Roger Jones and Nicholas Penny, *Raphael;* and Frances AmesLewis, *The Drawings of Raphael. Italian Quarterly* 28.108 (Spring 1987): 124-26.

David Rosand, *Painting in Cinquecento Venice: Titian, Veronese, Tintoretto. Italian Quarterly* 26 (1985): 54-57.

Paul Watson, *The Garden of Love in Tuscan Art of the Early Renaissance. Italian Quarterly* 23.87 (Winter 1982): 111-13.

INDEX

A

Aachen 192, 193, 196, 200, 204, 205
Abraham and Isaac 2
Accademia Fiorentina 172
Actium 243
acts of mercy 135
Adam and Eve 2
Adriaen de Vries 57
Adriano Fiorentino 44
Africa 245
Agnus Dei, image of 136, 141, 142, 146
Aimon of Halberstadt 143
Alberti, Leon Battista 10, 12, 13, 18, 20, 21, 196, 203; *On Painting* 12, 14, 19–18
Alcantara, order of 241
Alexander VII, pope 277; tomb 286, 288
Algardi, Alessandro 284, 288
Alhazen 5, 16; *De aspectibus* 16
Allegory of Divine Misericordia 131–160
Amadeo, Giovanni Antonio 44
Ames-Lewis, Francis 199
Ammanati, Bartolomeo 59; Fountain of Neptune 250
ancient art restoration 284
Andrea da Firenze 36, 37
Andrea di Bonaiuti, *Way of Salvation* 147, 160
Angilbert 202
Angiolini. Franco 242
Anonimo Magliabechiano 85
Antico 118
Antioch 215
Antonius 174
Apocalypse 203; illustrated manuscripts 142. See also, Last Days and Last World Emperor
Apollonio di Giovanni 87
Apollo Playing the Lyre 286
Aquila, Francesco 287
Aquinas, Thomas 5
Aranjuez, palace of 287
Archenholtz, Johann Wilhelm 280
architecture, Tuscan Romanesque 197–198
Arcucci, Camillo 272, 303

Arezzo 72, 100, 172, 173, 188, 247; Museo Statale d'arte medievale e moderna 110; S. Francesco 201
Ariadne 58
Aristotle, *Rhetoric* 166
Arno River 197, 244
Arte di Calimala 184, 187, 189
Assisi, S. Francesco 8
Athaulf, king 192
Athena 284
Augustine 5, 6; *De civitate Dei* 140, 143, 144, 146; *De civitate Dei*, illustrated manuscripts 142, 160; Rule of 218
Augustus, emperor 243
Avery, Charles 65, 73, 167
Azzolino, Decio, cardinal 275–276, 284, 294–295
Azzolino, Pompeo 295

B

Bacchic Altar 282, 285, 289, 299
Bacchus 167
Bacon, Roger 5
Baldinucci, Filippo 278
Balestra, Pietro Maria 286, 288
Baltimore, Walters Museum 122, 181
Bandinelli, Baccio 45, 120; *Apollo* 170; *Ceres* 170; statue of Andrea Doria 120; statue of Giovanni delle Bande Nere 120
Bandini, Giovanni, Monument to Ferdinando I 240, 252–253, 256–257, 259, 263
Baptism 146
Barbary Coast 241, 256; pirates 255
Barberini, Francesco, cardinal 271
Barbino, Pietro 161, 163, 165, 170, 175
Belviglieri, Carlo 220
Benedictine Olivetan Order 205
Berlin, Staatliche Museen 108
Bernini, Domenico 278
Bernini, Gian Lorenzo 267–304, 277–280, 293–294
ancient art restoration 285–289
Apollo and Daphne 294

A SCARLET RENAISSANCE ■

Bernini *continued*
 Bust of Louis XIV 288
 Constantine the Great 277
 Elephant Carrying the Obelisk 286
 Faun Teased by Children 286
 Salvator Mundi 279–280, 299
 St. Theresa in Ecstasy 289
 tomb of Cardinal Pimentel 286
 Truth Revealed by Time 279
Bernini, Luigi 278
Berthelot, Guillaume 284
Bianco, Simone 118
Bible moralisée 142
Billi, Antonio 85
Bologna 250, 270; Fountain of Neptune 59
Bomarzo, Sacro Bosco 169
Bona, siege of 241, 252, 255
Bonaparte, Napoleon 219
Borghese, Scipione, cardinal 284
Borghini, Raffaello 58, 69, 98; *Il Riposo* 58, 219
Borgo San Sepolchro 173, 247
Borromini, Francesco 272
Botticelli, *Primavera* 98
Bourdelot, Pierre 269, 271
Boyer, Ferdinand 282
Bracciano 271
Braccio di Bartolo, see Morgante
Brandenburg 282
Bregno, Andrea 40, 45
Bronzino, Agnolo 57–82, 166–167; portrait of Cosimo I de' Medici 250; *Morgante* 60, 76, 180; *Reclining Venus with Cupid and a Satyr* 57, 62, 70, 74, 75; *Resurrected Christ* 60
Brunelleschi, Filippo 12, 85, 92, 94, 102, 196
Bruni, Leonardo, *History of Florence* 191, 197
Brusati, Giuseppe 272
Brussels 270
Bufalo family 67
Buggiano 85, 92, 94, 99, 102, 104
Buglioni, Santi 91
Buontalenti, Bernardo 170
Burgundy, dukes of 241

C

cabinet of curiosities 168, 169
Caesar, gilded bronze statue 285, 289
Cain and Abel 2
Calamech, Andrea, Monument to Don Juan of Austria 254

Calatrava, order of 241
Callot, Jacques 161
Careggi 86, 88
Carlo Emanuele I, duke of Savoy 64
Caroto, Gian Francesco, *San Giorgio and the Princess* 225, 226
Carpio y Heliche, marqués del 283
Cartari, Giulio 286, 287–288; Christina, marble bust portrait of 287; *Clytie* 287, 302
Castiglione, Baldassare, *Il libro del cortegiano* 50
Castiglione, Branda, cardinal 19
Castiglione Olona 19, 31
Cavalieri di Santo Stefano 239–266, especially 240–241, 246, 248, 250–251, 252, 254, 257; fleet of 246; iconography of 239, 247–248
Cavallini, Pietro 8
Cellini, Benvenuto 45, 91, 120; bust of Cosimo I 117, 118; *Ganymede* 70; *Perseus* 45, 55, 70, 117, 120
Cencio della Nera 60, 168
Cennini, Cennino 92
centaurs 165
Centula, St. Riquier 202
Chantelou, Paul Fréart de 278, 280
Chanut, Pierre 280
Charlemagne 174, 192, 195, 197, 200, 202, 204
Charles V, emperor 254
Chelli, Francesco 282, 285
Chiusi 172
Chosroes, king 200
Christina of Sweden 267–304
 ancient art collection 280–284
 conversion 269–270
 death inventory 282
 life 268–269
 manuscripts 270
 painting collection 270–271
 paintings by Bernini 279–280
Christine of Lorraine 249, 251
Cicero 47
Cioli, Valerio, da Settignano 161, 167, 169, 171, 172, 174, 175, 178
Civate, S. Pietro 142
classical learning, revival of 165
Claussen, Peter 36
Clementini family 282
Clement VII, pope 284
Cleopatra 58

INDEX

Clytie 302
Codice Strozziano 85
Cole, Michael 72
Colucci, Angelo 66
Commodus as Hercules, bust 119
Como, Cathedral 44
Condulmer, Gabriele 217
confraternities 132, 133, 148, 152
Constantine 193, 198–200
Constantinople 205
Constantius III, emperor 191, 192
Copenhagen 168
Correggio, Antonio da, *Venus, Satyr and Cupid* 65, 74
Correr, Angelo 217; Gregorio 50
Corsini family 291
Cortona 173, 247
Cosmas and Damian, saints 91
Cossa, Francesco 164
Cresci, Giovanni Francesco 46
Cross, cult of 198–205; legend of the True 200, 205
Crusade, First 244, 251
Cyclops 165
Cyprus 214, 215

D

Daddi, Bernardo 134, 153, 154
Daedalus 47
Dancing Faun 284
Danielson, Cornelia 254
Dante 131
Day 286
Dead Amazon 68
Dead Gaul 68
Decius, persecutions of 197
Del Drago family 282
Dempsey, Charles 83, 85, 100
Descartes, René 269
Desiderio da Settignano 94; *Laughing Boy* 93
Dietl, Albert 38, 47
Dioscorides 90
Dioscuri 300
Dominican Order 133, 147, 152, 199
Donatello 12–15, 20–21, 36–37, 39–40, 45, 47, 48, 50, 84, 92, 94; *David* 176; *Dovizia* XV; *Feast of Herod* 13; *Gattamelata* 48; *Judith and Holofernes* XV, 35, 52, 96; *Pecci Tomb* 56; *St. George* 13
Don Carlos, bust of 121

Douai, Flanders 57; Musée de la Chartreuse 95, 101, 106, 110
Dresden, Staatliche Kunstsammlungen 122
Dughet, Gaspard 290
Dürer, Albrecht, *Christ in Distress* 68

E

Ecclesia 146; image of 141
Ecclesiastes 16:15 144
Egypt 89
Einhard 192
Elba, Cosmopoli 164
Eleanor of Toledo 172
Escorial 64
Este, Borso d' 164; Francesco II d', duke of Modena 288; Ippolito d', cardinal 67
Etruscan art 171, 172; *Chimera* 172; *Minerva* 172
Etruscan origins of Florence 172, 174
Eugenius IV, pope 217, 227
Euterpe 286, 301
Ezekiel 150–151

F

Falda, Giovanni Battista, Aerial view of the Palazzo Riario 296
Farnese, collection 284; Isabella 295; Ottavio, duke of Parma 69; Ranuccio II, duke of Parma 267, 284
Faun with a Goat 284, 285, 286
Fazio, Bartolomeo, *De viris illustribus* 50
Fernando Álvarez de Toledo, duke of Alba 121
Ferrara 270; Palazzo Schifanoja 164
Ferrata, Ercole 286
Ferrucci, Matteo 101
Festina lente 175, 176, 182
Fiesole 173, 247
Fischer, Billie Gene Thompson 171, 172, 175
Florence 81–117, 131–160, 173
 Accademia Fiorentina 58
 Badia 131
 Baptistery 1–24, 12, 31, 37, 97, 131, 135, 146, 147, 196; *Last Judgment* 158
 Bardini Museum 94, 105
 Bargello 60, 106, 115, 118, 260
 Boboli Gardens 161, 169, 170, 176, 179, 250; Limonaia 176
 Brancacci Chapel 13

313

Florence *continued*
 Campanile 90, 103, 131, 135, 150
 Cathedral 37, 85, 99, 102, 131, 135, 147, 150, 183
 Christianity, founded in 197
 Giardino Botanico de'Simplici 170
 Holy Sepulcher iconography in 203
 Kunsthistorisches Institut 178
 Loggia dei Lanzi 69, 168
 Mercato Vecchio xv
 Misericordia, Compagnia di Sta. Maria della 132–133, 156, 157; residence of the 131
 Museo Archeologico 58
 Museo del Bigallo 131, 156, 157
 Orsanmichele 13, 37, 188, 189; Compagnia di Sta. Maria d' 135, 149
 Ospedale degli Innocenti 97
 Ospedale di S. Giovanni Evangelista 149
 Palazzo dei Priori 12
 Palazzo del Podesta 131
 Palazzo di Parte Guelfa 59
 Palazzo Pitti 161, 162, 169–170, 250
 Palazzo Vecchio 61, 88, 164, 173, 174, 244; Salone del Cinquecento 173; Salone del Cinquecento, *Foundation of Florence* 173, 175
 Piazza della Signoria xv, xvi, 59, 120, 131, 244, 246, 250; *Neptune* 59; plan 155
 Piazza S. Giovanni 133, 134, 144, 148, 149
 Piazza S. Lorenzo 120
 Roman origins of 172–173, 197
 Salviati Chapel 64
 S. Lorenzo 131
 S. Marco 199; Casino di 60
 S. Miniato al Monte 183, 195, 197, 207; chapel of the Cardinal of Portugal 195; imperial patronage 195–196; plan 210; Tabernacle of the Crucifix 183–212, especially 186, 206, 208, 210; S. Pancrazio, Rucellai Chapel 203, 204
 SS. Annunziata 183; Guadagni Chapel 60
 Sta. Croce 131, 201; Cavalcanti Altar 85; Pazzi Chapel 94
 Sta. Maria Maggiore 131
 Sta. Maria Novella 13, 131, 133, 203; chapter house 147, 211
 Sta. Reparata 131, 149
 Sta. Trinita 185
 Temple of Mars 196
 Uffizi 168, 180; Tribuna 168, 170
 Villa della Petraia 249
 Villa Il Riposo 58
 Florentie Urbis et Reipublice Descriptio 146
 Fontana, Carlo 287; Simone 71, 73
 Fra Angelico, San Marco Altarpiece 91
 Francavilla, Pietro 70, 72, 248; Monument to Cosimo I 240, 248–50, 258, 260, 262; iconography of 250–251
 Franciscan Order 201
 Frederick II, emperor 193
 Frederick III, emperor 195
 Freinsheimus, Johan 269
 Frugoni, Chiara 145
 Fruosino, Bartolomeo di 87, 103
 Fuga, Ferdinando 291, 295
 Fusina, Andrea da 40

G

Gaasbeek 121
Gabrio Serbelloni, bust of 122
Gaddi, Agnolo 185, 200
Galen 90
Galla Placidia 191, 199, 204; *see also* Ravenna, Mausoleum of
Gaulin, Gilbert 270
Genoa 120, 245
Ghiberti, Vittorio 97, 107
Ghiberti, Lorenzo 36, 39, 40, 45, 48, 50
 Commentaries 4, 5, 17
 Gates of Paradise 1–34, 37, 53; Adam and Eve 26; Cain and Abel 4, 29; Flagellation 25; Jacob and Esau 2–24; Noah 2, 3, 27; Resurrection 25; Sacrifice of Isaac 1, 25; Solomon and the Queen of Sheba 30; St. John before Herod 18
 St. John the Baptist 35, 37, 51
Giambologna xiii, 57–82, 165, 167, 170, 248, 254; Cosimo I XV, 246; Fountain of Neptune 250; *Morgante Riding a Sea Creature* or *Morgante on a Dragon* 60, 61, 77, 168, 181; *Oceanus* 250, 260–261; *Rape of the Sabines* 69; *Reclining Nymph/ Venus* 57, 62, 66, 71, 73–75, 78, 80; *Resurrected Christ* 60; *Samson Slaying a Philistine* 59; *Venus* 63
Giambullari, Pierfrancesco, Il Gello 172
Giotto 38, 131
Giovanni di Martino da Fiesole 45, 56

■ INDEX

Giustiniani, Lorenzo 218
Giusto de' Menabuoi 8
Gnocchi, Lorenzo 194
Godfrey of Bouillon 251-252
Goes, Hugo van der, *Portinari Triptych* 98
Golden Fleece, Order of the 241, 250-251, 252
Golgotha 200, 202, 203
Gonzaga, Barbara 164; Ferrante 114; Ludovico 164; Vespasiano 121
Good Friday 202, 204
Good Shepherd 199
Goritz, Hans 66
Granvelle, Antoine Perrenot, cardinal 121
Grassi, Alessandro 122
Graziani, Francesco 292
Gregory I, pope 223
Gregory XII, pope 217, 228
Grotius, Hugo 270
Guidi, Domenico 286, 288-289; *Andromeda and the Sea Monster* 288; *Divine Love* 289; *Lamentation over the Body of Christ* 288; *La Renommée* 288; *Terrestrial Love* 289; *Vision of St. Joseph* 289
Guillelmus, sculptor 47
Gunegonda, empress 195
Gustav Adolf, king 268

H

Hamburg 270, 275; Museum für Kunst und Gewerbe 119
Heinsius, Nicolaas 269, 271
Heitz, Carol 202
Hendler, Sefy 61
Henri II de Lorraine, Duc de Guise 268
Henry II, emperor 195, 196
Heraclius, emperor 200
Hildegard, wife of Charlemagne 195
Hippocrates 90
Holderbaum, James 60
Honorius, emperor 192
hunting 162, 170
Hygiaia 284
Hypnertomachia Poliphili 65, 89, 99, 109

I

Iberian Peninsula 241
Imperium Romanum 193
India 245

India, Bernardino, *Martyred Saint(s)* 222, 237-238
Innsbruck, Hofkirche 270
Islam 241
Israel, Manasse ben 270

J

Jacques de Broeucq 57
Jerome 9
Jerusalem 216; Holy Sepulcher 186, 200, 202-205, 252; New 139, 141-152
Josephus 7, 8, 23
Julius II, pope 66
Juren, Vladimir 42

K

Karl Gustav, king of Sweden 270, 278
Ketham, Johannes de 90; *Fasiculo de medicina* 90
Knights of Malta 239, 240, 255
Krautheimer, Richard 10, 11, 16

L

Lamberti, Niccolò, *St. Mark* 37, 52; Piero di Niccolò 45, 56
Last Judgment 135, 136, 138-152, 147
Last World Emperor 200, 204
Le Blon, Michel 281
League of Cambrai, War of the 227
Leonardo da Vinci 58, 90; *Treatise on Painting* 71-72, 269
Leoni, Leone, Bust of Charles V 111-130; *Charles V and Fury Restrained* 254; medals 115, 116, 124
Leoni, Pompeo 64, 113
Lepanto, battle of 241, 254
Lepidus 174
Levant 241, 245
Liebenwein, Wolfgang 185
Lionne, Madame de 278
Livorno 173, 245-47, 252-253, 255-257; plan 264; view 264; Piazza Micheli 259, 265-266; sculpture 239
Livy 69
Lodi, Museo Civico 122
Lombardo, Pietro 40
Lombards 192
London, British Museum 124
Louis XIV 278, 289
Lucca, Cathedral 60

Ludovisi Dioscuri 283
Lutheranism 269
Lützen, battle of 268
Lycosthene, Konrad, *Prodigiorum ac ostentorum chronicon* 166
Lysippus 39

M

Madrid, Museo Nacional del Prado 112, 123, 295, 299, 300, 301, 302
Maffei family 66
Maiestas Domini 204
Malatesta, Sigismondo 193, 194
Mandel, Corinne 176
Manetti, Antonio, biography of Brunelleschi 12, 50
Mannerist period 166
Man Riding a Tortoise 182
Mantegna, Andrea 164
Mantua 270; Castello, Camera Picta 164
Maratta, Carlo 283
Marc Antony 243
Marciano in Val di Chiana 242–243
Marcus Aurelius, Equestrian Monument to 254
Maria Eleonora, princess of Brandenburg 268
Marini, Angelo 122; bust of Alessandro Grassi 129
Martin, Thomas 118
Mary, queen of Hungary 111, 121
Masaccio 12, 13, 15; *Holy Trinity* 13, 14, 21, 203, 211; *Tribute Money* 13; *Feast of Herod* 19, 31
Massimo, Carlo Camillo II 283
Mattei family 282
Matthiae, Johannes 268
Maxentius 198
Mazarin, Jules, cardinal 269, 271, 272
McHam, Sarah xi, xii, 84
Medici
 Carlo de', cardinal 276
 Casino de' 59
 Cosimo I 57, 59, 161, 162, 164, 165, 167, 168, 171, 172, 173, 175–176, 183, 190, 191, 199, 239; horoscope of 243; victory over Siena 173, 174. *See also* Francavilla, Pietro, Monument to Cosimo I;
 Cosimo II, de' 253
 Cosimo III, de' 176
 court 57, 59, 74, 91, 163, 167
 devices 183, 197, 205
 dwarf, *see* Morgante
 dynasty 199
 Ferdinando de' 59, 60, 62, 64, 67, 72 239–266, especially 246–48
 Ferdinando II de' 253
 Francesco de' 59, 62, 64, 164, 167, 168, 170
 Giovanni delle Bande Nere de' 64
 Lorenzo de' 44, 88, 93, 172
 Piero di Cosimo de' 183–212
 hegemony 252, 257
 iconography 245, 252
 inventory of 1574 171
 legitimacy 195, 243, 244
 Palace, studiolo 194
 Piero de, library 191
 policy 240–241
 villas, Careggi 86, 88, Castello 163, Pratolino 98
 zoo 176–177
Melioli, Bartolommeo, medal of Lodovico III Gonzaga 119
Messina 254
Michelangelo 45, 59, 73, 113; Bust of Brutus 118; *David* 163; *Pietà* 42, 48, 49, 54
Michelozzi, Girolamo 58
Michelozzo 3, 93, 186
Milan 64, 101
Mino da Fiesole 36, 37, 39, 40, 95, 96, 106; Bust of Piero de' Medici 118
Modena 282
Moderno 40
Monnot, Pierre 285
monsters 165–166
Montagnana, Bartolomeus 90; *Tractatus de urinarum iudiciis* 90
Montauto, Torquato di 276
Montecuccoli, Raimondo, count 277
Montemurlo 242–243
Montepulciano 173, 247
Moretto da Brescia, *Saint Cecilia and Female Saints* 219, 220, 222, 226, 228, 234
Morgante, Medici court dwarf 60, 161, 162, 163, 165, 167
Morosini, Angelo 277
Moscardo, Ludovico, *Historia di Verona* 220
Mount of Olives 200

INDEX

N

Narcissus Admiring His Own Reflection 284
natural wonders 165, 166
Naudé, Gabriel 269, 271
Neptune 163
New York, Metropolitan Museum 117, 182, 286, 288; Quentin Foundation Collection 62
Niccolò, pupil of Wiligelmo 35
Niccoli, Niccolò 191
Night 286
Nocchieri, Francesco Maria 287, 292, 302

O

Octavianus 174
Odescalchi inventory 285
Odescalchi, Livio 285, 295
Onofri, Crescenzio 290
Oratorians 284, 285
Orcagna 189
Orsini, Alfonsina 68; Paolo Giordano II 271; Vicino 169
Ottoman Empire 239, 241–242, 245, 247, 252
Ovid, *Metamorphoses* 69, 294
Oxenstierna, Axel, chancellor 268–269; Gabriel 268–269
Oxford, Ashmolean Museum 116; Bodleian Library 140

P

Paatz, Elizabeth 198
Padua 38, 271
Padua, Baptistery 8; basilica of Saint Anthony xiv
Paestum, temple of Hera at Foce del Sele 171
Pagno di Lapo 85, 102
Palbitzki, Mathias 281
Panisperna Venus 282, 290
Panofsky, Erwin 16
Paoletti, John 183
paragone 58–82
Parione 66
Paris, Louvre 65, 94, 96, 105, 119, 120, 278, 284; Musée Jacquemart-André 93, 104; National Archives 282; Pont Neuf 254
Parma 272

Partridge, Loren 164, 248
patronage 183, 184, 195–196, 198, 205, 245
Pavia, Certosa 44; S. Lanfranco 44
Peckham, John 5
Pellizzone, Andrea 64
Penny, Nicholas 118
Persico, Giovan Battista Da 220
Petrarch, Francesco 38, 47
Pfisterer, Ulrich 38
Phalanthos 172
Philip II, busts of 120
Philip V of Spain 295
Pierino da Vinci 86, 100, 101, 110
Piero della Francesca 201
pilgrimage 144, 189, 200, 205
Pimentel, tomb of cardinal 286
Pisa 173, 243–245, 246, 247; botanical gardens 170; Cathedral 47; Palazzo degli Anziani 244; Piazza dei Cavalieri 245, 246, 248, 253, 257, 258; sculpture 239–266
Pisano, Andrea 90, 103; Giovanni, *Madonna and Child* 38
Pistoia 173, 247; Ospedale del Ceppo 91
Pius IV, pope 240
Pius V, pope 215, 218, 228, 229, 242
Planiscig, Leo 116
Pliny xvii, 36, 44, 45, 90; *Natural History* 42, 165, 166
Poliziano, Angelo 42
Pomposa 142
Porta, Guglielmo della, bust of Paul III 119
Portigiani, Fra Domenico 64; Zanobi 72
Pozzo, Bartolomeo Dal, *Le vite de' pittori* 219
Pozzo, Cassiano dal 271
Prague 64
Prato 173, 247; Cathedral 85
Preveza, capture of 241, 252
Putto Mictans 81–117

Q

Quicchelberg, Samuel 168

R

Rainaldi, Carlo 272
Raleigh, North Carolina Museum of Art 87
Randolph, Adrian 194
Raumschüssel, Martin 63
Ravenna 186, 189–192, 197; Mausoleum of Galla Placidia 190, 191, 194,

317

Ravenna *continued*
 195, 199, 210; Sant' Apollinare in Classe 193; S. Giovanni Evangelista 204; Sta. Croce 199; S. Vitale 191, 192; tomb of Valentinian the Elder 191
Reformation 217
Regensburg 200
relics 197; of the Passion 200, 202, 205
Riario, Ottavio 295
Richelieu, Armand, cardinal 269
Richelson, Paul 244
Richter, Gisela M.A. 171, 172
Ridolfi, Carlo, *Le meraviglie dell'arte* 219, 220
Rimini 193; Malatesta Temple 193; S. Francesco 193
Rizzo, Antonio 50
Robbia, Andrea della 97, 108; Luca 12, 186, 194
Rodari, Tommasso and Giacomo 44
Romano, Gian Cristoforo 50; tomb of Gian Galeazzo Visconti 44
Rome 59
 Capitoline Museum 119
 Cappella del Palazzo del Monte di Pietà 288
 Casino Riario 273
 Castel Sant'Angelo 91
 Chiesa Nuova 284
 Dioscuri 38
 Galleria Borghese 294
 Lungara 267, 273
 Milvian Bridge, battle of the 198
 Old St. Peter's 8
 Palace of Decius 282
 Palazzo Altemps 284
 Palazzo Corsini, see Palazzo Riario.
 Palazzo Farnese 267
 Palazzo Riario 267, 272–276, 289–294, 296–298, 303
 Palazzo Rospigliosi-Pallavicini 272
 Pantheon 287
 Ponte Sant'Angelo, Angel with the Cross 286, Angel with the Lance 289, Angel with the Superscription 288
 Porta del Popolo 270, 273, 277
 Quirinal 272
 S. Lorenzo in Lucina, Cappella Fonseca 288
 S. Lorenzo in Panisperna 282
 S. Paolo fuori le Mura 8
 S. Sebastiano Fuori le Mura 299
 Sta. Cecilia in Trastevere 8
 Sta. Maria della Vittoria, Cappella Cornaro 289, 293
 Sta. Maria in Campo Marzio 139
 Sta. Maria sopra Minerva 113, 286; Piazza di 286
 St. Peter's 37, 48, 286, 287, 288
 Vatican 58, 66; *Ariadne* 67; *Belvedere* 66; Cathedra Petri 286; Pinacoteca, *Last Judgment* 139, 159; Scala Regia 277
 Villa Borghese 274
 Villa Farnesina 274
 Villa Madama 284
 Villa Medici 62, 68
Romolo del Tadda 161
Rosetti, Giovanventura, *Plictho* 92
Rossellino, Bernardo 94, 104, 107
Rouen, Musée des Beaux Arts 219
Rovere, Francesco Maria II della 71
Rucellai, Giovanni 204. *See also* Florence, S. Pancrazio, Rucellai Chapel.
Rudolf II, emperor 64, 121

S

Salviati family 67; Alamanno 62, 64; Jacopo 62, 64; Maria 64
Sandrart, Joachim von 281
Sangallo, Francesco da, Bust of Giovanni delle Bande Nere 115
San Ildefonso Group 290, 300
Sanmicheli, Michele 222
Sansovino, Andrea 45; Jacopo 45
Santo Stefano, Order of, see Cavalieri di Santo Stefano
sarcophagi 190
satyrs 165
Savelli family 282
Schedel, Hartmann, *Liber Chronicarum* 166
Schlegel, Ursula 203
Scocola 164
Secular Canons 213, 216, 228
Segovia, La Granja de San Idelfonso 286, 287, 295
Serbelloni, Gabrio, bust of 122, 130; Giovanni Antonio, bust of 122
St. Barnabas, imagery of 226–228; life 215; miracle of 216. *See also* Veronese, Paolo, *Saint Barnabas Healing the Sick*
St. Fermo 223

INDEX

St. Giovanni Gualberto 184, 187; crucifix of 201; cult of 187, 205; description 187–188; moved 185. *See also*, Florence, S. Miniato al Monte, Tabernacle of the Crucifix. St. Helen 200
St. Jerome 223
St. John of Jerusalem, Order of 240
St. Lawrence 199
St. Matthew 136, 139, 142, 152; Gospel of 131, 214, 216, 229
St. Mark 216, 229
St. Minias 188, 189, 197
St. Paul 215
St. Rustico 223
St. Stephen 243
Shakespeare, William 95
Siena 39, 173, 243, 247; Baptistry 13, 18, 84; Cappella Chigi, St. Catherine 286; Cathedral 56
Silenus 163, 167
Silfvercrona, Pieter Spiering 281
Simian Mountains 165
slave trade 255–256
Sleeping Ariadne 66, 76
Smaghi, Lorenzo Bini 61
Soykut, Mustafa 247
Sperandio 40
Spezioli, Romolo 295
spolia 192–195, 198
Stampa, Giacomo Maria, bust of 122, 128
Starn, Randolph 164, 248
Statue of a Faun 285
Steinberg, Leo 82
Stockholm, Nationalmuseum 303; Riddarholmskyrkan, Karolinska Chapel 278
Susini, Antonio 72, 73

T

Tacca, Pietro 72; Monument to Ferdinando I, Four Moors 240, 252–255, 259, 265–266
Tadda, Francesco del 176
Taracone 89
Tasso, Torquato, *Gerusalemme Liberata* 251
tau, the symbol of the 150–151
Tempesta, Antonio, *Pianta di Roma* 296
Tetrode, Willem Danielsz. van 70
Tertullian 151–152
Tessin, Nicodemus, the Younger 278, 290–291

Tetrode, Willem Danielsz. van 70
Texeira, Manoel 295
Theodoric, Ostrogoth king 192
Theophilus 90, 92
Titian 74; *Bacchanal of the Andrians* 97; *Pardo Venus* 65
Tivoli, Hadrian's Villa 284, 286
Torso Belvedere 68
Trasimene, lake 172
Traversari, Ambrogio 190, 191; *Hodoeporicon* 190
Trent, Council of 213, 217, 223, 224, 226, 229
Trichet Du Fresne, Raphael 269, 271
Tullio Lombardo XIII
Turin 64
Turpin, Adriana 168

U

Urban VIII, pope, tomb 286
Urbino 270
Utens, Giusto 170, 181
Utrecht 270

V

Valentinian III, emperor, See Ravenna, tomb of Valentinian the Elder
Valentinianus 192
Vallombrosan Order 187
Valori, Baccio 58
Varchi, Benedetto 58, 61
Vasari, Giorgio 13, 59, 62, 86, 164, 168; *Lives* 50, 100, 117, 162, 163, 186, 222; *Salone del Cinquecento* 173, 174, 175
Vecchietti, Bernardo 58, 59
Venetian Republic 229
Venice 101, 218, 270; Galleria del Seminario 119; Galleria Giorgio Franchetti alla Cà d'Oro 119; Porta S. Giorgio 227; S. Giorgio in Alga 216, 228; S. Sebastiano 119; SS. Giovanni e Paolo, tomb of Doge Giovanni Mocenigo xvi, 45, 56
Venus Anadiomene 290
Venus Bathing 290
Verona, Borgolecco di S. Giorgio 227; hospital of St. Barnabas 226–227; S. Giorgio in Braida 213, 235, 236; S. Giorgio in Braida, plan 233; S. Giorgio in Marega 225; S. Zeno 35

319

Veronese, Paolo 213–238; *Apotheosis of Saint George* 222, 225; *Martyrdom of Saint George* 213, 230–231; *Saint Barnabas Healing the Sick* 213–238, 232, 236, iconography 223, location 219–224
Verrocchio, Andrea del 86, 88; *Putto with a Dolphin* 176
Verrocchio, Tommaso del 86
Versailles, Neptune Fountain 289
Vienna 93; Kunsthistorisches Museum 107, 121; Nationalbibliothek 142
Villani, Giovanni, *Chronicle of Florence* 188, 191, 195
Villani, Matteo 133
Vistarini, Ludovico, bust of 122
Vitruvius, *De architectura* 16, 17
Vittoria, Alessandro 118; bust of Benedetto Manzini 119; bust of Giambattista Ferretti 119; bust of Marcantonio Grimani 119; bust of Nicoló da Ponte, doge 119
Volterra 173, 247
Voragine, Jacobus de, *Golden Legend* 200, 201, 215

Vossius, Gerard 270
Vries, Adriaen de 63, 64, 73, 121, 122; *Bacchus Wearing a Silenus Mask* 64; bust of Christian II of Saxony 122; *Christ in Distress* 68; *Crouching Gladiator* 63; *Reclining Venus/Nymph* 65; *Satyr* 79

W

Wang, Aileen 48
Warren, Jeremy 116
Washington, National Gallery of Art 117, 119, 121, 125, 126
Wefelt, Leon, count 295
Wiles, Bertha Harris 161
Wiligelmo 35, 52
Windsor Castle 121, 127
Witelo 5
Witte, Peter de (also Pieter Candido) 74

Z

Zeno, Byzantine emperor 192

*This Book Was Completed on February 4, 2013
at Italica Press, New York, New York.
It Was Set in Gills San and ITC
Giovanni. It Is Printed on
60-lb Natural Paper
in the USA, EU
and UK.*

www.ingramcontent.com/pod-product-compliance
Lightning Source LLC
Chambersburg PA
CBHW020726180526
45163CB00001B/126